A HISTORY OF

Far Eastern Art

Far

A HISTORY OF

Eastern Art

BY SHERMAN E. LEE

Director, and Curator of Oriental Art, The Cleveland Museum of Art

PRENTICE-HALL, INC., ENGLEWOOD CLIFFS, N. J.
AND HARRY N. ABRAMS, INC., NEW YORK

Milton S. Fox, *Editor* Philip Grushkin, *Designer*

Library of Congress Catalog Card Number: 64-11575
Printed and bound in Japan

CONTENTS

PREFACE

IF ONE BEGAN THE STUDY of Oriental art in the 1930s, as the author did, one often heard the query still current among students in the 1960s: Where can I find a general survey of the art of Eastern Asia? What book can be recommended to the art major in college, or to the interested layman who is aware of the Orient but unable or unwilling to plow through the ever more forbidding number of general works — studies of the art of China, or India, or Japan? Books in each of these categories may include numerous references to the arts of other Asian countries, but only as incidentals. The main relationships become lost in the forests of national interest and book space requirements. Even more frustrating are those general works that cater to the minority interest in the "mystery" of the East, or to the guilty conscience of those who deplore the West's assumedly materialistic attitudes. These introductions are legion and can be countered only by reference to such an obscure and specialized source as "Chinese Civilization in Liberal Education" (in *Proceedings of a Conference at the University of Chicago,* Chicago, 1959), in which Dr. Alexander C. Soper III has written the sanest and most telling, if curt and fragmentary, account of the place of Chinese art in the liberal arts.

A general introduction to Far Eastern art, although it is apt to be doomed by the results of new research and wider knowledge, has been badly needed; the usefulness and succession of comparable surveys of Western art have underscored this lack in regard to the art of the Orient. Interest alone demands a launching pad, however unstable, to the higher reaches of specialized knowledge; and scholarship needs occasional broad panoramas to modify or correct, thus automatically providing the grounds for new locations of the framework or new directions for the vehicle. It is, in my opinion, more important for the layman or beginning art historian first to know the place of great Indian sculpture or Chinese painting in the art of the Far East, and of the world, than to begin studying these contributions merely as documents of the national history or the religion of their respective areas.

But the works of art in their own contexts indicate their outer relationships only too clearly. The international flavor of classic Buddhist art, in India, Java, Central Asia, China, or Japan — is apparent in its forms, just as the national character of later Cambodian art is as clear as that of certain so-called derivative phases of Japanese art. Again, a broad view, especially of style, is of the greatest importance in recognizing that the art of the Orient, like that of the Occident, is not a special, unique, and isolated manifestation. Related art forms appear on an international stage as often as isolated national styles develop on a contracted geographic stage. Seen in this light, without romantic mystery as well as without the paraphernalia of esoteric scholarship, the art of Eastern Asia seems to me more readily understandable, more sympathetic, more human. We can never see a Chinese work of art as a Chinese does; much less can we hope to know it as it was in its own time. On the other hand, we should not, unless for some really valid reason, violate the context of the work of art. But here are thousands of still meaningful and pleasurable works of art, part of our world heritage — and we should not permit them to be withheld from us by philologists, swamis, or would-be Zen Buddhists. What are they? How are they to be related to each other? What do they mean to us as well as to their makers? These are proper questions for a general study.

So far no one student has commanded the disciplines necessary to present such a broad survey in really satisfactory form. Since the Second World War the fields of Oriental history, political science, economics, and art have burgeoned, but it is unlikely that such paragons of learning could be forthcoming soon. Any effort inevitably will have numerous shortcomings, some of them perhaps fatal; but, if the effort is worth a try, then at least some of these shortcomings should be faced and either controlled or baldly admitted. The present work makes no pretense to provide more than the briefest historical or religious background to the works of art. In many cases the subject matter, when it is of a particularly esoteric nature, has been slighted or ignored. But questions of style, of visual organization, of aesthetic flavor or comparison, have been emphasized. Since the one really unique and unforgettable quality of a work of art is its visual appearance, and since as Focillon said, the artist's "special privilege is to imagine, to recollect, to think, and to feel in forms," it seemed only logical to me that forms should be the principal concern of the book. Furthermore such matters interest me more than others.

There is one other aspect of Far Eastern art that has not been limited in the present work. Numerous media were used by the Oriental artist. It is quite impossible to know Chinese art without knowing such so-called minor arts as ceramics and jade. Lacquer is very important in Japan. In India, architecture, per se, is of more limited interest than in Japan. This study pre-

sents the various *styles* of Far Eastern art in the media used by the artists in the most creative way. Thus, there is much on Indian sculpture but little on Indian ceramics. Contrariwise, late Chinese ceramics are emphasized while late Chinese sculpture is conspicuous by its well deserved absence. The same selectivity is applied to the choice of styles for discussion. While conservative modes are of considerable interest as foils or reacting points for the more progressive styles, their persistence beyond a certain point can only be called ossification, and one can indulge in the satisfaction of dropping the vestigial remainder; thus the slighting of the Kano school in Japan or of the court-academy painters of the Ming and Ch'ing dynasties.

Other omissions and weaknesses are less deliberate. They involve the shortcomings of the author's acquaintance with some of the many and complex areas of Far Eastern art. The sections on Javanese art, the art of the steppes, or on Mughal painting fall into this category. Recent excavations on the Chinese mainland are numerous, excellent, and fruitful sources for future knowledge. But still, I feel that the present effort is worth the making; this is not an encyclopedia, a complete history, or a handbook of iconography, but an *introduction* to the creative art of Eastern Asia.

The plan of the book is simple. It begins with the early East Asiatic cultures, Neolithic and Bronze Age, with special emphasis on the Indus Valley civilization which is related to the other ancient urban river cultures of Mesopotamia and Egypt, and the great bronze culture of early China. This section is followed by a study of the rise of Buddhist art in India and of its influence throughout Eastern Asia. The following sections trace the rise of "national" art styles in India, Southeast Asia, Indonesia, and the Far East. The latter section, with major emphasis on China and Japan, stresses the alternating national and international character of the art of the Far East. The modern art of the East is omitted on the grounds that its creative side is more a part of worldwide internationalism than of the tradition of art presented in this volume.

Further reading for those so inclined is suggested by a general bibliography and by a specific list of significant sources for each chapter.

The author is much indebted to the various persons who helped in gathering photographs and information, and with the burdensome task of typing, proofreading, and compilation. Particular acknowledgment should go to Mrs. Margaret Fairbanks Marcus for her patient and critical reading of the draft; Dr. Thomas Munro, Mr. Edward B. Henning, and Mr. Milton S. Fox all read the manuscript and offered excellent advice which was usually heeded; Mr. Wai-kam Ho was most instructive with regard to early Chinese material. My book owes a great deal to the diligence and expert craftsmanship of Mr. Philip Grushkin, Mrs. Susan A. Grode, and Miss Harriet Squire, of the Abrams staff. Mrs. Nancy Wu Stafstrom, Mrs. Susan Berry, and Mrs. Margarita Drummond bore the brunt of preparing the list of illustrations and arranging for photographs, while Miss Louise G. Schroeder was responsible for the equally onerous task of typing and retyping. I am particularly indebted to Messrs. Junkichi Mayuyama, Inosuke Setsu, Manshichi Sakamoto for most of the Japanese photographs, while Dr. J. E. van Lohuizen, Dr. Benjamin Rowland, and Mr. S. E. Tewari were most kind and helpful with certain rather difficult Indian material. To these, and many others unnamed, the author proffers humble and sincere thanks. Finally, and by no means least, he is grateful to his wife who endured his late hours and by no means unexpressed frustrations with the work in progress.

S.E.L.

A HISTORY OF FAR EASTERN ART

The Wade System for the Pronunciation of Romanized Chinese Words

ai = *y* as in *why*; ao = *ow* as in *how*; an = long *a*; ang = very long *a, ong* in many words; ch = initial *j* as in *jam*; ch' = an emphatic initial *ch* as in *church*; ê, ên, êng = nearly *er*, or short *u* as in *flung*; en = as in *ten*; ei = *ey* as in *Weybridge*; eh = French *é*; i = *ee* as in *see*; o = nearly *or*; ou = o as in *Joseph*; u = *oo* as in *too*; ü = French *u*; ung = *oong*; hs = emphatic initial *sh* (*s* in the South); hua, huo = *hwa, hwo*; huï = *whey,* j = between an initial *r* and *z*; k = initial *g*; k' = emphatic initial *k* aspirated; p = initial *b*; p' = emphatic initial *p*; ssŭ = *sir* with hissing *s*; t = initial *d*; t' = emphatic initial *t*; ts = *ds*; ts' = emphatic *ts*; tz = *dz*; tz' = emphatic *tz*. The two very common words "tzŭ" and "wang" are pronounced *dzer* and *wong* respectively.

The Pronunciation of Romanized Indian Words

The vowels should be pronounced as in Italian; it is important to remember that "a" (short) should be pronounced like *a* in America, never like *a* in man. "C" should be pronounced like *ch* in *church*, and "s" like *sh* in *ship*. In the case of "kh," "gh," etc., the aspirate should be distinctly heard. "H" is like *ch* in *loch*; the sound of "kh" and "gh" in Persian words such as "Mughal" is somewhat similar. Most of the other consonants may be pronounced approximately as in English.

The Pronunciation of Japanese Words

Japanese is pronounced as spelled, with, in general, no accent.

To assist the reader, all diacritical marks have been eliminated from the text and appear in the Index.

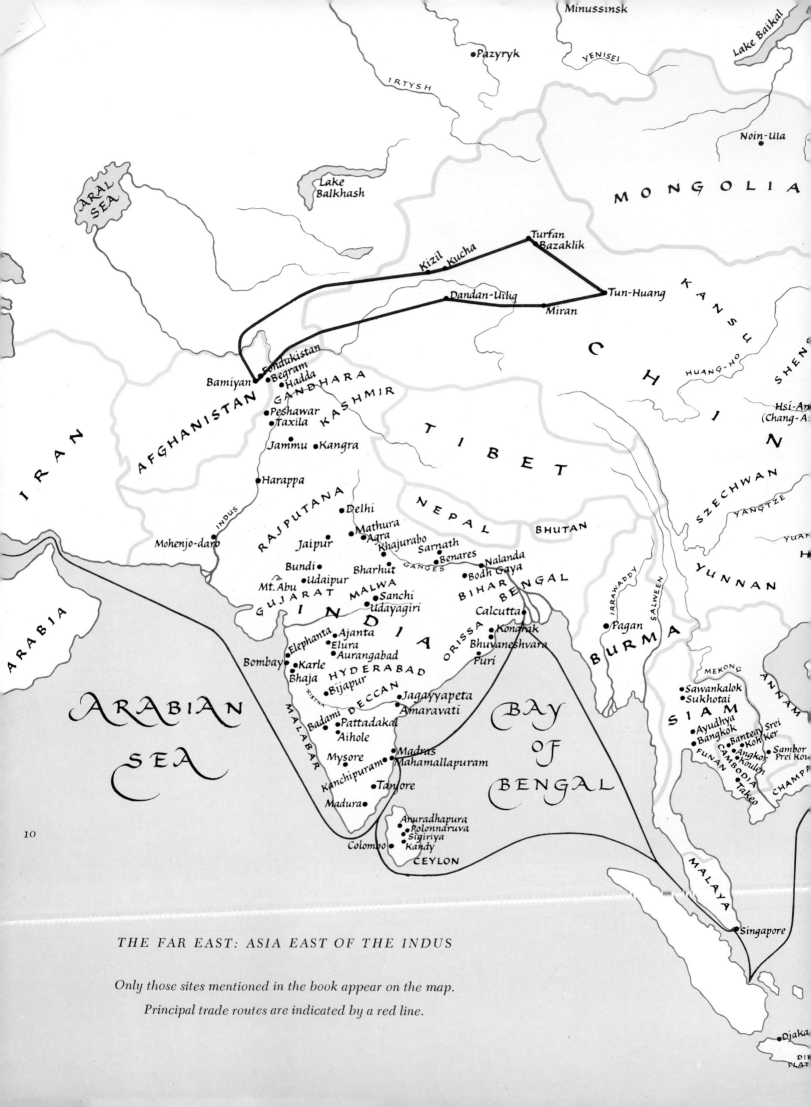

THE FAR EAST: ASIA EAST OF THE INDUS

Only those sites mentioned in the book appear on the map.

Principal trade routes are indicated by a red line.

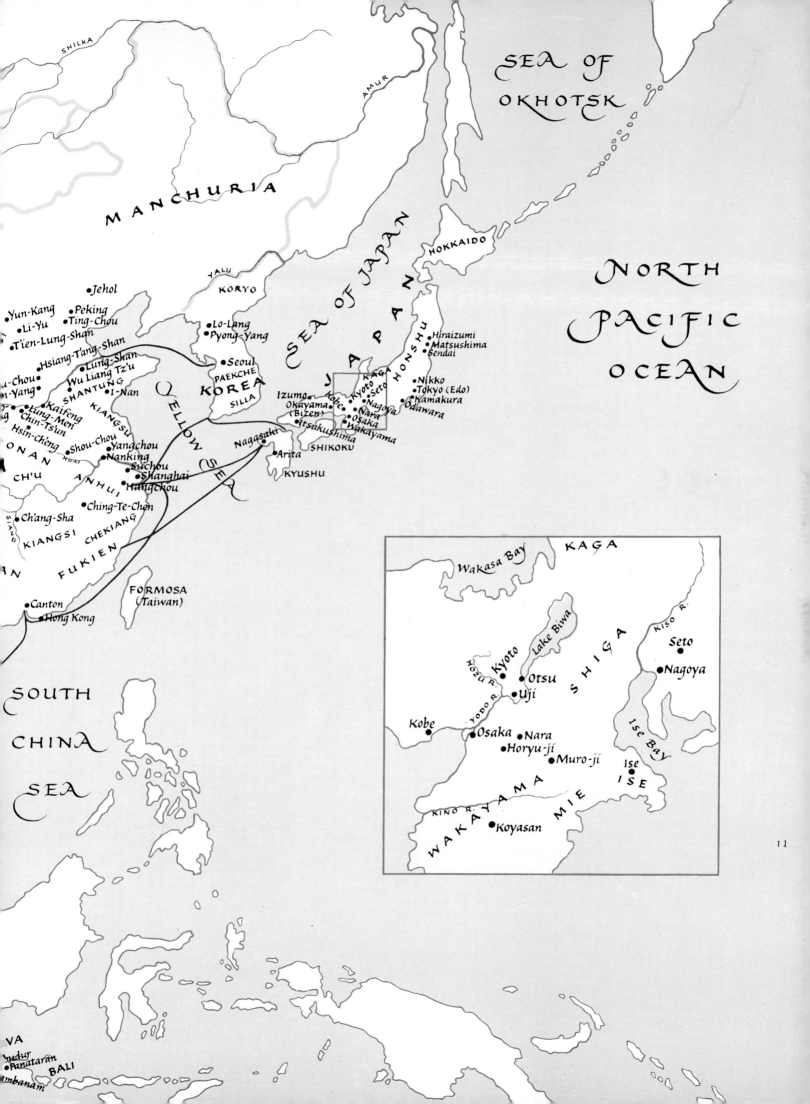

SEA OF
OKHOTSK

NORTH
PACIFIC
OCEAN

SHILKA
AMUR

MANCHURIA

HOKKAIDO

Jehol

Yun-Kang
Li-Yu
T'ien-Lung-Shan
Peking
Ting-Chou
Hsiang-Tang-Shan
Lung-Shan
Wu Liang Tz'u
SHANTUNG
I-Nan
Kaifeng
Lung-Mei
Chin-Tsun
Hsin-Chêng
Shou-Chou
Yangchou
Nanking
Suchou
Shanghai
Hangchou
Ch'ang-Sha
Ching-Te-Chen
KIANGSI
CHEKIANG
FUKIEN

KIANGSU
ANHUI
CH'U
ONAN

SIANG

i-chou
-Yang

YALU
KORYO
Lo-Lang
Pyong-Yang
Seoul
KOREA
PAEKCHE
SILLA

SEA OF JAPAN

YELLOW SEA
HUAI

Nagasaki
Arita

KYUSHU

Izumo
Okayama
(Bizen)
Itsukushima
SHIKOKU

JAPAN
HONSHU
KAGA
Kyoto
Kobe
Seto
Nagoya
Nara
Osaka
Wakayama

Hiraizumi
Matsushima
Sendai
Nikko
Tokyo (Edo)
Kamakura
Odawara

Canton
Hong Kong

FORMOSA
(Taiwan)

SOUTH

CHINA

SEA

VA
ndur
Panataran
BALI
mbanam

Wakasa Bay
KAGA

Lake Biwa

Kyoto
Otsu
Uji

Kobe

Osaka
Nara
Horyu-ji

Hozu R.
Yodo R.

SHIGA

KISO R.
Seto
Nagoya

Ise Bay

Muro-ji

Ise
ISE

KINO R.
WAKAYAMA
MIE

Koyasan

11

A COMPARATIVE
TIME CHART FOR
FAR EASTERN ART

Horizontal color spreads indicate
cultural continuities regardless
of the vertical chronological sequence:
i.e., light green = Bronze Age;
light blue = Iron Age; etc.

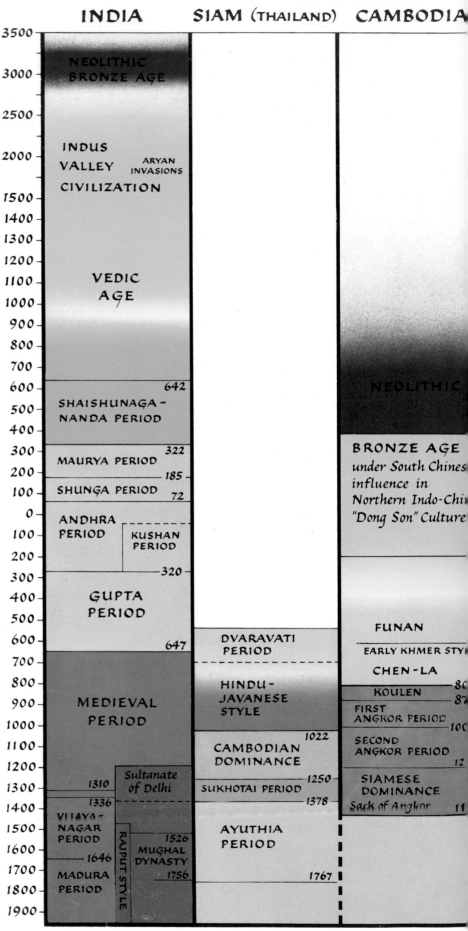

SOUTHEAST ASIA
INDIA SIAM (THAILAND) CAMBODIA

INDIA

3500
3000 NEOLITHIC
 BRONZE AGE
2500

2000 INDUS
 VALLEY ARYAN
 INVASIONS
1500 CIVILIZATION
1400
1300
1200
1100 VEDIC
 AGE
1000
900
800
700
600 642
 SHAISHUNAGA-
500 NANDA PERIOD
400
300 322
 MAURYA PERIOD
200 185
100 SHUNGA PERIOD
 72
0 ANDHRA
100 PERIOD KUSHAN
 PERIOD
200
300 320
400 GUPTA
 PERIOD
500
600 647
700
800
900 MEDIEVAL
 PERIOD
1000
1100
1200
 1310 Sultanate
1300 of Delhi
 1336
1400
 VIJAYA-
1500 NAGAR 1526
 PERIOD RAJPUT STYLE MUGHAL
1600 DYNASTY
 1646
1700 1756
 MADURA
1800 PERIOD
1900

SIAM (THAILAND)

DVARAVATI
PERIOD

HINDU-
JAVANESE
STYLE
 1022
CAMBODIAN
DOMINANCE
 1250
SUKHOTAI PERIOD
 1378

AYUTHIA
PERIOD
 1767

CAMBODIA

NEOLITHIC

BRONZE AGE
under South Chines
influence in
Northern Indo-Chi
"Dong Son" Culture

FUNAN
EARLY KHMER STYL
CHEN-LA
 80
KOULEN 87
FIRST
ANGKOR PERIOD
 100
SECOND
ANGKOR PERIOD
 12
SIAMESE
DOMINANCE
Sack of Angkor 11

INDONESIA especially JAVA	CHINA	KOREA	JAPAN	The WEST
	NEOLITHIC			NEOLITHIC Early Mesopotamian Culture and Egyptian Old Kingdom
	Painted Pottery Culture — Black Pottery Culture			
		NEOLITHIC		New Kingdom in Egypt
	BRONZE AGE			
	1523			IRON AGE
	SHANG DYNASTY		NEOLITHIC	
	AN-YANG PERIOD			Assyrian Empire
NEOLITHIC	1028			
	EARLY CHOU PERIOD			
	MIDDLE CHOU PERIOD			
	Spring and Autumn Annals 722		JOMON PERIOD	Rise of Greek Art
	LATE CHOU PERIOD — Warring States 481			Alexander the Great
BRONZE AGE under South Chinese influence	IRON AGE 221	BRONZE AGE	200	
	CHIN DYNASTY 206	108		
	WESTERN HAN DYNASTY 9	57	YAYOI PERIOD	Roman Art of The Early Empire
	25 EASTERN HAN DYNASTY			
		NAKNANG PERIOD	BRONZE AGE	
	220		IRON AGE 200	
HINDU CENTRAL JAVA (First Period)	SIX DYNASTIES	THREE KINGDOMS PERIOD	KOFUN PERIOD (Haniwa Culture)	
	589		552	Early Byzantine Art
	SUI DYNASTY 581 618	668	ASUKA PERIOD 645	
SHRIVIJAYA AND SHAILENDRA KINGDOMS	T'ANG DYNASTY	SILLA KINGDOM	NARA PERIOD 794	Charlemagne
850			JOGAN PERIOD 897	
HINDU CENTRAL JAVA (Second Period) 930	FIVE DYNASTIES 909 960	935 918	HEIAN PERIOD	
EAST JAVANESE PERIOD	NORTHERN SUNG PERIOD		FUJIWARA PERIOD	Romanesque Art
1222	1127	KORYU KINGDOM	1185	Gothic Art
SINGASARI	SOUTHERN SUNG PERIOD 1279		KAMAKURA PERIOD	
1292	YÜAN DYNASTY 1368	1392	1333	Renaissance
MAJAPAHIT			NAMBOKUCHO PERIOD 1392	
1478	MING DYNASTY	YI (LI) DYNASTY	MUROMACHI PERIOD 1573	Baroque
WAYANG STYLE — ISLAMIC STYLE	1644		MOMOYAMA PERIOD 1615	Rococo
	CH'ING DYNASTY		EDO PERIOD	
	1912	1910	1868	Impressionism and Post Impressionism

CHRONOLOGICAL TABLES

INDIAN ART

Pre-Buddhist Period Early times – c. 322 B.C.

 Indus Valley Civilization c. 2500 – c. 1500 B.C.

 Aryan Invasions c. 2000 – c. 1500 B.C.

 Shaishunaga — Nanda Period 642 – 320 B.C.

Period of Buddhist Dominance
 c. 322 B.C. – after A.D. 600

 Maurya (Ashoka) Period 322 – 185 B.C.

 Shunga Period 185 – 72 B.C.

 Andhra Period c. 70 B.C. – 3rd Century A.D.

 Satavahana Dynasty 220 B.C. – A.D. 236

 Kushan Period (including Gandhara)
 c. A.D. 50 – 320

 Gupta Period (including Harsha) A.D. 320 – 647

Medieval Period c. A.D. 600 – c. 1200

 Pallava Period (South) c. A.D. 500 – c. 750

 First Chalukyan Period (North) A.D. 550 – 753

 Rashtrakutan Period A.D. 753 – c. 900

 Pala and Sena Periods (Bengal) A.D. 730 – 1197

 *Medieval Kingdoms of Rajputana
 and the Deccan (North)* c. A.D. 900 – c. 1190

 Chola Period (South) Mid-9th Century A.D. – 1310

Later Medieval Period A.D. 1200 – 1756

 Sultanate of Delhi (North)
 c. A.D. 1200 – 14th Century

 Vijayanagar Period (South) A.D. 1336 – 1646

 Madura Period (South) A.D. 1646 – c. 1900

 Mughal Dynasty A.D. 1526 – 1756

 Rajput Style (North) c. A.D. 1500 – c. 1900

INDONESIAN ART

CAMBODIA

Pre-Angkorean Period (Early Khmer) (Indian influence)

 "Funan" ? – c. A.D. 600

 "Chen-la" c. A.D. 600 – 802

Koulen — Transitional Period A.D. 802 – 877

First Angkorean Period A.D. 877 – 1002

Second Angkorean Period A.D. 1002 – 1201

Sack of Angkor A.D. 1437

SIAM (THAILAND)

Dvaravati Period (Indian influence)
 6th – 10th Century A.D.

Hindu-Javanese Style c. A.D. 700 – c. 1000

Cambodian Dominance A.D. 1022 – c. 1250

Sukhotai Period c. A.D. 1250 – 1378

Ayuthia Period A.D. 1378 – 1767

 Ayuthia and Lopburi Schools

JAVA

Hindu Central Java (First Period)
 7th and 8th Centuries A.D.

*Shrivijaya and Shailendra Dominance
 from Sumatra* c. A.D. 750 – c. 850

Hindu Central Java (Second Period) c. A.D. 850 – c. 930

East Javanese Period c. A.D. 930 – 1478

Muhammedan Conquest 15th and 16th Centuries A.D.

Wayang (Native) Style 15th Century A.D. – to date

KOREAN ART

Naknang (Han Chinese Dominance) 108 B.C. – A.D. 313

Three Kingdoms 57 B.C. – A.D. 668

 Kokuryo Dynasty 37 B.C. – A.D. 668

 Paekche Dynasty 18 B.C. – A.D. 663

 Old Silla Dynasty 57 B.C. – A.D. 668

Unified Silla Kingdom A.D. 668 – 935

Koryu Period A.D. 918 – 1392

Yi (Li) Dynasty A.D. 1392 – 1910

CHINESE ART

Shang Dynasty 1523 – 1028 B.C.

 Capital at An-Yang 1300 – 1028 B.C.

Chou Dynasty 1027 – 256 B.C.

 Western Chou Dynasty 1027 – 771 B.C.

 Eastern Chou Dynasty 771 – 256 B.C.

 *Period of Spring and
 Autumn Annals* 722 – 481 B.C.

 Period of Warring States 481 – 221 B.C.

STYLISTIC DATING
OF CHOU PERIOD:

 Early Chou Period 1027 – c. 900 B.C.

 Middle Chou Period c. 900 – c. 600 B.C.

 Late Chou Period c. 600 – 222 B.C.

Ch'in Dynasty 221 – 206 B.C.

Han Dynasty 206 B.C. – A.D. 220

 Western Han Dynasty 206 B.C. – A.D. 9

 Eastern Han Dynasty A.D. 25 – 220

Six Dynasties A.D. 220 – 589

 Northern Dynasties A.D. 317 – 581

 Northern Wei Dynasty A.D. 386 – 535

 Northern Ch'i Dynasty A.D. 550 – 577

 Southern Dynasties A.D. 420 – 589

Sui Dynasty A.D. 581 – 618

T'ang Dynasty A.D. 618 – 907

Five Dynasties A.D. 907 – 960

 Liao Kingdom (in Manchuria) A.D. 936 – 1125

Sung Dynasty A.D. 960 – 1279

 Northern Sung Dynasty A.D. 960 – 1127

 Southern Sung Dynasty A.D. 1127 – 1279

Yuan Dynasty A.D. 1280 – 1368

Ming Dynasty A.D. 1368 – 1644

 REIGNS:

 Yung Lo A.D. 1403 – 1424

 Hsuan Te A.D. 1426 – 1435

 Ch'eng Hua A.D. 1465 – 1487

 Cheng Te A.D. 1506 – 1521

 Chia Ching A.D. 1522 – 1566

 Wan Li A.D. 1573 – 1619

Ch'ing Dynasty A.D. 1644 – 1912

 REIGNS:

 K'ang Hsi A.D. 1662 – 1722

Yung Cheng A.D. 1723 – 1735

Ch'ien Lung A.D. 1736 – 1795

Chia Ch'ing A.D. 1796 – 1820

JAPANESE ART

16

Archaeological Age Early times – A.D. 552

Jomon Period Early times – 200 B.C.

Yayoi Period 200 B.C. – A.D. 200

Kofun Period (Haniwa) A.D. 200 – 552

Asuka Period (Suiko) A.D. 552 – 645

Nara Period A.D. 645 – 794

Early Nara (Hakuho) Period A.D. 645 – 710

Late Nara (Tempyo) Period A.D. 710 – 794

Heian Period A.D. 794 – 1185

Early Heian (Jogan) Period A.D. 794 – 897

Late Heian (Fujiwara) Period A.D. 897 – 1185

Kamakura Period A.D. 1185 – 1333

Nambokucho Period
 (Northern and Southern Courts) A.D. 1336 – 1392

Muromachi (Ashikaga) Period A.D. 1392 – 1573

Momoyama Period A.D. 1573 – 1615

Edo (Tokugawa) Period A.D. 1615 – 1868

Early Edo Period A.D. 1615 – 1716

Late Edo Period A.D. 1716 – 1868

Modern Japan A.D. 1868 – to date

Meiji Period A.D. 1868 – 1912

Taisho Period A.D. 1912 – 1926

Showa Period A.D. 1926 – 1945

NOTE TO THE READER

In the picture captions the locations and collections appearing in roman type indicate that the work is NOT *in situ*. Measurements are not given for objects that are inherently large (architecture, architectural sculpture, gardens, temple sites). Dates in the captions are based on documentary evidence, unless preceded by "c." Dates for specific periods are listed in the Comparative Time Chart and Chronological Tables at the beginning of the book. A list of photographic credits for the illustrations appears at the end of the book. The notes, indicated by superior numbers in the text, appear in a separate section preceding the Bibliography.

Early Culture and Art:

The Stone Age,

The Bronze Age, and

The Early Iron Age

1. Urban Civilization and the Indus Valley; Neolithic and Pre-Shang China

MANY BOOKS ON ORIENTAL ART have adopted the now classic opening statement, "Asia is one," with which Okakura Kakuzo began his book, *The Ideals of the East.* The statement is far from true. Asia is not even one continent geographically; and the idea that the cultures of Asia are one, that there exists such a thing, for example, as the "Oriental mind," or that all the peoples of these regions are united by a highly developed metaphysical approach to life, is false. In his many writings, Ananda Coomaraswamy developed with great insistence the view that Chinese, Japanese, and Indian artists all worked within a single metaphysical framework. This attitude is understandable, even though it is biased. Asian countries, remote from Far Western centers of

1. Mohenjo-daro, aerial view. Indus Culture

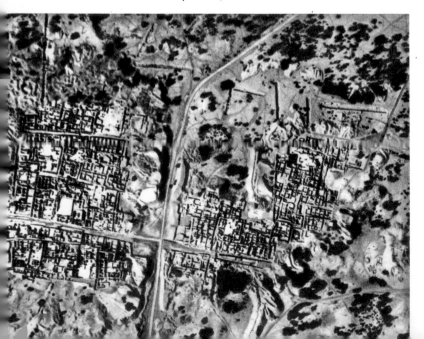

culture and evolving in isolation from all but superficial contacts with them, were ravished by adventurers who represented only an unfortunate aspect of the Western world. Such intrusions made Asiatics particularly aware of their traditional ideals. They forgot the discrepancies, the contrasts, and the multiple factors that were also a part of their heritage and spoke only of what they treasured most and liked to believe was their unique contribution, in contrast to the assumed aggressive materialism of the West. Such error is all too human, and is present in Christian attitudes toward "savages," in Moslem opinion of the Hindu, or in the peculiar serenity of the Chinese, who called their country the Middle Kingdom, believing that it was the center of the universe.

This book does not accept these attitudes, and begins with the idea that Asia is not one, but many. It is a collection of peoples, of geographic areas and, finally, of cultures. Each has its own assumptions, its own views and uses of art. There are, of course, influences and counter-influences; there are interweaving patterns derived from religion, from the migrations of peoples, and from the effects of trade and commerce. We are, then, confronted in Asia with many different entities. It is impossible, for example, to speak even of Chinese art as if there were one "mystique" behind the whole. We have to speak of Chinese art of the Bronze Age, and of Chinese art in the more sophisticated periods of the T'ang and Sung dynasties. We shall see those Japanese arts that are partially derived from Chinese art; but then we must examine even more carefully those arts that are uniquely Japanese and radically different,

not only in appearance but in motivation, from those of China.

With this approach in mind, we can survey the arts of the countries of Eastern Asia: India and Nearer India — that is, Nepal and Ceylon; Farther India — that is, Cambodia and Siam; and Indonesia — that is, Java and Sumatra; and China, Korea, and Japan. We include Central Asia insofar as it was a passageway between India and the Far East and a means of transmitting certain influences from the Western world to the Far East.

Asian art begins with the emergence of man as a species, both in Java and China. The earliest Hominidae developed a half million or more years ago and the first evidences of human, purposeful effort are the rude stone-choppers found in the dwelling areas of Java and Peking man. These Early Stone Age artifacts are the first in a series of stone implements that progresses through Mesolithic flaked hatchets, points, and flake-scrapers to the honed and polished stone implements and beads of Neolithic origin. The investigation of Stone Age man in Asia is still in its beginnings; and until the undoubtedly numerous remains from India, Central Asia, China, and Indonesia are found, studied,

and related, a general summary would be meaningless. The last decade alone has seen a great proliferation of material remains from all areas of China, materially altering previous prehistorical studies and conclusions.

But the great transition that really begins the story of art for us in Asia is that same transition that begins the story of developed civilized art everywhere in the world: the transition from a nomadic, food-seeking, hunting culture to a village and finally to an urban, food-storing, surplus-using culture. This evolution did not occur in China until perhaps 1600 B.C., while it occurred in the Indus Valley of Northwest India perhaps just before 2000 B.C. With this change we enter also into the realm of complex art forms.

In this valley, Indian and English excavators found an extraordinary culture, one of the most recent discoveries of a major culture. In the early 1920s the excavations were done in a rather haphazard way and the importance of the site was not realized until Sir John Marshall dug at Mohenjo-daro and at the second city, Harappa. The culture, sometimes called the Mohenjo-daro or Harappa culture, is now most often referred to as the Indus Valley civilization. In the early 1930s, to the excitement of the archaeological world, remarkable

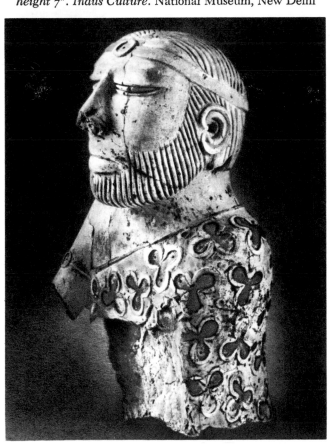

2. *"High Priest," from Mohenjo-daro. Limestone, height 7". Indus Culture.* National Museum, New Delhi

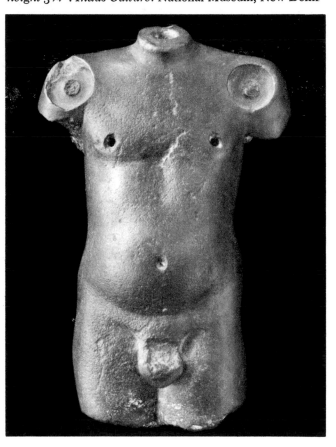

3. *Nude Male Torso, from Harappa. Red sandstone, height 3¾". Indus Culture.* National Museum, New Delhi

19

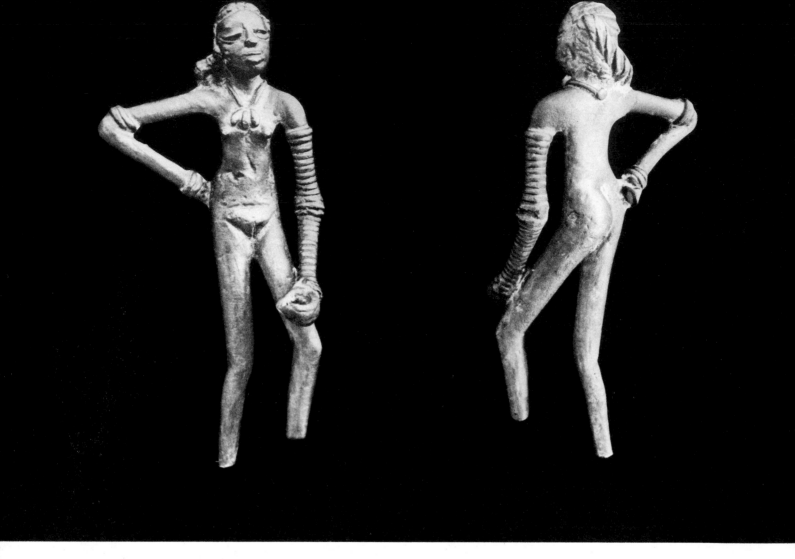

4. Dancing Girl, from Mohenjo-daro. Copper, height 4¼". Indus Culture. National Museum, New Delhi

finds were made, and excavations interrupted by the Second World War are now continuing. Here was a full-bloom urban culture comparable in extent and quality to those of Mesopotamia and Egypt. The fragments of script remaining have not as yet been deciphered; and we are only now beginning to learn an appreciable amount about the life of these cities.

An aerial view of the excavations at Mohenjo-daro reveals that subsidiary buildings and structures were axially oriented with relation to certain main streets, indicating that the city was highly organized in a political and social way and not just a haphazard line of dwellings along a road or river (*fig. 1*). Not only was its plan an orderly one; it had a highly developed irrigation and sewage system as well. There were numerous buildings of some scale, such as the so-called Great Bath. What this structure was used for we do not know, but there have been some fascinating specula-

tions. Some have suggested that the inhabitants of Mohenjo-daro kept crocodiles or some other aquatic animals in the pool; others guess that it was a place where wealthier citizens bathed. In any event, it was a public structure of some scale and had a very elaborate system of drainage so that the water could be kept fresh. Cubicles and rooms around the tank were perhaps intended for use by priests or bathers. The Great Bath was a large and important structure implying a socially and technically advanced society.

In the early years of the excavations, fortifications and citadels were conspicuously absent at both Mohenjo-daro and Harappa. Utopian idealists were tempted to hope that they had found the perfect state, composed of a peace-loving people, warriorless and classless — a prototype of the ideal state. But in 1946 Sir Mortimer Wheeler began to excavate at Harappa and found the citadel. He studied a large and previously ignored

mound, cut across it very carefully, and found the fortress. Here the military rulers of the Indus Valley had lived and here, as their piled-up bodies proved, they had met their end, probably at the hands of Aryan invaders, about 1500 B.C. Indus Valley culture was at its peak from around 2200 to 1800 B.C., and sometime between 2000 and 1500 B.C. waves of Aryan invasions utterly destroyed it.

Numerous important works of art were found at both Mohenjo-daro and Harappa. The fine-grained limestone bust of a man, approximately seven inches in height, has traces of color on the trefoil pattern of the robe (fig. 2). The type of representation is of interest because it appears to be related to some of the early Sumerian figures, particularly those found at Tello and Ur. The figure, a formal, dignified, sculptural achievement, calls to mind a deity, priest, or important official, and is therefore referred to as "High Priest." The suggestion has been made that the downcast eyes portray a yoga disciple of contemplation; but this hardly seems likely. It is a formal and hieratic sculpture. This is of interest, as two radically different types of sculpture are found in the Indus Valley: one, this formal type, and the other, a highly naturalistic, "organic" type. The latter style can be seen in the red sandstone torso from Harappa, about four inches high (fig. 3). There are some skeptics who deny that this sculpture is of the period and believe it represents a considerably later style, of perhaps the second or first century B.C. However, the general consensus is that the figure does date from the Indus Valley Period, and this is not difficult to believe, in view of other objects which have been found. The Harappa figure is suavely modeled, with a tendency toward what we shall call organic style; that is, the forms seem natural and living, soft and flowing, rather than crystalline and angular in structure, as are some inorganic forms. It shows intelligent study of the human body — what it looks like and how it works — and that study has been appropriately expressed in the material. This concept of organic sculptural style is particularly significant in later Indian sculpture. No one has satisfactorily explained the curious circular drill impressions in the shoulders. Perhaps they were meant for the attachment of movable arms; or, less likely, they are symbolic markings. Only two stone figures of this organic type were found; the other is in a dancing pose.

In early Egyptian and Mesopotamian art, artists apparently disregarded, or lacked interest in, the way the body looks and moves, and attempted to make it timeless and static — frozen in space. This Indus type, however, seems much more of the moment, more immediate in the reaction of the artist to the subject and in the communication of that reaction to the spectator. The whole effect is rather like the feeling of surprising immediacy one receives from Magdalenian painting of bison, deer, or antelope. The Indus Valley sculptor seems to have breathed the shape and form of the human body into stone, even causing it to appear soft. To what extent this organic style is influenced by clay modeling it is impossible to say; but some such influence seems likely.

The work that provides a link between the organic and the more formal, hieratic styles of the Indus Valley culture is a copper figure of a dancing girl from Mohenjo-daro (fig. 4). The excavation reports indicate quite clearly that it was found with Indus Valley pottery and other materials. Further, the head, particularly the way in which the eyes and the nose are modeled, recalls the limestone "High Priest" of figure 2. But in the modeling of the back and the side one sees the same organic style as is found in the red sandstone torso of figure 3. In this case it is certainly influenced by clay modeling for, of course, the figure had to be modeled in clay or wax before it could have been cast in bronze. The elaborate asymmetrical hairdo is very much like that to be found in later Indian sculpture, while the use of bangles and the nudity of the figure are also in keeping with later Indian practice. In the little dancer the type and pose may be related to clay fertility images, such as those found throughout the ancient Near East. A considerable point has been made of the Negroid features of the dancing girl, which seem to confirm the theories of certain ethnologists on the movements of ethnic strains in India. She may represent one of the

21

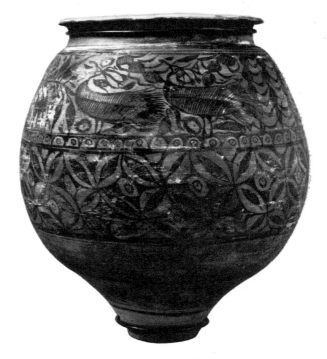

5. Storage Jar, from Chanhu-daro. Pottery, height 20¾". Indus Culture. Museum of Fine Arts, Boston

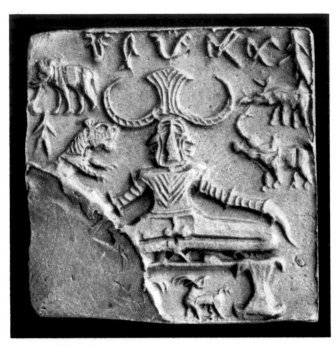

6. "Shiva," from Mohenjo-daro. Square stamp seal
with inscription, white steatite, width 1⅜". Indus Culture.
National Museum, New Delhi

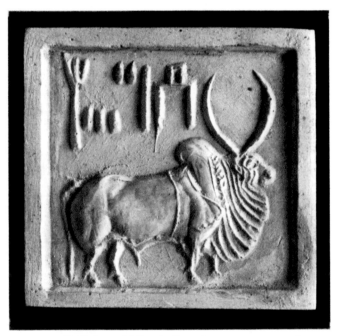

7. Bull, from Mohenjo-daro. Square stamp seal
with inscription, white steatite, width 1½". Indus Culture.
National Museum, New Delhi

of bangles, beads, toys for children, copper knives and spindles, all the impedimenta of the kind that pile up in one's attic — were found in the Indus excavations. Among them are extraordinary, large storage jars with painted designs of birds or animals in an organic style, which seem to be related to even earlier Neolithic potteries of the region (fig. 5). The geometric patterns in these designs seem to be more related to plant life than to anything else.

The most distinctive creations of the Indus Valley artist are the stamp seals, found in considerable quantity and inscribed with legends in the still undeciphered Indus Valley script. They are carved in fine-grained steatite, and most of them are in the form of stamps rather than of the cylindrical shape characteristic of Mesopotamian seals. Carved in intaglio, the designs on Indus Valley seals often have an animal as their principal subject. A few have figures, alone or with animals. One famous seal displays a seated figure in a Yogi-like pose (fig. 6), while another presents a combat between a cow-headed female and a tiger. But the characteristic seals are those depicting bulls, in most cases bulls with big humps (fig. 7). In subject matter one or two of the seals showing combat scenes are like those found in Mesopotamian sites. Stylistically, however, they differ. The seals of the Mesopotamian region tend either to be geometric, as in the very earliest examples, or to move in the direction of a highly stylized expression that cleverly uses drilling and incision to give an effect of movement and a degree of naturalism. On the other hand, the Indus Valley seals are carved in a painstaking, fully modeled way, with sleek outlines, and have very few traces of the tool or technique. The Indus carver tended to obliterate the evidences of technique in order to achieve a final, stylized but naturalistic effect, while the Mesopotamian artist seemed to delight in playing with toolmarks. The Mohenjo-daro seals are midway between the organic figures and the hieratic figures of the "High Priest" type.

Indus Valley seals also provide us with the means of correlation with the early cultures of Mesopotamia, and allow us to date the Indus Valley civilization with some certainty. Seals of the Indus type have been found in Mesopotamia in Akkadian sites at levels which allow us to arrive at dates for the Indus Valley civilization of at least as early as 2500 to 1500 B.C. The Indus Valley culture does not appear to be as old as the Mesopotamian culture or the Egyptian "river culture," and may well have received stimuli from these, but it is still one of the four great river-cradles of civilization: the Nile, the Tigris–Euphrates plain, the Indus, and the Valley of the Yellow River, to the last of which we now turn.

The first historic dynasty of China, the Shang, is dated from about 1523 to 1028 B.C. While we know a

Negroid peoples still found in South India, where they presumably migrated when forced out of northwest India by the Aryan invasions of about 1500 B.C. or slightly earlier.

The usual implements of an early culture — all kinds

great deal about the Shang Dynasty from about 1300 onward, only recently have we found evidence for the earlier period.

The great problem in discussing the early culture of China is to determine whether it is native or acquired; that is, is it a culture that grew in the regions of China, or is it in part an imported culture? There is strong evidence to indicate that at least some basic elements are imported. There is also conclusive evidence that some equally strong elements were native. But it is important, in studying the emergence of this extraordinary Bronze Age culture in China, to understand that the various imported and native strains merged to form the later unified Shang culture with its unequaled bronze technique.

One fundamentally important aspect of pre-Shang or Neolithic China is the division of the Yellow River or Northern area into two markedly different areas, the plateau and the plains, with a third central area at their meeting points. The plateau is the area now comprising the provinces of Kansu, Shensi, and parts of Shansi and Honan. The plains move eastward and embrace the arc from Port Arthur through Shantung and south to the region of Hangchou. The meeting point of the

plateau and the plains is just east of the first great bend of the Yellow River. Significantly, it is at the central meeting point that we have the coalescence of the three cultures which produced the developed Shang culture. This area, known to the Chinese as Chung Yuan, or central plain, has always been the heartland of the "Middle Kingdom."

The type-site — that is, a site that sums up the characteristics of a culture — of the plains is Cheng Tzu Yai, and the culture revealed there is called Lung-Shan. One of the characteristics of this plains culture is the use of pounded earth for dwellings and walls; it is to be noted that the later Shang people also used pounded earth. Another is the use of a very thin, black pottery. It is perhaps the finest Neolithic pottery made, so thin it reminds one of "egg-shell" porcelain despite the fact that it is clay (fig. 8). The elegant shapes seem characteristic of the Lung-Shan culture. A third is the practice of divination by means of a crack pattern produced by the application of a hot point to scraped bone. While this is not exactly the same system as that used by the later Shang peoples — for they preferred the underside or plastron of a tortoise — the purpose is the same: consultation with ancestors by divination. This is the most

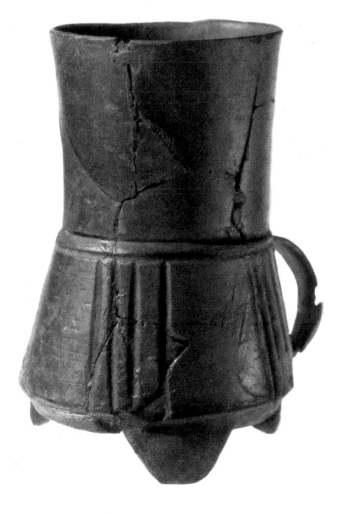

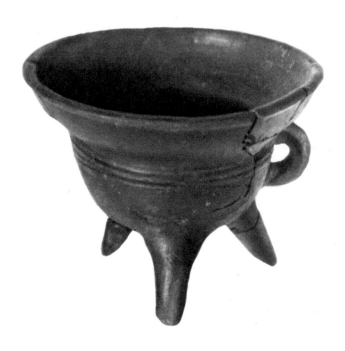

8. *Pottery, from Lung-Shan.*
Chinese, Neolithic, c. 2000 B.C.
Academia Sinica, Formosa

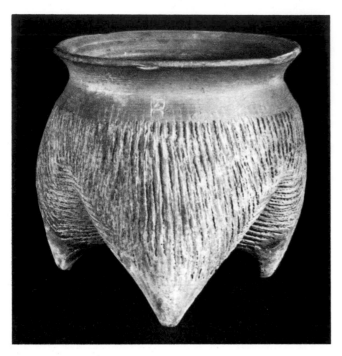

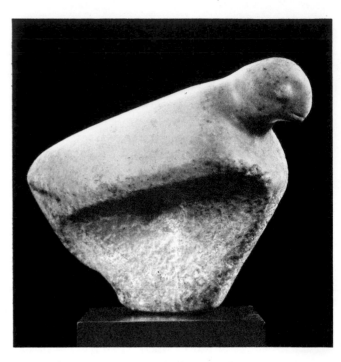

9. *Li Tripod, from An-Yang, Honan.*
Pottery, height 6". Chinese, late Neolithic type.
The Buffalo Society of Natural Sciences

10. *Bird. Jade, height 4⅛".*
Chinese, Neolithic. Nelson Gallery-Atkins Museum
(Nelson Fund), Kansas City

important link between the Lung-Shan and the later Shang dynastic cultures.

The second culture, that of the plateau, is sometimes called the painted-pottery culture to distinguish it from the black-pottery culture. The type-site is a place called Yang-Shao near the meeting place of these two cultures. Two of the characteristic artistic elements of the Yang-Shao culture — red and painted pottery, and the elementary use of jade — are of considerable significance in terms of later Chinese culture. Instead of having walled villages of pounded earth, the Yang-Shao people lived in small villages with either pit-homes or simple above-ground dwellings. They had fewer domesticated animals than the men of the black-pottery culture. But they produced some of the most beautiful Neolithic painted pottery that the world has ever seen. Many of these painted pots, in their designs, appear to be similar to the painted pottery of the Black Earth region north of the Black Sea. It has been suggested that the techniques and designs of this Chinese painted pottery were imported from the West to the plateau in China, and this is not impossible, as the pottery of the Anau region in the Black Earth belt is very much like that found in Northwest China. The large and perfect funerary urn in the Seattle Art Museum is a characteristic example of Chinese Neolithic pottery from the Pan Shan cemeteries (*colorplate 1, p. 33*). We know that it is a funerary piece because of its serrated pattern, which Andersson, the principal excavator of this

area, has identified as the symbol of death. There are two types of painted pottery: one with black designs and one with serrated motifs in red and black. As the red and black is always found in the funeral areas, while the black-painted pottery is found only in the work and living areas, Andersson called the red and black markings the "death pattern." Sometimes these painted potteries have very interesting combinations of geometric and naturalistic designs. The naturalism is usually veiled by presentation in a geometric guise. On many urns there are simplified representations of cowrie shells which have been found in the sites of the Yang-Shao culture. In many parts of the world the cowrie has been used as money and worn as an amulet because of the magical properties attributed to it, especially those associated with birth and fertility. The combination of the death pattern with one of birth and fertility may be yet another expression of the desire for life after death or, at the very least, for continuity in the social order.

The shapes of the painted pots are always full-blown and the vase walls are of very thin red clay. They are usually made by coiling and, while there have been some attempts to prove that these Neolithic wares were made on the potter's wheel, the best that can be shown is the use of a slow turntable. The fundamental method, however, was coiling — building the rolled clay in coils and forming shapes by means of pads and fingers.

The type-site for the central Neolithic culture is

24

Hsiao-T'un, named from the site in Honan which was later to be the last capital of the Shang Dynasty. It seems certain that the mound-dwelling Hsiao-T'un culture was slightly later than those of Yang-Shao and Lung-Shan and that it owed much to the latter of the two flanking cultures. If red (or painted) pottery and black pottery are the dominant traits of its sister cultures, then gray pottery must be the popular designation for the most characteristic product of the central area. Finely levigated and carefully fired, the gray pottery was formed and decorated at the same time by the use of corded beater pads, to make a characteristic overlapping decoration which could be more properly described as a texture. Like the Lung-Shan culture, that of Hsiao-T'un used the *li* tripod.

This artifact, the *li* tripod, found in all three native cultures, testifies to their close relationships and is of some significance in the development of later Chinese Bronze Age culture (*fig. 9*). Its appearance suggests that it is the result of making three vases with pointed bottoms and leaning them together. From this may have developed the tripod with hollow legs which allowed the heat of the fire almost direct access to the contents of the tripod. The solid-leg tripod was also made, perhaps slightly later. Since one of the most important bronze shapes of the Shang Dynasty is a three-legged tripod, the *li* tripod seems to show a definite continuity from Chinese Neolithic culture into that of the Shang Bronze Age.

We also have a few rather interesting Neolithic sculptures in stone and jade. They have appeared on the market as a result of "clandestine" excavations or grave robbings, and there is good reason to believe them to be Neolithic, although this is only speculation. Perhaps the most interesting of these is in the William Rockhill Nelson Art Gallery in Kansas City. It is only about four inches long, an unpolished jade lump that has been formed very simply, following the original boulder shape, into the representation of a bird, with indications of wings and head and with a circular pit for the eye — very simple, very sleek, yet monumental despite the size of the piece (*fig. 10*). We must remember particularly that this jade is a relatively simple form, certainly far from complex. There is no development of the inner surfaces, no elaborate patterning or incising. The whole shape is elementary, with a vaguely naturalistic profile — a sharp contrast to the later, developed Bronze Age art in China.

The sequence of these pottery cultures, very important in terms of chronology, has been established tentatively in the An-Yang region, the type-site for later Shang Dynasty culture, notably at Hou-Kang and Hou-Chia-Chuang. At the bottom level — the earliest — of excavated areas was the painted-pottery culture, followed, in ascending order, by the black-pottery culture, and both intermingled with the gray pottery of the central region. So the Neolithic sequence is Yang-Shao, Lung-Shan, Hsiao-T'un, followed by the coalescence of these Chinese cultures with possible outside influences from the north and west; none of the three pottery cultures used metal, and the developed use of metal is the most characteristic feature of Shang culture.

2. The Steppes and the "Animal Style"

WE CAN NOW CONSIDER THE PROBLEM of the relationship of the art of the Siberian Bronze Age to that of the Bronze Age in China and go on to glance at the "animal style" associated with the steppes of Central Asia. The relationship of this Siberian Bronze Age to China is a highly controversial matter, one in which important discoveries are still being made. Some of the most interesting excavations of the last decades have been made by Russian archaeologists in Central Asia. The great excavations at the sixth- to fourth-century tombs of Pazyryk have been astounding, considering only the bizarre and exciting material recovered, quite apart from its historical significance. As numerous other ex-

cavations have been published in the Russian scientific journals and as analytical reports appear, we realize that there are many and significant cultures to be reckoned with in the steppes and forests of Central Asia. Some of the Bronze Age sites there are of great antiquity — earlier than 2000 B.C.

The Siberian cultural sequence germane to our study here is Afanasieva, Andronovo, and Karasuk. The most likely dates for these cultures are: about 2000 B.C. or earlier for Afanasieva; perhaps 1800 to 1500 B.C. for Andronovo; and perhaps from 1400 to 1100 B.C. or even later for the Karasuk culture. The latest of these Yenisei area cultures reveals influences from Shang China,

11. Combat Scene: Hero Wrestling with a Lion. Design from cylinder seal, height about 1½".
Mesopotamian, Dynasty of Akkad, c. 2500 B.C. British Museum, London

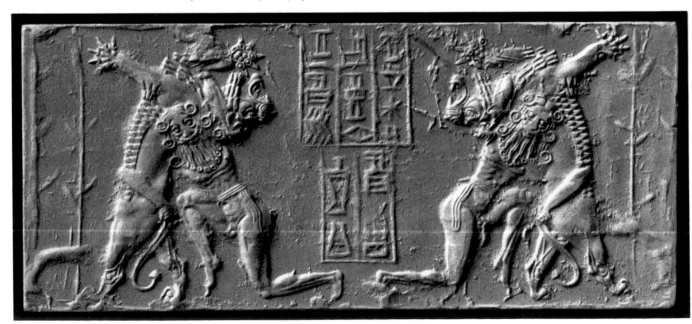

while there may be some influences from the Andronovo culture on early China. Such an instance of cultural action and reaction is repeated again in the journey of Buddhist art across Central Asia in the fourth to the eighth century A.D. The relationship of the Afanasieva and Andronovo cultures to the earlier cultures of the Anatolian Near East has been proven to a considerable degree. There is thus a possibility of the influence of the ancient Near East, on Central Asia and Siberia and thence on to China, with a returning influence from China at a slightly later date. The strikingly unusual and often mentioned problem of the Shang Dynasty bronze culture in China is that it appears to have few antecedents. We are confronted, between about 1600 and 1300 B.C., with bronze vessels imitating bone, pottery, and wood shapes, cast by complicated processes, and incorporating intricate designs and patterns. Recent excavations at sites like Erh-Li-Kang at Cheng-Chou have revealed middle Shang bronzes of primitive type and there is now a strong body of opinion that the use of bronze was both a native invention and development. However, it still seems possible that the use of bronze, in weapon form at least, was introduced into Neolithic China from Western Asia by way of Siberia.

Shang Dynasty bronze vessels display fantastic animal designs: ornamental motifs, with feline, cervine, and bovine types. To these are added very complex geometric design elements. Some of the animal elements are related to those of the ancient Near East, while the geometric ornament appears to be in part native, like that we have seen in the painted pottery culture, and in part related to certain Siberian cultures, notably that of Andronovo.

The general movement of the animal motifs seems to have been from the ancient Near East via the Armenian or the Kurdistan regions into the flatlands of Central Asia and then on into China through Mongolia and Suiyuan above the Gobi Desert. In the Suiyuan, the Ordos region, even down until the Han Dynasty and later, the persistent animal style is found on the small bronze horse trappings used by nomads and hunters of that region. Indeed, one might better consider the developed animal style-early China relationship more properly in the context of the Late Chou Period. In the West a similarly persistent animal style continued in Europe and is found in medieval times in Sweden and Norway in that combination of animal and geometric form so characteristic of Viking art.

Two examples of early Mesopotamian art illustrate animal style and combat motifs. One is a combat between man and beast on an Akkadian seal showing a bearded hero holding the forelegs of a deerlike animal. Another, shown here (fig. 11), has a god with bearded human head grappling with a lion beside a tree. Animal combat can be seen in an ivory from Lagash on

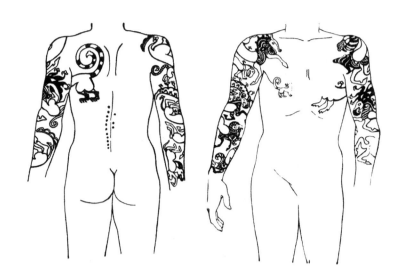

12. *Tattooed Man of Pazyryk, Tomb II.*
Front and back views. 6th-5th Century B.C.
The Hermitage, Leningrad

which a lion leaps upon a bovine creature to devour it. There is a peculiarly significant treatment of the lion's head, forming it as a mask biting the neck of the animal. This type of representation is sometimes cited as a prototype for the Shang devouring mask or *t'ao-t'ieh*.

Perhaps the most interesting of all the animal style sites is Pazyryk and although it dates from a time some six hundred years after the end of the Shang Dynasty and displays some influences from Late Chou style in China, it still may be used as a characteristic representative of the developed Siberian animal style. One of the most incredible finds ever made is that of the tattooed man of Pazyryk, preserved in a deep-freeze environment twenty feet or more under the tundra (fig. 12). The body, minus head and left hand, was tattooed with an almost all-over pattern of animal style designs. One animal metamorphoses into another: a lion becomes a bird, or a lion's tail ends in a bird's head. The artist figuratively dismembers the animals and uses a part to stand for a whole.

Also from Pazyryk is the wood and leather griffondragon devouring a reindeer (fig. 14), markedly similar in style to the bronze dragonhead from Chin-Ts'un in China (colorplate 3). The parts stand for the whole victim: the head with the antlers stands for the whole deer. This design technique of dismembering animal forms and then reassembling either all or some of the parts recalls Shang bronze ornamentation.

The Pazyryk finds would seem to be one culmination of a Central Asian style, going back many centuries. Though we do not now have the evidence for its earlier phases beyond single animal-headed knives from the Andronovo culture, this style surely comes from the Mesopotamian-Caucasus region. It is this earlier and

27

cruder strain that may have penetrated China, to be transformed there. One of the motifs which the Chinese archaeologist, Li Chi, points out as being particularly significant in this context is that of intertwined snakes, like the caduceus of Mercury. Sometimes the snakes have heads of a feline type or have a mask joining the two bodies at the top. This device, which we find at Ur and Lagash in Mesopotamia, is found at An-Yang in the tombs of the Shang kings and is interpreted by Li Chi as an importation.

The combination of animal and geometric motifs in early China is demonstrated in a particular Chinese bronze which, there is good reason to believe, pre-dates the An-Yang Period of the Shang Dynasty, before 1300 B.C. (fig. 13). Here two almost identical mules or horses, side by side, share the bronze base plate below and reveal simplified outlines, rather long, exaggerated, dachs-

hund-like bodies, and an eye rendered simply by an incised circle. The casting is not technically advanced for there are areas where all the metal did not fill in the mold. This combination of technical primitivism with the characteristic animal-style outlines of the horses and the bands of geometric fret ornament similar to the decoration of some weapons of the Andronovo culture, appears to provide tantalizing clues to Siberian-Chinese relationships before the development of the great vessels of the Shang Dynasty. However, it must be admitted that the recent, numerous excavations in China have given strong support to those who claim an indigenous development of bronze technique. In any case, the later connections between the animal style of Central Asia and the Late Chou and Han art of China are clearly established and will be mentioned in later chapters.

13. Pair of Horses, probably pre-An-Yang.
Bronze, height 4½". Shang Dynasty.
Cleveland Museum of Art

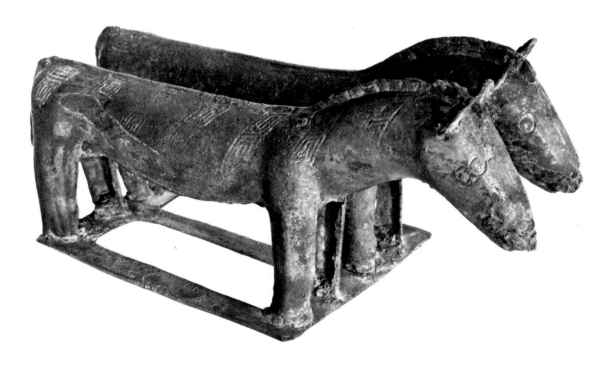

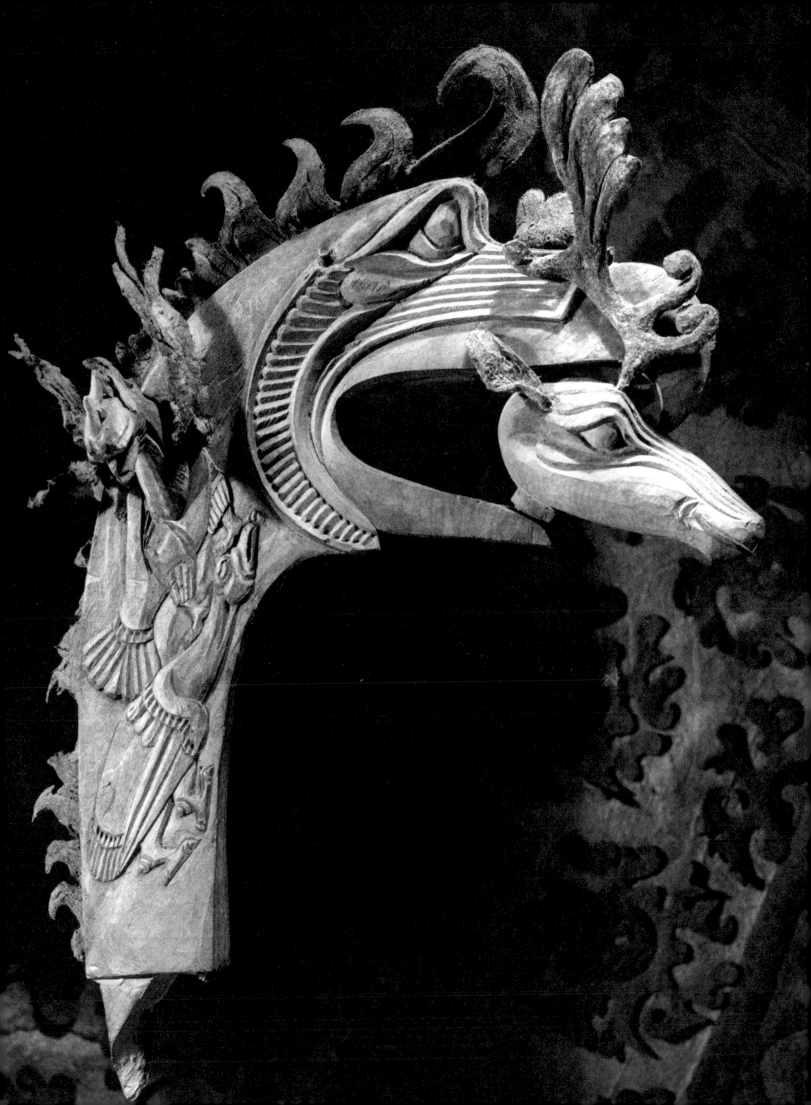

3. Chinese Art of the Shang and Chou Dynasties

FROM EARLY TIMES the written history of China has maintained the tradition of a Shang Dynasty, mentioning even a chronology with a list of rulers, and a dynasty preceding the Shang, called the Hsia. Until the late 1920s, there was no scientific evidence indicating that these texts were anything more than legends. However, as early as the late nineteenth and early twentieth centuries, finds were made, largely in surface excavations by peasants, of some curiously inscribed bones and marked

15. Shang Royal Tomb, An-Yang, Honan, aerial view

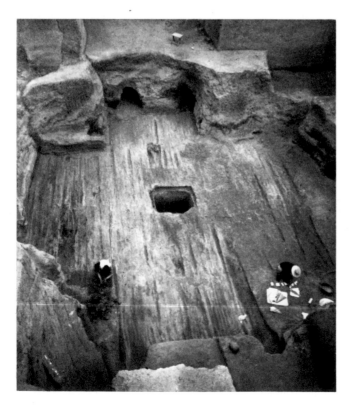

tortoise plastrons, the underside of the tortoise. The markings on these were caused by burning. For a while these bones and plastrons were thought to be forgeries. Some of them were looked upon by the Chinese peasants and medicine men as dragon bones and were ground up and used for medicine, because everyone knew that dragon bones were good for various ailments. Then, in 1928, excavations were begun at An-Yang, in Honan province. These were scientifically controlled and took advantage of previous probing by grave robbers. The interested world knew that great Chinese bronze vessels had already appeared on the Northern Sung market as early as the eleventh century A.D., but there was no way to account for the culture that produced them until the Chinese government was able to begin excavations in 1928 and to establish scientifically the truth of the Chinese legend: there was a Shang Dynasty. They were able to establish the authenticity of the oracle bones — bones with inscriptions in what proved to be archaic Chinese. They were able to correlate the oracle bones with the magnificent bronzes and jades which were found at An-Yang. Succeeding excavations, many still in progress, have revealed an extremely rich variety of sites, most of them centered in the central plains. While the Shang Dynasty lasted, according to historical records, from 1523 to about 1028 B.C., the material that we are to study is found at An-Yang, the capital of the Shang Dynasty from about 1350 on.

Who were the Shang? They now appear to be native Chinese, perhaps the people of the central gray pottery culture, and inheritors of the combined wealth of knowledge and invention of the three dominant Neolithic cultures — Yang-Shao, Lung-Shan, and Hsiao-T'un. At their dominating location in the central plains they created the most highly developed bronze technique of pre-industrial times. They practiced the art of divina-

tion by means of heat applied to tortoise plastrons. In that, they seem vaguely related to the people of the plains, of the Lung-Shan culture. They also built dwellings and walls of pounded earth, and this, too, relates them to the people of the plains. Certain shapes of their bronzes appear to be derived from ceramic shapes of both the plateau and the plains cultures. But three crucial innovations mark the emergence of historic Chinese culture and of a great civilization: the invention and development of a written language; a vastly increased control of the environment, from the standpoints of agriculture and of a developed hunting technique, which included the importation, for hunting and menagerie purposes, of some of the most exotic creatures known to all of Asia; and the first appearance of bronze in China.

Let us mention briefly the problem of Shang religion and symbolism. A great deal has been written about the meaning of the decorations found on Chinese bronzes. We know the questions that were asked on the oracle bones, for the script written on them is fundamentally the same language as modern Chinese, even if more primitive and archaic in form, more pictographic than the language of the present day. The questions which are asked on the oracle bones indicate, for example, a belief in an overlord somewhat like a supreme deity, and in certain spirits. There was definitely a shaman cult whose priests were very important. But above all else, the questions have to do with the hunt and with war: Will the hunt be successful? Will the battle against the enemy be in our favor?

Many authors attempted to explain in detail the symbolism of the various animal designs represented on Chinese bronzes. I agree with Alexander Soper, who describes one of these explanations as "moon-struck." We do not know, and will not speculate here. Still, we must agree that there is a highly developed animism along with the concept of a supreme deity, a belief in magic, and a belief in the possibility of control by propitiation through sacrifice of both animals and men. The interpretation of the king's dreams of ghosts and spirits played a part in the text of the oracle bones.

We shall first consider Shang funerary architecture and sculpture, then pottery and jade, leaving the most important objects, the bronzes, until last. Our map (*page 10*) gives some idea of the location of the principal sites. An-Yang is between Shantung in the plains and the highlands of the Shensi and Shansi. This is the great site to which the Shang moved from Cheng-Chou about 1400 B.C. At An-Yang we find a further development of the amalgamation of the three Neolithic cultures begun in the relatively simple bronze culture recently discovered at the earlier Shang capital of Cheng-Chou. The combination of these three cultural elements produced the great culture we know as Shang. The first excavations at An-Yang were of the royal

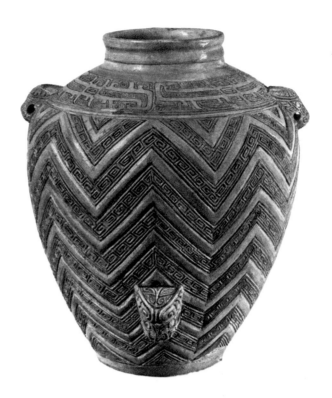

16. Vase, from An-Yang. White pottery with impressed decorations, height 13¹⁄₁₆". Shang Dynasty. Freer Gallery of Art, Washington, D.C.

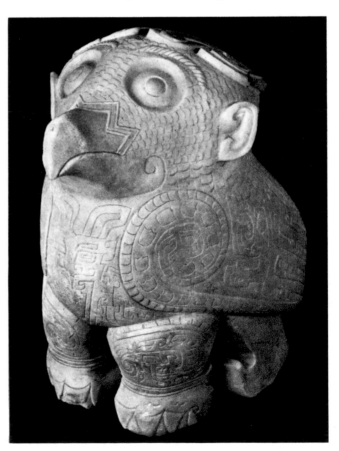

31

17. Owl, from Hou-chia-chuang cemetery site in An-Yang, Honan. Marble, height 17¾". Tomb 1001. Shang Dynasty. Academia Sinica, Formosa

tombs, while later smaller burial grounds and living areas were found. The extensive hoards of bronzes were from royal tombs of great size, some of them reaching a depth of over 60 feet. One can get an idea of the scale from the view from above a cross-shaped royal tomb (fig. 15). The floor level housed the body of the king and most of the bronzes and implements buried with him. The hole leads to an underground chamber for dog sacrifices. In the burial ceremony dozens, and in some cases even hundreds, of human and animal sacrifices accompanied royalty to the grave.

Grave robbers did not excavate by digging, but used long copper or bronze probes which they pushed into the ground. It was only when they hit something that sounded metallic or that firmly stopped their probes, that they dug to the obstruction and pulled it and its neighbors out, sometimes in pieces. These could then be cleverly repaired and placed on the market.

In the An-Yang tombs few architectural fragments were found; that is to say, there were not actual wood fragments but impressions left in the soil by various timbers. Thus we know little about Shang architecture. It was a post-and-lintel system, with some timbers decorated with painted designs rather like those found on the bronzes. It is of considerable importance, as we shall see, to realize that the wood was decorated.

Coarse gray pottery for everyday use was found in the living areas. Some traces of rudimentary glazing are reported to have been discovered by Li Chi. A second, white pottery type was found, unique in Chinese history until this time and in a sense the beginning of the great tradition of Chinese ceramics. The gray pottery is not unlike that found in Neolithic plateau and plains sites, but the Shang shapes are somewhat more

developed and are influenced by the bronzes. But the second type, the white pottery of An-Yang, was made of a very fine, white-paste clay, fired at a low temperature, and covered with designs impressed in the clay. These are like the designs found on the bronzes—usually a pattern with a fret interlock, very similar to the decor on the two pre-An-Yang bronze horses—and may provide a link between pre-An-Yang culture and "Northern" or Siberian geometric decoration. Above this pattern the white pottery vase has a design of eyes and heads like that found on the bronzes (fig. 16). Bovine masks in high relief were applied to the surface of this type of vessel, such as the one now in the Freer Gallery of Art. A great many fragments of white pottery have been found, but the Freer vase is the only nearly complete major piece so far recovered.

Another product of the Shang Dynasty, not seen before in China, is stone (marble) sculpture in the round or in relief, influenced by the shape and decoration of the bronzes. This appears to have been used largely for architectural purposes — supports for columns of wood or pedestals for platforms of wood. Some of the figures have mortises cut into the back to hold the tenons of now-missing wood beams. The two most extraordinary specimens found at An-Yang by the Academia Sinica are an owl (fig. 17), and a tiger, incised with the same elaborate designs found on the bronzes. One can see from the marble sculptures that these designs have something of the unique quality of Shang art: a combination of elegant and refined detail with tremendously powerful silhouettes and shapes that contribute to an effect that is, on the whole, frightening. We are inspired with awe and terror when looking at these beasts with gaping mouths, and at these birds of prey.

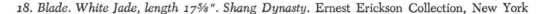

18. Blade. White Jade, length 17⅝". Shang Dynasty. Ernest Erickson Collection, New York

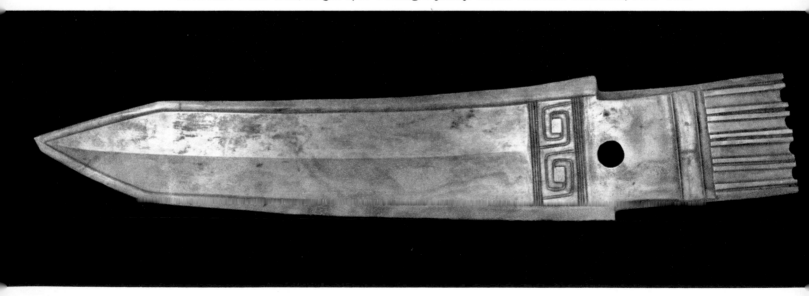

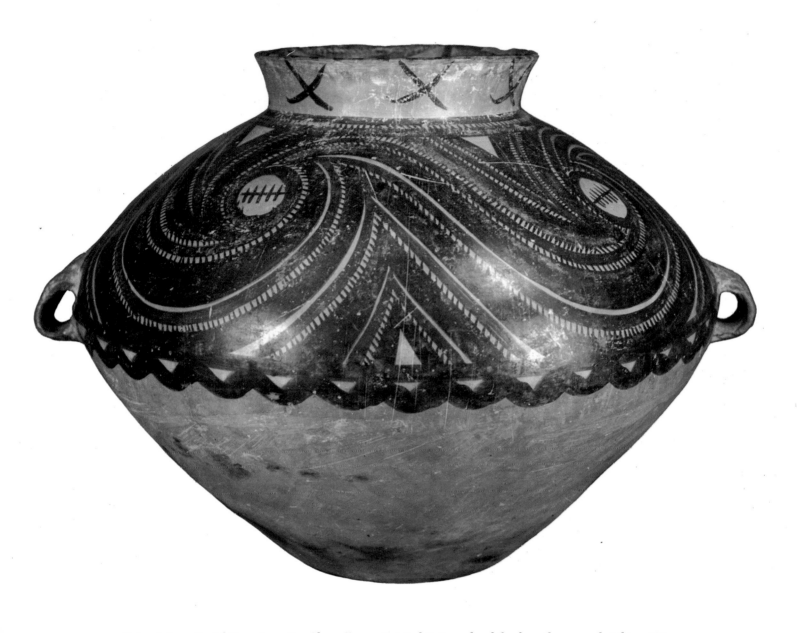

Colorplate 1. Burial Urn, from Pan Shan, Kansu. Painted Pottery, hard-fired earthenware, height 14⅛"
c. 2200 B.C. Seattle Art Museum

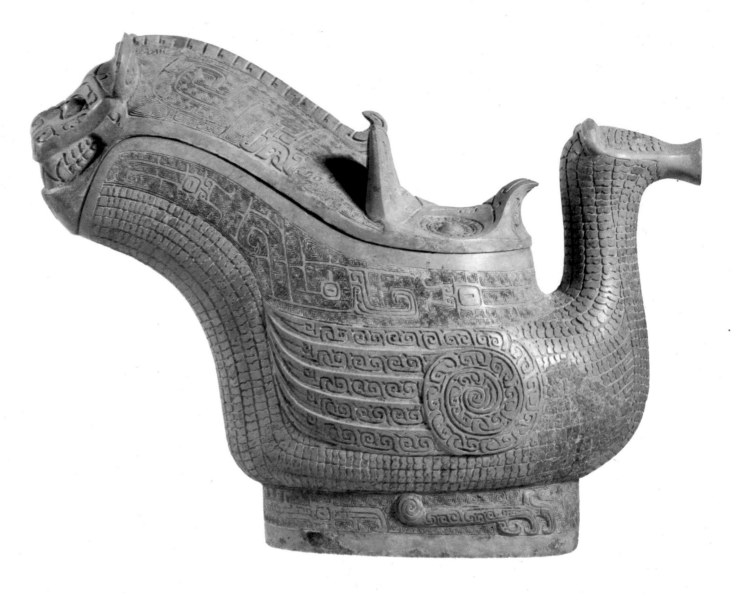

Colorplate 2. Kuang. Ceremonial vessel, bronze, length 12¼". Shang Dynasty.
Freer Gallery of Art, Washington, D. C.

In addition to sculptures in marble, many miniature jade sculptures, perhaps amulets and charms, were found. The use of jade was not altogether new; a few examples of simple types were found in the Neolithic plateau sites, but by the time of the Shang, jadeworking had developed to a very complex degree technically and representationally, exhibiting an extraordinary control of the material. Certain pieces, however, are very simple, as is the Erickson blade, over a foot long and probably made from a long boulder, sliced or sawed, and then polished to its final shape (fig. 18). Such a blade, which would have served no useful purpose, as jade is very brittle and could not withstand severe impact, probably copied a bronze weapon and was used for ritual purposes. As there is no decoration beyond a spiral pattern near the handle end, it remains an austere, straightforward form related to the few known Neolithic examples. In addition to such shapes, there are animals in the round, like the squatting bear whose unadorned surface recalls Neolithic techniques (fig. 19). To be sure, there are animals of unknown provenance which may be Neolithic jades or jadelike stones carved in the shape of squatting animals similar to the bear, so there may well be some carry-over both in style and technique from Neolithic sculptures to the Shang jades. But the little bear displays one very significant addition — the typical Shang motif of the "hawk-eye," with the pupil or circle of the eye indicated as larger than the oval rim of the eye, and the tear duct as beak-shaped.

A third jade example in the form of a composite head is unlike any prototype. In connection with the animal style, we mentioned the metamorphosis of one creature into another (fig. 20); this is a major motif in Chinese bronzes. Here an elephant trunk grows out of a leonine or tigerlike head with sharp teeth, while the top of the head is crowned with capped bovine horns, thus forming a metamorphical representation of three different animal elements within the three inches of a single piece of jade.

It may seem surprising to see an elephant's trunk in North China, but the skeleton of an elephant was found at An-Yang, and even more exotic forms — a whale, a rhinoceros, and a varied assortment of animals brought from all over Eastern Asia. While it may be possible that the elephant ranged as far north as An-Yang before 1000 B.C., the likelihood is that it was imported from the south to a royal park or zoo. There are one or two rare bronze representations of the Indian rhinoceros.

Among the thousands of early jades that still exist, there are a few typical Shang representations of animals of the early animistic pantheon — principally rabbits, deer, bears, and tigers. All these animals must have been necessary to the Shang hunter-warrior, to Shang magic, and thus to Shang art. It is a little easier

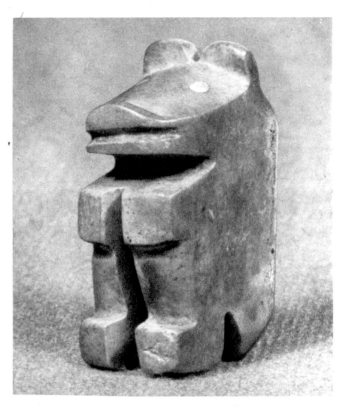

19. Squatting Bear. Jade, height 2⅛". Shang Dynasty. Fogg Art Museum, Harvard University, Cambridge

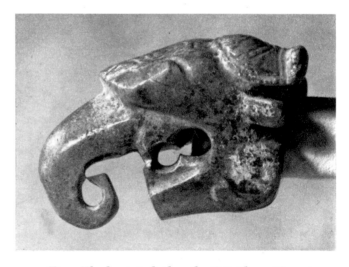

20. Tiger-Elephant. Jade, length 1⅝". Shang Dynasty. Cleveland Museum of Art

to study the animal shapes first in jade than to go directly to the vessels on which they are piled one on the other in metamorphic profusion.

And now to bronze, the key to the whole civilization. As we have seen, the casting technique may have been imported first from Siberia, which received it in turn from somewhere farther west; and objects, rather than technique, must have come at first in the form of

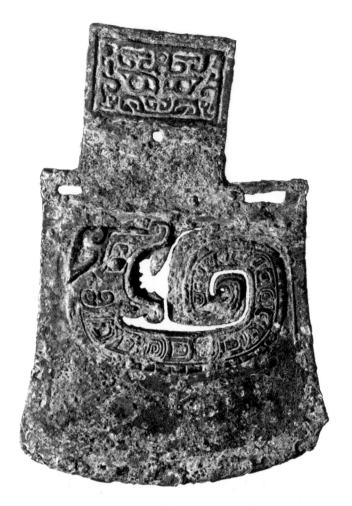

21. Axe. Bronze, width 5⁹⁄₁₆". Shang Dynasty
Cleveland Museum of Art

weapons such as the axe and the dagger. With the grad-
ual flourishing of Shang culture, the bronze technique,
once achieved, was used to create vessels of all types,
including large and magnificent castings for which
there are few local antecedents. Recent excavations
have disclosed somewhat earlier and more archaic ver-
sions of the vessels called *chueh* and *kuei,* but these
are still more advanced than the presumed weapon
prototypes. The axe in the Cleveland Museum of Art
shows the type of weapon developed from the imports
and embellished by the Shang with two of their char-
acteristic motifs (*fig. 21*). One of these is the so-called
t'ao-t'ieh, which means, in modern Chinese, "ogre mask"
or "gluttonous mask." The term was applied to this
Shang motif by Chinese connoisseurs of much later
times and is a misnomer that has stuck, despite the fact
that the mask may be of many different animals: bull,
tiger, and deer, among others. In our illustration some
kind of a feline creature, perhaps a tiger, looks straight
out at the spectator and, as has been often pointed out,
is similar to masks in the much later carvings of the
American Northwest Coast Indians. It looks as though
the skull of the animal had been split and the two sides
of the head spread out to the front plane, so that one

sees two side views from the front. The result makes a
rectangular pattern, with staring eyes and bared fangs.
Below, on the axe, is a second important element of
Shang decoration, called "the *kuei* dragon," a single-
legged creature with horns, fangs, teeth, and usually a
gaping mouth. From the evidence of the hundreds of
decapitated human figures buried at An-Yang, we may
conclude that an axe of this size and type was used for
human sacrifice.

Before we look at the bronze vessels themselves, let
us examine a drawing that indicates the possible deri-
vation of some of their shapes (*fig. 22*). The drawing
includes only three of the large numbers and variations
of shapes that have been found. But these are signif-
icantly common and are further related to those of the
earlier Neolithic cultures of China. On the right, in our
illustration, above, is a vessel of a type found in the
Neolithic plain culture; below is a Chinese bronze ves-
sel of the Shang Dynasty of the *kuei* shape. Above, in
the center, is the *li* tripod in bronze. On the left is the
solid-legged tripod in clay, a type found at Yang-Shao,
the type-site for the painted-pottery culture; below is
a three-legged *ting,* with solid legs in bronze, of the
Shang Dynasty. There is some continuity in these shapes
and it would be very simple if we had only these three;
but there are many more shapes which are without
precedent.

Where do the elements of Shang bronze decoration
come from? The most convincing theory is that of Li
Chi, the Chinese archaeologist who first excavated at
An-Yang. Li believes that they derive from the painted
decoration of wood. From the evidence found at An-
Yang, he knows that there was painted decoration of
wood, and he has compared this decoration with the
decoration on bronzes and found it to be similar. He
has, furthermore, shown how the shapes of wooden ob-
jects influenced the shapes of bronzes as in a unique
specimen, the famous bronze drum in the Sumitomo
Collection (*fig. 23*). Here the original three-piece drum
was cast in one bronze whole, save for the removable
lid. The drum has a central decorative motif of a hu-
man being with a winged headdress. Below is a mask
with two eyes looking in from the side. There are two
birds and an ogre mask on the cover. The ends of the
bronze are cast to simulate crocodile hide. Presumably
the Sumitomo bronze is derived from a wooden drum
with crocodile skins as drum heads. The meaning of
the symbols is not known to us. This drum is one good
indication of the influence of earlier wooden prototypes.

The *ting* is a vessel which Li Chi uses convincingly
as evidence of a wood derivation for the bronze ves-
sels (*fig. 24*). It is a four-square vessel, as if made of
boards of wood, with painted decoration, peglike legs,
and loop handles on the sides. The decoration, in this
case, is easy to read, and very unusual. The main mask,
on the sides of the vessel, is a deer mask, with two

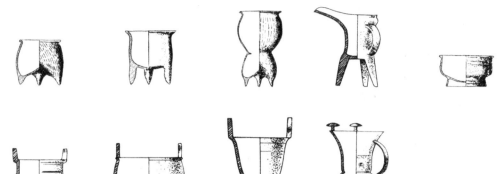

22. Drawings showing relationship of shapes in ceramic (above) and bronze (below)

hook-beaked birds, perhaps owls, on either side. Above and below this is a band with a series of little monsters in dragonlike form. This specimen was excavated at An-Yang and is of tremendous size — over two feet square.

The Sumitomo Collection provides us with another extraordinary bronze for which there is no prototype in Neolithic shapes — a very complicated vessel in the form of a bear or a tiger squatting on its haunches, with its tail used as a third support, and surmounted by a deer on its head (*fig. 25*). The bail-like handle is composed of serpents, while the points of the handle's junction with the vessel are capped with the head of a bovine animal. The *kuei* dragon is a prominent part of the animal's side decoration. On the legs are snake forms, and the flanks of the beast display even clearer indications of the snake in a diamond-backed form. Clutched in the arms and maw of the beast is the figure of a man with his head turned sideways. Whether this is a representation of the perils of the hunt or whether it is a representation, as Hentze and Waterbury believe, of the eclipsing sun as devourer, depends largely on one's disposition to believe in the universality of these myths. But there is no precedent for a vessel such as this. It is a Shang invention and embodies the principal elements that make up the Shang bronze style — the combination of many animals on one form, the metamorphosis of one animal into another, the desire to cover the whole vessel with a complex design, and the tendency toward powerful, compact sculptural forms that in later Shang bronzes tend to project into space.

We have included a representation of numerous vessels to show many different shapes and a wide range of decoration. The three-legged *ting* is a classic example (*fig. 26*). The mask faces out at the intermediary ribs rather than at the legs. Above is the oft-repeated band of curious animals, two heading toward one rib, and two toward the other rib. The whole design is actually a symmetrical pattern exactly duplicated on each side

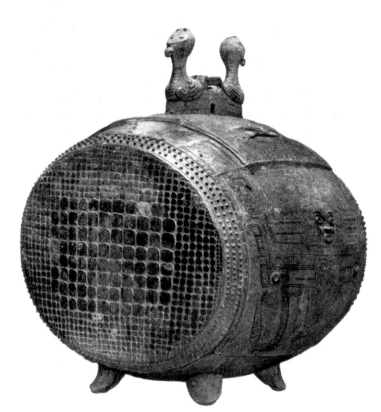

23. Drum. Bronze, height 31⅜". Shang Dynasty.
Sumitomo Collection, Japan

of the flange. The pattern — mask with four animals — is repeated three times. Below, on the tubular legs, is the cicada, a design found many times in jade.

A word about patina may be in order at this point. The beautiful greens and blues found on the Chinese bronzes are completely accidental, the product of many centuries of burial in the earth. The action of salts in the earth produces various oxides that give the beautiful colors to the surface of the bronze — colors that are the result of burial and aging, and not the intention of the artist. When bronzes come out of the ground, they look like nothing so much as large incrusted oysters.

37

They are cleaned by the "excavator" or the dealer, sometimes by simply applying peaches to the outside and allowing them to acidify. The mild acid tends to weaken the incrustations, which are then tapped with a hammer and fall off. Then the cleaner can begin removing smaller incrustations until the design begins to appear. Much work is involved in preparing bronzes for the market. Originally, of course, the vessels were a lustrous copper-bronze color and, in some cases, had inlays of a black pigmentlike substance.

A *kuang* in the Freer Gallery embodies Shang concepts of metamorphosis very beautifully (*colorplate 2, p. 34*). A tigerlike cover changes at the back into the mask of an owl with eyes, eartufts, and beak. Some insist the bird is a pheasant, despite the fact that it has been scientifically identified as an owl. But the pheasant is a sun bird, and so more useful to the modern symbol seeker than the less convenient owl. The whole back of the *kuang* is treated as if it were a spoon-billed bird. The artist has combined three presumably incompatible elements—an owl, some other kind of bird, and a tiger—into one functional design. The neck of the second bird provides the handle by which one tilts the vessel and pours when the cover is removed. The ground of the vessel is elaborately developed with a pattern of squared spirals, sometimes called the thunder pattern. This provides a texture against which the low relief and the large design elements stand out.

25. Yu in the Form of a Bear Swallowing a Man. Bronze, height 12⅞". Shang Dynasty. Sumitomo Collection, Japan

24. Square Ting, from Hou-chia-chuang, An-Yang, Honan. Bronze, height 24½". Tomb 1004. Shang Dynasty. Academia Sinica, Formosa

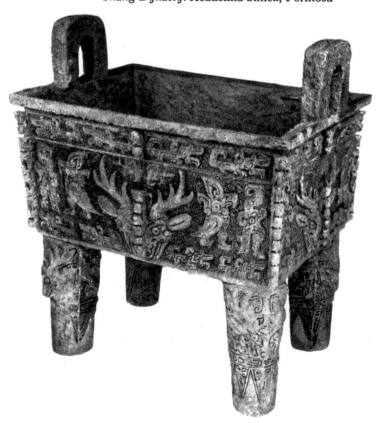

The Shang bronzes were apparently cast by the piece-mold process: sections of the planned design were carved in reverse in clay as hard as leather, and the sections were joined by keys before the metal was poured into the assembled mold. Some effort also has been made to suggest the use of the lost wax process, and it seems likely not to have been used before the Late Chou Period. The molds were prepared for each vessel and were never repeated. The casting is extraordinary. Just imagine the precision and care required to cast the small thunder-pattern motifs in intaglio (*fig. 27*). The walls of the thunder spiral are quite perpendicular; the bottoms of the tiny channels are as if one had dug a perfect groove. The metal fills in the forms completely; very little plugging was done. Again, it is extraordinary that, with but a few rather crude precedents, there developed this magnificent technique, brought to a higher point in China than in the Bronze Age of any other people or group.

38

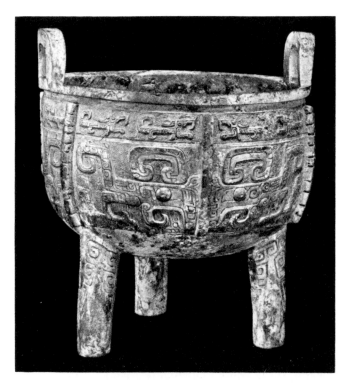

26. Ting. Bronze, height 9½". Shang Dynasty.
Seattle Art Museum

Another shape, the *chueh*, is a vessel apparently used, according to Yetts, for heating liquids to extremely high temperatures; the three legs were probably set directly in the fire so that the heat could reach the bowl. When the vessel was sufficiently hot, it was lifted by the two flanges at the top and tilted by the projecting point at the right so that the liquid would run out the spout. A larger vessel, four-legged, and not to be confused with the *chueh*, is called the *chia*. The example shown in figure 28, also in the Freer Gallery, is perhaps the most magnificent one known and is of an early type. The decoration keeps closely to the surface so that the profile appears to be self-contained. In this case the lid is surmounted by a bird, perhaps an owl. The casting is refined and perfect.

A very common shape among the Shang bronzes is the *ku*, a tall, trumpetlike vessel, related to earlier pottery shapes of Neolithic times. Still another type, called the *i* is used by Li Chi to demonstrate his wood derivation theory, the shape of the *i* being derived from that of a simple house, its fundamental arrangement derived from wood construction. The *i* in the Freer Gallery has one of the clearest representations of the ogre mask, as well as that projection into space characteristic of the later Shang and Early Chou vessels.

Loehr shows in his stylistic sequence that the development of Shang bronze style appears to be from a rather tightly controlled decoration kept within the

contour of the vessel toward a more baroque and bristling style in which the vessel appears to project into space. In this transition to the Early Chou Period, some shapes simply disappear. Of the Shang shapes we have seen, the *i*, the *chueh*, the *chia*, and the *ku* disappear. When something as radical as that occurs, when four of the most popular shapes of a period are suddenly ignored, then we may infer a marked change in the society that makes them.

The shift from the Shang to the Early Chou style is to be seen in several securely dated vessels bearing inscriptions. One of these is a four-legged *ting* in the Nelson Gallery (fig. 29). In the early Shang bronzes, there is often no inscription, or at best one of a single character as, for example, a clan name such as *Ko*. Later in the Shang Dynasty, two-, three-, and four-character inscriptions appear; and by the time of the transition to Early Chou, there are long inscriptions of sometimes as many as 497 characters. This particular *ting* has an inscription of three characters, allowing us to date it at the very beginning of the Chou Period in the reign of King Ch'eng, who began his rule seven years after the fall of Shang. There are many elements of late Shang style; the form of the vessel has now expanded into space, and the flanges project in high relief, as do the mask, legs, and horns. Even the handles, so tightly contained in the Shang *ting*, are now crowned with horned animals, cast so that they project far beyond the outlines of the vessel.

We have already seen in the beginnings of the Chou bronze style the visual evidence of radical changes in the profiles of shapes and the disappearance of certain

27. Kuang. Detail of colorplate 2

types which suggest a marked change in the demands of the new society. The change was primarily caused by the triumph of a new and very vigorous stock from the tributary state of Chou in the west. The Shang people were defeated and An-Yang surrendered. The hunting aspects of this early Chinese culture were de-emphasized. Feudal control of organized agriculture became dominant. The Chous did not obliterate the Shang or their culture. They, as do most wise conquerors, absorbed much of it and made it their own. A new capital was established not far from the later capital of Ch'ang-An. The empire of feudal states established by the house of Chou endured almost a thousand years (1027-256 B.C.) with varying degrees of fortune. Politically, economically, and artistically this phenomenal time span falls into three major phases: Early Chou (1027-c.900 B.C.), Middle Chou (c.900-c.600 B.C.), and Late Chou (c.600-222 B.C.). The last period, one of gradual decline, is best characterized by the descriptive Chinese terms: the period of Spring and Autumn Annals (722-481 B.C.) and the period of Warring States (481-221 B.C.).

The Chou rulers formulated the principles of statesmanship, the moral code that endured for thousands of years as one of the foundations of traditional Chinese culture. These formulations are recorded in the great classics: the *Canon of Changes* (*I Ching*), the *Book of Odes* (*Shih Ching*), the *Book of History* (*Shu Ching*), the *Book of Ritual* (*Li Chi*), and the *Spring and Autumn Annals* (*Ch'un Ch'iu*). The period also saw a gradual change in religious attitudes. Animistic elements declined and first mention was made of the concepts of heaven and earth. The already existing ancestor cult moved toward maturity. In general, we find a situation often repeated in the development of an early culture: a change from a mixed agricultural-hunting culture to an organized urban and feudal agricultural state, with the accompanying gradual change from animism to more abstract forms and concepts of religion.

We have mentioned the continuity of bronze technique and the survival of many Shang bronze shapes and decorative motifs. We have mentioned the increasing importance of the inscriptions, which sometimes approach chapter length, on some of the later bronzes. Fundamentally, the Chou bronze styles can be divided, in conformity with stylistic appearance, into three units: Early Chou, Middle Chou, and Late Chou. In general, the Early Chou style is a continuation of the Shang, with variation of some shapes and omission of

40

LEFT:
28. Chia. Bronze, width 9⅞". Shang Dynasty.
Freer Gallery of Art, Washington, D.C.

BELOW:
29. Four-Legged Ting. Inscribed with name of King Ch'eng, bronze, height 11". Early Chou Period.
Nelson Gallery-Atkins Museum (Nelson Fund), Kansas City

others (fig. 30). The Middle Chou Period brings a radical change in style and an apparent decline in technique. Finally, with the Late Chou Period comes a renaissance of the decorative innovation and technical skill, the flamboyance and love of detail characteristic of Shang bronzes.

Let us first look at the characteristic Early Chou vessels. The *yu* (fig. 31) existed in the late Shang Period. It is fundamentally a pail with a cover and was evidently much in demand. A particularly interesting element is the decoration of the main body of the vessel, especially the two birds with the markedly upswept tails. This motif of the bird with upswept tail, whether simple, or flamboyant, as in this case, appears to be an Early Chou invention. In this vessel it replaces the more characteristic mask of the Shang Dynasty. The masks are now small, and confined to knobs in the middle of the sides and at the ends of the handle. There is also a slight loss in technical facility; details are not as crisp as they were before.

A fundamental change, the first major change from Shang modes, occurs not at the beginning of the Early Chou Period, for this period usually worked with what had existed before, but at the beginning of the Middle Chou Period, when a series of new vessel shapes with a new and very limited type of ornamentation appears (fig. 32). Where the Shang vessels seem to be vibrant and those of Early Chou either flamboyant or carefully balanced, the Middle Chou vessels seem heavy and squat. They hug the ground; and if we may judge weight by appearance, the Middle Chou vessels appear to be very heavy. The decoration reflects this changed character. In some cases it disappears, and aesthetic variety is achieved with the plain surface of the vessel, or by horizontal grooving, which emphasizes the weighty and close-to-earth qualities of the vessel. Even the masks disappear from the handles, which are treated as simple rings. The total form is extremely austere.

A pair of bronze tigers demonstrates what happens to animal forms and their decoration in the Middle Chou Period (figs. 33 and 34). The animals now appear earthbound. Of course, they are tigers, but if one looks at the backs, bellies, and legs one realizes how much more static they are than the Shang representations of the beast. The decoration has lost its metamorphic character, and there is no use of many different animal forms. Further, the decoration is consistent and all of a piece. The whole representation has reached a logical and unified concept, from a naturalistic point of view. The two tigers were probably for architectural use, as there are openings in their backs, and they are far too heavy and clumsy to have been used as vessels. Perhaps they were supports for the pillars of a throne or canopy.

Bronze animals in the round first appear, generally, in Middle Chou. There are a few naturalistic animal

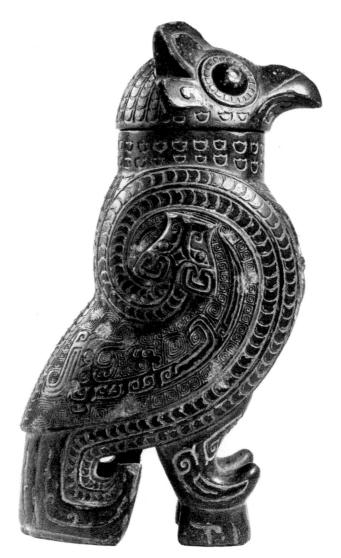

30. *Tsun in the Shape of an Owl. Bronze, height 8¼".
Early Chou Period.* Cleveland Museum of Art

vessels in the Shang Dynasty, but in the Middle Chou Period we find one of the first representations of an animal without a known functional purpose. The buffalo in the Pillsbury Collection may have been an image, an aid to worship, or an aid to ritual as a representation of sacrifice (fig. 35). But, above all, it is a sculpture in the round and looks more naturalistic, more "real," than do the Shang buffaloes. And, while it has lost the vitality of Shang technical dexterity, it possesses greater unity.

In jade, too, the changes are clearly perceptible. Shapes become simpler. The Early Chou jades continue Shang types, but they also establish new types, such as the white jade fish in the Cleveland Museum — simple and severe, recalling a Neolithic style (fig. 36). The Middle Chou Period witnessed some extreme simplifications of geometric shape, such as that found in the *ts'ung*, with its squared tubular conformation. There is a great deal of controversy as to the precise meaning and use of this shape. It is traditionally described in the old Chinese texts as the symbol of earth; the *pi*

41

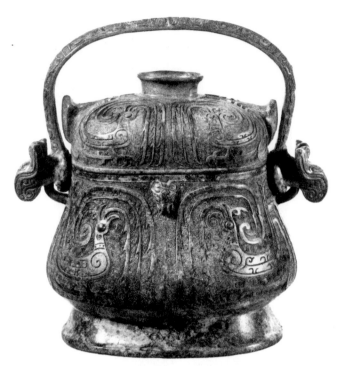

31. *Yu. Bronze, height 9". Early Chou Period.*
Freer Gallery of Art, Washington, D.C.

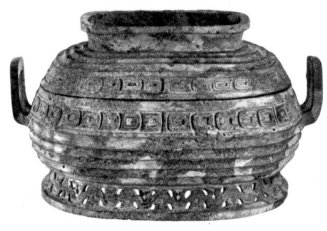

32. *Grooved Kuei. Bronze, length 12½".*
Middle Chou Period. Minneapolis Institute
of Arts (Pillsbury Collection)

was the symbol of heaven — a large disk with a hole in the center, the diameter of which is usually one-third the total diameter of the disk. Bernhard Karlgren, the Swedish Sinologist, believes that the *ts'ung* was originally a casing for a phallic symbol (*fig. 37*). The trouble with his theory is that very few phallic symbols have been found in jade or any other material, and yet we have many examples of the *ts'ung*. But the shape, as a controlled form, appears to begin in Middle Chou, and

seems in keeping with other developments of that style. It is one with that period's attempts at unification and simplification of the total form of the object. As to the *pi*: while large circles of jade exist from Neolithic times, they were not carefully controlled, and the shape was probably not fully codified until the Middle Chou Period.

One of the most fascinating periods of Chinese history is the Late Chou Period, sometimes called Late Eastern Chou and divided into two parts — the period of Spring and Autumn Annals and the period of Warring States. The Late Chou Period is a time of troubles — the breakup of the Chou feudal system, wars between many small states, the change and modification of the old philosophical traditions and the old rituals, and those shifts between high and low intellectual traditions which Ralph Turner has shown to be so important. More people became familiar with writing and higher culture. Civilization was expanding, and South China came more and more into the high cultural orbit. If Late Chou, from the standpoint of the well-being of the states, was a period of decline as a result of an almost constant state of war, it was also a period of tremendous intellectual and artistic ferment. We can date the beginnings of the great Chinese philosophical traditions from the Late Chou Period. Confucius (born 551 B.C.), lived in this time, as did Lao-Tse (born 604 B.C.), Mo Ti (born c. 500 B.C.), the teacher of universal love, and many others including the triumphant Legalists, the philosopher-statesmen who justified the almighty state and thus ultimately aided the rise of the totalitarian Ch'in Dynasty (221-206 B.C.).

The two main streams of philosophy of primary importance from this time on were those of Confucianism and Taoism, the latter term after Lao-Tse's favorite word, *Tao* — "the Way." In general, Confucianism can be described as a humanistic system, perhaps rather pessimistic and traditional, but fundamentally concerned with man and his place in nature, with the emphasis on man. Taoism, on the other hand, tends to be pantheistic and mystical. It is more concerned with harmonizing man with nature and thus with finding nature's essential rhythm. It is of some interest that in this Warring States period, with its accompanying breakdown of the social order, Confucianism with its desire for peace, prosperity, and order, should have risen. Taoism's reaction tended to be more escapist, seeking in nature relief from the social troubles the Confucian philosophers tried to remedy.

There are many Late Chou archaeological sites. We will list only some of the more important ones in more or less chronological order: Hsin-Ch'eng, Li-Yu, Chin-Ts'un, Hui-Hsien, and Ch'ang-Sha. The first four are northern sites and are to be dated approximately as follows: Hsin-Ch'eng, seventh-sixth centuries B.C.; Li-Yu, sixth-fifth centuries B.C.; Chin-Ts'un and Hui-Hsien,

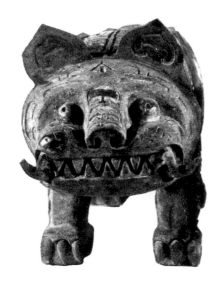

LEFT: *33. Pair of Tigers.*
Bronze. Middle Chou Period.
Freer Gallery of Art,
Washington, D.C.

BELOW: *34. Tiger.*
Side view of one of the pair in
figure 33, length 29⅝"

43

35. Buffalo. Bronze, length 8⅛".
Middle Chou Period. Minneapolis Institute
of Arts (Pillsbury Collection)

36. Fish. Jade, width 3 9/16".
Early Chou Period. Cleveland Museum of Art

37. Ts'ung. Jade, height 8 1/8". Middle Chou Period.
Freer Gallery of Art, Washington, D.C.

fifth-third centuries B.C. Ch'ang-Sha is the most impor-
tant site now known in the South. The material that is
being excavated there dates from the fifth century to
the Han Dynasty (206 B.C.-A.D. 220), and provides an
ever clearer picture of the culture of the Ch'u state, the
dominant political entity of the South in the Late Chou
Period, and one of the most original states of the time
in its innovations in material techniques and imagina-
tive figural subject matter and symbolism. Hui-Hsien
is a most recent excavation by the Chinese Commun-
ists, and is comparable in some of its materials to Chin-
Ts'un. We are therefore dealing with more known sites
than we have dealt with before, and from a wider geo-
graphical range.

There is also a much greater variety of material, be-
cause the Late Chou Period witnessed a great expansion
of Chinese techniques and knowledge of raw materials.
Undoubtedly, some of this expansion was under stimu-
lus from the West, as is indicated by the influence of
the later animal style and the importation of glass
beads. The period also saw the first native production of
glass, which had great implications for the ceramic in-
dustry, for it is no coincidence that the development of
purposeful glaze dates from this time despite Li Chi's
evidence for traces of glazing on some of the Shang
vessels from An-Yang.

Late Chou bronze style achieves another high de-
gree of complexity; but now, instead of a complexity
made up of many cryptic and awesome symbols, the
complications tend to be more playful, elegant, and re-
fined. This style may be described perhaps as more
consciously aesthetic. While Confucius deplored lux-
ury, the Late Chou style in bronze, gold, silver, jade,
and lacquer is, above all, a luxurious style. For ex-
ample, one of the new shapes is that of a bell called
chung (fig. 38). Bells were made as early as the Shang
Dynasty, but they were relatively simple, barrel-like
constructions. In the Late Chou Period, we find refined
barrel shapes, oval in cross section, with a slight entasis
and with the bosses — used to insure a clearly struck
tone — in the form of coiled snakes. The handle above
is transformed into paired dragons. Below is a revival
of the ogre mask in pairs, but handled in a very playful
and decorative way. Parts of these masks, in turn, de-
velop into other animals such as snakes and birds, rein-
stating the idea of metamorphosis. Bells came in sets,
each one for a different tone. A complete set exists in
Japan in the Sumitomo Collection. This particular bell
must be from a very large and elaborate set excavated
at Chin-Ts'un. A characteristic technical detail of the
Late Chou style is the "Late Chou hook," a squared
spiral with a tight raised curl at the end of the spiral,
projecting from the surface of the vessel. This hook
occurs very often in bronze and jade whenever the art-
ist works in low relief.

Another innovation in the bronzes of the Late Chou

Period was the use of inlays of precious metal. We have mentioned the use of black pigment as inlay in the Shang Dynasty bronzes. But with the Late Chou Period, we see silver, gold, an early type of speculum metal, and even glass used as inlays. There is a particularly fine example of this in the Pillsbury Collection in a typical Late Chou shape—a three-legged *ting* with a profile completely modified from that of Shang or Early Chou (*fig. 39*). The *ting* is now rounded and the legs conform to the softer structure of the vessel proper. The whole shape has a roughly spherical character. The Middle Chou grooves are maintained but not used repetitively. But this *ting* is especially important for its six dragons inlaid in gold on the cover. The lid is designed to be used also as a plate, with three legs in the shape of reclining rams in high relief. The body of the vessel is decorated with an abstract pattern of interlocking triangles, with typical Late Chou hooks for further embellishment. One of the most beautiful of all Late Chou pieces is a finial in the shape of a dragon biting and being bitten by a bird (*fig. 40*). It is an extraordinary tour de force. The long head of the dragon dominates the composition; but sitting on the dragon's lower jaw, clutching it with its talons and with its tail

feathers curling under the dragon's chin, is a small bird bending over the top and tearing with its beak at the dragon's snout. The subject is a combination of the animal combat and metamorphosis, and characteristic of Late Chou revival and innovation. The finial is elaborately inlaid with silver, gold, and, in some spots, with speculum metal. Some of the inlays are designed to imitate spotted glass beads. The final achievement is a complex series of varied and interweaving themes. Thus, the bird motif is repeated on the neck of the dragon in flat, ribbonlike relief at the base of the dragon's head. Despite the fact that it is only about six inches long, this important finial is very complex in its organization, full of that peculiarly delicate, closely curling movement and rhythm characteristic of Late Chou style.

In addition to innovations in material and technique, the period saw the rapid development of sculpture in the round, especially of animal subjects. In the case of the tapir from Li-Yu, dated around 475 B.C., there is an evident carry-over of the interest in sculptured animals seen in Middle Chou (*fig. 41*). But how different that interest is when compared to the rather static and yet ferocious effect of these Freer tigers! Here there is a more playful, elegant kind of decoration with a tend-

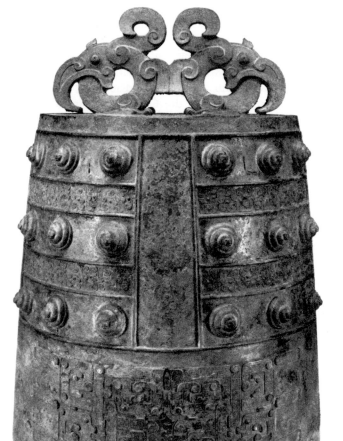

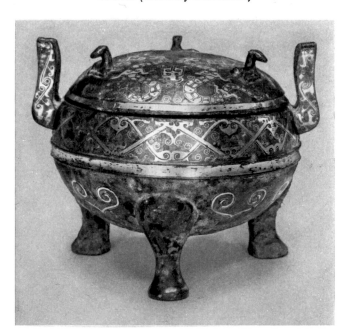

LEFT:
38. Chung. Bronze, height 26⅛". Late Chou Period. Freer Gallery of Art, Washington, D.C.

BELOW:
39. Inlaid Ting, from Chin-Ts'un. Bronze, width 7⅛". Late Chou Period. Minneapolis Institute of Arts (Pillsbury Collection)

45

ency to make the ornament seem even more real and a part of the structure of the animal. A scaly character is emphasized in the tigers, while in the tapir a feathery character dominates. The gilded bronze dragon head reveals sophistication in the handling of new processes such as gilding, and imagination in formulating a convincing dragon type which is, on the whole, standard from this time on (*colorplate 3, p. 51*). One might say that the Late Chou artist imagined realistically.

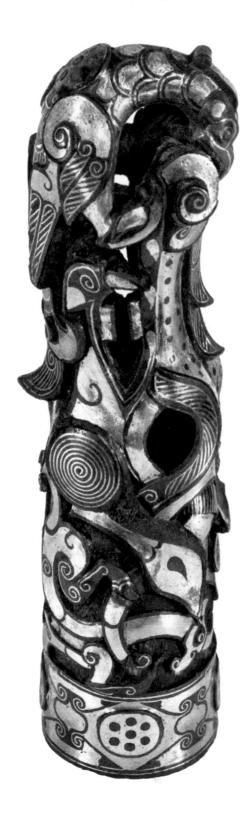

While animal figures have been seen before, sculpture in the round of the human form was extremely rare. At first, figures were used on the lids of vessels, as parts of fittings, or as lamp bearers; but later in the period they appear in the full round, perhaps for their own sake. The bronze figure of a dancing boy on a toad is most extraordinary, especially in the way that the figure is projected almost spirally into space (*fig. 42*). The figure of the kneeling man is typical of Late Chou, and was one of several excavated at Chin-Ts'un. It appears to be a lamp bearer or incense bearer, and is rigidly frontal in pose. The figure is held in an imaginary boxlike structure, quite in contrast to the more playful movement of the dancing boy. Whether this indicates a difference in date or a difference in point of origin, we do not know; for now geography is beginning to play a major part in our study. Materials from the South show certain characteristics rather different from those of the North. One of the most interesting sculptures is the group of two wrestlers of unknown provenance in the collection of Captain E. G. Spencer-Churchill (*fig. 43*). It is an interesting sculpture if only because of its ingenuity. The two figures are exactly the same but are oriented in opposite directions, with their hands joined as if executing a pas de deux. This interest in two figures with this rather complex relationship is entirely new.

Recent excavations in Southwest China, in the province of Yunnan, next to Burma and Siam, have revealed a remarkable sculpture of a kneeling figure holding a staff, most likely of the Han Dynasty, and several bronzes with elaborate and relatively naturalistic figure compositions in the full round. While they are related to the figures just discussed, they show closer connections with the Chinese provincial bronze culture of Indo-China.

One of the most numerous and varied of Chou bronze categories is the mirror, which is preceded by at least one example from the Shang Dynasty. These mirrors are a study in themselves, and thousands of examples are known. We shall see only two as types. Both reproductions are of mirror backs, where the design was always placed; the other—the reflecting—side was polished. Mirrors were often buried with the dead and in some cases, suspended over the body with the polished side down, thus simulating the sun and making the mirror a cosmic symbol. The first mirror is a classic Late Chou type from Shou-Chou, with a repeated dragon pattern on a ground of interlocked Ts (*fig. 44*). The very stylish, dashing dragons in bandlike relief are ancestors of many of the later dragons of Chinese paint-

40. Finial, from Chin-Ts'un. Bronze, inlaid with gold and silver, height 5⁹⁄₁₆″. Late Chou Period.
Cleveland Museum of Art

46

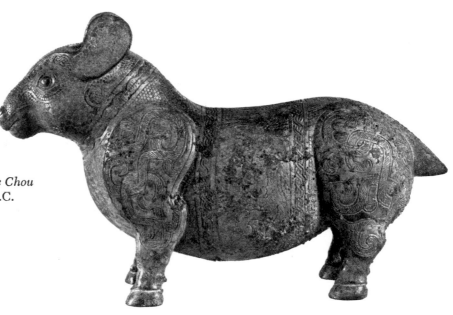

RIGHT:
41. Tapir, from Li-Yu. Bronze, width 7⁹⁄₁₆". Late Chou Period. Freer Gallery of Art, Washington, D.C.

BELOW:
42. Boy on a Toad. Bronze, height 4". Late Chou Period. Ernest Erickson Collection, New York

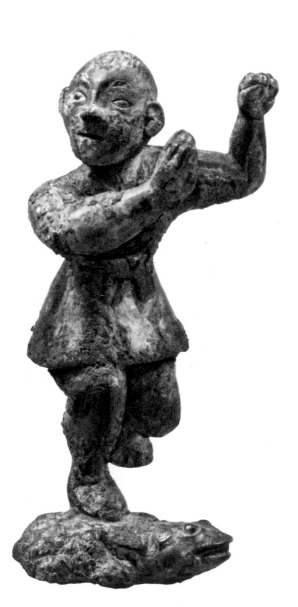

43. Wrestlers. Bronze, height 6⅜". Late Chou Period. Captain E. G. Spencer-Churchill Collection, Gloucestershire, England

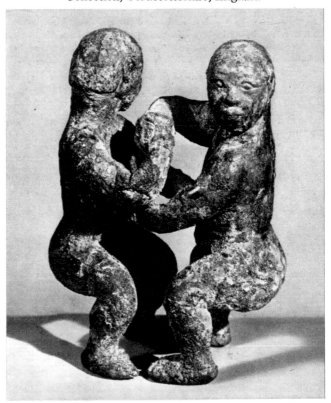

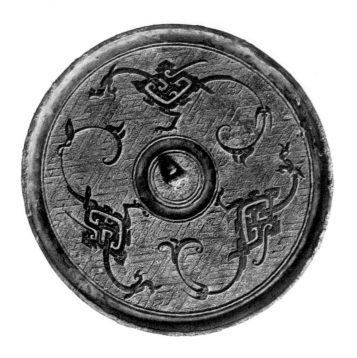

44. *Interlocked "T" and Dragon Mirror. Bronze, diameter about 7". Late Chou Period.* Museum of Fine Arts, Boston

45. *Huang. Jade, width 5¹⁄₁₆". Late Chou Period.* Cleveland Museum of Art

ing. They are repeated three times around a central lug. Certain of the symbols on other mirrors are more explicit than these that are essentially decorative. A second mirror is from Chin-Ts'un, and is the most elaborate specimen known (*colorplate 5, p. 69*). It is of particular interest because of its inlays. If we look at a detail, we can see how utterly refined is this inlay with its little granulations of gold and silver. The figure on horseback brandishes a short sword like the Scythian *akinakes,* which appears to have originated in Central Asia and to have been used in China and in the Mediterranean world. The warrior is attacking a tiger, shown completely in granulated and linear inlay, while the horse and rider are rendered partly in this technique and partly in more solid inlays of silver.

We must anticipate here for a moment, because we are now at a point where we first find Chinese pictorial art. The mirror reproduced in our colorplate is of great interest, as the horse and rider are in three-quarter view, revealing considerable interest in foreshortening and action, and clearly indicating a growing skill in handling human and animal forms in movement and space.

The Late Chou style found a rich and sympathetic material in jade. It is no exaggeration to say that the jades of the Late Chou Period are the finest ever made, not only technically but also from the standpoint of design. The Late Chou jadeworkers were not surpassed even during the Ch'ien Lung reign, the zenith of elaborate jades. Jade was the most precious of all materials to the Chinese; and with these elaborate, complex, and playful designs the results were the wonderful works of art shown in the plates.

First to be mentioned are two *huang,* or segments of a disk (*fig. 45*). One can see small and large masks. A dragon shape binds the masks together with interweaving sinuous bodies. The result, aesthetically, is a major and a minor motif, interwoven in a delicate curving relief, with some incising for the even finer details of eyes and scales. A plaque in the Freer Gallery represents a feline creature with a body covered with classic examples of the Late Chou hook, and this is as characteristic of jade plaques as it is of bronzes (*fig. 46*). The honey-colored jade from Ch'ang-Sha presents an example of visual double meaning, typical of so much Late Chou art (*fig. 47*). The solids make a pattern of dragons interwoven with birds turned upside down, while the voids present a widely grinning ogre mask. In the presence of such an extremely sophisticated sculptural double-entendre one can see, perhaps, why Confucius was concerned about luxury-loving courts in the Late Chou Period.

Among the important artistic contributions of the Late Chou Dynasty are the large numbers of new techniques and new materials introduced. In this time of troubles and ferment, the catalytic action was carried over into the techniques of the arts. In clay we find the first use of pottery figurines as occasional burial substitutes for the actual animals and objects previously interred with the deceased. One of the important recent finds by Chinese archaeologists has been a grave site in North China at Hui-Hsien, where dozens of chariots and horses were excavated. At the same site and from the same time figurines were found, some of a gray and others of dark, almost black, pottery, executed in a lively and naturalistic style. The realistic figurines of dogs, pigs, and other domestic animals look almost as if they had been cast from miniature animals.

A second group of works in clay, representing a distinct innovation in Chinese art, are utilitarian ceramics with the first deliberately created glazes. It seems only

logical that, along with the first manufacture of glass in the Late Chou Period, we have the first consistent glazing of ceramics. The two naturally go together since a kiln temperature high enough to fuse quartz and produce glass is necessary also for making ceramic glazes. Whether this achievement is due to the influence of Mediterranean glass, found in China from perhaps the third century B.C. onward, or whether it was a local, spontaneous invention we cannot say. We do know that two distinct types of glass beads have been found — one a Mediterranean import and the other of Chinese manufacture. The second can be proved to be Chinese because of its large barium content; Mediterranean glass has only traces of that element.

The usual ceramics were also produced — a gray pottery and, in the more provincial areas, painted red earthenware pots of Neolithic type. Some of these were so convincingly Neolithic that Andersson mistakenly dated one group to about 3000 B.C., whereas they more correctly date from about 500 B.C. In the outlying areas, then, the Neolithic techniques continue to the Late Chou and even into the Han Dynasty.

The beginnings of glazing are interesting, and reveal an occasional naïveté. A small piece in the Nelson Art Gallery is made of very soft clay with glass beads imbedded in it (fig. 48). It is but a step from this process to an attempt at glazing the surface of the pot by firing; and this significant step was taken at this time. The pot in figure 49 is very high-fired stoneware with a gray body burnt brown on the exterior where exposed to the flame. It has large t'ao t'ieh masks on the handles and a shape which resembles that of the bronze hsien. The ceramic has incised decoration on the shoulder and originally had a pierced cover allowing the air to ventilate whatever was stored in it. The shiny olive substance on the shoulder is glaze. It seems probable that such a glaze developed when potters were able to heat kilns to higher temperatures. Quite by accident they seem to have found that some of the pots had a natural glaze where the ash from the fire settled on the surface of the pot; this acted as a flux, drawing the quartz elements of the clay to the surface, producing a spot of glaze. It was then that the potters purposely agitated the fire so as to force a heavy deposit of ashes onto the upper surfaces of the pot. The more concentrated flux then drew forth more of the quartz elements and thus formed a glaze. We reach this conclusion because the glaze on these early wares is found mainly on the upper surfaces of the vessel. Later potters developed techniques of either dipping the pot into an actual glaze mix or covering the vessel with ash so that a glaze would coat the whole surface.

In addition to glazed ceramics we have, for the first time, actual remnants of wood — not simply imprints in the earth like those found at An-Yang. The first discovery of these woods was an accident, occurring at railroad excavations of the early 1930s in the South China province of Hunan, at the city of Ch'ang-Sha. While digging the roadbeds, workers came upon tombs, the contents of which were astounding, for until then they were unknown in Chinese art. Many of these objects were preserved in almost perfect condition, because of the constant dampness of the earth. It is change of humidity or temperature that damages such objects; where temperatures and humidity are constant, however extreme, objects are often well preserved. From ancient Egypt, with its very dry and hot climate, we have well-preserved objects of wood and other kinds of fragile and perishable materials. The same preservative effect

46. Tiger Plaque, from Chin-Ts'un. Jade, length 5⅞".
Late Chou Period. Freer Gallery of Art, Washington, D.C.

47. Interlaced Dragon Plaque (Mask),
from Ch'ang-Sha. Jade, width 2¹⁵⁄₁₆". Late Chou Period.
Cleveland Museum of Art

49

48. Jar, from Shou-Chou, Anhui. Clay with glass inlays, diameter 5". Late Chou Period. Nelson Gallery-Atkins Museum (Nelson Fund), Kansas City

is true of extreme humidity. When moisture is constant, objects such as the log foundations of the Swiss Neolithic lake dwellings are preserved. At Ch'ang-Sha, objects of wood, bamboo, lacquer, and even cloth, were preserved intact in the damp tombs. Some of the artifacts recently excavated at this site are bamboo strips with notations in archaic script; an intricately carved

wood panel coated with a layer of brown lacquer; and figures, perhaps burial substitutes or possibly actual images used as aids to shamanistic practices, carved of wood painted with lacquer in a curious doll-like fashion.

The lacquer medium and the techniques of working it were other great innovations of the Late Chou Period. It seems probable that the origins of this work are to be found in the South. The most remarkable of all the objects excavated at Ch'ang-Sha is in the Cleveland Museum of Art and was found in 1934 (fig. 50). This very large composition of birds and snakes, the so-called *Cranes and Serpents,* is the earliest and one of the greatest Chinese wood sculptures that has been preserved. They are covered with designs, painted in lacquer, which imitate the inlaid bronze designs. There is some disagreement as to how these birds and snakes were originally grouped. It was reported by the dealer who had the piece that, when it was discovered, remnants of a wooden drum were also found and that the birds and snakes were therefore a drum stand. It is supposed that the drum was suspended from the necks of the birds as they stood back to back. There are two arguments against this supposition — one that the arrangement seems highly unfunctional, for if one hit a drum suspended between two such slender necks they would probably snap off; and the other that a close examination reveals that these birds are not cranes but peacocks or, perhaps, fabulous birds like the phoenix; the feathers of the tail and wings are eyed feathers like

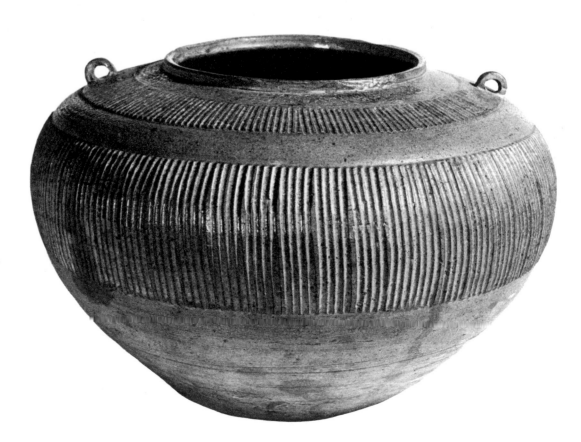

49. "Protoporcelain" Jar, Shou-Chou type, Anhui. Pottery, diameter 12⅛". Late Chou Period. Museum of Eastern Art, Oxford, England

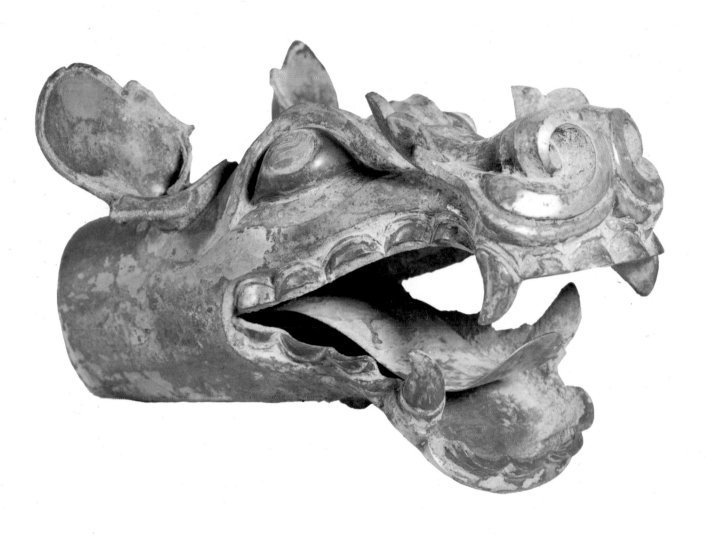

Colorplate 3. Dragonhead, from Chin-Ts'un. Gilt-bronze, overlaid with silver foil, length 10¹⁄₁₆".
Late Chou Period. Freer Gallery of Art, Washington, D. C.

Colorplate 4. Birds and Snakes. Detail of figure 50

50. *Birds and Snakes, from Ch'ang-Sha.*
Lacquered wood, height 52¾". Late Chou Period.
Cleveland Museum of Art

those of the peacock, not the crane. It is possible that this is not a functional instrument but a fetish or totem of some type, and that originally the birds were intended to stand face to face, making a compact, rather vertical composition. (In support of this theory is the fact that in North Indochina, a region where many early Southern Chinese folkways persist, large wooden sculptures of peacocks and snakes are often placed outside houses to ward off evil spirits.) The birds are of one piece of wood, with their heads and legs attached separately, as are their tailfeathers and wings, which are fashioned from flat boards. A detail of the snakes from the front shows the same design one finds on inlaid bronze tools and vessels *(colorplate 4, p. 52).* The two snakes are differentiated; one has a completely geometric type of design while the other has a design simulating scales. Perhaps an early manifestation of the male and female principle of *Yang* and *Yin* is expressed in the paired serpents. The color scheme of the lacquer is not simply red and black, as is often the case, but a combination of red, yellow, black, and a very dark blue lacquer, producing a rich and complex effect.

A more characteristic example, in a remarkable state of preservation, is a utilitarian lacquered utensil from Ch'ang-Sha, a bowl now in the Seattle Art Museum *(fig. 51).* It is made of a very light wood with a fine cloth covering. On top of that is lacquer in two colors only — red and black — in a design of dragons, birds, and banners. This design of the two beasts and the pennant on a pole is repeated three times around the bowl. In the center is a semi-abstract design of dancing bears and bird forms. All of these lacquered vessels with intricate designs display extremely lively and highly abstract treatments of natural forms, as if the painter had already begun to use line for expressive purposes alone, as was characteristic of later Chinese painting.

From the Late Chou Period dates the beginnings of the painting that was to be so highly developed in China. We are referring to painting with a brush, its flexible use in terms of thick and thin lines, and the

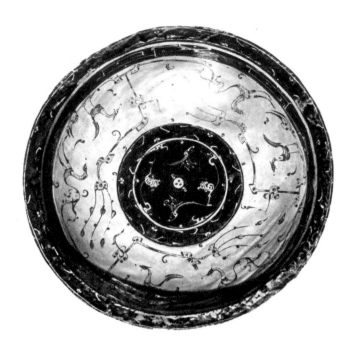

51. Bowl, from Ch'ang-Sha. Lacquered wood, diameter 10".
Late Chou Period. Seattle Art Museum

representation of movement by means of those lines. We now have a few fragments of this early type of painting; until recent years we had nothing. At first there were preliminary and rather tentative types of painting such as an illustrated text on silk found at Ch'ang-Sha. It is an herbal-bestiary with representations of various plants and fantastic animals, including a three-headed man, probably made for a shaman. It is not much of a painting, being rather stiff and crude, obviously just a "cookbook" page, and not to be looked upon as a great work of art.

But we do have other recently excavated paintings from Ch'ang-Sha. Among them is a faintly preserved ink painting on silk depicting a lady with a phoenix and a dragon; it bespeaks a highly developed painting technique. Another example is a design on a lacquered

vessel called a *hsien*, a cylindrical covered box (*fig. 52*). The design on this box has been schematically extended in the illustration to reveal the whole. On the left, moving over a small hill, is a two-wheeled chariot drawn by a single horse, followed by two riders, one on a white horse, the other on a green one. This scene of action is followed by one of repose; here are trees, one in flower, two seated men, one in a small enclosure, and a man in an odd hat who stands facing the observer. Above and below these are designs painted in imitation of the inlaid bronzes. The representation of the horse at a flying gallop, derived from the animal style, is extremely lively. The skillful but simple representation of the tree shows a level of brushwork that indicates many years of development even before this stage had been reached.

The Cleveland Museum of Art has two rare and exquisite painted low reliefs executed on clam shells (*colorplate 6, p. 70*). They are reputed to have been found in North China, and this seems most likely; before they were cleaned they had been published as Han or later. After their cleaning with distilled water and restoration with watercolor, two scenes were revealed. The first shell shows the chase. A two-man, two-wheeled chariot drawn by four horses is pursuing a deerlike animal and a tiger. Below, a similar chariot is following a deer. Two little dogs, similar to dachshunds, are running below with the chariot. The other shell depicts the sequel to the first scene. The now-stationary four-horse chariot is seen head-on with two men still in it. Two men have appeared on foot, having dismounted from the other chariot, and are approaching a doe. One holds a long spear and one a knife. Two arrows are lodged in the doe's hindquarters. Below, one of the hunting dogs is chasing deer, while two bristling boars run nearby. During the cleaning and restoration it was hoped that there would be some indication of landscape, and at last it was found: two kinds of trees, one with three branches and one a stump with a protruding branch. Close to the latter is a halberd, thrust into the ground while the owner deals with the stricken doe. One can also make out, on each of the shells, a

52. Hsien, from Ch'ang-Sha. (The design has been "unrolled," showing it as a continuous band.)
Painted lacquer, height about 6". China (Whereabouts unknown)

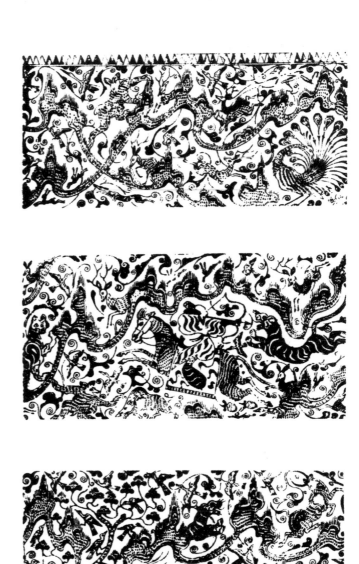

ABOVE:
53. *Inlaid Tube (shown in three sections).*
Bronze, length about 8". Early Han Dynasty.
Tokyo Art School

RIGHT:
54. *Drawing made from the tube*
illustrated in figure 53, showing
the gold inlay design

55

pole staff with three trailing pennants. This was a type of clan banner. A front view of a quadriga is most extraordinary in so relatively archaic a stage of painting. Here is a Late Chou, Ch'in, or Early Han painting revealing an advanced stage of accomplishment, showing a psychologically unified scene, involving actual events and spectators observing them. They are so unified in composition, within the area of the shells, that we have not stiff, geometric, static diagrams, but lively pictures, vivid representations with a brilliant use of silhouette.

The hunt, less pictorially handled, is also a characteristic of some of the bronze vessels of the Late Chou Period. There are vessels with silhouette scenes in low relief made up of panels with rather geometric, static hunting scenes. However, on an inlaid bronze tube in the Tokyo Art School, dating from the Early Han Dynasty, is as dynamic a hunt as that on the shells (*fig. 53*). The drawing in figure 54, made from the tube, shows in black that part of the design which is gold inlay. Some of the elements we have already seen: the running tiger, the horse at the flying gallop, the archer. But there is a greater wealth of detail: undulating hills, the bear and the boar, a landscape filled with varied representations of animals and birds, full of life, but with that interweaving, curling style characteristic of the Late Chou Period. Notice, incidentally, the remarkable representation of a camel, the Central Asiatic two-humped type, with a monkey about to climb onto its back. This is one of the very earliest representations of the camel in all of Chinese art. The phoenix or peacock with the eyed feathers is not a crane any more than were the lacquered birds discussed earlier.

Although we are concerned in this book with the visual arts, it should be noted that music, valued by Confucius above all other arts, the dance, and poetry all reached high levels of attainment in these years.

4. The Growth and Expansion of Early Chinese Culture through the Han Dynasty; Korea and Japan

THE CHINESE CALL THEMSELVES Sons of Han; and the Han Dynasty saw the beginning of a Chinese world empire. Actually, the first empire, called Ch'in, a short-lived dynasty (221-206 B.C.), immediately preceding the Han, was founded by Shih Huang-ti (died 210 B.C.), a dictator who ordered the Great Wall of China, who built an empire with the bodies of his enemies, and who burned the classic books. His dynasty lasted until his death, for his son could not carry it on; and in the ensuing struggle for power the peasant Liu Pang, a doughty warrior, won out and became the Emperor Kao Tsu and the founder of the Han Dynasty. He was able to take over, hold, and consolidate what Shih Huang-ti had put together. China's borders were extended from Indochina on the south, to and including Korea on the north, and from the China Sea on the east to deep in Central Asia on the west. While it was not the greatest extent reached by the Chinese — the T'ang Dynasty went even farther — it was their first great world empire.

In art and thought the Han Empire consolidated the contributions of the Late Chou Period. Scholars restudied and reconstituted the Confucian system. Taoism, interpreted by court magicians, degenerated into a fabric of myth, miracle, and magic; and there was considerable rivalry between the Confucians and the Taoists for the favor of the throne. The Han Empire may be said to have established the Chinese cultural patterns until modern times. Foreign contacts were numerous. The Late Chou Period was, of course, not without foreign influence, but the Han Dynasty had many more contacts with the Mediterranean world, with India, and Southeast Asia. North China was urbane and civilized, while the South still preserved many exotic elements — the magical lore and primitive practices of the folk.

In architecture, which we will consider but briefly, the tomb-architectural tradition was maintained, though large mounds were used for the first time for imperial or noble burial. The earlier burials of the Shang kings were of a subterranean type. This type was carried on into the Han Dynasty, too; and we owe some of the finest objects of the period to the excavation of subterranean tombs in Korea.

We now have some information that enables us to understand something of Chinese palace architecture — not actual architectural remains, but remains in the form of clay models used as burial substitutes. The very large — about four feet in height — model of a house is of gray clay covered with white slip painted with red pigments (fig. 55). There are other examples of the type, some with a green-lead glaze, and altogether they are enough to establish a fairly clear picture of Han architecture. Chinese architecture had developed a post-and-lintel system with roofs of tile; a system which has persisted until the present day. The weight of the roof in most Chinese buildings is borne, not by the walls, but by posts or columns, after it is distributed down through the bracketing system. The walls proper are simply screens of clay on bamboo matting strung between the columns and beneath the lintels. Such a post-and-lintel system needs to be rather heavy, for it has to bear the considerable weight of the tile roof. Since it was based on a post-and-lintel system, the size of the Chinese building was increased by the process of addition. The

basic unit of the system is the bay; that is, the four columns forming a square with their lintels make a single basic unit. This unit is limited because, after all, trees do not often produce more than forty to sixty feet of wood useful for a large lintel. The size of the building must then be achieved by adding other bays to the basic single-bay unit. The palace is simply a larger building than a hall, with higher and bigger bays; but it is still made up of a number of bays put together. The decoration of the post-and-lintel system was important and was achieved with inlays of metal, precious stone, and jade, or colorful paint and lacquer. The literary descriptions of certain Han palaces reveal that they were extremely rich and sumptuous.

We also know something of the general layout of the cities and, from this time on, the arrangement became a tradition. The city as a whole is oriented to the four cardinal directions in a geometric pattern. The emperor,

58

55. House Model. Painted pottery, height 52". Han Dynasty. Nelson Gallery-Atkins Museum (Nelson Fund), Kansas City

in the capital, or the emperor's representative, in a provincial town, occupied the area north of the center of the city, and the highest ground. Everything was oriented to the central authority and the city became, in a sense, a diagram of the universe — in this case an imperial one, the emperor taking the place of the sun at the center. The plan has a strictly geometric character, which is of some significance. We have seen certain geometric shapes in jade — the symbols of heaven and earth — and we have indicated the quality of almost geometric order and logic that was so important for the Confucian system. Such an order was carried over into city planning. The informal kind of organic planning found in a Japanese medieval town is not present in Chinese cities, although it may be found in small, provincial villages.

The tower, as seen in the clay models, is an important element used not only as a means of guarding cities, but as one of the principal aids to hunting. It was used like a shooting box by archers who shot at birds attracted to it by bait. With the development of Buddhism and the growth of temple sites, towers, now called pagodas, took numerous forms, their many roof lines influenced perhaps by King Kanishka's great *stupa*, near Peshawar in Northern India, with its thirteen-storied superstructure.

Han painting continues and consolidates the innovations and forward-looking styles of the Late Chou Period. In general, we can distinguish two major styles, while a third one, now becoming clear, may have to be taken into account. The formal, official style is a rather stiff, geometric, almost hieratic type of painting that stresses silhouette. We find examples of the official style largely in sculpture. The painting style is in the manner already observed in the lacquer dish and the painted shells of the Late Chou Period.

The invention of paper in A.D. 105 was of the utmost importance. Painting on silk, of course, had been practiced; there are the Late Chou examples from Ch'ang-Sha. But the invention of paper must have been a great stimulus to the development of brushwork, for paper is the most suitable ground for that most flexible of all writing instruments, the Chinese brush. Unfortunately, we have no Chinese painting on paper or silk from the Han Dynasty. We possess only a few paintings on clay, some lacquer paintings, and the evidence that we are able to glean from reliefs in sculpture and from designs in metal. There are also references in literature, notably to vast mural decorations on palace walls.

Admirable examples of the official style, with some influence of the freer painterly tradition of the South, are found in the tomb of I-Nan, which dates from the end of the second century A.D. Here the stone reliefs may well give an indication of the nature of murals on palace walls and of the degree of maturity the Han art-

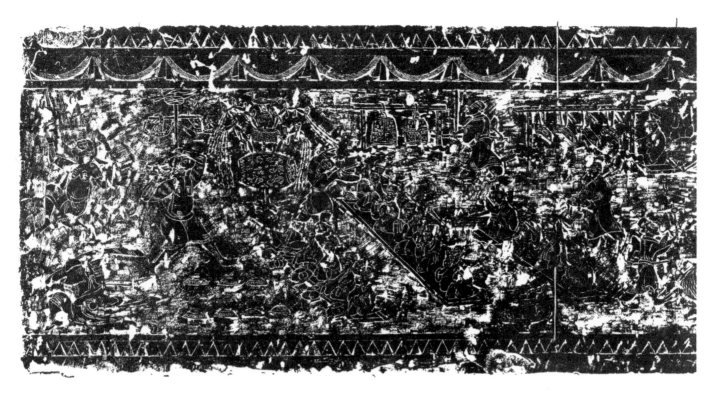

ABOVE: *56. Rubbing of Stone Relief, from I-Nan, Shantung. Later Han Dynasty, 3rd Century* A.D.

RIGHT: *57. Detail of figure 56*

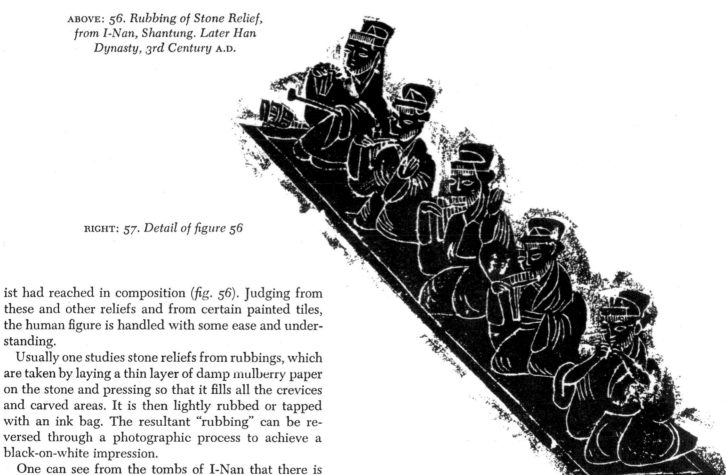

ist had reached in composition (fig. 56). Judging from these and other reliefs and from certain painted tiles, the human figure is handled with some ease and understanding.

Usually one studies stone reliefs from rubbings, which are taken by laying a thin layer of damp mulberry paper on the stone and pressing so that it fills all the crevices and carved areas. It is then lightly rubbed or tapped with an ink bag. The resultant "rubbing" can be reversed through a photographic process to achieve a black-on-white impression.

One can see from the tombs of I-Nan that there is one important concept already established by the second century A.D., and that is the use of organized space and of a systematic convention to indicate depth (fig.

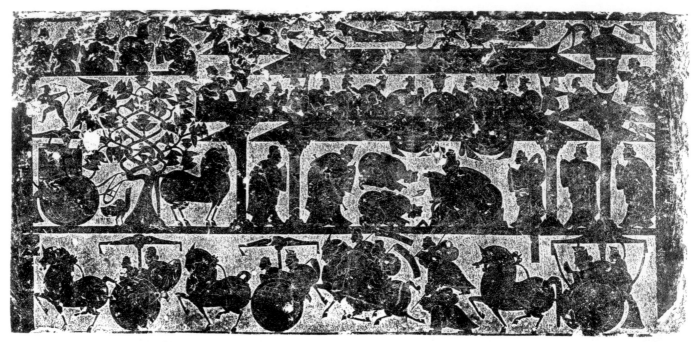

58. Rubbing of Stone Relief, from Wu Liang Tz'u, Shantung. Later Han Dynasty

57). All systems of perspective, however "natural" or "real," are nevertheless systems. There are many of these, and we see here one of the early Chinese methods. The diagonal tables lead back into a shallow space ending at the rear in the racks with the hanging bells and musical jades. In the foreground, in the space defined by the slanting diagonal platforms, are the musicians, ranged in echelon formation. The individual figures appear rather stiff and are silhouettes despite the fact that they are represented in three-quarter view. The whole effect is formal and rather like much Chinese figure painting of later periods. One can imagine a palace room with balanced decorations of banquet or hunting scenes, with carefully balanced perspectives ranged in perfect symmetry.

Other examples of a formal style are provided by a famous tomb group, that of Wu Liang Tz'u, dated about A.D. 147–151 (fig. 58). These reliefs have a different type of incised decoration. Where the I-Nan tomb tends to indicate a type of painting relying somewhat on line, the Wu Liang Tz'u reliefs seem to indicate a type which is more formal, static, and involved with careful placing and spacing, but concerned primarily with silhouettes. In the scene reproduced we see a frieze below, with movement to the left in a procession of chariots and footmen quite separate from the scene above. The ground line for the scene above is indicated by the heavy black line. In contrast to the I-Nan reliefs, which indicate depth by means of a short recessional diagonal, the Wu Liang Tz'u reliefs use only the crudest indications of depth; in general, everything is handled as

if it were on one plane. But if there is any attempt at depth — not in this particular case but in others — it is done simply by placing one object or person higher than another without any indication of the connection from foreground to background by means of a diagonal line. Note, too, the landscape element — in this case a magical Sun Tree with birds flying about it, an archer shooting at them. This stylized, almost Late Chou method of treating trees, includes the use of natural leaf forms as a decorative pattern. The trunk is bent into an almost perfect Late Chou hook.

A word should be said of the horses on the Wu Liang Tz'u reliefs, for they have become extremely popular. The breed that appears here for the first time seems to have come from Central Asia — a short-bodied, heavy-barreled horse with large nostrils. We read much about the excursions of the Han military cohorts into Central Asia for the express purpose of collecting horses from the Tartars and other peoples in that region. The work in the Wu Liang Tz'u reliefs is earlier in date than the reliefs from I-Nan and certainly shows a less advanced stage in the development of space in the composing of figures. While there is some overlapping — one of the most primitive ways of suggesting space — there is almost no representation at Wu Liang Tz'u of the three-quarter view. The whole effect is much more archaic than the slightly later reliefs of I-Nan.

The famous painted basket from the Chinese colony at Lo-Lang in Korea is in the same formal, official style (fig. 59). Lo-Lang must have been a most important Han outpost. Many wonderful lacquers were found there in

60

LEFT:
*59. Scenes of Paragons of Filial Piety,
from Lo-Lang, Korea. Painted lacquer basket,
length 15⅜". Later Han Dynasty.*
Korean National Museum, Seoul

BELOW: 60. *Detail of figure* 59

61. Fragment with Dragons and Rabbits, from Lo-Lang, Korea. Lacquer. Later Han Dynasty. Whereabouts unknown

61

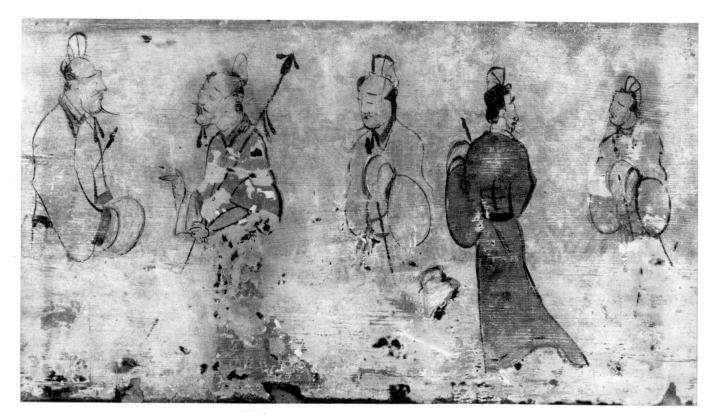

62. Painted Tile (portion). Terracotta, polychrome painting on hollow tiles, width 94⅝".
Later Han Dynasty or Early Six Dynasties. Museum of Fine Arts, Boston

water-saturated, wood-lined subterranean tombs. The wicker basket with a lid is the most extraordinary of all the finds. The outside of the cover and the high interior sides which receive the lid are painted with scenes of filial piety (*fig. 60*). It is interesting to find so appropriate a combination of official style and Confucian subject — a perfect meeting of form and content. We see somewhat the same handling of figures as in the tomb at Wu Liang Tz'u, though in this case the effect is more fluid and lively because we are looking at actual painting, even if in lacquer. Most of the figures are silhouette-like, a few in three-quarter view, and nearly all are isolated with little overlapping. All occupy the same ground line and so there is no indication of depth. However, they appear lively and animated. The inscriptions indicate the names of the paragons of filial piety, so we have again the full flavor of an official moralistic attitude. Above and below, the borders show a degenerated imitation of inlaid designs of gold and silver in bronze harking back to the Late Chou style.

In contrast to this official, formal style is a painterly style which, in some cases, is found alongside the other. Some lacquer fragments from Lo-Lang have most lively and suggestive renderings of movement in subjects consisting largely of dragons and rabbits (*fig. 61*). These figures seem to rush across the space, in part apparently propelled by the long lines behind, which give the impression of speed as the animals move along. This movement is also due in part to the brushwork, which is not calm and measured but extremely rapid and spontaneous. Here we have a treatment that seems to be applied particularly to themes involving everyday subjects, or animals. The famous painted tiles in the Boston Museum have numerous scenes, but one in particular is of interest, as it shows what mastery of the brush had been achieved by the end of the Han Dynasty (*fig. 62*). We find not only suggestion of speed or flexibility in terms of pigment and line, but also the use of the brush stroke as a means of defining character. The three-quarter view is skillfully used. The whole attitude and pose of each figure convey something of the psychology of the person involved: the patient listener, the rather pompous talker, and the extremely decorous and patient man waiting to get a word in edgewise. Notice, too, the extremely skillful handling of the figure in three-quarter view from the back, indicating an almost twisting movement in shallow space. At the same time, we should note the extremely primitive handling of the figures in terms of space and placement in space. They still appear to be on the same ground line, and a setting is hardly indicated at all. But the use of the brush in a typically Chinese manner for figure painting can be seen developing rapidly here. From this to the famous scroll, *The Admonitions of the*

Instructress, the earliest great Chinese painting left to us, is not a great distance.

A third type of painting now to be taken into account, because of recent excavations in West China at Szechwan, is exemplified by some extraordinary clay tiles, with scenes, such as the threshing scene reproduced, which show naturalistic handling of figures, of animals, and of birds in flight (*fig. 63*). They also reveal an advanced stage of space composition. All this allows us to assume that some Han painters had an organized and intuitive feeling for space. In this tile the indication of space by means of a diagonal spit of land running out and then behind the figure at the right, and by the diminishing sizes of the fish and lotus, is very sure and developed. In the threshing scene the figures are shown in echelon, thus indicating the field in depth. All of this is indicated in a lively, naturalistic manner, in contrast to the rather static style of the stone reliefs. We will undoubtedly have to revise our rudimentary conceptions of Han painting as more material of this type becomes known.

Relatively few sculptural monuments of the Han Dynasty are left to us — that is, of large-scale formal sculp-

63. Rubbing of Pottery Tile, from Cheng-tu, Szechwan. Height 16½".
Han Dynasty. Richard Rudolph Collection, California

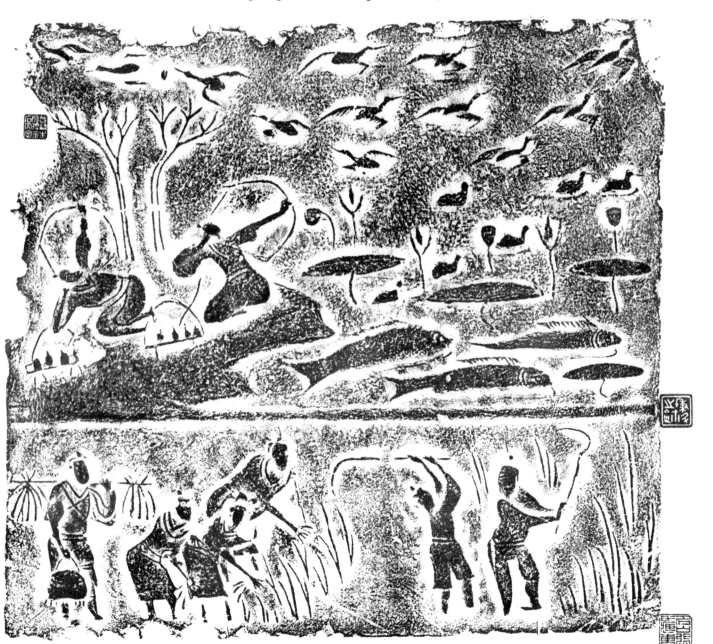

63

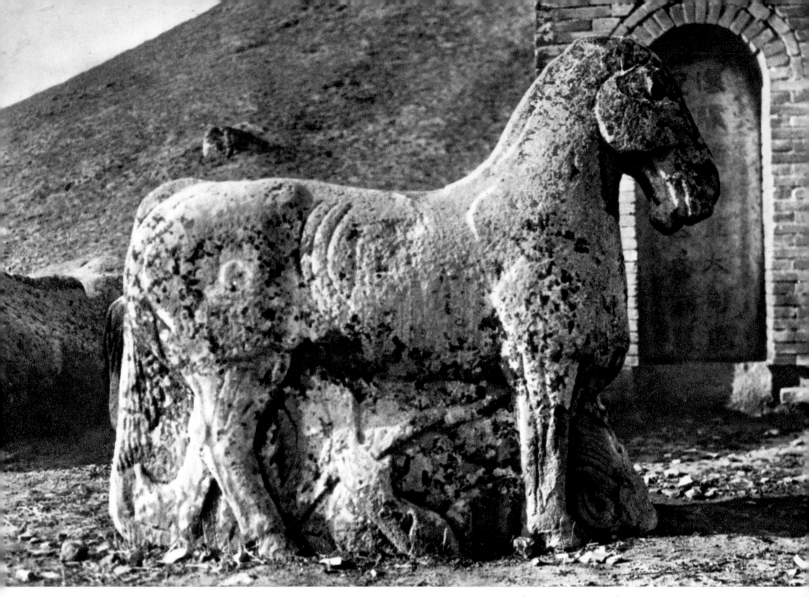

64. Horse, from the Tomb of Ho Ch'u-p'ing, Shensi. Stone, length 75″. Dated 119 B.C.

ture. We have hundreds, even thousands of little pottery burial figurines, but large sculptures are extremely rare. Those we do have are in several different styles, but on the whole the extant material is dominated by a certain powerful if slightly crude naturalism, with occasional memories of the late animal style. The combat motif at the tomb of Ho Ch'u-p'ing is reminiscent of Shang motifs and of the animal style. The sculpture of a horse with an incidental figure of a man at this tomb is solidly contained within the stone block (*fig. 64*). It is in the round, but blocklike and not cut away beneath. The ribs of the man and the muscles of the horse's legs are indicated by grooving rather than by modeling in relief. The head with the heavy crescent of the cheek is a characteristic Chinese rendering which becomes even more noticeable later on. At the same tomb is a sculpture carved from, or rather on, a large boulder. The carving is in relatively low relief on the surface of the stone. A bear wrestles with a large ogrelike man provided with extraordinarily prominent incisors. Again, as the horse follows the four-square block, this figure

follows the natural form of the boulder. Both sculptures are determined by the contours of the original stone. Such relative limitation, or better, such respect for the original material, is characteristic of most archaic sculpture. The development of sculpture, from a lack of desire to interfere with the stone to a growing virtuosity which delights in cutting into the block, is characteristic of most Western as well as Oriental sculptural styles.

The Pillar of Shen is a stone imitation of a tower, with the stone above carved to imitate a tile roof (*fig. 65*). Under the roof are stone renderings of the wood bracketing and scenes of combat: a nude warrior with a bow shooting at an oxlike animal, while being pursued in turn by a dragon; and a running figure with flying birds. The sculpture has burst the bounds of the simulated architecture. The scenes occur on the surface of the architectural details: the monkey hangs under the bracketing, the dragon cuts across the architrave.

The seated mastiff in the Musée Cernuschi is one of the appealing animals in the Han ceramic menagerie

64

— one of thousands of tomb figurines (*fig. 66*). Some are of gray clay with a covering of white slip, while others are of clay alone. Still others have a lead glaze which deteriorates on burial and becomes iridescent, an effect treasured by collectors and museums despite the original color of the glaze, olive or deep green. The mastiff in gray clay with white slip decoration is admirable for the knowing naturalism of the representation. Sculptors of these figures knew animals so thoroughly — pigs, chickens, and other favorite subjects — that they produced them in a rough-and-ready naturalistic style with no thought of formal decorative development. Tomb figurines give us a glimpse of Han culture and are some of the best documents of the life of the folk.

A word must also be said about the use of metal in the Han Period. The art of metal-casting declined, with one exception: Han vessels are usually undecorated and not too well cast; they seem to have lost their luxury status. With mirrors, however, the casting technique continued at a high level, and the designs of the backs show new creative efforts. One, called the TLV type because of the apparent Ts, Ls, and Vs on the design, usually dates from Early Han and is an adaptation of a sundial design to the back of the mirror, which thus becomes a cosmic symbol (*fig. 67*). All of the design elements — the Mountain in the middle, the Four Directions, and the Ts, Ls, and Vs — are related to solar orientation and the mirror, a source of light and insight, is a figurative sun. The fantastic animals of the Four Directions are portrayed in a "thread relief." Characteristic of Later Han are mirrors which maintain the cosmic diagram, but treat it more naturalistically. Some were cast in stone molds. As a substitute for the sundial design, a frieze of symbolic animals or figures is depicted

LEFT:
65. The Pillar of Shen, Ch'u-hsien, Szechwan. Stone, height 105". Eastern Han Dynasty, 2nd Century A.D.

BELOW:
66. Mastiff. Pottery, height about 11".
Musée Cernuschi, Paris

65

67. *Mirror with "TLV" Design. Bronze,
diameter 5⅝". Western Han Dynasty.* Freer Gallery
of Art, Washington, D.C.

68. *Mirror. Bronze, diameter 8¼",
dated* A.D. *174.* Freer Gallery
of Art, Washington, D.C.

69. *Yueh Basin, from Shao Hsing.
Bronze form with incised fish decor
on bottom, diameter 13¼".
Later Han Dynasty or Early Six Dynasties.*
Sir Percival David Foundation,
London

in the official, formal style (*fig. 68*). In this case the decoration consists of the deities of East and West, Tung Wang Kung and Hsi Wang Mu, respectively. It is still a cosmic symbol but designed in a manner that may derive from scroll painting.

Han pottery vessels can be divided into two basic types. The first is lead-glazed, an effect that appears to be an importation from the Mediterranean world. The beautiful silvery green is a result of the vulnerability of the glaze when exposed to the salts in the soil. One of the most characteristic products of this kind of burial pottery is the "hill" jar, a cylindrical shape on three bear-shaped legs, with a cover representing the magic mountain, the axis of the universe (*fig. 70*). The Chinese have always had great reverence for mountains and, as we shall see, the mountain is the dominant element in Chinese landscape painting: mountain–and–water pictures. On the hill jar the waves of the world-sea lap at the base of the world-mountain. The bodies of such jars often have a frieze with animal combat or hunting scenes coupled with representations of Taoist sage-wanderers. These are executed in a style already seen on the bronzes of Late Chou. A rarer type of burial ceramic is covered with white slip and painted designs. One found during recent railroad excavations in

*70. Hill Jar with Cover.
Pottery, height 8¹⁵⁄₁₆". Han Dynasty.
Freer Gallery of Art, Washington, D.C.*

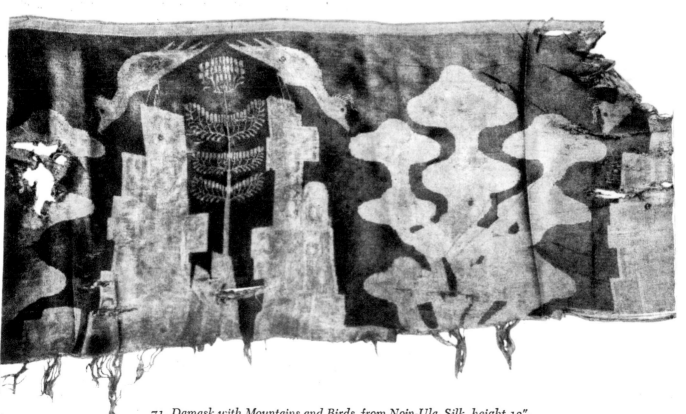

*71. Damask with Mountains and Birds, from Noin-Ula. Silk, height 12".
Han Dynasty. The Hermitage Museum, Leningrad*

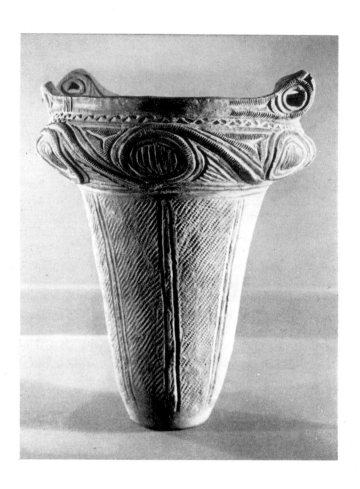

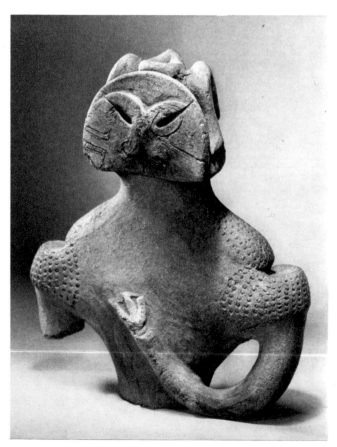

LEFT: *72. Jomon Pot. Pottery, height about 12".
Japanese, Prehistoric.* Cleveland Museum of Art

BELOW LEFT: *73. Jomon Figurine. Clay, height 10".
Japanese, Prehistoric.* Tokyo National Museum

China is a well-preserved and extraordinary example. The vessel imitates a bronze shape, the *hu,* with the bronze handles in clay relief.

In utilitarian ceramics, there was the continued development and refinement of the glazed stoneware which led to the great Chinese ceramic industry. We will not discuss such ceramics in any detail until somewhat later but we must note that in the Han Dynasty the potters developed the technique of glazing to a point where they could cover the whole pot with a uniform and rather thick olive-colored iron glaze. This olive-colored ware was produced in South China, not far from present-day Shanghai, and is called *Yueh* ware (fig. 69). It is an important name. *Yueh* is the first of the classic Chinese wares and continued to be made from Han until early Sung times — from the second to the tenth century A.D. It was the ancestor of the celadon tradition and began to reach a high state of perfection at the end of the Han Dynasty.

We will examine only one sample of the textile arts, simply to know that it exists and on a very high level. Sir Aurel Stein, Peter K. Kozlov, and others found remnants of textiles in Central Asia. Some, such as the one illustrated in figure 71, have stylized designs of mountains, trees, and birds. In this silk tapestry the mountains are constructed in a rather geometric, step-pyramid fashion, and the trees look like enlarged mushrooms. Two birds sit on the two mountains, on either side of the central tree motif, making a balanced, formal design which is a distant ancestor of the great landscape tradition of later Chinese painting. Other complex weaves have been found, often with all-over patterns of hooks or interlocked diamonds which recall the bronze designs of the Late Chou Period.

Among the territories brought into the empire in the interests of security, largely during the reign of Emperor Wu Ti (140-87 B.C.), was Korea. Here, a gifted people had long profited by contact with the older culture. Korean arts of the Bronze Age owe much to Chinese influence. The centers of Lo-Lang (Nakmang) and Ta-Fang (Tapang), flourishing in Han times, had been settled long since by Chinese who had emigrated there. Indeed, many of the objects found at Lo-Lang were certainly imported from China, as was the painted lacquer basket in figure 59. It is noteworthy, however, that pottery jars found in Neolithic mounds in Kyongju

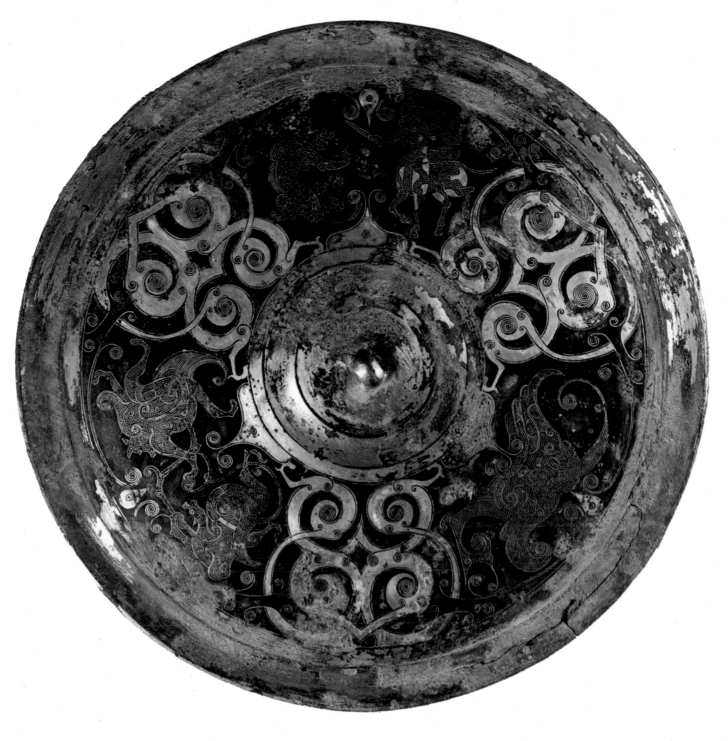

Colorplate 5. Inlaid Mirror, from Chin-Ts'un. Bronze, diameter 7¹¹⁄₁₆″. Late Chou Period.
M. Hosokawa Collection, Tokyo

are unique to Korea and may have had some influence on the remarkable Neolithic pots of Japan. Korea's influence was particularly noticeable in protohistoric Japan of the third to the sixth century, both in the spread of its own material culture, particularly ornaments, jewelry, and black pottery, and in the transmission of Chinese artifacts. Korean influence reached its highest peak when the Kingdom of Paekche introduced Buddhism to Japan.

Neolithic artifacts, particularly pottery, of the pre-Bronze Age cultures of Japan, are truly impressive. The Jomon phase, named for the cord pattern found on pottery vessels, had endured from at least 3500 B.C. to as late as 200 B.C. and appears related to the Neolithic phase in Manchuria. Early Jomon pots adhere to simple corded decoration, but by the middle of the third millennium decoration in extremely high relief was achieved, thus producing a somewhat fantastic effect (fig. 72). Such pots appear to be growing before our eyes, expanding into space with their bizarre ornament. Later Jomon types are more tightly organized around their surfaces, but still retain something of that corded, knotted effect so characteristic of this pottery. Jomon figurines were made concurrently with the vessels and with the same curious knotted and corded decoration. Often they are female figurines whose characteristics emphasize fertility, and this agrees with the implications of the numerous stone phallic objects from the middle Jomon Period (fig. 73).

The Neolithic Jomon culture was succeeded by an age termed "bronze-iron" by Kidder, the most characteristic culture of which is called Yayoi, after a neighborhood of Tokyo where its typically plain but refined and sometimes incised pottery was found (fig. 74). The cultural development of these peoples seems from ar-

ABOVE: *74. Yayoi Jar. Pottery, height about 10".*
Japanese, Prehistoric. Tokyo National Museum

RIGHT: *75. Dotaku. Bronze, height 16⁹⁄₁₆".*
Japanese, Prehistoric, Yayoi phase.
Tokyo National Museum

OPPOSITE: *Colorplate 6. Painted Shells with Hunting Scenes.*
(above) The Hunt; (below) The Kill. Actual width 3½". Late
Chou or Early Han Period. Cleveland Museum of Art

71

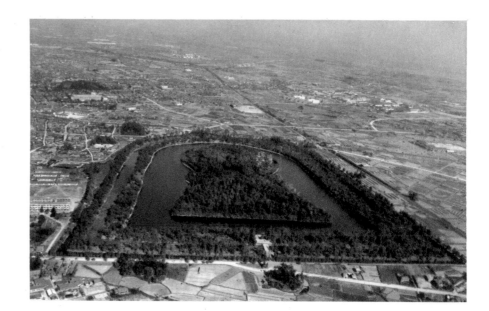

76. *Tomb of Emperor Nintoku,
near Osaka, Japan, aerial view*

77. *Shrine at Izumo, Japan*

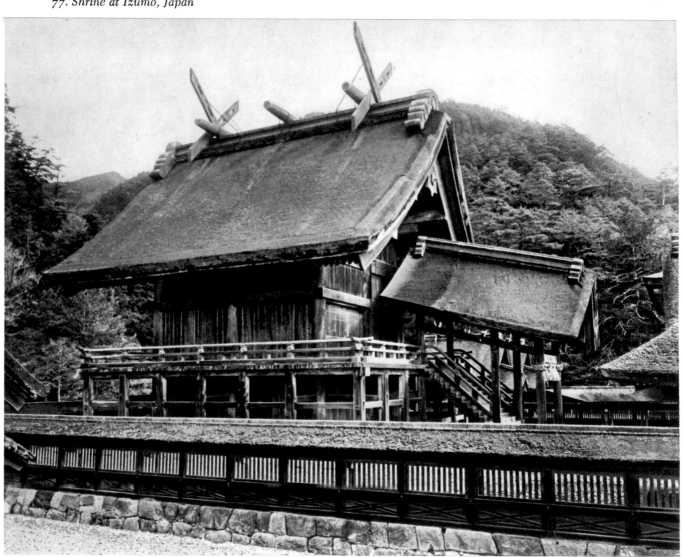

72

seized eagerly on the arts brought from the mainland, but produced at the same time clay sculptures called *haniwa*, completely native in style and radically different from the burial figurines of the mainland.

Characteristic of the later Japanese Bronze Age are large mound-tombs. An aerial view of the tomb of the Emperor Nintoku not far from Osaka reveals a great keyhole-shaped mound or tumulus surrounded by three moats, the whole originally occupying a space almost a half of a mile long (*fig. 76*). Much material in jasper, glass, jade, and gilt-bronze is found in tombs of this type, including the well-known *magatama*, comma-shaped beads derived from Korea. Many of these are highly polished jade of jewel quality.

The architecture of the protohistoric period is far advanced over the Neolithic circular pit dwellings characteristic of the Jomon and early Yayoi phases. It contains much that we now assume to be typically Japanese, particularly the subtle but direct use of unpainted and undecorated wood, thatch, or shingle roofing, raising the structure on wooden piles or columns, and a sympathetic adaptation of the architecture to the natural environment. Several existing Shinto shrines are traditionally associated with the protohistoric period, notably those at Izumo and Ise. Though periodically

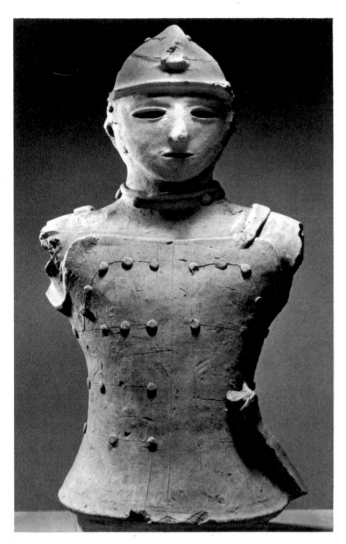

78. *Haniwa Warrior in Armor. Clay, height 25". Japanese, 3rd-6th Century* A.D. Negishi Collection, Saitama, Japan

chaeological investigation to have been stimulated by invaders from Korea who brought advanced arts of agriculture and introduced bronze-casting; with them came many bronze objects, including mirrors in Han style from China. Profiting by such advanced skills, the Yayoi peoples, or perhaps neighboring clans, cast bronze bells called *dotaku* (*fig. 75*). These are imposing in shape and sometimes have decoration, in low relief, of houses, boats, animals, and scenes of everyday life — hunting, fishing, and cultivating — in an amusing, primitive "stick-style."

But the most intriguing arts of pre-Buddhist Japan are those of the Haniwa Period, the age of ancient burial mounds, or the protohistoric period, ranging in date perhaps from the third to the sixth century A.D. This period saw the rise of the imperial Yamato clan, for whom most of the great burial mounds were made. It was a time of immense activity, when the Japanese

79. *Haniwa Horse. Terracotta, length 26". Japanese, 3rd-6th Century* A.D. Cleveland Museum of Art

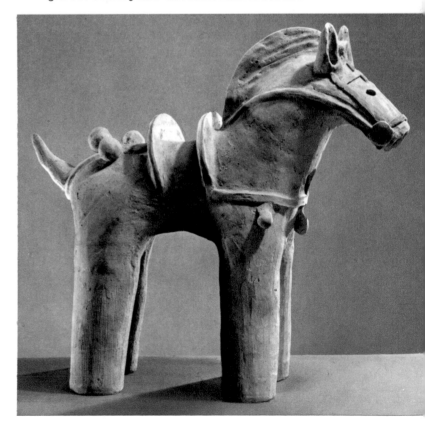

— and ritually — rebuilt, these two seem to be reasonably authentic documents of the early building styles. Izumo Shrine is the more "primitive" of the two; it is entered on the short side and incorporates the casual asymmetry of a peasant dwelling (*fig. 77*). One cannot but remark on the similarity of these buildings to those still used in Indonesia, notably by the Batak of Sumatra.

The more balanced arrangement of the three buildings of the inner area at Ise, as well as the central entrance on the long side of the main building, suggests an awareness of Korean or Chinese architecture on the part of the Japanese builder of the later protohistoric period. The magnificent setting in the Ise forest dominates the shrine, which seems an integral part of its surroundings. The simple agricultural-forest character of the buildings seems to provide the prototypes for later Japanese insistence on humble qualities as a cloak for the hypersophistication evident in Zen Buddhism and the tea ceremony.

Haniwa, meaning literally "circle of clay," were sometimes simply clay cylinders placed around a gravemound or tumulus to strengthen the sides of the mound and prevent earth washouts. Never used as furnishings within the tomb, they were placed tightly together, one against the other, like a picket fence around the gravemound (*fig. 78*). Some with a head at the top may represent the survival of a primitive type. But the *haniwa* that interest us are rather highly developed. They maintain the character of a cylinder at their base; but set on the base are many lively subjects: human figures singing in chorus, warriors in armor, coy ladies, animals, birds, and even houses. Like the Han Dynasty figurines, which they do not at all resemble, the *haniwa* give us some idea of the early life of Japan. The technique of the *haniwa* maker was designed to emphasize the material, to use clay so that the technique seems to derive from it. The material dominates the concept: tubes of clay, ribbons of clay, slabs of clay. In Chinese tomb figurines, on the other hand, the artist tends to dominate the material. There are two fundamentally different concepts here; and, in general, we find in them one of the distinctions between Japanese and Chinese art. A *haniwa* horse is totally unlike a Chinese horse (*fig. 79*). The modeling of the head, like that of a toy horse, has no indication of a cheekbone, no interest in the structure of the eyes of the horse, and no interest in the nostrils. Rather, marks are placed here and there: this is a nose, this is an eye; but the mark is dictated by the nature of the material. The Japanese tend to let the material take charge as much as possible, while the Chinese tend to dominate it, to bend it to their will. To contemporary artists, the *haniwa* figures, with their bold, geometrical, simplified shapes, and their respectful use of clay, are among the most interesting of ancient sculptures.

International Influence

of Buddhist Art

5. Early Buddhist Art in India

FOLLOWING THE DESTRUCTION of the Indus Valley civilization, there is a huge gap in our knowledge of Indian culture and art until about the fourth century B.C., for almost no actual objects remain. However, during these centuries, as we know from other sources, a city architecture developed; palaces and dwellings, shrines and temples were built, as we know from the distinctive forms represented in early sculptural reliefs at Bhaja, Bharhut, and Sanchi. Aside from their foundations these early structures were largely of wood and have disappeared. There undoubtedly was sculpture too, probably of wood and clay, as well as painting on perishable grounds. The literature of these centuries, the philosophical *Upanishads* and the great epic poems, *The Mahabharata* and *The Ramayana*, gives us much evidence of ideals, values, customs, rites, and ways of life. But, as far as actual objects are concerned, we have very little until the rise of Buddhism, its development after the death of the Buddha, and its eventual adoption as a state religion by the Emperor Ashoka. From this time on there is a considerable production of sculpture.

The Buddha's traditional dates are c. 563-483 B.C. We know that he was a prince, probably from the region of Nepal, and that in his lifetime he was a great ethical teacher. But we do not know that he made any claims of religious leadership during his lifetime or that he made any effort to form a religious order. All of this appears to be a development after his death. However, we can read the historic Sermon of the Buddha in the Deer Park at Benares which corresponds in Buddhist tradition to the Christian Sermon on the Mount.

"There is a middle path, a path which opens the eyes and bestows understanding, which leads to peace of

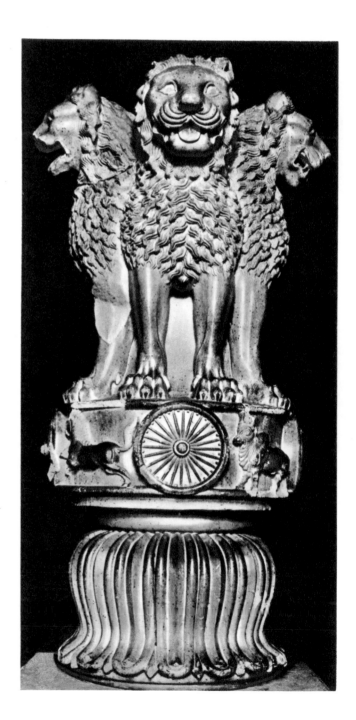

80. *Lion Capital, from Ashoka column in Sarnath. Polished chunar sandstone, height 84". Maurya Period, c. 274-237 B.C. Museum of Archaeology, Sarnath*

mind, to the higher wisdom, to full enlightenment. What is that middle path? Verily it is this noble eight-fold path; that is to say: Right views; Right aspirations; Right speech; Right conduct; Right livelihood; Right effort; Right mindfulness; Right contemplation.

"This is the truth concerning suffering. Birth is attended with pain, decay is painful, disease is painful, death is painful, union with the unpleasant is painful, separation from the pleasant is painful. These six aggregates which spring from attachment are painful.

"This is the truth concerning the origin of suffering. It is that thirst accompanied by starving after a gratification or success in this life, or the craving for a future life.

"This is the truth concerning the destruction of suffering. It is the destruction of this very thirst, the harboring no longer of this thirst.

"And now this knowledge and this insight has arisen within me. Immovable is the emancipation of my heart. This is my last existence. There will now be no rebirth for me."[1]

We know of the chaotic conditions existing at that time, and that Buddha's teachings must have come as a source of great moral strength to the people who knew him. His relationship to earlier Indian thought, Brahmanism, was that of a reformer rather than a revolutionary. He attempted to modify, reinterpret, and revivify the teachings laid down in the earlier religious texts. He preached a very simple message: that the world was fundamentally a snare and a delusion, and that the only way to fulfillment was to escape from the Wheel of Existence, an escape to be accomplished through non-attachment, meditation, and good works. Despite his idea that the world was a passing thing, he taught moral behavior, kindness, and love as means of coping with the problems of the world. The development of Buddhist thought after his death is the story of a faith that commanded a powerful following with extraordinary rapidity. Soon after his death orders were formed, for both men and women, although there was great discussion whether there should be an order of nuns. The events in the Buddha's life were codified. Eight were chosen as being of particular importance: the story of his supernatural Birth from the side of his mother, Queen Maya; the story of his Renunciation of the princely life after four encounters with a beggar, a sick man, a corpse, and an ascetic; his Meditation in the forest; his Assault by Mara, the demon of evil, in an attempt to force him to abandon his meditations; his final Enlightenment underneath the Bodhi tree; the Preaching of the message of enlightenment at Benares; the great Miracle of Sravasti; and finally the Parinirvana, not a death, but an end when he cannot be further reincarnated: he has become the Buddha. This "primitive" Buddhism is maintained in what is called the Lesser Vehicle (Hinayana), and is still the religion practiced in Ceylon, Burma, and Siam. Mahayana, or the Greater Vehicle, developed after the time of Christ; it was a complex philosophical and ritualistic system which related what was until then a minor sect to the whole scheme and tradition of Indian thought. Buddhism, like Christianity, is a proselyting religion, and it spread rapidly — thanks in great measure to the conversion of the Maurya (Central Indian) Emperor Ashoka and the Kushan (Northwest Indian) Emperor Kanishka — through Central Asia to China and Japan and across the Indian Ocean to Cambodia and Indonesia. The majority of the later works of Indian Buddhist art and those that we will see outside of India are products of the Mahayana faith; while Hinayana is the Buddhism of the earlier Indian monuments and those of Ceylon, Burma, and Siam.

81. Bull Capital, from Ashoka column in Rampurva. Polished chunar sandstone, height 105". Maurya Period, c. 274-237 B.C. National Museum, New Delhi

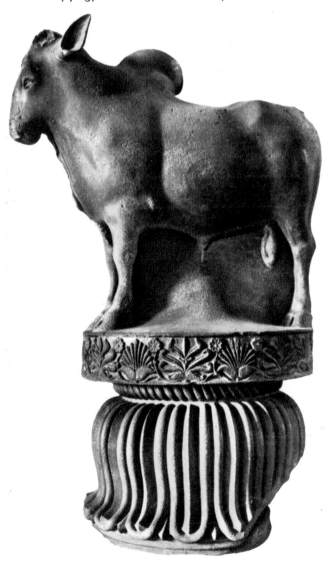

77

Contemporary with the Buddha was another teacher, Mahavira (c. 548-c. 476 B.C.), who also preached a reformed faith quite comparable to Buddhism, with certain major exceptions. These are notably a concept of a soul and free will, not encompassed by Buddhism, and an extreme dualism of spirit and body which the Buddha did not acknowledge. Jainism — as the faith which Mahavira founded is called — like Buddhism, developed into a complex theological system with esoteric overtones and complexities hardly thought of by its founder. Jainism is almost as important as Buddhism in terms of the sculptural monuments left to us, particularly in the Kushan art of Mathura. But Buddhism is the religion which became the great evangelical faith of Asia, and consequently is the one which has excited the imaginations of an endless number of Orientals and Westerners.

Little is known of art just before the earliest productions of the Buddhist artist. Various forest cults, perhaps stemming from the Dravidian fertility cults of the Indus Valley civilization, must have used shrines and images, but these are now lost to us except for one or two isolated sculptures and literary references. The coming of Alexander the Great to the Indus River in 327 B.C. was an event that had little effect on the India of that time. The impact of the Mediterranean world was to come at the time of Imperial Rome.

The earliest Buddhist monuments extant were produced in the Maurya period (322-185 B.C.), notably works ordered by the Emperor Ashoka (273-232 B.C.). The reign of Ashoka is of the utmost importance, for the Emperor himself was converted and adopted the Buddhist Law of Piety as the law of his lands. To commemorate his conversion and to expand the teaching of the faith he ordered many stone memorial columns to be set up at points associated with important events of the Buddha's life. These monoliths reveal the influence of Persia. It is a smooth aristocratic style with little influence on later Indian art. Made of beautiful cream-colored *chunar* sandstone, they were of considerable size. Great shafts with the edicts of Ashoka engraved near their bases were crowned by an animal or animals on a bell-shaped capital recalling the bell-shaped capitals of the later Persian Achaemenid Empire of Darius and Xerxes. The capitals were highly polished by a process requiring considerable technical skill. This, too, is thought to be an influence of the official and hieratic style of Achaemenid sculpture and has been called the "Maurya polish"; but many have questioned the propriety of this designation, since the technique could reasonably have continued beyond that period. The best preserved of these great columns is the one excavated at Sarnath and now kept at the museum there (*fig. 80*). Most of these columns have fallen and the capitals have consequently been moved to museums. The Sarnath capital is surmounted by a plinth with four animals and four wheels in relief which, in turn, is surmounted by

four lions back to back. The lions themselves are remarkably like those of Persepolis and Susa, in Persia. The stylization of the face, particularly of the nose and whiskers on the upper part of the jaw, the rather careful rhythm and neat barbering of the mane, the representation of the forelegs by long sinewy indentations and, especially, the stylization of the claws, with the deep valleys between them, and the slightly hunched posture of the animals — all these are elements to be found in the representations of lions at Persepolis. The representations on the plinth are more unusual. The horse, the best preserved of the four figures in relief, has that sympathetic naturalism we have learned to expect from the Indian sculptor. Despite the stylization of the mane, the treatment of the body of the horse and of the legs shows a much less decorative intention than does the treatment of the lion above.

The subject matter is of great symbolic interest because the lion is the symbol of royalty, and the Buddha, described in the texts as the lion of the Shakya clan, was himself of royal blood. The representations on the plinth are more difficult to explain, and many efforts have been made to do so. But certainly the Wheel, symbol of the Buddha's Law, requires no explanation. Later representations of the Buddha show his hands in the motion of teaching or turning the Wheel, symbolic of his preaching the Sermon at Benares, where he "set the Wheel of the Law in motion." The animals represented may perhaps be those associated with the Four Directions, or they may symbolize lesser deities of the Hindu pantheon as it existed at that time. The horse, in particular, is associated with Surya, the sun god who travels across the sky in a chariot as Apollo, the Greek sun god, did. The Brahmany bull, which in the illustration can just barely be seen on the right of the plinth, is associated with the great god Shiva, one of the two most important male deities of the later Hindu pantheon. It has been suggested that the animals on the base represent such non-Buddhist deities at the service of the Buddha. The capital from Rampurva has, in addition to the now familiar bell-shaped capital, a plinth decorated with water flowers and plants, motifs that will become extremely important in later Buddhist art. The plinth is surmounted by a bull, treated in a somewhat blocklike character below for the functional reason that the bull's legs alone would not have been capable of supporting the stony mass of his body (*fig. 81*). This treatment does, strangely enough, recall certain Hittite and Persian versions of the bull where the area below the stomach is treated as a block with the genitalia shown in relief on this block. But the style of the animal itself has none of the rather awesome and overpowering quality of works from the ancient Near East; rather it has a certain quiet simplicity and gentleness characteristic of later Indian representation of animals.

At the same time that works were being produced

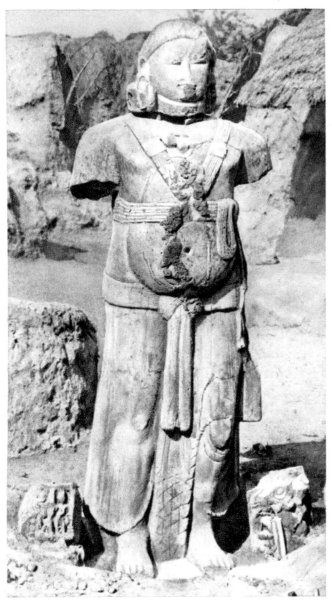

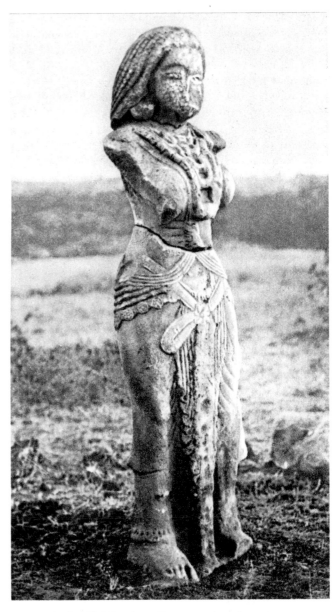

82. *Yaksha, from Parkham. Sandstone,*
height 104". Late Maurya Period, 2nd Century B.C.
Museum of Archaeology, Mathura

83. *Yakshi, from Besnagar. Sandstone,*
height 79". Late Maurya Period, 2nd Century B.C.
Indian Museum, Calcutta

under imperial patronage in an official style with traces of Persian influence, other sculptures were produced which have no precedents in the arts of the ancient Near East. They appear to be representations of nature deities, Yakshas (male) or Yakshis (female). Whether these images were placed at Buddhist sites and connected with Buddhist ritual it is at present impossible to say. The two key monuments of this native style are the Parkham Yaksha (*fig. 82*), in the museum at Mathura, and the Besnagar Yakshi (*fig. 83*), in the museum at Calcutta. The illustration is one of the most interesting and exciting of all pictures of Indian sculpture, for it shows the Parkham Yaksha as it once may have stood,

in the midst of a village, and not within the protective walls of a museum. In the days of the King Bimbisara, a contemporary of the Buddha, says a Tibetan source ". . . one of the gate-keepers of Vaisali had died and been born again among demons . . . he said, 'As I have been born again among demons, confer on me the position of a Yaksha and hang a bell around my neck.' So they caused a Yaksha statue to be prepared and hung a bell round its neck. Then they set it up in the gate-house, provided with oblations and garlands along with dance and song and to the sound of musical instruments." One can sense something of the monumental grandeur of these early images. The large figure is of

cream sandstone, now badly eroded. It is architectonic, frontally organized, massive in its proportions and, in a sense, held within the block of stone. One might also say that it is contained in a tree trunk, because it is likely that most of the native style sculpture of the period preceding the rise of Buddhist stone sculpture was in wood. And it may well be that the Parkham Yaksha and the Besnagar Yakshi are translations into stone of a tradition of monumental wood sculpture carved from great tree trunks. The relaxation of the Yaksha's left knee makes us wish we had some earlier work for comparison, because the bend naturally leads one to think of the relaxation of the knee one finds in the development of archaic Greek sculpture. It is a first tentative gesture toward a more informal, less rigid treatment of the figure. The Yaksha's paunch or pot belly is a constant feature of Yaksha iconography, seen especially in Kubera, god of wealth and chief of all Yakshas, and in the elephant god Ganesha, a Yaksha type.

The date of the Parkham Yaksha is a much-debated subject. There is a present tendency on the part of some scholars to place it later than the previously accepted date within the Maurya Period. It has now been suggested by W. Spink that it is a work of the Shunga Period, some hundred years later. He points to such details as the heavy necklace as characteristic of Shunga forms. At the side of the figure in the illustration is a little stone piece of much later date. This relief of two figures, as late as the ninth or tenth century A.D., or even later, is set up alongside the big Yaksha as part of the village cosmology. At the time the Yaksha was discovered by an outsider who came to the village, it was included in daily ritual worship.

Again, we are fortunate to have a photograph showing the Besnagar Yakshi outside the walls of the museum, a tall and powerful figure slightly smaller than the Parkham Yaksha, rather sadly damaged but with the same general conformation as the Yaksha. The left knee is very slightly bent, less so than in the Parkham Yaksha, but the proportions of the figure are equally monumental. The tremendous development of the breasts, the relatively small waist, and the large hips show one of the fundamental Indian representational modes. The female form must suggest its functions — life-bearing, life-giving, and loving. The exact date of the Besnagar Yakshi is as open to argument as that of the Parkham Yaksha. There are certain similarities — particularly in the headdress, the necklace, and the treatment of the girdle and skirt — to works as late as the first century Yakshis at Sanchi. One thing that helps to create an archaic effect, in both the Parkham Yaksha and the Besnagar Yakshi, is the weathered condition of the sculptures, which adds decades to their appearance.

In contrast to these monumental works in stone, which may be continuations of a wood-carving tradition, we must now consider an example of work in terracotta,

because the influence of terracotta technique on Indian sculpture is of the utmost importance (fig. 84). Many of the earlier terracottas come from excavations near Sarnath and Benares on the Ganges, as well as from other sites in North Central India where archaeological strata indicate a Maurya date. This female figurine is far more sophisticated than the Parkham Yaksha and the Besnagar Yakshi. While the pose is rather frontal, the treatment of the skirt, the face, and the elaborate headdress contributes a mood of freedom and gaiety. She has a lightness and a plastic quality, something of the softness of clay, that is extraordinarily pleasing. It seems probable that in the Maurya Period three different styles flourished: an official one, associated with the court; a native, forest-cult style of images of titular deities of trees, streams, or villages which were rather rigid and archaic; and a style, largely lost to us except for the terracottas, which was an emerging native style of sophisticated sculpture, perhaps an urban product somewhere between the court style and the cult style. Cer-

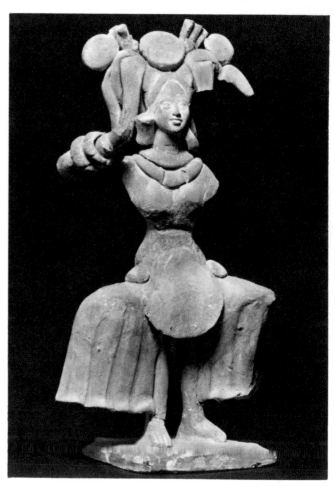

84. Female Figure, from Pataliputra, Bihar. Terracotta, height 11¼". Maurya Period, c. 200 B.C. Patna Museum, Bihar

85. *Chaitya Hall, Bhaja, exterior view. Late Shunga Period, c. 1st Century* B.C.

tainly this extremely knowing young lady, with her panniered skirts, breathes an air different from either the animal capitals of Ashoka or the Parkham Yaksha.

The Maurya dynasts were followed by the Shungas, a family reigning in North Central India from 185 to 72 B.C. Now there is more material more safely dated, and the beginning of an elaborate development of Buddhist sculpture. The first important Shunga site is the *chaitya* hall ("nave-church") and the *vihara* (the refectory and cells of the clergy) at Bhaja. Bhaja is a Buddhist monument, but the sculpture presents the Vedic deities of sun and storm, gods of the pre-Hindu religious environment in which Buddhism developed. One can see from the general plan of the *chaitya* hall why from the early nineteenth century it was called the Buddhist cathedral (*fig. 85*). There is a central nave, two side aisles, an ambulatory at the back, and a high, vaulted ceiling. But while this designation is an apt one visually, it is not too close in actuality. This *chaitya* hall and many others

are carved out of living rock, but their prototypes were wood structures whose arched roofs were formed of boughs bent in a curve, lashed to upright beams, and thatched. The focus of the nave is a monument, the *stupa*, which looks like the Indian burial mound. The *stupa*, commemorating the Parinirvana — or most exalted condition — of the Buddha, is here a symbol of the Buddha and his teaching, and is the focus of the naves of nearly all remaining *chaitya* halls. The façade of the Bhaja *chaitya* hall is also carved to simulate wood construction. In this case it is almost as if the *chaitya* hall were surrounded by a heavenly city of arched pavilions, long railings, and grilled windows. One can make out on one side the head, earrings, breasts, waist, and hips of a large Yakshi. There were two such Yakshis at Bhaja, good examples of the early use of fertility deities to glorify the Buddha. These were very quickly absorbed into the current of Buddhism, and we find extraordinarily sensuous sculptures on both Buddhist

81

and Jain monuments. There is both a low and a high intellectual tradition, and the one cannot live without the other. One of the best demonstrations of this is in the iconography of early Buddhist art.

The *vihara* are small cells for monks and at Bhaja they run along the cliff to the east. One of the farther ones has a porch, on which are carved in low relief some extremely interesting non-Buddhist subjects (*fig. 86*). These represent Vedic deities: Surya, the sun god, in his chariot, and Indra, bringer of storms, thunder, lightning, and rain, riding on his vehicle, an elephant who uproots trees and tramples the ground. Below are people worshiping at sacred trees, while nearby and slightly higher others flee in terror of the storm. At the lowest register, at left, a music-and-dance performance is in progress before a ruler seated in the posture of royal ease. The style of this relief, with the mounted

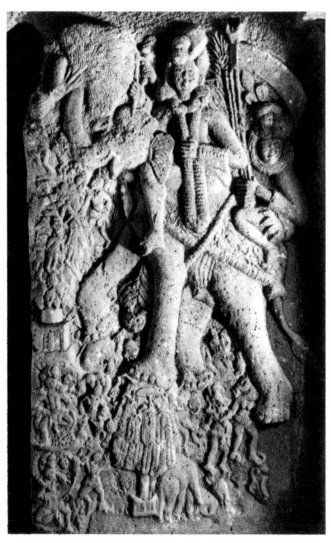

86. *Indra over the Court of an Earthly King, from Bhaja. Stone relief. Late Shunga Period, c. 1st Century* B.C.

deity and the escort behind him who holds his symbols, is distinctively archaic, notably in the treatment of the figure with its stiff shoulders and rather frontal posture. At the same time, the escort, the elephant, and the figures below display an active and free style, emphasizing curvilinear structure, with one form flowing smoothly into the other, rather like the Maurya terracotta. Bhaja is dated variously, from the end of the second century B.C. to the very beginning of the first, but the second century B.C. seems preferable. Significantly enough, there is no representation of the Buddha, nor are there, aside from the *stupa*, any symbols of the Buddha.

The second great monument of the Shunga Period is a construction; it is not carved from the living rock. This is the now largely destroyed *stupa* of Bharhut, of the late second or early first century B.C. The sculptures from Bharhut were found in the fields but have now been removed to the Indian Museum in Calcutta. All that remains of the *stupa* are a part of the great railing, one of the gates (*torana*), and other fragments (*fig. 87*). In America, some of these may be seen at the Freer Gallery in Washington and at the Museum of Fine Arts in Boston. Bharhut is a good example of the imitation of wood construction in stone. Obviously a tower gate of this type, with several cross-lintels, is more appropriately constructed in wood than in stone, though its permanence as a monument is considerably greater in stone; hence the use of that material in these great religious monuments. The gates of cities or palaces were very much like this gate, except that they were constructed of wood. Bharhut is the first classic example of the use of aniconic (noniconic) symbolism, so called since it does not represent the figure of the Buddha; the symbols, in a sense, invoke his presence. Bharhut is also a fine example, in better condition than Bhaja, of the incorporation of the male and female fertility deities into the service of Buddhism.

The form of the *stupa* was very simple: a burial mound surrounded by a railing of great height. The railing was divided vertically and horizontally, and at each junction between the vertical and horizontal members was a lotus wheel or a medallion in relief representing busts of "donors" and aniconic scenes from the life of the Buddha. The coping above has a lotus vegetation motif while the gate pillars proper repeat the motif of the Maurya bell column, with lions supporting the upper architraves of the *torana*, which in turn is crowned by the Wheel, symbolic of the Buddha's Law. A detail of the sculpture on the *stupa* reveals characteristics we might well associate with wood carving. In the representation of The Dream of Queen Maya, the mother of the Buddha dreams of a white elephant, symbolic of the coming of the Buddha to her womb (*fig. 88*). The scene, with its tilted perspective and the seated attendants seen from behind, is represented in a rather

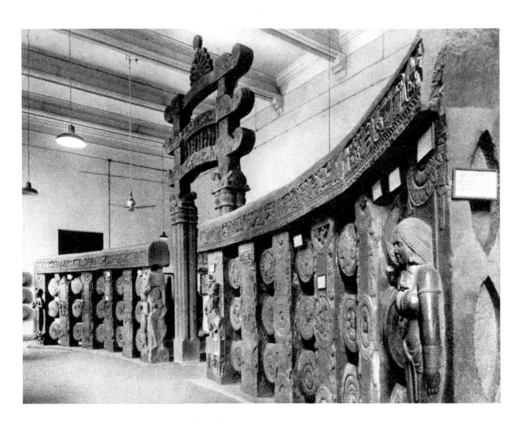

*87. Gateway and Railing of Stupa,
from Bharhut. Gateway height about 20'.
Shunga Period, early 1st Century* B.C.
Indian Museum, Calcutta

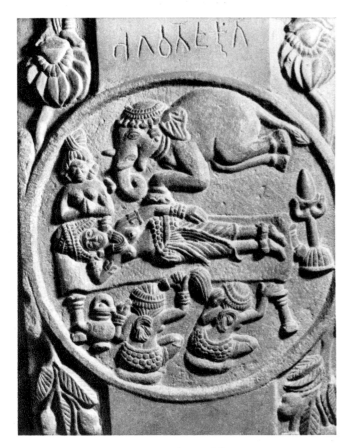

*88. Dream of Queen Maya.
Pillar medallion on railing of stupa shown
in figure 87, height 19"*

stiff way, simplified in a manner not like stone carving, but like carved wood. Other scenes from the Life of the Buddha are shown, as are numerous Jatakas, tales of previous incarnations of the Buddha, and representations of such water and vegetative symbols as the *makara* — half fish, half crocodile. A characteristic motif at Bharhut is the lotus medallion with the bust in relief of a turbaned male. At the corner column of each of the *toranas* at Bharhut were representations in relatively high relief of male and female deities, Yakshas and Yakshis. Among the Yakshis several represent the woman and tree motif, a favorite and auspicious one, repeated in Indian art again and again. The Yakshi, Chulakoka Devata, with one hand holds the branch of a blossoming mango tree and twines one leg around its trunk (*fig. 89*). The subject illustrates a familiar Indian belief that the touch of a beautiful woman's foot will bring a tree into flower, a ritual embrace still practiced in South India. The Yakshis of Bharhut are singularly wide-eyed and confident, their gestures explicit and naïve, the first of a long series of female figures that represent Indian sculpture at its best.

The Satavahana Dynasty (220 B.C.-A.D. 236) ruled over the Andhra region covering both Central and Southern India. Consequently, its arts include monuments which vary in style. One, the greatest monument of the early Andhra Period in Central India, is Sanchi. The other prime monument of the period is the group of *stupas* in South India, the most famous being Amaravati. The

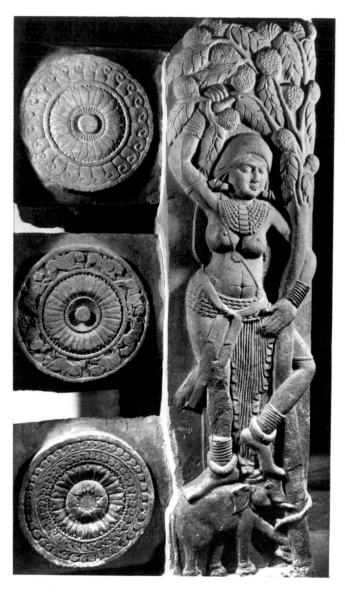

89. *Chulakoka Yakshi, from Bharhut. Pillar relief
of stupa, red sandstone, height 84".* Shunga Period,
early 1st Century B.C. Indian Museum, Calcutta

Stupa of Amaravati was constructed over a considerable length of time, from as early as the first century A.D. until after the fall of the Andhras in the fourth century A.D. Most of the remaining sculpture from Amaravati is of the third and fourth centuries A.D. Sanchi, on the other hand, is primarily important for its sculptures of the second and first centuries B.C. and is the type-site for the early Andhra Period.

Sanchi is on a hill rising out of the plain just north of the Deccan Plateau, not far from Bhopal. On the hill are three *stupas*: Stupa 1 is the "Great Stupa"; Stupa 2 is the earliest in date, about 110 B.C., and also has a few sculptures of late Shunga date; Stupa 3 is a smaller monument of the late first century B.C. and the first century A.D. *Stupas* may have enclosed relics of the Buddha,

and great ones were erected at various holy places in India — hills, confluences of streams, and other sites. Generally speaking, they all followed the same plan: a mound of earth faced with stone, covered with white and gilded stucco, and surmounted by a three-part umbrella symbolizing the three aspects of Buddhism — the Buddha, the Buddha's Law, and the Order. The umbrella was usually surrounded by a small railing at the very top of the *stupa*. This perhaps goes back to the old idea of the Sacred Tree with a protective railing such as those we saw in the Bhaja reliefs. Around the mound proper, a path was laid out so that the pilgrim to the holy spot could make a ritual, counterclockwise circumambulation of the *stupa*, walking the Path of Life around the World Mountain. This path around the *stupa* was enclosed by a railing pierced by gates at each of the Four Directions. The railing and the four gates provided the occasions for rich sculptural decoration. The *stupa*, like so much Indian architecture, is not so much a constructed space-enclosing edifice as it is a sculpture — a large, solid mass designed to be looked at and to be used as an image or diagram of the Cosmos.

The Great Stupa at Sanchi was erected over a period of time (*fig. 90*). The illustration shows it as it exists today after the Archaeological Survey of India achieved a careful and respectful restoration. The site is now beautifully planted, and is one of the most lovely in all of India. The body of the *stupa* proper was constructed of brick and rubble faced with gilded white stucco. There is a massive Mauryan rail around the base, and a path above that level on the *stupa* proper with a railing of the Shunga Period. There are four gateways, all masterworks of early Andhra sculptors. We should recall that there are other Shunga relics at Sanchi, largely on Stupa 2, down the hill from Stupa 1 and dating from about 110 B.C. But any beginner studies Sanchi for the Great Stupa, whose famous gateway is that on the east. The stone of the Andhra gates is rather white, and gleams in the sunlight against the rubble and brick base of the *stupa* behind, making a contrast of ivory white against the deep brown and green of the rubble and moss. We have mentioned that the sculptural style of Bharhut was influenced by work in wood. From an inscription on one of the gates at Sanchi we have further evidence for the derivation of sculpture in stone from work in other materials. It speaks of one group of carvings as being a gift of the ivory carvers of Videsha, a village not far from Sanchi. So we may well have a translation of work in ivory into a stone style in some of these sculptures.

The four gateways, or *toranas*, are made of the same elements: each has two major posts or columns, crowned by three architraves (*fig. 91*). On the topmost architrave there are *trishulas*, symbols of the Buddhist Triad. The *trishulas* are supported by Lotus Wheels of the Law, and the three architraves are elaborately carved with

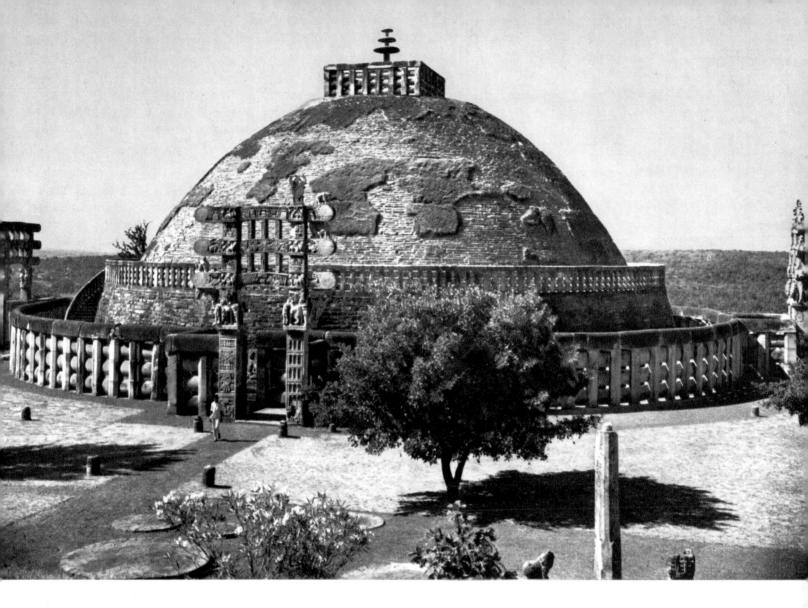

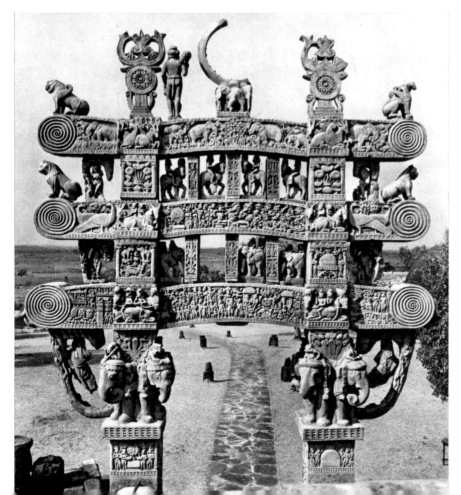

ABOVE:
*90. The Great Stupa, Sanchi.
Shunga and Early Andhra Periods,
3rd Century* B.C.–*early 1st Century* A.D.

LEFT:
*91. North Gate, the Great Stupa.
1st Century* B.C.

85

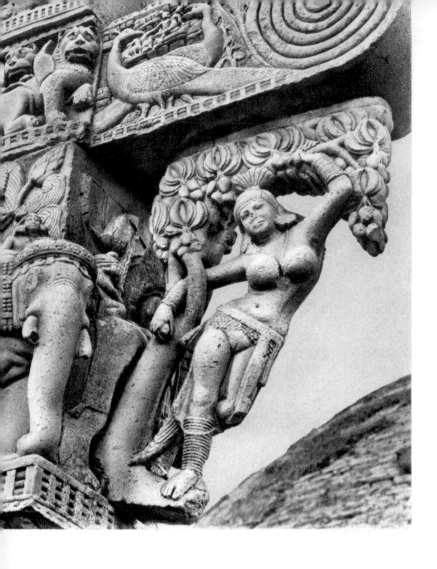

Jatakas in which the Buddha is sometimes a human being, sometimes incarnate as an animal. Jatakas all follow similar patterns and are charming folk tales with homely morals. They provide an engrossing picture of forest culture and lore. The capitals that crown the posts, just below the level of the architraves, are rather like those at Karle, and are composed of four elephants with riders going counterclockwise around the column. The sculptured stories on the architraves are confined to the space between the extensions of the main pillars, while the parts outside these show single scenes of the life of the Buddha, or previous lives of the Buddha, or symbols associated with Buddhism. The lower parts of the main pillars have representations of scenes from the "lives" of the Buddha on three sides, and their interior faces are carved with large guardian figures of Yakshas and Yakshis. It is significant that, as at Bharhut, the Buddha is not represented in figural form. The symbolism is still aniconic, and the Buddha is represented either by a Wheel, Footprints, a Throne, or some other symbol.

The Yakshi brackets are of particular importance for their sculptural quality. The most famous one, principally because she is almost perfectly preserved, is the figure on the East Gateway, from about 90 to 80 B.C. (fig. 92). The Museum of Fine Arts, in Boston, has a fragment of a figure from one of the other gates. Again we find the fertility goddess in a pose rather like that of the Yakshi of Bharhut. She grasps the bough of a tree with one arm while the other is entwined around its trunk. Her left heel is placed against the base of the tree trunk, thus giving the ritual blow in the traditional marriage rite of the maiden and the tree. This motif is met here for the second and by no means the last time. However, the Sanchi Yakshi is of a different cast than her sister at Bharhut. She is some fifty to eighty years later in date and, in terms of technical and compositional development, has progressed considerably. She is no longer simply a relief on the face of a pillar, standing woodenly, implacably looking out at the observer with an almost Byzantine iconic stare. Now she twists her body and there is a development of movement in depth, though the figure is still largely confined to a frontal plane. In that sense the figure is somewhat archaic. There is a much more complex development of the pose in the balancing movements of the arms, which are still angular, and the contrasting heavy curves and

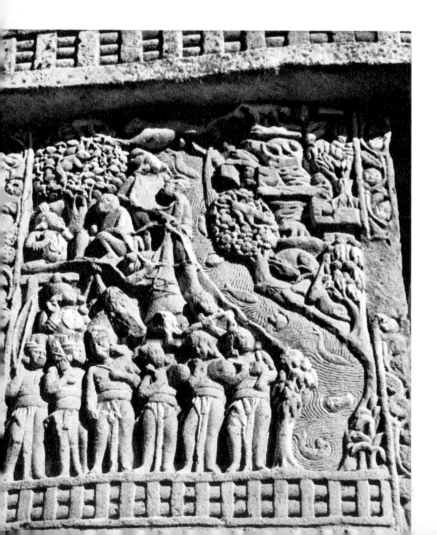

ABOVE LEFT: 92. *Yakshi, from the East Gate of the Great Stupa, Sanchi. Bracket figure. Early Andhra Period, 1st Century* B.C.

LEFT: 93. *Monkey Jataka, from the upper part of the south pillar, West Gate of the Great Stupa, Sanchi. Early Andhra Period, 1st Century* B.C.

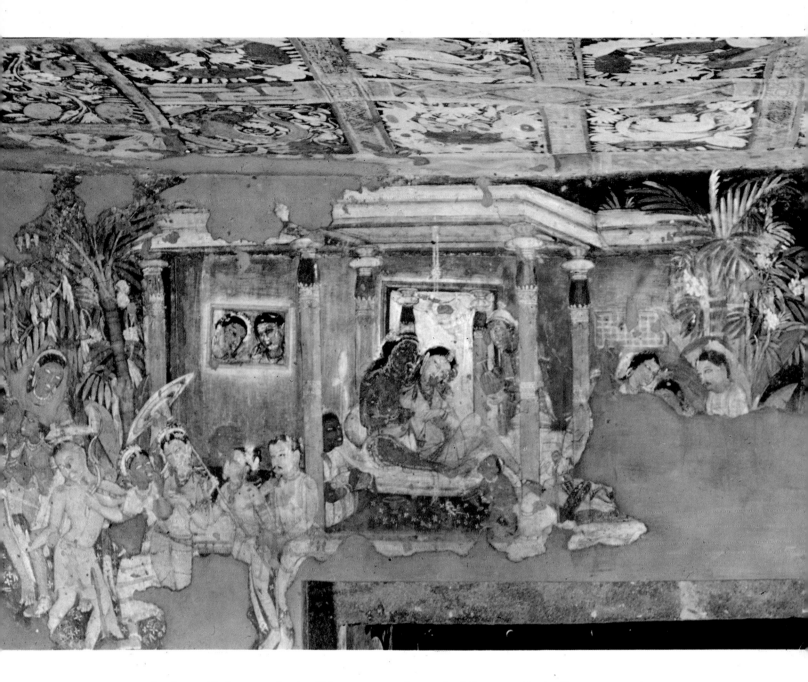

Colorplate 7. Vishvantara Jataka. Palace scene on the porch of Cave 17, Ajanta. Fresco. c. A.D. 500

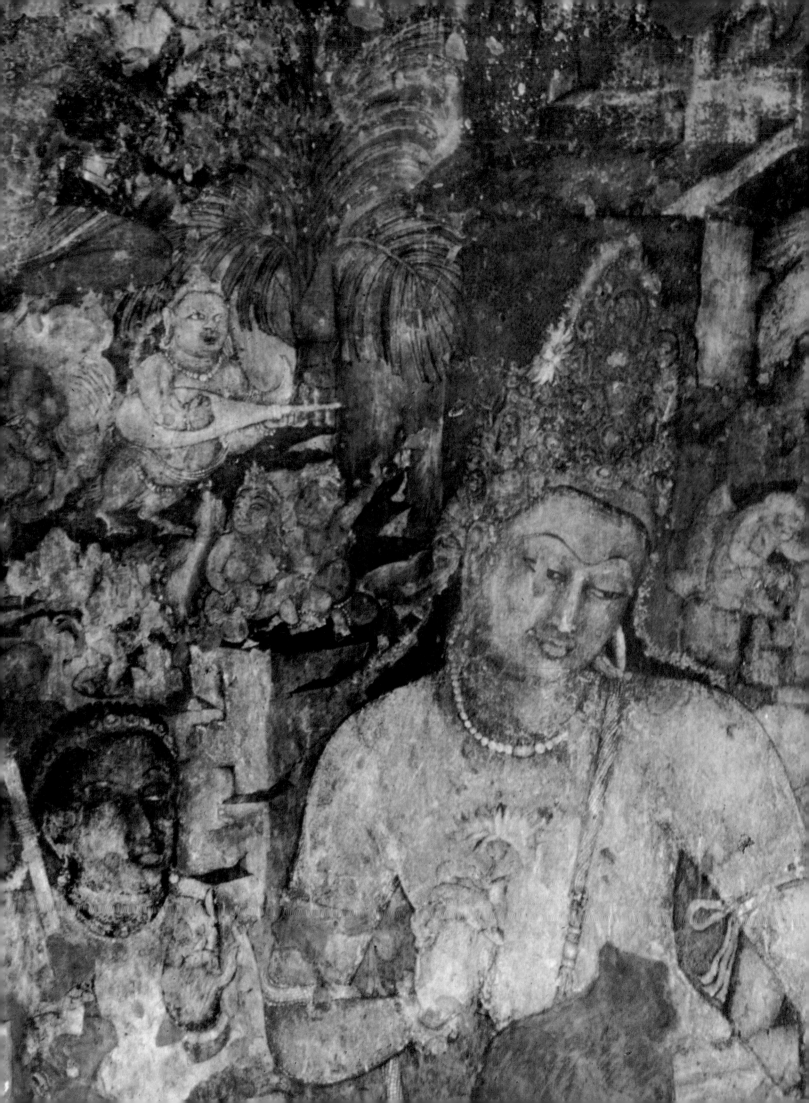

voluptuous movements of the body. One sees more use of open space. The sculptor is beginning to cut away the stone so that openings silhouette the figure against the air. At the same time, the figure maintains the character of a bracket. The heavy shape of the tree is squared off at the top and that shape is developed as a right angle. The thrust of the body, up through the knee into the torso, elbow, and out, acts as a structural as well as a bodily support to the architrave above. Functionally the figure does not support anything; it is a remnant of wooden construction. As images on a religious monument the Yakshi and Yaksha certainly served as supports for Buddhism, for the lesser folk, the illiterate, the great mass of people who but dimly understood the significance of the teachings of the Buddha, could be comforted when they saw the local tutelary deities, male and female, welcoming them to the austere and abstract *stupa*.

A fine and completely illustrated book has been written by Sir John Marshall on the sculpture at Sanchi, showing its wealth of detail in the many panels with their narrative content. Our illustrated panel is a good example of a Jataka scene; its treatment of the subject illustrates the stage that narrative had reached in the early Andhra Period (fig. 93). A single panel is framed below by a railing, and at the sides by a rinceau vine-pattern of grapes which gives a lush, rich movement to the edges, expressive of the vegetative forces of life. These enclose a picture plane crowded with figures, in effect a map of an enclosure packed with people. A river begins at the top of the panel and runs diagonally to the bottom from left to right, thus preserving a map-like view of a landscape whose details we see in side view. The trees of the landscape are shown in their most characteristic shape — the silhouette — while the topography is shown as in a plan. In this landscape we find representations of trees, hills, and rocks presented in profile. The human and animal figures are shown in typical side view, but on a ground line almost as if they were a separate composition within the landscape. The figures are at ease and are individually quite accomplished and subtle. The representations of monkeys and of their movements are highly convincing. The artisan handles with ease not only individual figures, but those in groups as long as they are all seen from the same point of view. However, the juxtaposition of these units in terms of over-all organization reveals a lingering archaic approach.

The story told here is that of the Buddha when he was King of the Monkeys. In this incarnation the Bud-

dha-to-be had as enemy and rival his wicked brother, Devadatta. The monkeys were attacked by archers of the King of Benares and, in order to save his followers, the Buddha-to-be stretched his huge simian frame from one side of a river to the other, allowing the monkeys to cross over on his body and so save themselves. But the last to pass over was Devadatta and, as he passed over, he thrust his foot down and broke his brother's back. The King had the Buddha-to-be brought from the tree, bathed, rubbed with oil, clothed in yellow and asked him: "You made yourself a bridge for them to pass over. What are you to them, monkey, and what are they to you?" The dying monkey replied, "I, King, am lord of these bough beasts . . . and weal have I brought to them over whom governance was mine . . . as all kings should." After that the King of Benares ruled righteously and came at last to the Bright World. The story is typical in that it shows the future Buddha as a royal figure; he is usually a king or a prince among men or among animals. Further, as the Bodhisattva (Buddha-to-be; as one capable of Buddhahood but renouncing it, dedicated to acts of salvation), he offers himself again and again as a sacrifice in order to save his fellow beings.

This composition has much in common with some Early Christian ivories: in the "feel" of the medium, the way the figures are carved, and the way they are composed. And this bears out the inscription on the gateway. It is an art vibrant with life, full and abundant. It is a style for those who like their art full, rich, and crowded.

Another important early monument is the Great Chaitya Hall at Karle, previously dated rather too early (fig. 94). We now know, from inscriptions on this *chaitya* hall, that Karle was made between about A.D. 100 and 120 and is therefore an accomplishment of the mid-Andhra Period, or rather of a minor kingdom related to Andhra. A general exterior view of Karle is not as impressive as that of Bhaja, because at Karle much of the exterior stonework, including a screen over the opening, has remained. This obstructs the view of the *chaitya* hall proper; and further, a modern Hindu shrine has been erected in the court and this also tends to block the view. The hall at Karle is cut into a mountain, some hundred miles southeast of Bombay at the top of the Western Ghats leading from the low-lying coastal plain up to the Central Plateau. The area is rather barren, looking not unlike certain sections of Utah and Colorado, with great vistas across the table-land, and with mountains or buttes (ghats) rising directly from the plateau.

The idea of the cave excavated in the mountain is one which appears to be especially characteristic of India and, through its influence, of Eastern Asia. In India the *chaitya* hall and the *vihara* are often cut into living rock. In Central Asia we find cuttings in the clay

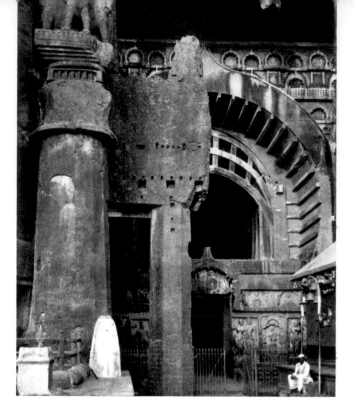

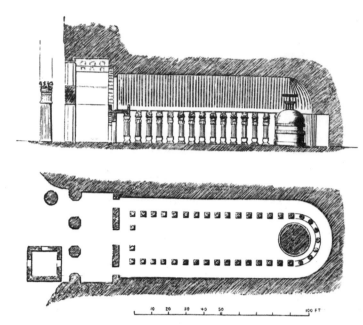

94. *Chaitya Hall, Karle, general view.*
Andhra Period, early 2nd Century A.D.

95. *Plan and Cross Section of the*
Chaitya Hall, Karle

cliffs. In China there are a great number of Buddhist cave temples; but in Japan the motif occurs hardly at all. Some very interesting psychological and aesthetic problems are raised by the cave complex. The Indian genius is primarily sculptural. There is no question that if one were to name the great sculptural styles of the world, one would have to include the Indian. If it is true that the Indian genius is primarily sculptural, it would seem to be confirmed as well by their architecture, as Medieval Hindu architecture demonstrates. The Indian does not conceive of architecture as primarily enclosing space. He conceives of it as a mass to be modeled, to be formed, and to be looked at and sensed as a sculpture. Perhaps, then, the practice of carving in living rock is understandable. It is possible that primal ideas of fertility are involved, of penetrating the womb of the mountain, or the desire for security in the womb.

The plan section of Karle gives some clue to the great structural *chaitya* halls, for there were free standing ones, some of wood, and later, of brick and stone (fig. 95). These exceptional structures are a true interior architecture intended to house a congregation, and made so that the worshipers could perform a ritual circumambulation of the *stupa* at the focus of the nave. Those at Bhaja and Karle, carved in living rock, are models of those now-lost, constructed *chaitya* halls. There are no even reasonably well preserved, constructed, early *chaitya* halls remaining in India. On the Karle plan we note a porch, a narthex or inner porch, and a three-fold entrance — one into each of the side aisles and a main entrance into the nave proper. The nave is a simple, long space defined by the columns

which flow around the *stupa*, making an ambulatory (fig. 96). There are no chapels built out to the sides as one finds in Medieval Western churches. The elevation shows the developed column type, with "vase" base and bell capitals. By the light from the great horseshoe arch of the façade, one can make out the form of the *stupa* at the end of the nave, and the vault above, which is an imitation of wood and thatch construction. The main nave at Karle is most impressive, reaching a lofty height of forty-five feet. The vase bases are probably derived from earlier wood construction which required columns to be placed in ceramic vases to keep out wood-devouring insects. The bell-shaped capitals of Karle, undoubtedly derived from the Ashoka columns, are surmounted by elephants and riders as at Sanchi. But in this case there are just two riders, facing out so that they are oriented only to the nave. The stone at Karle is a hard gray-blue granitic type, and the whole effect is somberly majestic, in contrast to the severity of Bhaja, where the columns, perfectly plain prismatic shafts with no capital or base, rise directly from the floor and move directly into the vault. At Karle we find much more elaborate figural forms, richly sculptured. The space of the interior at Karle seems to be more flexible, more flowing than the rather static kind of space we sense at Bhaja.

Only superlatives are adequate to describe the sculpture of the great period we now enter. The narthex screen at Karle is sculptured on the exterior with panels containing large-scale male and female figures somewhat questionably called "donors" (fig. 97). There are many other panels with routine Buddhist images ranging from

90

the fourth century A.D. to the sixth or seventh century A.D.; but the only work which concerns us here is that of the first century A.D. — the donors. They are of noble type, but we know not whether they are actually donors or loving couples (*mithuna*). Seldom in the history of art have male and female forms been conceived on so large and abundant a scale, with that sheer physical health which seems to brim from them in an ever-flowing stream. The quality, *prana*, or breath, which we must mention now and again in connection with Indian sculpture, is obviously present in these figures. Perhaps for the first time we sense that intake of breath when the dancer comes to the climax of his performance, when he comes to the pose that strikes the final note, a pose prepared by a sudden inhalation that arches the chest and achieves perfection with the fullest expanse of the body. Breath and dance are very important in understanding why Indian sculpture looks the way it does, why the stance and the representation of the body is the way it is. We can imagine the Indian sculptor studying closely not only performances, but rehearsals of the various royal and princely dance companies. From the study of such long and elaborately developed bodily exercise, to the heroically posed figures carved in stone, is a logical development.

The donors at Karle are more than life-size and their attire is princely. The male, torso naked, wears a turban; the female wears jewelry, heavy earrings, and a pearl girdle, with her figure draped from the waist down with very light cloth. We are overwhelmingly aware of the masculinity of the male and the femininity of the female — youthful types in the prime of life. Again we note the broad shoulders of the male, the broad chest, narrow hips, and virile stance. The female is quite the opposite, with narrow shoulders, large breasts, small waist, and large hips. At Karle we have perhaps for the first time the perfectly controlled expression of this Indian ideal and the masterly represen-

91

96. Nave of the Chaitya Hall, Karle

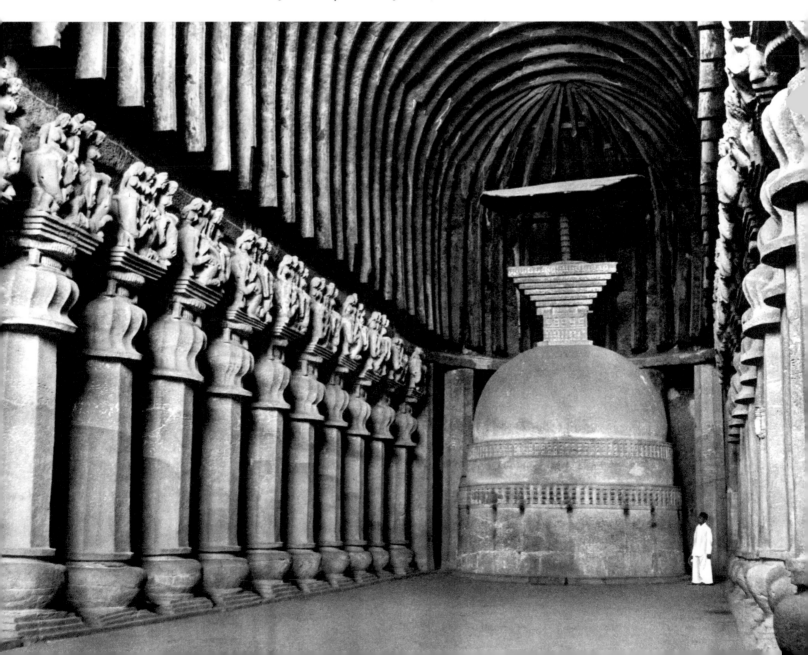

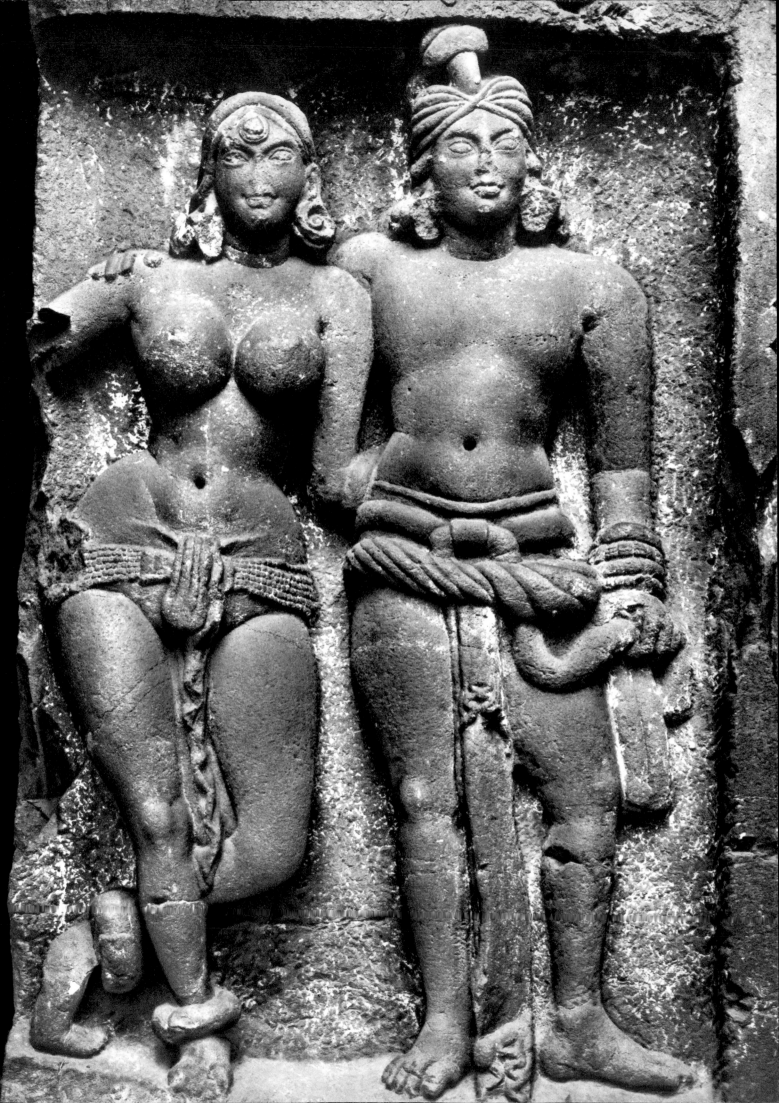

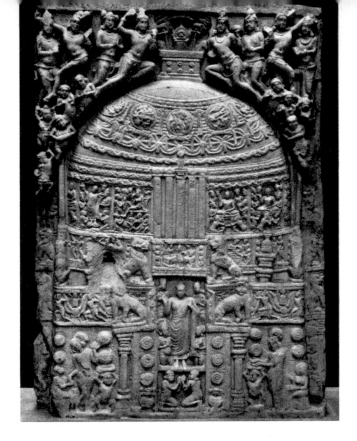

OPPOSITE:
*97. Couple, from the façade of the Chaitya Hall,
Karle. Andhra Period, early 2nd Century A.D.*

RIGHT:
*98. Slab Depicting the Stupa, Amaravati. Marble,
height 74". Late Andhra Period, late 2nd Century A.D.
Government Museum, Madras*

tation of male and female figures which continues
almost without fail up to the tenth and eleventh cen-
turies.

The donors are in rather high relief and are not too
crowded in their assigned space. While the lintel does
come down rather tightly on the heads, it serves to in-
crease the large scale of the figures. If there were any
real space above them, they would appear smaller. In-
stead, they thrust upwards, almost supporting the lintel
above. The rather easy postures show no trace of the
angularity to be found in the arms of the Sanchi Yak-
shi. With the Lady Under the Tree from Bharhut, the
bracket Yakshi from Sanchi, the donors at Karle stand
as the third of the greatest monuments of early Indian
figural sculpture.

We now move south to examine the remains of a
series of *stupas*. These are of great importance from
the standpoint of quality and of their influence on style
in the art of post-Buddhist times, in South India, when
Hinduism became dominant. This development was al-
ready in movement by the fifth century. By South India
we refer to the region around the Kistna River, inland
from the sea some three or four hundred miles, in an
area scheduled for inundation by the waters of a great
new dam. The Stupa of Amaravati is the type-site for
this region. Two other *stupas* are well known in the
area: Nagarjunakonda and Jaggayyapeta. The *stupas*
were built under the Satavahana Dynasty, the same dy-
nasty that extended into North Central India and pro-
duced the Great Stupa at Sanchi. In the South the
Dynasty continued much longer than it did in the North
and consequently there is material ranging in date from
the first century B.C. to the fourth century A.D. The most
important works from Amaravati are in the Madras and
British museums. In general, the style of Amaravati can
be characterized as more organic and dynamic than
anything we have seen before. In contrast to the some-
what geometric character of the Kushan work in the
north, a softer and more flowing manner seemed to
flourish in the South. And it is surely no coincidence
that the Andhra Dynasty is a native rather than a for-
eign dynasty as was that of the Kushans, to be consid-
ered shortly.

All three of the Great Stupas in the Kistna region are
largely ruined. In the nineteenth century they were
threatened with complete destruction. Until the Eng-
lish stopped the destruction of the sculptures, they were

93

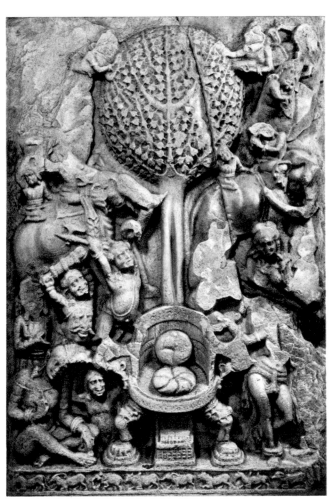

*99. Cushioned Throne, with The Assault of Mara,
from Ghantasala. Detail, gray marble, height 69¾".
School of Amaravati, late Andhra Period, late
2nd Century A.D. Musée Guimet, Paris*

100. The Universal King "Chakravartin," from the Stupa of Jaggayyapeta. Fragment of the paneling, marble, height 51″. Andhra Period, c. 1st Century B.C.
Government Museum, Madras

footprints for the Presence, etc. Atop the *stupa* is a railing around the Tree symbolized by the parasol, in this case, with two sets of parasols on either side of a central shaft.

From this slab one can see that the style has little in common with the Kushan style of the North. Here all things are treated in curvilinear and flowing forms, with the exception of architectural members. The angels above, with their bent legs and arms, are treated in a relatively flexible manner. At the side of another fine slab, we see the aniconic imagery used again in the cushioned Throne (*fig. 99*), with four attendants worshiping the symbols of the Buddha. The upper frieze displays an actual representation of the Buddha, seated in the Lotus pose with a halo behind him, tempted by the Daughters of Mara. So, together on one slab we have the use of the Buddha image, which may have developed independently at Amaravati by the third century A.D., and the older method of aniconic symbolism. Two illustrations present the early and the late styles of Amaravati. The styles are usually broken into four parts, but in a more general way we can distinguish an early and a late style. The famous slab from Jaggayyapeta, in the museum in Madras, dates from the very beginning of the Andhra Period, perhaps to the first century B.C. (*fig. 100*). It shows a subject often connected with Bud-

94

burned for lime or used in other structures. However, we are able to reconstruct the appearance of the *stupa* at Amaravati (and, by inference, those at Nagarjunakonda and Jaggayyapeta), from reliefs which show the *stupa* as it appeared in its final form. The most perfectly preserved of the representations of the Great Stupa of Amaravati is on a slab from one of the later railings of perhaps the third century A.D., which shows us a great mound faced with brick or stone, and finished with stucco (*fig. 98*). There is a series of large reliefs around the base of the drum and the upper balustrade, punctuated by a curious five-columned tower at each one of the entrances. These correspond to the *torana* at Sanchi, but have a completely different shape. Finally, there is a very high exterior railing with a profusion of lotus rosettes, and with reliefs of Yakshas bearing the Lotus Garland of Life around the top register. The entrances also have lions atop pillars, with an architrave going back to the gate, thus making a kind of porch or enclosure leading to the *stupa*. At the focus of these entrances there are sculptured slabs with both aniconic and iconic representations of the Buddha. The usual symbols are often used to represent the activities of the Buddha—the Wheel of the Law for the sermon,

101. The Buddha Taming the Maddened Elephant, from the Stupa of Amaravati. Railing medallion, marble, height 35″. Late Andhra Period, late 2nd Century A.D.
Government Museum, Madras

102. *Statue of Kanishka, from Mathura. Red sandstone, height 64". Kushan Period, c.* A.D. *128 or 144.* Museum of Archaeology, Mathura

103. *Statue of Vima Kadphises, from Mathura. Height 82". Dated the 6th year of Kanishka's reign,* A.D. *134 or 150.* Museum of Archaeology, Mathura

dhism — a *chakravartin*, or prince, for the Buddha was a *chakravartin*. The tall figure stretches his right hand toward clouds from which fall a rain of square coins. He is surrounded by the Seven Treasures, his wheel of dominion, his horse and elephant, his light-giving jewel, his wife, his steward or treasurer, and his minister or general.

A text later than the relief — the *Prabhandhacinta-mani* of Merutunga — has it: "O King! When the cloud of your hand had begun its auspicious ascent in the ten quarters of the heavens, and was raining the nectar flood of gold, with the splendour of the trembling golden bracelet flickering like lightning . . ." The style here is comparable to that of Bharhut, except for certain local characteristics, such as the greatly extended figures with their rather angular and wooden appearance. The prince's costume, too, with its great beaded necklace, heavy rolls of drapery at the waist, and the large asymmetric turban, is like costumes at Bharhut and Stupa 2 at Sanchi.

The later style at Amaravati is a culmination of the tendencies of the Andhra school and is perhaps best exemplified in the well-known roundel from the railing, showing the Buddha Taming the Maddened Elephant (*fig. 101*). The representation tells the story of the beast by the method of continuous narration both in its first appearance, as it tramples on figures beneath it, lifting one by the leg and swinging it to the side, and in the aftermath, as it kneels and bows its head before the Buddha, who quells the angry beast. In many ways this is the most advanced piece of sculpture to date, from the standpoint of complexity, handling of space, and representation of the human figure. Despite the method of continuous narration, the scene has visual unity. There is also a rather successful attempt to indicate a shallow stage or setting for the drama, with the architectural details of a city gate at the left and buildings at the back with figures peering from windows above the balustrades. There is a sophisticated treatment of scale, in part owing to the inescapable fact that the elephant is large and the figures small. The descending size of the most distant figure in comparison with the nearest ones is clearly shown. The psychological unity of the whole scene is carried into units within the total

95

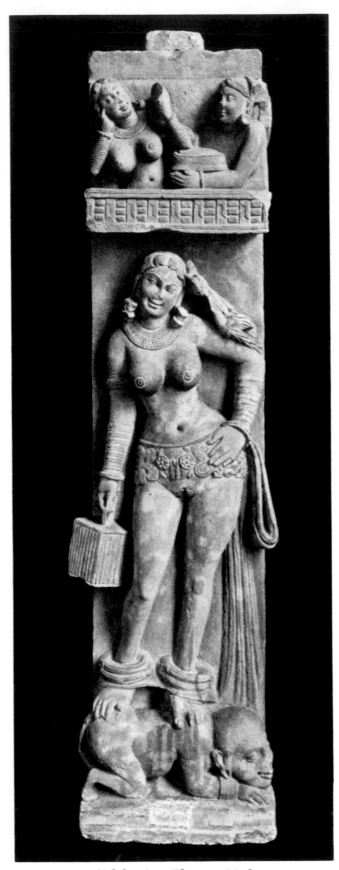

104. *Yakshis, from Bhutesar, Mathura.*
Railing pillars, red sandstone, height 55". Kushan Period,
2nd Century A.D. *Indian Museum, Calcutta*

representation, as in the little group where a woman shies away from the elephant and is calmed by the figure behind her. The whole composition probably shows the influence of the kind of painting that was being done at this time in the caves at Ajanta. The tremendous naturalism, which ranges from an occasionally pathetic figure to violent activity or calm inspection, is quite extraordinary. There is hardly, aside from the architecture and one or two of the elephant's halters, a straight line in the composition; everywhere there are slightly twisting or undulating curves and fully rounded shapes. There are no flat planes; everything is treated in an organic and sensuous way. It is a style which will greatly influence the development of South Indian Hindu sculpture in the Pallava Period (c. A.D. 500 -c. 750).

The Buddha image was developed under a non-Indian dynasty, the Kushan, established in Northwest and North Central India by an Eastern Iranian people of Central Asian origin. We can see something of the impact of these Kushan rulers on Indian sculpture in two very important effigies, the first of King Kanishka (c. A.D. 120-62) (*fig. 102*), the second of the preceding king, Vima Kadphises (*fig. 103*). Both effigies are now in the Mathura Museum. The un-Indian appearance of these images comes as something of a surprise. It must be remembered that they were made after the time of Sanchi, and the donors at Karle. Certain elements in their stark, rather geometric and abstract style can be attributed to the Scythianlike costume of the ruling Kushans. They wore padded boots and a heavy cloak covering the whole body, often seen in Chinese paintings of the barbarians of Central Asia. Still, we may well ask why they continued to have their effigies made in this costume if it were not because the stark geometry of the outlines of the costume appealed to them enough to be translated into permanent representation in stone. It certainly is true that these sculptures have a completely different flavor from what we have seen developing in the organic Indian style. The line of the cloak is drawn as if it had been laid out by a straightedge and there is great emphasis on the repeat pattern of the long mace and cloak edge. The statue of Vima Kadphises is less well preserved, but we can see geometric elements in it which correspond to those in the statue of Kanishka.

Whether one subscribes to the Mathura origin or the Gandharan origin of the Buddha image, it was under this dynasty that the first representation of the Buddha appears. The significant fact is that these effigies are almost the only works we have, aside from certain transitional Buddha images which show this rather harsh style. Most of the sculpture produced in the Kushan Period follows the organic development we have seen from Bharhut to Sanchi. Either the ruling class was not sufficiently large or sufficiently dominant artistically to impose a foreign style upon the Indians, or the style

was very quickly absorbed, just as the ruling class itself was absorbed into the great Indian mass. It is important to stress the difference between these sculptures and the native Indian tradition, because it is of some interest in relation to the development of the Buddha-image type, which seems to have an outside influence that must be accounted for.

As evidence that the development of the organic tradition of Indian sculpture continued unhindered despite the Kushans, we can point to three of the best preserved and most beautiful of the Mathura red sandstone figures, from Bhutesar (*fig. 104*). They embody perhaps an even more frank and unabashed nudity than that we saw at Karle. They are in higher relief and great emphasis is placed on the organic and flowing character of the female body. However, this character is modified somewhat by a certain emphasis on rather rigid linear forms, particularly in the jewelry and lines of drapery; but in general these figures carry on the great voluptuousness of the sculptures of Karle. They are fragments from a railing which enclosed either a Buddhist or a Jain monument, but either religion hardly envisaged in its dogma even the decorative use of such fertility deities as these, probably modeled on court ladies of the time. Some wash their hair, some look at themselves in mirrors, in most instances the figures are clad in elaborate jewels, wide coin belts, huge earrings, and anklets. The lengths of transparent cloth that form their skirts are gathered in loops at the hips. The poses use the motif of the crossed leg, in some cases with the sacred tree, and in others, without. All three of these female deities stand upon dwarflike Yakshas symbolizing earthly powers. These corpulent figures are shown at other times with vegetative motifs issuing from their mouths to make part of a great rinceau pattern. They are vegetative forces, the lords of life, but subdued here by fertility deities. The upper register of these pillars is marked by a miniature railing. Above are narrative scenes, usually of amorous couples. In the Kushan art of Mathura there is a growing tendency to leave the background as a flat, open area, allowing figures to stand out in high relief against a simple ground and achieving an uncrowded and monumental style. In the Bhutesar figures the type of face is stylized with a certain geometric handling of the modeling and representation, perhaps influenced by the Kushan official portrait style.

Most of the stone sculptures of North Central India from the Kushan Period are made of what is called Mathura or Fathepur Sikri sandstone common to the region south of Delhi, where the great quarries are found. It is a smooth-grained, red sandstone with some imperfections in the form of creamy white spots or streaks. Images of such stone were apparently made in the Mathura region and exported, because they are found widely distributed over the whole area of North

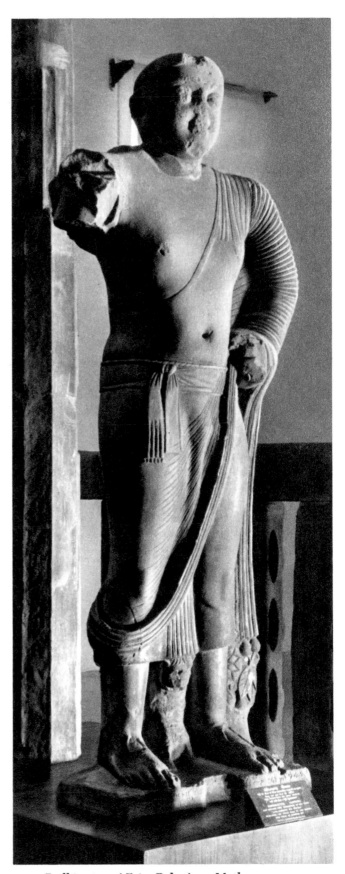

105. Bodhisattva of Friar Bala, from Mathura. Red sandstone, height 97½". Kushan Period, A.D. 131 or 147. Museum of Archaeology, Sarnath

97

Central India, including such great centers as Sarnath, until the late Gupta Period, when cream (*chunar*) sandstone became more popular.

In addition to the Yakshi motif used on the railings, we find decorative motifs, the Lotus Stem of Life and the Lotus itself. A more limited range of subject matter survives than that found in the earlier monuments and this is not surprising as Mathura, the holy city that Ptolemy called "Mathura of the Gods," was razed to the ground by Mahmud of Ghazni in the eleventh century. With the abandonment of the aniconic representation, where Jataka narratives provided great variety; the iconic method, with the Buddha image as the primary subject, became rather repetitious. Narrative elements began to disappear and there was a more limited range of subject matter, nearly always a single human figure, whether the Buddha, Yakshi, Yaksha, or Bodhisattva, standing erect, or, more rarely, seated.

The question of the origin of the Buddha image has been overargued, in part because national sensitivities were at stake. The earliest major publication on the subject is by A. Foucher, the French scholar who wrote in the early twentieth century on the art of Gandhara and the development of the Buddha image. It was his thesis that the Buddha image was developed in Gandhara under the influence of Hellenistic art, particularly of the Apollo image. Against this the Indian scholar Ananda K. Coomaraswamy, late Curator of the Indian Collections at the Museum of Fine Arts, Boston, published his thesis on the Indian origin of the Buddha

image. It is no coincidence that this occurred at a time of growing Indian national awareness. Coomaraswamy gave a very thorough and convincing argument for an Indian origin evolving from the Yaksha image, as convincing as Foucher's argument for a Classical origin. Both were right. There is no question that the Buddha image developed in the Kushan Period, and that it has

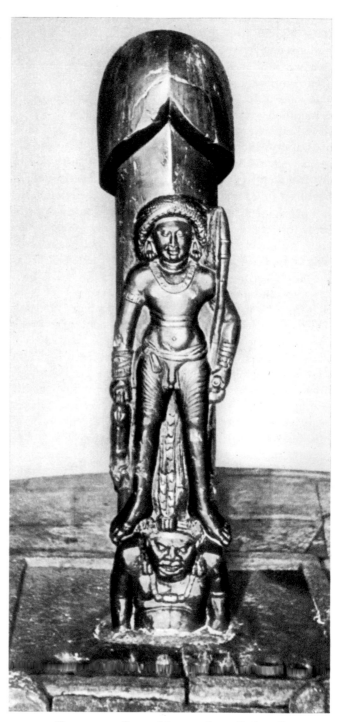

107. Parasurameshvara Lingam, from Gudimallam. Polished sandstone, height 60". 1st Century A.D.

106. Parasol, from the Bodhisattva of Friar Bala, from Mathura. Red sandstone, diameter 10'. Kushan Period, A.D. *131 or 147.* Museum of Archaeology, Sarnath

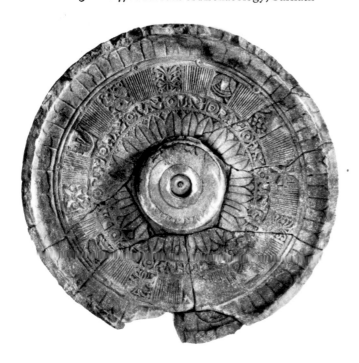

98

both Indian and Classical elements. Which came precisely first is a matter of the chicken or the egg, and is involved with several reign-dated objects which can be dated three or four different ways, depending upon the particular calendar chosen. This highly technical problem need not detain us here; however, it is significant that the development of the Buddha image occurred under the foreign Kushan Dynasty, and had to come because of the growing elaboration of Buddhism. Furthermore, Buddhism undoubtedly had to compete with a growing Hinduism, a highly figural religion with numerous images of deities. The rapid development of Roman influence on the art of Gandhara at the northwest frontier of the Kushan Empire may have stimulated the imagery of Buddha in human form. Foucher thought the Classical influence was Hellenistic; but it is quite clear that the main influence on Gandharan art is that of Rome at the time of Trajan and later.

The inscription on the image of the *Bodhisattva of Friar Bala* says that it is the gift of that monk and that it was made, again depending upon computations of reign periods, just before or after A.D. 100 (*fig. 105*). The inscription declares the image to be a Bodhisattva — a potential Buddha; but for all intents and purposes, it is a Buddha image. We see it here in order to compare it with the king effigies of Kanishka and Vima Kadphises. A strong geometric character in these early Buddha images is to be seen in the shoulders, which are much more square than in the figures of Karle; in the emphasis on linear pattern in the drapery and the very straight, rigid line of the textile borders; in the profile of the legs; and, if the face were well preserved, in the very sharp linear handling of eyes and mouth. It is almost more of an abstract symbol than the aniconic symbol of Tree, Wheel, or Footprint and seems more forbidding, more awe-inspiring, more remote than these. The lion at the feet of the Friar Bala image indicates the Buddha as the lion among men, and testifies to his royal origin. This sculpture originally stood with a tall prismatic column behind it, capped by an impressive stone parasol, another symbol of royalty, some ten feet in diameter and carved with signs of the zodiac and symbols of the celestial mansions (*fig. 106*). Thus the parasol interior is a representation of the Universe and the Buddha is Lord of the Sun and the Universe. The complete image must have been tremendously awe-inspiring. There is enough relationship to the Yakshas at Bharhut and Sanchi to say that it is not chiefly a foreign invention; but at the same time, one can see that there is something different here, something more abstract, more

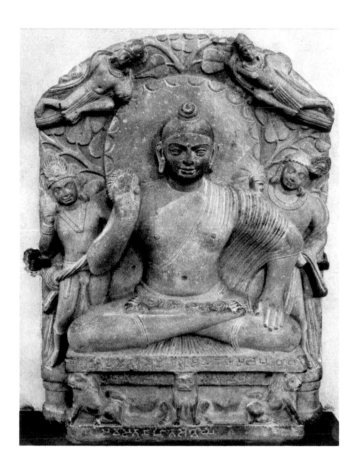

109. A "Bacchanalian" Scene, from Mathura. Height 21⅞". Kushan Period, 2nd Century A.D. Museum of Archaeology, Mathura

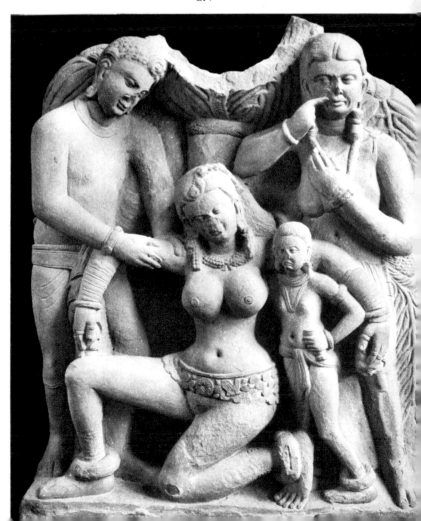

universal. The rigid frontality of the figure outdoes that of the Parkham Yaksha some three centuries earlier. There is no slight bend of the body, no bend of the knee; but such developments were to come.

A Hindu image may give some idea of how the likenesses of native deities may have helped in the formation of the Buddha image, and also point out the slight differences in style between them (*fig. 107*). This is a sculpture of Shiva from Gudimallam which none but a Hindu may see, for it is still used in temple worship,

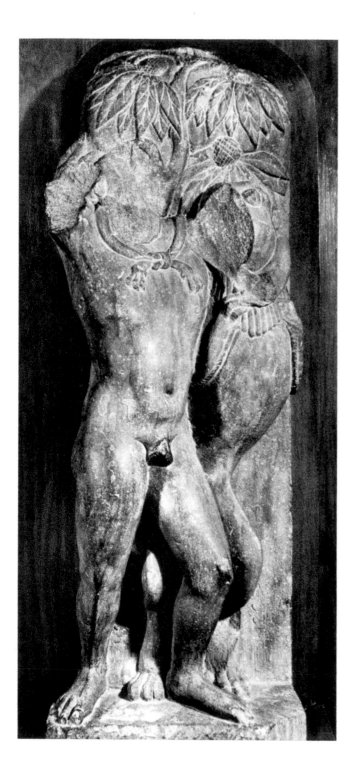

100

and dates from the Kushan Period, probably in the first century A.D. The earliest known and clearly identified stone representation of that deity, it shows Shiva in both figural form and in that of his principal symbol, the *lingam*, standing on a dwarf Yaksha, as were the fertility goddesses from Mathura. The surface is shiny because the figure is daily anointed with oil. The Kushan geometry of the almondlike eyes is notable but the formation of the torso, chest, and stomach is very different from that of the Kushan Buddha. The whole image is somewhat more organic, more naturalistic than a comparable Buddhist image in a similar pose. Perhaps it was the influence of images like these and the more popularly appealing Yakshas and fertility deities which led to the development of the Buddha image.

The standing image was not to be the major type. The standard Buddha image was the seated one, usually shown either in meditation or as preaching the First Sermon. A remarkably well-preserved, seated Buddha image in the museum of Mathura is in the form of a stele, a sculptured figure backed by a mass of stone, slightly rounded to contain a representation of the Sacred Tree (*fig. 108*). The Buddha is seated in meditation beneath the Tree with a parasol-like halo symbolizing the sun behind his head. He sits in the traditional meditative pose of the Yogi, and has the signs of the Buddha: the *urna*, the tuft of hair between the eyes; the *kaparda*, or snail, later to be transformed into the *ushnisha*, the protuberance of wisdom; and the Lotus signs on the soles of the feet. The long ear lobes record the Buddha's renunciation of his princely status. At that time he removed his jewels, among them the heavy earrings that had lengthened forever the lobes of his ears, and assumed the austere garb of a monk. One sees again the rather geometric character of the treatment of the drapery, the smooth arch at the termination of the drapery on the legs, the emphasis on the linear character of the drapery below the body, the strongly arched eyebrows, and the linear pattern of the hair. The image still has a rather un-Indian look when compared with most Indian sculpture. The Buddha's hand forms one of the *mudras* — hand gestures with very specific meanings, in a prescribed and carefully organized system. The *mudras* are extremely important in the language of the dance and of images, defining the particular aspect of deity represented. There are many different *mudras*; this particular one, *abhaya mudra*, means "fear not." Other gestures include the Touching of the Earth (*bhumisparsha mudra*), calling the Earth to witness the failure of the assault and temptation of

110. "Hercules and Nemean Lion," from Mathura. Stone, height 29½". Kushan Period, 2nd Century A.D. Indian Museum, Calcutta

cause, in terms of sheer sculptural quality, it is one of the greatest productions of the Kushan Period and one of the finest statements of the masculine ideal in early Indian sculpture. While the subject may derive from a Classical source, the treatment of it, the proportions of chest and waist, and the heaviness of the legs are all Indian qualities rather than Classical. It should be noted that the subtle modeling of the human figure, its relation to the lion, and the interweaving of forms in a single sculptural composition show a great advance over the sculpture just preceding the end of the second century, the date of this combat scene.

Jain sculptures, particularly those of Tirthankaras (Finders of the Ford, or Way) are in the very same style as the Buddha images, and in most cases cannot be distinguished from them unless one notices the lozenge shape on the chest, the mark of the Tirthankara. A few Hindu subjects are found as well, notably Krishna lifting Mount Govardhan, but they, too, are in the same style as the Buddhist sculptures.

The second dominant style of the Kushan Period is that of Northwest India, the Gandhara region. As we have seen, this region bordered directly on some of the post-Alexandrian and later kingdoms and so had numerous contacts with the Mediterranean world. The art of Gandhara has been much admired by the Western world and the reason is not hard to find. For persons accustomed to the Classical tradition it was the most palatable art that India produced. It was called

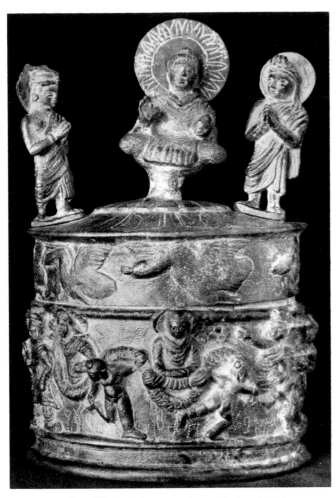

111. Kanishka's Reliquary, from Shah-ji-ki-Dheri near Peshawar. Metal, height 7¾".
Kushan Period, A.D. 128 or 144. Archaeological Museum, Peshawar, Pakistan

112. Reliquary, from Bimaran, Afghanistan. Gold, height 2¾". Early 3rd Century A.D. British Museum, London

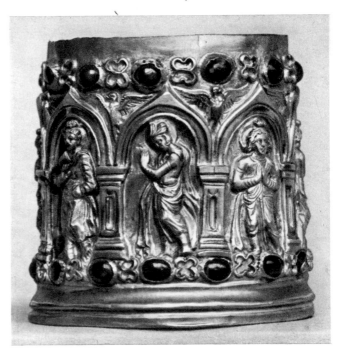

Mara, the deity of sin incarnate; and the gesture of the Turning of the Wheel of the Law (*dharmachakra mudra*). The Buddha is attended by figures recalling Yaksha types, one holding a fly whisk (*chauri*), the symbol of royalty. Still the full type of Buddha image is not yet clear by this time in the second century A.D. The treatment of the hair is not in the standard snail-like form it later develops.

In addition to these Buddha-image types, the Kushan Period also produced a few works of more narrative character. Two of the most famous and the most interesting are shown here (*figs. 109 and 110*). One is a convivial scene recalling the Bacchanalian depictions found on Roman pottery or Roman reliefs showing the pot-bellied Silenus. The second illustration is a sculpture often called *Hercules and the Nemean Lion*, again reminiscent of a Classical scene. It represents a man struggling with a lion beneath a tree. In this case we need not develop the iconographic problem at all, be-

101

Greco-Buddhist art; but now, thanks to B. Rowland's and H. Buchthal's studies, it is more properly described as Romano-Buddhist. The influences came not from Greece or the Hellenistic world, but from Rome and Roman styles of the late first and second centuries A.D.

Important as evidence of Roman inspiration at this time are two small reliquary caskets, one, the Kanishka reliquary, with an inscription giving a reign date (*fig. 111*), the other, the Bimaran reliquary named for the place where it was found (*fig. 112*). The crux of the matter lies in relating to our Western calendar this date of the first year of Kanishka's reign. But one must know the dates of this monarch's reign in order to arrive at a firm date. Since there were at least three different methods of dating available to Northern Indians at that time, there are various exact but rather different dates assigned to this casket. It is now generally believed to be a work of the second quarter of the second century A.D. Foucher wished to put it back to the year A.D. 78 and so establish the early presence of Classical influence. There is no question that the reliquary of King Kanishka shows definite Classical influences, as the little bands of Erotes or Cupids in garlands are taken directly from Classical pottery and sculpture. But the presence of the Buddha image, and its type, confirm the second-century date. We might even date the reign of Kanishka from the style of these figures rather than try to argue the date from the various calendars available at the time. The Bimaran reliquary, a precious object of gold, has evidence which fully confirms Roman rather than Greek or Hellenistic influence. This is the motif called by the scholars of Early Christian art the *homme arcade,* a repetition of figures in arched niches found especially in Early Christian sarcophagi from Asia Minor, most notably in the famous sarcophagus with the figures of Christ and His Disciples in the museum of Istanbul. As the *homme arcade* is a motif of the late first or second century A.D., the date as well as the source is confirmed.

The characteristic art of Gandhara is executed in two major media: stone — a gray-blue or gray-black schist — and stucco. Most of the early sculpture is carved in stone; no early sculpture in stucco — that is, of the first, second, and perhaps the third centuries A.D. — is known. A typical schist product is the relief representing the Birth of the Buddha (*fig. 113*). Classical art is above all figural and the gods are represented in human form, so it was natural that in the art of Gandhara, influenced by Roman work, Buddhist deities were so represented. No Gandharan sculptural representations with an aniconic representation of the Buddha are known. Thus in the Birth of the Buddha we see a Roman matron who miraculously produces the Buddha from her left side as she holds the Sacred Tree. The pose — the hands pull-

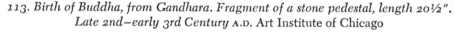

113. Birth of Buddha, from Gandhara. Fragment of a stone pedestal, length 20½".
Late 2nd–early 3rd Century A.D. Art Institute of Chicago

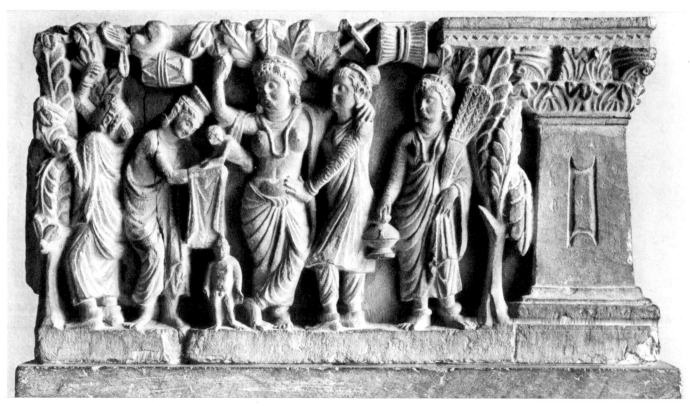

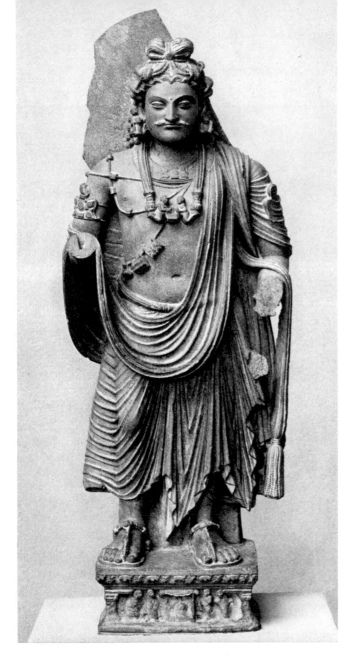

114. *Standing Bodhisattva, from Gandhara. Stone,*
height 43". 2nd century A.D. Museum of Fine Arts, Boston

little indebted to Rome, and the Northwest Indian sculptor is on his own.

The other side of the coin of Gandharan style is found in stucco figures. One must succumb to the charm and technical virtuosity of these plastic images. It is no coincidence that the production of stone sculpture in Gandhara tends to end by the third or fourth century and that the later work is executed in stucco, as the native Indian genius for working in plastic and fluid forms reasserts itself. Taking the stylistic elements left over from stone sculpture, combining them with Gupta influences from Kashmir to produce works of such unity and originality, the later Gandharan sculptor was a true creator (*fig. 115*). There are, to be sure, traces of

115. *An Adoring Attendant, from Hadda,*
Afghanistan. Stucco, height 21½".
5th-6th Century A.D. Cleveland Museum of Art

ing down the bough and the heel against the trunk — are in the Indian tradition; but not so the Apollo and barbarian types, or the stereotyped drapery derived from that carved on Roman sarcophagi. In general this is a "degenerated" Roman style and is of particular interest to historians of Classical art and to students of provincial transformations of style. It is no coincidence that the style fascinates André Malraux, as does that of late Roman coins, because in them he sees in the degeneration of one style the birth of a new one.

Perhaps the most notable Gandhara creations are schist images of moustachioed Bodhisattvas with faces like that of an Apollo, heavy jewelry of the Classical type, and boldly organized, rather geometric draperies (*fig. 114*). Below this figure is a scene from the Life of the Buddha. In such images, the Gandharan style is

103

ABOVE: 116. *Head of Bearded Ascetic, from Hadda,
Afghanistan. Stucco, height 4⅜".
5th-6th Century* A.D. Musée Guimet, Paris

RIGHT: 117. *Demon, from Hadda. Stucco, height 11⁹⁄₁₆".
5th-6th Century* A.D. Musée Guimet, Paris

Classical shapes influenced by Kushan geometry: the
arched eyebrows, the sharpness of outlines about the
eye, and the modeling of the forms of the cheek. The
figure of a bearded man is a Classical type and reminds
one of works influenced by the school of Skopas, par-
ticularly in the psychological overtones of the knitted
eyebrows which form a heavy shadow under the brows
(fig. 116). But the modeling of the mouth is plastic,
claylike, formed as one's hand, working directly and
instinctively, would achieve it, not in a manner precon-
ceived before cutting into the stone. One of the most
famous Gandharan stuccos in the Musée Guimet in
Paris is a representation of a demon, perhaps one of
the followers of Mara attempting to force the Buddha
to abandon his meditations (fig. 117). The fluid bend of
his body speaks of the touch of one who knows the use
and handling of clay. The forms are no longer even
semigeometric; and the texture of the drapery, pro-
duced by scratching the surface of the clay, is sketchy
and evanescent in style. The various sites from which
the stuccos come range in date from the fourth century
to as late as the eighth and ninth, and are found in
Gandhara, in the region of present-day Afghanistan,
Fondoukistan, and Kashmir. The fluid style associated
with stucco spread all over the Northwest and is com-
parable in quality and motivation to that of the terra-
cottas of North Central and Central India. It is the
great contribution of the Gandharan style to the history
of Indian sculpture, however fascinating the hybrid
work in stone may be.

6. The International Gupta Style

IN A.D. 320, WHEN, AFTER THE BREAKUP of the Kushan Empire, Northern India was divided into a number of petty kingdoms, the king of a small principality, probably Chandragupta, possibly his son Samudragupta, established the Gupta Dynasty. The kingdom was so strengthened that Samudragupta was able to subdue the states around him and achieve imperial status for his dynasty. A succession of able warriors and gifted rulers blessed with long reigns brought peace and prosperity to a vital area in North India extending from coast to coast. The Chinese pilgrim Fa Hsien, who visited India between 405 and 411, was immensely impressed with the generous and efficient government of the Guptas and with the magnificent cities, fine hospitals, and seats of learning in their domains. He writes of the happy contentment of the people, the general prosperity, and says that "the surprising influence of religion can not be described." While the Guptas were Hindus, they contributed to the support of both Buddhism and Jainism and it is recorded that one of the last great rulers, Kumaragupta I (413-55), built a monastery at the famous Buddhist center of Nalanda.

It was a time of cultural expansion and colonization which saw the influence of Indian art and ideas extending into Central Asia, China, and Indonesia. Bodhidharma, the famous priest, traveled to China. It is very possible that the poet Kalidasa was attached to the court of Chandragupta II (376-414). The great drama *The Little Clay Cart*, written in this era, gives a vivid picture of life in the city of Ujjain, where it is believed the later Guptas often held court. The visual arts, especially sculpture and painting, reflect the secure and leisurely atmosphere of the time. It was indeed a Classic, Golden Age as was that of Pericles in Greece. However, these were the last great days of Buddhist art. Except for the Pala and Sena schools of Bengal, its future will lie elsewhere, as Hinduism crowds out the Buddhist faith in India.

Few free-standing Buddhist structures survive, among them a *chaitya* hall of brick at Cherzala and a notable small fifth-century shrine at Sanchi, which stands near the Great Stupa. Temple 17 is a simple cell, very much like an early Greek temple, in which the shrine could be approached through a porch supported by stone columns (*fig. 118*). Behind this temple a taller structure, Temple 18, is one of the very few constructed, early *chaitya* halls remaining in India. All that is left are some of the great columns, much higher than in the little cell shrine, and parts of the architrave. The outline of the foundations is no different from the plan of the early rock-cut *chaitya* halls. One must distinguish between the assembly hall and the cell. The latter ultimately became dominant because a Hindu worshiper moves forward to confront the deity alone, while in Buddhist worship there was much group adoration,

118. Temple No. 17, Sanchi. Gupta Period, 5th Century A.D.

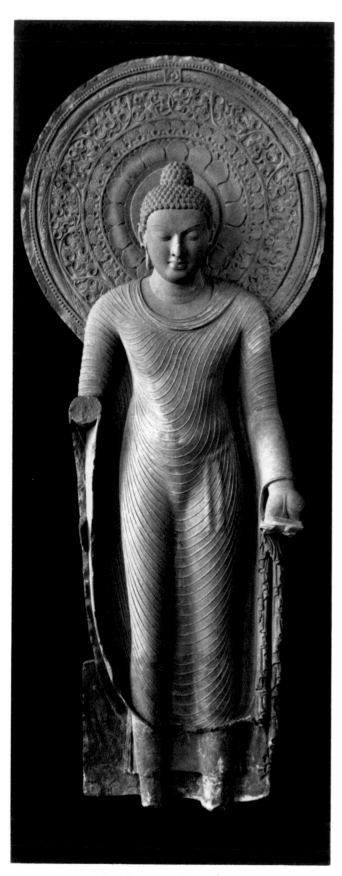

*119. Standing Buddha, from Mathura.
Red sandstone, height 63". Gupta Period, 4th Century A.D.
National Museum, New Delhi*

often by circumambulation of the *stupa*. Thus the Buddhist *chaitya* hall was the most elaborate form of interior architecture known in India until the coming of the Moslems, and the example at Sanchi is as full a statement as this form ever achieved in Buddhist art. The other remaining architectural monuments of the Gupta Period are largely monastery complexes, the most extensive being that at Sarnath, covering about a square mile of land and consisting of the repetition of one-cell units with variations in the form of courts.

Gupta sculpture, the classic creation of Buddhism in India, established the standard type of the Buddha image. This was exported in two main directions — to Indonesia, and through Central Asia to the Far East. Whenever one thinks of the Buddha image one thinks of the Gupta type or its derivatives. There are two major geographic styles in Gupta sculpture, with many secondary styles and geographic variations of minor importance. One, the style of Mathura, represents a continuation, yet a softening and leavening of the harshness of the Kushan style; the other is the manner of the region of Sarnath, where the Buddha preached the First Sermon. Sculptures from the Mathura region are made of a moderately fine red sandstone which can be worked in some detail, but not to ultimate refinement. The sculpture of the Sarnath region is of a cream-colored sandstone, the same sandstone used by the Mauryans for their columns and capitals, and capable of being worked to a high degree of detail and finish.

In the New Delhi Museum is a red sandstone standing image of the Buddha, dating from about the early fourth century A.D., with stylistic remnants of Kushan geometry in the drapery and the markedly columnar type of leg (*fig. 119*). But if one looks at the face and neck, the roundness and softness of modeling are quite different from the more extroverted and powerful modeling of the Kushans. The source for the "string-type" drapery here, also found on Chinese and Japanese images, is much debated. Does it come from the Gandhara school or is it Kushan work from Mathura? There seems to be no question that it appears in the third century on transitional images where the drapery is sometimes indicated as if a series of strings were arranged in a careful pattern on the surface of a nude body. The curves indicating eyelids, eyebrows, mouths, necklines, etc., are not free curves but geometric arcs, carefully controlled, almost as if they had been laid out with a compass. Images from the sixth century and later display a softening of the style and a growing freedom in the treatment of details. The images of the Mathura school begin to lose popularity in the fourth century A.D. and most images of later date are in other material. Still, it is curious that many of the cream sandstone sculptures at Sarnath were covered with red pigment, so that they would look like the red Mathura sandstone, perhaps because of the particularly holy

the Wheel of the Law seen from the front, a piece of virtuosity on the part of the sophisticated sculptor. The Deer Park is indicated by two deer, now damaged, on either side of the Wheel, flanked by six disciples in attitudes of adoration. The Buddha's throne is decorated with lions of a fantastic winged type, called leogryphs, who serve to indicate the lion throne of royalty. Behind his head, and centered on the *urna*, the tuft between the eyes, is the halo, the Sun Wheel, indicating the universal nature of the deity, clothed in the sun. The halo is decorated with a border of aquatic motifs, principally lotuses, recalling the ancient fertility and vegetative symbols associated with Yakshas and Yakshis. On either side, like angels in Italian Renaissance painting, are two flying angels who rush joyfully in to praise the Buddha. This image is not as harsh or as architectonic as the image from Mathura. The treatment of the hands with their elegant but rather limp fingers, the narrow chest and shoulders, the face with its softer outline and double reflex curves instead of simple geometric curves,

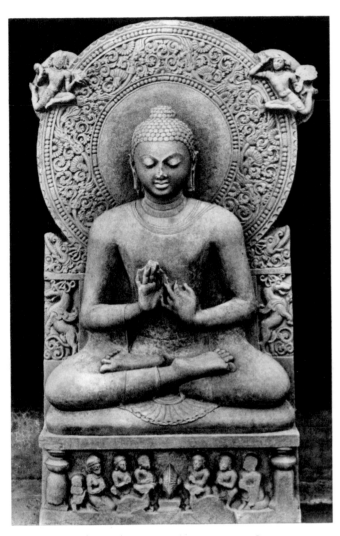

120. *The First Sermon, from Sarnath.*
Stele, chunar sandstone, height 63″. Gupta Period,
5th Century A.D. Museum of Archaeology, Sarnath

traditions of the earlier images. Other carry-overs from the Kushan style are the wide shoulders and large chest of the Buddha image, quite different from Sarnath images, and the rigid frontality of the image, almost more so than such early pre-Buddhist images as the Parkham Yaksha.

The most famous and most copied of all the Buddha images of the period is the fifth-century *chunar* sandstone image in the Sarnath Museum, representing the Buddha turning the Wheel of the Law in the Deer Park at Sarnath, a suburb of Benares and a great Buddhist center (*fig. 120*). The image presents the Buddha seated in the pose of the Yogi ascetic, the soles of his feet up, his hands in the *dharmachakra mudra*, the Turning of the Wheel of the Law. He is frontally oriented, seated on a cushion, with drapery carefully fluted to suggest a lotus medallion. Beneath the cushion on the plinth of the throne is an aniconic representation,

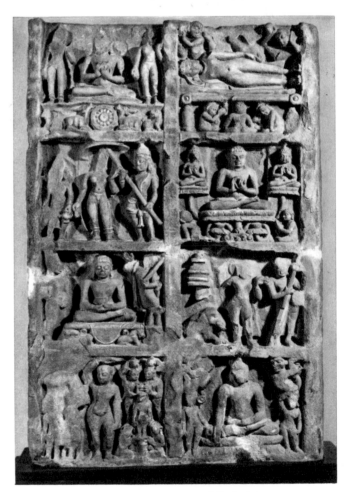

121. *Eight Scenes from Buddha's Life.*
Chunar sandstone, height 37″. Gupta Period, late 5th-6th
Century A.D. Museum of Archaeology, Sarnath

107

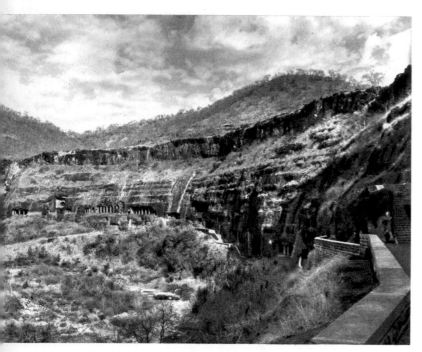

122. Ajanta, general view.
1st Century B.C.–*9th Century* A.D.

123. The Chaitya Façade of Cave 19, Ajanta.
Gupta Period, first half of 6th Century A.D.

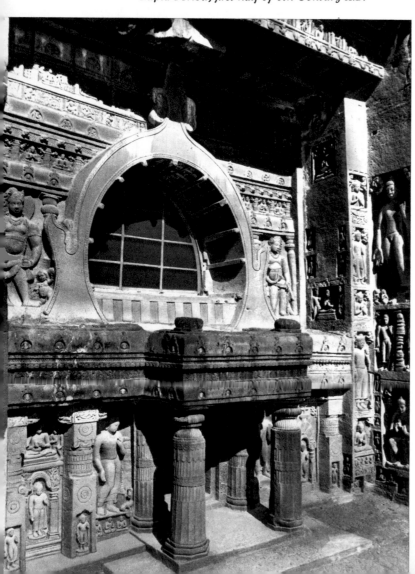

the foliage motifs — all combine to give the impression of a softer and more organic style. At the same time the symmetrical shape of the image — its frontality, the precision of the gesture — tends to add an architectonic frame to the organic detail. The result is a style with its own characteristic traits, quite unlike the almost frenzied energy and movement of Hindu images of slightly later date. The flying and gesturing angel at the upper right is much freer than the main image. Again we are confronted with a situation similar to that in Italian painting where, in the altarpieces, the principal figures of the large panels follow rigid, iconic modes of earlier years, while the secondary figures, either tucked in the sides of main panels, or more often in the predella panels, show more advanced styles with an adventurous handling of space and figures.

The language of poetry and prose exerted great influence on Indian sculpture and painting. Religious texts, drama, and poetry are full of metaphor and hyperbole — the hero's brow is like the arc of a bow, his neck like a conch shell; the pendant arm of Maya, the mother of the Buddha, hangs like the trunk of an elephant, the curl of the lips is like that of a reflex bow. It is such comparisons that the sculptor and painter translate, and in following the literary figure make curves derived from geometry or volumes like idealized shapes evolved from the more irregular forms of nature.

After various classic-image types were established there was a consequent impoverishment of subject matter. The rich iconography of the Jataka tales at Sanchi — the donors, jatakas, and other subjects at Bharhut, the wealth of representational material on the Great Stupa at Amaravati — became but memories. At Sarnath, in some of the steles representing scenes from the Life of the Buddha with the developed use of the Buddha image, we begin to sense an impoverishment of imagination and subject. This is particularly true with the Mahayana material, where images are repeated for their own sake and ultimately reach their most elaborate forms in the Buddhism of Nepal and Tibet, with frightfully complicated and seemingly endless systems of quantities and manifestations. One of the most famous steles, at the Sarnath Museum, represents the eight most important Scenes from the Life of the Buddha (fig. 121): from the upper left downward, Buddha Turning the Wheel of the Law, an unidentified scene, the Temptation of Mara, the Birth of the Buddha with Queen Maya Holding the Bo Tree, the Buddha Calling the Earth to Witness, the Buddha Taming the Maddened Elephant, the Great Miracle of Sravasti, and the Parinirvana of the Buddha. With all the possibilities of this rich subject matter there is an almost boring repetition of stock motifs. The Buddha image is established; and seated or standing, the various figures look very much alike and because of repetition the forms have degenerated. The images are squat, and do not

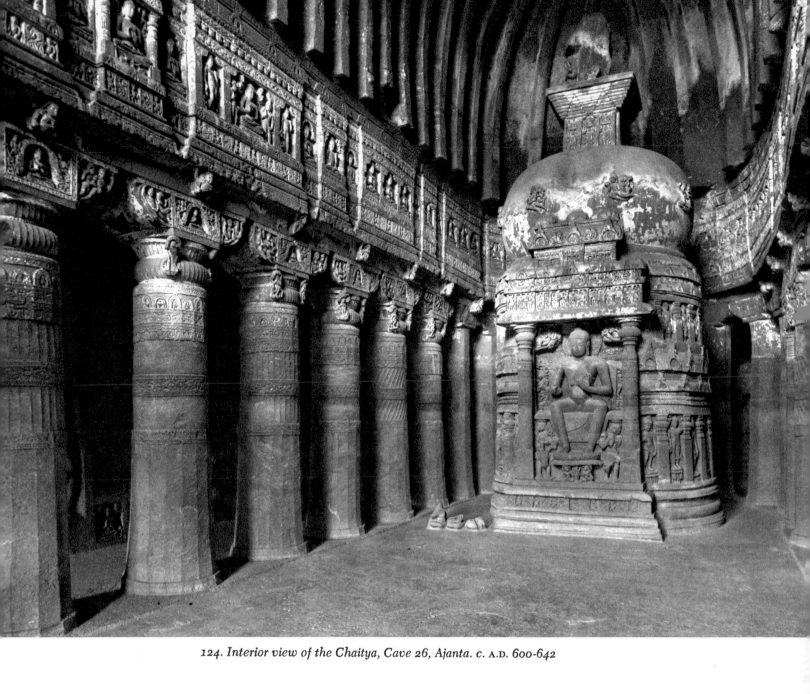

124. *Interior view of the Chaitya, Cave 26, Ajanta. c.* A.D. *600-642*

have the grace and proportion of the great seated image of the Buddha preaching. What is gained in the simplicity of each image as it stands out clearly against a plain background is lost in the bareness of the almost nonexistent narrative description.

The type-site for later Gupta art, but a site with material ranging in date from the first century B.C. to the eighth and ninth centuries A.D., is Ajanta. Only there do we have any considerable remains of the great Gupta and early Medieval school of wall painting. Let it be said at once that painting at Ajanta shows complete mastery and wide range; but the sculpture, largely of the later Gupta Period, reveals a considerable decline from the work produced in the fifth century. Ajanta is located in the northern part of the Deccan, not far east from Sanchi (*fig. 122*). The caves are situated on the

horseshoe bend of a stream in a somewhat desolate and wild region. Even today it is the haunt of cougars and other wild animals. It was probably chosen as a religious site because of its relative isolation. It was a refuge as well as a place of pilgrimage; and the proportion of the number of monks' cells to the places of worship tends to confirm this. The caves at Ajanta are numbered from 1 to 29 and are carved from the living rock. They represent not only great physical effort but a vast expenditure of funds and demonstrate that even at this late date the Buddhist church was still able to produce a major effort. The largest *chaitya* (Cave 10) dates from at least the first century B.C., while most of the *viharas* (monks' living quarters) appear to date from the sixth and seventh centuries A.D.

There are few architectural problems posed at Ajanta.

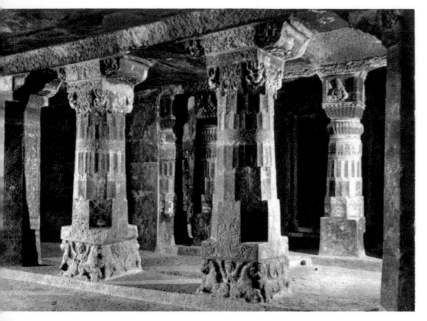

125. *Column before the central shrine,*
Cave 17, Ajanta. Gupta Period, c. A.D. *470-480*

126. *Apsaras, from Cave 16, Ajanta.*
Bracket figures. Gupta Period, c. A.D. *470-480*

Being carved from the living rock, the caves are really sculptures modeled on constructed *viharas* or *chaitya* halls. It is likely that at this relatively late stage, in Cave 19 of the sixth century for example (*fig. 123*), these are more free sculptural inventions than accurate models of constructed halls. By this time artisans were so used to working in the living rock, and had so many precedents, that they were able to indulge in reasonably free inventions. It is doubtful, for example, that the elaborate sculptured façade and interior of Cave 19 was duplicated in a constructed *chaitya* hall. This "architecture" is really sculpture and the Indian genius is primarily sculptural. In this case, the façade is elaborately developed, with a small porch flanked by monotonously repeated images of the Buddha and a few guardian kings. The character of the *chaitya* hall as a great opening into the hill is denied by the elaborate development of the porch, and so we are confronted with a cutting which does not as fully express the design of the interior as do earlier rock-cut *chaitya* halls.

The interior of Cave 26 shows the great elaboration characteristic of later *chaitya* halls (*fig. 124*). The columns are treated with bands of alternate, spiraling, carved devices; the capitals are highly developed, too, with friezes above, elaborately carved with repetitive images. The *stupa* itself is no longer simply the representation of a burial mound, but is placed on a high drum carved with images of the Buddha, the principal one being that of the Buddha seated Western style and turning the Wheel of the Law. The interior was heavily polychromed and must have had a rich, jeweled effect. The tendencies toward a detailed and more

pictorial treatment of the interior are not unexpected, for painting is the great art of Ajanta.

The *viharas,* or monks' quarters, which one would have expected to be simple, lonely, and devoid of ornament, are as elaborately developed as the *chaitya* halls themselves. Cave 17 has a low ceiling and an interior court surrounded by cells — that is, a communal living and cooking area, surrounded by sleeping quarters (*fig. 125*). The main axis culminates in a cell with an image of the Buddha for communal or individual worship. On the ceiling are paintings of Buddha images and decorative designs of lotus flowers and fantastic animals. The interior is encrusted with color on the carved columns and on every available flat surface. One significant detail creeps into the later Gupta style, to become especially characteristic of Indian Medieval art. (Medieval is used as a general term for the period of Indian art between the decline of the Guptas, about A.D. 600, and the foundation of the Great Mughal Empire in 1526; see page 175 ff.). Standing or flying figures of different sizes—dwarfs, Yakshas, Yakshis, and angels — are inserted in the corners of the capitals almost at random, as if the sculptor were at play (*fig. 126*). In these figures we sometimes find great movement and vigor — a freer spirit, less monotonous and dead than that in the rather repetitive main images. They are asymmetric in arrangement and, in some cases, are so located on the capitals that they almost deny the character of the architecture. This sculptural representation of movement or flight on the surface of the architecture indicates the direction in which Indian sculpture is moving at this time.

In addition to these architectural sculptures, a few of the finest of the exterior sculptures at Ajanta can be considered as things in themselves. Some are to be found at the sides of the porches leading to the *chaitya* halls or the *viharas*. In one particular case, the subject is not that of a Buddha or a Bodhisattva, nor of any deity belonging in the main Buddhist hierarchy. This sculptor seems to have found a challenge worthy of his skill in the subject of a Naga king and queen (*fig. 127*). The Naga king, a serpent deity with a hood of seven cobras behind him, is attended by his queen, with a single hood, and a figure holding a fly whisk symbolic of the royal nature of the Naga. This delightful composition depicts the king in the posture of "royal ease," with one knee up, seated next to his queen. The contrast between the elaborate jewelry of the headdress of the king, and the deep shadow caused by the Naga hood is aesthetically extremely effective. The composition, with its subtle placement of the attendant in the shadow of the pillar, is a representation of husband and wife, male and female, in the best tradition of great Indian scupture. The sculptor places the drapery of the king and the queen as falling over the block forms in a simple, incised pattern, with little ripples lightly cut into the surface to indicate folds of drapery. Further, he achieves the ultimate of sophistication by carving rocks in the living rock, producing an aesthetic double-entendre. This effect is influenced by painting,

111

127. *Nagaraja and His Queen, from an exterior niche, Cave 19, Ajanta. Gupta Period, c.* A.D. *500-550*

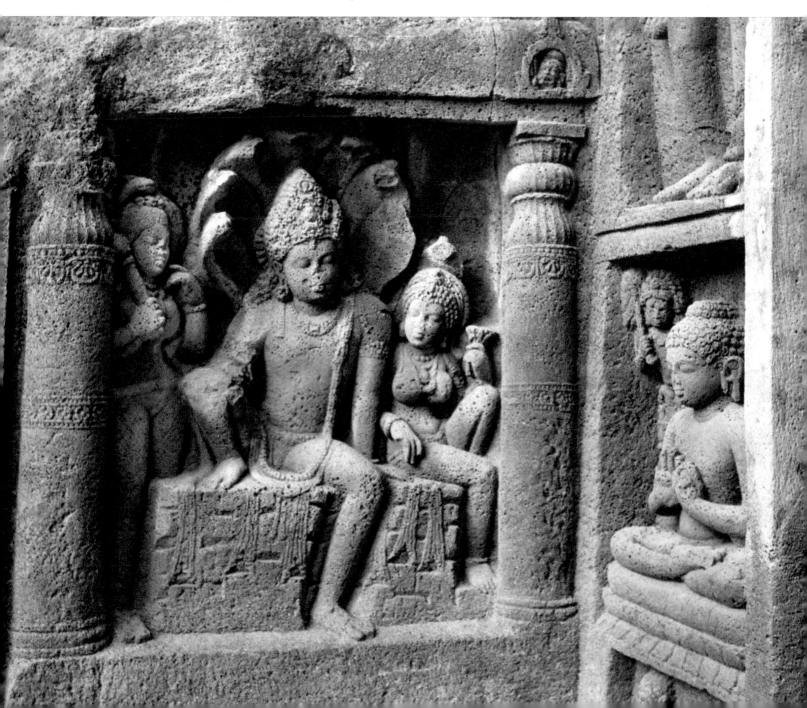

128. *Saddanta Jataka: The Queen Fainting at the Sight of the Tusks. Drawing of Andhra Period fresco, from Cave 10, Ajanta. 1st Century* B.C

129. *Sculptured figure of Hariti and a portion of the fresco, from Cave 2, Ajanta. Gupta Period, c.* A.D. 500-550

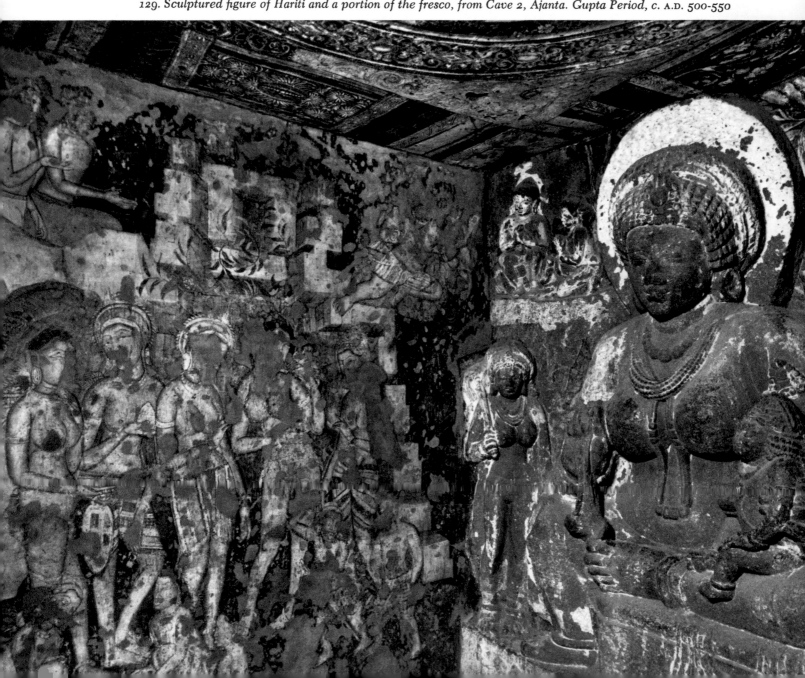

for there are characteristic ways of indicating rock forms in the paintings of Ajanta repeated here: a rather geometric series of interlocked steps.

The unique art of Ajanta is painting; and it is only because of the relative isolation of the site that it is preserved at all. The paintings, executed from the third to the seventh century, lasted until the nineteenth century in relatively good condition; and when they were discovered they were justly heralded as one of the great discoveries of all time. But more open exposure to weather and especially to the treatment of early twentieth-century restorers has hurt them, and they are probably not in as good condition today as when discovered. The early *chaitya* hall No. 10 boasts remnants of painting from the first century B.C. — an Andhra fresco, of the same period as Sanchi, representing a Jataka tale, and revealing a surprisingly advanced stage of pictorial development (*fig. 128*). The illustration is but a drawing from the fresco; the now shadowy

painting is an amazing production. The figures are not just drawn in outline, but are modeled in light and shade, in a way similar to the Roman and Pompeian frescoes. The general color scheme of the figures is brown; but the modeling of the heads and the emotions expressed in the faces indicate a control of advanced means of painting, of convincing methods of representing psychological states, not to be found in the sculptures, which may well have been produced by a lower hierarchy of artists. The painters seem to have been far ahead of their compatriots in other fields. The composition of the numerous figures is a much more convincing representation of related figures in space than that we find in the Jataka tales carved in stone at Sanchi. It is not only a matter of quality but of development and complexity and of the artists' ability to solve problems of space and individual representation.

In addition to the fragments of the early Andhra Period, there are many frescoes whose precise dates

113

130. *"The Black Princess,"*
from Cave 1, Ajanta.
Fresco. c. A.D. *600-650*

are much argued, but whose sequence is generally agreed upon. The murals of Cave 2, with Buddhist devotees coming to a shrine door (*fig. 129*), are of a radically different type from those in Caves 1 and 17. The Cave 2 group must be dated as middle Gupta — that is, about the fourth and fifth centuries A.D. The figures are placed in a definitely indicated space, bound on the front by a ground line with small dwarfs (*ganas*) moving in a procession, and behind by curious geometric rock forms. On this shallow stage, space is indicated by movement from below to above, and at the same time by overlapping. The placement of the figures in space is simple, recalling the plain backgrounds of the Gupta sculptures. We are not confronted with great complexity, but with a relatively simple placement of figures in limited space with no great turmoil, activity, or movement except in the case of the *ganas* in the lower right-hand corner. The modeling of the individual figures is accomplished by light

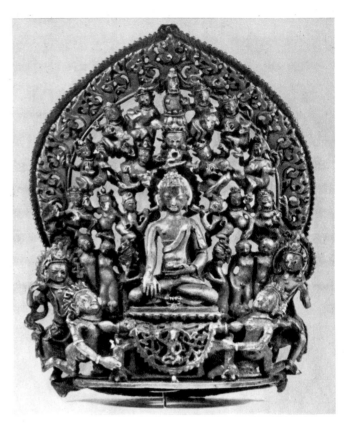

132. *Temptation of the Buddha. Bronze, height 5½". Nepalese, 15th–16th Century* A.D. Cleveland Museum of Art

and shade, and quite differently from the system employed in slightly later frescoes. The modeling is at the very edges of the contour; the arms, legs, and bodies are treated as tubes, the breasts as mounds. But the indication of modeling is forced to the edges, leaving large areas of flat light color. The closest visual analogy is that of a photographic negative which has forced contrasts of light and dark. The result is a curious but rather solid and simple effect. The figures with these large light areas and the sharp modeling at the edges are clearly differentiated, one from the other, in contrast to later styles.

The developed late Gupta style of the sixth century is most characteristically seen in the porch of Cave 17, an entrance to a *vihara* (*colorplate 7, p. 87*). Above the door and to the left is a scene, set in a forest or park-like exterior, of a prince and a princess in a palace. The general color scheme of this painting, in contrast to the rather quiet reds and soft blues of the paintings in Cave 4, is almost hot: oranges, rather sharp blues, yellows, and greens with a warm orange tinge. The representation of the figures is quite different from the middle Gupta style. There is little modeling and, in the case of the female figure and one or two others, there is greater emphasis on linear detail. But above all, the

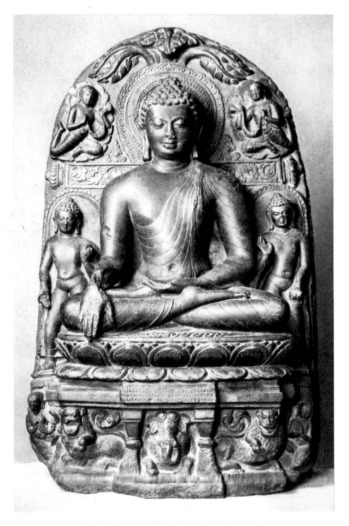

131. *Buddha in the Earth-Touching Pose. Black chlorite, height 37". Bengalese, Pala Period, 9th Century* B.C. Cleveland Museum of Art

composition is more intricate with greater overlapping and compression of figures than in the rather noble and stately style of the earlier murals. This complexity is supported by the profusion of the jungle background. Indications of space are also more accomplished with a stagelike palace setting rendered in a free perspective not based upon a rigid geometric scheme. We say "free" since there are many inconsistencies in the treatment of the perspective. It is used practically rather than logically. At the same time, early figure conventions going back as far as Sanchi, such as the large heads looming at the windows, are carried on. The procession with parasols, moving out to the left, reveals a greater use of overlapping than before. These figures are crowded, but there is little indication of depth by the archaic means of movement from bottom to top. The whole emotional and psychological effect is one of sensuous movement, breathing something of that warmth found in the Indian air, reinforced by the supple grace of the bodies. Judging from the remnants of Roman painting and the evidence they give for Greek painting, the paintings of Ajanta represent a greater achievement of narrative art, if perhaps not so rational in perspective or developed in representing deep space.

One detail of a charming princess in Cave 1 epitomizes the last painting style of Ajanta — that of the

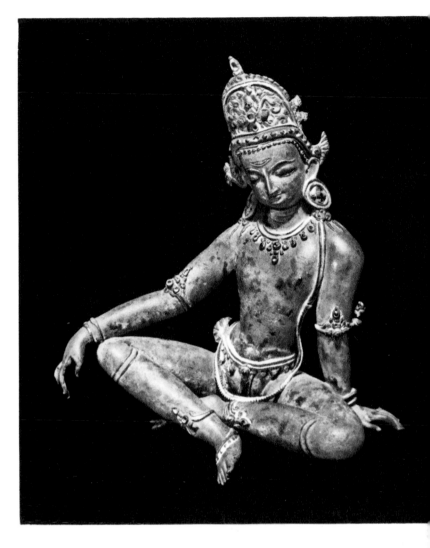

RIGHT: *133. Indra. Bronze, height 10". Nepalese, 13th-14th Century* A.D. Seattle Art Museum

BELOW: *134. "Moon Stone," from Anuradhapura, Ceylon. Doorstep, granulite. 5th Century* A.D.

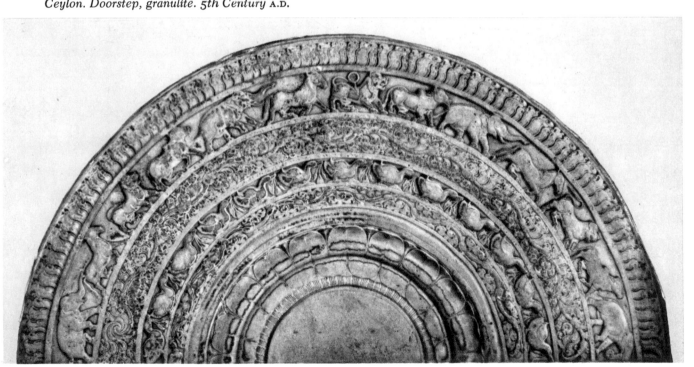

115

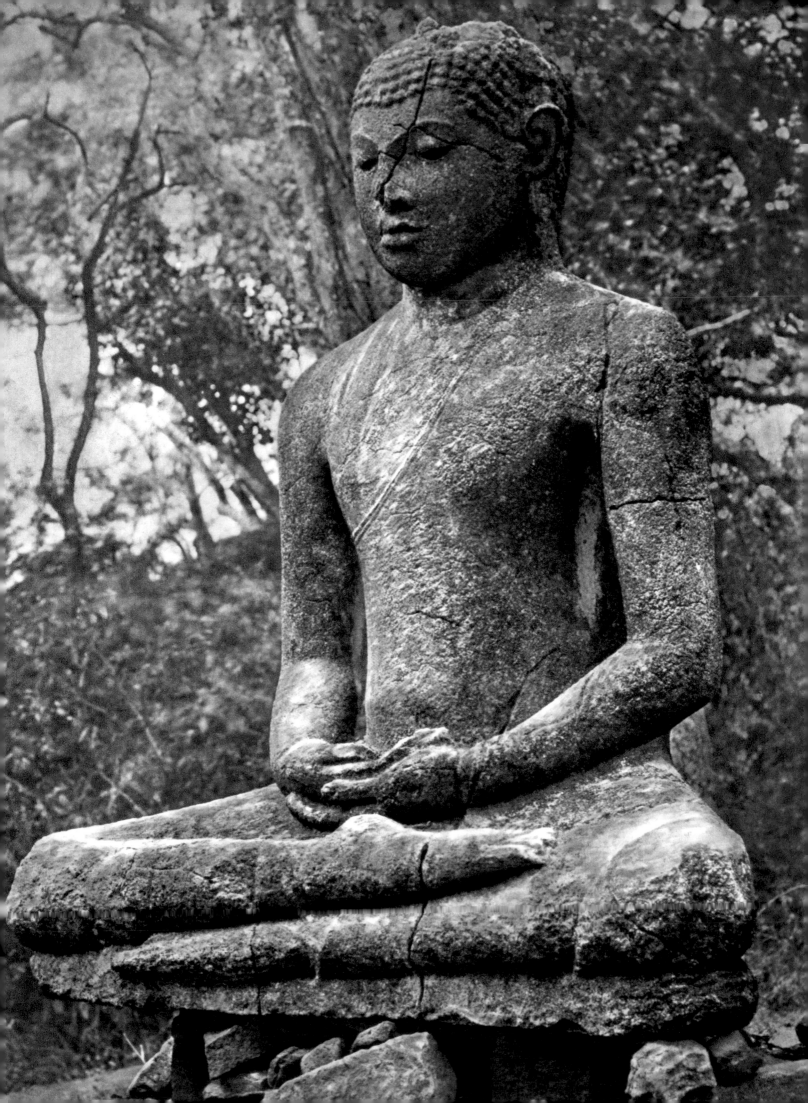

early Medieval Period in the seventh century (*fig. 130*). It is from the Jataka and gives some idea of the emotional and visual impact of the original. One can see from the detail the difference in the modeling of this figure from that of the rather firm and noble middle Gupta figures of Cave 2. There are no large areas of light color; there is a gentle modulation from dark to medium dark except for the narrow highlights. The richness of the figure does not depend upon the modeling of the interior surfaces of the figure proper, but upon the adornment of those surfaces with ropes of pearls, headdress, and other jewelry. The loving exaggeration of the lower lip harks back to pure Gupta style. The heavily arching eyebrows and the reverse curve of the eyes are formulas dear to the Gupta sculptor and painter. The warmth of the color is largely a falsification resulting from the varnish used by restorers of the late nineteenth and early twentieth centuries. We can see something of the method of painting in this detail. The roughened stone was covered with a mixture of chaff and hair bound with plaster to produce a surface on which the underdrawing and then the final painting could be executed on the still slightly damp plaster.

The most famous figure at Ajanta is in Cave 1 and has been often described as the "Beautiful Bodhisattva" (*colorplate 8, p. 88*). It represents Padmapani holding a blue lotus, and is located at one side of a cell entrance. The figure is much destroyed from the waist down; but the noble torso, and especially the head, with its beautiful countenance and downcast eyes, express that compassion and humility which is the great achievement of Buddhist art. Let it be added, though, that not all the figures at Ajanta are noble types. We find in some details figures which are grotesque and ugly, as well as figures drawn from everyday life, merchants and others, representing the Gupta world as observed by its painters. A brief treatment of the Ajanta caves gives no idea of the complexity and richness of the subject matter, or of the variety of aesthetic techniques to be found at this great site.

With Ajanta, we have perhaps the last great monument of the principal Buddhist style of India. While Buddhism was still to be found in certain pockets, it was maintained in strength only in Northeast India, particularly the region of Bengal. The two important dynasties of the region are the Pala and Sena, lasting from c. A.D. 730 to c. 1197, by which time the Mohammedan invasion had smashed the Sena rulers. The great achievement of the art of Bengal was to preserve the

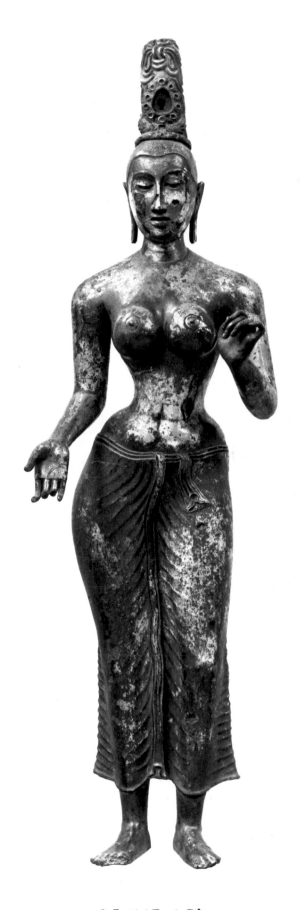

117

136. Pattini Devi. Gilt-copper,
height 57". Eastern Ceylon, 7th-10th Century A.D.
British Museum, London

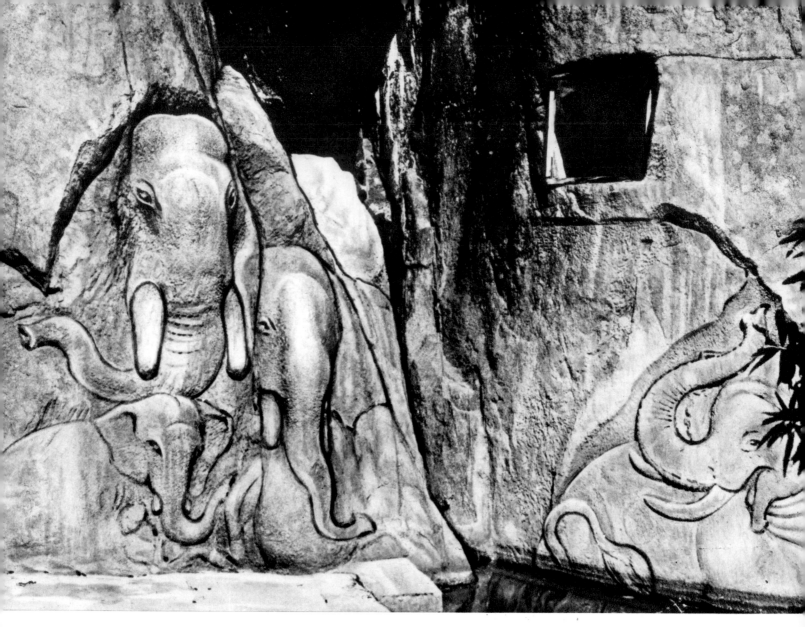

137. Elephants Among Lotuses, from Insurumuniya Vihara, near Anuradhapura. Granulite. Probably 7th Century A.D.

Gupta formula with considerable quality over a long period of time, and to transmit it to Nepal, Tibet, Burma, Siam, and Indonesia. This is not to say that the artists of Bengal did not achieve great masterpieces in their own right. One of the greatest achievements of the Pala artist, a representation of the Buddha in the Earth-Touching pose, made of the characteristic black chlorite stone of the region, shows the style at its best (*fig. 131*). Even in this very noble and massive black stone, the treatment of details of the halo, of the throne, and of the small figures below, is so metallic that it would be very difficult indeed to say from the photograph whether the image was made of metal or stone.

The tendency in Pala sculpture, and exaggerated in the Sena Period, was toward a detailed metallic style in using this hard, very fine-grained black stone. And so we are not surprised to find numbers of small bronzes and images of gilt-bronze, silver, and gold from the region. These were exported in some quantity. Indeed, they are found today throughout Farther India and

Indonesia, and were the models used when the native sculptors, especially the Javanese, first began the task of representing the Buddha image (*fig. 132*). The metal images are usually found in two ways: from excavations, or by chance export from monasteries in Tibet or Nepal. In the latter circumstance they are in excellent condition and look remarkably new; but the earth is not kind to the particular alloy used by the Bengal artist, with the result that the excavated pieces are severely encrusted. These metal sculptures depend on the Gupta style for their character and conformation. This is not to deny variations and elaborations.

We can see this more clearly by an illustration indicating a standard type which preserves and develops this style in Nepal. The seated image of Indra, dating perhaps from as late as the thirteenth century, still is grounded in Gupta habits (*fig. 133*). At the same time there are certain new traits, particularly the small mouth characteristic of the later Nepalese and Tibetan art and probably derived from China. The use of semi-

118

precious stones in numerous details of jewelry, while undoubtedly derived from earlier Indian practice now lost, adds a support to this small-scale, jewellike art. Nepal was thoroughly Mahayana and, later, Tantric in its Buddhist faith. Tantric Buddhist systems emphasized complex preparation for initiation: Yoga practices under strict discipline of the *guru*, or teacher, and the equal importance of the female principle as the *shakti*, or energy, of the male deity. Images with several arms and heads are commonly found. In these the delicate casting and accomplished gilding technique fortify the often miniature size and hyperrefined detail. When one thinks, for example, of the flowering organic forms of modern sculptors such as Lipchitz or Roszak and then observes the Nepalese images with their fluid grace and metallic expansion into space by means of projections and apertures, one senses a true aesthetic achievement.

In painting, the artists of Bengal preserved in manuscript illuminations something of the Gupta and the early Medieval style of Ajanta. We have no large-scale painting left from the Pala or Sena dynasties. But we do have some rare manuscripts painted on long strips of palm leaf, usually with much text and a few illustrations. These were the means by which the Gupta painting style, with its concepts of figure and space representation, was transmitted to Nepal and Tibet. A detail of one of the rare manuscripts from Bengal shows some modeling around the edges of the body, the use of landscape setting, and a simple indication of space by placing an object above to indicate that it is behind (*colorplate 9, p. 121, above*). In one of the other details

from this manuscript are the same curious geometric rock forms which we saw at Ajanta. In this particular case, the representation is that of a Buddhist ascetic, raising his hand in blessing of an antelope that is standing before a palm tree. The rich color effect is unlike the rather soft, subdued color of Ajanta, and is in part due to the miniature format.

A second manuscript of Nepalese origin, based on the style of Bengal manuscripts exported to Nepal, has been dated 1111, some fifty to one hundred years later than the other (*colorplate 9, p. 121, below*). We witness a greater sophistication in the Nepalese manuscript, particularly in the handling of line. The modeling, in either color or shade, is almost flat. Indications of contour or of movement are given by exterior lines. In this manuscript, we have representations of deities only, existing in the timeless setting of their own halos. There are no scenes representing landscapes, interiors, or any setting in space. It is a more iconic, hieratic art, fully dominated by the iconography of Mahayana Buddhism but, like the bronzes, full of grace and linear sinuosity in the figures.

Ceylon is at an extreme geographic remove from Nepal; and the Buddhist art of Ceylon is a contrast to that of Bengal, Nepal, and Tibet. For its Buddhism is Hinayana, with its emphasis on a relatively simple and evangelical form of Buddhism, and recognizing only the Buddha Shakyamuni — that is, the "historic" Buddha. Thus, Hinayana does not have the complicated iconography, the delight in numbers, and complexity characteristic of the Mahayana school. The style of

119

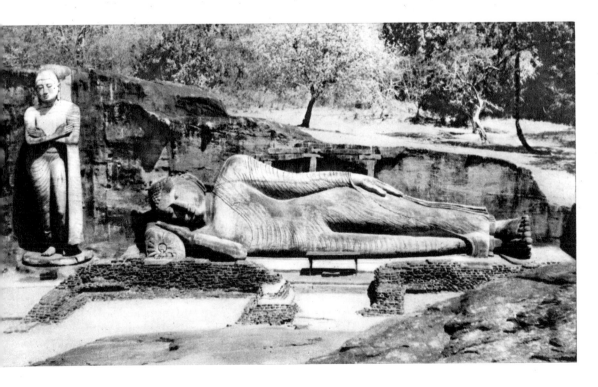

138. Ananda Attending the Parinirvana of the Buddha, from Gal Vihara, near Polonnaruva. Granulite, height nearly 23'. 12th Century A.D.

Ceylon was historically important, since it was exported by sea to such regions as Burma and Siam, which are dominated today by the Hinayana Buddhist sects, while Cambodia, Java, China, and Japan were dominated by Mahayana doctrines.

The early Buddhist art of Ceylon is much influenced by the Southern School of Amaravati; and so in the famous Moonstones — stepping slabs leading to platforms at Anuradhapura — we find the same style as that in the casing slabs from Amaravati (fig. 134). They are in the form of half-wheels with concentric bands of representations of the Sacred Goose (hamsa), lions, horses, elephants, and bulls on the exterior rim, which is treated like a Lotus Wheel of the Law. Under the rather austere doctrines of Hinayana Buddhism, early

*139. Shakyamuni Buddha. Limestone,
height 44". Siamese, Mon-Gupta Style, Dvaravati Period,
6th-7th Century A.D. Seattle Art Museum*

OPPOSITE:
*Colorplate 9. (above) Two scenes from an illuminated
palm-leaf manuscript of the Gandavyuha. Height 1⅝".
Bengalese, 11th–12th Century A.D.; (below) Cover and
one leaf from an illuminated palm-leaf manuscript of the
Astasahasrika Prajnaparamita. Height 2⅜". Nepalese,
A.D. 1111. Both: Cleveland Museum of Art*

Sinhalese artists produced one image in particular which takes its place as one of the greatest known representations of the Buddha (fig. 135). Dating from perhaps the sixth century A.D., the image owes to Gupta formulas its simplicity, pose, and treatment of the curled hair. But the austerity or rationality of the image and the corresponding lack of the sensuous qualities to be found in any Gupta sculpture indicate its Sinhalese origin, and give it that particular quality which places it far above the level of average production. The head has none of the sometimes rather shallow prettiness to be found in some Gupta sculpture, but has a facial breadth achieved by the expansion of the cheekbones and of the powerful jaw. The enlargement of the size of the ears adds to the scale of the head and allows it to crown in proper proportion the large and imposing body. Some of the mystery of this figure is derived from the fact that it is quite badly weatherbeaten. To like this great image for such a reason is to succumb to the "driftwood" school of sculpture and to confirm the taste of those who prefer their bronzes encrusted, their sculptures well worn, and their paintings well rubbed.

Remains of Gupta style painting are found in Ceylon on the great rock of Sigiriya which was used as a fortress retreat from A.D. 511 to 529 by the parricide King Kassapa. A long cleft in the side of the cliff contains a fresco procession of heavenly nymphs (apsaras), the lower parts of their opulent bodies obscured by conventionalized clouds (colorplate 10, p. 122). Their general style is similar to that of the fifth-century fresco in Cave 2 at Ajanta; but their distinctive orange and pale-green color scheme and the somewhat exaggerated sensuality of the representation is unusual — perhaps somewhat provincial. However, these graceful and easily moving ladies may well be characteristic of secular painting in the Gupta Period. The lack of a landscape or architectural setting emphasizes the erotic appeal of the apsaras. One could expect royally commissioned palace decorations to be motivated by a sensuous materialism in contrast to the combination of sacred and profane found in purely religious painting.

The same sensuous appeal is found in the somewhat later Pattini Devi in the British Museum (fig. 136). It is a bronze image of more than ordinary size and clearly based upon some elements of Gupta style. At the same time it has an absolutely individual and unique character of its own. Observe the tense roundness of the breasts and of the face, the sensuous and flowing qual-

याग्रधर्ममत्रयापम्पाठुममनया
ममाऽिनघावािमज्ञानामग्रुका
मधाग्रगुणानवलनिर्देप:।
यमनिर्मालनवेधाममक्वयम्ब
र्देश:।यइममवङ्ग्रयन्माठु

मन्त्रपाठुममनयामवधाभाकपाठुम
पयनिश्म॥दशनिर्नेर्दपयर्दे:
यद्नममवबहुक्कजनधागनममये
नविद्वक्रुणमपाठुयर्पनिर्देप
वर:।मवग्रविद्रयनयानालावह्र

मन्त्र
कन्
ग्रन
य
वि

ननवर्पेलमर्देमत्र
मवग्रलावािमज्ञा॥
लिपानिःनवठु।या
विद्रानावािमज्ञानाः
प्रल्या ब्रदीयद्नः

द::वाधिन्रुवयममणायवाि
नावगयद्ननरुलानवगमाय॥
निहःसर्वेमवग्रलवान्मानम्
मवबहुपमसुब्रलनयामद्
नामवमवक्रुणालार्कलनया

मवानांमद्रत्
मवब्रद्रममव
ग्रनपयानानि
मरकचानादृष्ट
भआयमानाश्

बृहलनिर्देव्रे

न
ह्र
ह्री
इ
व

यद्वनानिविर्ववद्रिसत्रहग्रनवधाग
मरमहायानामञ्ज्ञानधिबर्वर्द
यानेमग्रनामयमयायामसही
यननयरमसुनवग्रवागनर्द
उधाग्रन्नमायस्क्रयाभिनर्म
मायवार्मक्वयदनानिविर्ववद्रि

नद्मायस्क्रयाभिगामामर
गनिनागयिसत्रमग्रमधागनर्श
यानिविर्ववविगनियधाग्रग्र
स्क्रयाग्रमिनामागमयायमया
गमायमयालामममहायानार
द्रवनवधागनवमायस्क्रयाभि

याग्रयम
मद्वाक्व
ज्ञनानि
नाममर
मज्ञानाः
नामग्र

Colorplate 10. Apsaras, from Sigiriya, Ceylon. Fresco. c. A.D. *479-497*

rather with undulations which move along the thighs. With a masterpiece such as this, the art of Ceylon can take its place near the top of any Oriental hierarchy.

South India continued to dominate the arts of Ceylon and from time to time extended its influence to political control. Some seventh-century sculptures near Anuradhapura are almost indistinguishable from the Hindu sculptures of the Pallava Period at Mahamallapuram (*fig. 137*); and Hindu metal sculptures of pure South Indian type have been found in quantity in Northern Ceylon.

But the last significant productions of the island are the large stone *stupas*, temples, and sculptures at Polonnaruva dating from the twelfth century. These Hinayana Buddhist images are noteworthy for their scale. The colossal scene at the Gal Vihara of the disciple Ananda mourning at the Parinirvana of the Buddha is cut into the living rock and is based on a combination of earlier Sinhalese and Gupta sculptural formulas but

140. Standing Buddha. Bronze, height 8¼". Siamese, Mon-Gupta Style, Dvaravati Period, 7th Century A.D. Cleveland Museum of Art

141. Bodhisattva Torso, from Jaiya, Siam. Bronze, height 24¹³⁄₁₆". Shrivijaya Style, 8th-9th Century A.D. National Museum, Bangkok

ity of the fingers and the hands, and at the same time the emphasis upon the underlying structure of the hips and their relationship to the waist. The Pattini Devi is quite unique in this depiction of underlying structure; it seems to be the product of an artist or studio working in an individual and free manner, neither anticipated nor repeated. The tall, very narrow headdress is an integral part of the total effect. Crowning the full and voluptuous body with this thin, tall tower gives an added height and elegance. The drapery is not handled either as a linear pattern or as a mass, but seems to be in character with the modeling of the body, being just slightly modeled with no sharp ridges or lines, but

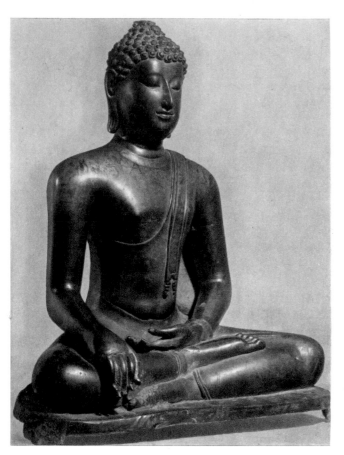

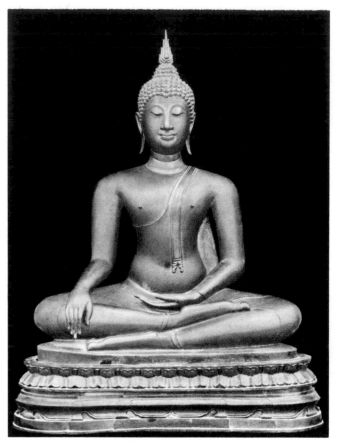

142. Seated Buddha.
Bronze, height about 30". Siamese,
Sinhalese type, 14th-15th Century A.D.
Museum of Fine Arts, Boston

143. Buddha Calling the Earth to
Witness. Bronze, height 37⅜". Siamese,
Sukhodaya High Style, 14th Century A.D. Collection
of H.R.H. Prince Chalermbol Yugala, Bangkok

shows little interest in the sensuous grace of the latter style (fig. 138). All the shapes and details seem purified and, it must be added, mechanized to a point where their appeal is primarily intellectual. We are fascinated in following the patient logic of the sculptor despite its exclusion of the warm, living qualities of the medieval mainland styles. Such images are of great importance in the development of Siamese art, for the Hinayana faith was common to both Siam and Ceylon, and the latter played elder brother to the major Hinayana country of Farther India.

The two major influences on the Buddhist art of Farther India and Indonesia were the products of Ceylon and Bengal. Since Ceylon continued to be primarily Hinayana in its faith, its influence was largely confined to those farther countries of the same belief, notably Burma and Siam. This is not to deny the place of Bengal, a prime pilgrimage center, in any story of Burmese and Siamese art; proximity alone made Northeast India important for this. In Malaya and Java, however, the dominant influence on figural art before the rise of a

national style was that of Bengal. However, with few exceptions the earliest sculptural influence in all of these regions was the Gupta image, whether of terracotta, stone, or metal. The style of each region began with this type of image, and the gradual achievement of distinctive regional styles was largely the work of the local culture, leavened by subsequent exposure to the formulas of Bengal or Ceylon.

The first significant art of Siam was sculpture, and it remained the favorite form of religious expression. The early peoples of southern Siam were dominantly Mon, from Burma, and some Thai elements from Southwest China (Yunnan) and perhaps Tibet. Their Dvaravati Kingdom lasted from at least the sixth to the tenth century, when the rising power of Mahayana and Hindu Cambodia reduced Siam to virtually a cultural province with its center at Lopburi, producing works little different from those of the dominant Khmers. The Mon-Dvaravati style of c. 600-800, whether on a large scale in stone (fig. 139), or in smaller bronzes (fig. 140), is a consistent rendering of the Gupta manner of Sarnath with its smooth, clinging drapery without folds,

and its subtle, flowing transitions from one shape to another. But much of the sensuousness and plasticity of the Indian technique is lost or ignored in favor of a greater emphasis on more austere profiles anticipating the great simplicity and stylization of the classic Siamese style of the fourteenth century. Another deviation from the Gupta way lies in the greater attention to linear detail, particularly about the features of the face. Double outlines around the eyes and mouth hint at coming decorative qualities based on severe stylization. The emphasis on simplicity is in keeping with the growing importance of Hinayana Buddhist culture in Siam at this time.

One unusual find from Jaiya now in the National Museum of Bangkok is a notable exception to the prevailing simplicity of Mon art (fig. 141). This bronze torso of a Bodhisattva is clearly the product of a different tradition and attests to the wide influence of the great Shrivijaya Empire of Java, Sumatra, and Malaya. Here the complex jewelry, the metallic impression, the momentary and melting expression of the attractive face, and the exaggerated hip-shot pose derive from the earliest Pala traditions of Bengal. But this was not to be the line of development for Siam after the decline, beginning about 1220, of Cambodian control.

A new native kingdom expanded from the north and the Thai peoples established a capital at Sukhodaya in Central Siam. The nearby kilns of Sawankalok produced quantities of stoneware and by the fourteenth century the production of Buddhist images, principally of metal, figuratively matched the ceramic output. The enthusiasm and vitality of the Hinayana rulers and monks seemed inexhaustible. Except for the images of the *U-Thong* type made in Southern Siam after the expulsion of the Khmers, it was as if the Cambodian phase had never been. The elaboration and masculinity of Khmer art was gone and in its place came the typical and highest expression of Thai sculpture imagery — the bronzes of the early Sukhodaya school. While painting certainly plays its part — witness the evidences from the engraved stones of the Wat Si Jum at Sukhodaya — the images of stucco and of metal are more dominant.

Various traditions went into the making of these "high-classic" images — A. B. Griswold's term. The old Mon-Gupta style was surely not forgotten and was probably preserved in a few particularly holy metal or stone images. The simpler Pala Buddha images, especially those in Meditating or Earth-Touching poses like the Cleveland stele, were known to the monks and travelers through major examples and through the smaller terracotta ex-votos carried home from Nalanda as souvenirs. Ceylon was an especially important source, and tradition as well as history attests to the close connections between the two countries. After all, Ceylon was the fount of Hinayana Buddhism, and one particularly holy Thai image type is called "The Sinhalese Buddha."

144. Walking Buddha. Bronze, height 88".
Siamese, Sukhodaya Style, 14th Century A.D.
Monastery of the Fifth King, Bangkok

125

This particular form is probably what the fine image at Boston represents, with its distinctive nose, full cheeks, and limited linear emphasis about the eyes and mouth (fig. 142). Another important source was the Hinayana scripture with its metaphorical descriptions of the various aspects of the Buddha figure — the golden skin, parrot-beak nose, petallike fingers — and the signs of his godhood — flame, lotus, wheel, and curls

145. *Crowned Buddha Torso.*
Bronze, height about 22". Siamese, Ayudhya type,
16th-17th Century A.D. Collection Walter Siple

tion — the Walking Buddha (fig. *144*). Conceived as a representation of Buddha Shakyamuni (*see page 120*), as Missionary, the image appears particularly unnatural at first glance; but here especially one must remember such literary metaphors as "arms like the hanging trunk of an elephant." The superhuman ease of the gliding pace is matched by the exquisitely estimated reflex curves of the fingers and the particularly careful calculations in the undulating edge of the drapery falling from the left arm. "All passion spent" is succeeded by the sculptor's poised, ecstatic vision.

Because of the great strength of Hinayana Buddhism among the Thais during and after the fourteenth century, the tendency to repeat particularly successful sacred images was impossible to resist. A continuous stream of such images poured from the sculptors' foundries in Northern, Central, and Southern Siam. Minor variations are found and quickly exhausted. In the North a Chieng Sen "Lion type" is chiefly distinguished by a lotus bud *ushnisha* on the skull rather than the

146. *Padmapani, from Bidhor, Malaya. Bronze.*
6th-7th Century A.D. Perak Museum, Malaya

"like the stings of scorpions." Priority for the emergence of the typical Siamese Buddha image is variously given to Sukhodaya or to Chieng Sen in the North. The images of the latter type are remarkably close to some Pala sculptures. If they are earlier than the products of Sukhodaya they are nevertheless less unified, less creative manifestations of still unabsorbed influences; if later, they are somewhat provincial manifestations of a Pala revival based on reverence for the images at the great Temple of Bodhgaya, scene of the Buddha's meditation.

The fusion of the various source elements in the Sukhodaya style is complete (fig. *143*). No clear trace of origin remains in this new and original image type. The influences disappear as if exorcised by fire and the resulting diamond-sharp configuration recalls the abstraction of geometry. The dangers inherent in such a thorough stylization of linear elements and complete simplification of forms are many — coldness, rigidity, and emptiness are a few and these are soon to appear — but at the moment of perfect balance in the fourteenth century the result seems a perfect expression of Hinayana simplicity and asceticism.

The seated images are the most numerous; but one particular Sukhodaya creation deserves special men-

ABOVE RIGHT: *147. Borobudur, Java, aerial view. Late 8th Century* A.D.

CENTER RIGHT: *148. Borobudur*

BELOW RIGHT: *149. View of the corridors, from the first gallery of the West Façade, Borobudur*

flame of Sukhodaya and by the lotus pose being accomplished with the soles of both feet placed uppermost rather than — tailor-fashion — one leg above the other. If this is a giant among minor variations, the resulting aesthetic monotony of the immense production is assured.

One later southern variation bears the name of Ayudhya, the Thai capital from about 1378 until 1767 (*fig. 145*). In these images of the sixteenth century and later, ornament, whether of crowns or heavily jeweled garments, is the attempted means of rejuvenating the exhausted formula. In a few restrained cases a very decorative and elegant effect is achieved, but the inner life of the lines of brows, nose, and mouth is largely gone, and a growing superficial prettiness remains. Small wonder that some modern interior decorators find fragments of these images attractive as a means of achieving an acceptable "Oriental flavor." A glance back to the Mon-Dvaravati images and particularly to those of Sukhodaya clearly reveals the unique contribution of the Thai to the international world of Buddhist art.

The principal means by which Mahayana Buddhist imagery was transmitted to Indonesia was the Gupta and post-Gupta art of Bengal. We must imagine the monks and traders of India and Indonesia traveling to and from their homelands. Since they were devout Buddhists, in addition to being sharp businessmen, we know from inscriptions that they commissioned works of art in the great centers, particularly in Bengal. In some cases the Indonesians even built temples in Bengal as an act of homage or memorial. So there was great interchange in terms of trade and economic activity and the movement of people and of images. Historically, the introduction of Buddhism to Indonesia is associated with the Srivijaya Empire, whose capital was not on Java but on Sumatra. Some of the greatest of the early Indonesian metal images have been found on Sumatra and in Malaya. Despite the unusual find in Celebes of a bronze Buddha image in Amaravati style of the third or fourth century, the pure Early Srivijaya style is based almost completely on the Gupta style as transmitted through the early bronzes of Nalanda. In an image such as this Padmapani (Lotus-bearer) we might well use the descriptive terms applicable to Gupta style (*fig. 146*). The fluidity of the figure is quite extraordinary and reveals the influence of clay tech-

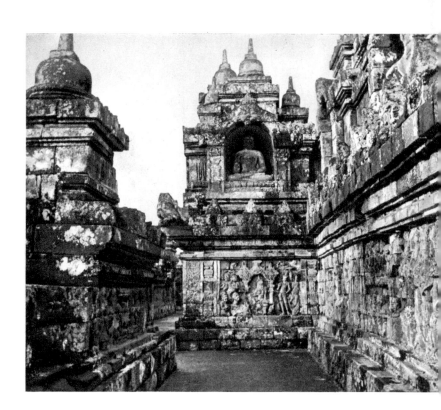

*150. Hiru Lands in Hiruka. Bas-relief No. 86, from the first gallery of Borobudur.
Lava stone, width 108". Late 8th Century A.D.*

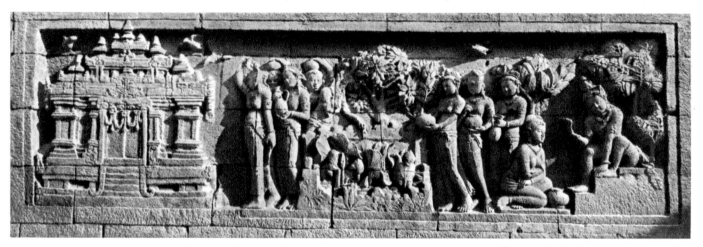

*151. Prince Sudhana and His Ladies Drawing Water from the Lotus Pond near the Palace.
Bas-relief No. 16, from the first gallery of Borobudur. Lava stone, width 108".*

nique. From such beginnings the Javanese developed a great style of their own, and created one of the most significant monuments of Buddhist art.

The greatest example of Buddhist art in Southeast Asia and Indonesia is certainly the Great Stupa of Borobudur, situated on the central Dieng Plateau of Java (*fig. 147*). The monument, carefully preserved and restored by Dutch archaeologists, is a fantastic microcosm, reproducing the universe as it was known and imagined in Mahayana Buddhist theology. The monument dates from about A.D. 800, and apparently was built in a relatively short period of time — a colossal achievement. It is approximately 136 yards long on each side and some 105 feet high. There are in all more than ten miles of relief sculpture. For many years arguments raged as to the precise nature and meaning of the monument; but Paul Mus' book resolved all doubts. Borobudur is a *stupa*; the profile is that of a hemisphere crowned by a smaller *stupa* (*fig. 148*). The monument is oriented to the Four Directions, and is arranged ver-

tically in accordance with the Mahayana cosmogony. Beneath the level of the earth are reliefs representing the doctrine of Karma, the cycle of birth and rebirth, of striving and nonrelease on the Wheel of Life. The lower exposed levels of the monument have reliefs with the previous lives of the Buddha, beginning on the lowest level with the Jatakas, moving into the Life of the Buddha on the next higher level, and then reaching higher into the Mahayana hierarchies of Heaven. One proceeds from low to high, from the base to the pure. When one reaches the top of the rectangular part of the monument, one leaves lower regions which, however divine, are less so than the perfect figure of the circle, which forms the three repeated terraces of the upper levels crowned by a *stupa*. In each of the lower niches facing the Four Directions is a Buddha image appropriate to that direction, while each of the miniature *stupas* on the terraces contains a Buddha image in the preaching *mudra*. The central closed *stupa* also contained a Buddha image, which B. Rowland

equates with the God-King himself. This expresses a phenomenon which we will discuss when we come to Hindu art in Cambodia: the cult of the Devaraja, the God-King, in this case the Buddha on Earth. Borobudur is, then, a magic monument, an attempt to reconstruct the universe on a small scale. The interior is rubble faced with the carved volcanic lava stones. The pilgrim enters the magical structure and performs the rite of circumambulation, which figuratively recreates his previous lives and foreshadows his future lives. While pursuing his pilgrimage, he sees the reliefs of the previous lives of the Buddha, the Life of the Buddha, and those depicting the various Heavens.

The corridors that surround the monument are open to the sky; there are no interior corridors (fig. 149). The reproductions give some idea of the wealth of sculptural representations on both sides of the corridors. These reliefs are obviously influenced by Gupta style in their concept of figural representation. On the other hand, the narrative content is much richer than anything to be seen in the Gupta reliefs of India; and it is

this aspect which seems particularly attuned to the native spirit. The development of later Javanese art is in the direction of a narrative style, even of a dramatic-caricature style, and will be considered when we come to the Hindu art of Java. Here, then, is a pictorial representation, in a framed picture-relief with numerous figures and with a firm concept of spatial setting (figs. 150 and 151). This may be limited, shallow, and sometimes with odd juxtapositions, such as the figures on land with the ship shown as if it were on the same plane; but in general, the landscape settings and the overlapping of figures display a remarkably advanced complexity. The reliefs are also a great treasure house of information on the mores of the day. We find, for example, representations of early Indonesian houses like the primitive Dyak houses still to be seen today.

The serene reaches of the upper terraces with their many perforated *stupas* take us to the highest and most abstract levels of the Buddhist hierarchy. The seventy-two images contained within the *stupas* echo this clean and severe atmosphere (fig. 152). Derived from such

129

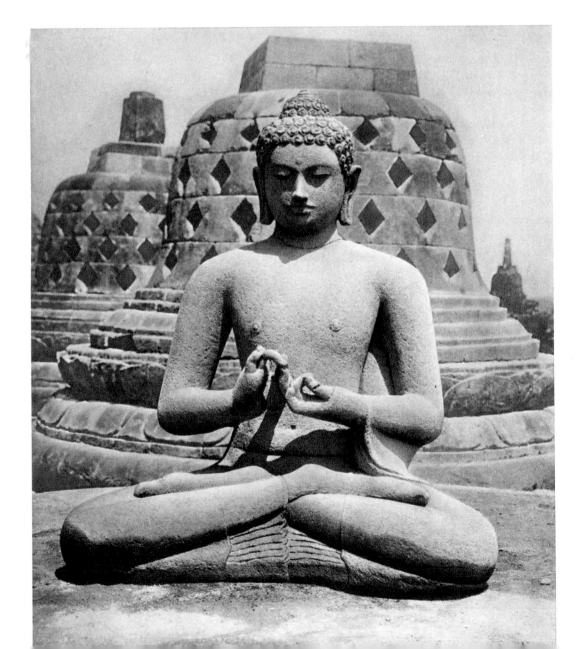

152. Dhyani Buddha, from Borobudur. Lava stone. Late 8th Century A.D.

Gupta prototypes as the famous Preaching Buddha of Sarnath, these Buddhas seem even more chaste with intellectual overtones in keeping with their almost geometric environment. Straight lines are more in evidence, particularly in the profiles of shoulders, arms, and legs. One form moves smoothly into another with no perceptible transitions. The usually benign, gracious, and appealing countenance of the Buddha seems more severe, concentrating on an unpeopled world, or rather a heaven filled with multiplications of his own image. In contrast to the type of simplification practiced by the Siamese image makers of the Hinayana tradition, the Javanese style with its Mahayana background is less decorative and sleek and has more of the substance of religious fervor. The Buddha image of the central *stupa* of the terrace, though unfinished, is comparable in style to the others and, as we have seen, is considered to represent the Devaraja, the God-King.

While the later developments of Javanese art are largely Hindu, some Buddhist images date from this period of sculptural elaboration. The most notable of these is the often shown free-standing stele of Queen Dedes (?) (c. 1220) as Prajnaparamita, the Goddess of Transcendental Wisdom (*figs. 153 and 154*). The face and the nude parts of the torso show a smoother and ultrarefined continuation of the style seen at Borobudur, but the elaboration of the jewelry, costume, and throne back reveals the influence of metalwork, particularly of those Javanese wax-cast bronzes which depend upon the complication of numerous details achieved by the repetition of curling or droplike motifs. Something of the serenity and intellectuality of the earlier Javanese styles is preserved in the ramrod straightness of the torso and the clean, simple, straight lines of the lower part of the throne. These qualities, so appropriate for Buddhist art, are but a small part of a later Javanese art largely dominated by the vigorous development of a native pictorial style under Hindu religious inspiration. Again we witness the end of a Buddhist tradition in an Indian or Indonesian area well before the decline of that faith in the Far East.

130

BELOW: *153. Queen Dedes as Prajnaparamita, from Chandi Singasari. Andesite, height 49½". Early 13th Century* A.D. Rijksmuseum voor Volkerkunde, Leiden

OPPOSITE: *154. Detail of figure 153*

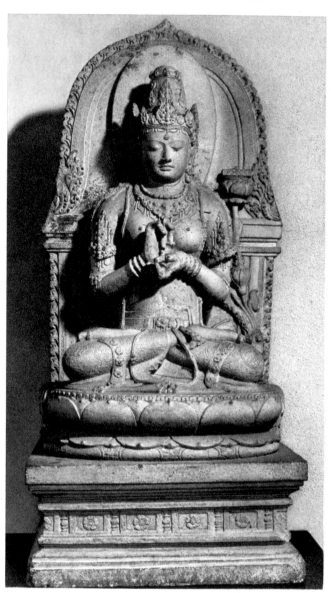

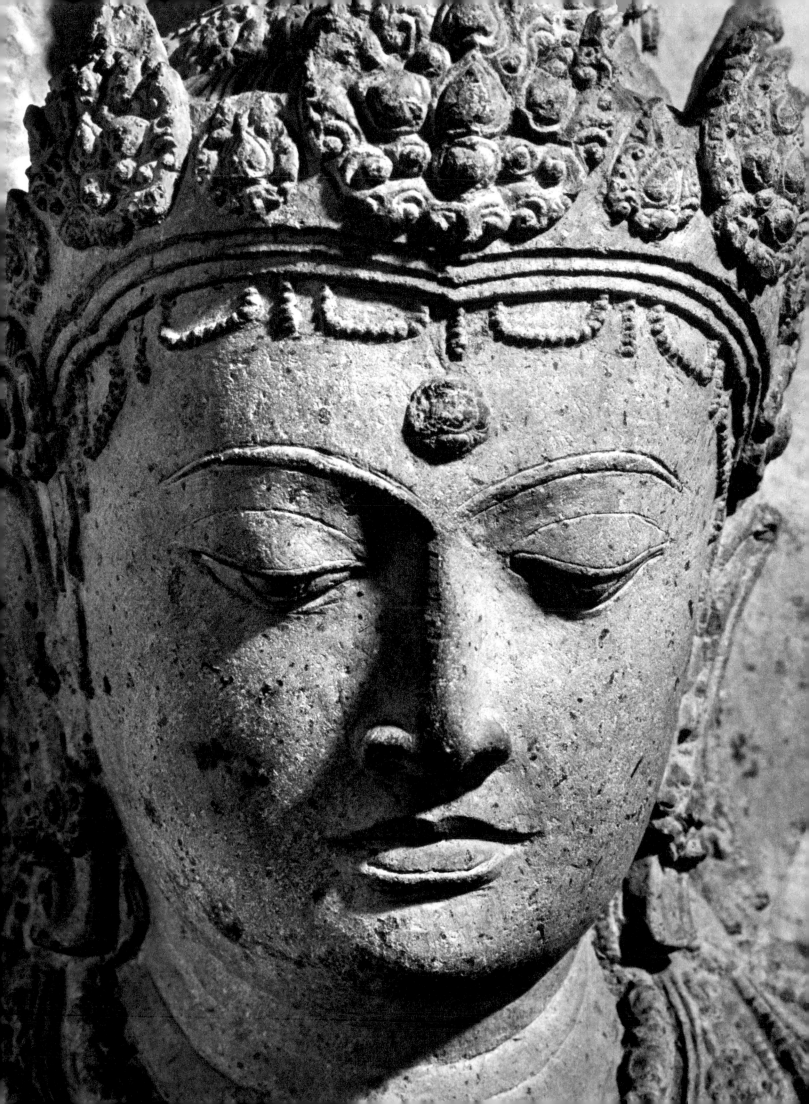

7. The Expansion of Buddhist Art to the Far East

INDIAN STYLE AND BUDDHIST ICONOGRAPHY were transmitted eastward not only by sea and land as far as Indonesia, but also by land over the mountain passes and through Central Asia to China and Japan. Central Asia was a flourishing region, a region of oases and of some agricultural development, as well as a hunting ground for nomads. The means of Buddhist expansion was the already existing network of three principal routes by which trade, especially in silk, was carried on between China, India, the Near East, and the Western world. The western terminus of these routes was near Bamiyan, outside Northwest India, a trade and pilgrimage center under the political rule of an Iranian dynasty, where an Indo-European language was principally spoken. East of Bamiyan there were centers at Qyzil, Kucha, Miran, Turfan, Bazaklik, and numerous others. The eastern terminus of the routes was Tun-Huang in the far northwest corner of China.

The principal media which concern us here are sculpture and painting, particularly painting in a fresco technique on mixed clay and plaster walls, in caves cut into the earth cliffs or river banks of Central Asia. Four major stylistic elements coexist in this Central Asia region — a Romano-Buddhist style, a Sassanian style based on that of the Persian Sassanian dynasty, a mixed Indo-Iranian or Central Asian style, and finally a Chinese style representing a later retaliatory influence. We cannot overemphasize the importance of the Central Asian styles of painting in the development of Buddhist painting in China and Japan. These were the principal means by which the iconography of Buddhism was transported. The many stylistic elements took hold for a time in China, even permanent hold in the case of Buddhist icons made for the temples, but only a temporary hold in the case of sophisticated Chinese painting, which very quickly absorbed the Central Asian and Indian elements and reworked them into a native idiom.

The most extraordinary object at Bamiyan is the

155. Colossal Buddha, from Bamiyan, Afghanistan. Height 175'. 4th-5th Century A.D.

Colossal Buddha (fig. 155), remarked upon by all who saw it, including Hsuan Chuang. The Bamiyan Buddha, because of its impact on the traveler, was of great importance, for its particular iconography and style were transported both in small-scale "souvenir" objects taken back to China and in the minds of those who saw it. It is a rather stiff rendering of a standing Buddha with "string" drapery, and a face of a rather rigid Northwest Indian type, judging from the terribly damaged remains. But the rhythmic geometry of the drapery, derived in part from Gupta and Gandharan elements, provided a prototype for numerous images made in China and Japan on both a small and a large scale. The figure is colossal, dominating the human figures of the pilgrims that pass by it. The niche, shaped as a body halo (mandorla), with the usual halo behind the head, produces a double halo much copied in China and Japan, even in remote cliff carvings which re-created Bamiyan abroad.

Inside the upper arch, over the main halo of the smaller, 120-foot-high image at Bamiyan, one can see the remnants of a fresco symbolizing the sun or the vault of heaven over the Buddha (fig. 156). The representation may be identified as that of the Hindu deity, Surya, the sun god, or Apollo, or, most likely, Mithra, the Persian sun deity. The solar deity, clothed body and head in the sun, drives a chariot drawn by horses and attended by winged angels. The angels are of two particular types. The two in human form, with wings that fall from the shoulders to the knees and spread in a symmetrical pattern on either side, are certainly derived from Persian and Mediterranean prototypes. The others appear to be *kinnaris*, deriving ultimately from Greek harpies, winged figures with bird's feet, and the bodies and heads of human beings. These heavenly attendants are executed in a decorative and flat style more in keeping with the Persian tradition, in contrast to the Indian style of Ajanta, which was carried into Central Asia as well.

The principal site where the Romano-Buddhist type appears is Miran. The style is particularly evident in a painted frieze of human figures bearing garlands (fig. 157). Their faces look almost like Fayum portraits of Coptic Egypt, and are treated in late Classical style, with wide, staring, almost Byzantine eyes. The motif of the garland-bearer is also of Classical origin. These frescoes bear the signature Tita (Titus?) perhaps an itinerant painter from the late Roman Empire.

The third Central Asian style is a mixture of Indian and Iranian elements, with the most important sites located at Kucha, Qyzil, and Dandan Uiliq. The illustration from Dandan Uiliq shows a remarkably well-preserved fresco depicting seated figures in priests' robes, executed in a mixed style, and a Yakshi bathing in the water with a lotus rising near her knee and waist, showing a large measure of Indian influence in

156. Sun God, from Bamiyan, Afghanistan. Copy of fresco. 4th–5th Century A.D.

her voluptuous outlines (fig. 158). Still the nose is rather sharper and the eyes slant much more than is customary in purely Indian painting. The whole effect is eclectic, but unified to a degree justifying a Central Asian designation. The dryad at Dandan Uiliq happens to be the most striking and aesthetically interesting of the numerous examples of the style and is of interest also because this is probably the farthest eastward extension of the nude female motif. The subject never appealed to the Chinese and Japanese, except in offhand, informal sketches or as illustrations for pornographic literature.

The Central Asian style makes much use of a "web" technique, the word being used to describe a netlike pattern that unites the composition. This stylistic peculiarity is typical of paintings from Qyzil. The representation of the cremation of the body of the Buddha, an event following the Parinirvana and found in later elaborations of Buddhist iconography, shows flames rising above the coffin with its raised top, and the Buddha reposing peacefully within (fig. 159). There are some traces of Indian-style modeling in the slight trace of shadow around the face, which gives a modest illusion of volume. At the same time, the small eyes,

133

134

ABOVE:
*157. Garland Bearers, from dado of
shrine at Miran. Fresco, height about 48"
Late 3rd Century* A.D. *Museum of Central
Asian Antiquities, New Delhi*

RIGHT:
*158. Yakshi, from Dandan Uiliq.
Fresco. 5th-6th Century* A.D. *Destroyed*

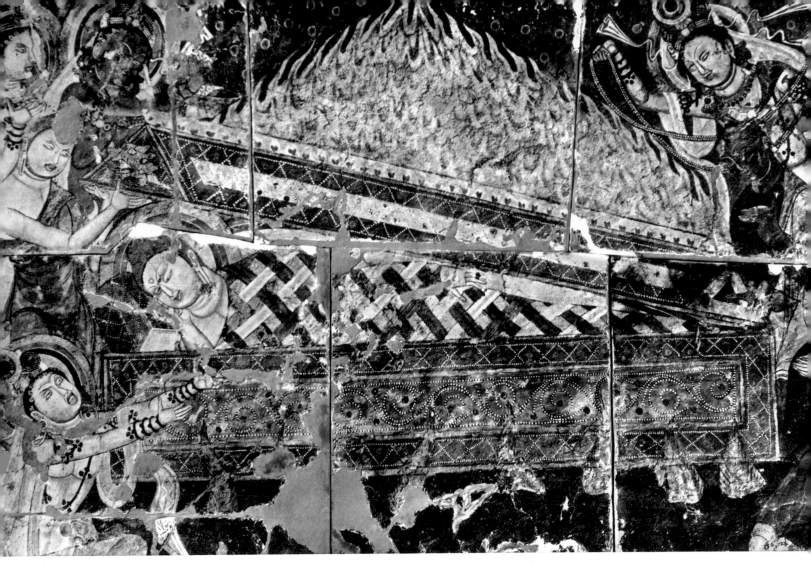

159. *Cremation of the Buddha, from Qyzil. Fresco. 6th Century* A.D. Museum für Völkerkunde, Berlin

tiny mouth, and high pointed eyebrows are character-istic of Iranian style. One can even see some traces of Roman or Mediterranean style in some of the disciples and guardian figures with their bearded faces, who remind us of the various river and sea deities shown on Gandharan reliefs (*fig. 160*). But the distinctive color scheme owes little to Persia, India, or China: orange mixed with blues and malachite greens, and shading done in red in the case of benign figures, and in blue or black in the case of guardian figures or demons. The schematization of anatomy in fingers, folds of the neck, and peculiar facial types suggests a distinctive Central Asian style. Frescoes of this type were executed by artisans of the region, and since frescoes cannot travel but artists can, it must have been these men, moving according to the demands of the monasteries on the pilgrimage routes, who spread these styles through Central Asia to China and Japan.

Unless we think of the Crusades, we cannot imagine the religious enthusiasm that motivated the burgeon-ing of these shrines along the pilgrimage and trade routes. Yet, it was not a mass movement like the Cru-sades, but a succession of individuals or small groups who made the pilgrimage to see the homeland of the Buddha. A great many Chinese and Japanese went to India; and of course Indians, priests, and traders visited China. Most people in the modern West, with their motor cars, trains, and planes seem to think that travel is a Western word and that few people ever went anywhere until the automobile was invented. But the volume of travel in the ancient world was quite extraordinary. Remember the Roman trading station on the eastern coast of India or the one discovered in Siam; consider that the most beautiful ivory of Andhra type was discovered in Pompeii; and that one of the finest Late Chou bronzes was recently excavated in Rome. Travel was a normal function in ancient society, and certainly so for the monks and pilgrims and for those active in trade.

The Chinese influence in Central Asia is slightly later in date than most of the material just discussed. It is an interesting example of a cultural phenomenon that might be called "backfire." We find the influence of Indian Buddhist art and of Persian painting style amalgamated in Central Asia, moving to China, pro-ducing an impact there, and developing a varied icon-

135

160. *Mahakasyapa from a Parinirvana, from the Greatest Cave of Qyzil. Fresco, length 27½". 6th Century* A.D. *Museum für Völkerkunde, Berlin*

161. *"Donor," from Bazaklik. 8th-10th Century* A.D. *Museum of Central Asian Antiquities, New Delhi*

ography in a new Chinese style, which then, because of the imperial ambitions of the T'ang state, moved westward back along the same routes into Central Asia. For this phenomenon the most characteristic site is Bazaklik. Here a tenth-century "donor" displays an almost pure Chinese style (*fig. 161*). The headdress is of Chinese type; the peculiar facial proportion, with the long nose, round chin, and conventionalized ears, is as purely Chinese as is the flowing linear base of the design.

The eastern focus of the trade and pilgrimage routes was Tun-Huang, the great staging center at the far northwest reaches of China. Here, in hundreds of caves — hence the appellation "Caves of the Thousand Buddhas" — are sculptured figures in clay, frescoes, libraries of scrolls, manuscripts, and banners. In this Chinese outpost one finds a fusion of Central Asian elements with an extended range of Chinese styles from the fifth century to almost modern times, in a myriad of examples often well preserved by the dry, desertlike air. This rich material is a happy hunting ground for the scholar and provides many clues to now lost sculptures and paintings from China's great urban centers. Some of this material will be mentioned in later considerations of Chinese and Japanese figural and landscape art, but only when no surviving sophisticated examples are available. The Tun-Huang material, though rich and varied, is most likely provincial in character and gives only tantalizing glimpses of the main stream of Far Eastern art. Its very primitiveness, though appealing to modern Western critics, would be unacceptable to the highest standards of traditional Chinese critical judgment.

The traditional and fairly well-established date for the introduction of Buddhism to China is A.D. 68. Undoubtedly this was the first time that somebody associated with the Buddhist church appeared in China. But, according to Chinese records, by the third century A.D. there were only five thousand Buddhists in all of North and South China. So we cannot imagine that Buddhism conquered all, because of the merit of its doctrine or because of an enthusiastic mass movement. Rather we must associate the rise of Buddhism in China particularly with the Central Asiatic Tartars who, by the fifth century A.D., succeeded in establishing control over much of North China. The Tartar dynasty of particular importance for our purpose is that of the Northern Wei Dynasty (A.D. 386-535). Fervent Buddhists, they were fortunate that the faith was an effective means of extending social and political control over the native Chinese population. It must not be assumed that this was done easily, for we have records of their success before A.D. 440, of the coming of a new ruler and the persecution of Buddhism in A.D. 446, then of the coming of yet another ruler who re-established

Buddhism, and of its consequent flourishing expansion. Certainly it is true that by A.D. 450 Buddhism was a great force in North China, and that it expanded rapidly from that time on, though it did not achieve even a moderate degree of power in South China until later.

In China, Buddhism became the great patron of the arts during the Six Dynasties period, a name traditionally given to the period (A.D. 220-589) between the Han and the Sui dynasties. In Chinese Buddhist style in this time we can witness a consistent development from an eclectic mixture of Central Asian and Chinese styles to a fully realized Chinese style, which was to become a second international style of Buddhist art culminating in the style of the T'ang Dynasty (A.D. 618-907). As a second international style it represents, as did the Gupta style, one that spread beyond national boundaries and became a dominant style for a larger geographic area, including principally China, Korea, and Japan. The styles that led up to the T'ang style are numerous and difficult to follow. They have been placed for purposes of clarity in three main pigeonholes, which like all such arbitrary compartments are to be considered as only that. The development is by no means so simple. But, in general, one can speak of an Archaic Style, lasting until about A.D. 495, with a type-site for that style at the great cave temples at Yun-Kang (Cloud Hill); an Elongated Style, which lasted from about 495 until the middle of the sixth century, whose type-site is a second cave complex at Lung-Men (Dragon Gate); followed, in turn, by a Columnar Style, particularly associated with the Northern Ch'i Dynasty of A.D. 550-577, and with a principal

137

162. Colossal Buddha, from Cave 20, Yun-Kang, Shansi. Stone, height 45'. Second half of 5th Century A.D.

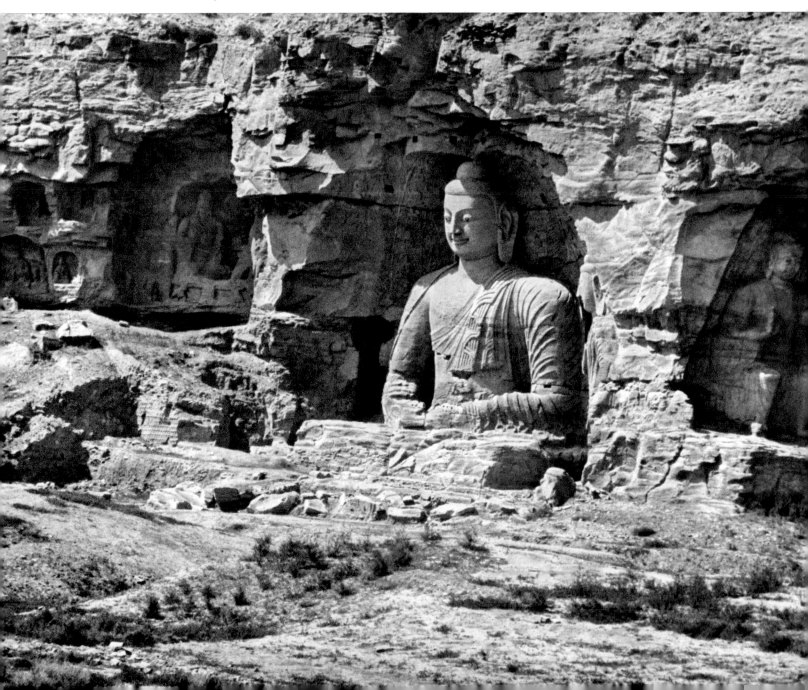

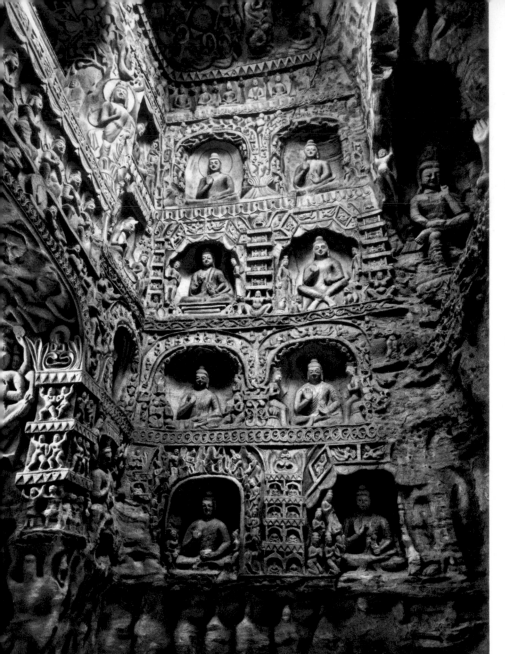

type-site, at Hsiang-T'ang-Shan (Resounding Hall Mountain). These three major styles of the Six Dynasties Period were succeeded by a synthesized style at the time the country was unified, politically and socially, by the short-lived Sui Dynasty (A.D. 581-618), which in turn was succeeded by the long and splendid T'ang Dynasty. These great sculptural styles are figural and represent a new departure for the Chinese genius. While the Chinese had carved only some few figures before the rise of Buddhism, the imagery and iconography of these sculptures were dominantly Indian and consequently teemed with figures. Mahayana Buddhism was certainly a major stimulus for Chinese achievement in figure sculpture.

We should mention parenthetically that China is quite logically divided into North and South and that, in general, South China was not noted for its cave sites;

native Chinese dynasties accompanied by an already traditional art of painting flourished more continuously there. Also, animal sculpture and tomb sculpture of traditional Chinese type flourished longer and more fully in the South. Contrariwise, in the North we find greater foreign influence, more Buddhist material, great cave sites, and probably greater ferment and complexity. This is a period of many states; hence the name, the Six Dynasties. Actually there were many more, but this is the traditional name of this period of political and social unrest, not unlike that we have already seen in the Late Chou Period.

Let us first consider the Archaic Style and its representative sculptures. The Colossal Buddha at Yun-Kang gives some idea of the general nature of the first phase of the style (*fig. 162*). The tradition of carving into the living rock was probably imported from India.

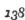

138

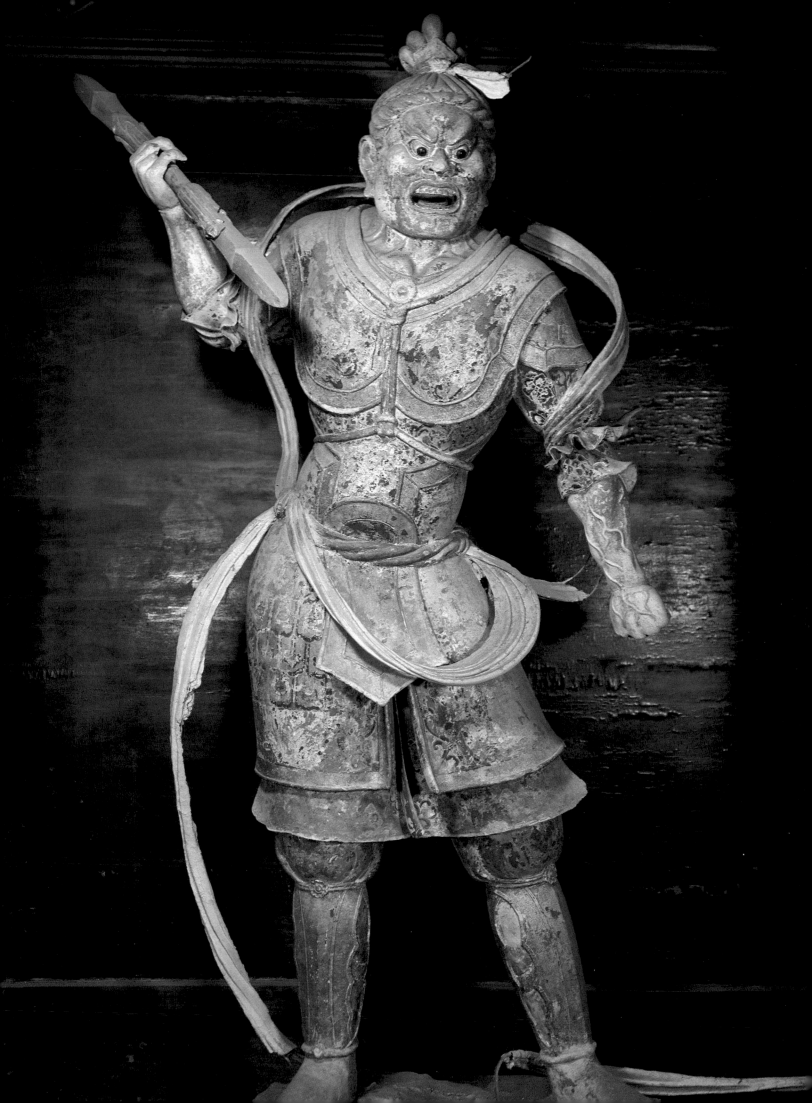

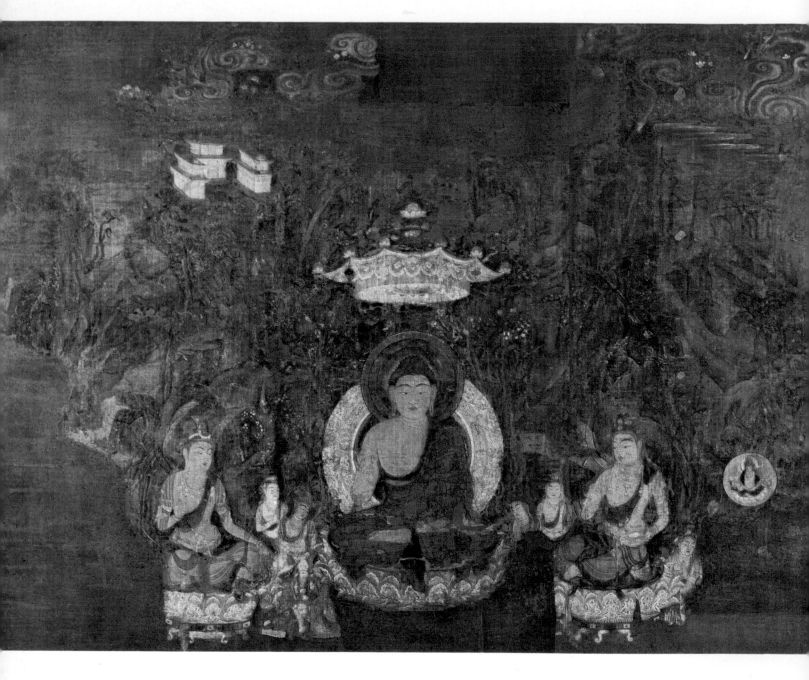

Colorplate 12. Hokke Mandala, from the Sangatsu-do, Todai-ji, Nara. Color on hemp cloth, width 59".
Nara Period, late 8th Century A.D. Museum of Fine Arts, Boston

*164. Buddha in the Preaching Pose, from Cave 249,
Tun-Huang, Kansu. Fresco. Northern Wei Dynasty*

ly Indian manner, whereas the central image of the
cross-legged Buddha below is taken from Iranian icon-
ography. On the other hand, particularly in the flying
figures of the ceiling, the flowing movements from one
form into the other seem to be derived from native
Chinese style, like that in Late Chou and Han Dynasty
painting, inlaid bronzes, and lacquer. The term "Ar-
chaic" seems appropriate for this style because, in ad-
dition to being a beginning, it also has that particular
smiling countenance so characteristic of Archaic Greek
art and which has so beguiled art historians that it has
been christened "the archaic smile."

The influence of Central Asia is found as well in
Buddhist painting of the fifth century, as can be seen
in the earliest of the wall paintings at Tun-Huang (*fig.
164*). These seem even more archaic than the sculp-
tures, even to the point of caricature. An almost frantic
energy possesses these figures as the artist attempts to
deal with such problems as the concept of modeling

*165. Sculptured wall with a niche dedicated in A.D. 527,
from Cave 13, Lung-Men, Honan*

Little if anything like this had been known before in
China. The colossal figure, with the drapery derived
from the Bamiyan string-pattern and the face showing
traces of Gandhara style, gives the impression of a
hybrid and stiff conformation. This style is repeated in
the interiors with polychromed sculptures in great pro-
fusion. The porch to one of the caves shows a typical
Central Asian proliferation of images by simple addi-
tion, without much symmetry; above we see a care-
fully worked out order whereas the lower frieze is a
mixture balanced in an asymmetric way (*fig. 163*). The
impression is one of images added one after the other;
and this is probably the way the sculptures were done
as donor after donor ordered and dedicated a carving.
One might also note a trace of vulgarity in the color-
ing. While much of the existing coloring is modern —
for example, that at the bottom is completely new —
the original coloring, where it exists, was of a similar
quality. Bright blues, reds, greens, and whites were
applied in a rather flat way, denying the sculptural
form. The artists, largely of Central Asian origin or
tutelage, attempted to reproduce the paintings and
stuccoes of Central Asia in sculptured stone. Above are
representations of Bodhisattvas under trees in a vague-

*166. Shakyamuni Trinity. Stele,
limestone, height 30½". Eastern Wei Dynasty,
A.D. 537. Cleveland Museum of Art*

now been a thorough assimilation by the Chinese artist of the first elements of Buddhist iconography and of Central Asian style. We are not dealing here with Central Asian craftsmen working for Chinese or Tartar patrons. There is a much greater use of linear movement than in the Archaic Style; the sculpture appears

by light and shade. His eagerness reduces the more subtle Indian and Central Asian shading to a broad streak outlining the edges of the shapes bounding and within the figures. The result is more linear and energetic than any of the prototypes and may well testify to the first shock of the meeting of Chinese painting style with the new Buddhist imagery and foreign techniques of representation, perhaps as early as A.D. 420. If these truly primitive forms are compared with the contemporary and highly accomplished linear style of such native painters at the Southern courts as Ku K'ai-chih, some hint is given of the discrepancy between the old tradition and the new stimulus — a large gap which was closed with startling ease and rapidity.

The second style, which we have called Elongated, can best be seen at the type-site, Lung-Men. There has

*167. Buddhist Memorial Stele, from Shansi.
Gray limestone, height 84". A.D. 554.
Museum of Fine Arts, Boston*

flatter and the movements on the surface of the sculpture, of the drapery, even of the halos and *mandorlas* behind the figure, are executed in very low relief, giving the effect of a flickering, sinuous, and rhythmical dance (*fig. 165*). The careful and continuous repetition of forms causes the rhythmical effect. The figures have become much more slender and elegant. The necks are longer; the faces are no longer of a Central Asian or Gandhara type. The figures are not static — they move. The guardian figures, instead of being stiffly alert, bend and grimace. Angels are not flat silhouettes against a ceiling but move within their outlines as well as in their silhouettes. A very particular element of this style is the emphasis on the drapery. This assumes characteristic and repeated forms, particularly for seated figures, where we note a cascade or waterfall effect. The artist obviously delights in the drapery falling over the knees and hanging down in carefully pleated folds below the legs. Such figures are repeated again and again not only at Lung-Men, but in other caves of lesser renown.

Perhaps we can see the style even more clearly in another medium. Sculpture in stone was to be found not only in the caves. It existed in the temple steles, which were of two major types: the pointed type with images in high relief, and the tablet form in low relief or with figures set into niches cut into the vertical stele. The pointed stele of the Eastern Wei Elongated Style, dating from about A.D. 537, is very much like the sculpture at Lung-Men (*fig. 166*). The same archaic smile which we remember from Yun-Kang is to be seen in a much more refined form, with a greater feeling of graciousness and immediacy. The eyes have taken on a characteristically Chinese linear character. The long necks and waterfall drapery are emphasized wherever possible in an entirely new and easy way. They are carved in extremely low relief, so low that they almost appear to be painted. A Chinese note is introduced into the primarily Indian iconography of a Buddha flanked on each side by Bodhisattvas, for directly above the Buddha we can easily discern a demon mask. This mask dominates the lotus rinceau which has been derived from Buddhist iconography. In many other steles artists introduce the traditional type of Chinese dragon, or winged lion. These are evidences of the growing dominance of a Chinese idiom over the imported styles and iconographies.

The second type of stele is basically the Chinese tablet on which commemorative inscriptions were usually carved; but in this case and in that of Six Dynasties sculpture in general, it is adapted to the requirements of Buddhism, with many residual Chinese elements in iconography and style (*fig. 167*). The date of this stele is A.D. 554; thus it is a late example of the Elongated Style. One element of that style, the waterfall drapery, is executed here in a slightly decadent way. On the

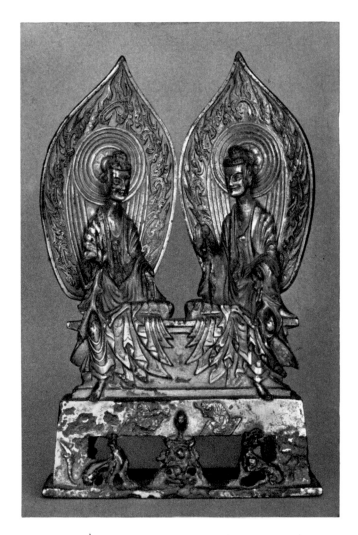

168. *Shakyamuni and Prabhutaratna. Gilt-bronze, height 10¼". Chinese*, A.D. *518. Musée Guimet, Paris*

other hand, the figures of the angels, demons, and lions are executed in a fully Chinese rhythmical style. The seal, the inscription, and the long dedicatory inscription are carry-overs from the Chinese inscribed tablet. The lower registers use Chinese motifs: a donor, horses, and chimera or lion styles. Particular attention should be paid to a motif to be examined later in connection with the development of Chinese painting: the presence of landscape elements in stone relief. In this case, they are representations of trees on either side of a scene in a pagoda, providing a landscape setting and an example of pictorial influence on stone sculpture. The tablet is simply divided into registers, and these in turn are divided into niches for figures. The arrangement is not always symmetrical, by any means. In effect, these are the ingredients of a cave temple placed on a Chinese inscribed tablet; but figures of acrobats and monkeys are depicted with quite un-Indian angularity, their long, slender figures moving in seemingly frenetic activity.

143

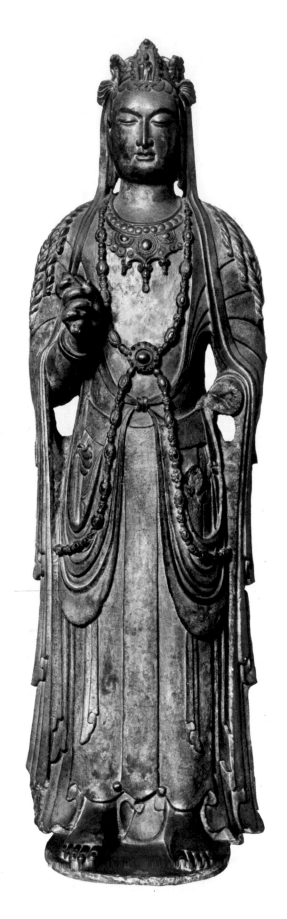

The essential qualities of the Elongated Style are perhaps most clearly seen in the gilt-bronze ex-votos, or altarpieces, remaining from the sixth century. The illustration represents the meeting of the two Buddhas, Shakyamuni, the historic Buddha, and Prabhutaratna (*fig. 168*). The full and complicated story of this particular scene and of the Diamond Sutra associated with it is translated by H. Kern in the twenty-first volume of *The Sacred Books of the East*. Shakyamuni was seated on the Vulture Peak expounding the Lotus Law when a *stupa* appeared in the sky. He arose, "stood in the sky" and opened the *stupa*, where sat a Buddha of the past, Prabhutaratna, who had come to hear the Law. Shakyamuni sat beside him and continued his discourse. In the bronze in the Musée Guimet, in Paris, the two Buddhas are seen side by side, *mandorlas* with incised head-halos behind them, seated on a throne supported by lions in front of which is a caryatid. A design of a kneeling priest holding a censer is incised on the bronze base. In this altarpiece we find the elongated proportions, the sharp noses, the almond eyes, the bewitching smile, the waterfall drapery, and the sawtooth drapery edges—another copybook motif—which occur again and again from about A.D. 510 to 550. Such gilt-bronzes were made in some quantity for families as portable altars, or as offerings to temples; and very often they are inscribed and dated, this particular example being of the year A.D. 518. The borders of the *mandorlas* are treated with a flame pattern recalling the Late Chou hook-and-bend motifs, almost as if they had persisted and been adapted as a flame motif.

The third style is called here Columnar and evolves either through a particular kind of patronage, or through a new wave of influence from India, probably from the Gupta Period. The markedly linear character of the earlier sculpture in the round or in high relief is largely abandoned and, instead, we find rich, full-bodied monumental sculptures on which the jeweled ornament is applied to the smooth surface of columnar forms. The whole effect is highly architectonic, and one which, in a quiet, reserved way, becomes most imposing. The illustration is particularly characteristic—a Bodhisattva from the cave-temple complex at Hsiang-T'ang-Shan (*fig. 169*). The few details of ornament accent the smooth surfaces on the columnlike figure. The facial type is developed largely from the second style; it is the torso which shows the radical change in form. The monsters, whether attendants or caryatids, at Hsiang-T'ang-Shan are among the most imaginative and sculpturally convincing products of the period (*fig. 322*). Like other members of the same family in gilt-bronze (*fig. 170*), they are bizarre arrangements of volumes and voids as well as being representational grotesques. They take their proper place in the long history of Chinese secular sculpture, though here they supplement a foreign imagery and faith.

169. Bodhisattva, from Hsiang-T'ang-Shan, Shansi. Stone, height about 72". Northern Ch'i Dynasty, A.D. 550-577. University Museum, Philadelphia

Various sculptures, in stone and metal, epitomize the unification of style that took place during the Sui Dynasty (A.D. 581-618), but none does this better than the famous bronze altarpiece in the Boston Museum, dated A.D. 593 (fig. 171). It represents the Buddha of the West, Amitabha — called Ami-to-fo in Chinese — seated beneath the jeweled trees of the Western Paradise, and attended by two acolytes, two disciples, two Bodhisattvas and lions and guardians with an incense burner between them directly in front of the Buddha, originally set into holes in the bronze altar base. The Amitabha altarpiece is, first of all, a carefully balanced composition with the axis at the center. There are minor variations in the poses of individual figures, such as the inward bend of the head of the Bodhisattva on the right, but careful symmetry is the rule. The style is one of simplicity and restraint, with a harmony between the major and the minor figures not found in earlier compositions. There is no longer a discrepancy between the iconography and style of the major Buddha images and the qualities of the attendant figures; and if the lions and guardians from the group, now in a private collection in Europe, were present, one could see the same unity of style in them as well. It is a mode based on the Columnar Style of the Northern Ch'i Dynasty and from this the great T'ang style develops. But before we turn to the T'ang international style, let us examine the extension of the Six Dynasties styles into Japan.

While many see in early Japanese Buddhist art a native quality distinct from that of China, none but the most nationalistic would deny — were he to assess objectively the elements of Chinese style and those of Japanese origin present in this material — that the proportion would be almost entirely Chinese with half of the tiny remainder Korean. To all intents and purposes, when we study the early Buddhist art of Japan during the Asuka (A.D. 552-645) and the Nara (A.D. 645-794) periods, we are studying Chinese art — first, that of the Six Dynasties Period, and second, that of the T'ang international type. It is indeed fortunate that this is so, for the continuous warfare in China, both internecine and foreign, succeeded in destroying many of the great monuments of Buddhist art. There is almost no early Buddhist architecture left in China. There are very few, if any, remaining Six Dynasties images of wood, very few large bronzes, and almost no images in precious metal or in other exotic materials. The images in clay can be numbered on very few fingers indeed. But quite the reverse is true of the material in Japan. There the combination of great good fortune and a marked reverence for the past, including the early monuments of Buddhism, has succeeded in preserving a considerable number of works in pure Six Dynasties and T'ang style. From these we can gauge something of the rich-

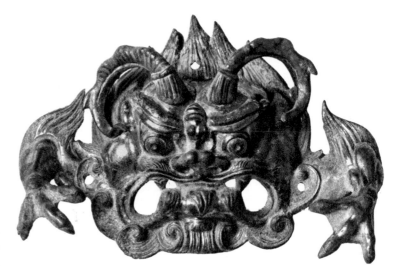

170. *Monster Mask Door-Ring Holder (P'u Shou). Gilt-bronze, height 5⁵⁄₁₆". Northern Ch'i Dynasty, A.D. 550-577. Cleveland Museum of Art*

171. *Amitabha Altar. Bronze, height 30⅛". Sui Dynasty, A.D. 593. Museum of Fine Arts, Boston*

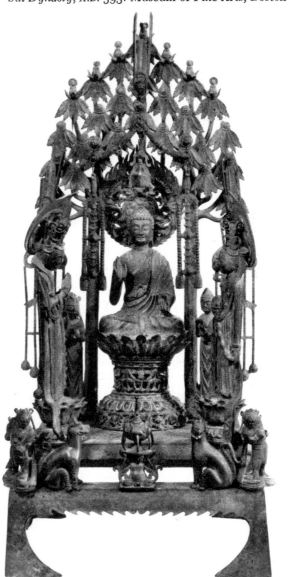

145

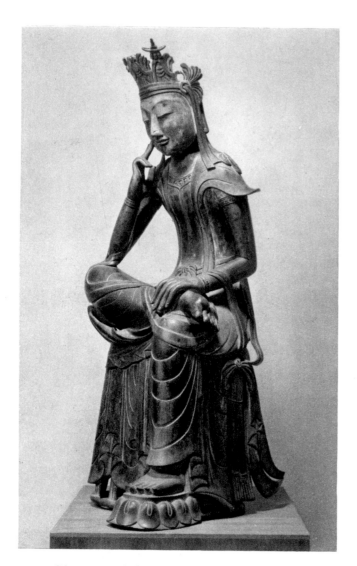

172. *Maitreya. Gilt-bronze, height 30". Silla Dynasty, 6th-7th Century* A.D. *Korean National Museum, Seoul*

advanced starting point for the newly converted Japanese.

The introduction of Buddhism into Japan succeeded largely through the efforts of the Prince Shotoku, or Shotoku Taishi (A.D. 572-621), Crown Prince "Sage-Virtue." By means of his pure faith, he succeeded in establishing Buddhism as the state religion. This was no mean achievement, if one is to consider the relatively short time in which it was accomplished and the opposition of an almost meaninglessly ritualistic native Shinto faith, as inadequate as Brahmanism was in India when the Buddha taught. Not only had the Buddhist faith become very sophisticated, it also had the great Chinese culture behind it — and mere multiplication of specific deities or spirits of forest, field, sky, and water was simply not enough.

With Buddhism, Chinese culture was introduced on an overwhelming scale. Writing of Chinese characters was imported at this time, as were the customs and hierarchical organization of the Chinese court, and the concept of city and temple planning along geometric lines. All the various orderly, logical, and rational elements that we associate with China were brought in with Buddhism. So it was not only Buddhism but also Chinese culture which was enthusiastically and wholeheartedly absorbed. Temples were built in great numbers; sculpture was produced in quantity; and the result was a flowering of figural art never surpassed in the Far East.

One must always be conscious of a time lag in assessing the relation of Chinese, Korean, and Japanese styles. The Asuka Period lasted from A.D. 552 to 645, but the art of the period is the Chinese style common from about A.D. 500 to 550. The type-site for the Asuka style, Horyu-ji (the suffix -ji means "temple"), the cradle of Japanese art, probably was founded about 610 (*fig. 173*). There is great argument as to whether this is the original construction; there are some who believe it was rebuilt in the early style at the end of the seventh century, after a disastrous fire. However, the Golden Hall (*kondo*), the pagoda, a part of the cloister, and the gate are in the original style but date from just after A.D. 670. These are not only the oldest wooden buildings in the world but also a complex showing the appearance of a Chinese temple of the Six Dynasties Period. Early in 1949 a tragedy occurred. The Golden Hall, part of which had been removed for repair, was burned, and the great frescoes inside were almost completely destroyed. The Japanese have reconstructed the hall, using the timbers that had been removed, and new elements as well, so that now it has its original appearance.

The beautiful and gently rolling hill country near Nara give Horyu-ji an extraordinary setting, and the pine trees rising out of the sand of the courtyard add to the ancient, noble, and archaic air of the whole. The

ness and splendor of Chinese sculptures in these phases.

Buddhism was introduced to Japan by a mission from Korea in A.D. 552. We cannot overestimate the importance of Korea in the transmittal to Japan of the style of the Six Dynasties Period. We know that the first generation of image makers in Japan were from the mainland and nearly all second- and third-generation artists had some continental blood. Korean sculptors of the Silla Period (57 B.C.-A.D. 935) were quick to master the imagery of Buddhism after the introduction there of that faith in the fifth century. While few of their best images have survived, one gilt-bronze masterpiece in Seoul shows how elegant and refined the Elongated Style could be in a large metal image of nonprovincial type (*fig. 172*). Such linear refinement and accomplished stylization was probably common in the best Chinese and Korean work and provided an

plan of the monastery is relatively asymmetrical, giving much prominence to the pagoda, a characteristic of a great deal of Six Dynasties architecture. Later in the T'ang Dynasty a more rigid and balanced plan oriented to the main hall was typical. The principal axis is through the gate, back between the pagoda and the Golden Hall, to a lost refectory behind. The east-west axis runs through the Golden Hall and the pagoda. The pagoda balances the Golden Hall, on either side of the north-south axis, so in that sense there is symmetry, but the two buildings are not, of course, identical. In later temples we shall see the use of two pagodas, sometimes inside and sometimes outside the cloister, in a rigidly balanced arrangement, with the Golden Hall placed on a central axis. The individual buildings are typically Chinese, using the bay system, post-and-lintel construction, tile roofs, and elaborate bracketing designed to transmit the thrust and weight of the heavy tile roof down through the wooden members into the principal columns that support the struc-

ture (fig. 174). They stand on raised stone bases — another Chinese element. The gate has a more flying, winged character typical of Six Dynasties architecture than does the *kondo*. The latter had a covered porch added in the eighth century and, in the seventeenth, dragon-encircled corner posts. These tend to obscure the early form and make it appear more squat and cumbersome than was originally intended. A closer view of the *kondo* shows the bracketing system with its complicated use of jutting members, carved in a linear pattern of a cloudlike form (fig. 175). All this adds to the springing and light effect characteristic of Six Dynasties style, in contrast to the somber and rather dignified style that succeeded it. The Golden Hall is laid out according to the Four Directions, with four stairs on each side, leading to four double doors. It is laid out in the same way inside, with a central dais on which the main images are placed, while above there are three wooden canopies hanging over the main images. On the four interior walls were painted fres-

147

173. Horyu-ji, Nara, Japan, general view. Asuka Period, 7th Century A.D.

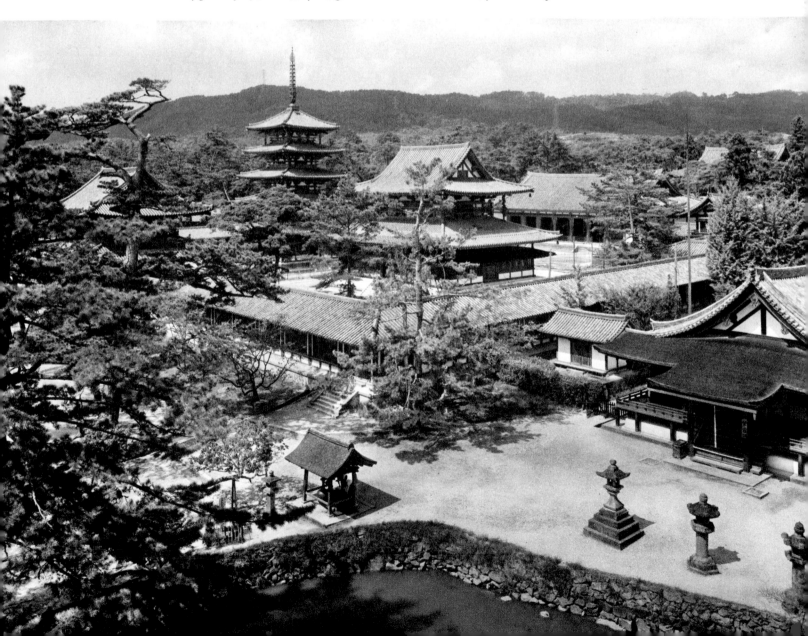

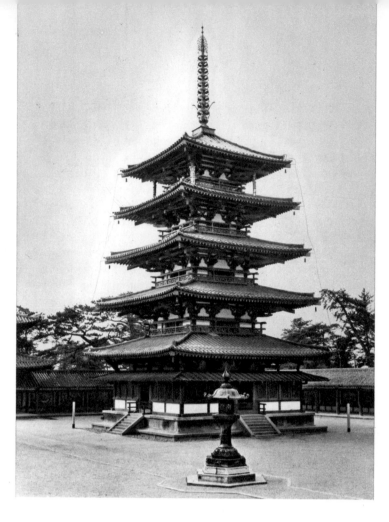

RIGHT:
*174. Goju-no-to (Five-storied Pagoda),
from Horyu-ji. Asuka Period,
7th Century* A.D.

BELOW:
*175. Kondo (Golden Hall),
from Horyu-ji. Asuka Period,
7th Century* A.D.

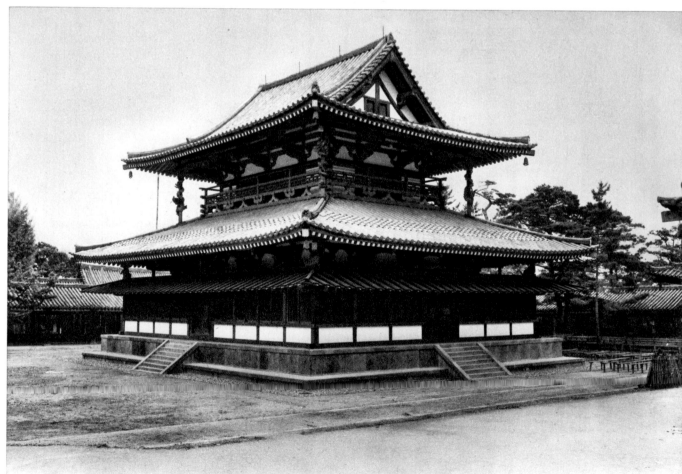

coes of about A.D. 710, showing the Four Paradises of the Four Buddhas of North, East, South, and West, with smaller wall panels of attendant Bodhisattvas. These are the paintings largely destroyed in 1949, but fortunately they are thoroughly documented by photographs and color reproductions, though these are admittedly poor substitutes for the original.

Painting of the Asuka Period is known to us principally through one monument in Horyu-ji known as the Jade-Beetle (Tamamushi) Shrine, a name given to it because the pierced gilt-bronze borders around the base and edges of the pedestal are laid over a covering of iridescent beetle wings (*fig. 176*). These shine through the gilt-bronze and produce an extraordinary effect. The Tamamushi Shrine is a wood-constructed architectural model meant to enclose an image. Resting on a large pedestal placed on a four-legged base, the entire shrine is more than seven feet high, and in almost perfect condition, with no restoration or addition. It is not only a beautiful form in itself, important for its paintings, but it is also of great value for the study of architecture of the Six Dynasties Period. Nat-

urally the Horyu-ji buildings themselves have been repaired; roofs have been changed, and oftentimes the lines of the structure are lost. But the Tamamushi Shrine is a small and perfect example of Six Dynasties architecture in excellent preservation. Indeed, modern Japanese architects were able to reconstruct the Golden Hall roof line more accurately by following this model. On the four sides of the pedestal are painted Buddhist scenes, one of them a Jataka, or story of the Buddha in a previous incarnation. Here, in order to save a family of tiger cubs from starving to death, the Buddha-to-be offered himself as food for the mother, who could then feed her young (*fig. 177*). The story is told by the method of continuous narration in three episodes. Above, the Buddha-to-be carefully puts his clothes on a tree. He is then shown diving off the cliff toward a bamboo grove, the tiger's lair; and at the bottom, veiled by the stalks, is the gruesome conclusion: the tigress eating the willing sacrifice. The representation is of great interest because it is one of the earliest examples of the painting of bamboo, a Far Eastern specialty; and because its general style, par-

176. Tamamushi Shrine, from Horyu-ji.
Lacquer painting on wood, height 92". Asuka Period,
7th Century A.D. Horyu-ji Museum, Nara

177. The Bodhisattva's Sacrifice,
from the Tamamushi Shrine.
Detail of figure 176

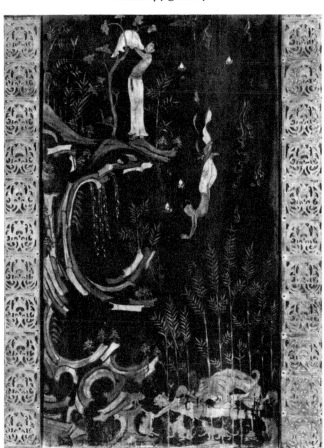

149

ticularly the way in which the curious rock formation is constructed, with ribbons of yellow and red lacquer, recalls nothing so much as Late Chou inlaid bronzes. The whole construction of this cliff, with its linear accents and its hooks and bends, is in pure Chinese style. Note, too, that the human figure is long and slender, a perfect example of the Elongated Style. There is great emphasis on linear motifs, in the clouds, in the falling lotus petals, and in the drapery which trails behind the Bodhisattva as he plummets to the bamboo grove below. The whole effect is replete with naïveté and charm and shows tremendous technical control.

The largest remaining Chinese bronze image of the Six Dynasties Period is perhaps a foot and a half in height. At Horyu-ji there are several images, including the famous group illustrated here (fig. 178), almost six feet high. The Buddhist Trinity, by Tori, a sculptor of Chinese descent, was made in A.D. 623, and represents the Buddha Shakyamuni seated on a throne, flanked on either side by Bodhisattvas, with a great *mandorla* behind. The image was made two years after the death of Shotoku Taishi and, as the inscription notes, was dedicated to the memory of the prince. It is in perfect condition, with considerable gilding remaining, and is

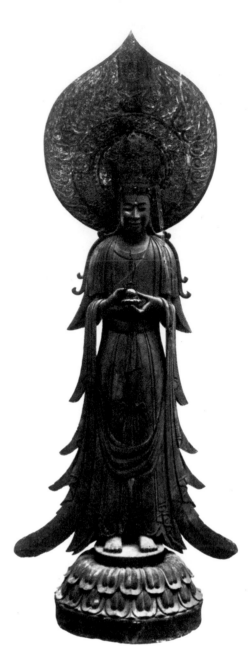

179. Kwannon, from the Yumedono. Gilded wood, height 77½". Asuka Period, early 7th Century A.D. Horyu-ji, Nara

178. Shaka Triad. By Tori Busshi. Bronze, height 69¼". Asuka Period, A.D. 623. Horyu-ji, Nara

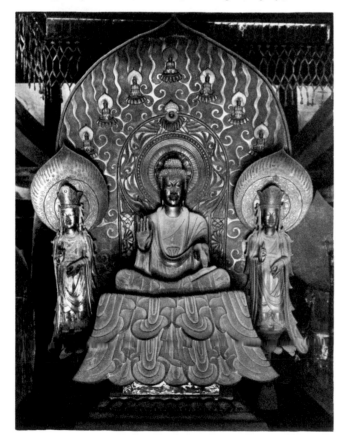

150

a fine example of the second style. If this were made of stone one would say it came from Lung-Men: the waterfall drapery, the serrated edges of the side draperies on the Bodhisattvas, the rather tall proportions, the type of the face, and the *mandorla* with its curling linear motifs are pure late Northern Wei. There is a slight tendency toward squatness in the proportion of the faces and in the relationship of the body to the feet, and this seems to be characteristic of some of the Japanese work of this period. Above the image is one of the three carved wooden baldachins, or canopies, placed over the main images of the raised dais of this Golden Hall. It recalls the painted and carved can-

opies on the ceilings in such early Six Dynasties sites as Yun-Kang and Lung-Men.

Perhaps the most beautiful of all the great images at Horyu-ji is the wooden Kwannon housed in an octagonal hall of the eighth century, called the Hall of Dreams (Yumedono) (fig. 179). Kwannon is the Japanese name for the deity called Kuan Yin by the Chinese and Avalokiteshvara by the Indians, the most popular of all Bodhisattvas. The *Yumedono Kwannon* has an extraordinary history. It was found by a group of scholars including the American, Ernest Fenollosa, who was then Curator of Oriental Art at the Museum of Fine Arts in Boston, carefully wrapped in cloth in its tabernacle, a secret image. Inside the wrappings lay the miraculously preserved image, some six to seven feet in height, with a halo which is one of the most beautiful examples in all the world of linear pattern carved in low relief. The figure had its original gilt-bronze jeweled crown, with the jade fittings and gilding all preserved. Even such usually lost details as the painted moustache are clearly visible. The front view reveals the serrated drapery type of the early Six Dynasties style and indications of the waterfall pattern and of the curling motifs of the hair at the side of the shoulders. The side view reveals the usual integrity of the Oriental artist in handling specific materials. We see an image which could not be anything but wood, despite the gilding. The serrated drapery derives its effect from its origin in a plank, first cut with a saw and then so finished that it retains, even in its finished condition, the character of sawn wood. Note too, the flatness of the figure — how the hands are pulled together and compressed to the chest, maintaining a relieflike character, although the image is technically in the round. The *Yumedono Kwannon* is, for this writer, perhaps the supreme example of the early Six Dynasties style in either China or Japan.

The second of the great wooden images at Horyu-ji is the so-called *Kudara Kwannon* — the Korean Kwannon — since Kudara was the Japanese name for one of the three kingdoms of Korea in the seventh century (fig. 180). In this image, while we have the same planklike character in the side draperies, we find a more columnar, trunklike quality in the torso, again most appropriate for wood. The *Kudara Kwannon* is not in quite perfect condition; a great deal of the polychromy has been lost, and the rather spotty effect that one finds on the halo and on the body is due to this loss. But the tremendous elegance implicit in the elongation of the figure and its great individuality make it unique. It is a little later in style than the image of the Yumedono, being in terms of Chinese style, A.D. 550 or 560 rather than 520; and the result is more individual than the Yumedono example. The support for the halo is wood carved to imitate bamboo.

In considering the sculpture of the Asuka Period we

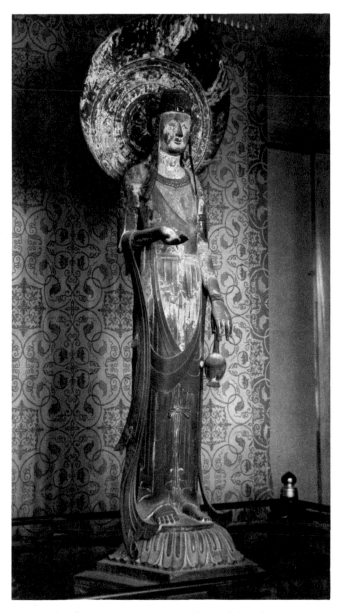

180. Kudara Kwannon. Painted wood, height 80⅝".
Asuka Period, mid-7th Century A.D. Horyu-ji Museum, Nara

cannot overlook an image quite different from the two that we have just studied, which seems particularly appropriate to its location, the little nunnery of Chugu-ji, an adjunct of Horyu-ji (fig. 181). The figure is properly referred to as the Chugu-ji Miroku, Miroku being the equivalent to the Sanskrit Maitreya, the Buddha of the Future. The Chugu-ji image has the various elements of Six Dynasties style seen in the other sculptures — the use of waterfall drapery, the simulated bamboo pole to hold the halo, the beautiful linear, flamelike pattern on the edges of the halo, the archaic smile, the indication of the serrated and curling edges of the hair as it falls over the shoulders. But here we have quite a different flavor — one of infinite sweet-

151

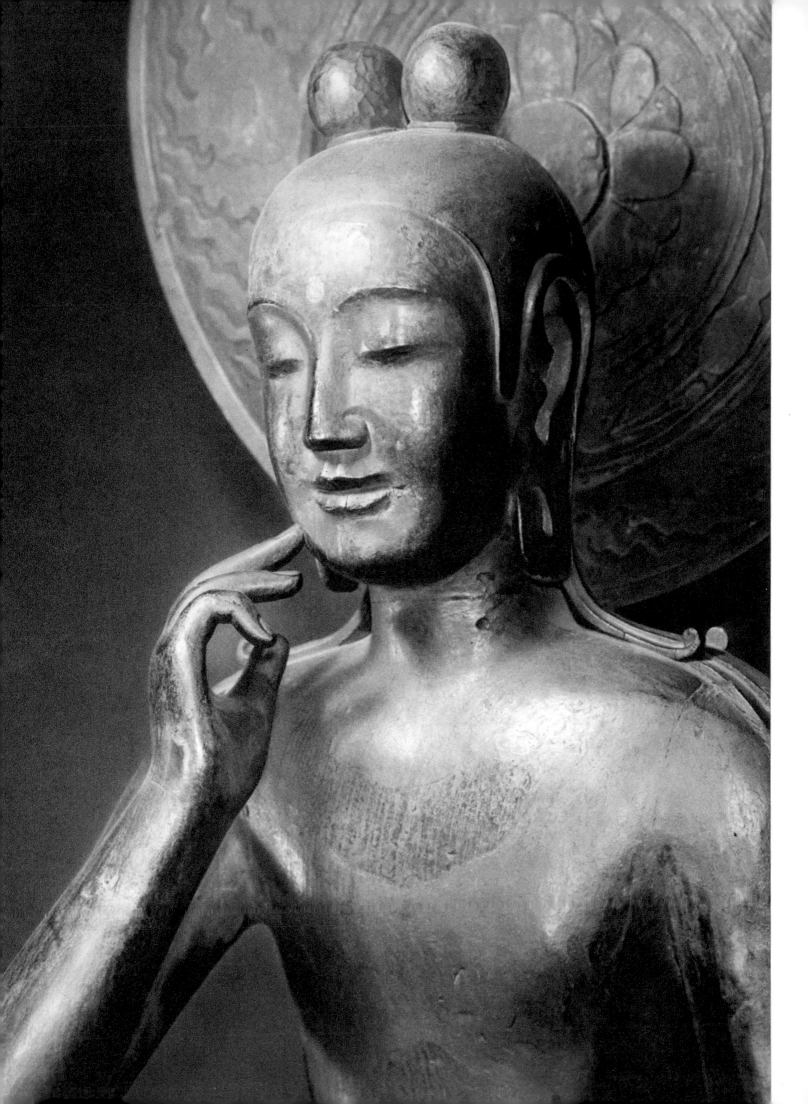

OPPOSITE:
181. Miroku (portion). Wood, height 62". Asuka Period,
mid-7th Century A.D. Chugu-ji, Nara

ness and softness, in short, a very feminine quality. Still one should not refer to Kuan Yin or Maitreya or any of these deities as female. The Chinese Kuan Yin does not become, even remotely, a female until the eleventh or twelfth century. Such images as these must be considered as masculine, not feminine. The gesture of the hand of the Miroku, as he places his finger close to his chin in a posture implying meditation, is a thing of infinite grace.

We have mentioned the carved canopies over the main altar of the Golden Hall of Horyu-ji. These wooden canopies were decorated with a sequence of phoenixes and music-playing angels, some of which were lost in the thirteenth century and replaced by contemporary copies. Still others were removed in the nineteenth century and sold to fortunate Japanese collectors. Only one is outside Japan and it is illustrated here (fig. 182). This angel, with its pierced halo, its linear and rhythmical development of repeated lines and gently swaying profiles, is characteristic of Chinese art in general and a demonstration of the truism that the Chinese are pictorial-minded. Their greatest sculpture looks more pictorial than it does sculptural; while the Indians, on the contrary, are more sculptural-minded, and in the classic phase of their painting at Bagh and Ajanta they are concerned with the painted representation of sculptural forms in space. In the angel illustrated, the particular flatness of the halo is achieved by means of a slight technical refinement: the beveling of the halo carving from the back. The resulting line is knife-edge sharp; one sees no thickness of wood from the front, only a crisp, flat pattern of a pictorial nature. Of course, the charm and the delightful elegance of the figure relates it more to the Chugu-ji Miroku than to the two earlier great images. There is good reason to believe that the angels do not date from A.D. 610, that is, from the earliest Horyu-ji construction, but from the end of the seventh century, when the canopies were probably put in place.

Buddhist art of the T'ang Dynasty (A.D 618-907) is rightly described as an international style whereas that of the Six Dynasties is but a preliminary — and a somewhat heterogeneous — one. During the earlier period China was divided politically, confused, and in the process of combining diverse racial, social, and religious factors. Without the concept of unity and authority, both in China and Japan, one could hardly speak with complete conviction of the sure transmittal of an international style. But with the T'ang Dynasty, we find a great world empire extending from the Caspian Sea

to Japan, from Manchuria on the north to Indochina on the south. At no other period — before or since — did China reach such powerful estate or exert such great influence. The capital, Ch'ang-An, was one of the greatest cities the world had yet seen. Travel between East and West increased enormously and was under the protection of a unified and centralized empire. The empire developed unified and sophisticated forms in its art, as it did in literature and in its social organization. It was not an age of dawning faith, of pilgrims' fervor, but one of confident mastery of the known world and society. Many different faiths were tolerated in China at that time — Buddhism, Nestorian Christianity, Hebraism, Mohammedanism, Zoroastrianism among them.

The derivations of the T'ang Buddhist style were, in

182. Music-Playing Angel, from a canopy of the Kondo, Horyu-ji, Nara. Height 19½". Hakuho Period, c. A.D. 700. Cleveland Museum of Art

153

LEFT:
183. Bodhisattvas, from T'ien-Lung-Shan, Honan. Stone. T'ang Dynasty, c. A.D. 700

BELOW LEFT:
184. Pagoda Base. Stone, height 27¼". T'ang Dynasty, early 8th Century A.D. Nelson Gallery-Atkins Museum (Nelson Fund), Kansas City

BELOW RIGHT:
185. Eleven-Headed Kuan Yin (fragment). Sandstone, height 51". T'ang Dynasty, c. 8th Century A.D. Cleveland Museum of Art

154

large measure, threefold: first, the India of the Gupta Period; second, its own background of the Six Dynasties and the Sui Period; and third, Central Asia and the Near East. Never — before or since — have so many Near-Eastern motifs appeared in Chinese art nor, on the other hand, were so many Chinese motifs imported into the Near East. We will look only briefly at T'ang material in China proper, because it is, like that of the Six Dynasties, more easily studied in Japan.

The type-site for T'ang stone sculpture is Tien-Lung-Shan (Heavenly Dragon Mountain). In particular, Cave 19 shows at its very finest the style achieved by the T'ang sculptor (fig. 183). Its elements are quite clear. Where before we were conscious of religious fervor, of a more abstract and mystical handling of the figure, of linear pattern, and of elongation, here we are more aware of a unified and worldly approach. All the parts seem fused into an integrated whole. The modeling of the figures is fleshly and voluptuous, perhaps in part under the influence of the Gupta style of India. The forms flow one into the other; the curve, the sphere, and the tapering cylinder are the basic elements. The drapery is no longer, as it was in the Northern Ch'i Dynasty, and even in the Sui Dynasty, applied on the surface of a volume beneath, but is integrated with the structure of the figure in a seemingly naturalistic way. This combination of a sinuous and sophisticated voluptuousness, together with the direct, even realistic, observation of nature, is what makes the T'ang style.

Few sculptures remain in an accomplished style fully realizing the most sophisticated intentions of the T'ang image maker. One of these, carved in a fine-grained standstone, is an Eleven-Headed Kuan Yin, probably from Shensi province, the home of the T'ang capital, Ch'ang-An (fig. 185). This Bodhisattva, one of the most popular and holy saviors of Mahayana Buddhism, is revealed as a benign but wordly being. The rounded face is a foil to the graceful linear geometry of its features and a contrast to the vigorous realism of the "angry" heads above. No trace of the struggle for stylistic assimilation remains; instead, the easy grace is matched by the technical ease of presentation. It seems a fitting visual and tactile summation of the T'ang ethos, a fully realized language derived from a foreign art vocabulary. No one would mistake this Kuan Yin for a Gupta example, despite the similarity of the literary terms that might be used to describe either — sensuous, worldly, yet removed from stress and struggle.

Much of this restraint derives from the subject matter. The realistic and vigorous accomplishments of the T'ang sculptor may be realized from such monuments as the small pagoda base now at Kansas City, on which the presence of guardians and dragons allowed the artist to indulge in the imaginative Chinese tradition of pre-Buddhist times (fig. 184). Such variety and

186. *Drawing of the Old Plan of Todai-ji, Nara.* A.D. *745-752*

187. *Kondo (Golden Hall), Toshodai-ji, Nara. c.* A.D. *759*

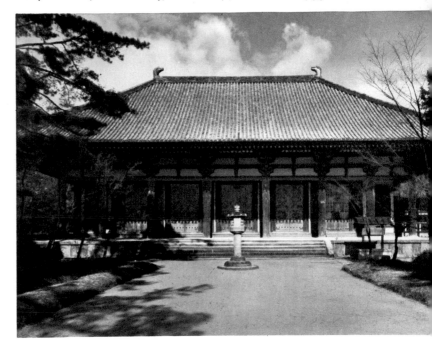

technical ease was eminently suited to the worldly aims of the dynasty and of the comparable Nara Period in Japan.

In architecture we can see the development of the temple plan in Japan at Todai-ji (fig. 186). The scale becomes huge — some five to six times the size of such small temples as Horyu-ji. The original main hall of Todai-ji was of such a size as to house a bronze Buddha image some sixty feet in height. The size of the temple enclosure expanded to such a degree that almost twenty acres were enclosed by the ambulatory. The pagodas of Todai-ji, now destroyed, were originally placed as a pair flanking the entrance, but outside the enclosure,

155

thus expanding the plan still farther. T'ang and Nara were centralized and expanding societies in their architectural planning as well as in politics.

The buildings show the same tendency to large scale and outward expansion into space. Observe the Golden Hall of Toshodai-ji (*fig. 187*) in contrast to the building of the same name at Horyu-ji. The latter's tightly organized and rather small scale, its vertical development, and its feeling of springiness are overpowered by the scale and mass of the later building. Instead of being completely enclosed, there is an expansion into space in the form of a porch. This was in part dictated by ritual requirements, as the porch gave a protected place for the wealthy or noble layman while he listened to the ritual inside. Not only is the size of the building immeasurably greater than that of the preceding period, but if we could see the inside, we would note in the development of the interior a more focused and unified handling of space (*fig. 188*). At Horyu-ji, the altar was meant to be walked around in the traditional Indian rite of circumambulation; at Toshodai-ji, the altar proper is backed by a screen, so that while one can still make the circumambulation, one's attention is focused on the images and on the altar in a framed view from the front. Again, this is a more unified and visually logical concept than the previous one. The various architectural members, columns, and bracketing are elaborate and massive. The color scheme in these temples remains the same: white-dressed clay on the walls; the large members treated with red oxide; window lattices painted a rich green; the roof tiles gray.

An interior view of one of these Nara Period temples will demonstrate the arrangement of an altar and its focused quality. The interior of one of the subsidiary halls at Todai-ji, March Hall ("third month hall": *Sangatsu-do*), possesses a very complete altar arrangement, with original sculptures of the Nara Period (*fig. 189*). This is the way a T'ang temple looked when one walked into it: a raised dais, a wall screen behind the

156

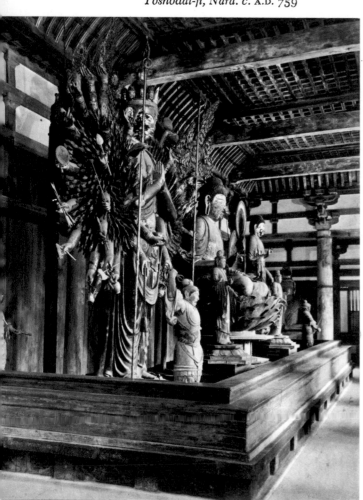

188. *Interior view of the Kondo (Golden Hall), Toshodai-ji, Nara. c. A.D. 759*

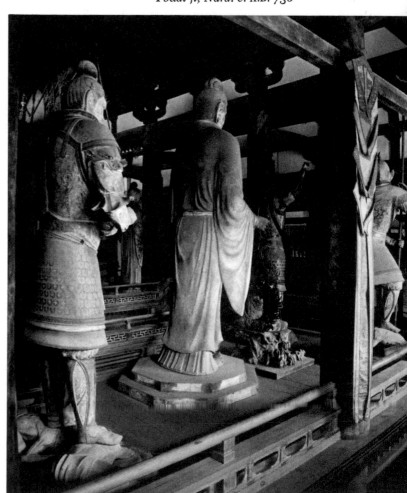

189. *Interior view of the Sangatsu-do, Todai-ji, Nara. c. A.D. 730*

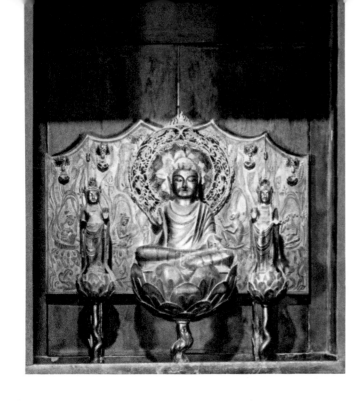

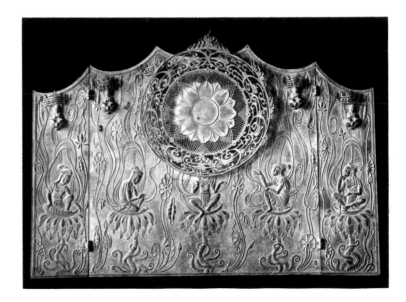

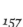

ABOVE:
*190. Tachibana Shrine. Bronze,
height of central figure 13⅜". Nara Period,
early 8th Century A.D. Horyu-ji, Nara*

ABOVE RIGHT:
*191. The Screen of the Tachibana Shrine.
Detail of figure 190*

BELOW RIGHT:
*192. The Base of the Tachibana Shrine.
Detail of figure 190*

altar focusing attention on the frontal view, and finally an altar crammed with large-scale, imposing figures of guardian kings, Bodhisattvas, and principal images, executed in a variety of media — dry lacquer, clay, and wood, rich with polychrome and full of realistic movement. The whole effect is a balanced combination of realism and religious feeling.

Here, and only here in all the world, one can see a group of T'ang sculptures arrayed on the altar of a moderately small temple. This is not, however, the original disposition. The complex represents an accumulation of sculptures: four of them, for example, were brought over in the tenth or eleventh century from a building destroyed by fire, and so it is not altogether sure that this is precisely the way they would

have been placed in the eighth century at the time of their making. But the ensemble has integrity; the mixture of media, clay, dry lacquer, and wood is normal; the relative scales are quite right; and they are grouped in a building of the same period: an eighth-century building, with an eighth-century altar group, on an eighth-century altar. You will remember that the style of the T'ang Dynasty, with its greater unity and sense of focus, was expressed in architecture by the use of a screen behind the altar, so that one saw the sculptures against a fixed background, in contrast to the earlier Six Dynasties style, in which the figures could be seen from all angles on the altar at the center of the room.

We have seen a sculpture group; now let us look at some individual examples of particular importance.

157

For the early T'ang style, certainly the most remarkable example is the bronze Trinity at Horyu-ji, within the Tachibana Shrine, named for a lady of wealth and aristocratic birth who gave the shrine to Horyu-ji (*fig. 190*). It dates from the very end of the seventh century or the beginning of the eighth century, roughly about A.D. 700. This is some eighty years after the beginning of the T'ang Dynasty in China; but, when looking at Japanese art in Chinese style, we must always keep the time lag in mind, and thus the Trinity represents the early seventh-century T'ang style. It is made of gilded bronze and is housed in a wooden tabernacle of the same time. Three major units make the composition: a flat base; a background screen in the form of a triptych; and the three main images, which sit or stand on lotuses rising from the bronze base. In scale, the total ensemble is two to two-and-a-half feet high. It is, therefore, a complete group on a fairly large scale and, most extraordinary of all, with its original base and background. We may be able to find isolated figures of comparable quality in Japan or, more rarely, in China, but to find such a complete ensemble intact is quite extraordinary. The representation is of the Amitabha Buddha in the center, rising on a lotus, and flanked on each side by two Bodhisattvas standing on lotuses. The Buddha makes the "lotus-holding" gesture, while that of the Bodhisattvas is that of "assurance." All of this is still slightly stiff, but this is the early T'ang style, immediately following the transition from the late Six Dynasties and Sui styles. While gestures are gracious and there is an easy naturalism in the faces and in parts of the drapery, the

193. Yakushi Trinity. Bronze, height 10′ 10″. A.D. 726. Yakushi-ji, Nara

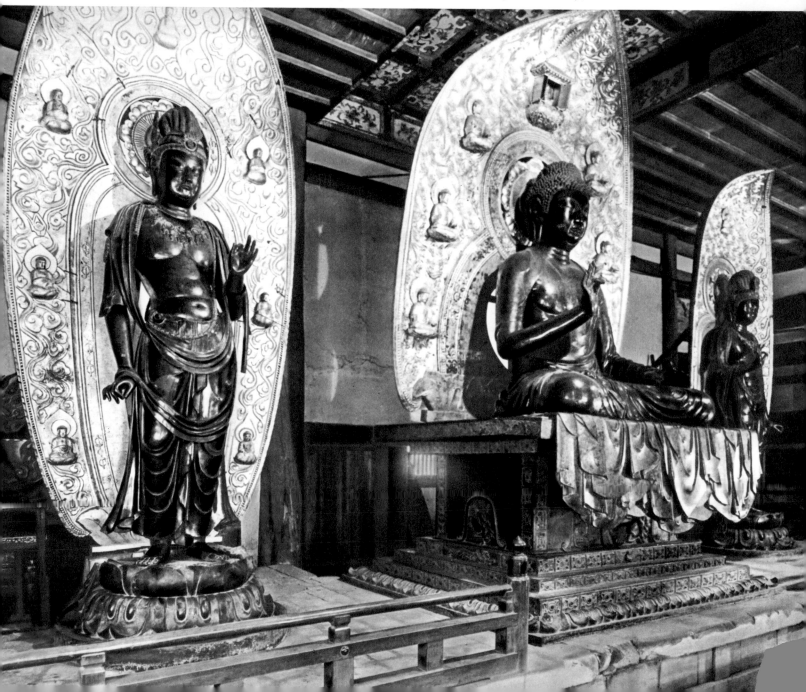

158

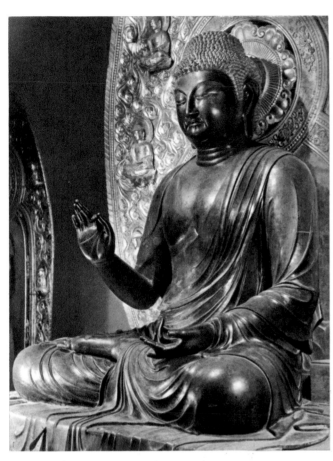

*194. Yakushi, from the Yakushi Trinity.
Detail of figure 193*

ance. The central figure has a fiery halo, indicated by flames at the top, while the main disk is treated in a fanciful cloud-and-hook pattern, which, like so much of the material that we have seen from late Six Dynasties, recalls the Late Chou hooks and spirals of inlaid bronzes. The central part of the halo is in the form of a lotus; the equation — lotus equals sun — is one which the beginning student of Far Eastern iconography learns first. The subject of the base is equally elegant, with a representation of little waves rippling over the surface, interspersed with representations of lotus leaves and the large twisting lotus stems for the three principal images (*fig. 192*). The ensemble, despite the three dimensions of the main images, tends to be pictorial, and in this it shows the influence of China, where sculpture often tends to develop pictorial effects.

A prime example of the middle or classic T'ang style in Japan is a bronze Trinity kept at Yakushi-ji (*figs. 193 and 194*). Yakushi is the name of the Healing Buddha, sometimes one of the Buddhas of the Four Directions, and his particular attribute is a medicine jar, which he usually holds in the palm of one hand. The main image of the principal hall at Yakushi-ji is a seated Yakushi, flanked on either side by a Bodhisattva, often referred to as the Moon and Sun Bodhisattvas. These show the developed T'ang style at its highest level in Japan, that is, in bronze. They are very large figures, approximately ten feet in height, a scale no longer extant in China. The halo is quite modern; the lumpy cloud pattern, so characteristic of late work, is offensive and contrasts crudely with the elegance and style of the figures. The bronze has turned a shiny green-black with time, and has the effect of having been rubbed with oil. Here there is no stiff frontality, but rather a hip-shot pose, with a gentle sway of the body. The legs are placed in different positions: one slightly bent, the other thrust forward. The draperies tend to flow more easily than those of the earlier period; the treatment of the hands is rounder and fuller, and the body, too, is fleshy. The whole effect is both sensuous and materialistic. At the same time, while the linear notes in the drapery and face have been maintained, the lips are now fuller and rounder, not abstract and sharp. The face, too, has become slightly corpulent, in contrast to the long thin faces of the early Six Dynasties, and the moderate fullness of Sui and early T'ang.

As an example of work in dry lacquer, no better image can be chosen than one of the large Four Guardian Kings from the Hokke-do (*Sangatsu-do*) in Todai-ji (*fig. 195*). The dry lacquer technique is peculiar. Sometimes it is formed on a clay base which is then dug out, but more usually an armature is used. The image is formed by taking alternate layers of cloth, usually hemp at the beginning, and ending with very fine silk or, in rare examples, a fine linen. These cloths are alternated with layers of lacquer, forming sculp-

figures are still frontal, and a certain rigidity is evident in the drapery, in the poses of the bodies and, particularly, in the mouth of the central image. The triptych screen behind the main images is executed in the most beautiful low relief, ranging from surfaces almost flush with the metal ground to a relief that projects — except in the small images of the Buddhas above — hardly more than a sixteenth of an inch or so from the surface (*fig. 191*). And yet within that very limited relief, a tremendous amount is achieved. The representation is pictorial in its general effect; that is, it is treated as if it were a translation of painting into metal. Everything flows with much more ease, much greater rhythm, and more suppleness than in the three principal sculptures. In this one can detect the influence of painting. The base, in the form of a pond in low relief like that of the screen, is thematically connected to the screen by octopi, whose tentacles, reaching up around the lotuses, support little angels. The composition is formally and symmetrically balanced. We do not yet have that typical Japanese asymmetry, which develops later; rather, this is a purely Chinese composition, with almost complete symmetry and bal-

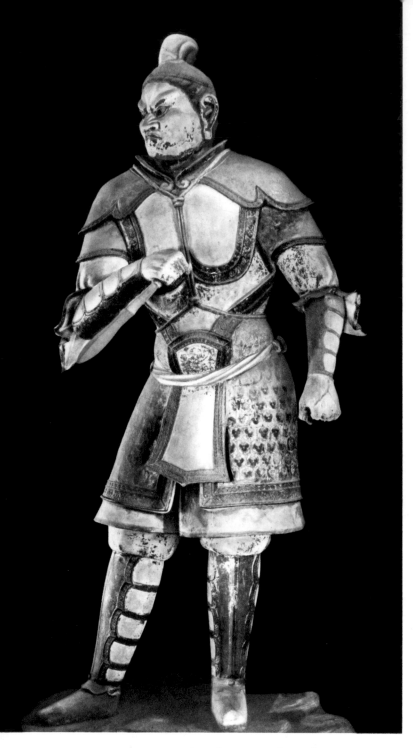

195. *Guardian King, from the
Sangatsu-do. Dry lacquer, height 10'. Nara Period,
early 8th Century* A.D. *Todai-ji, Nara*

ing up the main parts of the body, tubular shapes must predominate; and so the extremities — in this case appropriately enough, since the figure is armored — appear to be cylinders and increase in the whole a certain stiffness already inherent in the medium. On the other hand, such details as the modeling of the hands — for instance the veins — and the wrinkling of the nostril, or the bulge of the eyebrow, are accomplished in a plastic medium with a fluidity that belies the underlying geometric form. One may well ask why such a time-consuming technique was used. The most generally accepted reasons are that images of this type were light, easy to handle and move around, and they were not susceptible to attack by termites and wood ants. Certainly it is a laborious method of making sculpture, and in China we have but very few remains of the technique. We must look to Japan for great examples of the medium.

The technique of clay modeling was also much used in the T'ang Dynasty, and for the finest expression of this technique we must again travel to Japan and to the high altar of the Hokke-do where, on either side of the principal image of the Fukukensaku Kwannon, are two images representing Bonten (Brahma) and Taishakuten (Indra). They are life size, and extraordinarily heavy because they are solid clay. In these figures (one is shown in figure 196), the fluidity of the treatment of the face, drapery, and the bow hanging from the waistline has that quality which is not like wood, not like bronze, but plastic, as though modeled in wet clay. The pose of the figures, with folded hands and downcast eyes, has made them of special interest to photographers, and they have become two of the most famous sculptures from this particular hall. From China, we have only the fired-clay tomb figures, and the sometimes provincial images from Tun-Huang and so these two must stand for the sophisticated art of Buddhist clay sculpture in both China and Japan.

Another Nara image epitomizes that combination of secular feeling — in this case, ferocity — with religious awe that seems so typical of the T'ang Dynasty and of its style (*colorplate 11, p. 139*). The twist of the body, the bend of the hip, the flow of the draperies around the figure, the openings in these draperies, and the straining muscles of the neck are combined in a way that summarizes the dynamic interests of the T'ang sculptor. The image behind the screen of the Hokke-do, in a usually closed lacquer tabernacle, is a life-size image of the Vajra Bearer (the vajra is a thunderbolt symbol). The conception is somewhat comparable to that of the avenging archangel Michael in Christian iconography; the deity frightens evildoers and demons, and thus protects the faith. The image is a secret one, kept in a closed tabernacle which is opened only on rare occasions. But its magic power, even inside the tabernacle, continues to emanate in all directions.

160

tural shapes in laminated cloth and lacquer. The final details were applied, sometimes with a lacquer paste and, at other times — unfortunately, since these deteriorate very readily — with a kind of stucco paste. The combination of these two procedures — that is, the laborious building up of form by layers of cloth and lacquer, with the final touches executed in a temporarily plastic material — produces fluid details on an intractable foundation, a tense combination characteristic of work in dry lacquer. Obviously, in build-

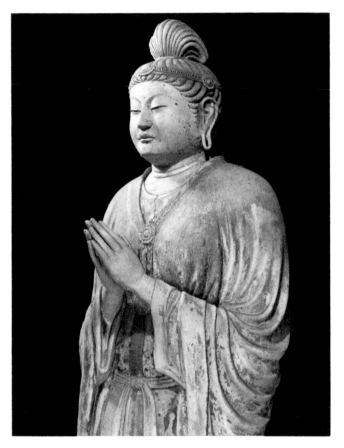

196. Bonten (Brahma), from the
Sangatsu-do. Clay, height 81¼". Nara Period,
early 8th Century A.D. Todai-ji, Nara

197. Portrait of Priest Ganjin, from the
Kaisando. Dry lacquer, height 31¾". Nara Period,
mid-8th Century A.D. Toshodai-ji, Nara

The last illustration of the T'ang international Buddhist style introduces a new category: the portrait as executed in dry lacquer, and polychromed (fig. 197). Priest Ganjin was the blind founder of the great temple, Toshodai-ji. It was at this time that the individual merit of a monk was recognized and the representation of this merit in an image was considered an aid to worship and to right living. The skin of the figure has a slight yellowish tinge. The eyebrows are painted in, as are moustache hairs and the stubble of the beard, but without that particularity which is so characteristic of later types of Japanese realism. The figure is both an individual and a generalized type, and this is the way most T'ang portraits strike us. The portrait of Priest Ganjin had much influence on Japanese art from the time it was made, and the school of portrait sculpture of the Kamakura Period was to some degree inspired by it.

Buddhist painting in the T'ang Dynasty, both in China and in the comparable period in Japan, encompassed two major formats: the wall painting and the portable painting, in hanging and handscroll form. The wall paintings decorated either the interiors of caves or

temples, and were painted both by anonymous artisans and by great painters whose names have come down to us as artists at the very pinnacle of Chinese pictorial achievement. One of the greatest names in all Chinese painting is that of the quite legendary Wu Tao-tzu — the greatest of Chinese figure painters and a creator of Buddhist wall paintings. As none of his works is extant, we must look at the works of anonymous artisans. While the most sophisticated and beautiful example of T'ang style wall decoration is in Japan, there are in China literally thousands of examples in some of the outlying, more provincial sites. The most important of these is the great pilgrimage center and trade-route terminus of Tun-Huang, which we have mentioned before. The representation of the Western Paradise, with the Buddha Amitabha flanked by two principal Bodhisattvas, many minor Bodhisattvas, and other deities of Paradise, is from that site (fig. 198). Most of the deities are seated on a raised dais protected with canopies, flanked by pavilions, and fronted by a lotus pond with platforms on which a celestial dance is in progress. On either side are raised platforms with other deities of the Western Paradise. The

161

either of Buddha or of a Bodhisattva; thus [the images of the Bodhisattvas and of Buddha] are found everywhere in that country. When this perception has been gained, the devotee should hear the excellent Law preached by means of a stream of water, a brilliant ray of light, several jewel trees, ducks, geese, and swans. Whether he be wrapped in meditation or whether he has ceased from it, he should ever hear the excellent Law. . . .

"He who has practiced this meditation is freed from the sins [which otherwise involve him in] births and deaths for innumerable millions of *kalpas,* and during this present life he obtains the *Samadhi* due to the remembrance of Buddha.

"And again, O Ananda, the beings, who have been and will be born in that world *Sukhavati,* will be endowed with such color, strength, vigor, height and breadth, dominion, accumulation of virtue; with such enjoyment of dress, ornaments, gardens, palaces, and pavilions; and such enjoyments of touch, taste, smell, and sound; in fact with all enjoyments and pleasures, exactly like the *Paranirmitavasavartin* gods. . . .

"And again, O Ananda, in that world *Sukhavati,* when the time of forenoon has come, the winds are greatly agitated and blowing everywhere in the four quarters. And they shake and drive many beautiful, graceful, and many-colored stalks of the gem trees, which are perfumed with sweet heavenly scents, so that many hundred beautiful flowers of delightful scent

198. *Western Paradise, from Tun-Huang, Kansu. Fresco. T'ang Dynasty, second half of 8th Century* A.D.

whole is a transcription in paint of passages from the *Sukhavati-Vyuha* and *Amitayur-Dhyana-Sutra,* Buddhist texts which describe the Western Paradise and the pleasures of being there with the Amitabha Buddha.

"When you have seen the seated figure your mental vision will become clear, and you will be able to see clearly and distinctly the adornment of that Buddha country, the jeweled ground, etc. In seeing these things, let them be clear and fixed just as you see the palms of your hands. When you have passed through this experience, you should further form [a perception of] another great lotus flower which is on the left side of Buddha, and is exactly equal in every way to the above-mentioned lotus flower of Buddha. Perceive that an image of Bodhisattva Avalokiteshvara is sitting on the left-hand flowery throne, shooting forth golden rays exactly like those of Buddha. Still further, you should form [a perception of] another lotus flower which is on the right side of Buddha. Perceive then that an image of Bodhisattva Mahasthama is sitting on the right-hand flowery throne.

"When these perceptions are gained the images of Buddha and the Bodhisattvas will all send forth brilliant rays, clearly lighting up all the jewel trees with golden color. Under every tree there are also three lotus flowers. On every lotus flower there is an image,

162

fall down on the great earth, which is all full of jewels. And with these flowers that Buddha country is adorned on every side seven fathoms deep."[2]

The Pure Land school of Mahayana Buddhism with its Amitabha Buddha and his Paradise appealed to the great mass of T'ang people, and its iconography is most typical of the religious faith of the time. The way to salvation was a relatively easy one — to be reborn into the Western Paradise one must simply worship the Amitabha Buddha with faith. The mural emphasizes particularly the pleasure-loving or sensuous aspects of this Pure Land and illustrates these with scenes which might have taken place in the court of a Chinese emperor. The foreground, for example, represents a series of court musicians, with a court dancer of Indian derivation performing on a court stage. The architecture is based on the palace style of the T'ang Dynasty. The organization of the composition is based upon Chinese hierarchical concepts of order, precedent, and position. The perfectly balanced, centrally oriented composition, the principal figures slightly higher than the secondary ones, while it represents the Western Paradise of the Buddha Amitabha, at the same time expresses a Chinese concept of order and also something of the sensuous and worldly ethos of the T'ang Dynasty itself. Surrounding the picture, at the border, are continuous narrative representations of stories from the Lotus Sutra or from the Life of the Shakyamuni Buddha. A photograph distorts the values of the colors because the figures which appear black are actually in paler pigments; however, the colors have indeed darkened with age.

An example of the larger portable paintings of the T'ang Dynasty, is the famous painting on hemp in the Boston Museum, called the *Hokke Mandala* — that is, the lotus diagram or lotus picture — representing the Shakyamuni Buddha flanked by two Bodhisattvas in a landscape setting (*colorplate 12, p. 140*). The dominance of the landscape element is surprising in this context, and we must mention, in anticipation, that landscape developed rapidly during the T'ang Dynasty. Still the setting of typical Western Paradise figures in the midst of a lush landscape is rather unusual and has led to much argument whether this picture is Chinese or Japanese. It has always been considered to

163

OPPOSITE:
199. Amitabha Trinity, from the Kondo, Horyu-ji, Nara. Fresco, height 10'. Late Hakuho or Early Nara Period, c. A.D. 710. Horyu-ji Museum, Nara

LEFT:
200. Head of Bodhisattva, from the Amitabha Trinity. Detail of figure 199

201. *Scenes from the Life of the Buddha (Birth of the Buddha), from Tun-Huang. Fragment of a border of a large mandala, width 6⅜". T'ang Dynasty.*
National Museum, New Delhi

be Chinese with Japanese additions and restorations. The latest opinion, however, based upon careful infra-red analysis of the picture which reveals most of the original state without repaint, gives some support to the argument that the picture is Japanese; if so, it must be an eighth- or early ninth-century example of the T'ang style in Japan. The composition is rather symmetrical, with a central figure balanced on each side by similar groups. Within these groups we find variations, and this — plus the fact that the figures are set in a landscape — provides a less rigid conformation than the Paradise pictures of Tun-Huang or similar paintings.

But the classic examples — the greatest examples — of T'ang style painting are the now destroyed murals from Horyu-ji (*fig. 199*). You will remember that the Golden Hall had on its interior walls representations of the Paradises of the Four Directions (*see page 149*). These were oriented to the Four Directions, with a particular variation required by the fenestration of the *kondo*, which necessitated rearrangement of the main iconic panels and those representing Bodhisattvas. The murals were painted on clay walls supported by bamboo mesh hung between the columns of the building. They were painted with considerable color, much of which had vanished even before they were destroyed and with an additional emphasis on linear development. We see in the illustration the Paradise of the West as it was before the fire. The murals still exist,

202. *Barbarian Royalty Worshiping Buddha. Tradition of Chao Kuang-fu. Handscroll, color on silk, height 11³⁄₁₆"; length 40¾". Northern Sung Dynasty.*
Cleveland Museum of Art

but the color was burned off most of them so that in a few one can see a ghostly black-and-white image which seems to hover on the surface of the clay. They most likely date from about A.D. 710; and so they represent fairly early T'ang style. The balanced composition uses a jeweled canopy with a gentle indication of hills behind, but not the great, complicated palace structures of the type we saw at Tun-Huang. It is as if we had taken a detail of one of those and had enlarged it, concentrating upon the three main figures. The linear development is of the highest importance. If we look at a detail of the Bodhisattva on the right — the one most often reproduced, in large part because of its splendid preservation — we find linear technique at its height. The line is relatively even in thickness, without that variation in width so characteristic of much later Chinese calligraphy and Chinese linear drawing. It is rather a thin, even wirelike line applied with the greatest care and in a pattern which can only be called geometric. If one examines, for example, the parabola that makes the elbow, the reverse curve of the forearm, the arcs of the neck and the face, or the absolutely straight line of the bridge of the nose, it will seem that the painters had a geometric conception of boundaries and used an even pressure on the brush (fig. 200). At the same time, this line is made so subtly that it serves to indicate depth or volume by means of the line itself, or by the turn of a line into another line. This is an extremely sophisticated device, but one which is at the

same time somewhat conventional. The general characteristics of the shapes of the figures are comparable to those we have noted in T'ang sculpture. The forms are rounded and fleshy; there is a gentle sway to the body; the face is slightly rotund; the whole effect is of that combination of worldliness and spirituality which pleases both the iconoclast and the believer.

The other form of painting was the portable handscroll, probably the principal means of spreading T'ang style and Buddhist iconography to the far reaches of China and Japan. The handscroll presented both writing and pictures to priest and layman alike. The scrolls, some as long as thirty or forty feet, could be rolled up and carried easily in robe or luggage. When unrolled a foot or two at a time and read, with text below and illustration above, they provided an illuminated "Bible" for both initiate and uninitiate. The best-preserved and most famous of Buddhist handscrolls in early style is the Sutra of Cause and Effect (*Kakogenzai Ingakyo*), existing in some rolls and fragments in Japan (*colorplate 13, p. 173*). The text is written in regular columns, in a fine, conservative, and legible style. The illustrations above display a slightly provincial air; they are not as supple as the Horyu-ji murals or as some fragments of Buddhist painting from Tun-Huang, but as we see them here in color with their bright oranges and malachite greens, their yellows and azurite blues, we see a style of great charm indeed — one in which the color is of that sensuous and worldly type so char-

acteristic of T'ang style. Note, too, the slightly fat facial types and the costumes derived from Chinese and Central Asian types.

Despite the provincial style and the slight naïveté of the conception, there is a general air of liveliness and of interest in the world — not just in religious narrative, but in landscape and in everyday happenings. It is the foreground conventions which betray provinciality. The artist simply made a few strokes over a blob of green to indicate the area as covered with blades of grass; this convention derives from the Chinese style where it was more carefully worked into overlapping patterns indicating recession in depth. Here it is simply used as a kind of decorative note, scattered over the surface of the ground The trees, too, show a conventional treatment rather than one based on observation of nature. Figure painting at this time in China and Japan was still ahead of landscape. (The last great period of figure painting was the seventh to the ninth century, while the first great period of landscape was the tenth and eleventh centuries.) The figure painting here, in terms of space organization, is ahead of the landscape development (*fig. 201*). The derivation of the Sutra of Cause and Effect is quite clear: it comes from the style found also at Tun-Huang in subsidiary passages in the wall paintings and in the fragments that have been found in the library there, painted in a curiously naïve, cartoonlike style. These are the two farthest extremities of the international Buddhist style of the T'ang Dynasty — Tun-Huang in Northwest China, and Japan, far to the east. The Tun-Huang figures are almost exactly the same in style as the Sutra of Cause and Effect, especially the little nude figure of the Buddha and the trees. Notice that in China, even at a provincial area like Tun-Huang, the landscape, with its receding hills and mountains and great distant peaks, is more sophisticated than that achieved by the relatively unsophisticated Japanese artist in his little handscroll. What the great Buddhist scroll creations from the urban centers looked like we can only imagine from these charming provincial remnants or from Chinese examples of slightly later date painted by traditional masters in the manner of late T'ang (*fig. 202*).

The Rise of

National Indian and

Indonesian Styles

8. Early Hindu Art in India

WE HAVE BEEN FOLLOWING for some time the development of international Buddhist art and its iconography, and the spread of a largely Chinese style in the Far East. Now we must examine the development of a style native to India where images were associated, in nearly all cases, with the Hindu faith. It was a style which did not survive export to Southeast Asia and Indonesia, where distinctive regional styles developed, especially in Cambodia and Java.

Hinduism is one of the most complex subjects for the Westerner. The reader cannot be given here a proper foundation in Hindu cosmogony or iconography. For one who wishes to pursue the subject at great length, there are many volumes on philosophy and iconography and translations of a vast store of literature. Still, we are confronted, by necessity, with the problem of giving a brief picture of Hinduism; and in doing this we must oversimplify, but it is hoped, not falsify.

There may be said to be two basic elements in developed Hindu thought: elements which derived from pre-Aryan elements of the population and are called Dravidian; and Aryan or Vedic elements, associated with the invaders who probably destroyed the Indus Valley civilization, and who contributed their way of thought to Hinduism. In general, the Dravidian elements can be described as sensual; qualities associated with the early fertility cults whose deities were found in Indus Valley sites of about 2000 B.C. They were frankly virile cults, involving a personal devotion (*bhakti*) to

168

LEFT:
203. Stone Bowl Supported by Female Figure, from Fyzbad. Sandstone, height 38⅝". Kushan Period, 2nd Century A.D. Bharat Kala Bhavan, Hindu University, Benares

OPPOSITE:
204. Bas-Relief of Heaven and Hell, from the south wing of the Gallery of Bas-Reliefs, Angkor Vat, Cambodia

and worship of male and female deities associated with procreation, whose powers were called on to induce fertility in all things, to stimulate the very pulse of life itself. Beginning with simple representations in pinched clay of fertility deities, the images of these cults were later included in the service of Buddhism. The typical Indian ideal woman was the Yakshi, like the one from Fyzbad, a fertility deity associated with the waters, who holds in her hand a flask containing the water of life (fig. 203). On her head, she bears a lotus capital; behind her, vines and creepers of the water grow about her. The emphasis upon female characteristics—breasts, hips, and pubic region — is presented forthrightly and with that slight exaggeration which allows the image to give full expression to the function of the deity. In many cases, these fertility elements were represented very literally and served as symbols — the phallus of the great God Shiva, the *yoni* of the great Goddess

205. Brahma, from Haccappyagudi Temple, Aihole. Stone relief, length about 96".
c. A.D. *500.* Prince of Wales Museum, Bombay

Devi. Symbols such as these are Dravidian, and can be traced back to the very beginning of Indian civilization. The phallus symbol is found quite often at Mohenjo-daro and Harappa.

In contrast to these down-to-earth and intuitive elements are those derived from the Aryan tradition, which can be described as formal or intellectual. Among these are the concepts of hierarchy and caste, of levels of society, as, for example, in the representation of Heaven and Hell at Angkor Vat in Cambodia, in the late twelfth century A.D., where below we see the road to Hell with its tortures and above the road to Heaven with its rhythmical and ecstatic procession of the saved (fig. 204). Such concepts of hierarchy and caste, of the saved and the damned, are quite in keeping with the Aryan element of Hinduism. Emphasis was placed on religious rites conducted by the Brahmin or priestly caste, in contrast to the personal devotion of the Dravidians. In connection with this formal quality, we have the mathematics of theology, the endless development of "significant" numbers, and of the accumulation of detail by addition as a means of assimilation and explanation. Thus we have the sixteen avatars of Vishnu, the many aspects of Shiva; the three

aspects of Being; the eight women in love *(nayakas)*, and many others. This Aryan element of Hindu thought influenced later Mahayana Buddhism, with its emphasis upon hierarchy, caste and number, and its attempts to find the Buddha everywhere, at all times, throughout eternity. Abstractions, the concept of zero, the elements that we associate with metaphysics and, to a lesser degree, with mathematics, were also primarily Aryan contributions. The Aryan pantheon which we know by name from the Vedas includes Agni, God of Fire, especially the sacred flames of the altar; Surya, whom we saw at Bhaja riding over clouds and dispelling the darkness of the old faith; and Indra, God of Sky and Storms, riding on an elephant over and above the tree-worshiping fertility followers of the pre-Vedic tradition. The Vedic gods continue as lesser figures in the vast Hindu pantheon. Indeed, the roles and characters of some of them become absorbed by the slowly emerging Hindu deities who, growing by accretion, are a synthesis of popular and philosophical concepts; their various aspects and activities accumulated from myth and epic, and the later Puranic collections of cosmic myths and ancient semihistorical lore. So Rudra, God of Storms and the destructive forces of nature,

was absorbed into the figure of Shiva; Varuna, Lord of the Waters, into that of Vishnu. If the combinations of gods or the various aspects of one god seem to reach the height of confusion at times, it must be remembered that, among the initiated, behind this multiplicity lies a faith in one divine being whose energy is manifested in many forms and that these forms have serene or divine *(sattvic)*, active *(ragasic)*, or fierce and destructive *(tamasic)* aspects. The various trinities and combinations of deities are instances of complexity. In one trinity representing the three great gods of Hinduism, Brahma is the Creator, Vishnu the Preserver, Shiva the Destroyer. In another Shiva alone plays these roles. In one image Shiva is both male and female, in another Shiva and Vishnu are combined.

Originally and in theory, Brahma, the Creator, four-headed, as you see him on a temple at Aihole, facing the Four Directions, and all-seeing, was one of the most important deities *(fig. 205)*. But in the days of developed Hinduism his position as a primary deity was not strong, and certainly he is artistically far from important. In an important Vaishnavite sculpture of the seventh century A.D. at Mahamallapuram his birth is shown: Vishnu lies on the waters on the coils of the serpent Ananta and Brahma issues from his navel to activate the world *(fig. 206)*. Of the members of the Great Hindu Trinity, Vishnu and Shiva are predominant. Vishnu had many avatars or incarnations when he assumed various forms to save the world from one disaster or another—that of the boar, the lion, and the fish among them. But one of the most important of these is that of Krishna as the cowherd of Brindaban, a lyrical personification of universal love, whose exploits as the lover of village maids and conqueror of demons are celebrated in literature and in later art, especially in Rajput paintings of North India. The Krishna of the *Bhagavad-Gita,* a work of the first century B.C., who as charioteer of the hero Arjuna revealed himself as the One God, was a more remote and abstract conception.

The third member of the Trinity, Shiva, is to his worshipers the Supreme Deity, encompassing all things. The most famous representation of Shiva, to Western eyes, is his manifestation as Nataraja, the Lord of the Dance *(fig. 207)*. The image reproduced shows Shiva Nataraja, dancing the cosmic dance, in which the universe is to be considered as the light reflected from his limbs as he moves within the orb of the sun. A fine

206. Vishnu Anantashayana, from Mahamallapuram. Granite relief. Pallava Period, 7th Century A.D.

description of the meaning of this image is to be found in the first section of Coomaraswamy's *Dance of Shiva*, a lyrical presentation as well as a reasonably complete one from an iconographic point of view. When Shiva is represented as Mahesha, the Supreme Deity, he assumes all the functions of the Trinity; and thus we find him in the great sculpture at Elephanta, a large carving in the living rock, some eleven feet high (*see fig. 243*). On the left his head is wrathful as a Destroyer, in the center benign as a Preserver, while on the right is his female aspect as Creator and giver of fertility — the Beautiful One.

To the figures of the great gods must be added that of the Goddess Devi, known under many names, whose worship as a Supreme Deity is as old as the Indus Valley culture. As Uma she is *sattvic*, the Great Mother; as Parvati she is the energy and consort of Shiva; as Durga she is active or *ragasic*; as Kali, Goddess of Death, she is *tamasic*. As Durga, for example, Devi is shown accompanied by her retinue of dwarf soldiers riding on her vehicle, the lion, slaying the wicked bull demon, Mahisha (*fig. 208*). There are many lesser divinities, among them: Ganesha, the elephant-headed God of Good Fortune, and Kartikkeya, God of War.

Certain basic concepts are essential for any real understanding of Hindu art, and certain misconceptions must be avoided. The concept of image and worship has been clearly presented by Coomaraswamy. In theory, and to the most initiated and adept of the Hindu faith, the image is not a magical fetish, worshiped

172

*207. Nataraja, Lord of the Dance. Copper, height 43⅞".
Chola Period, 11th Century A.D.*
Cleveland Museum of Art

魔衆手目催刀各盡
決定當成正覺是諸
奇我未曾有也菩薩
塵輩甘悲歎言嗚呼
異相猶如師子震於
動天地菩薩心定顏无
遶菩薩放大惡聲震
魔軍衆无量无邊圍
是來下側塞虚空見
慈悲心而愍傷之於
此惡魔憾賦菩薩以
孔面流淨居天衆見
慈魔衆瞋恚增盛毛
法天人諸龍兇菩恣
大海水一時涌沸譁
火烟塵暗无所見四
風舊霰震動山谷風
烟起炎爛衝天或狂
欲裂菩薩身或四方
殺圍遶菩薩或復有
等諸惡類形不可稱
或馳步吼嚥有如是
行跳擲或空中旋轉
然或瞋目怒辟戴傍
蛇遍經身或頭上大

Colorplate 13. Kakogenzai Ingakyo, from the Hoon-in. Sutra Scroll, color on paper, height 11". Nara Period, mid-8th Century A.D. Daigo-ji, Kyoto

Colorplate 14. Devotee of Kali. Copper, height 16¼". 12th Century A.D.
Nelson Gallery-Atkins Museum (Nelson Fund), Kansas City

*208. Durga Killing the Bull Demon, from Mahamallapuram. Rock-cut relief, height about 108".
Pallava Period, 7th Century A.D.*

in itself, but stands for something higher — a manifestation of the Supreme Being. The Hindu use of images was first of all an aid to contemplative discipline, a way of achieving identification with deity. Early and impermanent images of paste and clay were replaced with those of more permanent materials, describing the deity and his powers as accurately as possible. These representations were much influenced by devotional descriptions in poetry and scripture. If several heads or numerous arms were required to hold the symbols and attributes of the deity and his powers, then they were supplied. The end was realization of the deity's being, not the representation of a merely sympathetic human being. While the distinction between image and idol was essential, we must also understand that it was not clear to everyone; that, to the average person, the distinction was very hazy indeed. One can be sure that when a peasant went to Sanchi to worship the Buddha, the fertility deities at the gateway were his principal concern; that when an ordinary devotee prostrated himself before the image of Kali, the Goddess of Death and Destruction, or before Shiva, in his procreative aspect, fine distinctions were far

from his mind, for he was confusing the image with the god — in short, he was touched by idolatry. Still, the distinction exists in theory and high practice.

A further and significant characteristic of Hinduism is the concept of macrocosm and microcosm, of the desire to have the artist represent on a small scale the huge scale of the universe. For example, the Kailasanatha Temple at Elura, which we shall see, is not simply a massive stone cutting, but an attempt on the part of the architect and the sculptor to visualize the universe in a monument ninety-six feet high, and to orient and build it in such a way that it becomes a magical structure, one which contains the world within its compass. Thus the orientation of the plan is to the Four Directions, and in the cell of the temple — the basic unit for individual worship in the Hindu faith — there was planted a copper box containing "wealth of the earth, stones, gems, herbs, metals, roots, and soils." At this time the Earth Goddess was invoked: "O thou who maintainest all the beings, O beloved, decked with hills for breasts, O ocean girt, O Goddess, O Earth, shelter this Germ."[3] This, in the words of some Hindu texts, inseminates the temple and gives it life.

175

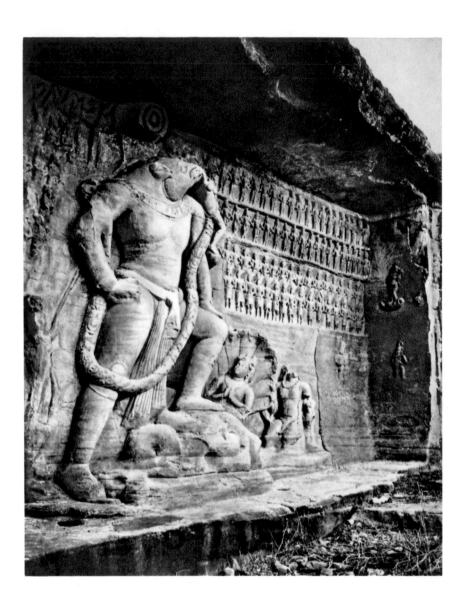

209. *The Boar Avatar of Vishnu, from Udayagiri, Madhya Bharat. Stone, height 12' 8". c.* A.D. *400*

The development of Medieval Hindu art was relatively rapid. Its foundations go back to Mohenjo-daro and the Indus Valley civilization of the second millennium B.C., with its fertility cults; and to such great remnants of early sculptural style as the Parkham Yaksha, and the Besnagar Yakshi (*figs. 82 and 83*). These were previously discussed as examples of forest deities placed at the disposal of the new Buddhist faith. We mentioned briefly the place of the then emerging Hindu deities as servants of Buddhism, and particularly the possibility that their symbols were present on the lion capital at Sarnath in the form of animals representing the vehicles of Surya, Shiva, Indra, and another deity. On the walls of a Buddhist monk's cell, at Bhaja, were Indra and Surya, Hindu deities. But our study of Hindu art, as a form in itself, begins with the Kushan Period and with the famous *lingam* image of Shiva from Gudimallum, mentioned briefly in the earlier consideration of the Kushan Period (*fig. 107*).

In the Gupta Period beginning in the fourth century A.D., we find an increasing number of Hindu sculptures in stone and terracotta and of buildings, indicating the growing strength of Hinduism. Buddhism was in its most powerful period from about the second century B.C. through the fifth century A.D.; then it gradually declined, to be found later only in limited areas, notably in the northeast and in Nepal and Tibet. Hinduism offered a practical and worldly rather than an ascetic way of life and with its old roots and vigorous image cult appealed to the mass of the people.

The first great Hindu monument of the Gupta Period is a relief of the boar avatar of Vishnu at Udayagiri in Central India, not far from Sanchi (*fig. 209*). There is no distinction stylistically in this period between Hindu and Buddhist subjects. Both are handled in the relatively quiet style of the Gupta artist. At Udayagiri a colossal relief carved in the living rock is conceived in a form that recalls such Sassanian Persian reliefs carved

in the living rock as those representing Shapur and Valerian at Naksh-i-Rustam. The Udayagiri relief represents Vishnu as a towering boar-headed human supporting on his shoulder the Goddess of the Earth, whom he has rescued from the Serpent King of the Sea at the lower right. The scene is witnessed by a variety of deities and angels arranged in the rigid rows of a geometric pattern behind and at the sides of the shallow cave. The composition is relatively static and organized in a single plane along the wall. The pose of the main figure fits into this plane, while the rigid rows of small deities reinforce this static effect.

Such a form was admirably suited to Buddhist art, and to the expression of the serene and contemplative Buddhist ideal; although this was one of the ideals of Hinduism, other ideals required sculpture of tremendous dynamism, capable of portraying movement and the narration of great epics. Such a style did not evolve until the end of the Gupta Period, then was further developed in the early Medieval Period, and continued until the eleventh or twelfth century A.D., after which time, except for such media as bronze or wood, it declined.

The first monument which shows the transition from the Gupta style to the Medieval style is the Parel Stele, a colossal marble image found by accident near Bombay some thirty or forty years ago (fig. 210). After excavation it was put into *puja*, or worship, at a nearby Hindu temple and is therefore removed from the eyes of Western man. But it has been thoroughly photographed and so we are able to evaluate it as one of the greatest and most significant of Indian sculptures. The upper part of the stele probably represents the three aspects of Shiva and their emanations. Below are representations of dwarfs, the usual attendants of Shiva; the main image wears the male and female earrings characteristic of all-embracing Shiva. But what interests us even more than its iconography is its style, because here we see for the first time that quality of movement and expansion where the sculptor denies the nature of the stone and makes the images appear to grow out of the material and dynamically project beyond its edges. This effect is achieved, in part, by such modeling details as the indrawn breath which increases the size of the chest, the very erect pose of the figure, with its chin thrust out, all helping the psychological creation of what H. Zimmer calls "expanding form." By the arrangement of numerous figures in a pattern suggesting movement and expansion, the main figures seem to grow as one watches them. Notice how the central figures rise almost to the top of the stele, and that the figures at the sides project to its edges. The repetition of the figures and of their parts, such as the knees or the patterns of hand and arms, creates an effect of rhythmic movement essential for Hindu art. The concept of such a dynamic deity as

Shiva, or of such an active one as Vishnu, or of such a sometimes terrible and awe-inspiring deity as the Great Mother Goddess Devi requires forms capable of more than contemplative beatitude. Such forms of expression developing out of the Gupta mode are called Medieval, a term chosen only because in point of time and social organization they parallel the period we call Medieval in the West. It is certainly an unsatisfactory, even arbitrary term, but now is in general use.

During this period from A.D. 600, there were numerous contending states but there was no great continental empire, as in the Maurya and the Gupta periods. The Parel Stele is a significant transitional work; but its direct descendant, the sculptures in the caves on the island of Elephanta, outside Bombay, must be considered later. Hindu sculptures have been found at Sarnath, carved in the cream sandstone associated with the Buddhist sculptures from that region, and there

210. Shiva Trinity and Host, called the Parel Stele. Stone, height 11' 5". Gupta Period, c. A.D. 600

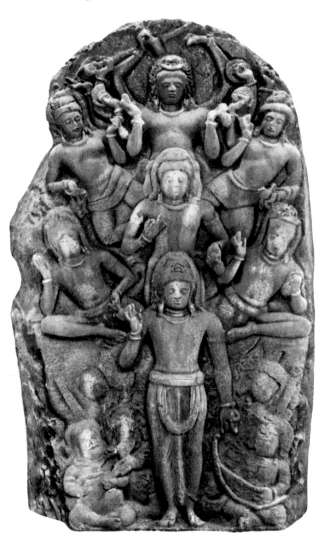

177

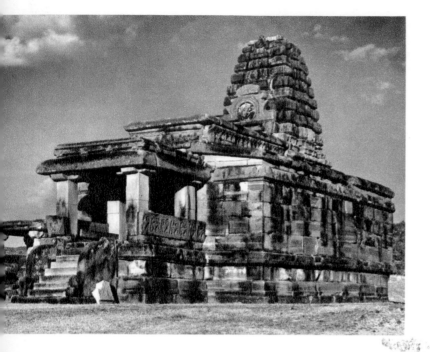

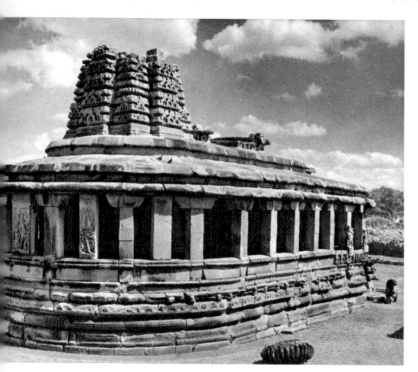

LEFT: *211. Hacchimalagudi Temple, Aihole. Gupta Period, 5th Century* A.D.

BELOW LEFT: *212. Durga Temple, Aihole. 6th Century* A.D.

examine at least two of the temples at Aihole — for architecture will occupy more of our time than before — because of the peculiar nature of Hindu architecture, or rather, we might say, of Hindu sculpture-architecture. The first of these temples is the Hacchimalagudi Temple, dated about A.D. 450 (*fig. 211*). The plan is a simple cell with a double ambulatory around it, and a porch. The temple is constructed on a post-and-lintel system derived from wooden architecture. The probable origins of such a style can be easily imagined: the combination of a stone or log base, wood post-and-lintel system, and thatched roof. The plan of this particular temple has no issue; it is the end of a tradition, not its beginning. The ambulatory was abandoned and thus also the concept of any kind of public access to the main area of the shrine.

The second temple is the Durga Temple built about a century later in the sixth century A.D., paired with the Buddhist cell-temple at Sanchi (*fig. 118*), to demonstrate the derivation of the Hindu temple and to show significant changes of importance for the future (*fig. 212*). While the Hacchimalagudi Temple is, in a sense, the end of a tradition, the Durga Temple is a beginning. It has a porch, and a stone megalithic roof — that is, a single stone covering the main area, deriving from archaic architectural construction in stone. It has an ambulatory that has been placed outside the building; that is, the porch is extended around the building so that one can walk outside the shrine, rather than in the building proper. The base has been elevated considerably; and there is a rudimentary tower placed over the main shrine area. These last two are of particular significance because they tend to remove the building from the realm of architecture and to place it in that of sculpture. And as we shall see, Hindu architecture must be considered primarily as sculpture. The tower will develop until it dominates the temple; the base will develop until it seems to dominate the lower part of the structure. The apse end of the Durga Temple shows more clearly the influence of the Buddhist *chaitya* hall, but with an outer ambulatory. The rudimentary tower is carved in great detail, with numerous representations including figures and miniature *chaitya* arches. We have seen such decorations on the Buddhist *chaitya* façades and in the caves; and they will develop into fantastic ribbonlike ornaments in the later Hindu Medieval style.

The sculpture at Aihole is more developed than comparable sculpture from the Bombay region, such as the

are Hindu sculptures of Gupta date from Central India. But *the* significant example, for our purposes, is the great stele from Parel.

A second Central Indian site, of great importance for the development of architecture as well as for sculpture in the Gupta Period, is Aihole. The architecture here shows some development beyond the single cell and *chaitya* type, previously seen in Buddhist architecture of the Gupta and earlier periods. We should

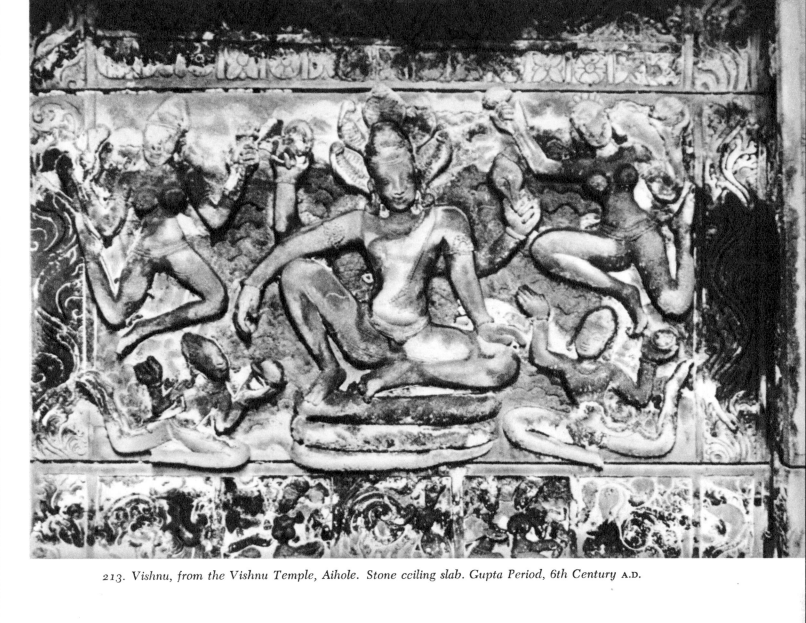

213. *Vishnu, from the Vishnu Temple, Aihole. Stone ceiling slab. Gupta Period, 6th Century* A.D.

Parel Stele, although it is of the same date, or slightly earlier. An image of Vishnu, seated upon the Serpent Couch, is carved on the ceiling of the Vishnu Temple at Aihole (*fig. 213*). And here we can see a variation of the expansive factor in early Hindu sculpture. Where the Parel Stele seems to develop this element by representing a certain physical type and by disposing these in an unusual fashion, giving the effect of expansion, the sculpture at Aihole, under the influence of clay technique, produces a more organic and fluid figure than any of those in the middle Gupta Period. The joints of the knees and elbows have lost any suggestion of bony structure and have become pliable, as if they were clay or some soft, plastic material that yields readily to the will of the sculptor. The relief is carved in sandstone, and one may perhaps think of this sculpture in terms parallel to those of purists of the modern school who say of painting, "What I ask of a painting is that it look like paint." These sentiments are all very well, but if we accept such so-called integrity of material, we must rule out, for example, many of the great

sculptors of the past and some of the great sculptors of today. Poor Bernini, for example, becomes a non-artist, simply because he finished marble to simulate the texture of flesh or of bark or of whatever he wished! Such restrictions also rule out some of the greatest of late Greek and Roman sculptures where the representation of skin textures is carried to extreme perfection. In short, if we take too pure an attitude, we rule out sculpture altogether and are left with the driftwood-and-boulder schools of modern sculpture. Hindu sculpture must be looked at — and especially this Medieval material — as an art that denies, or better, transcends, the material it is made of. Figures may seem to float off or on the surface of the stone, while others seem to emerge from the stone. The tendencies to be observed in the relatively balanced composition at Aihole enlarged and expanded as the Medieval style developed. In contrast to the fluid handling of individual figures, the Aihole compositions are relatively static when compared with the Parel Stele, for here is a figure balanced by four others in a rigid arrangement.

179

9. Medieval Hindu Art: The Southern Styles

WE ARE NOT FAR WRONG if we think of the Gupta sculptural style as a primitive Hindu one — primitive in the sense that it is archaic, early, and formative — while for Buddhism it was a Classic style expressing most completely Buddhist ideals and iconography. With this in mind, we can turn to the development of Medieval Hindu sculpture proper. There are various paths of exploration but, in general, it seems best to consider first the south of India and the sculpture of the region below the Kistna River. Madras is now the main city of this area. This region was largely controlled by the Pallava Kingdom from about A.D. 500 to 750. The capital was Kanchi, the modern Kanchipuram, about fifteen miles west of Madras. Pallava material necessarily comes first because this Southern style had tremendous influence on Central and even North India until the full development of a Northern style in the tenth or eleventh century. The origin of Pallava sculptural style we have already seen in the Buddhist sculptures of Amaravati and its related *stupas*. This manner has an organic character, the figures are more fluid and fleshy than structural and bony; they are in vigorous movement, the poses often varied and sometimes extremely exaggerated. At the time of the Buddhist *stupas*, this style was still kept within bounds by the use of architectural frames enclosing closely packed compositions, devices persevering almost until the end of the Amaravati school. Not until that time do we find figures of large scale with some space around them within which they can expand and move.

The Pallava style, derived from Amaravati and developed in its own right, is the dominant style of early Medieval art in South India and of great international importance. It was the Pallava Kingdom which had contact by sea with Cambodia and with Java; and it was through this commercial and religious contact, carried on by trade and by pilgrimage, that the influence of Pallava art was carried to Indonesia. Pallava sculpture and architecture is also important because of its influence on the style of Central India, an influence in part due to the warlike activities of Pallava rulers, but also to a hearty respect and imitation of a successful architecture which was even thought to be magical. When speaking of Pallava architecture, we can name a considerable number of constructed monuments dating back to at least mid-Pallava times. But we are more fortunate than that, for we have, at Mahamallapuram, large stone models of even earlier types. Mahamallapuram is a site on the Indian Ocean about sixty miles south of Madras, close to the deep blue sea with its beach of white sand. There are richly colored trees not far back from the sea, the whole site being a spit with salt-water inlets between it and the mainland. Mahamallapuram was a great pilgrimage site, and at the time of its flourishing from the sixth through the eighth century, there were numerous inns for pilgrims. The area was once populated by a considerable priest class, like any of the great contemporary pilgrimage sites in South India today, but it is now largely deserted, except for a cabin of the Archaeological Survey of India and the frequent visitor.

But the thing that distinguishes Mahamallapuram from other sites along the coast is the presence of great granite outcroppings, sometimes in the form of tremendous boulders larger than an elephant, or more often in the form of thrusting masses of rock anchored in the ground. Here was a material challenging to the sculptor and one which could be easily put to use; and the sculptors at Mahamallapuram carved a fantastic number of monuments in this living rock. One group, called the Five Raths, is an architectural museum, as if the designer deliberately intended to produce five model shrines, each one of a different type showing the development of Southern architecture from its ori-

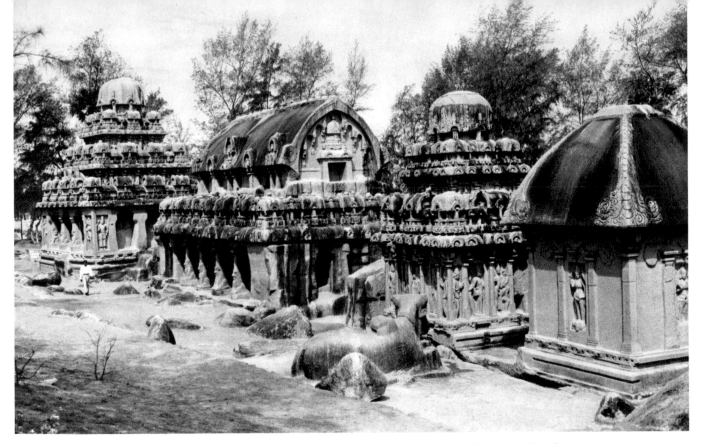

214. *The Pandava (Five) Raths, Mahamallapuram, eastern view. Pallava Period, early 7th Century* A.D.

215. *Durga Cell, from Pandava Raths*

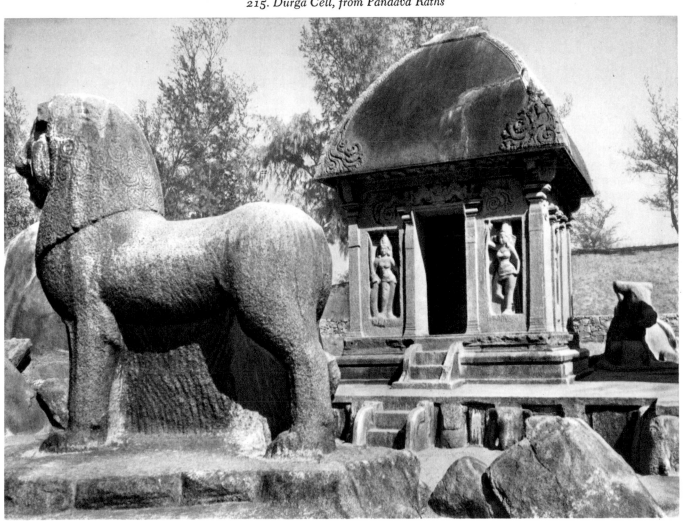

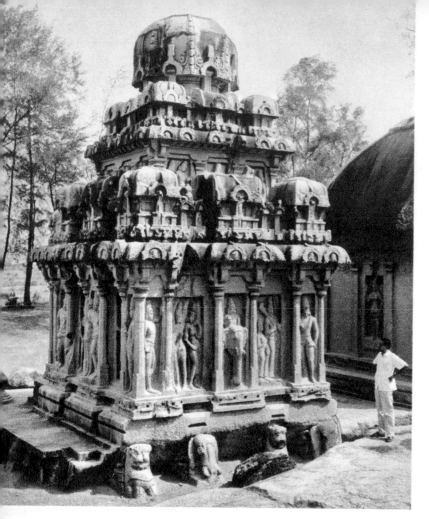

216. *Arjuna Rath, from Pandava Raths*

lookout posts applied to its surface. The emphasis in the tower is upon a horizontal conformation, and it has a primarily architectural and horizontal rhythm in contrast to the Northern style, which emphasizes verticality and appears to be much more organic in character. The tremendous capstone is also characteristic of the South. This stone, while cut in a large, mushroom shape, maintains an architectural character; the cap on the Northern style is more like an actual organic growth on the top of the tower. The full development of the peculiar type of Southern tower is seen in the Dharmaraja Rath (*fig. 217*). The vestigial wall with buildings and lookout posts can be seen very clearly. In this case it is in three stages with a marked emphasis on the horizontal. The Bhima Rath is a special type, a communal hall modeled on the *chaitya* hall. Its imitation thatched roof is derived from parabolic wood-vaulted construction. But this Rath is not typical, in contrast to the more characteristic South Indian types.

The term "stepped pyramid" may be used to describe the tower of the South Indian style and we will call the railing around the tower, derived from the enclosing wall of a compound, "vestigial model shrines." These two elements, the vestigial model shrines and the stepped pyramid *shikhara*, or tower, are the basic elements of the Southern or Dravidian style of architecture. There is one other architectural form found extensively in South India, and this is a form corresponding to the Buddhist *vihara*, the cell cut into a great boulder or hill to house priests or, more rarely, for purposes of worship. The type-site for early Pallava sculpture is the small *vihara* at Trichinopoly, dating from A.D. 600 to 625.

The great sculpture at Mahamallapuram and the one which concerns us most is the carving on two enormous granite boulders, often called the *Descent of the Ganges*, dating from the middle Pallava Period, A.D. 625-674 (*fig. 218*). In this particular monument we have one of the most published and most famous monuments of all Indian sculpture. One stands before a huge granite outcropping, some twenty feet high, with a natural cleft dammed so that the spring rains are collected in the pond formed at the top. At the height of the rainy season water pours over the dam and runs down the rock into the low enclosed pool in front of it, causing the calcium and iron discolorations at the central cleft. These hydraulics are essential for the completion of the sculpture, for here we have something comparable to a fountain by Bernini. The water moving across the face of the sculpture at the crucial point of the composition gives movement to the surface of the stone and reinforces the suggested movement in the stone itself. Nothing is more indicative of

gins to his own day (*fig. 214*). Such an intention was probably lacking, but fortunately the site provides just this. The Five Raths show the Dravidian or South Indian style in its early form. From right to left, we see the development of this South Indian style, beginning with a simple shrine, dedicated to Durga, having a pilaster at each corner and a thatched roof imitated in stone. From the other side, one sees a simple entrance to the shrine, all in a small structure not more than twelve feet in height, with the simplest proportions and the fewest elements, representing stage one in the development of the Hindu temple (*fig. 215*). While these elements are embellished with carved designs of tendrils and with images projecting from niches, they do not conceal the fact that the basic structure is that of a forest shrine — the simple cell.

The second building — the Arjuna Rath — shows an elaborated development of the cell type (*fig. 216*). It is still a square structure of post-and-lintel construction, but now we find a multiplication of sculpture around the sides of the building and an elaborately developed tower of a very particular type. The principal distinction between the Northern and Southern architectural styles lies in the tower. The tower of the latter style is constructed as if it were a simple forest shrine sitting on a base simulating a typical city wall with thatched

OPPOSITE: *217. Dharmaraja Rath, from Pandava Raths*

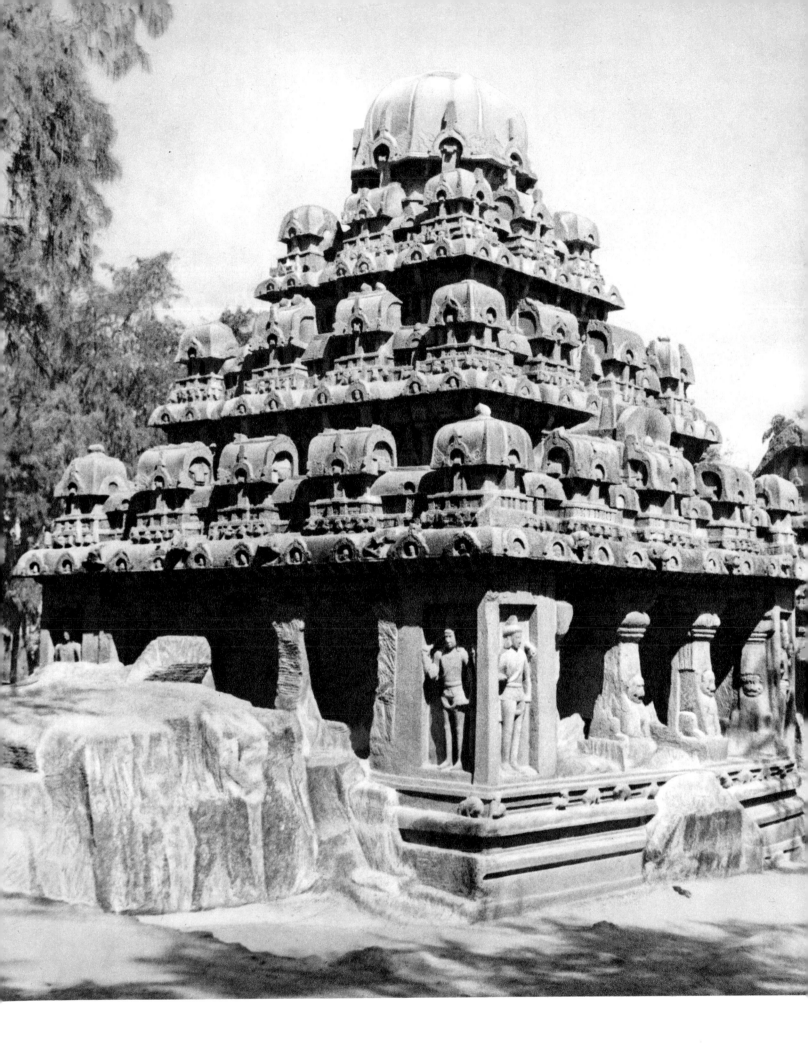

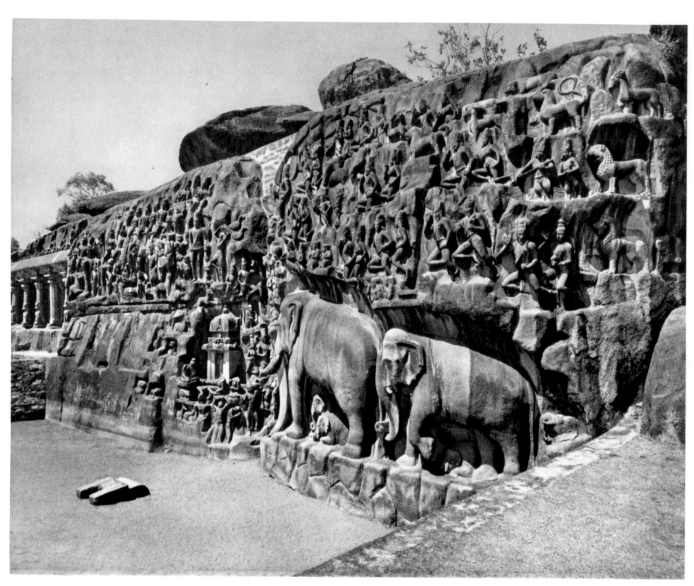

ABOVE: *218. Descent of the Ganges, Mahamallapuram. Pallava Period, 7th Century* A.D.

OPPOSITE ABOVE: *219. Ascetics and Nagas, from the Descent of the Ganges*

OPPOSITE BELOW LEFT: *220. Elephants, from the Descent of the Ganges*

OPPOSITE BELOW RIGHT: *221. The "Ascetic Cat," from the Descent of the Ganges*

the aims of the Hindu Medieval sculptor than this combination of elements at Mahamallapuram. The iconography of this particular sculpture is much debated, but current opinion inclines to its identification as the Penance of Arjuna.

A petitioner, by austerity, receives a favor from Shiva. The petitioner is shown twice — once standing in an ascetic pose with one foot elevated and arms raised overhead, looking up at the sun; and once seated in contemplation before a shrine. Shiva is shown as the granter of the boon, namely, the water of the Ganges River. Seldom in the history of art has so complete a

sculptural composition in stone been achieved. It is a veritable microcosm: deities of the river, elephants, bears, lions, gods, angels, men — all the living beings of the world congregate on the surface of this great carving. They move from two directions: from left and right to the cleft. The cleft is obviously the focus of the action, with representations of the activities of ascetics at the shrine and of ascetics with Shiva on the banks of the river (*fig. 219*). The river itself is populated with Naga kings and queens swimming upstream with their hands clasped in adoration of the God Shiva.

Partly because of the nature of the material this is

222. *Buck and Doe, from the Descent of the Ganges*

one of the most extraordinary achievements of the Hindu sculptor. The granite is very hard; the carving in some places is slightly unfinished. But everywhere the forms are more simplified than usual and the effect is of a slightly stronger, stonier style than that usually found in the softer sandstones of the North and Central areas. If we look at a detail, we may be able to see more clearly the elements of representation and of style. Notice, for example, the character of the figures which have come to the river bank to draw water — the chest of the dominant man, or the Naga king as he moves up the river. They all have that expansive quality which the Hindus call *prana*, or "inbreath." Notice too the representation of the animal world, for at Mahamallapuram we find a quality characteristic of Indian art in general: a sympathy for and understanding of the representation of animal forms comparable, in its way, to Chinese painting of fur and feathers. The elephants, ranging from the massive bull and the female to the small baby elephants below, are a most successful representation of, let us say, the nature of elephants — of their mass, their bulk, their deliberate movement and also of that expression which implies a degree of wisdom beyond their animal nature (*fig. 220*). At the foot of the elephant is a cat standing with upraised arms with its ribs showing through the skin (*fig. 221*); and near the cat are rats in worshiping positions. This is a key to the identity of the water coming down the cleft; the stream represents the River Ganges, one of the three great sacred rivers of India. The identification was made by Coomaraswamy and is

based on an old folktale of the cat who, pretending to be an ascetic, stood by the Ganges with upraised paws and, gazing at the sun for hours, convinced the rats and mice that she was holy and worthy of worship and so was able to provide food for more than the soul.

Some of the human figures are descendants of Amaravati; so to speak, one sees behind them, some three or four centuries earlier, the flying angels of that site. But here is a style which seems to be much more natural and organic, with that quality of ease and amplitude so characteristic of developed Pallava style. The organization of the area beyond the central focus is relatively rudimentary and does not go much beyond the arrangement of rows of figures in the boar relief at Udayagiri; but still it is not as rigid. There is more variation and flexibility in these ranks of celestial beings than in the earlier compositions. A detail at the lower left, of a buck and a doe by a river bank, displays a particularly interesting instance of that Indian sympathy for animal forms which reached its height at Mahamallapuram (*fig. 222*). They are informed with that tremendous simplicity, even stylization, which recalls the works of some modern sculptors.

The granite cave temples (*mandapas*) at Mahamallapuram are filled with famous representations in relief of scenes from the legends of Vishnu and Devi, the Great Goddess. Because it is related to a relief already illustrated from Udayagiri representing the boar avatar of Vishnu, so that one can easily see the difference between Gupta and early Medieval style, we illustrate a relief from the Vihara Mandapa, illus-

trating Vishnu's boar avatar (*fig. 223*). The monumentality, massiveness, and large scale of the Gupta representation has been exchanged for a more human scale. The figure of the Earth Goddess more closely approximates life size, and is more in keeping with the scale of the other figures. The attendant deities have been reduced to two or three in number and they too are of a scale comparable to the rest of the figures. The relief in these *mandapas* at Mahamallapuram is relatively high, but is kept very much to one plane so that the figures in general are related to the surface of the stone beneath. But there are some very curious and often striking exceptions. For example, there is considerable technical virtuosity displayed in representing figures in a three-quarters view from behind, so that they are forcibly integrated with the rear plane of the stone. But, in general, we are conscious of a very simple and relatively balanced form of composition, with

figures on a human scale and in a relatively quiet style quite different from that evolving in the North. Just as the architecture of the Southern style appears to be solid, more architectural, with less movement and appearance of growth, so Pallava sculpture seems when compared with the art of Central and North India.

This by no means exhausts all the sculptures at Mahamallapuram. For example, there is a second large-scale but unfinished representation of the so-called *Descent of the Ganges*. It was left unfinished because the cleft in the rock evidently did not function properly as a source for the water and so the sculptors moved to a second and final site. The quantity of work produced in this hard stone in a relatively short time is quite extraordinary. Also at Mahamallapuram, close by the shore, is a structure called the Shore Temple, which illustrates further development of the Southern architectural style (*fig. 224*). It is not carved from the

223. Boar Avatar of Vishnu, Mahamallapuram. Height about 108". Pallava Period, early 7th Century A.D.

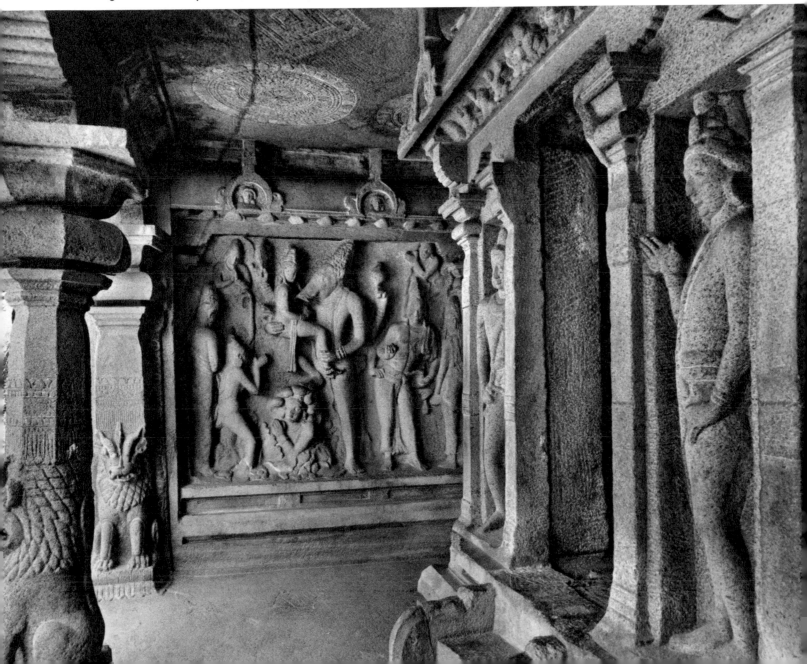

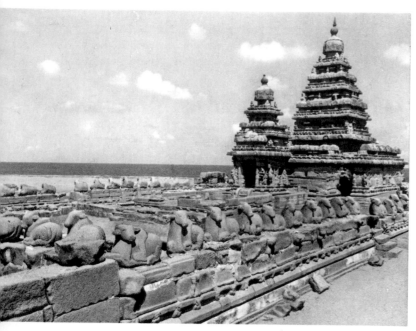

224. Shore Temple, Mahamallapuram. Pallava
Period, 8th Century A.D.

225. Lion Base, from Shore Temple

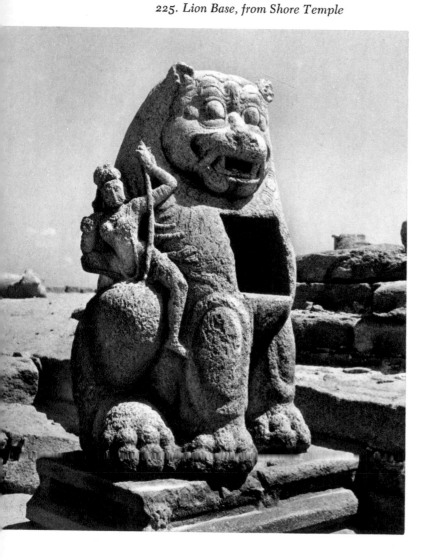

living rock, but is constructed of granite blocks. The temple is probably to be dated from the middle of the eighth century. Horizontality is still manifest, but there has been considerable vertical development in the tower. The building was surrounded by numerous sculptures: representations of Nandi, the Bull of Shiva, in rows on top of the wall; and some remarkable representations of archers carved in low relief on the backs of lions in the full round. One detail is of great importance in the development of later Pallava and Chola architecture and is in keeping with the general tendency of Indian architecture toward a less architectonic treatment. This is in the development of supporting animal figures into large-scale sculptures whose dynamic pose seems to deny their supporting role. In this case, lions are used as architectural members and they become almost a hallmark of later Pallava style at Mahamallapuram, and especially at Kanchi, where there are many eighth- and ninth-century temples (fig. 225).

A second great Pallava monument, perhaps not as fine qualitatively as Mahamallapuram, but of much greater importance for its influence in other areas at later times, is the principal temple at Kanchi, the Kailasanatha, built just before 700 (fig. 226). It is one of numerous Kailasanathas, Temples of the Holy Mountain dedicated to Shiva. Mt. Kailasa was the legendary birthplace and abode of Shiva high in the Himalayas. The Kailasanatha at Kanchi is the first of a series of three we will illustrate, one of the most extraordinary sequences in all Indian architecture and sculpture. This sequence begins with the Kailasanatha at Kanchi and moves north to a second at Pattadakal, and ends with the greatest of all, carved in the living rock at Elura in the North Deccan. The Kailasanatha at Kanchi uses architectural elements which are to be repeated twice over: a front screen with a main entrance gate, balanced originally on both sides by wall niches with images; a *chaitya*-type structure placed longitudinally athwart the gate as a tower; a porch behind the enclosing wall and attached to the main shrine; and a stepped-pyramid tower of typical South Indian style. Much of the complication of the Kailasanatha at Kanchi is complication by addition: more mushroom shapes used on the surrounding walls; a greater and more realistic development of the horizontal vestigial enclosures on the tower; and a more elaborate development of the "brimming vase" (*purna-kalasa* or *purna-kumbha*) used as a decorative motif on the roof. But the plan of an enclosure with a main gate with this particular type of tower over the gate, with the main temple inside, crowned by a stepped pyramid of this type, is first established in these proportions and with this distribution at Kanchi.

The plan and elevation are copied almost literally at Pattadakal. The Temple at Pattadakal is more often called Virupaksha, but it is also known as a Kaila-

sanatha (*fig. 227*). It was copied by a minor monarch from the one at Kanchi, and was the direct result of warfare between the two countries, resulting in the bodily removal of architects and workmen from Kanchi to Pattadakal. The illustration shows us a second important element of the plan, also present at Kanchi. Imagine that you are inside the enclosing wall and that you are looking at the main shrine, and that between the entrance gate and the porch there is a separate shrine for the bull Nandi, the vehicle of Shiva. Nandi is as usual a stone image, placed in the Nandi Shrine, facing the nave of the main temple toward the image of Shiva in the inner shrine. The porch itself has the simulated thatched roof characteristic of South Indian style. The construction is basically Southern but was adopted many miles north, at Pattadakal; and we will see it removed once again even farther north to Elura. I would draw attention here to one thing in particular: the base is considerably increased and enlarged when the second move north is made. But the

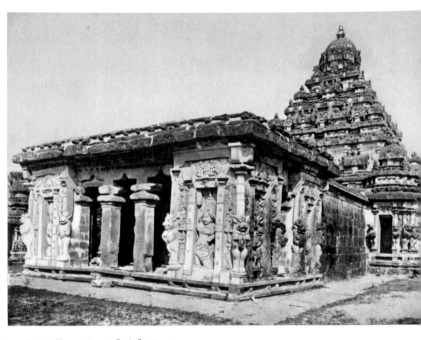

ABOVE RIGHT: *226. Kailasanatha Temple at Kanchi. Pallava Period, 8th Century* A.D.

BELOW: *227. Virupaksha Temple, Pattadakal. c.* A.D. *740*

228. Ravana Ka Kai, Cave 14, Elura.
c. A.D. 700–c. 750

229. Dancing Shiva of Rameshvara, from Cave 21,
Elura. Height about 96". c. A.D. 640–675

temple base at Pattadakal is still relatively small in
proportion to the rest of the building, and the support-
ing animal forms are somewhat small. One further
point: note the repetition of images in niches, either
on the main walls or on the corners of open buildings,
such as the Nandi Shrine. One must imagine them as
representations of what is worshiped within, emanat-
ing from the interior of the building out to the presence
of spectator or pilgrim. We can recognize, even at this
distance, one or two representations of aspects of Shiva,
for all three temples — at Kanchi, Pattadakal, and
Elura — are dedicated to him. The first two of these,

191

Colorplate 16. Madhu Madhavi Ragini. Color on paper, height 7⁹⁄₁₆″. Rajasthan, Malwa, mid-17th Century A.D. Cleveland Museum of Art

Kanchi and Pattadakal, are constructed temples made of blocks of stone and, while large, not as large as the last and greatest of them all.

Before we turn to the Kailasanatha of Elura, the culmination of much of what we are studying in the Southern style, we must look briefly at the developments in Central India before the construction of the Kailasanatha. This is particularly necessary in the field of sculpture, because a sculptural style was developing in the West Central area of the Deccan under the Chalukya kings which, when it was transferred to the North Central area, was to dominate the sculptural style imported from the South. While the architectural style of the South dominates in the region of the Deccan, the accompanying Southern sculpture is changed, more often than not, by the native style developed under the Chalukyas. The Chalukyan Dynasty, founded in A.D. 550, was largely destroyed in A.D. 753 by the Rashtrakutan rulers who built the Kailasanatha at Elura. And so we move to some of the earlier caves at Elura constructed under the Chalukyas, in the seventh and eighth centuries A.D.

Elura is an escarpment, a projection of volcanic stone like the stone found at Ajanta, jutting up out of the plain. It is situated not far from Aurangabad, one of the two great cities of the former Hyderabad, on that central plateau called the Deccan. Elura is the great site for the Hindu art of Central India and one of the greatest monuments in the world. There are some thirty-three caves at Elura: twelve are of Buddhist type dating from the seventh century, or slightly earlier, to the eighth, four are Jain caves, and the remaining majority Hindu. Some are two-storied *viharas*, and it is one of these, Cave 14, Ravana Ka Kai, that we illustrate (fig. 228). The light filters in from the front to the back where the main shrine is located. In each niche around the square assembly area, supported by columns, we find representations of aspects of Shiva carved from the living rock. The whole complex must be imagined as a sculpture — or rather as architecture in reverse, with the forms created by removing stone to "release" them.

Cave 21, Rameshvara, contains one of the earliest (c. 640-c. 675) representations of the Dancing Shiva in any medium (fig. 229). The image is also of interest because it is derived from Gupta style, and so is characteristic of the early Chalukya Period, before the arrival of Southern influence from the Pallavas. The early Dancing Shiva is only mildly animated; nevertheless he moves, particularly through the arms, to a degree unknown in classic sculpture. But in contrast to the later Dancing Shivas, the foot is hardly raised from the earth and the moving leg is not thrown high and across the body as it is in later images. The movement of the figure, while sinuous from the front, is strictly aligned to the plane of the wall facing the spectator. Note the

230. *Shiva and Parvati on Kailasa, from Dhumar Lena, Cave 29, Elura. Height about 96". c. A.D. 580–c. 642*

231. *Lion Avatar of Vishnu, from Das Avatara, Cave 15, Elura. Height about 96". c. A.D. 700-750*

use of figures framing the main image like a halo. The whole effect, while possessing energy and vitality, only begins to be free from the rock, and achieves none of the frenzy to be realized a century later. Like the Dancing Shiva, the representation of Shiva and Parvati seated on Mt. Kailasa above the demon Ravana (in Cave 29, Dhumar Lena), while more energetic than Gupta work, is relatively restrained, and the figures preserve the almost unfailing frontality (fig. 230).

The most significant transitional cave at Elura, which contains sculptures showing the "energizing" of the Gupta style, is Das Avatara, with a representation of Vishnu as Narasimha, his avatar as a lion (fig. 231).

193

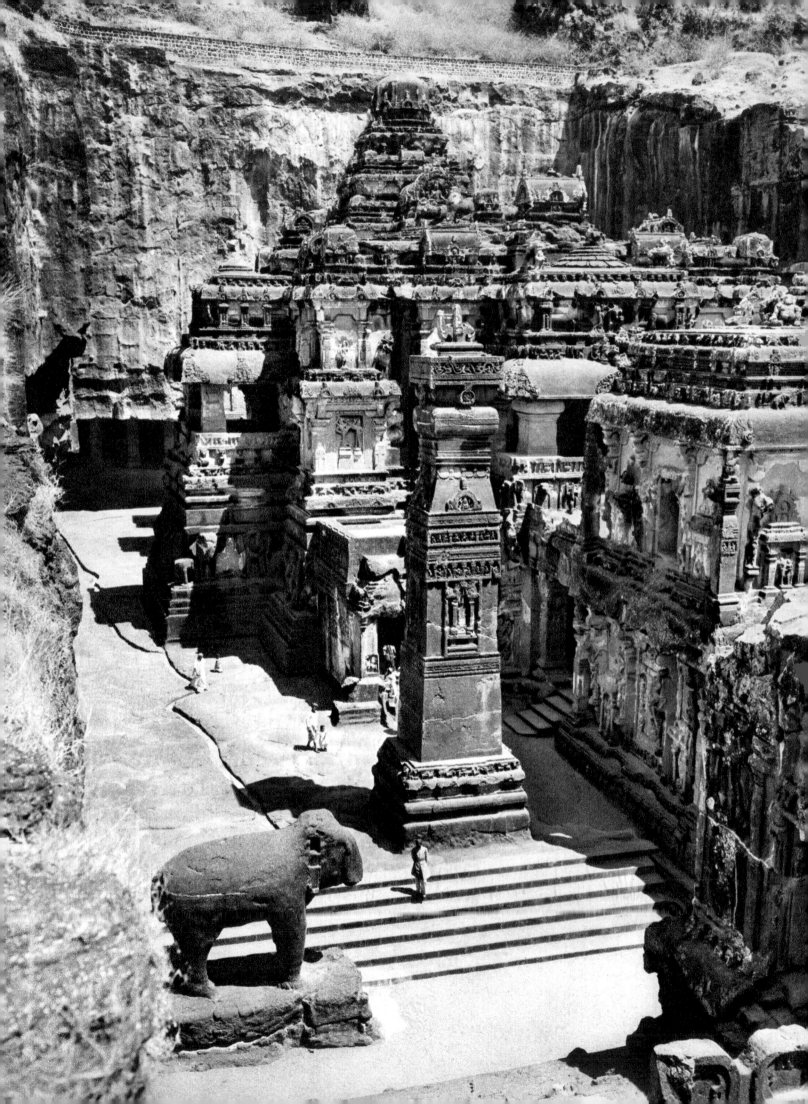

This composition, one of the most interesting in all of India, was produced by early Medieval sculptors. We can sense the derivation of the eye and other parts of the face from Gupta sculpture. The manner in which the drapery falls tight to the rock recalls a little the late Gupta or early Medieval sculpture of the Naga King and Queen at Ajanta. But with the Narasimha, we are aware of an expansive force already seen in the Parel Stele. The main figure is placed tightly in the frame; the headdress reaches to the top while the king's body fills the space to the right. The whole composition begins to burst from its boundaries. And now we find that the figures are not so tightly related to the rear plane of the rock. The king's body is turned; the head thrusts out; the arms stretch back. The figure of Vishnu is turned sideways, with the shoulders toward

OPPOSITE: 232. *Kailasanatha Temple, Elura. Height 96'. Early Medieval Period, second half of Rastrakuta Dynasty, c. A.D. 750–c. 850*

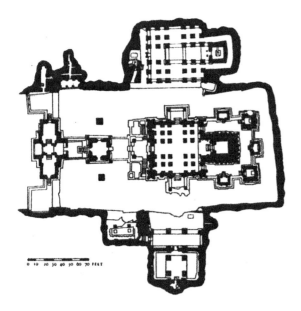

LEFT: 233. *Plan Drawing of Kailasanatha Temple*

BELOW: 234. *The Ramayana Friezes and the Nandi Shrine, from Kailasanatha Temple. Second half of 8th Century and early 9th Century* A.D.

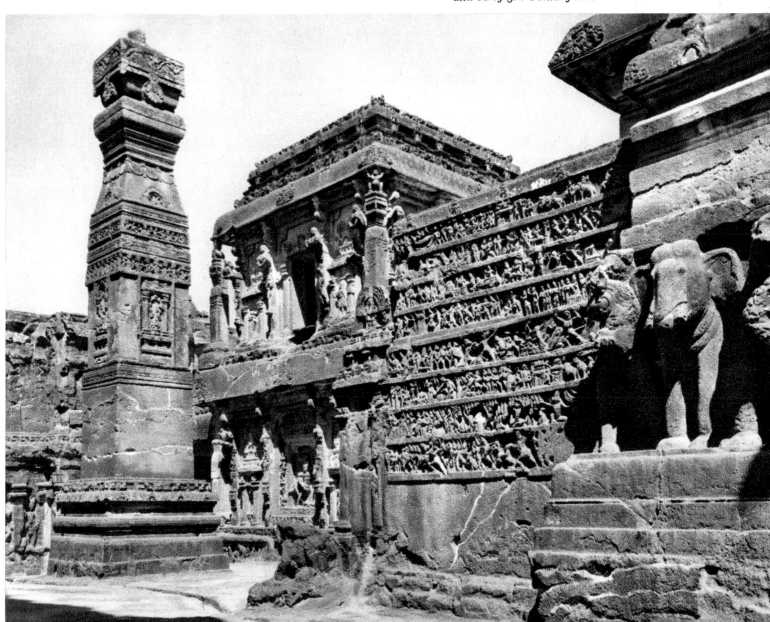

the onlooker; but the hips are seen from the side as the leg thrusts forward. The whole sculpture now seems to exist as a movement of figures in the rather deep, atmospheric space of the niche. They seem strangely trancelike when we know the story, one of the favorite subjects of the Hindu dancer. Vishnu turns into a lion to destroy a wicked king who had used his name in vain. In later Indian art, it is gruesomely shown with the king stretched on the knees of Narasimha as the God tears out his entrails with his claws. The representation is quite different in early Indian art, for while the subject can be frightening, here it is treated in a very lyrical and dramatic way. The lion rushes toward the king, but his hand is lightly placed on the king's shoulder, delicately, almost as if in a dance. Observe the king, the expression of his face, the movement of his body, not retreating, but swaying toward the figure of Vishnu in the measured, rhythmical movement of the dance. Someday someone will make a thorough study of the relationship of Indian sculpture to the dance, because it is quite certain that many of the major elements of representation in Indian sculpture, especially of the Medieval Period, of men and women, kings and queens, gods and heroes, are derived from dance and dance-drama. The iconography is dictated by the faith, but the style is produced by the sculptor from observation of the dance.

The culmination of the early Medieval style of the North Central Deccan is found in the Kailasanatha of Elura, begun in A.D. 757 under the successors of the Chalukyas, the Rashtrakutans, by the greatest early king of that dynasty, Krishna II, who reigned from A.D. 757 to 783 (fig. 232). The Kailasanatha is at the northernmost point of the penetration of Southern architectural style and, indeed, its architecture is almost purely Southern or Dravidian. The sculpture, while influenced by the Pallava style, is basically a continuation of the Chalukyan style found in the Cave of the Avatars, but carried to a higher pitch and, in some cases, almost reaching a frenzy. No words express better the feeling one has on looking at this great monument than the words of Krishna II himself: "How is it possible that I built this other than by magic?"[4] It is literally a "Magic Mountain" in living rock, an achievement of sculpture rather than of architecture. Its chronology is much discussed since an article appeared in *Artibus Asiae,* in which Goetz attempts to apportion the construction of the temple over a considerably longer period of time than had previously been allowed. His argument is interesting, but not widely accepted, and in general we must believe that the major part of the work at the Kailasanatha of Elura was accomplished under Krishna II, even if some of it was finished by his successor.

It is a Magic Mountain with a court 276 feet long and 154 feet wide and with a central tower reaching a height of 96 feet. The sheer physical problem of carving this tremendous temple from the living rock awes one. The height of the beginning of the cutting is higher still, the drop directly down to the court

235. Base of Fighting Animals, from Kailasanatha Temple. c. second half of 8th Century A.D.

196

236. *Flying Devata, from Kailasanatha Temple.*
Second half of 8th Century A.D.

237. *Shrine of the Three Rivers, from Kailasanatha Temple.*
Second half of 8th Century A.D.

behind the temple being 120 feet. The model used was that transmitted through Pattadakal from Kanchi; but this is on a larger scale, more elaborately developed from the standpoint of sculpture and of architectural decoration. We see the same front screen and the Nandi porch, but this time it is raised two stories so that it goes directly on a second-story level into the porch of the main temple. There is a tower over the main shrine, a subsidiary *chaitya* tower over the front porch, and the two side-porches of the main building that are characteristic of this imported model. But there are, in addition, two tremendous stone towers some sixty feet high, flanking the entrance, with representations of jewels and other riches of this world. The plan (*fig. 233*) reveals the layout more clearly than any view, with the screen, the Nandi Shrine, the two towers, the porches, three in all, the gathering place with its columned hall, the shrine proper, and the five subsidiary shrines on a second-story terrace outside the main shrine and dedicated to various deities associated with Shiva. As if this were not enough, around the sides of this tremendous sculpture are carved subsidiary shrines in the vertical sides of the pit: the Shrine of Ablutions, with representations of the Three Great Rivers; a long series of sculptures at the rear; a second-story temple carved in the rock, with a set of reliefs relating to Shiva; a series of reliefs of the avatars of Vishnu and aspects of Shiva on the ground floor around the side and completely enclosing the

back end; and a two-story temple on the right, connected by a bridge from the porch, with representations of the Great Goddess Devi and the Seven Mothers. Numerous smaller shrines complete the ensemble. While one can understand why Goetz believes that it was not all built in a short time, the basic elements represent the achievement of a single architectural conception.

The Kailasanatha is a massive work of sculpture, not architecture. On entering, after passing through the main gateway, one is struck by the contrast of the brilliant sunlight of the Deccan Plateau, streaming into parts of the court, and the deep blue shadows cast by the high surrounding mountainside. The wildly moving sculptural representations, the angels flying on the walls of the temple, the representations of Shiva produce so overwhelming an effect that one feels feverish, as if overcome by wildly exalted feelings. It is one of the most extraordinary sensations to be experienced in looking at Oriental works of art.

The Temple has never been fully published. There are adequate illustrations of some of it, but no publication that reveals its tremendous wealth of material. The illustration demonstrates the relationship of the Nandi Shrine to the temple proper (*fig. 234*). The Nandi porch and shrine are on the second level, running across to the front porch of the main temple. There are several points to be made with regard to this illustration. Note the sudden swelling of the base,

238. *Jumna, from the Shrine of the Three Rivers,
Kailasanatha Temple. Height about 72".*

Perhaps somewhat later in date, in accordance with Goetz's suggestion, are the narrative reliefs of the Ramayana on the side wall below the porch. These are in almost a scroll-painting form, with the narrative running horizontally in registers. But the individual scenes do not have the character, movement, and life of the sculptures on the main structure. We can see the ultimate development in the flying angels on the walls of the temple (*fig. 236*). These seem to soar off the walls and are completely nonarchitectural in character, almost denying the nature of the material, the substance and passivity of the architecture.

Onc can also see that the building was possibly originally painted over a covering layer of stucco. It is difficult to determine its original appearance. When the Moslems conquered the Deccan at the beginning of the sixteenth century, they called the temple the Rang Mahal — the Painted Palace; so at that time the temple was painted. There are remnants of a white gesso used to cover the volcanic rock; and on some of the angels, if one looks carefully with binoculars, one can see several older layers of gesso, which suggests that the figures may have been not only carved, but modeled. The finishing touches in eyes, nose, mouth, and so on were achieved in stucco and by means of the fingers or other pushing instruments that modeled the soft material before it hardened. This again fits in with the proposition of the influence of plastic materials on all Indian sculpture, but especially Medieval sculpture. This is also true of Pallava sculptures, particularly of those on constructed temples. For example, the Kailasanatha of Kanchi has remnants of what appears to be an old gesso covering, polychromed.

The shrine at the left on the plan, the Shrine of Ablutions, has three niches with sculptures of the three goddesses, Ganges, Jumna, and Sarasvati — the three great sacred rivers (*fig. 237*). In my own hierarchy of Indian sculpture, one of the river goddesses, Ganges, stands close to the top, particularly as representation of the female form. The three niches are similar, with a typical South Indian lion mask at the top of each niche. The background of each of the niches is rather deeply carved with a relief of lotuses, water flowers, vines, and tendrils. The background seems to be moving almost as if water were running down its surface, and this background undulation makes a texture from which the goddess emanates. The figure is cut so deeply in the round, even completely undercut, that it seems to project far out beyond the skillfully achieved light and shade behind (*fig. 238*). This clever use of light and shade in sculpture is characteristic of the best work at Elura, and again serves to equate it somewhat with the work of the great Baroque sculptors of Europe, who also played with material and seemed to deny it. The representation of the goddess herself, with her small

which is now developed so that it is a full story in height. Indeed, if one removed the lower base, one would have the earlier Pattadakal forms preserved intact. The base has become gigantic; and the elephants and lions of the base have become life-size, or larger (*fig. 235*). Here, too, is something not usually shown in the standard photographs of the animals on the base of the Kailasanatha. In these one sees the elephants standing rigidly stiff, acting as a support for the great mass of the structure above; but this is the most atypical part of the whole base. The typical part is seen in the shadows where the figures of larger-than-life-size lions and standard-size elephants are moving and rearing and, in some cases, actually tearing at each other. One has the sensation that the very base moves and trembles, and that the whole structure is almost ready to collapse in a cataclysmic fall. The standard representation of the base is of course the best preserved one: it is neat, tidy, and fits more stolid requirements. But it gives one no idea of the character of the rest of the base, with its violent shifting movement, as though an earthquake were in progress.

head, narrow shoulders, narrow waist, large hips, and long thighs in the pose of the dance, accords with the Indian ideal. The slight sway and curve of the body, and the extraordinary use of the plant pattern as a foil for the torso produces one of the loveliest female figures in all of Indian sculpture.

But the most famous of the sculptures at Elura is the representation of Shiva and Parvati on Mt. Kailasa, with Ravana below shaking the foundations of the Sacred Mountain (fig. 239). The legend must be retold briefly to understand the action. It is said that Ravana, a giant demon king, wished to destroy the power of Shiva, but was imprisoned in the foundations of the Mountain. Grasping it with his numerous arms, he began to shake it, so that all the gods felt certain the world would be destroyed. But Shiva, simply with the pressure of his toe on the mountain, crushed Ravana and thus saved the world. The subject is a demonstration of the power of Shiva, and one which allows for great representational possibilities. You will remember the relatively static composition at the Ravana Ka Kai. In contrast to that is the representation at the Kailasanatha, one of the remarkable compositions in stone in the whole history of art. We are shown Ravana, a powerful, massive figure with his numerous heads treated as a massive block on top of great square shoulders, with numerous arms placed in so deep a recess that the figure seems actually to move and tremble. The arms seem to move in the play of light and shadow behind. Above, in a more evenly lit area, is the representation of the God Shiva, with his consort Parvati, accompanied on either side by his usual dwarf attendants. Further above are the inhabitants of Heaven, the gods and deities who have come to witness this great event. In addition to the pictorial handling of light and shade, there are other pictorial devices used which are not so characteristic of sculpture as of painting: for example, the representation of rocks, mountains, and clouds by means of a linear pattern cut into the stone. The whole composition, partly as a heritage of the Gupta style and partly because of the fact that it is a sculpture carved in a niche, is held together by means of an almost geometric grid or checkerboard, balancing a projecting mass against a receding void in a positive-negative pattern. Other shapes tie the whole action together, and allow the frenzied movement to occur without completely destroying the enclosure. The niche is quite deep and is cut back some eight or nine feet.

The composition is treated not only in terms of light and shade in depth, but also sculpturally and representationally in depth. See, for example, the frightened maiden, alarmed by the shaking of the Mountain, who runs off toward the back of the cave and seems as if she were dissolving into it. Notice too, the pose of Parvati, whose knees are at the front of the composi-

tion, but who reclines back behind the God, clinging to him in fear. The figures of the two guardians at the sides show some trace of Pallava influence, as does the main figure of Shiva himself. But the whole representation is one in which we find a perfect blending of sculptural and pictorial quality in a unity that is not only aesthetic but psychological, expressed by the involvement of all the figures, in an almost human way, with the great activity that is taking place below. The result is a massive, large-scale composition, unique in Indian art and worthy of any great tradition at its peak.

We have mentioned that the Kailasanatha was called the Painted Palace. One illustration will show a bit of the remaining evidence. The underside of the roof of the porch still has remnants of mural painting (fig. 240). There are three layers of painting, of three different ages, the earliest apparently being slightly ob-

199

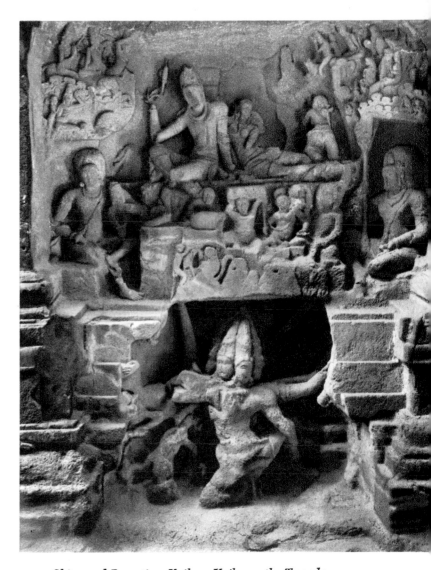

239. *Shiva and Parvati on Kailasa, Kailasanatha Temple. Height about 12'. Second half of 8th Century* A.D.

240. Painting on Porch, from Kailasanatha Temple. Late 8th or early 9th Century A.D.

scure figures in reddish brown, perhaps executed soon after the temple was built, late in the eighth century. Over this were placed figures of animals and cloud forms, and over those were placed other figures in a later, almost folk-art manner.

The last related monument we shall consider is the cave, or *mandapa*, of Elephanta, on the island of that name in the harbor outside Bombay. It may originally have been called Puri and was an ancient capital, conquered by the Chalukyas and Rashtrakutas in turn. The date of the sculptures at Elephanta is a much argued question: Sastri says seventh century; Coomaraswamy says eighth century. It seems likely that Elephanta represents an isolated phenomenon, the survival of a somewhat earlier style at a late date. It is an excavated shrine, similar to some we have seen at Elura; and aside from the fact that it has really *two* main axes instead of the usual *one*, it is not exceptional architecturally. The general view of the entrance and of part of the sculpture gives some idea of its present

condition (*fig. 241*). When the Portuguese occupied this area it seems that the commander of the military garrison stationed on the island amused himself by having artillery practice down the aisles of the *mandapa;* and thus nearly all of the sculptures are thoroughly smashed from the waist down. The figures are of colossal size, between eight and ten feet in height, and are of the greatest interest. They represent one of the most notable expressions of early Northern Medieval style, despite the fact that they may be somewhat late. Because Elephanta was politically a provincial site, it preserves some Chalukyan style elements without the influences of Southern style seen at Elura.

The shrine is dedicated to Shiva and has representations of his principal aspects. The sculptures at Elephanta are characteristically niche sculptures, predominantly square-framed, and reveal rather elaborate figural compositions. These usually involve a large-scale image of Shiva, sometimes supplemented with a fairly large-scale image of his consort, with numerous

smaller representations of other deities. The result is a complex focus often lacking in other Medieval sculptures. These huge and dominating figures, coupled with the complex representational elements behind, produce a rich and yet compact effect. And this is visually heightened by the fact that the stone at Elephanta is not coarse volcanic stuff, nor a fine-grained cream sandstone which seems somehow rather light and delicate, but a rich, chocolate-brown, fine-grained sandstone. This material can be cut with great precision and detail; but when viewed as a whole it has the same rich but compact effect that the sculptures themselves display in their organization. One supplements the other and the whole produces an extraordinary unity. One representation is that of Shiva as Lord of the Dance (fig. 242). When compared with the same representation at Ravana Ka Kai, the figure of the dancer has more movement and is more distorted.

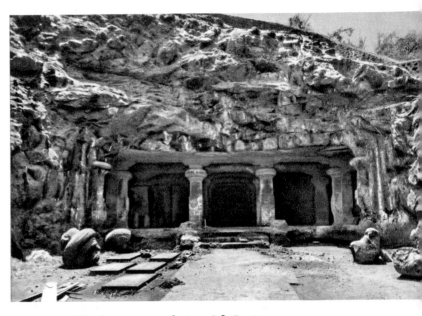

241. Elephanta, general view. 8th Century A.D.

242. Shiva Nataraja, Lord of the Dance, from Elephanta. Height about 10'. 8th Century A.D.

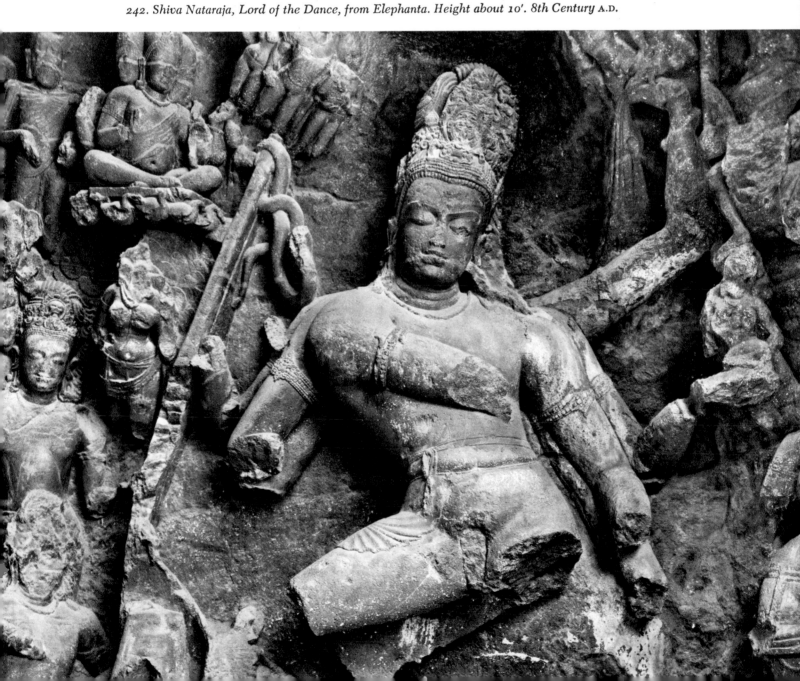

The gentle S-sway of Rameshvara is changed here to a very definite and supple turn of the body in a full S; and, were the legs complete, we would undoubtedly find that one leg was raised quite high, and that the dance was far more vigorous. The facial types at Elephanta, in contrast to those at Elura and other places, have a certain early, almost Gupta quality about them. Their eyes are usually downcast and the mouth full, and they seem much more serene than the more frenzied and dynamic examples from Central India. The modeling is soft and supple; and the rhythmical treatment is comparable to that seen before in Indian sculpture.

The most famous — and justly so — of the sculptures of Elephanta is considered to be the principal image at the site, even though it occupies, in relation to the usual central axis, a secondary position (*fig. 243*). However, it is marked quite clearly as the main image of the cave by the fact that it is cut in much deeper relief than any of the other representations, and that the scale is so much larger. It is the same height as the others, but shows only the shoulders and heads of Shiva rather than the whole figure, and as a result dominates the interior. The niche is the only one other than the *lingam* shrine or cell, which is flanked on either side by very large figures of guardians. The image represents Shiva in his three-fold aspect as Mahesha. On the left is Aghora, the wrathful one, with moustaches and bulging, frowning brows, holding a cobra in his hand. In the center he is Tatpurusha, beneficent and serene in aspect. At the right is Uma Devi, the blissful one, with the face of Uma, here Shiva's consort, with female earrings, and the full "bee-stung" lower lip of poetic description. The large lower lip and sharp, thin nose represent the very height of elegance and femininity. The combination of these three different aspects into one unified form is accomplished, in part, by the massive base of the shoulders, by the pattern of the jewelry in the headdress, and, above all, by a psychological unity which allows the wrathful to be not too wrathful, and unites it with the more serene and contemplative ideal expressed in the other heads. This is in keeping with the controlled character of the sculpture at Elephanta.

202

243. *Shiva Maheshvara, from Elephanta. Height 10' 10". 8th Century* A.D.

10. Medieval Hindu Art: The Northern Styles

THE NORTHERN MEDIEVAL STYLE of architecture, called Nagara by the Indians, as distinguished from the Dravida style of the South, is found at its most characteristic in that region of India ranging from Bengal and Orissa in the northeast through North Central India, past the region of Delhi and on into the Northwest area, including the Gujarat Peninsula. Various stones are found in these areas. There is the chlorite of Orissa, a brown-purple stone, pock-marked when exposed to the weather but, when kept in an interior location, retaining a very highly polished, smooth surface. There is the cream-to-tan sandstone of the North Central provinces, particularly the region of Bundelkhand, slightly north and west of Delhi and perhaps the greatest center of the Northern style. This sandstone is very similar to that of the Gupta images at Sarnath. And then there is the white marblelike stone of the Gujarat area. These stones of the North contrast rather sharply with the material available in the Central and Southern areas, especially the granite of Mahamallapuram in the South and the volcanic rock of Elura in the Deccan. It may be worth mentioning again the influence of materials on styles of art, particularly in relation to sculpture. It is manifestly difficult to carve detail in a stone full of holes. It is equally difficult to achieve broad pictorial effects in stone, which fact seems to invite the carver to dwell on detail and smooth finish when working with sandstone, for example. So perhaps some of the characteristics that we have mentioned in relation to the sculpture of Elura and Mahamallapuram, and which we will see in the sculpture of the northern regions, can be traced to the reaction of the artist to the material in which he works. These Northern materials, which seem to be more refined than those of the South and the Central areas, produced sculpture rich in detail; at the same time the temple structures retain the characteristics of sculpture rather than of architecture.

Let us first look at one of the Hindu temples at Khajuraho in North Central India, for an introduction to the form of the Northern temple (fig. 244). It is made of the warm, cream sandstone of the region and dates from about A.D. 950 to 1050. Sectarian styles are not involved at Khajuraho; that is, we cannot differentiate a Jain style from a Hindu one. The Northern style appears more organic than that of the South. The emphasis is primarily on verticality; horizontality is suppressed. And, further, the architectural character resulting from the vestigial wall and enclosure used as a decoration for the towers of the Southern style is absent; instead there is a series of small towers, repeated one against the other, building a form which ultimately becomes the large tower. There are quarter towers, half towers, and then, finally the full tower, each part leading to the other as if an organic vegetable growth rose from the earth. The shape of the crown on each of these little towers and on the large tower proper with its bulbous, mushroomlike appearance is more organic than the capstone used in the Southern style. The extremely high base again emphasizes the verticality of the whole; and the porch and congregation area, called the *mandapa,* which in the Southern style was clearly separated from the tower over the shrine, are integrated with the tower, and appear to lead up into its heights. The style of Northern structures, *mandapa* and tower, is more unified and organic than Southern ones. If it is true that Hindu architecture is primarily not architecture at all, but sculpture, then its most perfect expression is the Northern style.

There are two main type-sites for the Northern style, Khajuraho and Bhuvaneshvara. We will consider the latter first, since it has temples of somewhat earlier date than those of Khajuraho. Bhuvaneshvara is located in Orissa, the state immediately south of Bengal in Northeast India. A general view of the site shows

203

244. *Kandarya Mahadeva Temple, Khajuraho, Bundelkhand, general view.* c. A.D. 1000

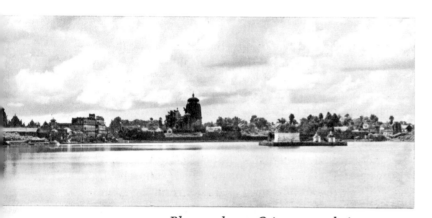

245. *Bhuvaneshvara, Orissa, general view.* 8th-13th Century A.D.

246. *Parashurameshvar Temple, Bhuvaneshvara.* c. A.D. 750

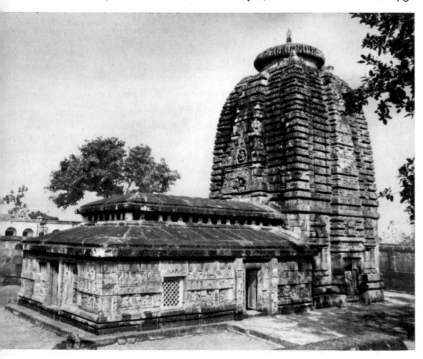

204

the great tank with trees surrounding it and the numerous towers of various temples and shrines in the area (*fig. 245*). These are but a small part of the number of temples visible from vantage points near Bhuvaneshvara. The effect is surprisingly like that of growths of organic or mushroomlike character sprouting over the countryside, almost as if they had appeared overnight. The earliest of the complete temples at Bhuvaneshvara is called Parashurameshvar, of about A.D. 750 (*fig. 246*). It shows a primitive stage in the Northern Medieval style, for here the separation of the porch or *mandapa* from the tower is clearly marked; the former is a slab structure covering an area horizontally, whereas the tower is a primarily vertical structure over the shrine. There is no transition from the *mandapa* to the tower (*shikhara*). The *shikhara* on this early temple at Bhuvaneshvara still has traces of strong horizontal units and has an angular four-sided character, like that of a primitive cell-shrine. But the incrustation of the surfaces with numerous small carvings tends to break down its architectural character and to produce a work of sculpture.

These tendencies, seen here in embryo, are carried further in the later temples of Bhuvaneshvara. One of the most fascinating of these is the Mukteshvara Temple, built around A.D. 950; it is the jewel of all temples of the Northern style (*fig. 247*). The Mukteshvara is very small — the tower is certainly no more than thirty to thirty-five feet in height — but it is quite complete with its own tank, entrance gate, and low railing around the whole enclosure. But what marks the Mukteshvara from all other temples of this group is the rich sculptural adornment which approaches a form of incrustation, as if stone jewelry had been hung on the surface of the tower. A certain type of ornament based on the old *chaitya* arch motif appears with the Mukteshvara Temple (*fig. 248*). The curving, parabolic ceiling or roof line of a *chaitya* hall is playfully repeated with numerous variations on the direction and thickness of the lines outlining the miniature arches. It appears almost as if someone had taken a tube and squeezed out this ribbonlike ornament which becomes characteristic for the Nagara style and certainly begins to appear by the ninth century. Here we see one of its richest manifestations. On the Mukteshvara, the development of ornamental figure sculpture is somehow architectural in character. This is particularly true of the caryatids — pot-bellied dwarfs in their square frames who support the weight above them. The projections made by their elbows, knees, stomach, and head form an abstract pattern of bulbous protrusions against the shadow of the undercut background. Another characteristic ornament of the Northern style is the Face of Glory (*Kirttimukha*), a mask of a devouring leonine monster, often used as a main motif on each side of the tower as well as over the false doors from which images of the gods seem to

emanate from the shrine within. The horizontality of the layers composing the tower, characteristic of the Parashurameshvara Temple, is broken here by the verticality of these ribbons that cut across the layers of cake, as it were. Now the emphasis is definitely on verticality and so the characteristic expression of the Nagara style is fully developed by the time of this little temple. The material of the temples at Bhuvaneshvara is chlorite, which deteriorates somewhat under the influence of weather. But it is capable of being worked in great detail, as can be seen on the well-preserved side of the building. Chlorite is extremely rich in color, ranging from orange through red to purple; and in the brilliant sunlight of Northern India it produces an extremely rich, even funguslike effect.

The largest temple at Bhuvaneshvara is the Lingaraja, dedicated to Shiva, and probably built around the year 1000 (fig. 249). It reveals the style at its height, or perhaps just past the peak. All the verticality of the little towers at the sides and of the small shrines surrounding the temple culminate in the main tower. The crowning stone, a giant mushroomlike shape, is of tremendous size, and seems almost to overweigh the tower. The sculpture is suppressed in this particular example, so that the towers seem slightly impoverished in their decoration, although the lower part of the *mandapa* and parts of the tower have much sculptural decoration. The side view of the Lingaraja is a classic picture of the developed Northern style of Orissa.

The sculpture associated with these later temples at Bhuvaneshvara is overwhelming in quantity and is often of very high quality. The detail shows the sculpture on the so-called Raja Rani, also built about A.D. 1000, and situated on the outskirts of Bhuvaneshvara. In addition to the decorative carvings of vine scrolls and lotus scrolls, the lion monsters and masks of glory, the Raja Rani Temple provides one of the best Medieval expressions of the traditional motif of the female fertility deity. The Raja Rani sculptures of the Lady Under the Tree, a motif going back as far as Bharhut (see page 80), are justly famous (fig. 250). There are many variations on this theme, both on a large scale and in the small, secondary sculptures around the niches. The poses tend to remain in the classic Gupta tradition and there is throughout a certain restraint in the sculpture at Bhuvaneshvara. Despite an occasional rather extreme twist of the hips and torso, the figures are well contained within the pillar boundaries. The forms are ample and round, again maintaining the tradition of Gupta sculpture. We do not find the long, sinuous shapes which are common in North Central India.

The most famous, or notorious, of the temples of Orissa, depending upon the frame of reference, is the so-called Black Pagoda of Konarak, a temple rather past the prime of the Northern style, and dating from about 1240 (fig. 251). It was called the Black Pagoda

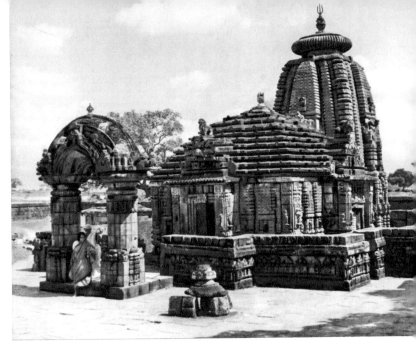

247. *Mukteshvara Temple, Bhuvaneshvara.*
c. A.D. 950

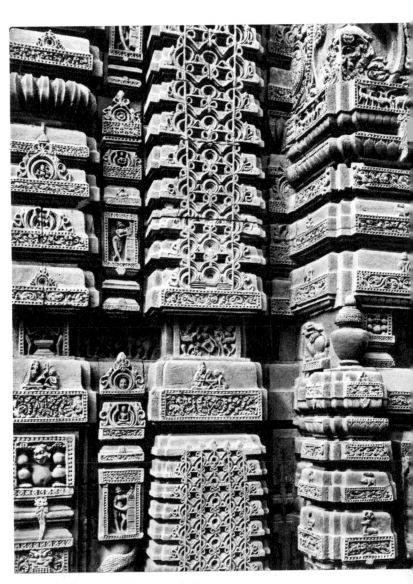

248. *Chaitya-arch Ornament.*
Detail of figure 247

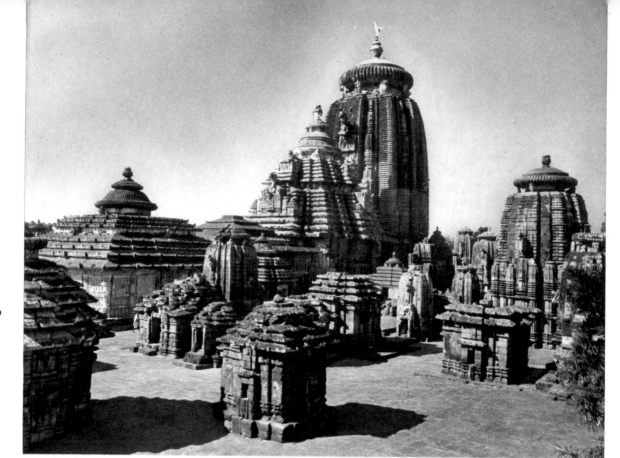

249. Lingaraja Temple,
Bhuvaneshvara, c. A.D. 1000

250. Lady under a Tree, from the Raja Rani,
Bhuvaneshvara. Height about 60". c. A.D. 1000

because from the sea it appeared as a dark mass and was a useful landmark for mariners coasting up the Indian Ocean to make a landfall near Calcutta. It is dedicated to Surya, the sun god, and is properly called the Surya Deul. What is left is a magnificent ruin. One sees only the *mandapa,* for the tower collapsed and is now no more than piles of fragmented sculpture and rock. The *mandapa* indicates that the original size of the temple was the largest of its type built in the North. The Black Pagoda is a particular temple type because, as it is dedicated to Surya, the temple — and especially the *mandapa* — was conceived of as a chariot whose wheels are carved in the stone at the base of the temple. Stone musicians play on the roof while colossal stone horses draw the heavenly chariot. The temple was constructed of chlorite, and, because of the proximity of the sea, the salt air and wind have badly eroded it on the two sides exposed to the sea, so that much of the sculpture is gone.

The Surya Deul is "notorious" because it is adorned with perhaps the most explicit erotic sculptures that have ever been made of male and female figures. The more aesthetic or mystical writers try one's credulity when they say that such sculptures indicate solely the union of the soul with God. Let us hope that the sculptural adornment of this temple is dedicated to concepts of both physical and mystical union. One of the great wheels supporting the *mandapa* reveals the same style of vine and tendril carving seen in the Mukteshvara, and so characteristic of ornament in Orissa (fig. 252).

The wheel is surrounded by figures, sometimes single figures of celestial deities and motifs of the woman under a tree, and at other points, embracing couples. The large sculptures are like those on the Raja Rani, voluptuous and full-bodied, not linear in their emphasis and not exaggerated in movement. The sculpture still retains a certain Gupta restraint. This may be due to the influence of Buddhist art of the Pala and Sena dynasties in Bengal where the Gupta style was preserved well into the eleventh and twelfth centuries. Another detail on the main *mandapa* at Konarak shows a late decorative note developed to an extremely high degree (*fig. 253*). This is a perforation technique used as a texture behind the images and floral ornament. It is almost as if there were a desire to destroy any architectural character and to create an embroidered or encrusted effect, which reaches such a high pitch that there is hardly a square inch of surface left uncarved. The tendencies under very strict control at the Mukteshvara have here run riot.

The second type-site for the Northern style is Khajuraho. The side view of the Kandarya Mahadeva Temple (*see fig. 244*), shows the elaboration and development of this regional version of Nagara style. The porches are multiplied into three units, each one increasing slightly in height and leading up to the Great Tower; the base becomes extremely high; and the repetition of the miniature tower motif building up to the central tower is developed to a particularly high degree.

The sculptures of the temples at Khajuraho are quite different in style and character from those of Orissa, although the motifs are often the same. They seem more varied, and the general impression is of a richer sculptural style. The detail gives some idea of the variety: single figures of celestial beauties (*sarasundari*) (*fig. 254*), lions, *maithuna* couples, and single images of deities. There is a marked development of the ribbon ornament we saw in one form in Orissa. The Khajuraho variation is particularly arresting in its pictorial, or light and shadow, style. The flat surface of the sandstone is cut sharply and deeply in the form of tendril scrolls or arabesques, and the raking light makes a sharp contrast of light and dark. There is no variation, no modeling around a shape, but rather an absolute contrast of light and dark, and the result is like a drawing in black on white. This type of ornament is used to great effect throughout the structure and helps to maintain, on some areas, a flat architectural surface contrasting with the extreme development of the sculptured human forms on the rest of the building.

At Khajuraho the sculptured figures are tall and slim; the legs sometimes become much elongated. The effects are linear, the poses exaggerated. A culmination of this tendency is to be found in one particular figure, perhaps the most interesting architectural sculpture at Khajuraho (*fig. 255*). It is a celestial beauty, occupying

251. Surya Deul (The Black Pagoda), from
Konarak. c. A.D. 1240

252. Great Wheel, from Konarak. c. A.D. 1240

253. *Mithuna and Perforated Screen, from Konarak.* c. A.D. 1240

of Northwest India where there is a group of marble temples dedicated to the Jain faith (*fig. 256*). They are a curious mixture. The exteriors of the temples are in the Northern style and so are many of the sculptures. It is seen to better advantage however, at Khajuraho. But, because these are Jain temples, separated geographically from the great region of Medieval sculpture, there is some influence of faith on style. Some of the curious character we find in these sculptures can be attributed to Jain iconography, and not to Medieval style. This can be seen most clearly in the main images, though there is some carry-over into secondary images. In general, there are two styles: one, based on the Jain faith — ascetic, denying the pleasures of the earth, antisensuous; the other, based on Northern Medieval style, is confined to the secondary images of celestial dancers, musicians, and so on. If we examine a main image of a Tirthankara, Finder of the Ford, we find a smooth and rather geometric, almost tubular treatment. On many occasions the style can be disturbingly geometrical and antihuman. The faith, more extremely passive than Buddhism in its pietistic attitude, has a rigid code; and these extremes are carried into the main images.

But in the secondary images — of the dancers, for example — some of the Medieval style still remains. The overwhelming impression of this latter variant of Northern Medieval style is of the overelaboration of an embroiderylike ornament (*fig. 257*). In one of the great ceilings over the porches, or *mandapas*, the repetition of the dancing celestial beauties has become rather mechanical, despite the fact that there are minor variations (*fig. 258*). The whole effect is now merely one of complexity, with an accompanying loss of spirit and movement, and a tendency toward the usually coarse results that are found in nearly all of the sculpture of North India after the fifteenth century. The only vitality then left is in folk sculptures rather than in the works of the fully professional artisan.

There are other variants of the Medieval style: the wood architecture of Kashmir, and the oddly similar wood architecture of the Malabar Coast in the South. There is a peculiar style to be found in the region of Mysore, where there are low, flat temples based on a star-shaped plan (*fig. 260*). The squat, truncated appearance of these is modified on closer examination by profuse sculptural decoration. The high bases seem encrusted with varied friezes of animals in apparently endless procession (*fig. 259*). Even the images of deities in their niches are thoroughly covered with a heavy and complex decoration, largely representing festoons of jewelry. What could have been excessive profusion is redeemed by the sensitive and precise cutting of detail as well as by the ever-present living breath of the Medieval style in stone.

We turn to the South, and principally the region of the former Pallava Kingdom. Here, because of geo-

a corner position transitional from one main wall face to another. She inhabits a space that could have been filled in a very simple way. The classic Gupta solution would have been simply to have a figure standing there and looking out; but this was too easy for the complicated and extraordinarily inventive minds working on this temple. They placed the figure in the space, with one foot flat against one plane, the other foot on a different plane, the buttocks parallel to the spectator, the waist turned, and the shoulders on a plane perpendicular to the plane of the second foot; finally, the head is turned to the back of the niche, with the arm making a connection from the body to the niche. The figure is spirally twisted so that it relates to all the real and implied faces of the space. The posture seems easy and natural, for the artist was master of linear effects. The emphasis is on the long, easily flowing line which repeats, with variations, the swelling curve of the hip. The scarf and breastband seem to ripple lightly over the torso. The drapery clings to the body and only the borders of the *sari* are used as proper subjects for the sculptor. Such consistent and subtle linearity is the most characteristic feature of the sculptures at Khajuraho.

The other variant of the Northern Medieval style in this region is found at Mount Abu, in the Gujarat area

254. *Celestial Deities, from Kandarya Mahadeva Temple, Khajuraho. c.* A.D. *1000*

and in South India generally, do not have the exuberance exhibited by those of the North. They are usually single figures in niches, and for a very good reason (fig. 262). By the tenth century, the technical dominance in the field of sculpture had passed from stoneworkers to workers in metal, and the single figure comes into its own, taking on the character of sculpture in metal. The forms in the illustration imitate copper images.

It was not known until a few years ago that the Great Temple at Tanjore also contained important Chola paintings. There is a narrow and rough corridor inside the walls of the tower around the shrine, and on its walls are frescoes, illustrated here in a detail. While the paintings can be seen only by Hindus, since the temple is still in worship, photographs show that the art of painting was in a high state in the Chola Period and that motifs of the dance were dominant (fig. 263).

The later development of South Indian architecture can be briefly summarized by two illustrations. One demonstrates the almost perverse development of the tower, not as the main tower of the shrine, but as tow-

255. *Celestial Beauty, from Parshvanatha Temple, Khajuraho. Height about 48". c.* A.D. *1000*

graphic position and the political strength of the later South Indian kingdoms, the native tradition was largely able to resist the influence of Mohammedan arts of foreign conquerors in North India. Here, too, in later Medieval times were preserved many Hindu crafts, especially textiles, jewelry, and the arts of the dance. During the Chola Period, from the mid-ninth century to about 1310, one extraordinary monument, the Brihadeshvara, or "Great Temple," at Tanjore, was produced in about the year 1000. Some idea of the political state of the South can be surmised from the fact that it was a combined fort and temple, with elaborate battlements and a surrounding moat. Tanjore represents the final development of the earlier Southern style before the decadence of later times. A general view of the Brihadeshvara, with the separate Nandi porch in the foreground, reveals that while the tower has developed into a very high structure, its general effect is still angular (fig. 261). A closer view would reveal the horizontal stages of the stepped tower characteristic of the Southern style. The temple is 96 feet high; the capstone is over 20 feet in diameter, and weighs approximately 20 tons. It was raised to position by means of a ramp two miles along, and is one of the most extraordinary and, in its implications, frightening feats of engineering in India. The sculpture on the temples of Tanjore,

ers over the various entrance gates (*fig. 264*). The major development here was toward height, the outer gate towers being the highest. In later Southern architecture, the enclosure and the enclosing walls are overdeveloped at the expense of the temple proper. A view of a typical temple of the fourteenth or fifteenth century is a very exciting panorama of great towers rising up out of the hot and steaming plain. It is very impressive until one realizes that the towers are simply gate towers and that the temple proper is in the interior somewhere, architecturally insignificant. There is a series of concentric walls; and as the walls get closer to the temple proper, the towers become smaller, a city within a city, within a city, within a city, and finally, a temple. Most of the activity of the town is contained within the wall enclosures in shops and bazaars. Along with this tendency toward giantism in the towers, one finds a proliferation of sculpture over all the surfaces of the gate towers, sculpture of such extremely poor quality that we need not examine it at all. The only sculptural achievement of any interest is the development of large columns or piers with rearing animals, horses, lions, or elephants, usually with smaller animals or attendants holding the hoofs of the major beasts as they rear on their hind legs (*fig. 265*). The result of a whole facade of such columns is to produce an uneasy but impressive effect, until one examines the sculpture in detail. Then one sees the beginnings of a rather crude naturalism, of a petrified anatomical interest, of a frozen, hard, and gross expression in the faces, and of a marked impoverishment in the representation of ornament and movement. They are more like theatrical settings than great works of sculpture. Sometimes, in the subsidiary reliefs around the bases, or narrative

*256. Temples at Mount Abu, general view.
Late Medieval Period*

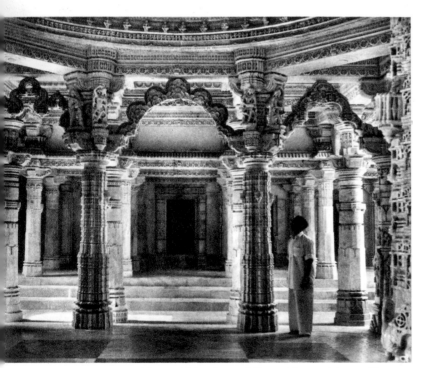

*257. View of Mandapa, Dilvara Shrine, Mount Abu.
13th Century* A.D.

RIGHT:
*258. Ceiling Frieze of Dancers, from Tejahpala's Temple
to Neminatha, Mount Abu. White marble.* A.D. *1232*

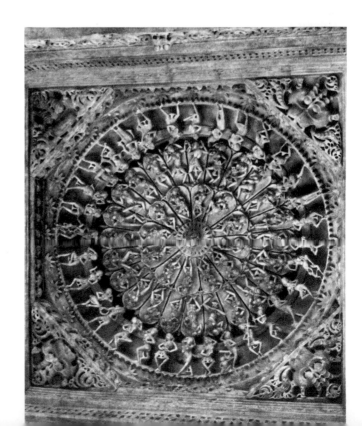

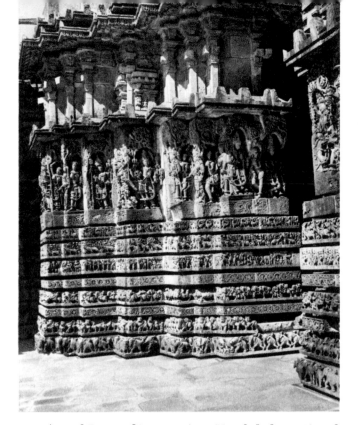

259. *Animal Base and Figures, from Hoyshaleshvara Temple, Mysore, Somnathapur. 13th Century* A.D.

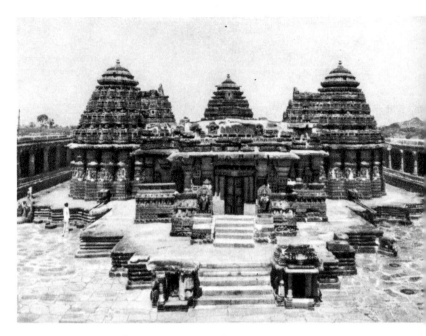

260. *Star Temple, Mysore, general view.* A.D. 1268

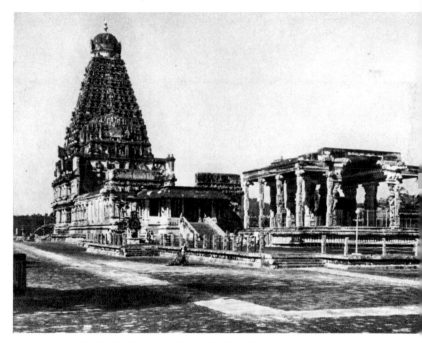

261. *Brihadeshvara Temple, Tanjore, general view. c.* A.D. 1000

friezes of the *Ramayana* or other epics, there is still some descriptive or narrative power. But, in general, stone sculpture in the South after the Chola Period is of little interest for us.

What is of interest from this time forward is the making of images in copper and bronze, particularly in copper. These range in size from tiny images meant to be carried by an individual, or used in personal shrines, to large images of almost life size. Most were cast by the lost wax process by hereditary guilds of craftsmen who produced some of the greatest metal sculptures of the world. They were meant to be used as aids to worship and were kept in *puja* (worship) in the temple, and consequently are often well preserved. Some of the images used for processions were taken from their niches or places of worship in the temples and carried in processions. On these occasions they were dressed in rich silks and cloths which hid the sculpture except for the face. Sculpturally, these bronzes, as we will call them, are the most significant objects of later South Indian art. If early stonework in the Pallava Period influenced metal, it is certainly true that, from the Chola Period on, metal dominates stone. There is a variety of subject matter, but usually it is based on the motif of the single figure.

In nearly all of the well-known image types the handling of the material, especially in the taut profiles and complicated turns of the limbs, seems particularly dictated by the requirements of metal. This lithe image of Shiva, though relaxed in pose, has something of the spring and tension of metal in contrast to the more static character of stone. Its proportions are derived from Pallava sculpture but its implied movement and conscious grace are contributions of the early Chola Period (*fig.* 266).

Many of the images are badly worn at the face, because the rite of *puja*, or worship, involves not only prostrating oneself before the image, but also the ritual touching of it. The side rings on the bases are used to hold a rod which was passed through them and fast-

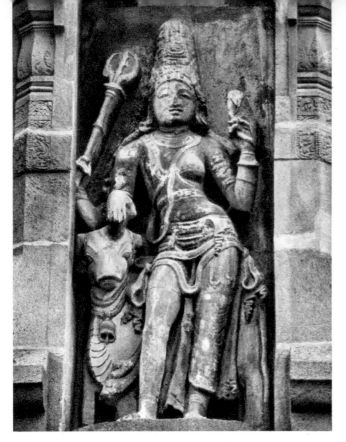

262. *Niche Sculpture, from Brihadeshvara Temple. Height about 84". c. A.D. 1000*

ened to the wooden base upon which the image was placed when in worship.

We have mentioned the influence of the dance before; here it is dominant. The poses of these figures, their attitudes and gestures, are all derived from the art of the dance. Something of the quality of movement, of rhythm, and of the physical expansiveness of these images is to be found in the great dancers and dancing traditions of South India. Those who remember the Indian dancer, Shankar, will realize how much the bronze caster's art owes to the art of the dance.

Rarely do we find groups, though occasionally groups of two or three are included in a single image, as in the excellent small example of Shiva and Parvati, here lacking a heavy *mandorla*, or body halo (*fig. 267*). Many of these images were provided with rather elaborate *mandorlas*, which often seem a hindrance to the aesthetic effect of the figures. In this work a wonderful relationship between male and female is partially expressed by the protective gesture of the dominant male. The litheness of the pose, the gentle bend and reverse bends of the bodies as they play in counterpoint, all show the Chola tradition of bronze-casting at its best. The images were not always of a beautiful or handsome type, but sometimes embodied ascetic devotees of Kali, the Goddess of Death and Destruction (*colorplate 14, p. 174*). These are shown as emaciated hags, with pendulous breasts, ribs starting out of the body, and awesomely hideous faces with fangs. But in this image, at the museum in Kansas City, we cannot but

be impressed with the sculptural quality of the whole. The alertness of the carriage, the still-wonderful quality of expansion, the physical well-being, despite the emaciated condition of the figure, seem to shine forth as from all great Indian sculptures.

One of the most entrancing of these conceptions, a subject particularly appealing to Westerners, is that of the Dancing Krishna—Krishna as the Butter Thief (*fig. 268*). It is one of the incidents in the Krishna legend, about a childhood prank undoubtedly common to Indian family life and therefore all the more endearing. Krishna is shown as a young, rather fat child, with one leg raised high, arms thrust out as counterbalances, dancing as he runs away with the butter. No subject shows more clearly the importance of the dance for these representational concepts, and none seems so singularly appropriate to the medium of bronze. The weight resting completely upon one leg, the thrust of the hip and of the left arm, all combine to make a metal image worthy of comparison with the great bronzes of the Italian Renaissance.

263. *Dancing Apsaras, from Chamber 7 at the inner ambulatory of the sanctuary, Brihadeshvara Temple. Fresco. c. A.D. 1000*

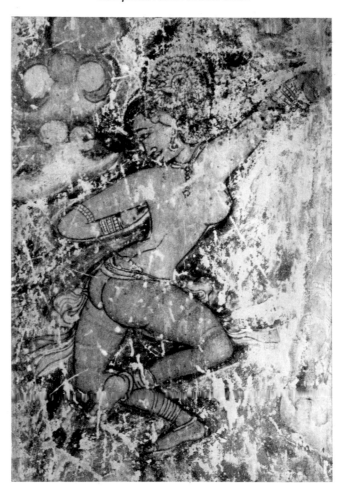

Rajput painting is the last expression of the Medieval tradition. With this subject, the question of decadent or retarded art forms in India immediately arises, for Rajput painting is in some ways a folk art or at least a semi-folk art, and it may well be this quality which has made it less appreciated in the West than it deserves. However, there are signs that this attitude is changing and numerous books on Rajput painting have appeared in the last few years. The Rajput style is found in miniature painting, with subject matter which ranges from the abstract and intellectual to the extremely concrete and emotional. The size may be partially due to the influence of the miniatures produced by Persian artists or artists under Persian influence at the Delhi Sultanate and later at the Mughal court. While the art of miniature painting had been practiced in India before the coming of Islam, it is likely that Rajput painting owes at least its format to the influence of Persian and Mughal painting. To this influence also may be attributed the heightened color, so characteristic of Rajput painting, which in many cases outdoes that of the paintings from which it is derived. The use of color by the Rajput painter is one of the most creative aspects of the style, for he often used it much more arbitrarily than the Mughal artist, and in a manner quite akin to that of the creative modern painter.

These small Rajput paintings, meant to be kept in albums and seen in sequence, are a product of a cultural atmosphere that included independent city-states; a regional point of view as opposed to the national or imperial one of the Mughal court; and the very important matter of patronage, for the miniature painter could not survive without the patronage of wealthy or royal personages. While Mughal influence is important, there is at the same time a basic difference between Mughal and Rajput painting. The former, with all of its detail and marvelously taut and powerful drawing, is still naturalistic in its approach. It tends to be realistic and desires to conquer the appearances of nature, particularly in human and animal portraiture. On the other hand, most Rajput paintings are conceptual in character as the artist was mainly concerned with the idea, whether religious or poetical, behind the picture, and used color and the patterning of shapes to express the mood or atmosphere of the idea, its *rasa* or flavor.

The origins of the Rajput style are two-fold. We have already mentioned the underlying influence of Indo-Persian painters, who in turn were greatly influenced by Persian miniaturists. The second influence is one out of Indian Medieval tradition, and from a very particular and specialized part of that tradition — the Jain and Hindu manuscripts made in the Gujarat regions of Western India for wealthy monasteries and merchants of the region. These manuscripts are painted on paper with the text dominating a small illustration on each page (fig. 269). They derive certain traits from

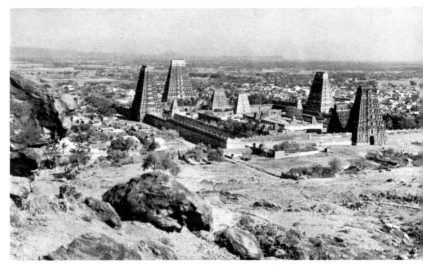

264. *Arunacaleshvara Temple, Tiruvannamalai, Madras. c. 12th Century,* A.D.

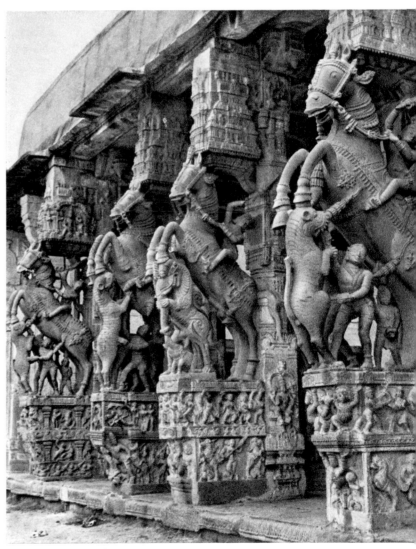

265. *Horse Columns, from the Temple of Vishnu, Shrirangam. Height about 12'. Vijayanagar Period, 16th Century* A.D.

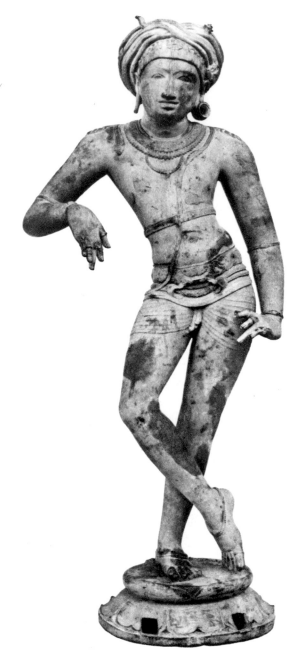

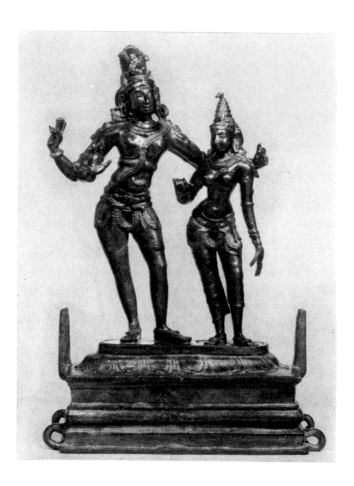

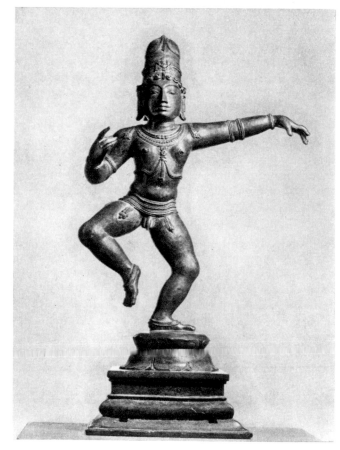

ABOVE:
266. Shiva (from a double image with Uma: Shiva Vrishbhavahanamurti), excavated at Tiruvenkadu, Tanjore. Copper, height 41". Chola Period, Reign of Rajaraja I (A.D. 985-1016). Tanjore Museum

214

ABOVE RIGHT:
267. Shiva and Parvati as Alingana-Chandrashekhara-Murti. Copper, height 10". South Indian, Chola Period, 11th-12th Century A.D. Cleveland Museum of Art

RIGHT:
268. Krishna as the Butter Thief. Copper, height 19" 14th Century A.D. Nelson Gallery-Atkins Museum (Nelson Fund), Kansas City

RIGHT: *269. One leaf of a Kalpa Sutra Manuscript.
Length 10⅜". Western Indian School, 16th Century* A.D.
Cleveland Museum of Art

BELOW RIGHT: *270. The Emperor Jahangir Receiving
Prince Parviz in Audience, from the Minto Album.
Attributed to Manohar. Color on paper, height 15". Mughal,
Jahangir Period,* A.D. *1610-1614.* Victoria
and Albert Museum, London

215

Medieval Hindu fresco painting, for they employ mannerisms characteristic of the fresco paintings, as can be seen in the murals that survive on the ceiling of the Kailasanatha at Elura (*fig. 240*). Persian influences are found mainly in certain textile designs and sprays of flowers; but no Persian would ever have painted a miniature of this type, which owes a large part of its style to the geometricizing, antihumanist approach already mentioned in connection with Jain sculpture in the Gujarat. Here is one of the most abstract, most conceptual forms of painting that the world has ever seen. Color is used in simple, flat areas; figures are arbitrarily conventionalized; the eye, for example, in a three-quarter view of the face, projects conspicuously as it does in the frescoes at Elura. This approach is not confined to the handling of the figures, for architectural details and interior furnishings, trees and the sky, all have their lively, stylized formulae. These are so constantly repeated that they often become monotonous. The patterning of the textile designs and the use of gold is also part of a seemingly desperate effort by the painter to reduce the visible world to a small conceptual framework which can be comprehended in a manner analogous to reading of the script next to the picture.

India's Mughal school of painting owed its existence to the munificent patronage of three outstanding emperors who were devoted to art. The development of the school, the direction it followed, the subjects it undertook, and the character it achieved were directly influenced by the personalities of these remarkable men: Akbar, his son Jahangir, and Jahangir's son Shah Jehan.

The Mughals came from Ferghana and were descendants of Tamerlane and Genghis Khan. The founder of the dynasty, Babur, who sought new lands to settle in and so moved to the conquest of India, was familiar with the refinements of Persian art; later, his son Humayun, when driven from India by a minor aspirant, sought refuge in the Persian court of Shah Tahmasp, where miniature painting flourished. Here he dreamed of court painters of his own and brought two Persian artists, Abd al-Samad and Mir Sayyid Ali, to his subsequent refuge in Kabul where his young son Akbar studied drawing and painting with them. When Huma-

yun returned in triumph to Delhi, the two Persians came with him. After his father's death Akbar increased the number of court painters; the majority of them, however, were not Persians, but Hindus. Akbar preferred their talents and his biographer reports that he remarked "the Hindus did not paint their subjects on the page of the imagination,"[5] that is, their paintings were close to nature. This judgment is confirmed by Tara-natha, the Tibetan historian who wrote in 1608 that Indian painters showed close adherence to natural appearances. However, Persian influence did not entirely vanish. Artists of the Mughal school had not only the earliest inspiration and the actual presence of Persian artists, but they had access also to the imperial library with its numerous albums full of Persian drawings and paintings. We can see minor Persian influences in the painting of a ceremonial gathering to witness the meeting of Jahangir and Prince Parviz (fig. 270). The Persian manner tended to flatness, a fondness for surface pattern, extreme elegance in line and decorative detail, and some freedom from symmetry in composition. Our illustration shows this Persian influence in the border of the painting with its Persian script, in the dominant Persian arabesque which runs straight down the composition at the right of the scene, in the flat design of the textile in which the emperor is dressed, in the carpet, and in the Persian formula of the cypress and the flowering trees beyond the wall. Distinctly not Persian is the formal balance of the picture, the absence of elegance in the figures standing in stolid array, the very realistic portraiture; and in the little vista at the top we see how a feeling for form and atmosphere transforms the typical Persian mountain cluster in the landscape, and the flowers in the foreground from flat patterns to warm and visually realistic areas.

Akbar was one of the world's great rulers and of a rare and remarkable character. While he was brought up a Moslem, as Emperor of India, a role he took with profound seriousness, he sought to bring his Hindu and Moslem subjects together. He married a Hindu princess. His dream was the creation of a philosophy which would reconcile Moslem, Hindu, and Christian thought. But "divine worship in monarchs" he said, "consists in their justice and good administration."[6] He welcomed Jesuit priests and on his walls and in his library were European paintings: Christian subjects, Dutch landscapes, and Flemish work. Mughal artists were quick to seize on the new aspects of these foreign

*272. Zebra, from the Minto Album. Painted by Mansur, in 16th year of Reign of Jahangir, 1621. Height 7³⁄₁₆".
Mughal. Victoria and Albert Museum, London*

pictures and to introduce landscape vistas, European perspective, and atmospheric effects, mist, twilight, or night light into their pictures.

His artists were called upon to record history and legend in pictures full of action and figures. *Akbar Viewing a Wild Elephant Captured near Malwa* from the *Akbarnama*, a history of the Emperor, is an admirable example of the work of his school (fig. 271). While there are many echoes of the Persian style in the elegant horse with its elaborately patterned saddle cloth and the curious rocks and shrubs, the elephants are not decorative but masterly in their depiction of form and action. Careful modeling brings out their massive bodies and their expressions show close observation of individual creatures. These qualities are not Persian, but Indian. The picture was painted by two artists, Lal and Sanwlah. Such collaboration was not unusual with Mughal artists, each man taking as his subject the one best suited to his talents. Jahangir later boasted that he could recognize the brush of each of his artists even when they may have contributed but a small part to a picture.

The Emperor was extremely interested in the work of his artists and saw that the means were at hand to improve the materials available to them; fine papers were imported or made, delicate brushes and expensive pigments were sought — lamp black, ground lapis lazuli, gold leaf, and powdered gold among them. The resulting excellence of craftsmanship and delicate perfection of textures and atmospheric efforts were admired by the Rajput princes who were often present in the palace. It became the fashion among them as it was the custom of the Mughals, especially in Jahangir's reign, to bring a train of painters along on their travels.

Akbar's attitude toward painting, frowned on by

217

273. *Death of Inayat Khan. Drawing, width 5¼".*
Mughal, School of Jahangir, early 17th Century A.D.
Museum of Fine Arts, Boston

274. *A Village Scene, from the Hamza Nama. Detail,*
color on cotton, height of whole page 26⅜". c. A.D. *1570.*
Victoria and Albert Museum, London

orthodox Moslems, throws light on the devoted absorption of the Mughal painter to the essentials of his subject. "It always seems to me," he said, "that a painter has very special means of recognizing God, for when he draws a living thing, and contemplates the thing in detail, he is driven to thinking of God, Who creates the life which he cannot give *his* work, and learns to understand God better."[7]

The influence of this attitude which induced the artist to render with the utmost care and skill the outward appearance of the subject is most clearly seen in the paintings executed during Jahangir's reign. He had a great reverence for his father, Akbar, and a passion for life; people, birds, animals, and flowers absorbed his attention. He demanded that his artists follow him everywhere to record the amazing wonders that met his eyes. No perfunctory stylized record satisfied him. As can be seen in our illustration of the zebra, the gentle eye, the position of the ears, the delicate hair of the mane and forelock, and the dark, soft muzzle are all carefully recorded (*fig. 272*). Jahangir was not equal to his father in wisdom, but his desire to continue his father's dream of bringing together the contributions of many lands is somewhat naïvely attempted in the marvelous painting which shows Jahangir seated on a jeweled hour-glass throne surrounded with a magnificent halo of sun and moon and receiving under his imperial aegis a Moslem divine, a Moslem prince, a European delegate, and an artist (*colorplate 15, p. 191*). The hour-glass throne sits on a Renaissance carpet and scattered about the composition are the figures of small cherubs copied from European paintings.

One of the masterpieces of Jahangir's reign has a curious history and reveals much of the Emperor's personality. The art of portraiture was one of the great contributions of the Mughal school to Indian painting. The interest in the character of individual faces can be seen in our first illustration where Jahangir receiving Prince Parviz is surrounded by the members of his court. Each face is thoughtfully studied and reveals the person, aged and wise, or aged and sterile, youthful and worried or unaware, middle aged and strong, or merely stolid. The great portrait is that of the dying Inayat Khan (*fig. 273*). Jahangir describes the occasion of its making in his diary.

"On this day news came of the death of Inayat K[han]," he writes. He was one of my intimate attendants. As he was addicted to opium, and when he had the chance, to drinking as well, by degrees he became maddened with wine. . . . By my order Hakim Rukna applied remedies, but whatever methods were resorted to gave no profit. . . . At last he became dropsical, and exceedingly low and weak. Some days before this he had petitioned that he might go to Agra. I ordered him to come into my presence and obtain leave. They

put him into a palanquin and brought him. He appeared so low and weak that I was astonished. 'He was skin drawn over bones.' Or rather his bones, too, had dissolved. . . . As it was a very extraordinary case I directed the painters to take his portrait. Next day he travelled the road of non-existence."[8]

The artist called in by Jahangir drew the dying man with an awesome compassion, directly and without flourish. The frail body is there, propped against massive, rounded bolsters, looking at death with quiet acceptance.

During the reign of Jahangir's son, Shah Jehan, the painting of the Mughal school grew in elegance of texture and color. Portraits, *durbars,* and other subjects were painted so delicately that a hazy bloom seems to lie over the surface of forms. Some aspects of European painting appealed to the Indian artist and these became assimilated into a thoroughly integrated style. During the reign of Aurangzeb, the last powerful prince of the dynasty, painting languished, for this emperor was a fanatical Moslem who discouraged figural art. A few portraits and battle scenes remain as a record of his day. Artists from the imperial household sought patrons elsewhere.

The Mughal style was primarily realistic and its natural outlet was portraiture and narrative. But there are details in some of the most famous of Mughal manuscripts on which Indian artists apparently worked where a blending of the two styles occurs and the conceptual, abstract approach of the Jain tradition was wedded to the Mughal observation of nature to produce a fused style, which we can call Rajput (*fig. 274*). This style, existing only in details or out-of-the-way passages of Mughal paintings, lay at hand and ready for a sympathetic subject matter, the material found in the literature of the later revival of Hinduism in Northern India.

There are some who see in Rajput painting only a decadent and degenerate form of Mughal painting, but this little illuminated manuscript, showing two dancers, has enough of the elements of the Gujarati manuscript style — particularly in the use of the projecting profile eye — to prove at least the partial development of Rajput painting out of that tradition (*fig. 275*). However, color is less abstract, more decorative, and we have the use, as W. G. Archer says, of passionate reds and verdant greens, to produce a new style which is primarily lyrical, rather than intellectual, one which appeals to the emotions rather than to the mind. The future of the Rajput style was not to be in the Western

219

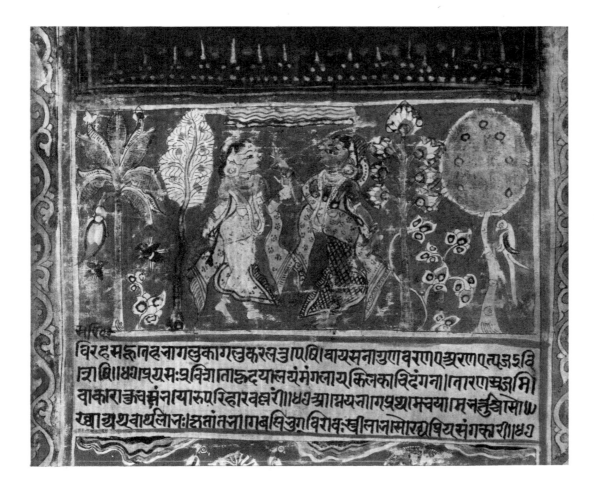

*275. Poems of Spring,
from the Vasanta Vilasa.
Color on roll of cotton cloth.
Western Indian, Gujarati-Rajput,
mid-16th Century* A.D.
Freer Gallery of Art,
Washington, D.C.

region, but in North Central India, at first in Rajputana, the same region that produced the Nagara style of Indian architecture and sculpture. Later the style was to flower in the foothills of the Himalayas. The first phase of the Rajputana style was primitive, derived from the fusion of the Gujarat and Delhi elements, and found in a few rare manuscripts from the sixteenth and early seventeenth centuries. One in particular is of the highest importance. It is a painting, representing the Month of Rains, with a cloudy sky and a representation of rain falling against a blue ground (*fig. 276*). There is an almost perfect fusion of the abstract patterning, the eye convention, and something of the color of the Gujarati manuscripts, with a new, fresh, complexity of composition, which becomes the Rajput style. Niches with their vases are still used

276. Month of Rains. Color on paper, height 9". Western Indian, mid-16th Century A.D. *Central Museum, Lahore*

220

as patterns; the figure is confined to profile or the full front view; but the new style is now capable of expressing an intensity of passion and, particularly through color, most appropriate to that revival of personal devotion typical of the Krishna cult in the Later Medieval Period. There are almost no traces of Mughal influence, except in architectural motives — and Mughal domestic architecture dominated North India. Representation of a cupola here, or of niches with their pointed arches there, are derived from the familiar Mughal architecture rather than Mughal painting.

There are three major geographic areas and schools of Rajput painting. The first and earliest is that of Rajasthan and Malwa, active in the seventeenth and eighteenth centuries and occupying the area which corresponds roughly to the region north and west of Delhi, as far as the foothills. The second is the school of the South, which does not mean the far South, but the region of the Deccan, the plateau of the Central region. This school was active from the late sixteenth century on, heavily influenced by Mughal style. The third is the school of the Punjab Hill States (Pahari), including such states as Basohli, Jammu, Guler, Garhwal, and Kangra, particularly active in the eighteenth and early nineteenth centuries. It produced the most charming and lyrical of the Rajput paintings, while the Rajasthani school provided the most powerful and the most daring.

The schools are unified to a certain extent by their subject matter and symbolism. Principal subjects illustrate seasonal songs called *ragas* or musical modes, epics, and literature concerned primarily with Krishna and, by the late seventeenth and eighteenth centuries, with Shiva. We find, particularly in the Rajasthani school, a union of music, literature, and pictorial art, through the musical mode. Such a unity could only occur where there was an accepted tradition of interpretation: where a given color, certain birds and flowers suggested particular moods or situations; where a representation of the month of August brought to mind the musical phrase appropriate and traditional for that month. Within the Rajput tradition, there was a truly unique union of music, literature, and painting, even beyond that achieved by the Baroque painters under the motto *Ut Pictura Poesis*. A pictorial representation of a musical mode has many levels of reference all united in one vision: a specific musical theme, a particular hour of the day, day of the month, and month of the year, as well as a familiar romantic situation between the protagonists, usually Radha and Krishna. Coomaraswamy's description makes clear this interweaving of the *ragmala*:

"A favorite theme of Rajasthani painters is a set of illustrations to a *Ragamala*, or 'Garland of Ragas,' poems describing the thirty-six musical modes. The *Raga* [male] or *Ragini* [female] consists of a selection

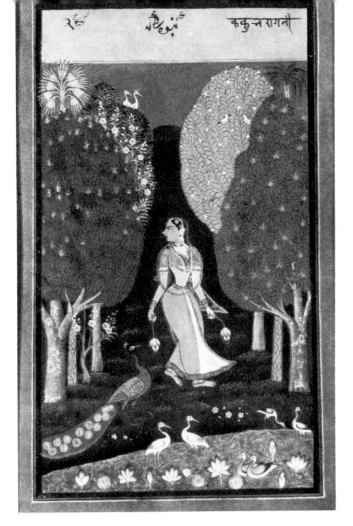

277. *Adhira Nayaka. Color on paper, height 10".*
Rajasthan, Mewar (Udaipur), early 17th Century A.D.
Cleveland Museum of Art

278. *Kakubha Ragini. Color on paper,*
height 10⁷⁄₁₆". Rajasthan, Bundi, c. A.D. *1680.*
George P. Bickford Collection, Cleveland

of from five to seven notes or rather intervals, distributed over the scale from C to C, the entire gamut of twenty-two notes being never employed in a single composition. . . . The *Raga* or *Ragini* is further defined by characteristic progressions, and a leading note to which the song constantly returns, but on which it does not necessarily end. . . . What is most important to observe is that the mode is known as clearly by the mood it expresses and evokes as by the technical musical definition. . . . The moods expressed . . . are connected with phases of love as classified by Hindu rhetoricians, and are appropriate to particular seasons or elements, . . . and all are definitely associated with particular hours of day or night, when alone they may be appropriately sung. . . . *Ragmala* paintings represent situations in human experience having the same emotional content as that which forms the burden of the mode illustrated. In other words, the burden of the music, the flavor of the poem, and the theme of the picture are identical."⁹

The *nayaka*, a subject dealing with types of women in love, generally eight of them, was also a favorite subject of the Rajasthani school (*fig. 277*). In this we find romantic love, that is love at first sight and usually extra-marital. This phenomenon seems characteristic of a well-guarded social order where marriages are arranged, and is based upon physical attraction which they do not distinguish from a spiritual one. *Abhisarika Nayaka* is she who goes out to seek her beloved, and the appropriate poem tells us that —

'Serpents twine about her ankles, snakes are trampled
 under foot, divers ghosts she sees on every hand,
She takes no keep for pelting rain, nor hosts of locusts
 screaming midst the roaring of the storm,
She does not heed her jewels falling, nor her torn dress,
 the thorns that pierce her breast delay her not, —
The goblin-wives are asking her: "Whence have you
 learnt this yoga? How marvellous this trysting, O
 Abhisarika!" '¹⁰

It is significant that in this early picture the representation of this *nayaka* is not literal, but general (*colorplate 16, p. 192*). In later depictions of this particular heroine, the representation becomes quite literal: we see the serpents, the jewels falling, and the rain.

The *nayakas* and traditional religious subjects, representations of Shiva, of Durga, and of Vishnu, are

221

279. *Tiger Hunt on a River Bend. Color on paper,*
width 19⁵⁄₁₆". Rajasthan, Kotah,
c. A.D. 1790. George P. Bickford Collection, Cleveland

श्रीकृष्ण रागमालगौरमल्हार

280. *Gaura Malhar Ragini. Color*
on paper, height about 5". Punjab Hills, Basohli,
c. A.D. 1695. Stella Kramrisch Collection, Philadelphia

characteristic of Basohli, the earliest of the Hill schools; while representations of the narrative stories of the Krishna cult seem most characteristic of the later Hill schools. Portraits and court groups occur in all schools, usually where Mughal influence is heaviest; but in the late eighteenth and nineteenth centuries, portraits of court groups and court functions seem to be common to all Hill schools (*see fig. 283*).

Priority for the development of a recognizable Rajput "primitive" style must be assigned to Southern Rajasthan and Malwa, geographically a part of Central India, but a close neighbor to Rajasthan. Pages from a few series are known, all in a similar style dated as early as 1540 by Gray and Archer, who assign them to Mandu (*colorplate 17, p. 225*). Some Persian elements are discernible in the ornament, but the colors and figural representations are clearly derived from the West Indian manuscript tradition and perhaps in part, from an almost lost mural tradition of the Medieval Period.

This new manner appears to have spread to the North and by 1630 there is a broadly homogenous style ranging from Malwa to Mewar with, of course, local variations and flavors. The famous Coomaraswamy series, with its distinctive dark blue backgrounds, shows the Malwa style in a particularly bold and daring way. *Abhisarika Nayaka* here is both a musical mode (*Mad-*

hu Madhavi Ragini) and a representation of a heroine, who goes in the night to meet her lover (*see colorplate 16, p. 192*). She comes through the black night with peacocks screaming about her, as rain clouds form, and lightning flashes; but the representation is not frightening. The situation is "conventional"; but if so, the use of color, shapes, and patterns of shape and color is hardly stereotyped. It is extremely daring and bold, and results in work which recalls Egyptian painting as much as it seems to anticipate some of the experiments of modern painting, particularly by artists such as Matisse. In this manuscript of about 1630 we have an early and classic statement of the Rajasthani style, after the assimilation of the varied elements contributing to it.

Another page, of about 1680, represents a musical mode in which there is the same daring use of color and patterning, but a greater emphasis on detail, and a degree of subtlety which we expect in the second or third generation of the school (*colorplate 18, p. 226*).

The development of Rajasthani painting in the eighteenth century is toward greater finish and perfection of detail, under the influence of Mughal painting; but it still maintains the brilliant and arbitrary use of color which is the particular hallmark of Rajasthan. These qualities are clearly present in the Bikaner and Jaipur pages. Bundi (*fig. 278*), and its derivative, Kotah (*fig. 279*), continue the bolder traditions of Rajasthan into the late eighteenth and early nineteenth centuries.

The second major school, that of the Punjab Hills is, in terms of quantity of work, probably the most important. In many cases it equals the Rajasthani school in quality, but of quite a different kind. It emphasizes linear drawing and, with the exception of the Basohli school, a lyrical, gentle style. The Basohli is the earliest school in the hills and makes the transition from the Rajasthani style to the developed Hill style. Basohli miniatures have something of the rich color and daring juxtapositions found in Rajasthani painting, but with something that is peculiar to the early Basohli school and its derivatives, Kulu and Nurpur, and does not appear in other later paintings of the Hill States (*fig. 280*). This unique quality is a use of extremely warm color, which makes them among the "hottest" paintings ever created. These mustard yellows, burnt oranges, deep reds, and torrid greens are pulled together in a unity as hot as Indian curry. The rigidity of the poses of figures recalls Rajasthani miniatures.

A very fine Basohli page of about 1690 shows a category of subject matter in which the Basohli school excelled: the representation of deities in almost iconic form (*colorplate 19, p. 243*). The manner goes back to earlier traditions — that is, rather rigid figures within a balanced composition and their representations of Shiva, Vishnu, Brahma, and others. In this case, we have a representation of Shiva and Parvati, but Shiva particularly, as the slayer of the elephant demon. They

float in the sky on the elephant's hide, against stormy, curling clouds above a warm, if rather sparse, Basohli landscape.

But the characteristic work of the Hill States is to be found in the paintings produced first in Guler, and later, when the style expanded, in all the Hill States (*figs. 281-283 and colorplates 20 and 21*). It is a gracious and poetic style, somewhat under the influence of

281. *The Road to Krishna, by the "Garhwal Master." Color on paper, height 8". Punjab Hills, Guler, c.* A.D. *1785.* Victoria and Albert Museum, London

282. *Durga Slaying Mahisha. Color on paper, width 10¹³⁄₁₆". Punjab Hills, Kangra, last quarter of 18th Century* A.D. Cleveland Museum of Art

283. *Raja Sansar Chand of Kangra with His Courtiers. Color on paper, height 9½". Punjab Hills, Jammu-Sikh School, c. A.D. 1780.* George P. Bickford Collection, Cleveland

later Basohli painting but with heavy Mughal influences. Its technique is more complex and tighter than that of Basohli. The miniature technique of the Mughal school, with its use of polished white grounds, under-drawing, over-drawing, and then a rich jewel-like application of color, was carried on by the Hill painters; but at the same time, some of the flat mural or jewel-like color of the Rajasthani school was also preserved. Subject matter tends to be involved with either the poetic revival of the Krishna cycle, with its pastoral symbolism and erotic overtones, or with the heroic epics of the past, the *Mahabharata* and the *Ramayana* (*colorplate 20, p. 244*). While the musical modes almost disappear, the subjects of the heroines, the *nayakas*, are continued, and also some of the traditional religious subjects. But in general, the characteristic Hill school subject matter is either from the *Krishna Lila*, or from the two great Hindu epics.

A particular album page by the "Garhwal Master," as W. G. Archer calls him, presents the characteristic elements of the developed later Punjab Hill style (*fig.*

281). There is an emphasis on decorative pattern achieved by line and shape repetitions. An attempt is made, perhaps under Western influence, at landscape vistas with architectural views and perspective in depth. A more realistic and observant delineation of the figure is achieved with an attempt to characterize youth, old age, and social position. All this is combined with enough decorative character to distinguish the style very sharply from that of the Mughal school. Guler produced works which combine the very best qualities of the Rajasthani and Mughal schools. Another page displays a rich use of color in the blue Krishna against pearly white accompanied by pale mustard yellow, a fascinating combination; while the pure linear drawing of the figure, profile, and drapery is a particular hallmark of the later Hill schools (*colorplate 21, p. 245*). The introduction of perspective in the little porch leading off the main room is unobtrusive and actually serves as a point of focus, heightening the interest in the main figure of Krishna, gazing off into the distance and yearning for his beloved, Radha. The knowing glances of the attendant girls are subtly depicted and the whole picture shows the hand of one of the great masters of the school.

The later schools of the Punjab Hills, particularly in rather large pages, show intense interest in the Hindu epics. Here realism is combined with something of a fairy-tale quality, in works of the greatest interest. Another Guler page is one of the masterpieces of the Hill States and a rare representation of a traditional subject. It is the same subject seen in pages of Bundi and Kulu origin: Durga slaying the bull demon Mahisha (*fig. 282*). The demon is a realistic bull and not a man issuing from a bull, as was the case of the earlier pages. Durga, on her chariot drawn by two tigers, and attended by her child-warriors, is drawn in a very beautiful, fine-line style. The landscape, used to reinforce the meaning of the composition, is divided into two parts: one, a rather barren and distant expanse with a storm, over the evil bull; the other, a lush view with a clear blue sky, over the forces of good. At the same time, the fairy-tale, never-never-land atmosphere of later Rajput painting fills the whole picture. We are no longer worried about the fate of the bull; the gory end in store for him does not bother us. The tigers are almost playful; and the goddess herself, even in her most vengeful aspect, appears as a lyrically beautiful young woman.

Rajput painting ends, as far as quality goes, by the middle of the nineteenth century, although some artists produced reasonably good pages up to 1900.

साधारास

Colorplate 17. King Parikshit and the Rishis (?) (The Opening of the Tenth Book of the Bhagavata Purana).
Color on paper, width 8⁹⁄₁₆″. Southern Rajasthan or possibly Central India, c. A.D. *1575. Cleveland Museum of Art*

Colorplate 18. Vangala Ragini. Color on paper, height 11⅝". Rajasthan, Malwa,
c. A.D. 1680. Cleveland Museum of Art

226

11. The Medieval Art of Southeast Asia and Indonesia

CAMBODIAN ART HAS RECEIVED much popular attention from the limited standpoint of romantic interest in the "smile of Angkor." Nearly all tourists who get to Southeast Asia make a point of the pilgrimage to Angkor Vat. There they are properly impressed with the size of the vast stone structure in the midst of the jungle. To an American student Cambodian art is usually a romantic subject. This is a limited approach for a variety of reasons, but most particularly because the Cambodian style is one of the really unique manifestations of art in Asia. We have seen briefly some of Cambodia's Buddhist art; but we properly left the larger part of our study to the Hindu section of our exploration of Indian and Indonesian art. Where India produced great sculpture in an organic tradition, one emphasizing movement and sensuousness, Cambodian art moves us by a peculiar combination of sensuality allied to a very strong architectonic character. It is almost as if it combined the sensuous elements of Indian sculpture with the strongly formal characteristics of Egyptian sculpture into a single unity.

Cambodia comprises a relatively small area in Southeast Asia, where the earliest artistic manifestations were under the influence of the North. From there certain techniques came from South China. A few intricately cast bronze drums and a few rudimentary animal sculptures in stone are among the artifacts left to us from this very early period in Indochina. But beginning about the third century A.D. there were important contacts with India by sea; and, as so often happens when the high culture of a fully developed and expanding state, such as India, comes in contact with a relatively low culture, the influence was sudden, dramatic, and overwhelming. Shortly after the fourth century A.D. we begin to get sculptural manifestations of this Indian influence in the regions of present-day Thailand and Cambodia. But this influence, not only sculptural or architectural, involved the organization of society on the higher levels as well. The impact was relatively slight on the lower levels of society, where even today we can find traces of pre-Hindu culture. Buddhism and Hinduism were both imported into Cambodia at this time. Hinduism was by all odds the strongest influence and the one largely dominant from that time, despite the evidence of numerous Buddhist monuments in Cambodia. There was a synthesis of Buddhism and Hinduism into a peculiarly Cambodian religious form closely involving the

284. Sambor Prei Kouk, Cambodia. Early 7th Century A.D.

style, that international style beginning in the third and fourth centuries A.D. in India, and thence exported to Indonesia, Siam, Burma, and Java. Although the point of origin was the Gupta style, the development in these countries was along different paths. While Siamese and Cambodian art, for example, are somewhat difficult to differentiate in their earliest manifestations, later they become more and more divergent, more individual, and are more easily distinguished. Successive waves of Indian influence can be detected, some of them from Bengal and some from the Pallava Empire in South India. Cambodian art ends in the fifteenth century, when the Siamese military power destroyed Angkor, after which the Cambodian style persisted only as a native folk art.

A monument prior to the cult of the Devaraja is

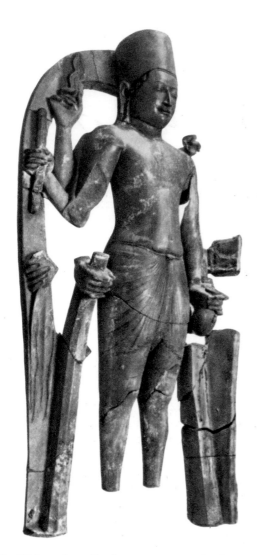

285. *Vishnu, from Tuol Dai Buon, Cambodia. Stone, height about 72". Early 7th Century* A.D. Musée Albert-Sarraut, Pnom-Penh, Cambodia

286. *Vishnu. Style of Prasat Andet. Pre-Angkorean, gray sandstone, height 34¼". Cambodian, second half of 7th Century* A.D. Cleveland Museum of Art

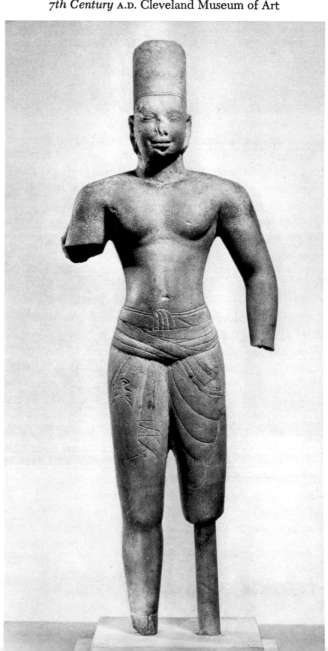

state. This particular state religion was the cult of the Devaraja, the God-King; and while it may have originated in Java under the great Shrivijaya Empire at a time when it exercised some control over Cambodia and Siam, it became the characteristic expression of Cambodian society and of Cambodian art. The Javanese version, in turn, was probably derived from the Hindu cult of the World Ruler, the *chakravartin*. But in Cambodia, the cult of the Devaraja took an extreme form; in effect, the king did become the god, and all power, religious and secular, was centered in him. The monuments of Cambodian art can be considered as personal constructions, monuments which continue the king after his death in sculptural form, and continue his world in architectural form.

The common point of origin for the various early styles in the region of Cambodia and Siam is the Gupta

Prei Kouk of the sixth or seventh century (*fig. 284*). It is of particular interest because of its Indian origins and because of its physical insignificance when compared with the later, magnificent developments under the cult of the Devaraja. Prei Kouk is a single shrine, despite its moderate size and the use of niches on either side of the entrance. It is fundamentally a cell, like the one at Mahamallapuram, with the niches containing images of the deity worshiped in the cell inside the shrine. The basic structure, despite the stone dressing, is brick; and this, too, is significant as a primitivism, for the later development and glory of Cambodian architecture depends upon the use of stone.

The sculpture of this early period, which we call Early Khmer, from the sixth to the ninth century A.D. is of greater artistic interest than the architecture. Despite the fact that the new sculptural style was derived from the Gupta manner of India, it seems as if the Cambodians were able to establish a monumental and architectonic character at the very beginning, quite radically different from the character of its Gupta antecedents. The earliest sculptures are of one basic type, with the S-curve (*tribhanga*) of the body, magnificent squared shoulders, a large chest, and a delineation of the stomach muscles that is completely unknown in most Indian sculpture. The appearance of the headdress, the tall miter-crown, is characteristic of this Early Khmer work (*fig. 285*). This — plus the fact that the figure is related to the *mandorla*, or body halo, that encloses it — produces an effect that can perhaps best be described as a wedding of what is characteristic of Indian sculpture and what is salient in our concepts of Egyptian sculpture — namely, a strongly architectural and firmly cubic conformation, which impresses us with the solid and immovable nature of the material, in contrast to the plastic and fluid concepts of Indian art. The earliest Khmer examples are, properly enough, those that still retain a certain sensuousness derived from the Gupta style. The later sculptures of the seventh and eighth centuries possess a much more powerful and architectonic character. Figures of this period, one of them an image of Vishnu, still show something of the subtlety and soft modeling of the earliest Khmer pieces (*fig. 286*). But the Cleveland Vishnu displays a strong cubic appearance; in this particular case, the size of the shoulders, the massiveness of the neck, the almost geometric character of the torso, and the careful use of incising to indicate drapery — so as not to destroy the blocklike character of the whole — are combined in a unified work of art which is easily distinguished from any Indian prototype. These early Khmer sculptures, usually sculptures of Vishnu or of the deity known as Hari-Hara, a combination of Shiva and Vishnu in one image, are the standard iconographical embodiments of Early Khmer style: single figures standing rather rigidly facing the

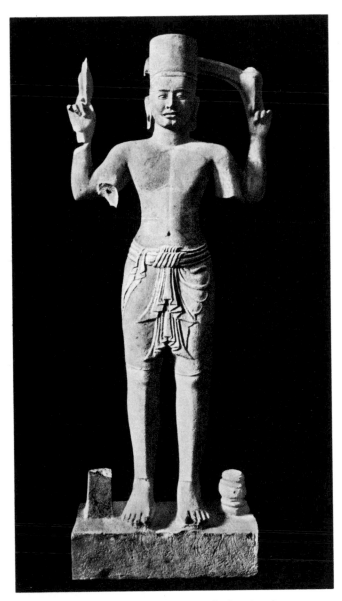

287. *Vishnu, from Koulen, Cambodia. Sandstone, height about 60". Early 9th Century A.D.*

spectator, oftentimes with a body halo in stone around the figure.

With the end of the eighth century and with the reign of the Javanese King Jayavarman II comes the introduction of the cult of the Devaraja. The concept of the World Mountain in Cambodian architecture also dates from this time. The Mountain is considered as an integral part of the architectural organization, whether it is a natural mountain or, as in the case of later Cambodian architecture, a constructed one. The Mountain is the axis of the universe and must be at the site of the temple and incorporated in the temple itself. The beginnings of this development are found in the shrine on a natural mountain; that is, a simple

229

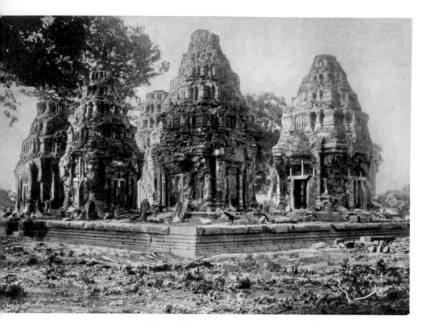

288. Prah Ko, Cambodia. A.D. 879

289. Ta Keo, Cambodia. c. A.D. 1000

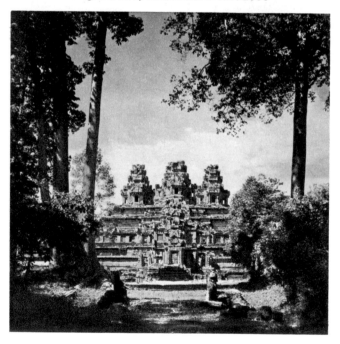

tively complete image of Vishnu from Koulen, though part of the body halo is missing, shows the god holding the disk, or wheel — the *chakra* — as his principal attribute (*fig. 287*). While it has still something of the particular architectural character of Early Khmer sculptures, it has begun to be modified in the lower limbs. The region from the hips down, particularly from the knees down, seems much less sensitive than similar modeling on the Early Khmer pieces. There is a quality here characteristic of much later Cambodian sculpture; the artist's sensitivity seems to end at the waistline. The legs become rigid and stiff, almost as if they were tubes; but the upper part of the body retains the quality of previous modeling and the head begins to show, particularly in the modeling of the lips, something of that sensuous and romantic quality which has so endeared Cambodian sculpture to the modern world. The mysterious smile of Angkor is beginning to play about the corners of the mouth. The drapery, too, is developed into a larger and more important part of the composition. It is in relatively high relief, and the pattern is emphasized in relief, not simply incised on the surface of the sculpture. Drapery is developing into a decorative motif in its own right. This tendency toward a decorative handling of drapery and accessories is characteristic of later Cambodian sculpture.

Cambodian art is generally divided into three categories: Early Khmer, from the sixth to the ninth century A.D.; and two units after that, the First Style of Angkor and the Second Style of Angkor. In architecture, the First Style of Angkor provides us with our first great monuments of a more complicated type. There are two particularly significant steps in the development that leads to Angkor Vat, represented by Prah Ko, dated A.D. 879 (*fig. 288*), and Ta Keo, dated about 1000 (*fig. 289*). Prah Ko is of mixed construction, brick and stone, and is more complex and developed than Prei Kouk. The six shrines, though they are still single cells, are grouped on a common pedestal. The architects have abandoned the concept of a shrine using a natural mountain as a base, and have begun building a microcosm which includes the mountain. But the combination of the two is not yet organic. At Ta Keo, on the other hand, we have a full statement of the essentials of the great Cambodian architectural style: a central shrine dominated by a tower and flanked by four subsidiary shrines and towers at the four corners. All this is made of stone, and placed on a pyramid of stone, with the beginnings of galleries around the central mountain structure. In the background near the palms, at the outer wall of the lowest level of the pyramid, there is a series of columns indicating a gallery around the whole structure. These essentials, towers of stone on a raised pyramid with surrounding galleries, are the basic elements of almost all later Cambodian architecture.

230

cell-shrine of the type of Prei Kouk is placed on top of a holy eminence. This is true at the earliest site of the cult of the Devaraja and of the new concept of the mountain-temple, Koulen. From this very simple beginning of a shrine on the natural mountain, the great complex stone architectural monuments of Angkor Vat and the Bayon in the region of Angkor were to develop. Koulen is also important because it produced a sculptural style which marks the transition from the Early Khmer to the developed Angkor styles. This rela-

290. *Lintel, from Sambor Prei Kouk,*
Cambodia. Sandstone. Musée Guimet, Paris

291. *Lintel, from Koulen, Cambodia.*
Sandstone. Musée Guimet, Paris

292. *Lintel, from Banteay Srei, Cambodia.*
Sandstone. Musée Guimet, Paris

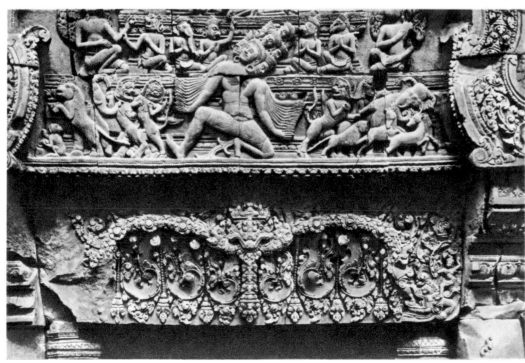

231

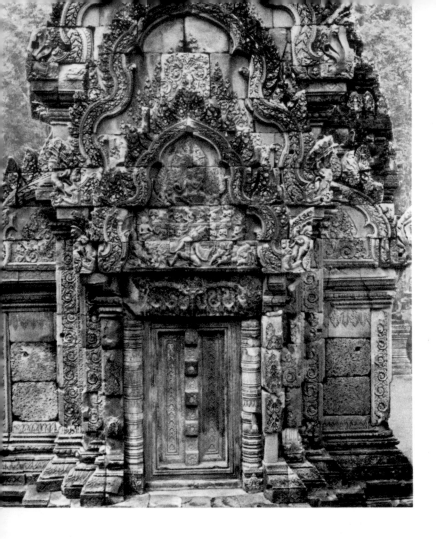

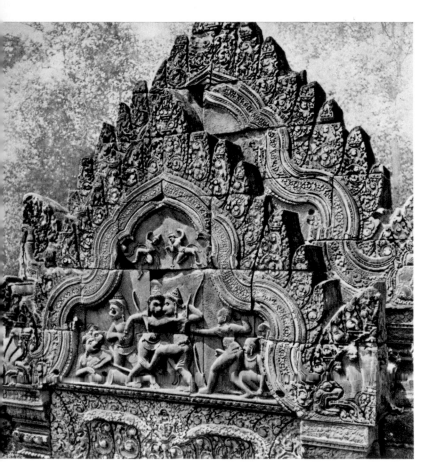

The development seen in architecture is paralleled in architectural ornament. We illustrate a sequence of three lintels in stone, covering the time traveled so far. Figure 290 is Early Khmer, figure 291 is a transitional example, corresponding to the style of Koulen, and figure 292 is from Banteay Srei. As one looks at the first, one can see that it is related in its general format to the South Indian architectural style. There are little roundels which correspond to the windows we saw at Mahamallapuram (*see figs. 216 and 217*). There are *makaras,* the dragon-fish, a typical South Indian and Sinhalese motif, and hanging jeweled garlands, found also in Ceylon and in some early monuments in South India. Note, too, how the whole design is held in bounds by a heavy border above and below, and that this border is repeated within the sculptural decoration, allowing the lintel to retain its architectural character. The carving is not insistent and does not yet dominate the shape of the lintel, when compared with what is to come. The second lintel (*fig. 291*) shows a much more elaborate sculptural development. The architectural boundaries of the lintel are violated — and the word is not used in a deprecatory sense. The lintel is carved and broken up so that there is a tendency for the design to become an over-all pattern. The third illustration (*fig. 292*) pictures a lintel of the First Style of Angkor, and gives some idea of the beginnings of the final style for Cambodian architectural sculpture. The concern with architectural structure is now at a minimum; it is reduced to a small beaded border, and the form of the arch has now become a hanging vine motif, incorporated into the sculptural foliage dominating the whole composition. Peering into this deeply cut vegetative ornament, one can make out *makaras,* lions, and small figures. But these figures are amalgamated with the foliage so that the whole effect becomes junglelike. This type of architectural ornament, a profusion of vegetative motifs, an abhorrence of a vacuum, and a desire to cover every possible area with as much carving as possible is characteristic of the developed Cambodian style.

Let us begin with sculpture in relief; and one particular monument provides us with a classic example of the early First Style of Angkor. Banteay Srei is to be dated in the tenth century, based on the evidence

of inscriptions which cannot be denied. The whole question of the dating of Cambodian sculpture and of Cambodian monuments is one of the most fascinating bypaths in art history. Before 1929, an apparently satisfactory system of dating had been proposed by French scholars. Then Philippe Stern published a small book called *Le Bayon d'Angkor et l'évolution de l'art Khmer*, in which he completely turned the tables of chronology, proving conclusively that monuments considered previously as of the thirteenth century were really of the ninth, and that monuments which had been considered ninth and tenth were of the thirteenth century. This was one of the most striking reversals in the dating of an important body of material ever published. If one can imagine, for example, that European art historians had confused the dates of Romanesque Conques and Gothic Amiens one may have some idea of Stern's revolutionary proposition.

Banteay Srei is the key monument in this sequence beginning with the ninth century (fig. 293). It is a jewel of a shrine, with important lintels showing scenes from the *Ramayana*. Note the character of the upper archi-

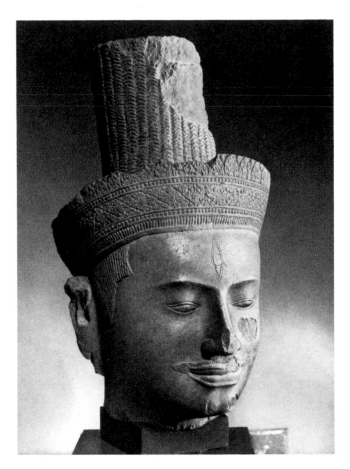

296. *Head of Shiva. Style of Koh Ker. Sandstone, height 16½". Cambodian, second quarter of 10th Century* A.D. Cleveland Museum of Art

295. *Female Deity, from Koh Ker, Cambodia. Sandstone, height about 60". Second Quarter of 10th Century* A.D. Musée Guimet, Paris

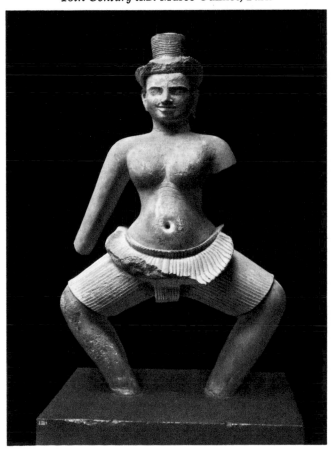

tectural ornament, a junglelike complex surrounding the arch. The character of the arch itself has taken on an undulating, almost snakelike, movement in keeping with the spirit of the carving. Inside the sinuously profiled arches the scenes are arranged in a formal way (fig. 294). There is an almost absolute balance, with a central figure and one on each side in reversed poses, and finally figures balancing the lower part of the composition on each side. This carefully balanced, rather static composition is characteristic of the single-scene reliefs of the First Angkor style. At the top are two flying angels, and if one remembers the flying angels on the walls of the Kailasanatha of Elura, with their boundless energy and their striking effect of movement, and compares those with these Cambodian angels in a similar architectural situation, one can realize the extent to which Cambodian figure sculpture tends to be relatively static rather than dynamic. These angels are frozen to the wall; they do not move, much less fly.

The sculpture in the round is of even greater interest. There are two basic manners associated with the First Style of Angkor: one associated with the monu-

233

ment called Koh Ker, and one associated with the Baphuon. The Koh Ker style can be seen in a characteristic example, the fragment of a female image riding on her now-missing vehicle, Garuda (?) — hence the curious pose (*fig. 295*). It is a relatively complete figure, and so fairly demonstrates the style of Koh Ker. First, the legs have the appearance, previously noted, of being relatively clumsy and heavy when compared with the rest of the figure. Second, the drapery has increased in size and depth of modeling, so that it becomes a very strong architectural and decorative part of the composition of the figure. Third, the treatment

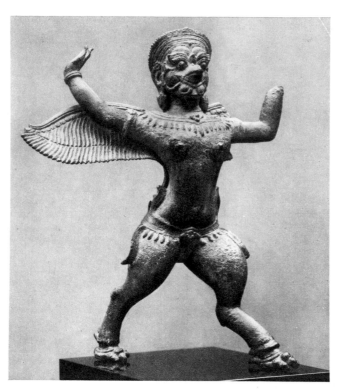

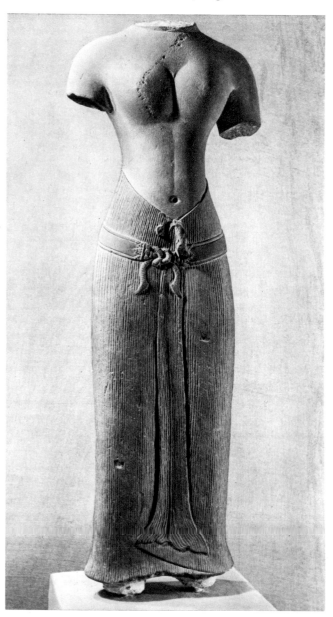

297. *Female Torso, from Baphuon. Sandstone, height about 48". Cambodian, mid-11th Century* A.D. National Museum, Saigon

298. *Garuda. Bronze, height 10". Cambodian, first half of 12th Century* A.D. Detroit Institute of Arts

of the head, particularly of the eyes and mouth, has taken on a distinctive and characteristically Cambodian aspect. The mouth, with the upturned smile and the double lines outlining the lips, is to all intents and purposes an early statement of the smile of Angkor. The treatment of the eyes, and especially of the eyebrows, finds a strong parallel in the line of the waist, the treatment of the headdress, and the generally architectural character of the whole body.

This particular female image is a "standard" example; that is, it is relatively complete and displays the basic elements of the style. But here we have a head of Koh Ker type which, in quality, is at the very summit of Cambodian sculpture (*fig. 296*). Let us consider the style of Koh Ker in relation to this head. One significant thing to point out about the modeling of the head at this time is its treatment as an architectural unit; the skin of the stone is preserved, with the exception of certain main features which have to be indicated in rather high relief, such as nose and lips. Everything else is kept on the surface or breaks the surface just as little as possible, so that when the piece is viewed in rather hard, flat lighting from the front, one loses almost all of the ornament and the cutting. But when sharply raking light is used, we can see that there is a very delicate and subtle pattern, built not

234

only in the ornament of the headdress but also in the treatment of the hair, the incising of the lines for the eyes, the moustache, and the double outlining of the mouth. All this is handled in an extremely delicate way, hardly breaking the skin of the stone, and producing an effect combining architectonic character with sensuousness. This combination of two seemingly incompatible ideals makes Cambodian sculpture a unique expression. Fine Cambodian sculpture will hold its own with the greatest in the world.

The second style, after Koh Ker, but within the First Angkor style, is that of the Baphuon, and we illustrate a typical female torso with a long skirt (fig. 297). The drapery now is not modeled in such high relief; the girdle is suppressed and tends to cling closer to the body. The whole figure still retains a strong architectural character, strengthened in this case by the long, ankle-length skirt with grooves or ribs giving a columnar character.

Attention is called to the existence of numerous images in bronze from the First and Second periods of

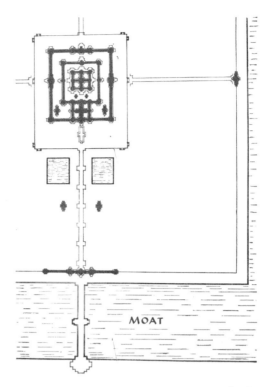

299. Plan Drawing of Angkor Vat, Cambodia

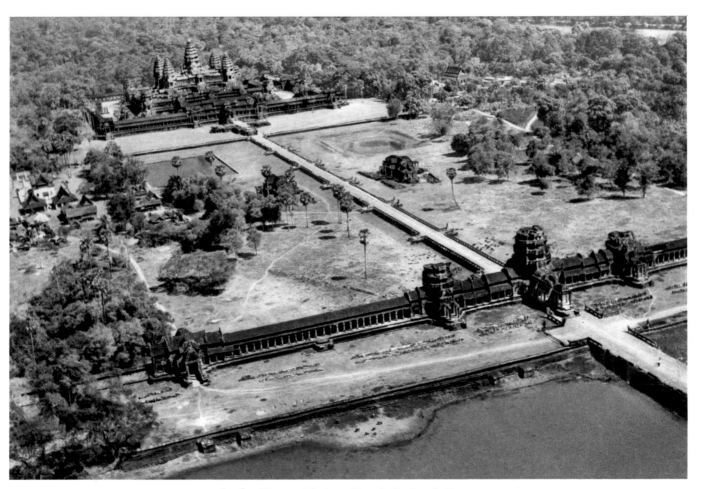

300. Angkor Vat, aerial view. First half of 12th Century A.D.

235

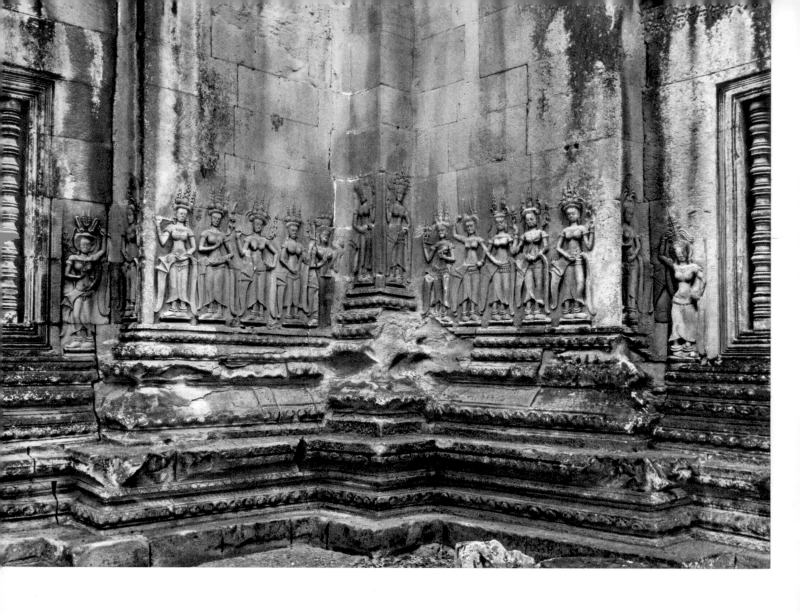

ABOVE:
*301. Celestial Dancers, from
Angkor Vat. Sandstone*

RIGHT:
*302. Army on the March, from
Angkor Vat. Sandstone*

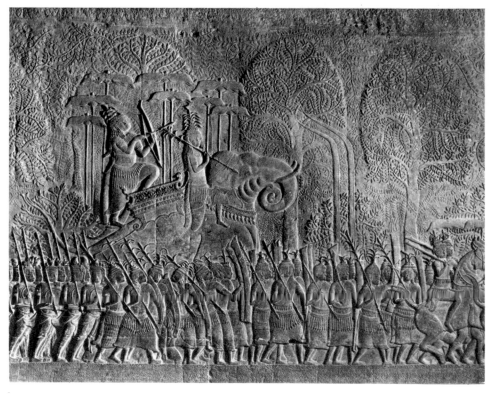

Angkor, usually ex-votos — small private altars or images — principally of Hindu subject matter, and usually associated with Vishnu, though Buddhist images are often found (fig. 298).

The Second Angkorean style produced the two most famous monuments of Cambodian art, Angkor Vat and the Bayon, both at Angkor. It is quite possible to write the history of Cambodian art after the Early Khmer Period by reference to Angkor alone. It was the capital, where each God-King felt impelled to outdo his predecessor in the size and merit of his architectural and sculptural accomplishments. The Second Angkorean style is considered by many as the classic Khmer style. Angkor Vat was built by Suryavarman II, who reigned from about 1112 to 1153. In the aerial view of this great monument one can see that it is largely an elaboration and enlargement of the architectural model set by Ta Keo (fig. 300). There is the same central tower, the four towers at the corners of the main pyramid, but the elaboration of the galleries is carried much further at Angkor Vat, and the size of the ensemble is enormously increased. The aerial view shows the one moat still in existence, with tanks on either side in the best South Indian tradition; but it gives no idea of the splendor or magnificence of the ensemble as it was in the twelfth century. For that we must examine a ground plan (fig. 299), which gives some idea of what the complete monument looked like; of

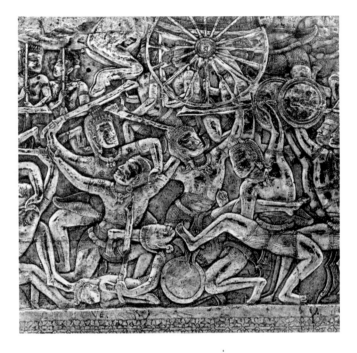

LEFT:
303. Detail of a Combat, from Angkor Vat

BELOW:
304. The Churning of the Sea of Milk, from Angkor Vat

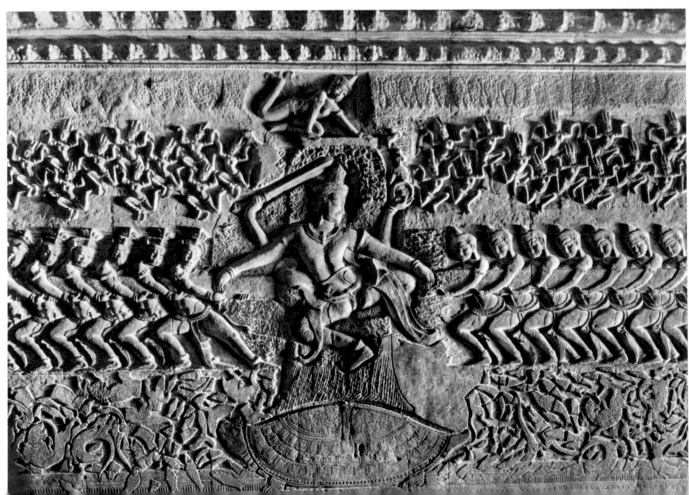

237

the tremendous size of the complex, with its great surrounding moat, the causeway over the moat leading to the exterior gallery wall, and the multiplication of these gallery walls, particularly in the main approach to the central shrine, all on a scale unknown before in Cambodia. The gallery roofs are built by means of corbeling; the arch was not used. Corbeling required a high roof line, so there is a considerable expanse of roof and rather tall proportions in all of the side corridors and galleries. A rising corbeled vault leads up to the main shrine, which is enclosed by a great tower.

Angkor Vat was dedicated to the God Vishnu and most of the sculptures are concerned with the various avatars of Vishnu. Before turning to the principal Vaishnavite relief let us examine a characteristic grouping of architectural sculpture at Angkor Vat. The exterior walls of many of the galleries are decorated above the plinths with figures of dancing celestial beauties, the same motifs which we saw in India; but here they are treated in a peculiarly Cambodian way (fig. 301). Cut into the sandstone after construction, they are placed against a relatively plain wall, so that they appear to be more related to the architecture than do the high reliefs and undercut relief productions of the later Indian Medieval school. The development of the drapery, the starched, band-shaped, heavy belts and the complexity of the high headdresses, show a decorative emphasis quite different from that of India. The smile of Angkor is evident in each face, and in some it reaches the point of caricature.

The interiors of the galleries are carved in low relief, almost as if painted in stone, with various scenes illustrating incarnations of Vishnu. One reveals an army on the march, a scene from the *Ramayana*, in which the Cambodians have depicted their own military forces in the guise of the forces ranged under Ravana and Rama (fig. 302). Note the abhorrence of the vacuum; every inch of the stone is carved with either jungle foliage or figures. Note, too, the rather awkward movement of the figures and their lack of

238

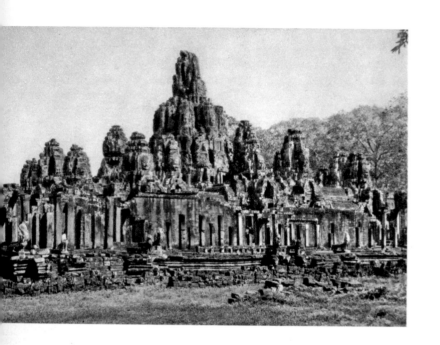

ABOVE:
305. The Bayon, Angkor Thom,
Cambodia, general view.
Late 12th–early 13th Century A.D.

RIGHT:
306. Bridge with the Churning of the
Sea of Milk, from the Bayon.
Early 13th Century A.D.

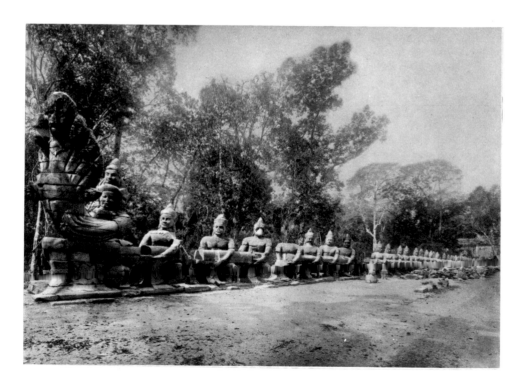

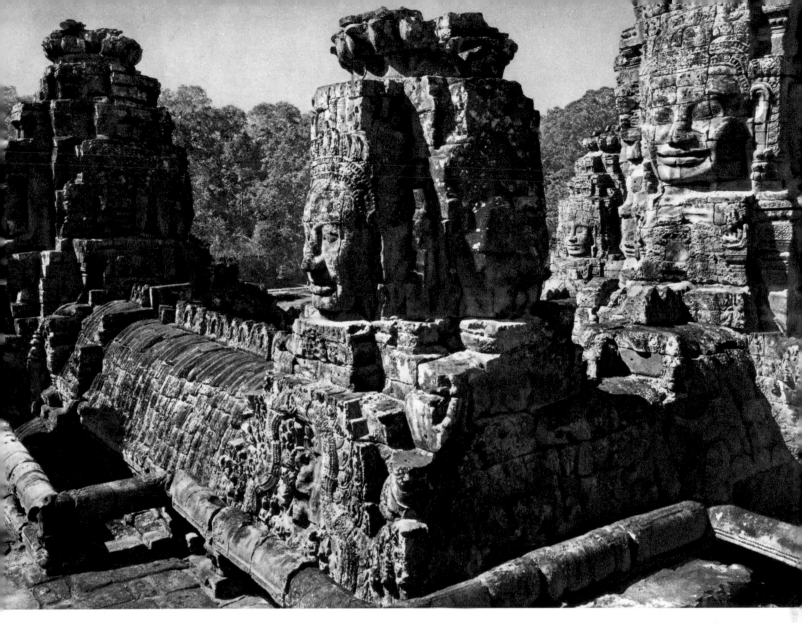

307. *Detail of the central towers of the Bayon*

narrative value. While each figure is there, each shown clearly, and all the details of armor are shown, details which provide a field day for the sociologist, anthropologist, and the historian of costume, we are more aware of decorative pattern and of a static presentation than we are of movement or conflict. When we examine a scene of combat we find in certain individual figures livelier and more active postures; at the same time there is an emphasis upon drapery patterns and the repetition of poses (fig. 303). The warriors appear immovable in the pose of a ritual dance. There are no more complicated representations of numerous figures in all of Oriental art than in these relief sculptures at Angkor Vat. If one thinks of those simple little bands of figures in the reliefs of the *Ramayana* at Elura, they seem the work of elementary and rather backward artists compared with the great variety of the low reliefs at Angkor Vat.

One of the most famous scenes at Angkor Vat is the story of *The Churning of the Sea of Milk*, concerning the famous tortoise avatar of Vishnu (fig. 304). The Gods and Titans (*ashuras*) made a truce so that they might churn the Sea of Milk, using the serpent Vasuki wound around the World Mountain, hoping to obtain the Dew of Immortality (*Amrita*). As the Mountain began to sink in the Sea, Vishnu assuming his avatar (a saving manifestation) of the tortoise, placed himself beneath it and supported it. The Sea gave forth various delights and finally the Dew, which Vishnu then obtained for the Gods alone by assuming the form of a desirable woman, Mohini, who seduced the *ashuras* into abandoning the elixir. The Gods then succeeded in defeating the demons and thus Vishnu reconstituted the balance of Good and Evil.

In the relief Vishnu appears twice, as deity bearing his attributes, mace and discus, guiding the operation and in his tortoise avatar below. The relief is so low that, like the *rilievo stiacciato* of Italian Renaissance

239

308. Seated Shiva, from Dong-Du'o'ong,
Champa. Brown sandstone, height 34". 9th Century A.D.
Cleveland Museum of Art

sculpture, it is a painting in stone; unlike Italian relief, it is not flowing and naturalistic, but formal and hieratic, with an especially effective use of silhouetted forms against textured grounds. Because of their rhythmical repetition, these reliefs have the character of an exotic, noble, and measured ritual dance not unlike that which is still performed by the court dancers of Cambodia.

The end of the Second Angkorean style is to be found at Angkor Thom and in the great mass of the Bayon at its center, built by Jayavarman VII, who reigned from about 1181 until some undetermined date early in the thirteenth century (*fig. 305*). The Bayon is a Buddhist monument, since it is dedicated to the Bodhisattva Lokeshvara, a manifestation of the most popular of all Buddhist deities, the Bodhisattva Avalokiteshvara. While Angkor Thom is nominally Buddhist, it is a syncretic construction. It includes representations of Hindu Gods; and one has the distinct feeling that

one is not dealing with either a Buddhist or a Hindu monument, but with a Cambodian monument truly expressive of the character of the ruler, Jayavarman VII — the God-King, the Devaraja. One enters Angkor Thom through a Hindu symbol. The gods and demons are shown as giant figures holding a long serpent, and re-enacting, as an entrance symbol, the Churning of the Sea of Milk (*fig. 306*). The central shrine, the Bayon, is a forest of towers of the most curious appearance; because carved on the faces of all the towers are gigantic faces of the deity Lokeshvara or, more probably, of Jayavarman himself (*fig. 307*). He surveys the Four Directions, a multiplied image of the visage of the God-King, looking out from the great central mass of towers over the kingdom of Cambodia, at its center in Angkor. The architectural character of the building has begun to be lost; and instead we are confronted with something that is, at least in theory, more like Hindu architecture — a work of sculpture rather than of construction. When one looks closely at some of these towers, one can see how completely the character is sculptural rather than architectural. The smile of Angkor has broadened, the lips are thicker and the nose flatter. The modeling of the face too, shows less emphasis upon linear incision and more on sensuous

309. Celestial Dancer, from Mi Son,
Champa. Sandstone, height about 36" 10th Century A.D.
Musée Henri Parmentier, Tourane

and rounded shapes. These are the most characteristic elements of the last style of Angkor.

The kingdom of Champa, which lasted from about the third century A.D. to 1471, was one of the principal rivals of Cambodia for military and political power, and depended for a large part of its income on piracy. Its history was one of constant warfare, and in 1171 Champa captured Angkor and sacked it, thus giving Jayavarman VII the excuse to build the Bayon. The principal difference of their architecture from that of Cambodia is its brick construction, and while it is generally parallel to Cambodian style, both in appearance and evolution, the architecture of Champa tends to be higher, more massive, and, at the same time, simpler in plan.

The evolution of Cham art can be traced best through its stone architectural decoration rather than through the monuments themselves, which changed relatively little in plan and conception. We have a definite chronological sequence of styles, established, like that for Cambodia, by the French scholars of the L'École Française de L'Extrême Orient. Unfortunately, we do not have the exact dating of the sequence; that is, we know which style followed which, but we do not know the precise dates for each one. There are five in all: first, an early style; second, the style of Hoa Lai; third, and most important, the style of Dong-Du'o'ong; fourth, Mi Son; and fifth, Binh Dinh, a style which corresponds to the development of a folk style in Cambodia. In sculpture, the most important style by all odds is that of Dong-Du'o'ong. It is a mixed native Cham and Javanese style, and its most characteristic products are images, not of Vishnu, but of the God Shiva. The seated image of Shiva in Cleveland is the only complete image in this country, and one of a very few outside of Champa proper (fig. 308). Dong-Du'o'ong art, as revealed in this image, is a highly individual one and quite different from that of their nearest neighbor, Cambodia. In this case, the blocklike character is paramount and is based upon the original cube of stone. Nearly all of the Dong-Du'o'ong sculptures, whether standing or seated, are placed upon a heavy plinth that retains the original dimension of the stone block from which the sculpture is made and determines the positions of the arms and legs. The second Cham characteristic, again very different from Cambodia, is a certain broad, almost coarse treatment of shapes which produces an almost animal-like effect in the faces of the male figures. The combination is one of architectural strength with physical coarseness; and the result is a rare but powerful style, not as well known or represented by so many examples as is the art of Cambodia. The style of Mi Son is also of great interest, and it produced some extremely interesting figures of celestial dancers, derived from Gupta and

310. Chandi Puntadeva, Dieng Plateau, Java. c. A.D. 700

311. Chandi Bima, Dieng Plateau, Java. c. A.D. 700

241

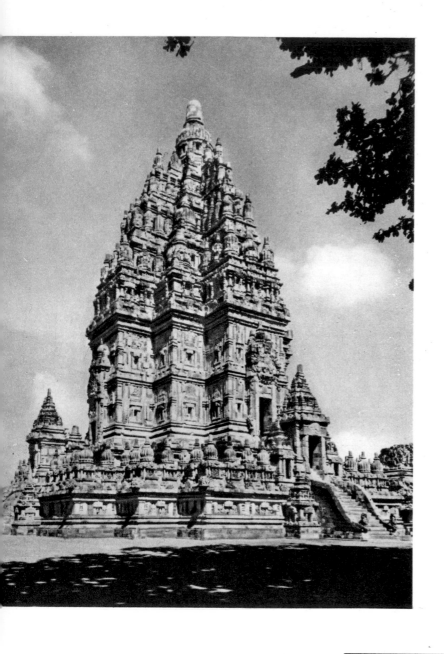

Pallava sculpture (fig. 309). The Binh Dinh style is a final development along the lines of folk art, with a triumph of decorative detail in works which emphasize the grotesque character of dragons and other monsters. The type is familiar to us from the folk arts of Southeast Asia today.

We have already considered perhaps the greatest monument of Javanese art, the Great Stupa of Borobudur. This Buddhist monument is so justly famous that it dominates the artistic map of Java. But we must remember that Java began under Hindu influence; and despite the domination of Buddhism in the eighth and the first half of the ninth centuries, the final triumph before the coming of the Moslems in the fourteenth century belonged to Hinduism. The period from A.D. 750 to 850 was the period of Shrivijaya rule, with the capital on Sumatra. While this was a period of Buddhist dominance, there were numerous Hindu shrines built in the early eighth century on the central plateau of Java, called the Dieng Plateau. These early Javanese Hindu single-celled shrines are relatively well preserved as a result of splendid repairs accomplished under the Dutch services of archaeology. Two sites are of particular importance for this single-celled type of architecture based upon South Indian prototypes. One of them is Chandi Puntadeva (fig. 310). The Shailendras used the high base of the Pallava style seen, for example, at Kanchi, and carried on to an elaborate degree at Elura, with an added emphasis on the niches projecting from the shrine. These go beyond the projections of the usual South Indian style. There are also certain playful elements involving the use of curves over the main door and on the balustrades up the steps to the main shrine. These, too, are elements we will find recurring in Javanese architecture. There is a

ABOVE:
312. Chandi Loro Jonggrang, Prambanam, Java. 9th Century A.D.

RIGHT:
313. Scene from the Ramayana, from Chandi Loro Jonggrang. Lava stone, height 27⁹⁄₁₆". *9th Century* A.D.

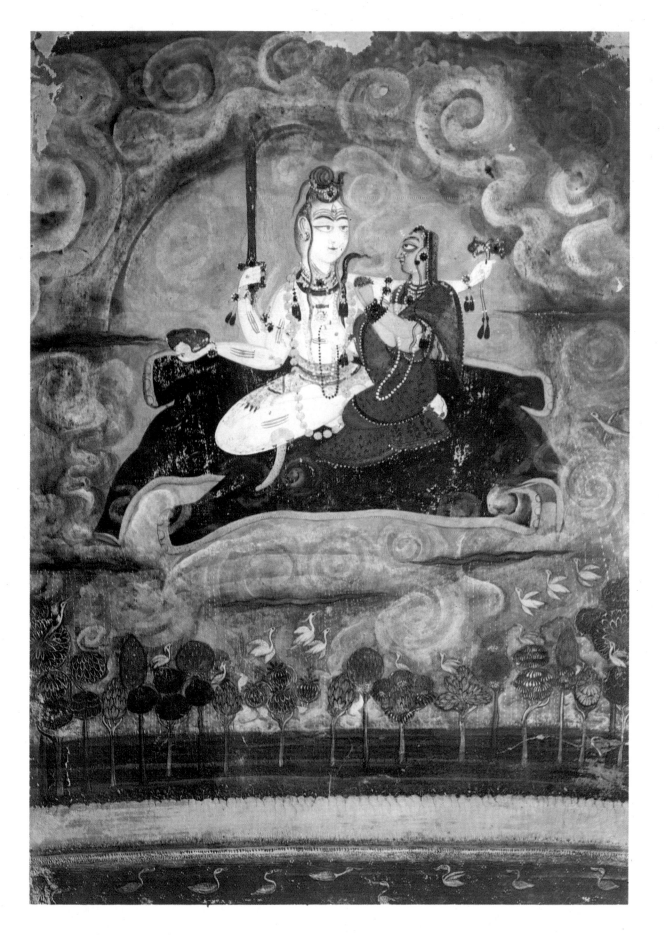

243

Colorplate 19. Gajahamurti (After the Death of the Elephant Demon). Color on paper, height 9⅛″.
Punjab Hills, Basohli, c. A.D. 1690. Cleveland Museum of Art

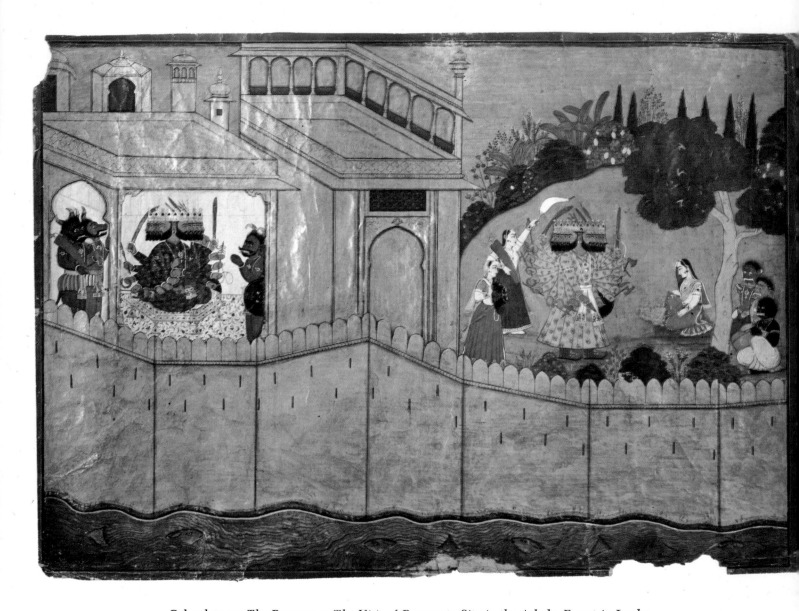

Colorplate 20. The Ramayana: The Visit of Ravana to Sita in the Ashoka Forest in Lanka.
Color on paper, width 33¼". Punjab Hills, Guler, c. A.D. 1720. George P. Bickford Collection, Cleveland

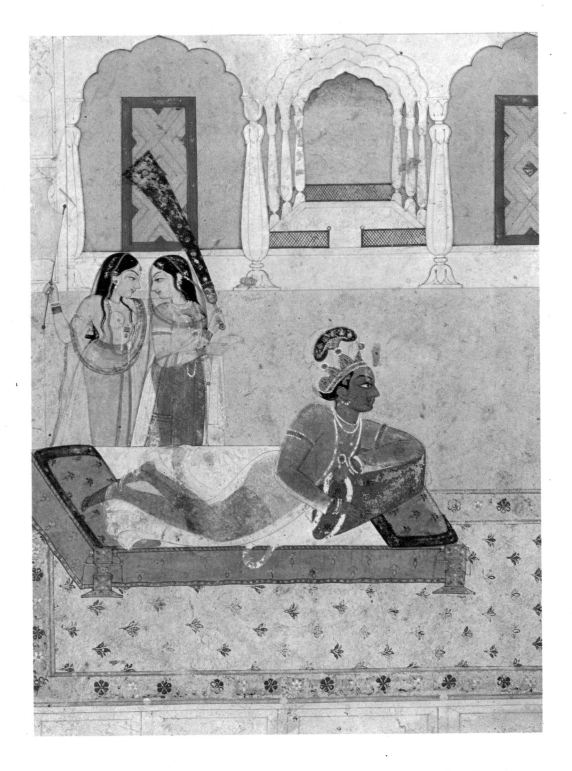

Colorplate 21. Krishna Awaiting Radha. Color on paper, height 7⁵⁄₁₆". Punjab Hills, Guler,
c. A.D. 1740. Cleveland Museum of Art

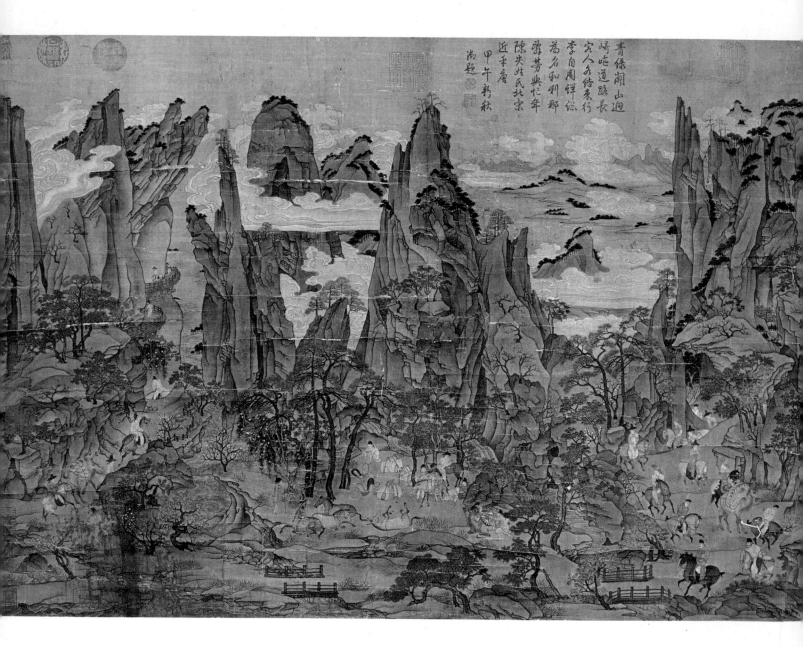

青綠開山迴
崎嶇道路長
客人多結束行
李自周詳絵
萬名和利郡
賽芳與忙年
陳失姓民北宗
近平居
甲午新秋
尚題

Colorplate 22. The Emperor Ming Huang's Journey to Shu. After Li Chao-tao (c. A.D. 670-730). Ink and color on silk,
height 21¾". T'ang Dynasty. National Palace Museum, Formosa

further tendency to playfulness in the handling of detail.

The second shrine, Chandi Bima, is of unexceptional type, except for the tower (*fig. 311*). This uses large *chaitya* hall openings with enclosed heads derived from South Indian motifs at Mahamallapuram and other places. These are so enlarged in size that they become almost comparable to the great faces that project from the Bayon, some three centuries later. But fundamentally we are still dealing with a simple cell with one entrance from the front through a small porch to the shrine proper. In most cases, these shrines are dedicated to the gods Vishnu or Shiva — most often the latter.

After the period of Buddhist dominance, resulting in the great monument of Borobudur, there was a distinct Hindu revival under the Javanese rulers who ruled from A.D. 850 to 930. This Hindu revival produced the principal monument of Hindu art on Java, the great temple complex of Prambanam which, like the monuments of Cambodia, is a shrine on a man-built mountain (*fig. 312*). The principal temple is dedicated to Shiva and has subsidiary dedications to Brahma and Vishnu. The appearance of the upper structure, thanks to Dutch restoration, is no longer problematical, and one can see that it is basically a shrine placed upon a high-terraced pedestal. A distinctive feature is to be found in the reliefs which

247

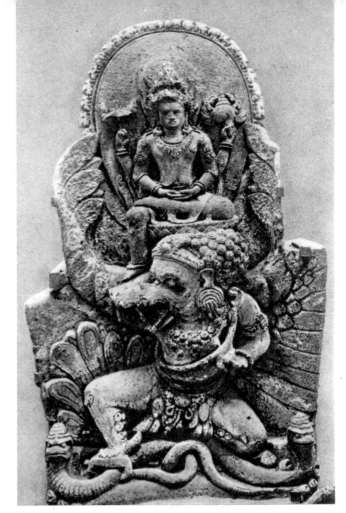

314. *Erlanga as Vishnu, from Belahan, Java. Reddish tufa, height 75". c. A.D. 1042. Madjakerta, Java*

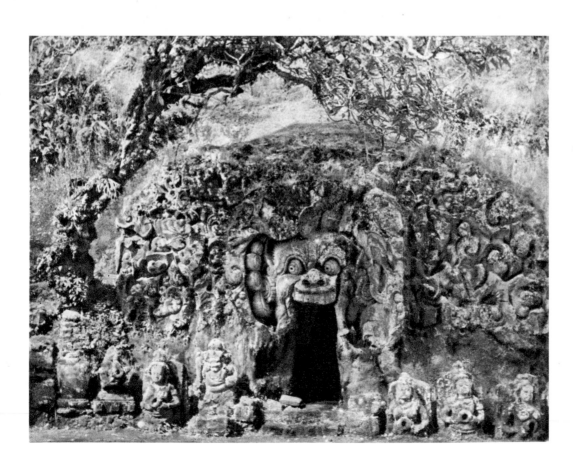

315. *Goa Gadjah (Elephant's Cave), Bedulu, Bali. Early 11th Century* A.D.

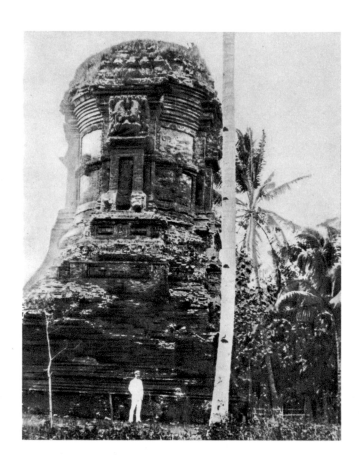

circle the terraces, reliefs usually with groups of three figures set in niches. The sculptures on the Prambanam are concerned not only with Shiva but also with such Vaishnavite epics as the *Ramayana*, and show a continuation of the Shrivijaya style of Borobudur, but with certain new elements indicating the future direction of Javanese sculpture. If one looks, for example, at the principal figure of Sita as she is being carried off by Ravana, one sees that she is represented in the classic Shrivijaya style, in turn derived from the Indian Gupta style (*fig. 313*). On the other hand, if one looks at the attendant servant girl, the representation is quite different. There we have an exaggeration of hairdress, of ears, of protruding eyes, of sharp and rather prominent teeth, along with a peculiar physical structure which embodies a square and angular shoulder line, large and rather pendulous breasts, and peculiarly large extremities. This tendency to caricature is one which becomes the principal characteristic of the later Javanese style known so well to the West through the Javanese shadow puppets. The rest of the sculptural relief from Prambanam shows the elaboration of this peculiarly interesting and rich narrative style, involving the representation in stone of architecture and plants against the relatively plain landscape background developed earlier at Borobudur.

ABOVE:
*316. Chandi Djabung, Java.
Mid-14th Century* A.D.

RIGHT:
*317. Kala-head, from Chandi
Djago, Java. Lava stone,
height 45". Early 14th Century* A.D.

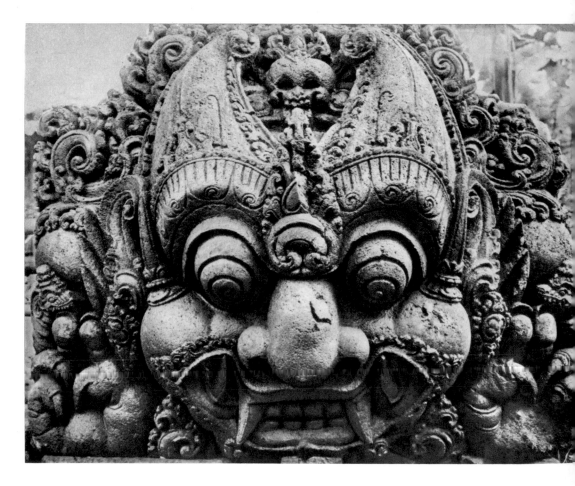

RIGHT:
*318. Ramayana Scene, from Chandi Panataran,
Java. Stone relief, height 27⁹⁄₁₆".
Early 14th Century* A.D.

BELOW RIGHT:
*319. Head of a Figurine, from Trawulan,
Java. Terracotta, height 3⁵⁄₁₆". 15th Century* A.D.
Trawulan Museum, Java

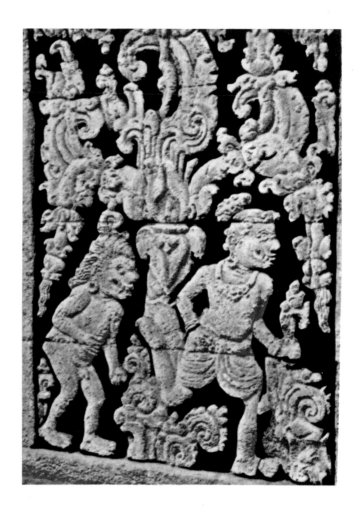

The period of Hindu revival is followed by one de-
scribed by Dutch scholars as the "intermediate period,"
when the capital was in East Java, not on the Plateau.
It is especially important for the regime of Erlanga,
who reigned from 1010 to 1042, and is marked by the
rise of a national literary language called *kawi*, the
theatre, and shadow plays, among other arts. One of
the most interesting productions of the whole reign is
an image of Vishnu carved in the characteristic vol-
canic stone of the island, about 1042. The personalized
representation of Vishnu can be explained as a portrait
of the God-King Erlanga (fig. 314). There is a very
curious combination of the individualized and rather
pinched portrait head, with the classic Gupta type of
the body of Vishnu. Below, the vehicle of Vishnu,
Garuda, trampling upon a snake, has assumed propor-
tions that dominate the whole sculpture. Again the
elements that the Javanese particularly liked — exag-
gerated movements and the use of grotesque animal
and human forms — come to dominance. One of the
most striking examples of this "grotesquerie" is the
eleventh (?)-century Goa Gadjah — Elephant's Cave —
at Bedulu on Bali, where the colossal mask of a witch
seems to emerge from a partly natural and partly carved
mountain (fig. 315).

The final phase of Javanese art, before the coming
of the Mohammedans and their triumph in 1478, is
called the East Javanese Period. In this we witness the
full development of the native or Wayang style, the
well-known style of the shadow theatre. A typical
monument of the late period is Chandi Djabung, a
circular brick temple built before 1359. Here we see the
most characteristic element of the later architectural
style: the great masks over the entrances (fig. 316).
These masks of glory, which on Hindu temples in In-
dia and even on earlier Javanese temples are subordi-
nated to the architecture, increase in size until they
become prominent elements that seem almost to threat-
en and subdue the rest of the structure. The single
mask from Chandi Djago probably dates from the thir-
teenth or, at latest, the fourteenth century (fig. 317).
Brick was also used in smaller, repeated shrines, as at
Panataran, an informally planned temple dedicated to
Shiva and built in the fourteenth and fifteenth cen-
turies. The sculptures of the main temple are of par-

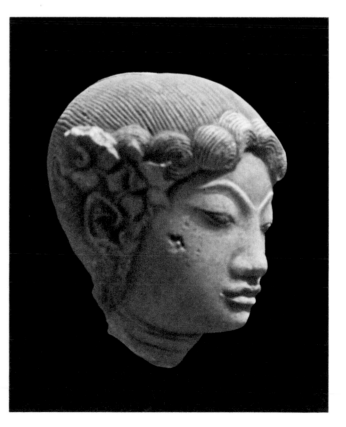

249

250

ticular interest because they are the first full statement of the Wayang style that was to last until modern times (*fig. 318*). The Wayang mode involved a loss of the plasticity and roundness which was a heritage from the Pallava and Gupta styles. Instead, the relief was flattened by deep but unmodulated cutting, which produced an effect of silhouette against a dark background. The result, with these grotesque profiles and physical conformations, was a flat sculpture like that of a shadow puppet. But some terracotta fragments of figurines from the Majapahit capital, Trawulan, display a subtle and gracious handling of such attractive subjects as princesses or celestial beauties that rivals the finest achievements of the Gupta sculptors of India (*fig. 319*). The Wayang style continued in outlying areas beyond the reach of the Moslem rulers, particularly in Bali. Even some of the old mosques, including one dated 1559, were decorated with nonfigural reliefs in a rich Wayang manner emphasizing a pictorial treatment of the lush tropical landscape (*fig. 320*).

320. Relief, from the Old Mosque, Mantingan,
Java. Height 19¹¹⁄₁₆". A.D. 1559

Chinese and Japanese National Styles and the Interplay of Chinese and Japanese Art

12. The Rise of the Arts of Painting and Ceramics in China

WE MUST RECAPITULATE certain elements of Chinese art in order to re-establish our position in time and space. While we have already discussed the period of great Buddhist activity — the cave sculptures and the Buddhist paintings of China and Japan — we must realize that there was some continuity of native Chinese style during this period. Despite the temporary decline of Confucianism, which was allied to the political weakness of the various states in the Six Dynasties Period, Confucianism still persisted, particularly in the South. Taoism, too, despite its minor position, was in competition with Buddhism. The high Taoist tradition represented by the philosophy and metaphysics of the great poem, the *Tao Te Ching*, continued to influence paint-

ing; while the lesser tradition of magic and alchemy was expressed in the iconography of certain pottery figures, as well as in the literature of the time. We must emphasize the importance of the South for the development of painting and calligraphy, the scholarly arts, in contrast to the North, where the new Buddhist forms were dominant. Confucianism and the accompanying importance of the scholar were not missing in the Six Dynasties Period, but were largely confined to the South. It is not surprising, therefore, that the first great developments in non-Buddhist painting took place in the Southern states.

The continuity of native traditions is notable in the subsidiary figures of Buddhist sculpture in both steles

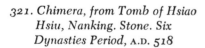

321. Chimera, from Tomb of Hsiao Hsiu, Nanking. Stone. Six Dynasties Period, A.D. 518

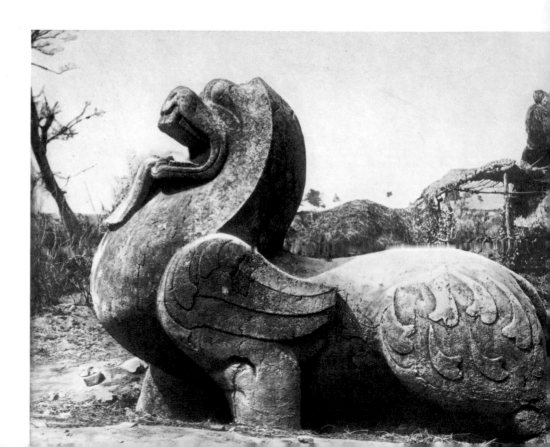

and cave temples. Here the Chou and Han spirit persists in the conformation and vigorous linear handling of the various dragons, lions, chimeras, and phoenixes. But there are monuments with no relationship to Buddhism which show these qualities in an even more pure and undiluted form. A whole series of the great chimeras of the early Six Dynasties Period of the third and fourth centuries exists, showing the vigorous, almost magical, qualities of Chinese animal sculpture (fig. 321). One is from the Liang tombs not far from Nanking. Another example of the very un-Buddhist kind of creature to be found in the Buddhist cave temples comes from the cave site of Hsiang-T'ang-Shan, a grinning chimera designed and originally placed as a caryatid beneath a pillar that flanked one side of a niche containing a Buddhist image (fig. 322). The squatting figure with its square mouth and buck teeth, with its claws gripping its haunches and with its great pot belly, shows a degree of vigor and humor characteristic of the great Chinese animal sculpture of much earlier times.

We find the same preservation of Han tradition in various tomb figurines of unpainted and painted earthenware. The tomb figurines of the period are numerous and are usually made of gray earthenware, painted with slip colors, usually of red, green, or yellow. They include chimeras such as the stone figure from Hsiang-T'ang-Shan, with dogs, lions, camels, and, above all, horses; and in these horse figurines of the Six Dynasties Period we have some of the most admirable Chinese animal sculptures (fig. 323). Many prefer the Six Dynasties horses to the strikingly realistic ones of the T'ang Period, as they have a peculiar charm of their own. They often have an elaborate molded design on the saddle panniers, very linear in character and again completely Chinese.

But the most important medium for the development of native style was painting, and in the Six Dynasties Period we find the first great names of Chinese masters and also the first treatises on painting and calligraphy. Hsieh Ho's *Six Canons of Painting* is the first of these, a work of fundamental importance in any study of the theory of Chinese painting. The Six Canons have been translated many times but their interpretation has been open to some doubt until recently, when William Acker in *Some T'ang and Pre-T'ang Texts in the Study of Chinese Painting*, and Alexander C. Soper in "The First Two Laws of Hsieh Ho" (*Far Eastern Quarterly*, VIII, 4), threw real light on their meaning.

The Six Canons are: first and most important, *animation through spirit consonance*, qualified in Soper's translation by the phrase, *sympathetic responsiveness of the vital spirit*; second, *structural method in the use of the brush*; third, *fidelity to the object in portraying forms*; fourth, *conformity to kind in applying colors*; fifth, *proper planning in the placing of elements*; sixth,

322. *Squatting Caryatid Monster, from Hsiang-T'ang-Shan. Stone, height 29½". Six Dynasties Period, late 6th Century* A.D. *Cleveland Museum of Art*

323. *Mortuary Horse. Pottery, length 8¾". Northern Wei Dynasty. Cleveland Museum of Art*

transmission of the experience of the past in making copies.

It can be seen from the simple listing of these canons that they represent a generalized approach. Various interpretations are possible, and the first canon in particular allows great subjective latitude. Animation through spirit consonance is interpreted as a kind of resonance or rhythm in the painting, an expression of

324. *Instructress Writing Down Her Admonitions for the Benefit of Two Young Ladies (last scene from The Admonitions of the Instructress to the Ladies of the Palace). Attribuited to Ku K'ai-chih (c. A.D. 344–c. 406). Handscroll, ink and color on silk, height 7⅝". Six Dynasties Period.* British Museum, London

the heavenly inspiration of the artist himself. The painting must have what the Chinese call *ch'i yun,* the spirit or breath of life. Actually, this criterion is about as good a one as can be asked for, because aesthetic quality is in the last analysis a matter of this intangible spirit or breath which the great work of art displays and which the great artist can impart. It is possible to show, for example, that Gerard Dou was using technique and composition in the same way as Rembrandt, but at the same time, there are few who would hold that Dou was as great a painter as Rembrandt. *Ch'i yun,* the life spirit, is the quality that separates the sheep from the goats, the great masters from the lesser ones. Acker relates the meaning of this particular canon to a very complex combination of Confucian and Taoist ideas involving concepts of the rhythm implicit in the *Tao Te Ching* of Lao-Tze and of the Confucian principle *li* by which man regulates his actions.

The second canon, structural method in the use of the brush, is almost equal in importance to the first, because in Chinese art we are dealing with paintings produced by the brush — the instrument used for writing. Because of the importance of the written word to the scholar and to literary tradition, the act of calligraphy was in itself a creative one. In the eyes of the Chinese, calligraphy was even more important than painting. Consequently, paintings were judged on the basis of the character of individual brush strokes, on the basis of the strength or weakness of a given line, or of the handling of a particular brush motif or technique. Embodied in this particular canon we have perhaps the

most trying and difficult concept, the one which produces the greatest gulf between East and West in the judgment of Chinese painting. This structural method in the use of the brush led, until recently, to almost complete confusion on the issue of quality and authenticity in Chinese painting. The Chinese will judge a painting solely on the basis of the character of the brushwork, whereas the Westerner begins with the qualities of composition, color, and texture, which are relatively unimportant to the Chinese. If we think of structural method in the use of the brush as being rather like the European concept of touch — of the difference between the "brush writing" of Rembrandt and Fabritius, of Seurat and Signac — then we may perhaps be able to comprehend something of the qualities that the Chinese are looking for in brushwork.

The third canon, fidelity to the object in portraying forms, is one which implies a certain degree of naturalism; when portraying a horse one is governed by the conformation of a horse. The fourth canon, conformity to kind in applying colors, applies most particularly to the use of colors in the decorative sense. It does not, according to Acker, imply that brown horses must be brown, but allows a certain leeway within a degree of naturalism. The fourth canon seems therefore to be somewhat related to the third. The fifth canon, proper planning in the placing of elements, is one which involves the Western concept of composition. At the same time it involves, to a certain extent, qualities inherent in the first canon: that the composition, the placing of elements in the picture, should correspond to principle and thus, to an extent, to natural law.

254

The sixth canon, the veneration for the past, is of great importance, not particularly in itself, but because it expresses a consistent Chinese attitude giving more importance to what has gone before than to what is to come. The making of copies was the discipline by which the painter, through the study of the brush of his predecessors, learned control of his own. Such copying was not done to deceive, but as a way of study, of allowing one's brush to retrace the inspired movements of the hands and arms of great masters.

The generalized approach of the Six Canons can be contrasted with another literary source from the Six Dynasties Period, a text written by the great Ku K'ai-chih, the painter we are to study first. His text *How to Paint the Cloud Terrace Mountain,* is translated by Shio Sakanishi in a little volume called *The Spirit of the Brush.* How does Ku K'ai-chih say he paints? How does one paint the Cloud Terrace Mountain? It is interesting that he does not use the general terms employed by Hsieh Ho, who, although later in date, represents the attitude of the critic, but holds to the practical and specific attitude of the artist. He says that he would place a figure at such-and-such a point; that he would paint this rock large and that one small and he would use green here and blue there; in short, he tells you literally how he would paint the Cloud Terrace Mountain. With this we can be somewhat reassured. If one had only the Six Canons of Hsieh Ho, one might well hesitate to judge Chinese paintings. But when one reads Ku K'ai-chih, one recognizes that one is reading the same — almost cookbook — recipe one finds in Cennino Cennini or, reduced to absurdity, in the present-day writings of those who would have us paint by numbers. The literal approach is often that of the artist. Despite much of the high-flown language he may use when addressing the public, when he speaks to his colleagues he describes directly what he is trying to do. We can be reassured by Ku K'ai-chih and know that with some modification of approach and with a certain amount of training we can look at a Chinese painting and see almost as much, if somewhat differently, as does the understanding Chinese.

While there are some remains of painting from the Six Dynasties Period, much of the authentic material is either provincial work by artisans who were, to a certain extent, folk artists painting the tombs of relatively wealthy people in the provinces, or we are concerned with second-hand "painting" as it is left to us through copies incised on stone or other hard materials. With regard to paintings of the first rank in the historic formats of the great Chinese painters, we are in a very unfortunate position. The ravages of war in the Six Dynasties Period made Chinese paintings of that period rare even for collectors of the succeeding T'ang Dynasty. And by the time of the Sung Dynasty even the greatest imperial collection of the Emperor

325. *Bed Scene (fifth scene from The Admonitions of the Instructress to the Ladies of the Palace). Height 7⅝"*

Hui Tsung, formed in the late eleventh and early twelfth centuries, was amazingly weak in works of the very early Chinese painters. Consequently, we are rather skeptical of any painting purporting to be an original work by one of the great early masters. However, our situation is not altogether hopeless, as we have a few very good copies in the style of these early masters and, in one case, a painting which seems to breathe the very spirit and style of the artist to whom it is attributed, Ku K'ai-chih. Master Ku lived in the second half of the fourth century and was attached to one of the important courts of the South. Again we must mention in parenthesis the importance of the South in the Six Dynasties Period as a region where traditional Chinese styles and the Confucian theory of art were maintained during a period of dominant Buddhist influence. Ku K'ai-chih's subject is *The Admonitions of the Instructress,* and its format is a handscroll painted on silk with ink and some color, mostly red with a little blue. Iconographically the picture is thoroughly Confucian. As the title suggests, it is a series of illustrations accompanied by text, incorporating rules of moral behavior proper to court ladies of the early Six Dynasties Period. The very word "admonition" implies Confucian rectitude.

At the end of the scroll, which incidentally is thoroughly and insensitively plastered with seals of the eighteenth-century Ch'ien Lung emperor, the moral tone is established by the figure of the Instructress as she writes on a scroll of paper in her hand, while the court ladies, who are presumably to follow her precepts, stand or kneel respectfully before her (*fig. 324*). Anyone looking at this painting for the first time must be impressed by its mastery of linear control,

255

326. *Landscape with Hunter (third scene from* The Admonitions of the Instructress to the Ladies of the Palace*). Height 7⅝"*

particularly in the handling of the drapery, where the effect is one of swirling and fluttering movement. The representational aspect of the picture is extremely archaic. These people look like the early tomb figurines of the Six Dynasties Period. Their headgear is appropriate to the fourth century and their garments and voluminous draperies, their rather square skulls, slightly pointed chins and noses, and sloping shoulders are completely of the period. But all this can be copied and one can argue that it is a faithful copy of a Ku K'ai-chih original. If we are dealing with a copy, it is indeed an extraordinary one. A close examination of the technique of the scroll reveals that the painting is handled in a manner quite unlike the method that a copyist would employ. There is a free preliminary drawing in pale red establishing the positions of the figures, general location of the draperies, and details of character in the face. These indications in red are then painted over, again freely, with a black ink which dominates the red line and produces the final impression. Such a technique is a very early one. We find it, for example, on Han or early Six Dynasties tomb tiles and in the earliest Buddhist paintings of the T'ang Dynasty, and would presumably find it in the portable Buddhist paintings of the Six Dynasties Period, if any had survived. The device implies that the artist was somewhat uncertain about the location of the various figures, and that therefore a preliminary drawing in red was necessary to establish the general layout and composition; and once this satisfied him, it became the basis of the final picture. A copyist would work differently for, being confronted with the disposition of the figures on the original painting, he could proceed without the need of a preliminary drawing in red. There is a very good chance that we have here, at the

very beginning of our study of Chinese painting, an original masterpiece of the period and one which presents a fine touchstone for the works that follow and purport to be early. None of them approaches *The Admonitions* in style or spirit, and we have a series of rather mediocre copies until the middle or even the end of the T'ang Dynasty.

The quality of an original can be seen in other details. The famous scene in which the emperor talks with one of the ladies of the court has a marvelous archaic quality in its general disposition (*fig. 325*). We see a curious inverted perspective consistently followed in the upper part of the scene; the throne or dais on which the bed is placed is archaic in form, with toothlike projections on the base in the style of Six Dynasties gilt-bronzes. The shading of the draperies suspended from the canopy over the bed is schematic and arbitrary and quite unlike methods used in the T'ang Dynasty or later. The disposition of the figures is fairly sophisticated and the relation of figures to their immediate surrounding, sure and convincing. The setting itself is placed in abstract space with no indication of a room or of other furnishings around the room, or around the dais. Instead, merely the essentials for the story are stated and this, while it is an advance over the kind of stage we have seen in certain Han Dynasty compositions, is still a long way from the developed environment for figures in T'ang paintings.

The Admonitions is extraordinary also in that it has one of the earliest representations of landscape in Chinese painting. Perhaps one of the reasons why critics are so suspicious, or rather unkind, is that the scroll offers so much. It is not just a figure painting, it is a complete world of its own from the expository

viewpoint of moral teaching; from the representational point of view wherein figures are shown in motion and seen from various angles; and finally from the standpoint of its aesthetic organization of line and color. In all these matters it is remarkably developed; and to have, in addition, a landscape is almost too much. However, while the landscape is present, it is there for moral and didactic purposes. The legend before this particular scene reads, "He who aims too high shall be brought low," and to illustrate it an archer takes aim at one of the phoenixes aspiring to the top of the peak (fig. 326). It is also worthy of note that it is not only an accessory landscape, but a symbolic one as well, for carefully balanced on either side of the mountain are a sun and moon, borne aloft on little cloud motifs that recall those of Late Chou and Han inlaid bronzes. These carefully balanced celestial symbols on either side of the central mountain peak are quite unsophisticated in comparison with the naturalistic details of the mountain proper. As with the "properties" of other scenes, the mountain is essential to the study and therefore it is not part of a range of hills, nor is it rising from a plain; it simply exists in the narrative. But within the actual outline of the mountain, we have a highly developed landscape, with indications of space on plateaulike ledges, of different types of trees, of overlaps of rocks as they move up the mountain, and a particularly good indication at the lower left of a plateau with a plain above leading to a forest just over the brow. One critic has called this a later painting because of this animated passage but, remembering the quite amazing development of landscape in the Han pottery vases and hill censers, it is not at all impossible to believe that an accomplished master of the Southern court in the fourth century could very easily achieve what we see in this scroll.

The brush line used throughout the scroll is not calligraphic. It is more like a pen line of consistent thickness — even wirelike — acting as a defining boundary around figure, drapery, or object. The brushwork of the text preceding each scene on the scroll is, however, more flexible than that used in defining figures or landscape. While there is a relationship between calligraphy and painting, it can and has been overestimated by a great many scholars, especially Chinese critics. The line used in the representation of early landscapes and figures is closer in many ways to that used, for example, in quattrocento drawing than to the flexible use of the brush to be found in Sung and later Chinese painting. It is not always essential that the spectator be a master of Chinese calligraphy to judge the quality of the brushwork in these early pictures.

A second handscroll associated with the name of Ku K'ai-chih, now in the Freer Gallery in Washington, is The Nymph of the Lo River, painted on silk with ink and slight color and generally accepted as an early copy of the late T'ang or early Sung Dynasty (fig. 327). It is certainly based on Ku K'ai-chih, as literary records confirm that there was a scroll of this title by him, and enough is left in the style of the figures, particularly the draperies of the nymph as she floats above the stream, to remind us of The Admonitions of the Instructress. On the other hand, the drawing of the face in this figure is precisely like that we would find in paintings of the early Sung Dynasty. The original must have been an apt illustration of the poem.

" 'They say . . . there is a goddess of this river whose name is Lady Fu. Perhaps it is she whom my lord sees. But tell me first what face and form are hers, and I will tell you if she is the goddess or no.' Then I said: 'She moves lightly as a bird on the wing; delicately as the rain-elves at their play; she is more radiant than the sun-flowers of autumn, more verdurous than the pine-woods of spring. Dimly I see her, like a light cloud that lies across the moon; fitfully as swirls a snow-wreath in the straying wind. . . .

" 'Her shoulders are as chiselled statuary; her waist is like a bundle of silk. Her body is anointed not with

257

327. The Nymph of the Lo River. Copy after Ku K'ai-chih (c. A.D. 344–c. 406). Section from the handscroll, ink and color on silk, length 10' 2⅛". Early Sung Dynasty. Freer Gallery of Art, Washington, D.C.

perfumes, nor is her face dabbed with powder. The coils of her hair are like cloud-heaps stacked in the air. Her long eyebrows join their slim curves....'"11

There is an elaborate development of landscape, a fairyland landscape in miniature with curious shifts in scale, but at the same time, particularly in the background with its overlapping mountain ranges, of a type probably not realized in Ku K'ai-chih's day. The history of the painting cannot be traced much before the twelfth century, a combination of factors that would confirm it as a Sung copy of a much earlier painting. However, its general composition and landscape aspects make it as interesting as its legendary subject does, indicating that to the artist the picture was the important thing, be the subject Taoist, Confucian, or Buddhist.

There are many other names from the Six Dynasties Period; but this is not a history of the names of Chinese artists and we must confine ourselves to those masters whose originals or reasonably good copies therefrom are extant. And so we are forced to jump some two or three centuries from Ku K'ai-chih to a great artist of the later Six Dynasties Period, Chang Seng-yu, active under the Liangs, a Southern Dynasty lasting from about A.D. 502-557. The handscroll *Five Planets and the Twenty-Eight Celestial Constellations*, now in the Abe Collection in the Osaka Municipal Museum, illustrates the style of this master (*fig. 328*). It is not however, by Chang Seng-yu, but is rather a copy, probably of the Sung Dynasty. The detail illustrated shows, particularly in the drawing of the hands, a rather dead

and lifeless line which, however excellent it is as a boundary, does not have any of the life or *ch'i yun* to be found in *The Admonitions of the Instructress* by Ku K'ai-chih. At the same time, it is so far superior to other copies of similar early paintings that it deserves our attention. Its subject makes a kind of astronomical-astrological picture, showing the five planets and the twenty-eight celestial mansions of star forms symbolized in Chinese lore by different figures or animals which are the burden of the picture. Each animal or figure is represented singly against a plain background of silk, with an attribute shown where necessary to identify the subject. If the figure must stand on a mountain top, this is indicated as an adjunct to the figure, not as a true landscape setting. In contrast to the earlier style of Ku K'ai-chih, with its flutter of draperies and movement of figures, there is a more static and, at the same time, more monumental concept of painting, an approach characteristic of late Six Dynasties painting and comparable to that change noted between the lively Northern Wei sculptures and the later more massive ones of the Northern Ch'i and the Sui dynasties — the difference between the desire for linear movement and one for more plastic, static forms. The use of color in the *Constellations* is in sharp contrast to the simple, almost single color system used in *The Admonitions*. Here there are almost rainbow hues; the line tends to disappear among the varied colors and only comes to the fore on the whites, or where the hands or faces of the figures are portrayed. The inscriptions are interesting and much more formal

258

328. *Chen Hsing (Saturn), from The Five Planets and Twenty-Eight Celestial Constellations. Copy after Chang Seng-yu (active A.D. 500-550). First section of the handscroll, color on silk, height 10¾".* Sung Dynasty. Osaka Municipal Museum

329. *Sarcophagus Engraved with Stories of Filial Piety. Stone, length 88". Six Dynasties Period, c. 6th Century* A.D. Nelson Gallery-Atkins Museum (Nelson Fund), Kansas City

than those found on *The Admonitions*. They are written deliberately in archaic, pre-Han style, a type of archaism characteristic of the growing sophistication of China at this time.

One of the most important evidences for the development of setting in Chinese painting in this period is found on a stone sarcophagus in the Nelson Art Gallery in Kansas City whose panels, executed on a dark gray stone with the design lightly incised into the surface, represent Confucian examples of filial piety (fig. 329). The monument is a curious combination of archaistic hang-overs, a sort of museum of antiquities, an adventuresome exploration into the future and an enthusiastic fulfillment of the project at hand. Artisans who executed tomb sculpture picked their motifs from many sources. The cloud patterns here, used also by Ku K'ai-chih, date from the Late Chou Period; rocks with their angular prismatic shapes, the little knolls in the foreground, and even trees are elaborated treatments of forms seen in Han compositions. Some figures, like the one on the right with flying draperies, recall the lithe creatures in Ku K'ai-chih's painting and in early Buddhist frescoes; while others are stocky peasants like certain tomb figurines of the late Six Dynasties Period. But in the handling of space the craftsman followed now-lost contemporary paintings, and records for us experiments definitely in advance of the picturesquely rendered earlier forms. In contrast to Ku K'ai-chih's primitive background details or the plastic monumentality which Chang Seng-yu achieved in his celestial subject matter, the Kansas City sarcophagus shows real ingenuity in the treatment of space, limited to be sure, but still a convincing background for numerous groups of figures related to one another in action and motivation. The settings are a series of shallow cells enclosed by planes of rocks. In the foreground a kind of *repoussoir* keeps the spectator a certain distance from the scenes beyond — like the window ledge of fifteenth-

century Venetian paintings. The relations between near and fairly near are established, but there is no indication of deep space. Here then, we are presented with but one step forward in the conquest of pictorial space as it moves slowly onward into subtleties and complexities of representation.

When compared with Ku K'ai-chih's work, the Kansas City relief is much more competent; in comparison with landscapes of the early Sung it is hopelessly naïve. Painters of the T'ang Dynasty who worked hard to create truly spatial scenes filled with life and atmosphere were hard indeed on the efforts of their predecessors. Critics said the mountains in Six Dynasties pictures were nothing more than the teeth of a lady's comb. Each generation thinks it has achieved a sense of reality in painting, and each succeeding generation finds its accomplishments amusing and inadequate.

The ceramic arts flourished in the late Six Dynasties period. The traditional use of burial pottery continued with wares usually of gray clay, sometimes painted with slip, but rarely, if ever, glazed. Burial figurines are of two basic types. In one group, the figures of native warriors, court ladies, and others are highly sophisticated and elegant, reflecting the art of men like Ku K'ai-chih (fig. 330). The second type, based on Buddhist iconography, and principally figures of guardians, derived from the Central Asiatic and Gandhara tradition, are infused with a fierce grotesqueness characteristic of the Chinese attitude to these quasi-military figures as well as to demons and mythical animals (fig. 331).

In addition to the making of burial pottery, there was a remarkable development of porcelain techniques in useful shapes used in everyday life. The Southern green-glazed stonewares, which began in the Late Chou Period and continued through the Han Dynasty, were further developed in the province of Chekiang, just south of modern Shanghai. The products of the principal kilns of the area are called *Yueh* ware. There

259

imagine the sensation that a ware of this type produced in a capital such as Baghdad when it was compared with the rather crude earthenwares then produced in the Near East or with the really crude material made in Europe at that time.

In the North a white stoneware was produced rather late in the Six Dynasties Period and it is this ware which laid the foundation for the great development of white porcelain in the T'ang and the Sung dynasties, especially of the famous *Ting* ware (*fig. 333*). It was a new development and apparently resulted from the discovery of suitable white porcelain clays in the North, principally in the region of Chihli. These white stonewares, such as the magnificent vase in the Nelson Art Gallery, are distinguished by very robust and simple shapes, a creamy-white glaze and an almost white body. There are clear articulations, between neck, lip, and body; the shape is extremely sculptural, as is also true of the *Yueh* wares of the same period in the South. As we begin to know more about Chinese ceramics — and this means adding to a still rather insubstantial foundation — developments in

*330. Female Figurine. Painted terracotta, height 10¼".
Six Dynasties Period.* Royal Ontario Museum
of Archaeology, Toronto

*331. Figure of Warrior in Leather Armor.
Terracotta, height 12¾". Six Dynasties Period.*
Cleveland Museum of Art

were several of these kilns and all produced a pale gray-bodied porcelain, with glazes ranging from gray-green to olive-green, certainly descended from Han glazed stonewares. They are furthermore direct ancestors of the celadon tradition of the Sung Dynasty. These *Yueh* kilns produced a great variety of shapes: bowls, vases, dishes, and cups. The little frog is a small jar intended to hold water for a writer's brush (*fig. 332*). It is a simple little pot with the projections on the sides indicating the head and legs of a frog. Often there is a technically advanced treatment of the gray-green glaze which produces brown spots on the surface at regular intervals, called the buckwheat pattern by the Chinese. It is very much sought after both in China and Japan, and is the ancestor of the spotted celadon produced in the Yuan Dynasty. *Yueh* ware was exported and this marked the beginning of a long ceramic relationship between the Near East and the Far East. *Yueh* products have been found as far away as Fostat in Egypt, Samarra in Mesopotamia, Brahminabad in India, and Nara in Japan. One can

the Six Dynasties Period become more and more important. The Western appreciation of Chinese ceramics began at the end of the nineteenth century, when we were captivated by the porcelains of the Ch'ing Dynasty. In the 1920s we discovered classic Sung wares and in the 1930s we collected early Ming porcelains and began to appreciate T'ang porcelains. Now we have discovered that many pieces we thought were T'ang are really of the Six Dynasties Period. As more excavations produce more material the picture may change again.

In considering the development of T'ang painting, sculpture, and decorative arts, we must recall what was said of the T'ang Dynasty (A.D. 618-907) when we surveyed the Buddhist art of that period. Every aspect of history — all social, political, military, economic, and cultural factors — contributed to make the T'ang Dynasty an international civilization and the greatest period in Chinese political history. The empire ultimately reached its greatest extent, stretching from the Caspian Sea to the China Sea and from Korea to Annam, and trade flourished, especially with the Near East. Many stimuli so important to the social organism — printing, the establishment of literacy, and the examination system — were developed, even further than they had been under the Han Dynasty, toward that complex and central position they later occupied in Chinese civilization. The first task of the new dynasty was to reduce the dispersal of powers characteristic of the Six Dynasties Period to order under centralized control. This was accomplished within the first years of the regime. The combination of these factors produced an especially rich environment for the rapid development of literature and the arts. The atmosphere, open to new ideas and eager for contacts with the outside world, was tolerant, and it welcomed the seven religions of the then-known world. Buddhists, Hindus, Mohammedans, Christians, Zoroastrians, Manicheans, and Jews were free to observe their rites, even to establish communities in the capital, Chang-An. It was an extraordinary achievement, even if it lasted only through the early decades of the dynasty.

In the arts the T'ang style as seen in Buddhist sculpture mirrored the power and culture of the empire. Sculpture was amply proportioned and fully three-dimensional. The same is true of painting and was already discernible in the monumental tendencies of Chang Seng-yu. More than this, the confident spirit of this time permitted the artist to observe the world around him with fewer strictures of custom and tradition. The resulting realism in painting and sculpture is marked, and the artist was able to command the technical means to record his observations in sketches to be translated into either schematic or idealized forms. Much attention must have been given to the problems of painting, since the considerable literature

on the subject uses specific terms and accurate analyses of Chinese style as well as exotic ones, particularly the Indian shading techniques transmitted through Central Asia.

It is possible that highly calligraphic painting styles, including the extreme forms of "flung-ink," began at this time, but probably not under Ch'an Buddhist influence, which figured in the religious life of the dynasty.

332. *Frog. Yueh pottery, length about 4". Six Dynasties Period.* Museum of Eastern Art, Oxford, England

333. *Vase. Stoneware. T'ang Dynasty.* Nelson Gallery-Atkins Museum (Nelson Fund), Kansas City

261

334. *Emperor Wu-ti of the Late Chou Dynasty, from Portraits of the Emperors. Attributed to Yen Li-pen (d. A.D. 673). Section of the handscroll, ink and color on silk, height 20 1/16". T'ang Dynasty.* Museum of Fine Arts, Boston

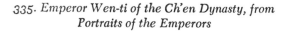

335. *Emperor Wen-ti of the Ch'en Dynasty, from Portraits of the Emperors*

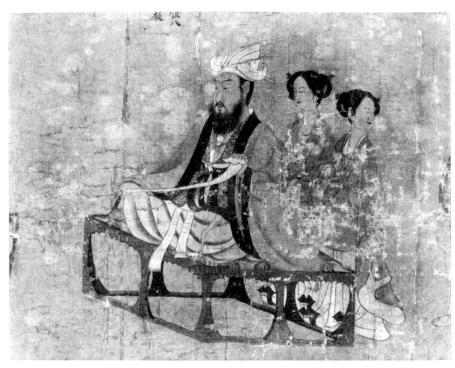

Now, too, we are in a position to study actual paintings, or almost contemporary copies of them, in greater numbers than before. One of the greatest masterpieces of T'ang figure painting, equal to that achieved in any Chinese dynasty, is the scroll *The Portraits of the Emperors*, almost certainly painted by Yen Li-pen, (d. A.D. 673), in the early part of the T'ang Dynasty (fig. 334). He was an official and administrator of the highest rank as well as an extremely important artist of the court, providing designs for architecture, sculpture, and wall paintings — in short, fulfilling all the Chinese requirements of an artist-hero. The *Emperor* scroll is the one remaining work which can in any way be considered to be his own. It represents thirteen emperors with their attendants. The first part of the scroll, the part that would necessarily have been rather badly damaged by unrolling, is a copy substituted for the original first six groups, but the latter part of the scroll contains seven groups of the highest quality. These show in brushwork, particularly line, in composition, and in the poise of the figures, a quality worthy of a great master. Format, compositional methods, colors, and the history of the scroll, going back to at least the twelfth century from the evidence of the seals of collectors, all combine to confirm the authenticity of the work. One can see in this painting a relationship to what has gone before, particularly to Ku K'ai-chih and Chang Seng-yu. At the same time one senses a completely new spirit in painting. The figures are larger, ample and serene, and in the treatment of the faces, despite the fact that line is still the

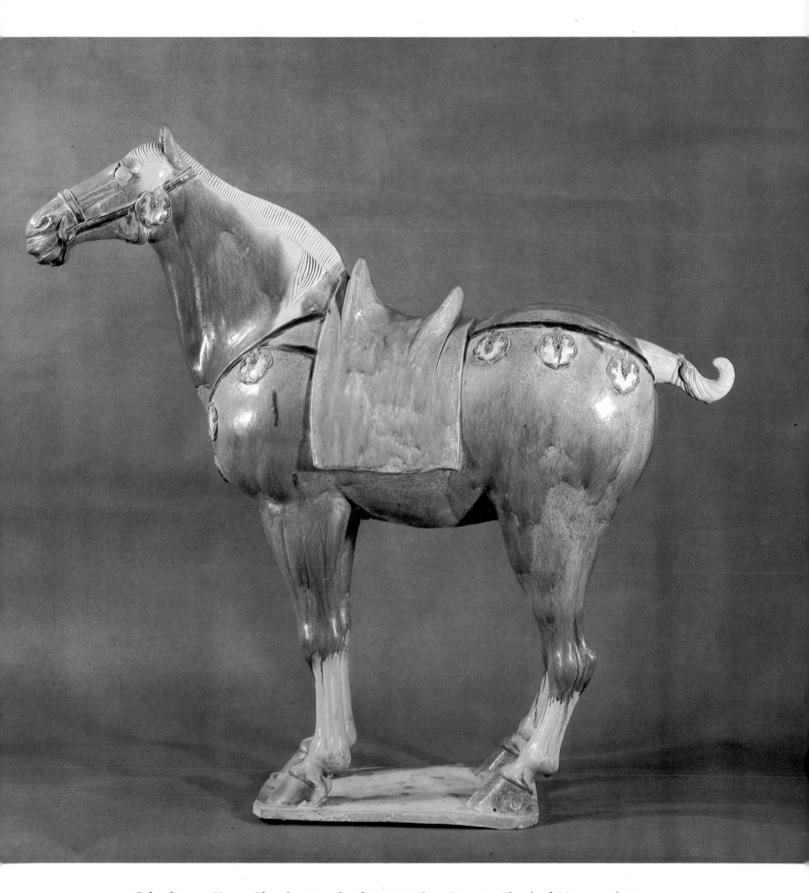

Colorplate 23. Horse. Glazed pottery, height 30¼". T'ang Dynasty. Cleveland Museum of Art

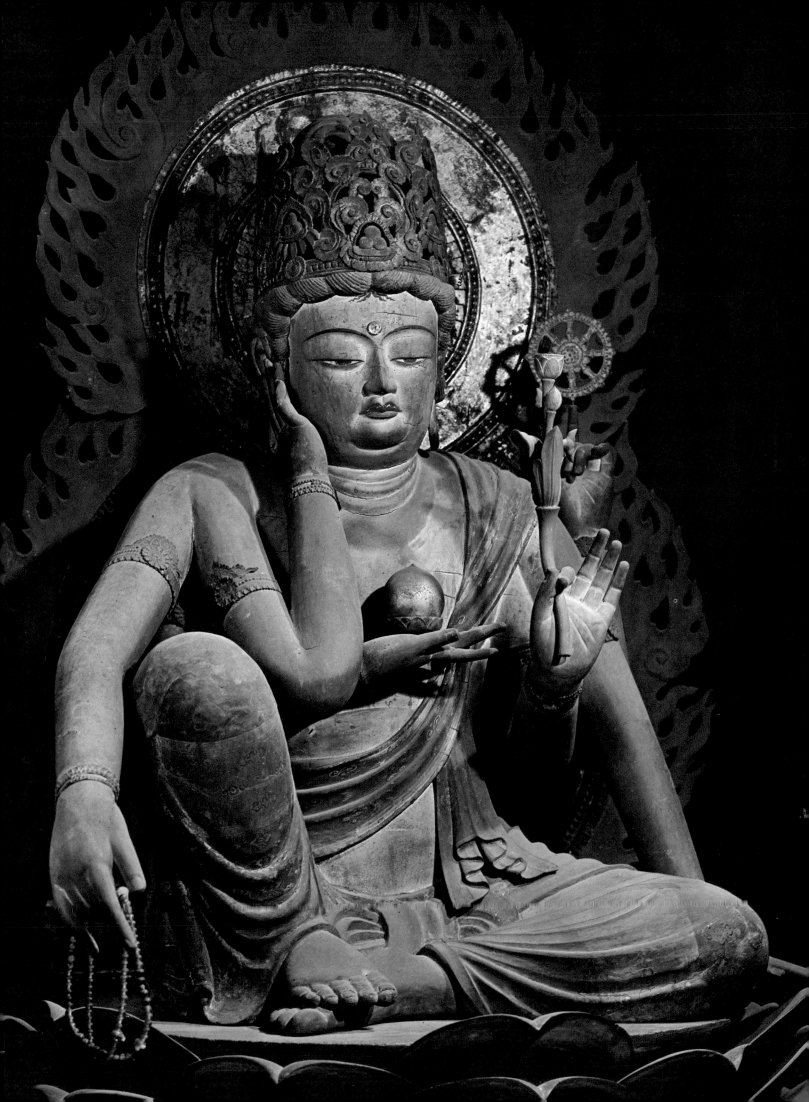

OPPOSITE: *Colorplate 24. Nyoirin Kwannon.
Colored wood, height 43". Early Heian Period,
early 9th Century* A.D. *Kanshin-ji, Osaka*

principal means of delineation, there is a suggestion of mass and volume quite different from the more linear style of the Six Dynasties Period. The modeling of the draperies, which in *The Admonitions of the Instructress* was handled in a quixotic and decorative way, is applied here more systematically and undoubtedly reveals the influence of Central Asian and even Indian painting in its modeling by means of red color, from dark to light. The setting is still abstract. The figures are shown only in relationship to their immediate environment, the dais on which the emperor sits. The perspective of the dais is precisely the opposite of the technique used in most Western painting, which recedes rather than expands; but this expansion is handled much more convincingly than in the painting by Ku K'ai-chih. The emperor of our illustration is Wen-ti; he is shown at ease, quietly sitting instead of standing in a dominating pose (*fig. 335*). His summer garments of soft materials contribute to the whole effect of an effete rather than a dynamic person. This characterization is part of the trend toward individual realistic portraiture in the T'ang Dynasty. The convention of drawing an ear or a mouth — and it is a convention — is based on actual appearance to a much greater degree than in paintings of earlier periods.

In the realm of color the *Emperor* scroll follows the same simple scheme used by Ku K'ai-chih, and this seems particularly appropriate to the subject matter where the characters of the great emperors of the past provide moral lessons for the present. The simple sobriety of the colors, predominantly red, creamy white, and black, with occasional traces of blue or pale green, produces an effect of great austerity. This, combined with the large scale of the figures, stretching from the very bottom to the top of the silk, increases the monumental effect. The scale of the figures, the sober color, and the powerful but simple linear drawing, harmonious and coherent, make the scroll at Boston one of the greatest and most important of Chinese paintings now extant. Yen was also commissioned to design sculpture, and his remarkable combination of realism and monumentality is to be seen in the four life-size stone reliefs of the horses of the Emperor T'ang T'ai-tsung, two of which are now at the University Museum in Philadelphia (*fig. 336*).

If Yen Li-pen was the great name and the great figure of the seventh century, certainly the greatest name of the T'ang Dynasty, if not the greatest name in Chinese painting, is that of the eighth-century master, Wu Tao-tzu. Wu died in A.D. 792 and unfortunately his work is known to us only from copies. In this he is at a disadvantage when compared with Yen Li-pen, whose wonderful *Emperor* scroll gives us some idea of his capacities. Wu Tao-tzu was much extolled even in his day, praised as the greatest of all figure painters and the epitome of the divine artist — and yet we have nothing even remotely close to his hand. We know that he was primarily a figure painter, that Taoist and Buddhist subjects were his field, and that he was able to create an effect of unusual power and movement, stress and strain, in figures and compositions. It is of Wu Tao-tzu that the story is told that when he finished his last wall painting, he opened the door to one of the painted grottoes, walked in, and disappeared, leaving but a blank wall. Such myths have become clichés about great Chinese painters, but in the case of Wu Tao-tzu, they actually indicate something of the magical impact of his paintings. At the same time, he is said to have introduced one of the most unrealistic elements of Chinese painting, although one of its greatest glories — developed calligraphic brushwork. He is given the honor of creating the thick and thin line, a means of expressing the movement and power of the brush, as well as modeling drapery. The copy (fourteenth century [?]) after one of his followers, Wu Tsung-yuan, probably gives a fair indication of his style (*fig. 337*). There is however, in the Shoso-in at Nara, a contemporary painted banner representing a Bodhisattva, the work of some fairly accomplished but unimportant painter, possibly an artisan employed by the Emperor Shomu or the Todai Temple (*fig. 338*). It is painted with a brush on hemp, with considerable vigor and with the use of this thick and thin line for depicting swirling drapery. It is our most spontaneous example of what may have been the art of Wu Tao-tzu.

If Wu Tao-tzu, the greatest of all figure painters, is represented only by copies, in the case of the minor master Li Chen we have one of the few documented originals by a known artist of the T'ang Dynasty (*fig. 339*). There is a restored set of the *Seven Patriarchs of the Shingon Sect of Buddhism* kept at To-ji, outside Kyoto. Five of the seven are Chinese originals, while two are Japanese additions to the set. The Patriarchs of To-ji, one in decent condition, are by temple records, the evidence of the inscriptions, and the quality of the painting itself, originals painted by Li Chen and exported to Japan in the ninth century. Li Chen was active about A.D. 800, and these pictures have a recorded history in Japan from that time. The portrait of the Patriarch Amoghavajra shows him seated on a dais, as were the emperors in the painting by Yen Li-pen. His slippers are under the dais and he sits with his drapery falling about him, his hands in a ritual pose of adoration characteristic of the Shingon sect. In spite of damage to the silk, details indicate a strangely pow-

265

336. Horse of T'ang T'ai-tsung, from Ch'ang-An, Shensi. Designed by Yen Li-pen (d. A.D. 673). Stone, height 68". T'ang Dynasty, 7th Century A.D. Pennsylvania University Museum, Philadelphia

OPPOSITE:

337. Eighty-Seven Immortals. After Wu Tsung-yuan (active beginning of 11th Century A.D.). Detail of the handscroll, ink on silk, height about 16". Sung Dynasty. C. C. Wang Collection, New York

erful realism. If this is the work of a minor master, then what must the great paintings by Wu Tao-tzu have been? The head, the ear, and the contour of the skull, which in later Chinese painting is represented as a very smooth arch, all have a sharply individual character, as do the representations of eye, eyebrow, eye socket, and the unusually shaped nose. Such a search for individual traits was prompted by the artist's need to present Amoghavajra as he really looked, or at least was imagined to look, in the hope that these depicted traits, real or imagined, might reveal the nature of a truly holy man. Li Chen's portraits are on silk in hanging scroll format of considerable size. Note the use of characters, Chinese and Sanskrit, around the figure in a formal pattern. This transforms the portrait into something of a magical *mandala,* a diagram of the type that is particularly associated with esoteric Buddhism.

From this purposeful realism to the grotesque and to caricature is but a step. Indeed, in various periods, both Oriental and Western, there is a close connection between a concentration on individual character and a corresponding interest in caricature and satire. In the later T'ang Dynasty, the representations of the Arhats, or saints of the Buddhist faith, the Eighteen Lohan, became the means for particularly extreme ex-

ercises in realism and the grotesque. In the work of Kuan Hsiu, who lived from A.D. 832 to 912, at the very end of the T'ang Dynasty, we find famous representations of these grotesque Lohan (*fig. 340*). Unfortunately, there is again a great deal of argument as to what paintings attributed to him are original. The best examples are certainly those kept in the Imperial Collection in Tokyo. Kuan's aim was to show the holiness of the saint by means of the grotesque realism of the figure. It recalls the truism of the rough exterior and the heart of gold; that the old gnarled tree is a somehow more rewarding object of contemplation than the young sapling. And so in figures, the more gnarled and grotesque, the more peculiar the glance, the more hairy the beard, and the more horny the feet, the more noble is the character. One must then exercise a great effort of will to ignore physical appearances and approach the spiritual nature of the Lohan. To make ends difficult of attainment is one of the important methods of Oriental mysticism and religion. The works of Kuan Hsiu, as we know them from the paintings in the Imperial Collection, prove that he was quite traditional in his use of line. He used a thin, wirelike line to achieve his realism, as Li Chen did. Evidently the use of the calligraphic line, in the tradition of Wu Tao-tzu, represents a separate strain, one persisting in later Chinese painting, as well as in the frescoes of the late T'ang and the Sung dynasties.

In contrast to these powerful painters of primarily masculine types is the emergence of specialists in other fields. We must particularly mention the artist Chou Fang, who lived at the end of the T'ang Dynasty and who was most famous for his representations of women. The picture which perhaps best expresses his particular style is one in the Nelson Gallery of court ladies listening to the *ch'in,* a zitherlike instrument played by a lady seated on a rock (*colorplate 26, p. 290*). It is a short handscroll on silk, with the remains of quite brilliant color. In the representations of court ladies and children the copious use of color was very much the mode. Colors in this scroll range from yellow, red, and orange to lapis blue, malachite green, and the usual black ink. Particularly interesting are the three ladies of the court, ideal beauties of middle and late T'ang taste who, not like the "morsels of jade," "swaying willows" with "petal faces" and "waists like bundles of silk" that Ku K'ai-chih loved to paint, are well filled out with moon faces and bodies like plump pears. They express perhaps the pride and pleasure men took in ease and

266

338. *Bodhisattva, from a painted banner. Ink on hemp cloth, height 52⅜". Nara Period, mid-8th Century A.D. Shoso-in, Nara*

tion to each other. The spectator observes from a respectful distance; he is not asked to participate. The strangely quiet effect adds to the musical mood and is achieved primarily by turning the very important foreground figure so that she looks away from the spectator.

Chou Fang established the formula for the representation of noble Chinese femininity, and his works were copied and used as models by all the great painters of women in the Sung, Yuan, and Ming dynasties. Later artists sometimes changed the physical proportions in accordance with the taste of the time, but the general use of color, drawing, subject matter, the relationship of figure to figure, and the general type of composition was largely established by Chou Fang.

In addition to artists who confined themselves to figure painting, there were specialists in even more restricted fields. Thus for the first time we encounter painters who primarily devoted their attention to horses and others to still life. The horse painter was most popular, as the horse was not only one of the main supports of Chinese military strength, but was also in polo play-

luxurious abundance in the waning years of the T'ang Dynasty. Tomb figurines of ladies of the late T'ang Period have the same proportions.

A setting or background for figures is not usually provided. We have seen an elaborate and developed setting in the Nelson sarcophagus; but we have not seen anything approaching this environment. We look into a garden; two trees, one in the foreground, the other a little to the left and behind a broad rock, establish an adequate, if limited, measure of space with the abstract background beyond, characteristic of Chinese painting. Very rarely, until the Sung Dynasty, does one see in figure painting a setting that explains the relation of every part of the composition to either an interior room or to infinite space. This problem seems to have been left to the landscape painter for solution. It was enough for the painter to concentrate on figures and the delineation of a relatively shallow stage for them to function in.

There is also in this picture a subtle relationship between the figures and the surface spaces that contributes an almost musical quality to the composition. The wedge-shaped gaps between the figures are varied in size and shape by the most sensitive and exacting means. Note especially the studied and careful manipulation of the figures in relation to the picture plane, beginning with a two-thirds view from behind, a three-quarters view from the front, then an almost full back view, then a head-on view, and finally a one-quarter view from the front; the artist carefully turns these figures in rela-

339. *Patriarch Amoghavajra. By Li Chen (active A.D. 780–c. 804). Hanging scroll, ink and color on silk, height 83". T'ang Dynasty. To-ji, Kyoto*

ing and hunting one of the principal sources of recreation for the aristocracy. The greatest artist here — and no name has ever surpassed his — was Han Kan. Perhaps the finest painting attributed to him is one only recently published in the Palace Collection, now on Formosa (*fig. 341*). The picture shows a horse accompanied by a mounted Central Asian groom, a combination often repeated in later painting. The realism of detail is notable, as is the now-customary abstract setting. Another painting on paper, long in the Imperial Collection, represents a tethered horse and even though somewhat restored, certainly shows the T'ang style of horse painting at its best (*fig. 342*). The head is modeled in very simple planes with the big forms blocked out as if they were hewn from jade. Modeling is in the simple Indian or Central Asian style of shading and is used to indicate the overlapping planes of the folds of the chest muscles as they move across the front of the horse. The stylized realism and the interest in the movement and characteristic pose of the horse, with one foreleg raised off the ground and the head thrown back, are in keeping with the aims of the period and produce a work which in its general outlines and composition is of impressive quality.

This small album leaf is perhaps an outstanding example of lack of taste in the use of collectors' seals, which can be and very often are used in a very circumspect and inoffensive way. The example before us reveals the worst tendencies of the Chinese collector.

One of the most significant contributions of China to the art of the world is landscape painting, which developed rapidly in the T'ang Dynasty and reached fruition by the early Sung Dynasty. Few can deny the unique character of Chinese landscape painting. While the first heights of this great tradition do not occur until the tenth century, certainly the preparation was made during the T'ang Dynasty. We have already seen tentative approaches to landscape in tomb tiles and inlaid bronzes; we have seen it as part of the development of Buddhist painting, as a setting for the dogma of the faith, we have noted it as an accessory to narrative style, in *The Nymph of the Lo River* by Ku K'ai-chih, or as an accessory to symbolism in the mountaintop in the painting of the planets by Chang Seng-yu. But the beginnings of landscape, for itself alone, are to be found in paintings recording great historic events. They go back to at least the seventh century in the work of Li Ssu-hsun (651-716 or 718), the greatest master of the colored and decorated narrative style, who was particularly famous for his use of color and of gold as a means of outlining rocks, architecture, and decorative elements. His artistic successor was Li Chao-tao (c.670-730), the "little General." Both are known to us today only through copies and literary sources. Their style was primarily decorative, dedicated to the narration of great courtly, military, or historical events. There

340. *Lohan. By Kuan Hsiu.* (A.D. *832-912). Hanging scroll, ink and color on silk, height 50".* Five Dynasties *Period.* Tokyo National Museum

341. Horses and Groom. By Han Kan (active A.D. 742-746). Album leaf, slight color and ink on silk, height 10⅞". T'ang Dynasty. National Palace Museum, Formosa

342. Night Shining White Steed. By Han Kan (active A.D. 742-746). Album leaf, ink on paper, height 11¹³⁄₁₆". T'ang Dynasty. Sir Percival David Collection, London

is one little painting on silk in the Palace Collection, executed in brilliant color, which depicts the travels of a T'ang emperor with his entourage through a landscape (colorplate 22, p. 246). The title of the picture suggests that the narrative was most important, the landscape has really become the subject of the picture. The figures, small in scale, occupy an unimportant position, even in the foreground where they are lost among the rocks, trees, and bushes, with the mountain landscape dominating the scene. While the tall, rather unreal and decorative peaks derive from the Six Dynasties Period and its "lady's comb-teeth" mountains, there is a substantial development of space and setting, with realism in the mountain outlines, character in the rocks, overlaps and planes in the mountain structure, and interest in space beyond the mountains. The artist paints dis-

tant trees and rivers, a great river landscape stretching back into infinity, clouds running behind the mountains, and mountains receding, layer on layer, into the distance. When compared with great tenth-century landscapes, this is still a relatively archaic and simple composition despite its apparent complexity, a complexity largely caused by adding as much detail and high color to the picture as possible. There is, for example, a definite lack of correlation between the view on the right and the view through the little gorge on the left. There is a lack of correlation in the scale of the trees in the foreground with that of the dwarfed figures of the travelers below. The whole problem of the precise location of elements in space and the unification of that space by means of atmosphere and logical relationships in scale is still in a relatively chaotic state. Still, in the

works of Li Ssu-hsun and his followers, a style that we can call courtly gives us the beginnings of a landscape art, albeit as an adjunct of narrative.

The master who is most closely associated with the beginnings of pure landscape painting is the artist-scholar, Wang Wei (699-759); he was reputed to have been not only one of the greatest of landscape painters, but to have pioneered in monochrome landscape painting. That any one artist did so we can well doubt; however, it was at this same time that some kind of monochrome style in landscape painting developed. As a matter of fact, we do not know of a single true monochrome landscape painting until well into the Sung Dynasty. Even in the great paintings of the tenth century some color was used, either in faint washes or with a bright and opaque use of color. But of Wang's contribution there is no doubt, and that further inventions are attributed to him is quite understandable. It was certainly Wang, judging from the evidence of remaining stone engravings, who "invented," landscape per se. The scroll painting of his country estate called *Wang Ch'uan* is the first true Chinese landscape (*fig. 343*). Where figures do occur, they are incidental; the landscape itself is the subject of the picture. The *Wang Ch'uan* is known to us in a variety of copies, all of them quite remote, but some less so than others. It also was engraved in stone, a copy which gives a fair idea of the quality and faithfulness of the painted versions. If the stone engraving is a fairly accurate version of the *Wang Ch'uan* scroll, there is a late copy, perhaps of the fifteenth or sixteenth century, sufficiently close to indicate something of the contribution of Wang Wei. This handscroll is painted on silk and quite properly enough, in color. Here is true landscape: a scene on an estate, a group of buildings, a few peasants working, a fishing boat on a stream. There is no narrative; instead we have a topographical treatment of nature. Each section is named for the part of the estate it represents, almost as if a surveyor were making the rounds of the estate and producing a pictorial map serving for both identification and delectation.

But the interesting thing in this painting, which after all is based upon a ninth-century "invention," is that we still find some uncertainty in the development of locations in the landscape. One "space cell," almost as simple and limited a space cell as those in the Nelson sarcophagus, is rimmed by mountains with rather curiously balanced and uniform waterfalls popping from their lower reaches. There is very little indication of anything beyond that, almost as if the landscape were tilted toward the spectator, who is presented with a segment instead of the whole. Then there is the great problem of the middleground. In the foreground scenes the artist has skipped the most difficult problem of all landscape paintings — the space between foreground and distance. If one asks what is in between, the artist answers, "Oh, there's water there," a well-known escape device for all primitive painters and indicating a still-archaic state of development. The rest of the scroll is much in the same vein, each section tilted as if it were a map and made into a space cell by the simple device of encircling mountains or rocks.

In addition to pure landscape painting, what about Wang Wei and monochrome painting? Undoubtedly, there was some monochrome figure painting at the time and it may possibly be that there was a kind of monochrome landscape painting as well, though we have no T'ang examples or even copies of examples at this moment. However, there is a small group of paintings, all of a similar type, one of them excavated from a tomb of the early tenth century, which indicates that the attribution of monochrome landscape to Wang Wei

271

343. *Wang Ch'uan. Copy after Wang Wei* (A.D. 699-759). *Section from the handscroll, color and ink on silk, height 11¹³⁄₁₆″. Ming Dynasty.* Seattle Art Museum

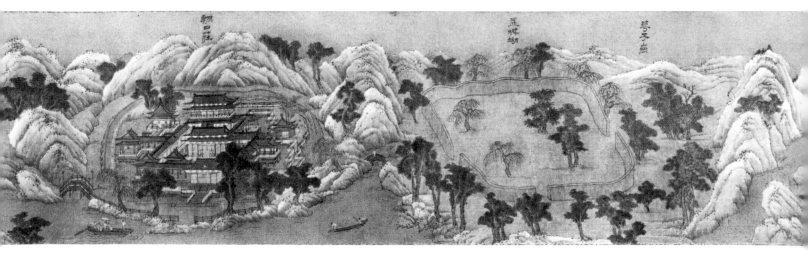

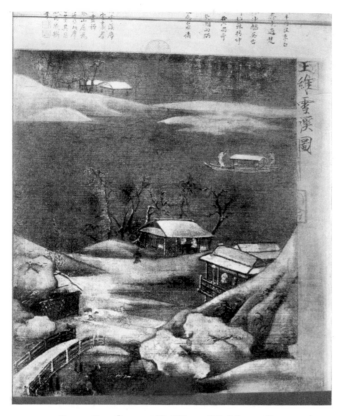

344. *Snow Landscape. By Wang Wei* (A.D. 699-759).
Album leaf, ink and white on silk. T'ang Dynasty.
Ex-Manchu Household Collection

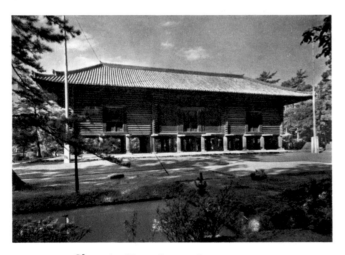

345. *Shoso-in, Nara, Japan, front view.* A.D. 756

monochrome painting; the toned silk provides the darks and the white opaque paint builds the highlights. The beautiful modeling of rock-forms in a simple and archaic way is quite unusual, as is the interesting "primitive" architecture. The solution of the middleground problem by means of an expanse of water between near and far is familiar, while the intimate quality proper for the album-painting size reminds us of the Wang Ch'uan scroll.

The worldly interests of T'ang civilization naturally called into being large-scale manufacture of luxurious decorative arts. Not since the Late Chou Period had there been so varied and opulent a production. Unfortunately much of this rich material is lost to us so far as the mainland is concerned. Only those materials which could survive burial and only those which were normally used for burial purposes are left, notably numerous splendid ceramics in both pottery and porcelain. Fortunately there is another source for our knowledge of T'ang decorative art — Japan, which we have seen to be still a cultural and religious satellite of China during the Nara Period. Almost miraculous circumstances contributed to the preservation, in the region of Nara, of decorative arts as well as of the Buddhist sculpture and painting previously considered. Horyu-ji and Todai-ji, the homes of so much of the best sculpture in T'ang style, also preserved some examples of useful and secular arts. But the greatest repository of all is surely the Shoso-in in the precincts of Todai-ji, a warehouse of all of the useful objects of the court given by the Emperor Shomu in A.D. 756 and almost completely preserved to the present day in its original log storage building (fig. 345).

A very few paintings of secular importance, preserved in Japan, should be mentioned before consideration of the decorative arts, for they shed additional light on some of the Chinese paintings we have just seen. While the subject of the small painting kept at Yakushi-ji is nominally Buddhist, a representation of the female deity of abundance, Kichijoten, derived from the Indian Lakshmi, the manner of representation and the style are purely T'ang, derived from such courtly representations of beauties as those by Chou Fang (fig. 346). Indeed, so well-documented and preserved is the Kichijoten that she may well serve as a standard by which to judge the various Chinese paintings which claim her age and style. The plump physical proportions we have seen before, but the lovely linear rhythm of the wind-blown draperies, the delicate and variegated color in the textile patterns, and the conscious grace of the hands seem far superior to almost all of the pretenders to her place. The graceful geometry of the facial features, notably the eyebrows and the small cupid's-bow mouth, are closely related to the high style of T'ang art in the eighth century, whether in paintings, sculptures, or the more lowly grave figurines.

and to the eighth century may not be wrong. This type is shown at its highest level in a small album leaf on silk (formerly in the Manchu Household Collection) (fig. 344), attributed to Wang Wei in an inscription of the early twelfth century written by the Emperor Hui Tsung. The subject is a winter landscape, a theme it shares with others in this group. The artist used opaque white pigments on the silk, producing a reverse

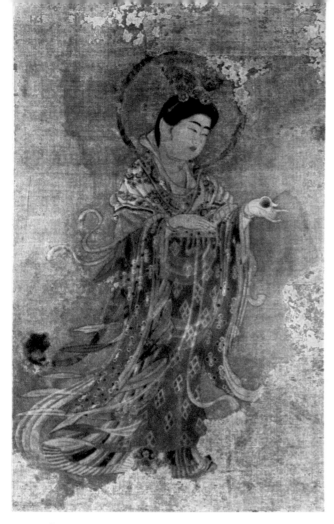

346. *Kichijoten. Color on hemp, height 20¹⁵/₁₆". Nara Period, 8th Century A.D. Yakushi-ji, Nara*

courtly style of Li Ssu-hsun these mountains have a fairy-tale appearance with their repetitive and undulating outlines of receding ridges. The arrangement of the mountains in the vertical format is one of the few remaining evidences for the landscape hanging scrolls of the T'ang Period and the division of the space by mountains on the left with a distant vista to the right is already a rather advanced compositional device. The charming miniature style in the small space available seduces us into believing more than is clearly true, for the actual definition of space and of the objects within that space is still highly schematic and adds little to such late Six Dynasties works as the Nelson Gallery sarcophagus. It is noteworthy that the musicians are Central Asiatic types, for nearly all of the arts of the T'ang and Nara periods, especially the utilitarian arts, show a thoroughly mixed character with much influence from Central Asia and even Sassanian Persia and Mesopotamia.

These decorative arts are our principal burden here and they are best studied in the remarkable assemblage in the Shoso-in. More than six thousand objects ranging from herbs and weapons to carpets, games, and musical instruments have been stored in the log-

347. *Portrait of Lady Under a Tree. Detail, panel of a screen, ink and color on paper, height 49½". Nara Period, first quarter of 8th Century A.D. Shoso-in, Nara*

The set of screen panels kept in the Shoso-in and representing court ladies beneath flowering trees is purely decorative and secular in nature (*fig. 347*). Circumstance now reveals the painting without its original overdecoration of applied feathers in various iridescent hues. Originally the screens must have presented an extremely sumptuous, decorative effect, but time and wear have revealed the painted skeleton, again in the style of T'ang painting we associate with Chou Fang. Probably such talented and famous artists worked on decorative panels of this sort in addition to the more usual formats of handscroll or hanging scroll. The linear basis of this figure style is evident, for the loss of decorative color does little to harm the sophisticated effect of the whole. Linear variations dependent upon subject matter are displayed in the difference between the delineation of the boundaries of figure, rock, and tree; the latter two are drawn with a varying, almost calligraphic line, while the figure is revealed by a more measured wire-like line.

Even landscape painting is to be found on some of the useful objects preserved in Japan. One of the *biwa* (lutes) in the Shoso-in has a plectrum decorated with a fanciful landscape with musicians riding an elephant in the foreground (*fig. 348*). Like the paintings in the

fitted warehouse since A.D. 756. Many of these things are as if made yesterday, for the log construction breathes with the seasonal changes in humidity, keeping out the damp and allowing the dry air of late summer and fall to circulate freely, airing the three interior storerooms. Here ranged row on row in chests and cases, one finds all the imperial accoutrements of the Nara court, and this must have been but a small part of what the Chinese emperor could command at Ch'ang-An. Some of the objects in the Shoso-in are undoubtedly of non-Japanese origin and many were undoubtedly gifts from abroad or represent the usual imperial accumulation of rare and exotic luxury items.

The textiles are particularly varied and numerous, and this is to be expected, for the Far Eastern silk industries were of legendary fame. Indeed, the trade lines to the West were called the silk routes. Many of the silks are dyed types with designs imprinted by sten-cils or by the more exotic and abstract method of tie-dyeing. The most sumptuous of the dyed fabrics were made by the Southeast Asian technique of *batik*, or wax-resist dyeing. The designs on these use typical international T'ang motifs — the hunt in a landscape with the horses and animals at the Scythian flying gallop (*fig. 349*), or plump court ladies playing musical instruments beneath large-leafed trees.

The woven silks exist in gauzes with varied and fine abstract patterns, rich brocades with figural designs placed in repeated roundels enclosed in vine arabesques linked by semi-abstract floral units, and twills of the same designs, but usually with a more thoroughly Near Eastern flavor closely related to, even copied from, Sassanian twills with their pearl-bordered roundels enclosing heraldic figure groups. While some of the textiles are fragments, others are incorporated in useful objects such as pillows, arm-rests (*fig. 350*), shoes, mir-

348. Painted Plectrum Guard on a Five-Stringed Biwa. Detail, height 20⁷⁄₁₆". Nara Period. Shoso-in, Nara

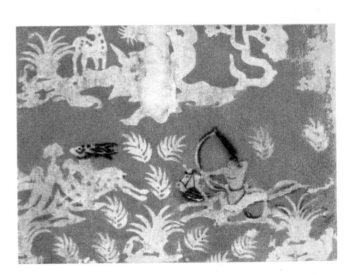

349. Screen Panel with Design of Hunter. Detail, batik-dyed silk, height 64¼". Nara Period. Shoso-in, Nara

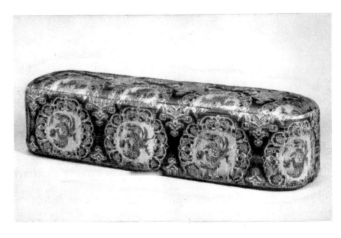

350. Arm-Rest. Wood, covered with brocade of Phoenix design height 7⅞". Nara Period. Shoso-in, Nara

274

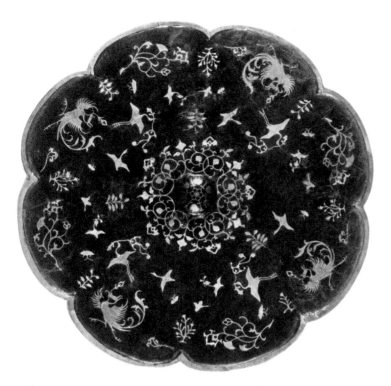

ABOVE: 351. *Eight-Lobed Mirror with Design of Flowers and Birds. Bronze, with lacquer inlaid with gold and silver (Heidatsu), diameter 11¼". Nara Period. Shoso-in, Nara*

ABOVE RIGHT: 352. *Jar Engraved with Hunting Scene. Silver, height 19¹¹⁄₁₆". Nara Period. Shoso-in, Nara*

RIGHT: 353. *Hunter and Boar. Detail of figure 352*

ror-box linings, costumes, hanging screens, and banners. Carpets are plentiful in the Shoso-in and are made in the Central Asiatic technique of pressed hair with inlaid hair designs of large floral units.

Metalwork is another large category and this, too, reveals the international character of the time. Vessels in bronze or gilt-bronze may be purely Chinese in shape and decoration or they may be direct copies of Sassanian silver and gold objects like those found in South Russia and now kept in quantity at the Hermitage in Leningrad. Numerous mirrors — that peculiarly Chinese category — of unusually large size are executed in techniques ranging from plain silver-bronze through silver- or gold-covered bronze to those with lacquer-inlaid designs in precious metal and mother-of-pearl (fig. 351). The designs on these are of the same family as those on the textiles and are both Chinese and Near Eastern in character. *Repoussé* dishes and flasks are also to be found.

The most extraordinary of the metal objects are the large silver bowls in Buddhist alms-bowl shape with engraved designs of hunting scenes. Small objects of this type are known from excavations in China, but the great size and accomplished technique of the Shoso-in examples place them at the head of their class (fig. 352). The landscape setting with its toylike mountains, scattered floral-and-foliage ground, and specialized decorative character provides a tapestrylike background for spirited vignettes of riders and hunted animals at the flying gallop. One detail might almost be a literal copy of the Sassanian royal hunt motif as found on the incised or relief-molded dishes of Persia (fig. 353). The rider has passed the boar and turns to shoot his arrow back over the hindquarters of his galloping horse at the charging, bristling boar. The motif is surely Sassanian but the apparent speed of the moving figures is achieved with the linear devices, peculiar to Chinese painting, imposed upon the derived silhouettes.

Ivory, too, is a favorite material, almost completely destroyed on the mainland but preserved in the Nara treasure hoard. It was used as a material in itself, plain or, in the case of some measuring rules (fig. 354), dec-

275

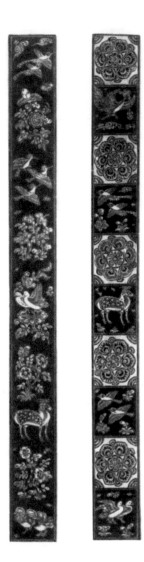

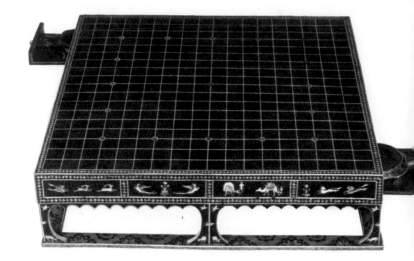

355. *Go Gaming Table. Shitan wood, with ivory and deer-horn inlays, length 19¼". Nara Period. Shoso-in, Nara*

354. *Foot Ruler with Design of Animals, Birds, and Flowers. (left) reverse, (right) obverse. Ivory carved and stained, length 11¹¹⁄₁₆". Nara Period. Shoso-in, Nara*

orated by carved and color-stained designs marking the units of measure. In these smaller, more formal patterns, birds, animals, and flowers, or floral medallions alternate. All belong to the same international decorative vocabulary already noted in textiles and metalwork. Ivory was also used with precious, colored woods for inlays in wood of a more sober appearance, particularly in the gaming boards and tables of the court. One example, a *go* table, in almost unbelievably splendid condition, has side panels amounting to framed pictures with genre scenes of foreshortened camels and attendants, as well as the more usual galloping creatures (*fig. 355*). If these lively scenes are the work of skilled artisans, what must the greatest paintings of the T'ang court have been?

Lacquer and lacquered wood were a traditionally native Far Eastern technique since the Late Chou Pe-

riod and it is not surprising that this medium is represented by some of the most beautiful objects in the Shoso-in. Vessels, mirrors, and other objects were decorated with designs painted, incised, or inlaid; but the most conspicuous and complex examples of the lacquer technique is the musical instrument called the *kin*, preserved at Nara and decorated in the *heidatsu* technique (*figs. 356 and 357*). A wood ground was carefully lacquered and then delicately cut sheets of silver and gold in floral and figural designs were imbedded in the lacquer and were in turn covered with additional coats of that juice. The whole was then ground and polished down until the precious metals could be seen clearly. The result is one of the most refined and beautiful utilitarian objects in all the world. The flower, wave, and cloud patterns provide the over-all background for the selected figures of musicians placed at regular, but widely spaced intervals over the surface of the instrument. The plectrum area is treated as a framed picture, with a carefully balanced composition of three musicians playing on a flower-and-bird-carpeted ground beneath a flowering tree flanked by bamboo. Above, in the rhythmically cloud-decked sky, balanced groups of fairies riding phoenixes on waves of clouds complete the carefully cloaked symmetrical arrangement. Much technical virtuosity was required in the *heidatsu* technique, for many of the intricately detailed trees are cut from single sheets of gold and silver. The delicate rhythms of the various designs, combined with the soft show of silver and gold, make a visual display which seems to imply the limpid and gentle sounds produced by the *kin*.

Experimentation with exotic materials was the order of the day. One example, again from among the mar-

velous group of musical instruments, will serve to demonstrate this facet of T'ang genius (*fig. 358*). One of the Shoso-in *biwa* combines sandalwood, tortoise shell, and mother-of-pearl in a plectrum guard design representing a musician playing a *biwa* while riding a camel in a spare landscape, indicated only by a centered plantain tree and few rocks and flowers. The mother-of-pearl silhouettes are incised on their interiors to give greater realism and movement to the scene. In China we know of such tours de force only through representations in painting or from a few battered and eroded mother-of-pearl fragments.

Realism, exoticism and, by extension, caricature, were characteristic interests of the artists of the T'ang Dynasty and the related Nara Period in Japan. Various details and secondary images in the Buddhist sculpture of the period evidence this. But the most direct and specialized expression of this interest lies among the quantities of wooden and lacquer dance masks preserved at Horyu-ji, Todai-ji, and the Shoso-in (*fig. 359*). While these *gigaku* masks were used for religious festivals, their intent and derivation were more profane. The *gigaku* performances, with their often vulgar comedy and grotesque motifs, must have seemed a welcome interval of respite in the extremely long religious ceremonies and festivals. The masks are larger than life-

356. *Decorated Kin. Lacquered wood, inlaid with gold and silver (Heidatsu), length 45". Nara Period. Shoso-in, Nara*

357. *Decorated Kin. Detail of figure 356*

358. *Biwa Flectrum Guard. Wood, inlaid with mother-of-pearl, length of whole 42¾". Nara Period. Shoso-in, Nara*

277

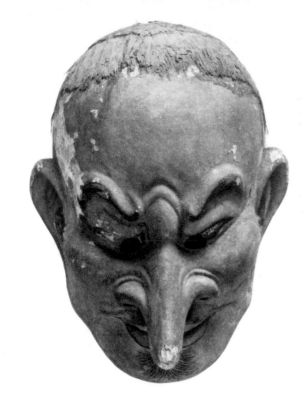

359. *Gigaku Mask. Lacquered wood, height about 11¹³/₁₆".*
Nara Period. Shoso-in, Nara

360. *Shallow Dish. Pottery, with polychrome glazes.*
T'ang Dynasty. Private collection, Tokyo

size. Unlike the small and subtle *noh* masks of later times, whose message was for the few, the *gigaku* masks had to make their message carry over considerable distance to large numbers; hence their size and their often very exaggerated conformation. Most writers agree that the masks as well as the dances for which they were designed have a Central Asiatic origin. But this tradi-

tion may refer largely to the racial types represented with characteristic T'ang curiosity and exaggeration. The realistic effect of these heads was much enhanced by the use of actual hair on the skulls and for moustaches and, in some cases, in the ears or nostrils. All of them were painted in the desired flesh tone and where hair was not used, a painted subterfuge was substituted. The facial expressions run from rage to hilarious laughter, from low cunning to benign wisdom.

Two important T'ang materials, ceramics and jade, are little or poorly represented in the Shoso-in and for these we must study the fortunately numerous materials from Chinese excavations and collections. The few ceramics in the Shoso-in are of a glazed earthenware comparable to more highly refined and dexterous Chinese varieties. Such lead-glazed earthenwares with their hues of brown, green, yellow or, more rarely, blue were predominantly used for burial furniture, whether in the form of figurines of animals and humans or in the guise of useful ceramic shapes, ewers, jars, plates, and cups (fig. 360). Their bold coloration is quite unlike the subtle monochromatic hues of the succeeding Sung Dynasty, and many would see in this a reflection of Western tastes. Still, such colors correspond well with the basically rich coloration to be found in T'ang figure painting and polychromed sculpture. The period was not a jaded or dominantly aesthetic one, and the vigorous social activity of the times was expressed by the equally bold use of color in the arts.

The burial figurines have become especially famous through the many examples in modern Western collections. These amazingly realistic and animated figures, destined to be seen only at the burial ceremonies and then buried—forever, it was hoped—provide a kaleidoscope of the T'ang world. All levels of society are represented, as are nearly all the beasts known to the artist of the time. The Han tradition of architectural models, however, had largely died out, perhaps because their static shapes held little interest for the dynamic vision of the sculptor. The figurines of horses and camels, some of them almost three feet high, are perhaps the most interesting of all (*colorplate 23, p. 263*). Seldom has the horsiness of the horse been so well represented; but then this was a period of such great painters of horses as Han Kan. The successful firing of such large ceramic objects was in itself a tremendous accomplishment; yet so accomplished were the artisans that literally hundreds of thousands of the figurines were made in varying quality for the different levels of society. The rarest of these ceramic sculptures, and often the most accomplished, are unglazed but are painted with colored pigments over colored slips covering the clay, which may be white or range to a pure terracotta red.

Few Buddhist subjects, save for guardian kings — and these might be Taoist or Confucian as well — are to be found in the tomb figurines. The greater propor-

tion are secular subjects — music-playing ladies, exotic court dancers, humorous foreign types, hunters, and many other categories are known in countless examples, some of them apparently made from the same or similar molds despite the different details of the finishing hand touches (*fig. 361*). The over-all impression of a complete set of tomb furnishings can be gauged from well-preserved excavated groups now stored in the Royal Ontario Museum (*fig. 362*). Whole cavalcades of horses and camels with their Central Asian attendants, whole groups of dancers and musicians, battalions of troops, on foot or mounted, were the usual accouterments of the tomb of a wealthy official. Their magical purpose of accompanying the deceased continued and perhaps their extreme sophistication and realism made them even more fit for this religious intention than the earlier, more stylized figurines.

Such lead-glazed earthenwares did not compose, however, the most progressive wing of the T'ang ceramic industry. Stoneware continued to develop, and true porcelains, even in the light of modern Western taste,

361. Harpist. Terracotta, height 12⅝". T'ang Dynasty.
Cleveland Museum of Art

362. Group of Figurines. Glazed pottery. T'ang Dynasty. Royal Ontario Museum of Archaeology, Toronto

279

363. Ewer. Hsing ware, height, 15⅜". T'ang Dynasty.
British Museum, London

were created at this time. The *Yueh* celadon wares of the South flourished and were exported far and wide. Greater decorative freedom is found on the T'ang examples in keeping with the interests of the period. Molded, incised, and gilded designs of flowers and figures were the order of the day but, unfortunately, few of these have survived in complete examples — though the skillful designs are well known from shards found at the kiln sites in Northern Chekiang.

At the end of the dynasty, the North was producing a pure white porcelain known as *Hsing* ware, usually in simply shaped bowls and dishes. Extremely rare vases of a more elaborate *Hsing* type are known, the most extraordinary being the well-known vase formerly in the Eumorfopolous collection and now in the British Museum (*fig. 363*). This robust vase with its bird's-head lip and floral arabesques on the body seems an epitome of the vigorous, wordly, and technically gifted T'ang tradition. These celadon and white porcelains were to be the foundations of the numerous and more subtle porcelain traditions of the following period.

We are only now beginning to recognize some T'ang examples among the thousands of jades preserved today. Enough has been found and reasonably well established to be of the period to make clear that here, too, the artists tried to find ways to work the material in the forms of their accepted vision. However, this most precious and equally intractable material was the least amenable to T'ang ideals of realism and movement. Consequently, however lovely they may be as things in themselves, the few remaining jades seem the least T'ang-like of the varied production in the decorative arts.

13. The Beginnings of Developed Japanese Art Styles

AFTER CONSIDERING THE ART of the Tempyo Period, when Japanese art was truly a mirror of the great Chinese imperial style of the T'ang Dynasty, we find an increasingly different environment with the beginning of the Heian Period in 794, which continued for some four centuries until its end in 1185. In this environment styles in art began to change, and for the first time we can recognize a truly native Japanese spirit, one in many respects quite different from the Chinese style from which it was ultimately derived, the first original contribution of the Japanese to the art of the post-Bronze Age of the Far East. This did not, of course, happen overnight. There were also transitional phases, and the Early Heian or Jogan Period, much shorter than the Late Heian or Fujiwara Period which followed it, effects this transition. In the Early Heian Period, the emperor was still to some extent an effective ruler and the style of the Early Heian Period displays qualities of power and strength. But as the imperial power declined, the following Fujiwara style was primarily delicate, fine, decorative, and highly aesthetic — an aristocratic style concurrent with the rise of a pleasure-loving court in Kyoto, which surrounded the impotent emperor in the Fujiwara Period.

The Jogan assimilation of Chinese elements extended to new types of Buddhist faith, notably the Tendai and the esoteric Shingon sects. In contrast to the rather straightforward type of Buddhist theology with which we have previously been concerned, the Shingon and Tendai sects emphasized mystery and secrecy. They developed an elaborate mythology which set great store by magical numbers, combinations, gestures, and sequences — in short, all of the ritualistic phases of religion which became so important in the later Buddhism of Nepal and Tibet and which by this time were beginning to take hold in China, whence they were imported to Japan. Secret images were kept in tabernacles, which

were forever closed to the laity or but rarely opened on special occasions, oftentimes with many years' interval between openings. Indeed, special provision was made for their housing because of the emphasis the esoteric sects laid on secrecy. The numbers of deities and their various manifestations were multiplied and iconography became extremely complex. If we were to study this iconography we would be in very deep waters indeed. Fortunately, some of the flavor of esoteric faith is found in the style of buildings, images, and paintings produced under the faith.

One significant temple complex can be described as the type-site for the Jogan Period and that is Muro-ji, outstanding for its sculpture, painting, and architecture, especially the latter (*fig. 364*). Here stand the only two remaining structures of the Jogan Period. Muro-ji is in a relatively remote area, some forty miles from Nara and twenty to thirty miles from Ise, in a high mountain region covered with heavy forest growth, principally of the great Cryptomeria, cedarlike trees reaching heights of over a hundred feet. That other Jogan architectural monuments must have had similar settings we know from literary sources and archaeological remains. The new sects preferred mountain retreats. While in the Asuka and Nara periods temples were placed on the plains in flat locations, open and accessible to laymen and clergy alike, Jogan temples were moved into secret locations in the mountains. The result for our pleasure and delectation is that the settings of these temples are among the most magnificent in the world. The setting of Muro-ji, with a forested mountain behind it and below, a small village resting at its foot, is unforgettable.

A second characteristic of the Jogan temple complex is its planned irregular character for, unlike the earlier symmetrical arrangements, Jogan temples were laid out in an informal way forced upon the architect by the

364. Muro-ji, Nara, Japan,
general view

lay of the land. This irregular ground plan is evidence
for tendencies that are to develop as the strongest
characteristics of Japanese architecture in native style:
asymmetry, irregular ground plan, and a close relation-
ship to the natural site. This relationship, first seen in
pre-Buddhist Shinto shrines such as Ise and Izumo,
recurs in the architecture of the Jogan Period. Other
evidence for the development of a native style in archi-
tecture can be seen in the shingle roof of the *kondo* of
Muro-ji (*fig. 365*), and in the thatch roof of another
partially restored structure. Tile roofs and stone plat-
forms were predominant in periods when Chinese in-
fluence prevailed. At Muro-ji are shingle or thatch roofs
and wood platforms. Japanese shingles are made of
very thin layers of Cryptomeria bark, and these laid
layer on layer produce a thick carpet of wood.

The size of architecture in the Jogan Period, as ex-
emplified at Muro-ji, is smaller and more intimate than
before. The *kondo* nestles in the trees on a small grassy
platform and seems a part of the forest. The *gojunoto*,
five-storied pagoda with its shingle roof and small
scale, seems almost a toy pagoda if imagined next to
the great pagodas of earlier periods (*fig. 366*); yet the
proportions of this lovely structure, with the gentle de-
crease in the size of the roofs and the small base on
the stone platform, add an air of intimacy and refine-
ment quite different from the massive scale and impres-
sive style of the works of the Nara Period.

We mentioned the twofold division of the worship
hall, dividing clergy from laity, in connection with the
porch of the *kondo* of Toshodai-ji, where for the first
time provisions were made to house the laity in an
area protected from the weather and yet separate from

282

365. Kondo, from Muro-ji. Early Heian Period,
early 9th Century A.D.

the actual worship area. This twofold division becomes
standard in the Jogan Period, with a sharp distinction
between the icon hall used by the clergy and the *raido*,
a separate, covered hall for the laity. The first appear-
ance of the *raido* is at once interesting and rather naïve.
The first solution, as we know only from literary sources,
was to build a slightly smaller building in front of the
icon hall, where laymen could hear the ritual proceed-
ings in the hall. Then a covered passage was added to
connect the *raido* and the icon hall. The next logical so-

lution was to place the halls side by side, producing a double-gabled affair, with the *raido* and the icon hall juxtaposed. From this to numerous variations, such as the gabled roof with a closed porch, making the *raido* an integral part of the icon hall, was but a step, but such variations never got beyond the simple separation of one room from another to preserve secrecy in these esoteric rituals.

If we have only two examples of architecture in the Jogan Period, we are in a much better position in the field of sculpture. A number of examples are left—some fifty or sixty, which is few enough, but still more than two. Indeed, works of sculpture are the most numerous monuments of the period and with Jogan sculpture, we are confronted with one of the truly remarkable sculptural styles in the world and also one of the most difficult. Its very difficulty is fascinating to the modern art historian because it confronts him with the familiar problem of unintelligibility in relation to art. Art that is difficult tends to be either ignored or disliked. We are also interested in Jogan style because there has been a rediscovery of various European, African, and Pre-Columbian styles that were considered at one time forbidding or even ugly but that are now looked upon as aesthetically interesting—indeed, aesthetically great. If we are really to enjoy sculpture of the Jogan Period, we must bear in mind that it is a hieratic art, produced in the service of a faith and strictly regulated by that faith. It is physically forbidding and produces types of imagery not in accordance with the norms of our society today. Its style, if physically forbidding, is also evocative of great awe. It is perhaps the most awesome style created in the Far East, just as the Byzantine style may well be the most awesome one created in Medieval Europe. Despite the fact that it is representational and primarily concerned with the image, the means by which these austere types are presented to us is almost geometric.

Let us look at an extreme example of Jogan style. The small image of the Healing Buddha, Yakushi, perhaps sixteen inches high, is carved from a solid block of Cryptomeria wood; it is a seated figure in the usual pose of the Buddha (*fig. 367*). The deity is presented as extremely corpulent, with a very heavy body, almost flabby chest, large round face, large lips, wide nose, and very wide eyes; the whole effect is massive or, in critical eyes, merely fat. If we can separate for the moment our dislike of fat from the physical appearance of the figure, we begin to notice certain extraordinary things. The figure, because of its size and these very simple contours, has a massive quality and a large scale that belies its small size. We note also that the rhythmical repetition of the drapery ridges adds to the solemn measure found in the image. The size of the hands is exaggerated, in keeping with the desire to pre-

sent a figure of monumental and forbidding aspect. If we look at the figure from the side, where its grossness is less evident, we are immediately more attracted to it, and this in itself is a degree of proof that the representational appearance of an image oftentimes conditions our aesthetic reaction. From the side, the fatness is seen only in the double chin, and we can now concentrate more upon the even flow of the drapery, with its simple, measured rhythm and its rather deep, but not undercut, modeling. This cutting seems to indicate the flow of drapery without destroying the character of the block of wood. We are also aware of certain forms, such as the ear, which have been simplified to an almost geometric formula of great abstract beauty.

We have begun with perhaps the most difficult of all Jogan images, simply to indicate the problems involved. Now let us look at some of the more famous images that show the style at its fullest and even most ingratiating.

366. Five-storied Pagoda, from Muro-ji. Height 53'. Early Heian Period, early 9th Century A.D.

The classic Jogan image of the Healing Buddha, Yaku-shi, is kept at the temple of Jingo-ji in the mountains west of Kyoto (fig. 368). One should realize first that both hands and forearms are modern restorations. If one looks even casually at this Yakushi, one may be disturbed by these rather puffy and formless attachments and one realizes that the secret of the Jogan style is not mere fatness or size, but what is achieved within those conventions assumed by the sculptor.

The image is carved from a single block of wood, and this is characteristic of most of the sculptures of the Jogan Period. The desire of the sculptor to have a columnar and massive icon seems dominant, while in the Fujiwara Period and later, various inlays and laminations of wood were used to allow greater undercutting, ease of pose, and prevention of warping and checking. One can almost guarantee that any genuine Jogan sculpture has a large split caused by contraction of the heartwood. The Yakushi of Jingo-ji shows the Jogan style at its most hieratic and formal. The Buddha stands erect, evenly balanced, on both feet, in a perfectly symmet-

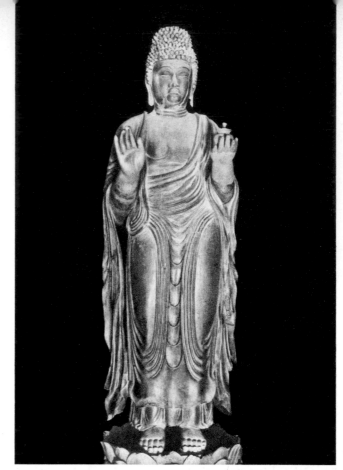

367. Yakushi. Wood, height 15⅜". Early Heian Period, 9th Century A.D. Todai-ji, Nara

368. Yakushi. Wood, height 42¼". Early Heian Period, early 9th Century A.D. Jingo-ji, Kyoto

OPPOSITE: *369. Head of Yakushi. Detail of figure 368*

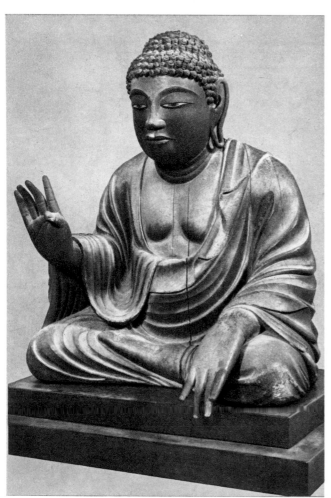

rical pose, facing the worshiper with no sway, no bending of the head, in a pose as rigid and formal as that of the most formal Byzantine icon. The expression of the face is forbidding; one rarely sees smiling Jogan figures. They were born without a sense of humor but are not less beautiful for that. The breast of the image is indicated by an almost pure geometric arch and the disposition of the folds of drapery, with a large area on the thigh left plain, emphasizes the columnar character of the wood. The drapery is in a sense forced to the edges of the pillars of the legs, and thus produces a pattern which again is symmetrical, balanced, and formal.

If we look at a detail of the head of the Yakushi, we notice certain other features characteristic of Jogan sculpture (fig. 369). The most important of these is a keen sense, not only of the material, but of the tool used to work it. There was no attempt to smooth over the cuts of the knife, as there was to be in later sculpture and as there was in much work of the earlier periods. This does not mean that the work was crude, though this is sometimes true of certain provincial Jogan pieces. It does mean that the knife was used extremely skillfully to produce very small cuts for finishing. If one looks carefully at the cheeks, one can discern the pattern left by the knife as it finished off the cheek,

284

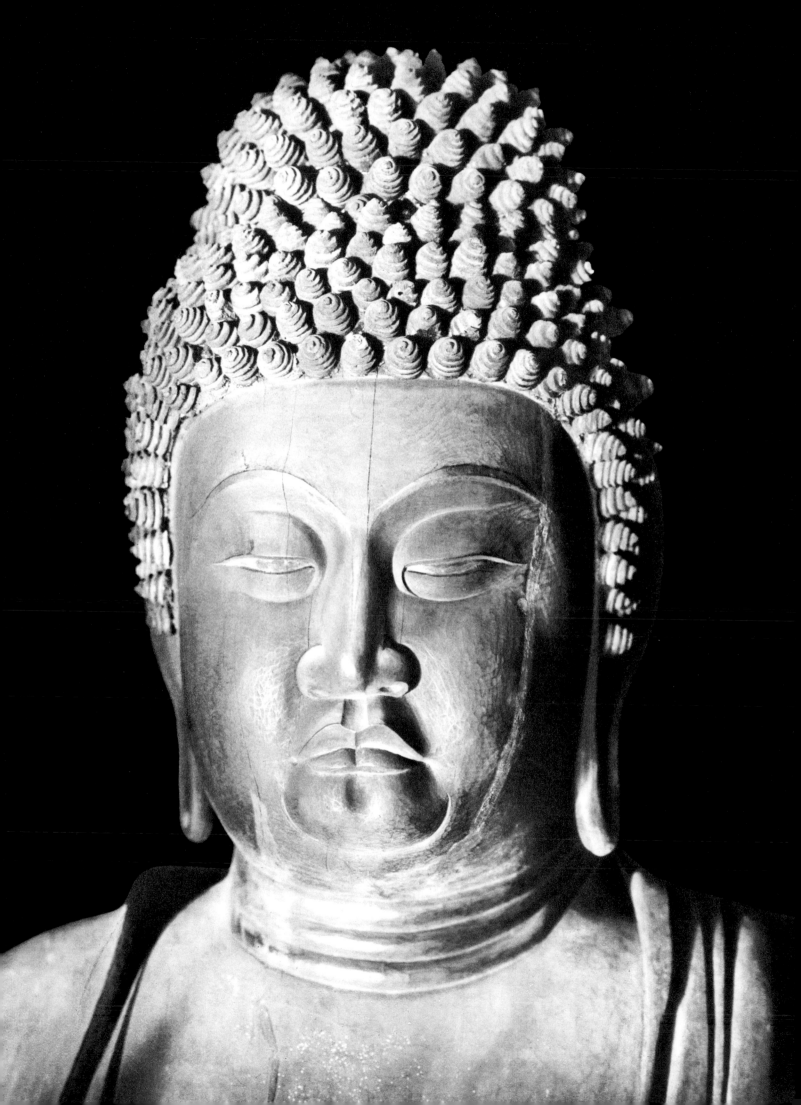

which was not further smoothed or changed. In some cases, the blade produced facets on the surface of the now darkly polished wood almost like those one finds on a cut diamond. Observe the treatment of the Mongoloid fold of the eye; notice the similar delicacy in the treatment of the nostrils and mouth. The edges are sharp, and again the knife was the final finishing tool. There have been very few sculptural styles displaying such a proper and convincing union of technique, tool, and material as that of the Jogan Period. The detail of the head shows particularly well the rather stern, almost scowling, expression characteristic of these Jogan images.

Even portrait sculpture, very rare in the Jogan Period, has the massiveness and scale characteristic of the style. In contrast to the portrait sculptures of the Nara Period, with their considerable realism, these buttress the realism with a more massive scale and, in the case of facial expression, with a more purposely somber ex-

terior far beyond that of the more sympathetic portraits of the Nara Period. In this portrait of the Priest Roben at Todai-ji, Nara, dated 1019, but preserving many elements of Jogan style, there is considerable use of polychromy, which in the Jogan Period is often applied directly to the wood; but in this particular case, gesso is used as an underlying ground (fig. 370). Most Jogan sculpture is but slightly colored, the wood being preserved as the dominant material.

The derivation of the particular type of drapery characteristic of the Jogan Period is reasonably clear. The motif is called *hompa* (wave) by the Japanese, and comes from the sculptural style previously seen in the colossal image of the Buddha at Bamiyan in Afghanistan. This towering image (*see fig. 155*) was a focus of attention for all pilgrims traveling the Central Asiatic pilgrimage routes to Bamiyan and then to India. A number of works done in this style were carried back by pilgrims to China and Japan, and so became prototypes

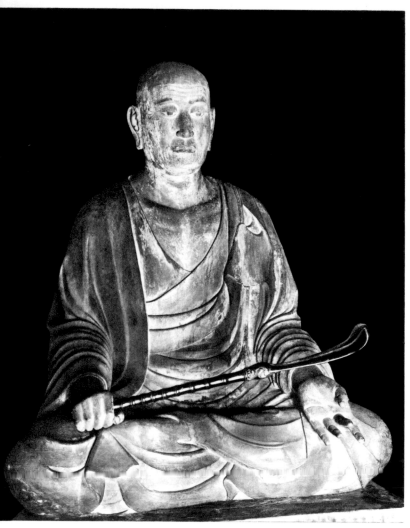

370. *Priest Roben (active c. A.D. 773), in the Kaisando. Colored wood, height 36", dated A.D. 1019. Todai-ji, Nara*

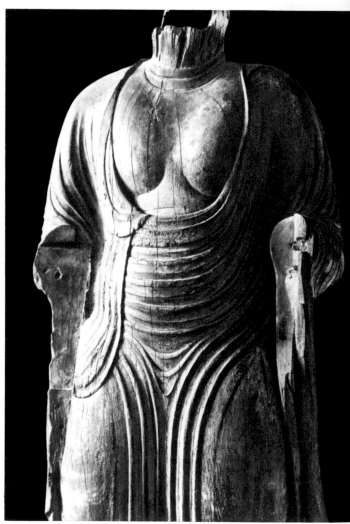

371. *Torso of a Buddha. Wood, height 69¼". Early Heian Period. Toshodai-ji, Nara*

286

for particular sacred or holy images. The peculiar string-drapery pattern of the Bamiyan Buddha, in turn derived from the Kushan art of India, was the dominant stylistic motif brought back in these "souvenirs." This motif was then modified in various sculptures of bronze and wood to produce a style which reached its first really perfect form in the transition from the Nara to the Jogan Period in a series of sculptures kept at To-shodai-ji, in Nara. Of these this torso is perhaps the most beautiful and famous example (fig. 371). In the purity of its form it is an image much admired by Japanese and foreigners alike. But since we are primarily concerned here with the peculiarly Jogan style of drapery called *hompa*, we can note an intermediate stage in the development of this mannerism derived from the colossal image at Bamiyan. But, if one looks at the folds of drapery at the elbow, one notices that these are not strings, but seem to have a triangular-shaped or wavelike appearance. The most typical example of the *hompa* drapery type is to be found on the Shakyamuni at Muro-ji, a figure which originally had some color applied on a white gesso ground (fig. 372). The image is otherwise in almost perfect condition and the drapery is a classic example of *hompa*. At any point, whether on the chest or at the knees, the drapery seems to have a rhythm like that of the waves of the sea. One begins with a large rounded wave, then moves to a shallow and smaller wave with a pointed profile and from there on to another larger wave with a curved profile. Alternating series of small and large waves of wood compose the folds of the draperies. The rolling rhythm, produced wholly with the knife, is used with variations. In general, the pattern is one of alternate small and large ridges, but sometimes this is varied in subtle ways.

The sculpture of the Jogan Period is not confined to Buddhist material. There are some Shinto examples, images used at shrines or at temples and dedicated to deities associated with the forests, the fields, and the waterfalls—the typically animistic deities of the Shinto faith. This female image coming from Koryu-ji in Kyoto shows a simple variation of the *hompa* pattern on the drapery folds on her arms, and is related to the seated Buddha images by her blocklike, massive character and by her slightly forbidding, or at least objective, expression (fig. 373). The headdress is interesting from an aesthetic point of view and also because it shows us the standard female headdress of the period. One could follow a pleasant digression, correlating, for example, the sculptural approach of a period with the costume or headdress of that period. It is certainly no coincidence that this massive headdress and heavy draperies are characteristic costumes of a period that produced sculptures with similar qualities.

Let us look, in contrast to this Shinto figure of a goddess, a somewhat provincial piece, at one of the

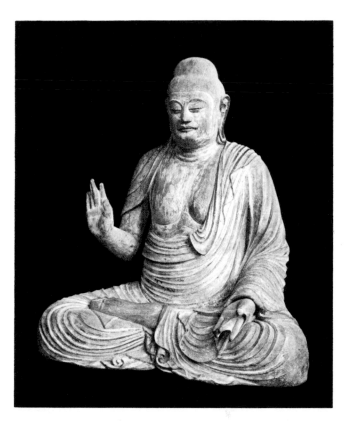

372. *Seated Shakyamuni. Wood, height 41". Early Heian Period. Muro-ji, Nara*

373. *Female Shinto Image. Wood, height about 39¼". Heian Period, 9th Century* A.D. *Koryu-ji, Kyoto*

287

374. *Shakyàmuni and Miroku. Stone relief, height 114".*
Early Heian Period. Kanaya Miroku-dani, Nara

limited to the surfaces of the material. Two reliefs of Buddhas, a Shakyamuni and a Miroku, translate the characteristic *hompa* drapery style into low relief of a somewhat provincial rendering when compared with the great works in wood (*fig. 374*).

Paintings of the Jogan Period are extremely rare. We have almost none, but those few are of great interest. One particular type of painting, derived from China, developed at this time and was continued by the esoteric sects to modern times, the *mandala*. Now the *mandala* is simply a diagram designed to make clear the relationships between various deities or to outline a particular cosmogony in visual form. There are two *mandalas* particularly important for the esoteric Buddhist sects of the period. The Garbha-dhatu (Japanese: Taizo-Kai) is the "womb circle" containing some 407 deities in twelve sections, explaining principles and causes. The Vajra-dhatu (Japanese: Kongo-Kai; *fig.*

375. *Kongo-Kai Mandala (detail of central section called the Joshin-Kai). Gold on purple silk, height of whole 13'.*
Early Heian Period, 9th Century A.D. Jingo-ji, Kyoto

OPPOSITE: *Colorplate 25. Red Fudo.*
Color on silk, height 61½". Early Heian Period.
Myoo-in, Koyasan, Wakayama

more suave and aristocratic productions of the Jogan Period (*colorplate 24, p. 264*). It is considered one of the two or three most important Jogan sculptures because of its quality and fine state of preservation. The base, the figure, and the body halo or *mandorla*, are all original and of the period, as is the polychromy. The figure of the six-armed *Nyoirin Kwannon* holding his attributes is shown in the usual pose, seated, with one leg up and with the chin resting on the side of the hand in a thoughtful gesture. In this particular case, despite the fact that the sculptor intended the image to be attractive, there is no smile to the mouth, and the eyes, with their long, flat upper lids, at best reveal a rather neutral or objective expression. The roundness of the face is evident and the most obviously so of the sculptures reproduced. But when compared with the Shinto figure, the difference between an urban, aristocratic production and a provincial one is clear.

Some sculpture in stone exists from the Jogan Period, and it is mentioned only briefly here because Japanese stone sculpture is on the whole unimportant. The natural sculptural medium for the Japanese is wood and yet, significantly enough, the one period from which some important figures in stone exist is the Jogan, when Japanese sculptural style achieved its most compact and massive qualities and when the carving was largely

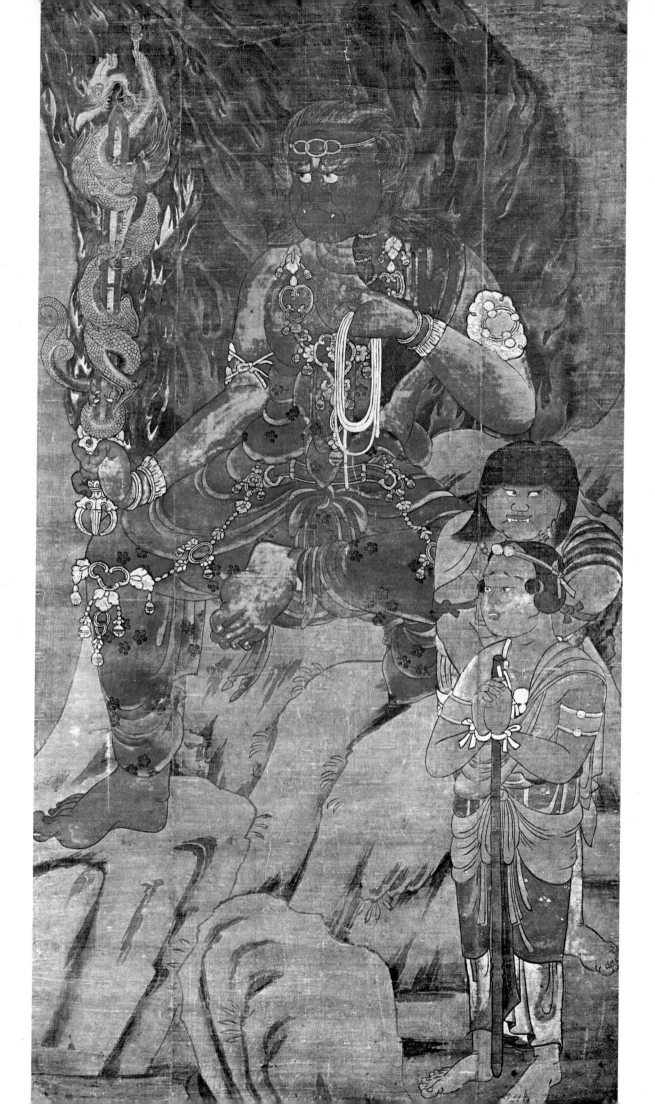

LEFT:
Colorplate 26. Palace Ladies Listening to Music.
By Chou Fang (active c. A.D. 780-810).
Handscroll, ink and color on silk, height 11". T'ang Dynasty.
Nelson Gallery-Atkins Museum (Nelson Fund),
Kansas City

BELOW:
Colorplate 27. Home Again. By Ch'ien Hsuan
(A.D. 1235-1290). Handscroll,
ink and color on paper, length 42". Yuan Dynasty.
Metropolitan Museum of Art, New York

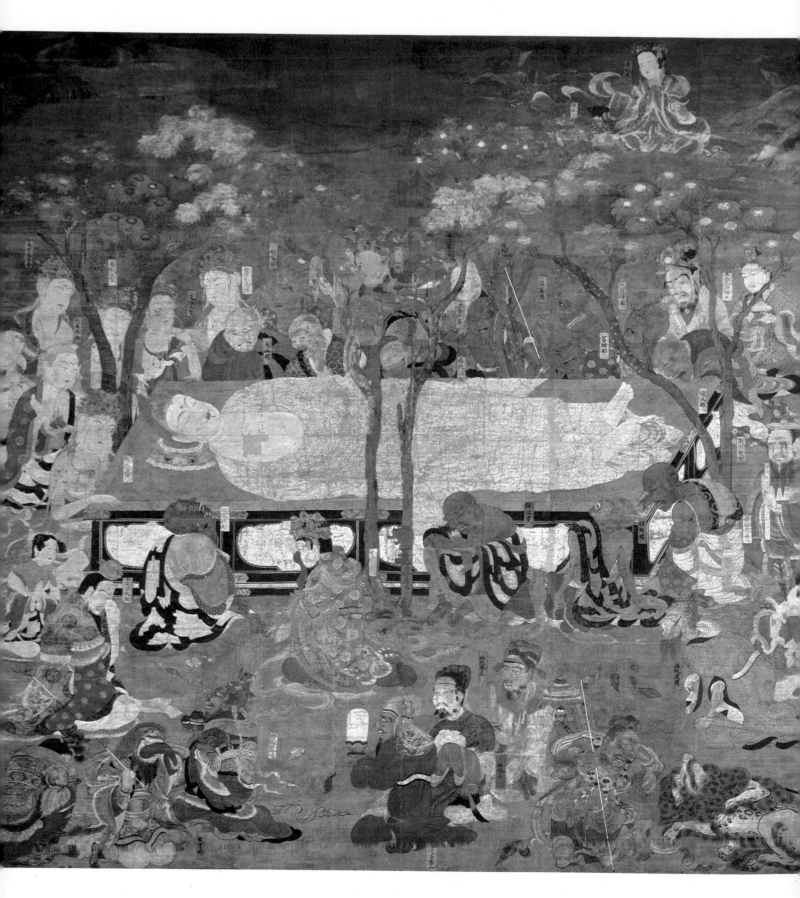

Colorplate 28. The Parinirvana. Color on silk, height 106".
Heian Period, A.D. *1086. Kongobu-ji, Koyasan, Wakayama*

375) is the "diamond circle" with some 1314 deities in nine sections, expounding reason and effect. Naturally the Supreme Buddha Mahavairocana or, in Japanese, Dainichi Nyorai, is at the core of each *mandala*, or diagram, explaining the complex Shingon hierarchy. Each of the myriad deities may, and should, be considered as an emanation from, and acting for, Dainichi Nyorai. The *mandalas* are combinations of both representation and an extreme form of symbolism, everything being arranged according to a rational scheme and presenting certain relationships. Thus, for example, the *mandalas* are nearly always laid out geometrically, on a grid pattern, in a circular form, or combining square and circle. Borobudur, the great monument in Java, is a *mandala* in stone (*see fig. 147*); here we are confronted with painted ones. In this case, the square center contains the five most important deities, Dainichi in the square center, the Buddhas of the Four Directions in the centers of each circle, and the deities of the Four Elements at the four corners of the outer circle. The placement in this work is geometric and primarily intellectual. It certainly does not completely enchant one by the subtly abstract arrangement or by its gold and dark-blue appearance at a distance. Indeed, the Kojimadera *mandalas* are eleventh-century versions, with variations, of a much earlier and finer, if sadly damaged, pair preserved at Jingo-ji in Kyoto. If one looks at details of these earlier paintings, one sees some remnants of the earlier style of the Nara Period, a certain grace in rendering figures recalling the frescoes of Horyu-ji or the painted banner in the Shoso-in. And when one looks even closer at the smallest details of the *mandala*, one sees how the style is really a continuation of the linear style of the T'ang Dynasty (*fig. 376*). In this case, a Dancing Bodhisattva attended by two music-playing angels is engaged in a type of dance recalling that to be seen in the foregrounds of representations of the Western Paradise at Tun-Huang in Northwest China (*fig. 198*).

However, the great contributions of the Jogan Period in painting are not to be found in the restricted art of *mandalas* but in the representational pictures which correspond to the sculptures, particularly in those icons representing the terrible aspects of deities. These manifestations are epitomized by the famous *Red Fudo* of Koyasan, a representation of an esoteric deity, dubbed the Immovable, a terror to evildoers (*colorplate 25, p. 289*). Immovable upon his rock, Fudo sits attended by his usual two youthful acolytes, glaring out past the worshiper. The linear presentation of the drapery is based upon the *hompa* pattern. The composition, filling the frame from the very bottom at the attendants' feet to the top, where the red flames reach even beyond the edge, produces a large-scale, massive effect controlled by the figures, especially Fudo, since his red color dominates the whole conception. The expression

of the deity with one fang up and the other down, with rolling, glaring eyes, combines with the *vajra* sword, a thunderbolt with a dragon coiled about its sharpened blade, to produce an effective pictorial realization of the awesome and the terrible. Fudo's two boy attendants, the bad one with fangs, glaring eyes, and thick lips, conform to the Jogan physical type (*fig. 377*). The style of the representation, the drapery with its reversed shading of the *hompa* folds, the heavy line with its simple, geometric treatment, not graceful and elegant like that of the Nara Period, but massive with an almost deliberately simple and rude effect, all combine to produce an over-all impression of awesomeness on a large scale.

One of the most impressive examples of Jogan pictorial style, despite its bad condition, is a representation of one of the lesser deities of esoteric Buddhism, Sui-ten (*fig. 378*). The impression of these squared, thrown-back shoulders, and the massive chest is par-

293

376. Taizo-Kai Mandala. Detail, gold on purple silk, height of whole 13'. Early Heian Period, 9th Century A.D. Jingo-ji, Kyoto

377. Attendants of Fudo. Detail
of colorplate 25

378. Sui-ten. Color on silk, height 63". Early Heian
Period, 9th Century A.D. Saidai-ji, Nara

ticularly strong. Unlike the vehicles of images of earlier and later periods, where the animals or birds may be rather small or even playful, the large tortoise vehicle has a dragonlike head as awe-inspiring and massively convincing as the image it bears. The big, sweeping curves of the neck of the tortoise, the curves of the dragon crown and the halo behind the head, and the roll of the drapery coming down the shoulders, serve to recall the stately rhythms of a *hompa* drapery pattern. These repetitions are part of the means used by the artist in achieving his monumental aim.

In metalwork, numerous ritual tools of esoteric Buddhism — bells, *vajra*, thunderbolts, ritual daggers, and other implements — were used in connection with the intricate hand motions, rhythms, and sequences that were part of the ritual of worship (fig. 379). These, too, are part of the Jogan ethos and are continued in the later periods.

We know secular art only from literary sources; and these indicate the beginnings of a decorative style of great importance for the later development of a Japanese art, a development whose first flowering followed the now lost objects of the Jogan Period.

After the Early Heian Period there is a change to a more refined, decorative, and aristocratic art. One can draw conclusions on the basis of the assumed influence of social structure and political events; and in the case

of the Fujiwara, or Late Heian Period, it is only too easy. But one must remember that such conclusions cannot always be considered as cause and effect and also that social and artistic similarities do not necessarily occur at precisely the same time. All we can say is that in considering the ethos of the Fujiwara Period, there seems to be a definite correlation between the type of the then developing society and the new tendencies of Japanese art. The power of the emperor was successfully usurped by the aristocratic clans at Kyoto. But where in Europe, or even in China, one might expect to find an overthrow of a king and the founding of a new dynasty, in Japan such changes were handled quite differently. The emperor and the emperor's lineage were maintained; he was given full honors, a palace in Kyoto, and in theory the power was still his. In practice, the power was wielded by the dominant clan, at first the Fujiwara; and this was the beginning of a system of government which continued in Japan without much change or interruption to the present day. The real power was wielded by the clan able to maintain itself in power, able, in fact, to govern Japan. Consequently, the stage was set for the development of internecine war, of palace struggles and intrigue on a grand scale; this in contrast to the relatively centralized power of the preceding periods. With the establishment of two courts at Kyoto, one associated with

theoretical power and the other associated with actual power, we find a split in court life. One court, more vigorous and active than the other — the imperial court — left the latter with considerable leisure for the appreciation and practice of the arts.

This is the period when extreme refinements of court life were developed; it is the period of the great poets, and of the appearance of the earliest form of the Japanese novel, *The Tale of Genji* by Lady Murasaki. This new ethos, highly aesthetic, self-conscious, subtle, indeed almost overly subtle, is reflected in the painting and sculpture of the period, particularly in that associated with the court, for in the purely religious centers, despite certain new influences, there was still a very strong maintenance of the Early Heian tradition. We will first consider the traditional religious material and its gradual changes, finding in those changes some hint of attitudes that were to reach their most specialized and highest form in the secular art associated with the court. One important facet of the art of any period is the conservative one. We can tell a great deal about a period from the kind of art continued from the previous

380. *Daitoku Myo-o. Color on silk, height 76".*
Heian Period. Museum of Fine Arts, Boston

period, and from the modifications that led to new styles and new thoughts. One can learn almost as much from these factors as one can from the innovations of a period. We will find, particularly in the Kamakura Period, that the conservative arts of that period are highly significant.

In the Fujiwara Period, the painting of Buddhist icons, as one might expect, continued in the earlier style, particularly in representations of the terrible aspects of deity, such as Daitoku Myo-o (*fig. 380*). Daitoku Myo-o was one of those fearsome deities imported to Japan with the rise of the Shingon and Tendai sects, and his image is handled by the early Fujiwara artist in very much the same way as before: a large-scale figure filling the entire silk to the edges of the frame; ample extremities; large planar structures patterned in a very bold and vigorous way, especially when compared with later, more delicate patterns. Only in certain minor details, notably in the more elegant geometry of the knees, legs, and body structure, is there any sign that this icon is over a century later than the Jogan Period.

The icon form is traditionally conservative because of the magical qualities associated with it, and its iconography is naturally continued. This is also true of rep-

295

379. *Bell with Vajra. Gilt-bronze, height 6⁵⁄₁₆"*
Heian Period. Y. Yasuda Collection, Japan

resentations of founders of the various Buddhist sects. The simple monumental style, based upon T'ang Chinese painting and continued in the one or two remaining fragments of the Jogan Period, is maintained in the Late Heian Period. The *Portrait of Jion Daishi* is in the tradition of T'ang figure painting in its fine, even linear quality, the restriction of the background setting to abstract space with the only indication of actual setting being a few attributes placed by the figure, in this case, a little table with scrolls and brushes (fig. 381). At the same time, if we were to see the original color, particularly the bands of color at the top under the calligraphy, rather varicolored and gay, one would sense the difference between the austerity of a Jogan portrait and the relaxation of that austerity in the Fujiwara Period.

If the icons and single figures tend to be conservative, certain other paintings associated with Buddhism are modified to a significant degree. One of the most important Buddhist paintings in Japan or, indeed, in the Far East is the great representation of the Parinirvana of the Buddha, a very large hanging scroll at Koyasan (*colorplate 28, p. 292*). The painting is beautifully preserved and presents in color a veritable kaleidoscope of soft green-yellows, pale oranges, greens, blues, mild reds, the usual malachite green, and numerous touches of gold. The effect is, strangely enough, not unlike that presented by a complex Italian altarpiece of the fourteenth century. The Parinirvana is dated 1086 and has both remnants of the past and important changes of the Fujiwara Period. The Buddha lies on a

296

381. Portrait of Jion Daishi. Color on silk, height 63". Heian Period, 11th Century A.D. Yakushi-ji, Nara

dais, represented completely in gold, with his head resting on a lotus pillow. About the dais are grouped the many Bodhisattvas, disciples and followers of the Buddha who have come to mourn the great event, and even some animals at the edges of the composition. The setting is a placid landscape of a decorative T'ang Dynasty type, with flowering trees reaching to the sky where the Buddha's mother, Queen Maya, appears descending to witness the "final extinction" of her son, the fulfilled Buddha. The composition is formed in a completely defined stagelike space, and in this respect follows T'ang custom. The foreground area leads up to the dais, slightly tilted in a space further marked by the careful placement of four trees neatly but slightly off center at each of the axes of the dais. The representation of the foliage and clouds finishes the picture, not only on the surface but also in depth, and serves to give a convincing spatial setting, modified and made more flat and decorative by the use of the color.

The representation of the figures is quite extraordinary, particularly in the revelation of various psychological states. It is certainly no coincidence that the Buddha is shown in gold and that the next members of the hierarchy, the Bodhisattvas, are also represented in gold, while the lesser members of the Buddhist hierarchy, the disciples and, of course, the animals, are shown in color only. It is also no coincidence that the psychological states correspond to this order. The Buddha and the Bodhisattvas are shown as relatively impassive. Their faces portray no trace of emotion; their eyes are closed or almost closed, producing the traditional masklike, slightly smiling countenance of beatific deity. On the other hand, many of the disciples are shown as grotesque types, like those of the T'ang Dynasty portraits of founders or patriarchs of the various sects, where rough exteriors and hearts of gold are presented in paint. The disciples mourn, pray, cry, or even shout, raising their heads to the sky, their faces distorted in agony (fig. 382). Even the figures of the guardian kings of the Four Directions at the lower left display elements derived from realistic observation. One of these is shown shielding his eyes with a hand covered by his sleeve. Such an effect is quite unusual, for here a usually fierce and overpowering figure is reduced to sadness and tears. The guardian on the right is in the same state, with his teeth bared in a mask of sorrow. The animals are also violently affected, since they are the lowest of the hierarchies presented. In the lower right, a lion, presumably the vehicle of the Bodhisattva Manjusri, is rolling on his back with his legs in the air. The combination of these elements of space, color, and pattern with the psychological unity of the picture and, within that unity, a progression from sublime calm to representations of extreme emotionalism, produces a masterpiece of Buddhist painting.

There is one other work comparable to the Pari-

382. Mourners from The Parinirvana. Detail of colorplate 28

383. Kinkan Shitsugen. Color on silk, height 63". Heian Period, late 11th Century A.D. Choho-ji, Kyoto

nirvana, not only in subject matter but in quality — a very unusual representation of the resurrected Buddha preaching to his mother (fig. 383), Queen Maya, who is just to the left of the dais. This hanging scroll looks almost as if it were by an artist trained in the studio that produced the Koyasan picture. In this case, the Buddha's aureole or halo is dotted with several representations of other Buddhas. The landscape setting with its T'ang type trees recalls the slightly earlier work, as

384. *Ichiji Kinrin. Wood, height 29⅛".*
Late Heian Period.
Chuson-ji, Hiraizumi, Iwate

does the differentiation of types ranging from the Buddha and Bodhisattvas to disciples and commoners who have fallen to their knees in adoration of the event. In both of these paintings, it is important to recognize the fact that they are not only icons, but also decorative and rich color orchestrations. This in itself is a distinct change from the art of painting in the Jogan Period, which tended to simpler color arrangements. In these two Fujiwara works we also have the beginnings of a sharp differentiation of types and of an interest in the psychology of the individual. These two modes, the decorative and the realistic, appearing for the first time in a clear way, are most important for future development, and we will be often confronted with this curious dualism, one of the outstanding characteristics of Japanese art.

In sculpture too, similar changes are evident in certain works produced toward the end of the Fujiwara Period. One could point out many sculptures of the earlier part of the period which are, in essence, continuations of Jogan style; but by the middle of the peri-

od, and certainly at the end, the sculptural style for even the principal icons changed radically. The illustrated image of the Supreme Buddha, Dainichi Nyorai, or Ichiji Kinrin, kept at Chuson-ji, a temple in Northern Japan near Sendai, is a telling example of this change in sculpture (*fig. 384*). The figure is actually not in the round but in the half-round, and is kept in a secret tabernacle. There is a complete use of polychromy, with an elaborate development of the cut-gold (*kirikane*) patterns on the draperies. The softness of the modeling is quite unlike the powerful forms of earlier periods, as is the aristocratic, almost effeminate, facial type with its small rosebud mouth, high-arching eyes, and very narrow, short, sharp nose, not unlike that to be seen shortly in the *Genji* scrolls.

But the work which summarizes extreme Fujiwara tendencies in sculpture is a famous representation of the Goddess Kichijoten (*colorplate 29, p. 301*). The figure, from Joruri-ji, is one of the most beautifully preserved sculptures of the period, and is executed in richly polychromed wood. The whole figure gives a

gay, almost gaudy, impression when one sees it for the first time. All the complicated trappings, drapery, and jewelry hanging from the skirt and the chest and encrusting the hair, are executed in carved and painted wood. In contrast to the relatively simple female forms of the Nara and the Early Heian periods, the Kichijo-ten of Joruri-ji has the same kind of feminine elegance to be seen in the Dainichi Nyorai; but here it seems somehow more appropriate and more related to the structure beneath, producing a unified and coherent work of art. One can see remnants of older traditions in the underlying structure of the figure, notably the large, falling sleeves with the hollow recesses, carved in a very simple way so as to preserve the essentially trunklike character of the body. Thus, there is a basic structure overlaid by the new Fujiwara interest in decorative style expressed in elegant and aristocratic detail. Where such decoration would have been painted on the basic structure in the Nara Period, here the painted decor has been transformed into complex sculptural form.

One particular aspect of religious art must be considered in some detail, and this is a new subject associated with a new sect of Buddhism, the Jodo (Pure Land). This sect is primarily associated with the worship of the Buddha of the West, Amida (the Japanese transliteration of the Sanskrit Amitabha). We have seen in the art of the T'ang Dynasty representations of the Buddha of the West in a Paradise depicted in the formal Chinese way. The Jodo sect took great hold in China and then in Japan. In contrast to the secret and awesome practices of the Shingon sect, Jodo was much simpler and more emotional in its appeal. One needed only adore Amida to be saved. The Western Paradise was painted as a bounteous land where jewels and flowers hung from every tree and where one was in the presence of continual celestial sights and sounds. The cult had tremendous appeal for both the aristocracy and the commoners — for the aristocracy, because of the aristocratic nature of the pleasures of the Western Paradise, as well as its emphasis upon a relatively worldly and sensuous approach to the faith; and for the common people, because of the relative ease of salvation in comparison with that of the esoteric sects.

One of the most favored subjects of the new sect was the *Raigo*, or Descent of the Amida Buddha. It is a subject that perhaps first appeared in Japanese art about 1053 on the doors of the Phoenix Hall. The likelihood is very strong that the *Raigo* is a Japanese contribution, even invention, and it represents one of the most lyrical visions of deity achieved by any faith. The essential part of the *Raigo*, in contrast to the secret and forbidding nature of the esoteric icon, is that the Buddha comes to the spectator, reversing the attitude of the esoteric sects. The Amida is not merely approachable; he approaches the spectator, and the picture rep-

385. *Amida Raigo Triptych. Color on silk, height 83". Heian Period, late 11th Century* A.D. *Koyasan Museum, Wakayama*

386. *Amida Kosho-ho. By Gensho* (A.D. 1147–c. 1208/23).
Drawing, ink on paper. Kamakura Period. Kozan-ji, Kyoto

resents the vision of the dying believer whose soul is received and welcomed into his Western Paradise by the Buddha. Now, this is psychologically an extraordinary change, and is accompanied by a very interesting pictorial development. The sequence seems to be from an iconic representation of the Coming of the Buddha to an asymmetrical composition, realistic in detail — a gracious and personal representation of his Descent.

The orientation of the earlier *Raigos* is toward the spectator, as if he were the dying person, as in the great *Raigo* triptych at Koyasan. Here the large figure of Amida accompanied by twenty-five Bodhisattvas floating on clouds faces the spectator and moves toward him, a movement indicated by the perspective of the clouds as they rise and recede to the left and top of the central panel (*fig. 385*). The vision hovers above a landscape clear at the lower left but barely visible at the right. But the landscape is a small part of the picture, confined to an unobtrusive place, so that the whole effect is a rather more iconic than realistic presentation of an imagined scene. Details of the figures reveal, just as in the Death of the Buddha at Koyasan, a marked development of decorative detail, color, and realism. The music-playing angels are particularly interesting. They are shown in poses observed from nature, dancing or playing their instruments, and puffing out their cheeks as they blow into the more difficult wind instruments.

Usually one can find the more advanced pictorial tendencies at a given time in secondary parts of pictures. Thus, for example, in Italian painting new developments are seen on the predella panels, or in secondary figures. In these the artist seems to feel freer to invent and improvise, whereas the central figures are more traditional and conservative. So it is here. The observa-

tion of nature and the development of new decorative patterns and color chords are found in the music-playing angels surrounding the Buddha, rather than in the Buddha himself.

The new realistic concepts behind the development of the *Raigo* are perhaps best indicated in a small sketch but recently discovered and kept at a temple in Kyoto (*fig. 386*). It is a monochrome satirical presentation of an Amida Buddha with strings attached to an unwilling victim who is being pulled toward him by force. The sketch dates about 1201, just after the end of the Fujiwara Period, but is executed in conservative style and signed by a priest, Gensho. This indicates that a realistic approach was sometimes evident in iconography and satire allowed in the sacred precincts of the icon.

The *Raigo* is also presented in sculpture, and for this we turn to the Phoenix Hall, a remarkable embodiment of the arts of the Fujiwara Period (*fig. 387*). It presents an intermingling of secular, aristocratic, and religious art. The design of the Ho-o-do of the Byodo-in has many elements derived from palace pavilions for secular use, and because its plan and appearance suggest a great bird in flight, it is called the Ho-o-do (Phoenix Hall) (*fig. 388*). The Ho-o-do is situated on a pond, beside the river — and its lovely reflection in the water is one of the striking images one brings back from Uji. There is a central hall with three large doors, a covered porch and two covered runways leading out from each side to covered tower pavilions. All of this is raised rather high above the ground on posts except for the central hall, which is placed on a stone platform. Certain Chinese elements have reasserted themselves here: the tile roofs and the stone platform. Indeed the whole arrangement of the elements of the structure recalls very much the kind of Chinese architecture portrayed in representations of Western Paradise at Tun-Huang. The Ho-o-do may thus be a conscious imitation of a building type associated with the Western Paradise and hence evidence of the importance attached to magical structures. Despite the Chinese influence, and in contrast to the rather severe and strong character of Jogan architecture, this Fujiwara building is decorative, light, and aristocratic in appearance, a mirror of the essential qualities of style that we find in the painting and sculpture of the period.

The interior of the hall was originally richly polychromed, and much of that polychromy still remains (*fig. 389*). The architectural form of the temple interior is transformed and to a certain extent denied by the rich decorative quality of the ornament. Not only are

300

OPPOSITE:

Colorplate 29. Kichijoten. Colored wood, height 35½"
Heian Period, late 12th Century A.D. Joruri-ji, Kyoto

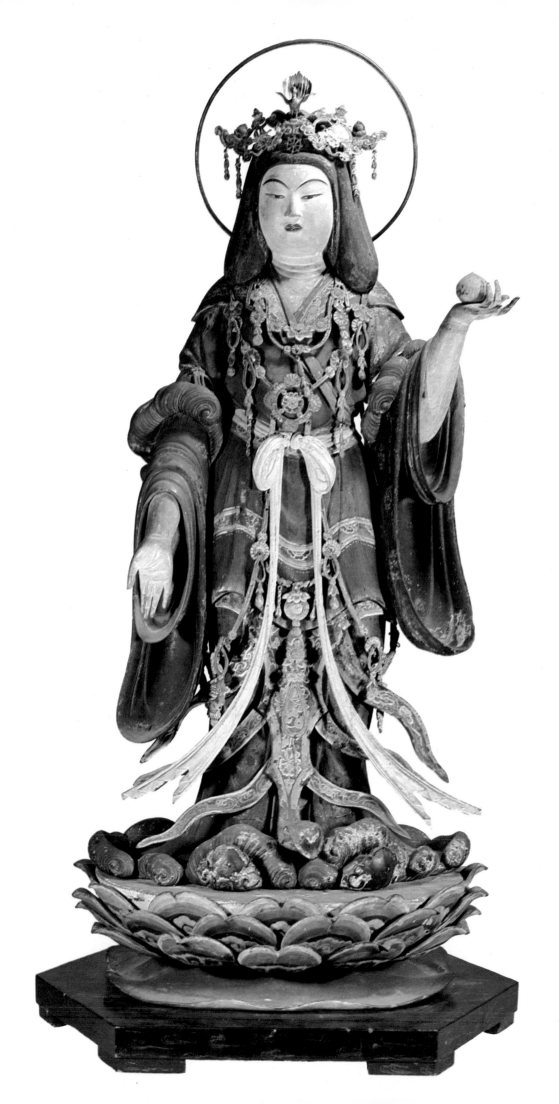

301

Colorplate 30. Second illustration to the Azumaya Chapter of the Genji Monogatari. Handscroll, color on paper, height 8½". Late Heian Period, 12th Century A.D. Tokugawa Museum, Nagoya

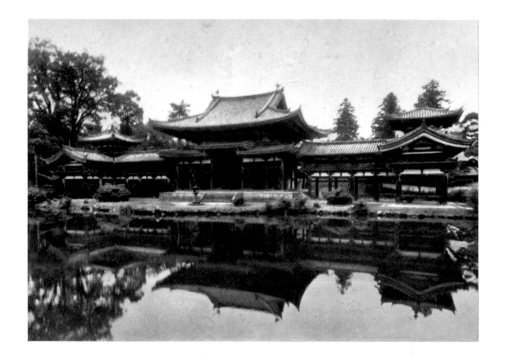

LEFT:
*387. Ho-o-do (Phoenix Hall),
Byodo-in, Uji, general view.
Heian Period, 11th Century* A.D.

BELOW:
*388. Plan of Phoenix Hall,
Byodo-in, Uji*

parts of the interior painted with representations of lotus, falling lotus petals, and other flowers, but there are mother-of-pearl inlays on the central dais and in some of the columns. All of this combines to produce the same kind of complex encrusted effect that we saw in the sculpture of the Kichijoten of Joruru-ji.

The interior of the main hall is used to house a sculptured *Raigo*. The image of the Buddha of the West, Amida, is seated on a richly carved lotus throne, backed by a halo carved of wood and gilded, on which are many music-playing angels in high relief (*fig. 390*). The ensemble is by a known sculptor, Jocho, and was completed about 1053. The Buddha is more elegant than the earlier seated figures, appearing lighter in weight, with a distinctly aristocratic turn of lip and eyebrow. Around the dais at the upper reaches of the interior walls, sculptured representations of the various Bodhisattvas and music-playing angels are placed on hooks around the walls, accompanying the Buddha as he descends from the Western Paradise. If one stands just inside the icon hall and looks directly to the altar, one sees in sculpture the same kind of representation to be seen in the painted triptych of Koyasan. The little music-playing angels, when seen in detail, show that same observation of natural movement displayed in the Koyasan picture, as well as a playfulness, an elegance, and a charm which is extremely courtly (*fig. 391*). Originally, the whole effect, with its color and inlays and with the complete ensemble of figures, must have been one of the most lyrical sculptural expressions of religious art that the Far East has ever seen.

The same aristocratic elegance to be seen in the Phoenix Hall on a considerable scale, for it is a rather large building, was attempted on a smaller scale in the North at Chuson-ji at Hiraizumi, near Sendai, where an icon hall was built, using mother-of-pearl inlay in lacquered wood. The interior of the temple at Chuson-ji looks like the precious and delicate work of a cabinetmaker (*fig. 392*). And yet the wealth of the Northern aristocracy was not such as to support such a massive achievement as the Phoenix Hall; the decorative quality is maintained only in the small central area of the building. The exterior is extremely plain, and even the interior ambulatory presents a severe appearance.

We must begin the study of secular art of the Fujiwara Period with a work which is nominally religious, but which is also the earliest remaining example of the

303

style of secular and aristocratic court painting in the period. Scrolls of the Lotus Law, the *Hokke Sutra*, are kept at the Shinto shrine at Itsukushima, south of Osaka. The *Hokke Sutra* at Itsukushima is a religious text and the scrolls were offered by the Taira family as an act of piety and devotion. They are kept in a box adorned on the outside with traditional types of Nara style dragons in gilt-bronze on a ground of black lacquer (*fig. 393*). Inside this conservative housing one would not expect to find anything radically new. But when we examine the twelve rolls kept in the box we find something quite extraordinary. The text sections are simply written, in columns of gold and silver characters, as one would expect; but the end papers — the first eight or ten inches of each scroll — are decorated with scenes which have, from the standpoint of their subject matter, an ostensibly religious meaning (*fig. 394*). In the scene of an aerial view of a house with the roof removed, showing a monk sitting next to a woman, with a court noble behind them holding a scroll at his writing desk, from the left we can observe golden rays coming from the direction of the Western Paradise of the Amida Buddha. The priest in the middle ground, hidden in part behind the rolling hill, is praying with

 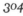

his head turned in the direction from which the rays come. The rays, and the written characters, in some cases Japanese and in others Sanskrit, incorporated into the rock structure of the garden outside the house tell the Buddhist initiate that this is a religious scene. But if we examine the scene from the standpoint of what is shown and the style in which it is shown, we note one of the first examples of a characteristically Japanese secular style which reached its greatest heights in the *Genji* scrolls to be considered shortly. In color these Sutra end papers are quite brilliant, with purples, reds, oranges, deep blues, yellows, and ink, and with a copious use of sprinkled gold as well. In the left foreground, for example, in the pond outside the garden, large squares of gold are apparently floating in the water. They are all of cut gold, as are the little straw-like sticks clustered on the surface of the water. All are part of the decorative patterning that we have seen to be characteristic of the cut-gold patterns of the religious paintings also. There is a high degree of observation of nature here: the bundled-stick hedge in the middle ground; the long bamboo runner with the water coming out and pouring into the pond; and the house itself. All these show a peculiarly Japanese quality in

OPPOSITE:
389. Interior of Phoenix Hall, Byodo-in, Uji

LEFT:
*390. Amida. By Jocho (d. 1057).
Gilded wood, height 112". Heian Period,
c. A.D. 1053. Phoenix Hall, Byodo-in, Uji*

BELOW:
*391. Angel, from a wall of the
Phoenix Hall. Wood, height about 28⅜".
Byodo-in, Uji*

the way they are handled, particularly the aerial view of the house with the roof removed. This representational device, so arbitrary and extreme as to be untypical of China, was used by the Japanese with great abandon.

The landscapes in the Itsukushima Sutras are derived from T'ang type landscapes, but have now become peculiarly Japanese (*fig. 395*). The term that the Japanese use again and again to describe the landscape of Japan seems most appropriate to the style used in representing it here: lovely. There is a gentle rhythm and roll to the hills and rocks; everything is stated in a subtle and yet rather decorative way. The tree forms, with their gracefully branching twigs and leaves, all seem to be part of the generally decorative treatment of the whole picture. This style, called *Yamato-e*, meaning Japanese picture, is one which is particularly important for the twelfth and the very beginning of the thirteenth centuries. It is a late Fujiwara style, secular and decorative; the realistic or even satirical treatment of *Yamato-e* that is more characteristic of the thirteenth century will be considered when we come to the Kamakura Period.

The greatest monument of *Yamato-e* is the group of

305

392. *Interior of the Konjiki-do. Late Heian Period,
12th Century* A.D. *Chuson-ji, Hiraizumi, Iwate*

pictures usually attributed to the painter Takayoshi
and kept in two private collections in Japan, the mu-
seum of the Tokugawa collection, at Nagoya, and the
Masuda collection, at Odawara (*fig. 396*). They were
originally part of a series of handscrolls of which only
remnants remain. The pictures have been cut into small
panels, and are now kept flat so that they will not be
damaged by the constant rolling and unrolling neces-
sary to view them. The narrative system used in the
Genji scrolls was a fairly primitive one, and by system
we mean the over-all scheme of organization. A scene
is preceded by a text, followed by the next text, fol-
lowed by the next scene, and so on. We are dealing
here really with framed pictures, pictures that have a
definite beginning and end, and which can be held and
viewed all at once as is a framed picture. This is in
marked contrast to the more complex development of
the narrative scrolls to be seen later. The text pages are
almost as decorative as the illustrations, being orna-
mented with cut gold sprinkled in an asymmetric and
uneven way which seems typically Japanese.

But the pictures particularly command our attention
and these are worth considerable study. They illustrate
The Tale of Genji (*Genji Monogatari*), a novel by

Lady Murasaki, justifiably famous in English-speaking
lands through the translation by Arthur Waley. The
Tale is a long one and is principally concerned with
the intrigues and doings of the aristocracy at Kyoto,
especially the aristocracy of the emperor's court. It in-
volves high nobility and their intrigues, often those in-
volving dalliance with the ladies of the court. The novel
is so completely subtle, cloaked with typical Japanese
nuances and evasive means of developing the narrative,
that it takes a very devoted person to follow it from
beginning to end in a continuous reading. One passage
may give some idea of the flavor and style of the liter-
ary work which Takayoshi illustrated:

"It was a morning when mist lay heavy over the gar-
den. After being many times roused Genji at last came
out of Rokujo's room, looking very cross and sleepy.
One of the maids lifted part of the folding-shutter,
seeming to invite her mistress to watch the prince's de-
parture. Rokujo pulled aside the bed-curtains and toss-
ing her hair back over her shoulders looked out into
the garden. So many lovely flowers were growing in the
borders that Genji halted for a while to enjoy them.
How beautiful he looked standing there, she thought.
As he was nearing the portico the maid who had opened
the shutters came and walked by his side. She wore a
light green skirt exquisitely matched to the season and
place; it was so hung as to show to great advantage the
grace and suppleness of her stride. Genji looked round
at her. 'Let us sit down for a minute on the railing here
in the corner,' he said. 'She seems very shy' he thought,
'but how charmingly her hair falls about her shoul-
ders,' and he recited the poem: 'Though I would not be
thought to wander heedlessly from flower to flower, yet
this morning's pale convolvulus I fain would pluck!' As
he said the lines he took her hand and she answered
with practiced ease: 'You hasten, I observe, to admire
the morning flowers while the mist still lies about them,'
thus parrying the compliment by a verse which might
be understood either in a personal or general sense. At
this moment a very elegant page wearing the most be-
witching baggy trousers came among the flowers brush-
ing the dew as he walked, and began to pick a bunch
of the convolvuli. Genji longed to paint the scene."[12]

Now we can see from this that a great deal is going
on, but carefully hidden in images of color, of costume,
of rooms and screens, of hurrying figures, of draperies
fluttering — in short, in all of the things represented in
the scroll by the artist Takayoshi and developed so that
the pictures become a delight for the eye at the same
time that the narrative content is kept to a minimum
(*colorplate 30, p. 302*). The colors of the scroll are ap-
plied rather thickly over a preparatory drawing on the
paper and range from rather pale mauve to deep
browns, purples, oranges, and greens, the whole effect
being distinctly aristocratic and decorative. The artist

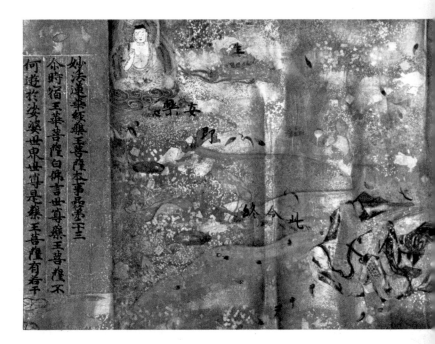

394. Prayer Offering, from Sutra offered by the Taira family.
Height 10½". Heian Period, c. A.D 1164. Itsukushima Shrine

395. Landscape Scene, from Sutra offered by the Taira
family. Height 10½". Heian Period, c. A.D. 1164.
Itsukushima Shrine

307

uses the screens, walls, and sliding panels of the Japanese aristocratic house of the Fujiwara Period as a means of breaking up the composition and of indicating the mood of the composition. Dr. Soper detects the mood represented in each scene by the angle of the principal lines of the composition: the higher the degree of the angle, the more agitated is the scene represented. Such an interpretation may very well be true, since the *Yamato-e* is a calculated decorative style. This is not a bold splashing about, but a carefully calculated art of placement, of juxtaposition of color and texture, but particularly of placement. Placement is almost everything, along with the interrelationships of elaborate patterns of angle and line, of triangle and square, and of the large over-all patterns found on the costumes worn by the participants.

Just as the actors in the novel do not have a clearly marked human character, tending to be types hidden beneath a mask of poetry or description, so in the paintings the figures are not shown except as heads and hands emerging from great masses of enveloping drapery. The women in particular, with their high, artificially arched eyebrows, seem to be little heads set on top of elaborately pleated and starched costumes — great mounds of colored drapery. If one looks carefully, one can follow the narrative content, but this is subtly restrained — cloaked or hidden by the over-all decorative emphasis on color and arrangement. The scene in our illustration is one with a contrast between the expectancy of the waiting Kaoru on the right and consternation on the part of the ladies at the left. The noble, at the right, turns his back on the befuddled group of court ladies in their typical, elaborately draped costumes. Their physical type is quite peculiar to the period: fat bodies, rather small heads, very heavily colored eyebrows, and long hair flowing down their backs mak-

ing a black pattern against the garments. Often, in three other scenes, clouds are used as a means of cutting off the top of the composition in an arbitrary way. We will find these cloud patterns used by the Japanese scroll painter and screen painter at all periods in a way that enhances the aesthetic development of his compo-

sition. Certainly, if one is to pick any one example of painting as the beginning of what we call here the Japanese decorative style, then the *Genji* scrolls are that beginning. There are related works in other collections, but the *Genji* scrolls are by all odds the most precious of all.

The refinements of court life and the rise of *Yamato-e* included a growing interest in landscape, as seen in two panels of a famous six-fold screen at To-ji, in Kyoto, reproduced in figure 397. It is a highly colored and decorative style of landscape painting used on an object whose purpose is primarily decorative: a folding screen. In the future of Japanese art, in the period from the sixteenth through the eighteenth century, the folding screen was to be the ground for some of the greatest painting produced in Japan. The figures are in T'ang style rather than that of *Yamato-e*, and have certain realistic tendencies relating them to developments in the narrative scrolls of the Kamakura Period, to be considered later. But here one's attention is drawn particularly to the landscape, the trees, the gently rolling hills, the flowering trees with the rhythmical profile of their trunks, and the use of the fence as a means of adding an architectural organization comparable to that found in the *Genji* scrolls.

The decorative arts, too, show the same development from a religious art with decorative overtones to an almost purely secular one in a decorative style. The early Fujiwara box for a Sutra (*fig. 398*), shows Buddhist subject matter, the sword of Fudo, the Immovable, on a rock in the sea, flanked by the two youthful acolytes previously noted in the *Red Fudo* of Koyasan (*see colorplate 25*). The representation is in gold and silver on a brown lacquer ground, with the falling petals of the lotus as a decorative accent in the background on either side of the flaming sword with its dragon. Here is a primarily religious subject with decorative overtones. But when we turn to later Fujiwara boxes, for example, we find that the decoration has become largely secular, with strong literary overtones. Thus this clothes box has a design of irises by a stream with plover flying overhead (*fig. 399*). The plover are made of mother-of-

396. First and second illustrations to the Suzumushi Chapter of the Genji Monogatari (The Tale of Genji). Handscroll, color on paper, height 8½". Late Heian Period, 12th Century A.D. Ex-Masuda Collection, Odawara

397. *Senzui Byobu. Two panels from a six-fold screen, color on silk, height 57¾". Late Heian Period. To-ji, Kyoto*

398. *Box for Buddhist Sutra. Lacquered wood, length 12¼". Mid-Heian Period. Taima-dera, Nara*

399. *Garment Box with Plover and Iris Design. Lacquered wood, height 11¹¹⁄₁₆". Late Heian Period. Kongobu-ji, Koyasan, Wakayama*

pearl, the iris gold and silver, as are the banks of the stream, against a dark, brown-black lacquer ground. The whole effect is decorative in the best sense of the word. Much of such subject matter was derived from poems written in the early Fujiwara Period to suggest the flavor of a place with double meanings or overtones associated with love and longing. This particular subject comes from Ariwara-no-Narihara's *Ise Monogatari*, and is the same subject as that used in the Iris screens by Korin and Shiko some six centuries later. Another garment box has a pattern of half-wheels in water, again a subject derived from the poetry of the period, and here interpreted as a bold asymmetrical decorative design, with no exact repetition of any one motif but al-

ways with a theme and variations: three wheels, two wheels, some widely spaced, some pulled together, and all united by the movement of the waves in the water (fig. 400). The wheels are in mother-of-pearl and gold on the dark ground, and the silver handles are also in a wheel pattern. For the first time in the Japanese utilitarian arts we have an original style, purely decorative in intention and secular in subject matter. The decorative style is the most important contribution of the Fujiwara Period and it was to have great influence on later Japanese art.

At the same time that the decorative style was flourishing, we can note the seeds of a narrative style, which can be called the *E-maki* style. *E-maki* means picture scroll; and it seems preferable to call this style *E-maki* to differentiate it from the style of the *Yamato-e*. The Japanese are inclined to use the term *Yamato-e* for all these pictures whether of the *Genji* scroll type or the more realistic narrative type. The result is unwarranted confusion and can be modified to a certain extent by arbitrarily calling the *Genji* style *Yamato-e*, and calling the narrative, realistic type *E-maki* style. The seeds for the *E-maki* are also to be found in religious art. You will remember we have seen certain minor passages in religious icons where we found an interest in realism, in the way people act and move, the way people look when they are frightened or trying to be fierce, and these seeds begin to reach fruition at the end of the

Fujiwara Period. Full fruition is to come in the Kamakura Period, but we must at least mention at this point one or two forward-looking examples of *E-maki* style.

One is a work of satire, the famous roll, or rather rolls, at Kozan-ji, associated with the name of Toba Sojo and dated by most Japanese scholars at the end of the twelfth century (fig. 401). It is not our intention to enter here into any scholarly discussions on dating. There may be good reason to date them slightly later, perhaps in the thirteenth century. But at any rate, they have been long associated with the late Fujiwara Period, and in certain details, such as the treatment of the flowers and reeds in the lower left, or in the rather rhythmical treatment of the tree trunks, we find elements related to the *Yamato-e* style. On the other hand, the representations of deities shown as frogs, priests as monkeys, and nobles as rabbits, cavorting about and behaving themselves in a totally informal, even sacriligious way, are certainly based upon observation—with a certain amount of editorializing that is not always favorable. These elements — pragmatic observation followed by the distortion of form in order to comment upon what is observed — are basic elements in the narrative or *E-maki* style. There are many amusing scenes, including one of rabbits diving into the water holding their noses, and another of a fox running about with his tail ablaze. In one part a large frog sits as a Buddha against a banana-leaf halo, receiving the adoration of

400. Half-Wheel Box.
Lacquered wood, length 12³⁄₁₆″.
Late Heian Period.
Horyu-ji, Nara

401. Rabbit Diving, from the Choju Giga. Attributed to Toba Sojo (A.D. 1053-1140). Section of the handscroll, ink on paper, height 12". Late 12th Century A.D. Kozan-ji, Kyoto

402. Monkeys Worshiping a Frog, from the Choju Giga

monkey priests (*fig. 402*). Other rolls illustrate absurd wrestling matches and contests between corpulent and emaciated yokels, while one roll is devoted to vigorous line representations of domesticated animals, notably of two bulls battling head on. The four rolls are certainly not all by the same hand nor of the same date, but are in a style associated with the name of Toba Sojo.

A second type of religious painting, with the seeds of the *E-maki* style, is that associated with representations of the Buddhist Hells. The most famous of these

scrolls, dating from the late twelfth century, and in some respects the most archaic of all the Buddhist Hell scrolls, is the *Gaki Zoshi*, the Scroll of Hungry Ghosts (*fig. 403*). The Buddhist Sutras describing the ghosts say that these are the souls of men and women condemned to Hell, but sent back to earth in shapes invisible to man but visible to themselves. These horrible and monstrous types are condemned to a life of eternal thirst and hunger, and so these ghosts attempt to find food in the graveyards, or water at a holy well where they are unable to touch a drop. The subject matter is

*403. Hungry Devils, from the Gaki Zoshi. Section of the handscroll, ink and color on paper, height 10¾".
Fujiwara Period, late 12th Century A.D. Sogen-ji, Okayama*

nearly always gruesome, frightening the observer and providing an example of how not to live. The style of the paintings is of the greatest interest, because in dealing with this often gruesome and repulsive subject matter, the artist was forced to observe and to translate his observations into painting. The ghosts were based upon observation of poor, unfortunate wretches, while the use of the skeleton required the artist to look at bones or corpses. Everyday scenes of life of a sometimes disgusting nature were natural outlets for Buddhist comments on the "dusty world." At the same time

that there is very close observation of individual figures and their movements and poses, as in the reaching gesture of the ghost at the upper left, the landscape setting is relatively archaic. The little hummocks with their small trees are really not too far advanced from the type of landscape setting which may be seen in the Sutra of Cause and Effect of the Tempyo Period (*see page 166 and colorplate 13*). The observation of nature as a setting providing a space for figures to move about in will occupy the handscroll painters of the Kamakura Period.

14. Japanese Art of the Kamakura Period

ASIDE FROM VERY GENERAL NOTICE, the foundation periods of the Japanese art tradition, Heian (A.D. 794-1185) and Kamakura (1185-1333), are scantily published by Western scholars, and so the student of art often receives a false impression of the original nature and significant achievements of Japanese art. The purpose here is to present a critical synthesis of the products of the Kamakura Period as documents of that culture and in many cases as original contributions to the history of art. While the decorative arts of Tempyo are most beautiful, they are still second-hand documents of T'ang China. On the other hand, the portrait sculptures, narrative scrolls, and landscapes of Kamakura are original statements of a native and universal nature. We shall consider the various arts of Kamakura as manifestations of the Contemplative Life, the Active Life, and the Aesthetic Life, with the understanding that for this period the first represents a fundamentally conservative or regressive style, the second a style most expressive of the period, and the third anticipates the developments of the succeeding Ashikaga Period.

The Contemplative Life. The highest aims of traditional society in the Orient have been contemplative, and the mature Heian Buddhism of the Tendai and Shingon sects was no exception. Its intellectual strength produced an austere, complicated iconography. This austerity, so well seen in sculpture, was displaced in Late Heian by a gentler complexity more suitable to the medium of painting. The greatness of Fujiwara is to be found in its pictures and decorative arts rather than in sculpture. The early Kamakura Period, inheritor of this unchanged Buddhist tradition, maintained it briefly before its inevitable decline (*colorplate 31, p. 319*). The pictorial representations of the principal esoteric subjects and scenes continue in the Heian style with perhaps a sweeter air.

The most striking example of the continuing Heian tradition is the *Raigo (fig. 404; see also fig. 385 and page 300).* This representation of the dying one's vision of Amida Buddha and his attendants come to welcome the departing soul is one of the great achievements of Buddhist painting. The concept is peculiarly real, a

404. Raigo. Gold and color on silk, height 57". Kamakura Period, early 13th Century A.D. Chion-in, Kyoto

vision of heavenly joy in tangible paint. Its reality and its moving sentiment make it particularly suited to the Kamakura Period and it may be said to reach its highest form in the late part of Heian and in early Kamakura. The classic Heian example at Koyasan concentrates more on the concept, portraying the figures themselves with little attention to the setting; but with the rise of Kamakura and the growing interest in the tangible world, an attempt is made to present the vision not only as it appears to the dying one, but also from a spectator's view. This is a less severely religious approach perhaps, but in keeping with the spirit of the age.

The earlier style is also continued in its most typical fragile and decorative materials, mother-of-pearl in lacquer and gilt-bronze. The case of sculpture is rather different, since the images produced in the Late Heian had already declined beyond continuance.

The Taira clan, in one of their last efforts to regain power, had burned Todai-ji, and the rest of Nara, especially Kofuku-ji, suffered as well. The old capital had fallen in neglect and would have been doomed to worse, had it not been for the decision of the new, all-powerful Shogun dictator Yoritomo to provide the funds and energies needed for rebuilding Todai-ji. A group of sculptors was at hand and new sculptures — as well as restoration of old — were in prospect. With their eyes on the relics of Nara they bypassed the intervening periods; the stimulus they received was of the sort that the *dugento* sculptors of Pisa received from the relics of Classical antiquity. We need not imagine this influ-

LEFT: *405. Youthful Shaka. Gilt-bronze. Kamakura Period, 13th Century* A.D. *Kofuku-ji, Nara*

BELOW: *406. Kakogenzai Ingakyo. By Keinin. Section of the handscroll, ink on paper, dated* A.D. *1254, height 11". Kamakura Period.* Nezu Museum, Tokyo

RIGHT:
407. Dainichi Nyorai. By Unkei (active A.D. 1163-1223).
Lacquered wood, dated A.D. 1175, height 39¼".
Late Fujiwara Period, Onjo-ji, Nara

BELOW RIGHT:
408. Great Amida Buddha. Bronze, height 37' 4".
Kamakura Period, A.D. 1253.
Kotoku-in, Kamakura

ence: it can be seen in the two sections of the *Sangatsu-do* — one Nara, the other Kamakura; in a Kamakura gilt-bronze image of the Youthful Shaka, a type popular in Nara but almost unknown in Heian (*fig. 405*); in the Kamakura rebuilding of Saidai-ji, by Eison, on the plan of Shitenno-ji, a temple of the Nara Period; in the Nara log-fitted style of To-ji's and Toshodai-ji's Kamakura *godowns* (storehouses). In painting there are two Kamakura versions of the Tempyo scroll, *Kako-genzai Ingakyo*, one close to Nara style, the other in a free Kamakura version dating from 1254 (*fig. 406*).

The sculptors' main accomplishments we will see presently, but now we can observe that, if only for a brief time, images such as that of Dainichi Nyorai, Amida, and Miroku, were imbued with a new and vigorous spirit within the traditional Fujiwara shapes (*fig. 407*). The sculptor Unkei leads the revival and other names—Kaikei, Jokei—are associated with these images, all products of the earlier quarter of the period. We can witness the later decline of real enthusiasm in the Amida of Horyu-ji, a Kamakura (1232) version of an Asuka bronze, as well as in the famous Great Buddha of Kamakura city (*fig. 408*), a paler recollection of its Nara predecessor.

While we witness the maintenance and decline of earlier tradition in the principal images and icons, we are confronted with a totally different picture with regard to the secondary images. Just as in early Renaissance Italy, where the most startling innovations seemed to be found in minor sections of the large altarpieces, so the guardians, attendants, and grotesques of Japanese Buddhism attracted the most creative instincts of the artists. The two figures of the priests Seshin and Muchaku, attributed to Unkei, and dating from the earliest part of the Kamakura Period, are unique sculptures (*figs. 409 and 410*). Larger than life and with a powerful realism hitherto unknown, they command instant respect. These figures are of laminated wood, a construction that became common in the Fujiwara Period and which was developed to a very complicated degree in the Kamakura Period. This allowed large statues to be made in wood without splitting or checking. Covered with polychromy, they convey an intense realism in the character of the drapery, but especially in the treatment of the head. Note the use of quartz inlay

315

409. *Seshin, in the Hokuen-do. By Unkei*
(active A.D. 1163-1223). Colored wood, height about 74".
Kamakura Period, c. A.D. 1208. Kofuku-ji, Nara

410. *Muchaku, in the Hokuen-do. By Unkei*
(active A.D. 1163-1223). Colored wood, height about 74".
Kamakura Period, c. A.D. 1208. Kofuku-ji, Nara

for the eyes, a characteristic technique of the Kamakura Period, and an index to the growing interest in realism. At first we may think they have no predecessors, but if we remember the general influence of the Nara Period, and then, since they were also made for the same temple, Kofuku-ji, we may confirm the fact that earlier dry-lacquer figures of the Twelve Disciples, in the same temple, were their prototypes. Where the Nara dry-lacquer figures of the Twelve Disciples are uncertain in their bodily forms, however intense in expression, Unkei's masterpieces have a massive monumentality that emanates from the firm handling of the drapery as well as from the broad characterization of the face. While maintaining the structural character of a tree trunk, these Kamakura figures possess an ease of

pose suggested by daring and deep cutting of the mantle folds.

The intense realism of the early Kamakura works can also be found in the wooden guardians, the *kongo-rikishi,* of the same temple, where the volatile nature of the subject allows greater freedom of motion and an opportunity for characterization bordering on the grotesque (*fig. 411*). We should note that these figures partake of the renaissance of Nara Period style in that they are still not twisted or undercut to a great extent. Broad, contained surfaces, however intense, are still very much in evidence (*fig. 412*). The figures have a beautifully preserved layer of polychromy: the flesh is a cream color, the drapery is heavily painted with decorative textile patterns transferred into terms of paint, and the

eyes have the typical Kamakura quartz inlay. The second figure shows an even more vigorous pose and threatening expression in the face. Rather typical is the exaggeration of muscular structure, of tendons and veins, but not in a particularly realistic way, in Western terms. Anatomically speaking, the figure is quite possible, but with that element of caricature characteristic of Japanese art in this period.

With the *Twelve Generals of Yakushi* at Muro-ji, the great Jogan site, we see the next developments at their highest expression (*fig. 413*). Though small in size, the effect as an ensemble and individually is completely new and without a close precedent. In the sculpture of Nara and Heian, the breakup of planes, volumes, and movements is on the surface of the figure. In the developed Kamakura style, whether it is a guardian in violent agitation or a priest in silent contemplation, the volume is penetrated by space. The trunk of the tree is no longer sacrosanct and the sculpture is built up with many laminations and blocks, allowing the sculptor greater freedom as well as protecting the wood

from checking. The woods are then pierced and twisted; they remarkably express the violent emotions and tendencies of a short-lived society which was not content to hide, but with frank exuberance laid itself open to scrutiny from without. These relatively realistic sculptures are truly dramatic. The juxtaposition of the Kamakura figures against the background figures of the Jogan Period is particularly revealing. Though only dimly seen, one senses the stolid and massive quality of these earlier figures in the background, while the photographer's light picks out the volatile swirl of drapery and exaggerated facial expression in the figures of the Generals.

The most extraordinary examples of undercutting and of the dramatic style of sculpture in the Kamakura Period are the two large guardian figures, by Unkei, each housed in one side of the Great South Gate outside the great temple of Todai-ji in Nara (*fig. 414*). The figures are almost thirty feet high, and are made of many sections of wood, undercut, and particularly emphasizing that exaggeration of muscle and tendon which

411. Kongorikishi. By Jokei. Colored wood, height 64".
Kamakura Period, c. A.D. 1288. Kofuku-ji, Nara

412. Kongorikishi.
Back view of figure 411

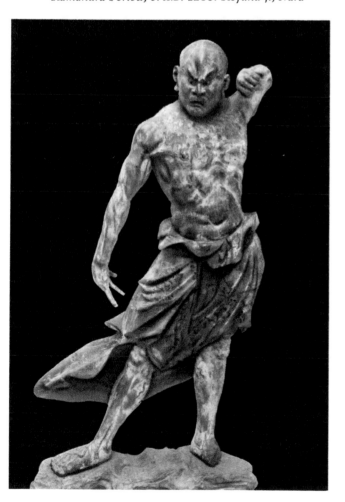

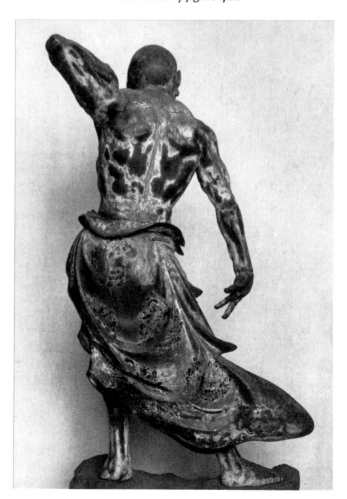

317

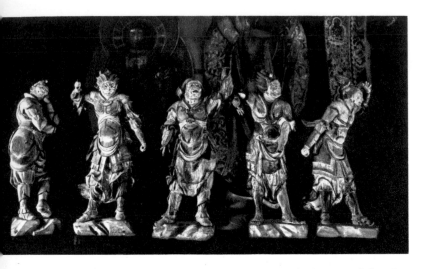

413. *Five of the Twelve Generals of Yakushi. Wood, height about 48". Kamakura Period, 13th Century A.D. Muro-ji, Nara*

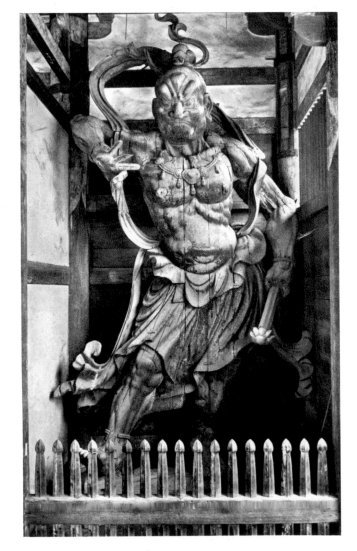

414. *Kongorikishi, at the South Gate. By Unkei (active A.D. 1163-1223). Wood, height 26' 6". Kamakura Period, A.D. 1203. Todai-ji, Nara*

we have seen to be the means by which the Kamakura sculptor expressed a great vigor and strength. The temple of Kofuku shows us another outstanding example of this sculptural style in a type peculiarly sympathetic to the artists of the period, the grotesque (fig. 415). Dated 1215, these weird lamp bearers support their burden with a vehemence that borders on the comic.

The grotesque is to be found in painting as well, both in subject and in treatment. The Six Worlds of Buddhism are a traditional subject, but not until the end of the Heian and the beginning of the Kamakura did they become subject for representation. The *Jigoku Zoshi* scroll representing the World of Hell combines the grotesque with an observant and illustrative style that we shall see again (fig. 416). No better description of the artist's narrative achievement can be given than that in the inscription on the scroll before this particular scene.

"Within the Tetsueisen there is a place called the Shrieking Sound Hell. The inmates of this place are those who in the past accepted Buddhism and became monks. But failing to conduct themselves properly and having no kindness in their hearts, they beat and tortured beasts. Many monks for such cause arrive at the Western Gate of Hell where the horse-headed demons with iron rods in their hands bash the heads of the monks, whereupon the monks flee shrieking through the gate into Hell. There inside is a great fire raging fiercely, creating smoke and flames, and thus the bodies of the sinners become raw from burns and their agony is unbearable."

In drawing the figures of these monks, the artist has deliberately used a rather short series of strokes, producing figures that are rather pathetic in their naked plight. On the other hand, the strokes that are used to show the horse-headed demons are rich, full, and "round nail-headed" types, producing powerful figures, almost like batters on a great baseball team, wielding iron rods with obvious pleasure and vigor. The representation of fire we will discuss again, but note that here it is perhaps as effective as any painted representation in Far Eastern or any other art. The sense of mutation must have been strong in the ethos of the time. No greater encouragement to these gloomy thoughts can be imagined than the internecine warfare between the various monasteries and the intolerable conditions in the capital that provided the Minamoto clansmen with their up-country support in their thrust to feudal power.

The representations of principal deities in their terrible aspects are allied to the grotesque. While beatific representations often have only a watered-down sweetness with little of the gently lyric qualities of earlier periods, the terrible deities descend from the abstract hints of Heian to the very real threats of Ka-

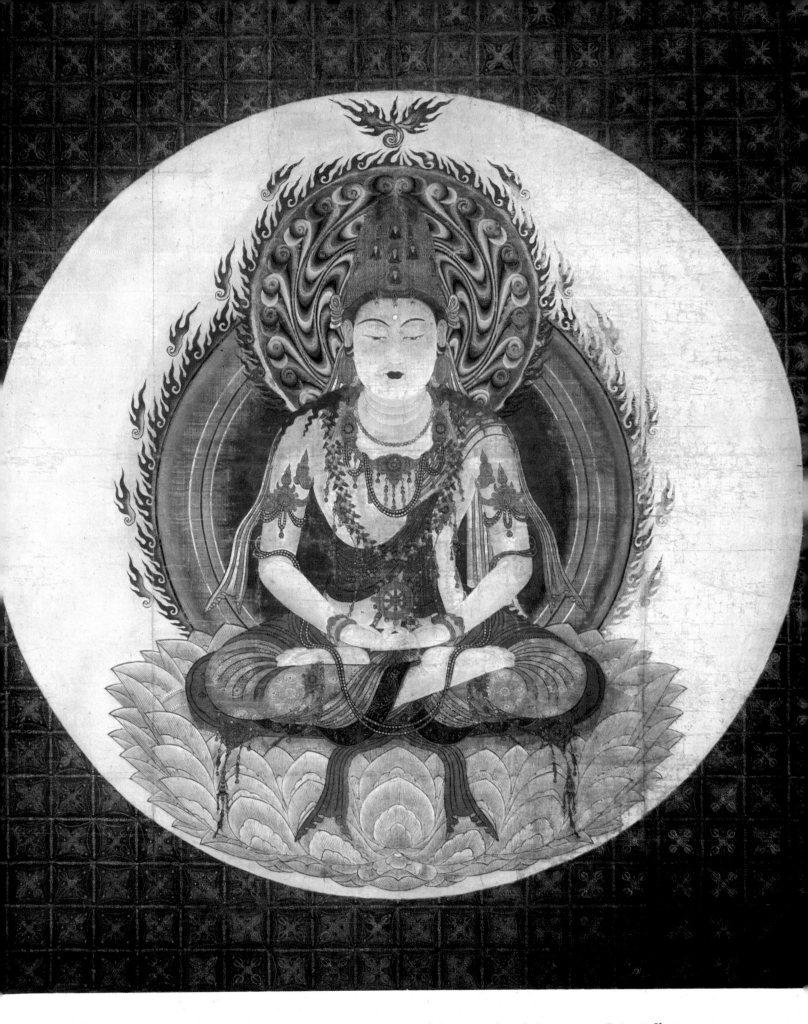

Colorplate 31. Dainichi Nyorai. Color on silk, height 37". Kamakura Period, 13th Century A.D. *Daigo-ji, Kyoto*

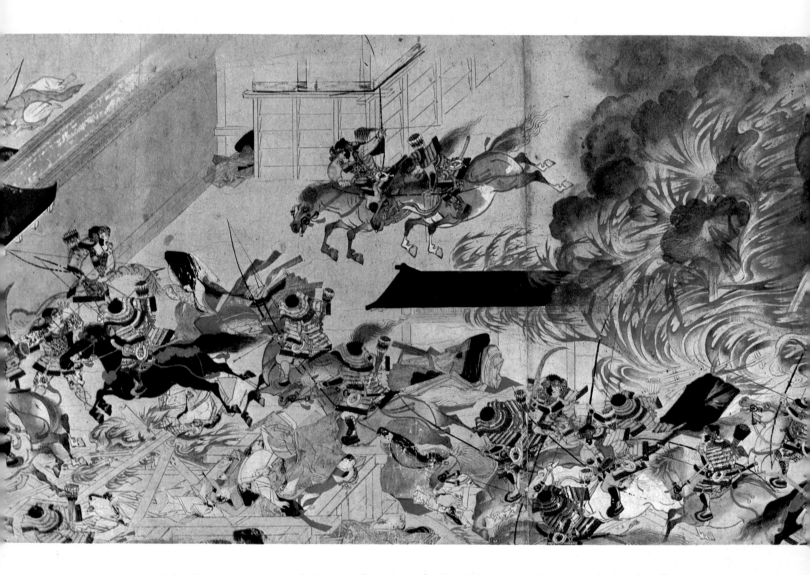

Colorplate 32. Burning of the Sanjo Palace, from the Heiji Monogatari. Section of the handscroll, ink and color on paper, height 16¾". Kamakura Period. Museum of Fine Arts, Boston

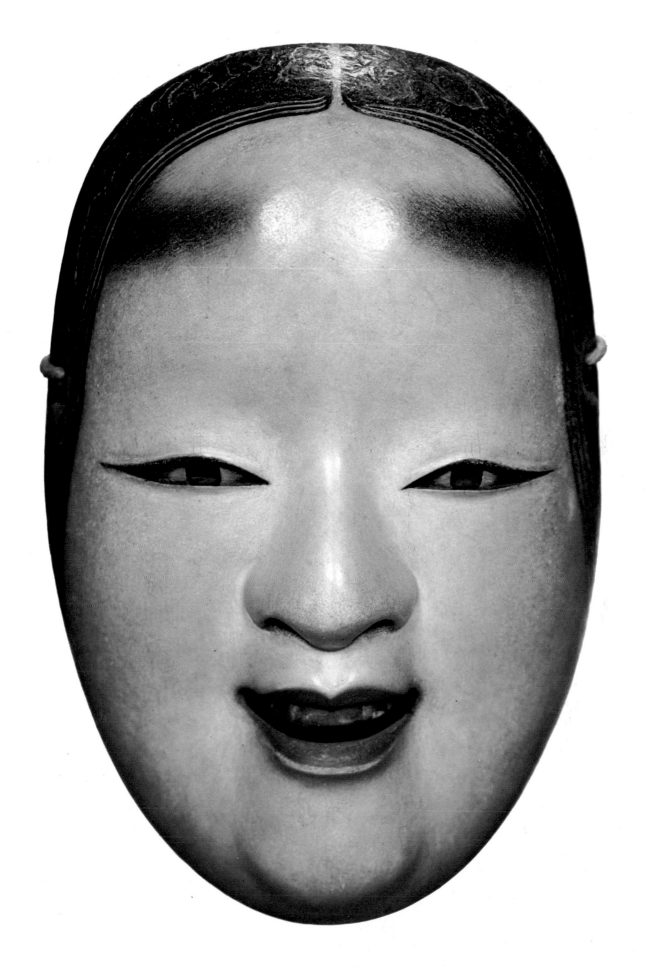

321

Colorplate 33. Noh Mask, Ko-omote. Painted wood, height about 10″. Ashikaga Period,
15th Century A.D. *Kongo Family Collection, Tokyo*

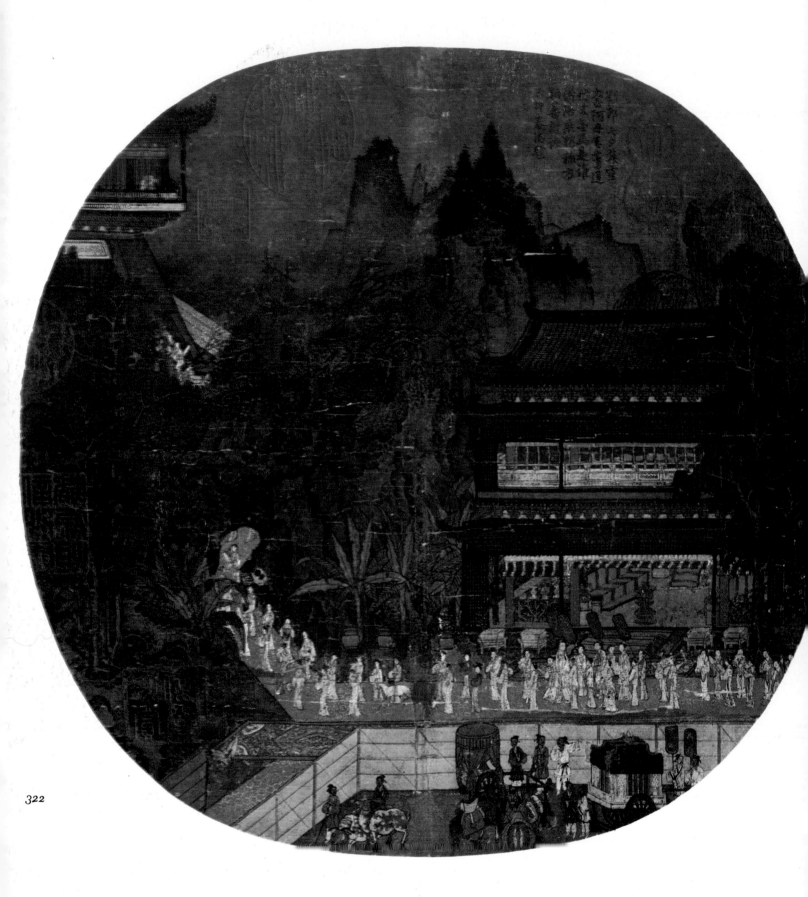

322

Colorplate 34. An Imperial Palace of the Han Period. Style of Chao Po-chu. Album leaf, ink and color on silk, diameter 9⅝". Sung Dynasty. National Palace Museum, Formosa

ABOVE: *415. Lamp Bearer. By Koben.*
One of two lamp bearers, colored wood, height 30⅝".
Kamakura Period, A.D. *1215. Kofuku-ji, Nara*

ABOVE RIGHT: *416. Hell Scene, from the Jigoku Zoshi.*
Handscroll, ink and color on paper, height 10¾".
Kamakura Period, c. A.D. *1200. Seattle Art Museum*

BELOW RIGHT: *417. Bato Kwannon. Wood, dated* A.D. *1241.*
Kamakura Period. Joruru-ji, Nara

makura. The *Bato Kwannon (Horse-Headed Kwannon)*, dated 1241, reveals the extraordinary power of the new sculptural style (*fig. 417*). But this new-found power is not to be attributed to the sculptural medium alone; it can be seen in the Fudo attributed to Shinkai and painted in 1282 (*fig. 418*). The extent to which this latter figure has become real can be gauged by the head, where reality borders on the merely humanly terrible rather than the true *terribilità* of the *Horse-Headed Kwannon* of 1241. Note, too, that the representation of the immovable rock on which Fudo stands is rather more realistic than that often found in earlier periods, as is the representation of the waves beating on the rock. This particular painting by Shinkai is a sketch, painted only in ink on white paper, and was undoubtedly either a preliminary study for a painting to be

323

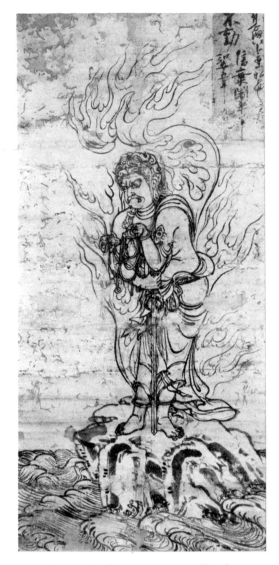

done in color or a copy-book model executed for members of the workshop.

The structural and practical world of architecture illustrates our thought with some difficulty. But perhaps the vigorous and grotesque can be equated with the Tenjikuyo (Indian) style of architecture best seen in the South Gate of Todai-ji, built in 1199 (*fig. 419*). While called Indian, its origins are to be found, as Soper shows, in the provincial style of Fukien, a southeast seacoast province of China. The gate structure is logical but simple, almost heavy rather than lucid, with a brute strength that overpowers memories of the refined Heian architectural style and which finds no later repetition. Like that of the great period of Kamakura sculpture, the life of Tenjikuyo is as short as its energies are long. The decline of the Hojo Regency after the Mongol defeat of 1281 ended in a culture that stressed near-perfection on a small and derivative scale but which never achieved the powerful victories of the earlier men: the sculptured demons, the painted grotesque, and the defeat of Kublai Khan. The decline in religious art begins quickly after 1250 and continues steadily. Human realism, dramatic style, and a false echo of Late Heian sweetness combine to produce a continuing series of images that range from the lovely, as in the Seishi with its almost feminine quality of elegance (*fig. 421*), to the vulgar, in the Jizo figure in the Hara collection, where one is unpleasantly aware of the fact that the figure might walk off the pedestal and

418. Fudo. By Shinkai. Hanging scroll, ink on paper, height 46". A.D. 1282. Daigo-ji, Kyoto

419. South Gate of Todai-ji, Nara. Dated A.D. 1199

420. Fudo Myo-o. Wood. height 34". Late Kamakura Period. Todai-ji, Nara

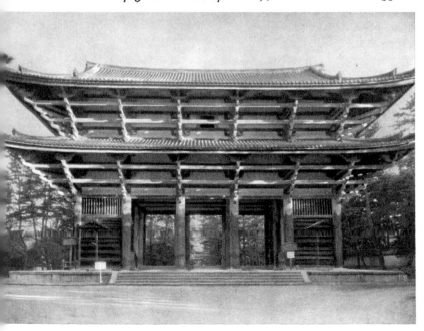

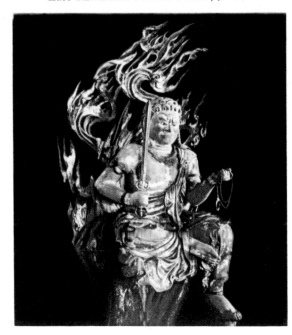

324

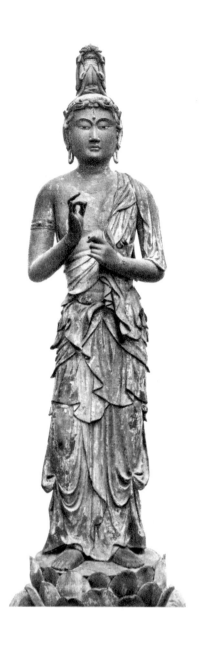

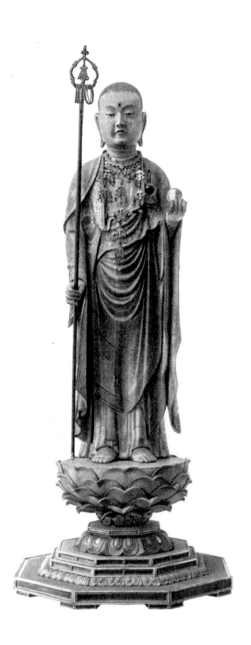

LEFT:
421. Seishi. Wood. Kamakura Period.
Tokyo National Museum

RIGHT:
422. Jizo Bosatsu. By Hokyo Kosei. Wood,
with cut gold and color. Late Kamakura
Period. Hara Collection, Yokohama

BELOW:
423. Hell Scene, from the Kasuga Gongen.
By Takashina Takakane. Handscroll,
color on silk, height 16⅟₁₆".
Late Kamakura Period, A.D. *1309.*
Imperial Household Collection, Tokyo

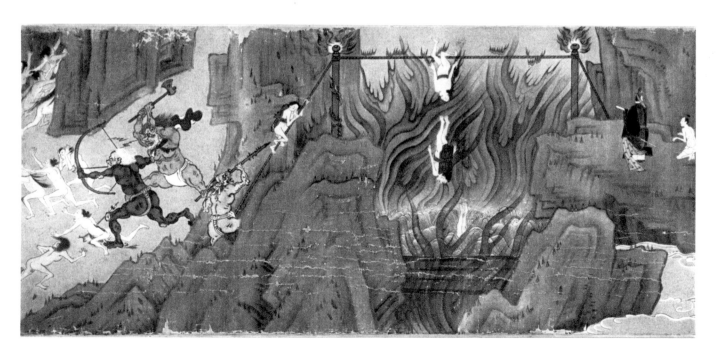

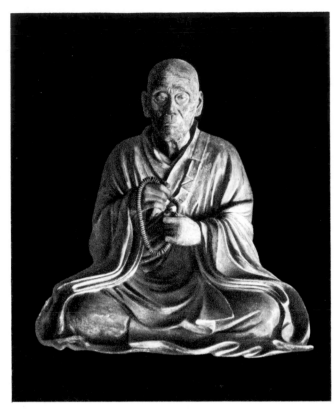

424. Priest Jugen, in the Shunjo-do. Wood, height 32¼".
Kamakura Period. Todai-ji, Nara

become merely human (*fig. 422*). Even the terrible fails. The Fudo of Todai-ji, while made technically and aesthetically interesting by the dexterity of its maker, has none of the reality or vigorous dramatic qualities of its predecessors (*fig. 420*). The forms are puffy, the facial furrows are part of a stylized grimace. The driving energy of the *Horse-Headed Kwannon* here is spent.

In painting, using as an example the *Kasuga Gongen* scroll, dated 1309, we see that stylization rules (*fig. 423*). The flames of Hell are patterned but give forth no heat; and the demons are a shell of calligraphic but often meaningless lines and shapes. Soon even interest in the subject of the Six Worlds recedes. It appears safe to say that the great Japanese tradition of Buddhist art, founded in Early Heian, is dead by the end of Kamakura in 1333, except for the later products of Zen Buddhism which were really not iconic in character.

The Active Life. The guardians and the *Bato Kwannon* have already introduced us to one facet of the active life as it influenced the world of icons. The ideal of the outlanders, who now wielded the power of the state, was the military man, the more active the better. Reaction against the elegant contemplatives — let us say aesthetes — of Kyoto led to the removal of the *de facto* capital from Kyoto to Kamakura. The Kyoto

425. Uyesugi Shigefusa. Wood,
height 26¹³⁄₁₆". Kamakura Period.
Meigetsu-in, Kamakura

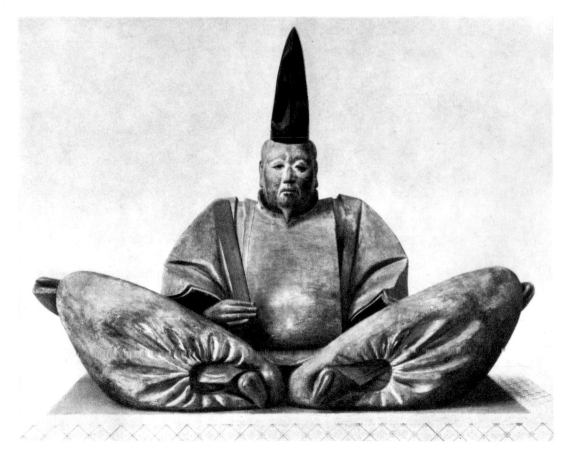

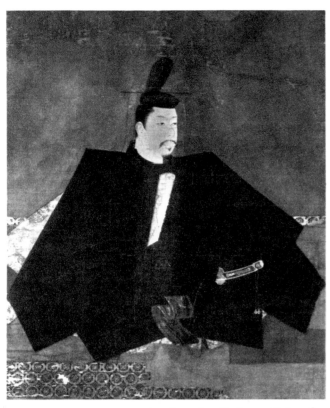

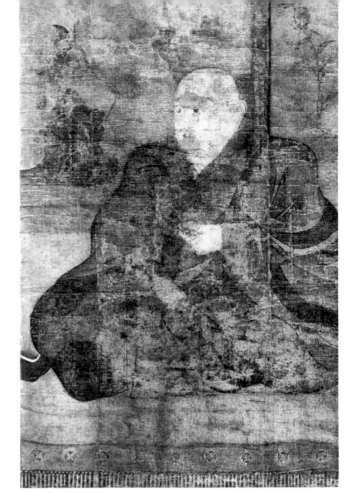

426. *Portrait of Yoritomo. Attributed to Fujiwara Takanobu (A.D. 1142-1205). Hanging scroll, color on silk, height 54¾". Kamakura Period. Jingo-ji, Kyoto*

427. *Retired Emperor Goshirakawa. Hanging scroll, color on silk, height 52". Kamakura Period, c. A.D. 1200. Myoho-in, Kyoto*

aristocracy might term the new period crass, vulgar, and brutal, but its vigor and determination before its decline into sentimentality produced a convincing and forceful self-portrait in the short time of fifty years. The parallel with the early Renaissance in Italy is striking — but should not be pushed too far — and the results were the same in at least three fields: a fine development of portraiture, narrative art, and military art. In a sense, portraiture was a revival of Nara precedents. There exist some lacquer and clay figures of seated priests at Toshodai-ji and Horyu-ji that may well have provided models for the Kamakura sculptures. Still, they seem more generalized alongside the vibrant realization of individual character to be found in Kamakura. We have already seen the head of Muchaku (*see pages 315 f. and fig. 410*), as an example of invigoration in secondary images, and it provides a starting point for a series of priest and warrior portraits, beginning with the truly remarkable portrait of Priest Jugen at Todai-ji, an old man holding his prayer beads with an intense concentration of effort, not in conflict with but supported by the frail and intense character of the body (*fig. 424*). The later portrait of the nobleman, Uyesugi Shigefusa, is kept in a temple in Kamakura (*fig. 425*). The eighth- and thirteenth-century portraits share a general frontality of pose and a characteristic

dramatic treatment of the drapery. But where once the effects were generalized, here we have remarkably individual characterizations. Each portrait remains in the mind as an individual as well as a type. This is no mere surface likeness, a matter of skillful techniques, but a searching gaze through the facial structure to the character within. A sculptural development can be seen from the taut and incisive forms of the earlier Priest Jugen to the softer and more self-conscious surfaces of the Shigefusa. Perhaps this latter character can be attributed partly to the influence of Zen Buddhism, to be discussed shortly.

While there were relatively few Heian precedents for real portraiture in sculpture, in painting the ideal portraits of the Seven Patriarchs of the Shingon Sect, as well as the representations of Shotoku Taishi, the historic founder of Buddhism of Japan, and others, provide a starting point for the surging interest of Kamakura painters in characterization. The famous portrait of Yoritomo, the "Great Barbarian-Subduing General" who founded the Kamakura power, contains much of Late Heian stylization in the draperies (*fig. 426*). Despite the stiffness and flatness of the clothing characteristic of the actual formal costume of the day, the daring outline is striking testimony of a new boldness. The head, defined by a wirelike line of infinite strength,

428. The Flying Storehouse, from the Shigisan Engi. Section from the handscroll, slight color and ink on paper, height 12½". Late 12th Century. Chogosonshi-ji, Nara

is in the temper of the times: serious and direct, practical in its attitude, ruthless in its application. In the same spirit Yoritomo and his immediate successors succeeded in consolidating their power at Kamakura. Even more typical and complete as an example of painted portraiture is the hanging scroll of the retired emperor Goshirakawa, from the Myoho-in, Kyoto (fig. 427). The body exists in bulk rather than flatness and the figure fills the field of view, even expanding beyond the boundaries. On the screens behind can be seen delicate paintings of birds and flowers which serve to magnify the dominance of the powerful figure.

The second aspect of the Active Life is to be found in a narrative art with a corollary interest in everyday life. Where the Tempyo Period has fortunately left us the utilitarian objects preserved in the Shosho-in from 753 onward, objects which document that age, the Kamakura Period has shown us a vivid and unforgettable picture of its appearance and culture in pictorial form. The *makimono*, or handscroll, was not originated in Japan but in China. The earliest known narrative scroll of Japanese origin, the *Kakogenzai Ingakyo*, illustrating the life of the Buddha, was painted in the Tempyo Period, which we have seen to be a period of overwhelming Chinese influence. But while the Chinese developed the landscape handscroll to great heights, the Japanese largely ignored landscape and developed the narrative-figural scroll to a level hardly reached by surviving Chinese examples. The technique should be obvious to people reared on comic strips, but only the

Japanese have realized the enormous possibilities of the method.

Imagine a long scroll more than forty feet long, unrolling from right to left and filled with the accouterments of narrative: hundreds of men, women, and children, animals, demons, storms, quiet landscapes, great fires — all the elements of divine and human drama. The story unfolds in space and time. The characters enter on stage from the left and pursue their quiet or turbulent ways. Rest spaces are provided by tranquil landscapes or open spaces of paper, while stiffening and setting for the story are provided by architecture depicted in conceptual fashion, rising sharply across the paper, limiting and defining the stage on which the characters move. The very method is exciting, but never before or since the Kamakura Period has the method been imbued with such enormous vigor and technical dexterity. Where the Fujiwara scrolls in the aesthetic court style are executed with underpainting and careful but stiff spacing, the scrolls that come at the beginning of Kamakura are executed with robust haste. The brush is used directly and the line is marvelously varied, bending to the grace of reeds or knotting to the bulging muscles of a demon. The essentials are put into line and shape. The color, largely incidental, is washed on surely but freely.

With such a supple tool, one needs narrative material, and the awakened interest of the artist found it in abundance. Each temple or shrine had its legend, which now could be put in vivid and readily under-

standable form. The miraculous virtues depicted in the *Shigisan Engi* (Golden Bowl of Shigisan), seen here in a detail from the first roll, tell the story of a priest with a miraculous golden bowl (*fig. 428*). In this particular episode, the bowl has gone off to the home of a rich but proud and greedy household, where it lifts into the air a storehouse with its bales of rice, and carts it off over hills and valleys to the residence of the priest who lived in solitude in the mountains of Wakayama. Fat ladies, well-fed members of the rich man's household, dash out through the gateway as they see their means of sustenance disappearing through the air. In the center, the owner or, rather, the former owner, of the warehouse is hastily getting on his horse to make pursuit, while at the left, household hangers-on gesticulate wildly with surprised or unbelieving facial expressions caused by the fantastic occurrence. A priest, another member of the rich household, is trying, by rubbing his prayer beads, to bring the warehouse back to its owner, but the miraculous virtues of the golden bowl triumph and the warehouse flies on to the priest's house, and ultimately is used as a means of bargaining with the rich man.

The historical feuds of the noble families were freely used, and these produced one of the greatest of the scrolls, *Ban Dainagon Ekotoba*, the story of how a children's quarrel revealed a conspiracy that led to the burning of the palace gate and brought retribution on a rival clan. The scene chosen from the second roll shows two children engaged in a typical village quarrel (*fig. 429*). At the left, an overly protective father runs out to separate the two boys, while at the lower

429. *Ban Dainagon Ekotoba. Section from the handscroll, ink and color on paper, height 12¼". Japanese, Late 12th Century.* Tokyo National Museum

430. *Figures from the Ban Dainagon Ekotoba*

RIGHT:
431. Yamai-no-Zoshi. Section from the handscroll, ink and color on paper, height 10". Japanese, Late 12th Century. H. Okura Collection, Tokyo

BELOW:
432. Caricatures, from the ceiling of Horyu-ji, Nara. 8th Century A.D.

part the father gives the other boy a kick with his foot which sends him flying, at the same time that he holds on to the miserable but triumphant urchin that is his son. At the right spectators cynically observe the disturbance. The story goes on to show how this particular quarrel brought the rumors of arson to the attention of a member of the rival party. One should note especially, in this particular detail, the drawing of the figures in a realistic style based upon observation. The movements of the father as he comes running out of the house and of the boy sent flying, or the expressions on the faces of the bystanders all show a close observation of nature. At the same time, they are not sympathetic; the artist looks upon these things coldly, objectively or, in some cases, with a satiric eye. There is little sympathy to be seen in Kamakura realism in particular, or in Japanese art in general.

The *Ban Dainagon* and the *Heiji Monogatari* (color-

plate 32, p. 320) contain two of the world's great depictions of fire and in their enormous crowd compositions show a mastery of grouping and disposition worthy of the term genius. The detail from the *Ban Dainagon* displays an arrangement of figures by means of semicircular grouping, by thrusts of numbers of figures, by turning people in various poses, achieving a very complex arrangement (*fig. 430*). This mastery of fire and crowds is a good indication of the principal origins of this style in observation of everyday life. No one who has seen a large-scale fire in Japan can doubt the accuracy of the artist's comment. The earlier contemplative discipline involved in drawing the fire halos of Fudo and other esoteric Buddhist figures contributed means to the painter's end.

Everything is grist for the scroll-painters' mill: servants bantering, all types of wild and domestic animals, storms at sea, details of human birth, growth, disease, and death; all these and more are in the scrolls. Thus in the *Yamai-no-Zoshi* (*Scroll of Diseases*), we see a woman afflicted with obesity attended by two other females, but observed by the village loafers who laugh with great glee at the unpleasant spectacle (*fig. 431*). Again, one is aware of a lack of sympathetic representation. While the patrons commissioning the scrolls specified appropriately lofty subject matter, the age was not content with only the pious life of a great saint or the story of a great battle. The meat of human life was added to the bones and so we are presented with a complete picture of the high and low in Kamakura culture. As a corollary of this narrative concern is the interest in what amounts to caricature — facial types distorted through joy, pain, emotion, or disease are humorously or cruelly handled, as in the *Scroll of Diseases*. These are the observations of a more pragmatic and cruder mind than that of the preceding age.

Still, a low tradition can be traced here and there in earlier times in the scribblings or sketches found on statue bases and more recently in the remarkable caricatures and obscenities discovered on the ceiling boards of Horyu-ji near Nara and probably dating from the early eighth century (fig. 432). These were probably executed by artists who painted the representations of Buddhist deities on the walls of the *kondo*, especially the famous and much admired representation of the Western Paradise (fig. 199). This interest in facial types, narration, and caricature had always existed in these nooks and crannies. It remained for artists of the Kamakura era to display them fully in such accepted art forms as the narrative scroll. This observation of everyday life extended to landscape and the native scene, which we shall discuss presently.

The last aspect of the Active Life, its most stirring, was in the field of military art. We can only allude to its importance and its nature. The foundations of the Kamakura Period were laid in military strength. Minamoto Yoritomo conquered the Taira by war, and the feudal outlanders that were the strength of the new supreme general were primarily military men, in contrast to the courtiers of Kyoto. The brutal interests of the period were frank and unabashed. The aesthetic life expressed in the tea ceremony and its allied cults had not yet been developed as a peaceful discipline and refuge from violence. The great developments in armor and sword-making are those of the twelfth and early thirteenth centuries, and it is claimed that no sword of any age or country can excell the Japanese sword of Kamakura (fig. 433). Keen of edge, strong in substance, severely and terribly beautiful in form, it was the image of deity to those who wielded it. This is no mere fiction, for the sword-maker was truly a priest, and performed rites of purification and consecration for the making of a blade. While Heian examples are few in number, Kamakura swords exist in considerable quantity. This quantity alone is evidence of the rise of feudalism and of provincial pride, for the variety in Kamakura sword styles enables Homma to identify sixteen province groups and, in the case of Kyoto, Bizen, and Yamashiro, to divide the local styles still further, into schools. Armor, too, received a degree of attention equal to that of the feudal warrior of late Gothic Europe. In the first part of the period, the earlier style of the Late Heian Period was maintained on a heavier and grander scale: the antlers or horns increased in size and dominated the headdress (fig. 434). Kamakura grand armor is especially rich in its decoration: gilt-bronze, patterned leather, and figured textile. With the enlargement of the art of war, especially under the continued stress of the Mongol threat, from 1234 to 1282, the foot soldier rose to a more important tactical position, and as a consequence ordinary armor became lighter and the horseman was

433. *Sword Blade. Signed: Yamato-no-Kuni Hosho Goro Sadamune (active* A.D. *1318-1335). Kamakura Period.* Metropolitan Museum of Art, New York

434. *Grand Armor. Kamakura Period.* Tokyo National Museum

331

435. Mongol Invasion. Section of a handscroll,
ink and color on paper, height 15½".
Kamakura Period, late 13th Century A.D.
Imperial Household Collection, Tokyo

436. Running Fudo. Hanging scroll, color on silk,
height 50". Kamakura Period, c. A.D. 1280.
Inoue Collection, Odawara

reduced in importance. The direct influence of the lightly armored Mongol soldier may be assumed. A similar development occurred in Europe when the heavily armored horsemen were superseded by the lightly armored men-at-arms.

The influence of the military on other arts was enormous. Tales of war and battles make up a large part of scroll painting, the *Heiji Monogatari* being the most often-reproduced example. The most interesting military example, however, is the scroll of the Mongol invasion in the Imperial collection (*fig. 435*). While illustrating one officer's claims for reward, it records in some detail the deeds of the defending army in the invasion battle and graphically illustrates the disposition and appearance of both Japanese and Mongol troops. One scene in particular, of Mongol foot bowmen dismounting a Japanese warrior, illustrates the military lesson which led to lighter armor. Military and athletic tastes extended to an interest in the strength and movement of horses, so well and cursively set down as to defy the competition of earlier or later Japanese artists. Military and courtly hierarchy also employed the painter for recording, in semidiagrammatic fashion, the order of seating on the occasion of state ceremonies.

But the most unique and significant example of the far-reaching influence of the military aspect of the Active Life is to be found in the well-known *Running Fudo* in the Inoue collection (*fig. 436*). Now, Fudo has from his earliest representations been recorded as the Immovable, a terrible manifestation of Mahavairocana in esoteric Buddhism, a scourge of the sinful. While his energy is enormous, he is usually depicted seated or standing as eternal and immovable. But in this picture,

attributed to the time of the Mongol invasion, he is shown running, his sword held behind and high, a veritable epitome of attack. It can be found that this interpretation is essentially sound from the tradition that the image was used by Emperor Kameyama in prayer for deliverance from the Mongol armies. No more striking example of the joint operation of the contemplative and active principles can be presented, and this union in this picture occurred in Kamakura's greatest hour.

The Aesthetic Life. After the defeat of the threat to the nation, the culture failed to regain its strength and its subsequent history is one of progressive decay in re-

ligious art, of decline in narrative effectiveness, and of an increasing tide of aestheticism. We have seen that the secularization of style under the new Kamakura motivation led to the decline of the traditional religious forms and to the rise of a short-lived but powerful, active, and realistic art. The way was then prepared for a new aestheticism, which in effect rushed into the growing vacuum left by the decline of these two former styles. The aesthetic mode most common in late Kamakura took the form of a restatement of the court style of the Fujiwara Period, a style, which though moribund, had never died in Kyoto. But the fourteenth century also witnessed the stirring of a second and more significant aesthetic mode rooted in the rapidly rising sect of Zen Buddhism and in the ever-present Japanese love for the irregular and intuitive aspects of nature. The continuation of the court style often produced patterns which were bold and striking, even in so delicate a medium as inlaid lacquer, and usually derived from literary sources. The aestheticism of the Fujiwara court, best exemplified in delicate calligraphy and poetry, was viewed with growing interest from the mid-Kamakura Period on.

The Thirty-Six Poets were a favorite topic for pictorial art and were treated in a relatively traditional manner, with great attention to the draperies and their fascinating pattern of angles (fig. 437). But the most significant examples of the new decorative tendencies are to be found in the narrative scrolls. Patterns of shape, space, and color became the major interest of the day and figures were frozen to immobility. Flat shapes and their placement ruled the paper. Facial types were stereotyped; colors emphatically bright. The foundations of the decorative style of screen painting culminating in the works of the Momoyama and Early Edo periods were laid here in the declining years of Kamakura. Even where color is not used, at the very end of Kamakura in a series of paintings of Fujiwara style we see the dominance of a patterning concept. The modern abstractionists are not far removed from this world of almost pure form. Even in architecture, pattern is triumphant. The Main Hall (hondo) of Kanshin-ji, dating 1334-35, at the end of Kamakura, best exemplifies that multiplication of interpillar bracketing which in later periods often made a functional jungle of the simple and monumental temple architecture of Japan (fig. 438).

Folk art is an excellent index to the aesthetic stage of a culture. A folk art, in a sense distinct from so-called fine art, can only exist when that fine art has been removed from a common tradition to a more sophisticated plane. In every case, it will be found that folk art is a submerged continuation of powerful early tradition, primarily religious in nature, while the contemporary sophisticated art of the higher social levels will be found to be more advanced, secular, aesthetic, and

refined. Thus the most interesting religious images of the post-Kamakura times are not the synthetic sentimentalisms of professional sculptors, but the coarse, common, and crude products of the faithful, believing village craftsmen. The true preservers of the narrative scroll style are the provincial artists of Ashikaga and later, the plebeian *Ukiyo-e* artists and Japanese printmakers of Tokyo, and the folk painters of Otsu (fig. 439). But these manifestations are outside the later recognized artistic traditions. The future development of the purely Japanese style was channeled into the decorative mode and it is this style, devoid of the daring of Sotatsu, or the control of Korin, that now confines and enervates the modern Japanese academy.

437. Portrait of Saigu Nyogo Yoshiko (poetess from one of a set of Thirty-Six Poets). Attributed to Fujiwara Nobuzane (A.D. 1176-1268). *Color on paper, height 14⅜". Kamakura Period.* Freer Gallery of Art, Washington, D.C.

438. Hondo, Kanshin-ji, Osaka. Kamakura Period, 14th Century A.D.

333

aesthetic masks of the later *noh* drama is apparent (*colorplate 33, p. 321*). Domestic architecture, too, was transformed, and the domestic style of Fujiwara, modified by moderate Chinese influence, was accepted. The forms of brackets and pillars were simplified and lightened with the resultant effect of delicacy and refinement.

It would require a separate discussion to attempt an understanding of the critical influence of Sung Dynasty China and Ch'an or Zen Buddhism at this point in late Kamakura. The developments of which we have spoken in architecture and *noh* drama are primarily products of Zen influence. The sect was based on a foundation of pure intuition and extreme simplicity. In Japan, after the Kamakura Period, this foundation was modified in spirit, for the intuition was elaborated into extremely sophisticated and subtle forms, while the simplicity was formalized and "aestheticized" into an often superb ritual. But later, the complicated means to achieve simplicity more often attained greater importance than simplicity itself; thus the *noh* drama and thus also the tea ceremony, which developed from using tea as an aid to contemplation and brotherhood, became abstract, aesthetic art forms of great complexity. The humble

439. *Otsu-e (A Courtesan). Hanging scroll, ink on paper. Japanese, 18th Century* A.D. *Folk Art Museum, Tokyo*

440. *Bugaku Mask. Painted wood, height about 12" Kamakura Period. Kasuga Jinja, Nara*

The initial rise of the aesthetic life in late Kamakura painting was expressed by decorative tendencies. This formalization extended into other fields with varied effects. Drama and the masks used for its various forms were strongly influenced by the new interests. At the end of Heian, *bugaku*, a form of musical dance-drama derived from T'ang China, was the standard form and was associated with Buddhist ritual (*fig. 440*). Gradually *bugaku* itself began to split. The ritualistic form became especially associated with the Kyoto aristocracy, and with the unfolding of the Kamakura Period, like religious art in general, it declined. *Gigaku* and *bungaku,* popular performances, developed in the folk tradition from the *bugaku*. When *bugaku* declined, its place was taken for the aristocracy by a stylized and formalized dance-drama which became *noh-gaku*. The difference between the magical masks of the early Kamakura Period for the *bugaku* performances, and the subtle,

441. Kumano Mandala.
Hanging scroll,
color on silk, height 52¾".
Kamakura Period, c. A.D. 1300.
Cleveland Museum of Art

qualities of the common tea bowls of Chinese *Chien* ware and the Japanese *Seto* ware were praised above all else, and the tea masters produced bowls that at first honored and often attained or surpassed this humbleness. The later grotesque and tortured simplicity is another story. The end of the Kamakura Period witnessed then the split of tradition into a high aristocratic art of great aestheticism and a low, humble, but traditional folk art of great frankness. The virile qualities of Kamakura were repressed behind an aesthetic facade. The repression is well exemplified by the elaborate but hidden precautions taken by Samurai teamasters against the altogether real possibilities of treachery and poison during the complex unrealities of the tea ceremony. The Japanese split personality of aesthete and warrior, produced by the separation of the contemplative and active lives, may be attributed to the critical century of split rule after the Mongol invasion.

The contributions of the Kamakura Period can be summarized by an examination of landscape painting. At the end of the twelfth century, landscape was an adjunct to the representation of deity or aristocratic narrative. With the thirteenth century, interest in portraiture and character was not confined to the individual, but extended to the topography of shrine or temple areas. Thus the *mandalas* or diagrams of Shinto and Buddhist enclosures began to show more of the landscape in a direct and real sense. The *Kumano Mandala* is a representation of three Shinto shrines in the mountains south of Nara, separated by a good many miles but drawn together in the painting for iconic purposes, allowing the believers to travel easily, if only visually, to these great pilgrimage shrines (*fig. 441*). The combination of little Buddhist deities with the Shinto shrines is an example of the syncretic movement in religion, developed in late Fujiwara and Kamakura in an attempt to tie the two faiths together under Buddhist dominance. But the portraiture of the Japanese landscape — gently rolling hills, flowering trees, and "lovely" aspects of nature — is especially developed at this time in the late twelfth and thirteenth centuries. The hills and valleys of Nara, or the waterfall of Nachi, were portrayed by a style rich in color and vigorous in detail. Above all it was the Japanese landscape. It looked like and felt like the local scene, despite the fact that these *mandalas*, this *Nachi Waterfall* (*fig. 442*), were primarily religious pictures, sacred diagrams of a holy place and of the deity residing there. The narrative scrolls include scenes of pure landscape, the hills of Shigisan, the forests of Mie, or the coastal

LEFT:
*443. Saigyo Monogatari. Section
from the handscroll, ink on paper,
height 12¼". Kamakura Period.*
Tokugawa Museum, Nagoya

BELOW:
*444. Ippen Shonin Gyojo Eden.
By Priest En-i. Section from the
handscroll, color on silk, height 15",
dated inscription* A.D. *1299.*
Kangiko-ji, Kyoto

beaches of Sumiyoshi (*fig. 443*). But, again, these are scenes that adorn the narrative in the best and truest sense of the word. In the year 1299 we can sense a new spirit in the *Ippen Shonin Gyojo Eden,* a narrative scroll in the best Kamakura tradition, with scenes of local Japan, including Enoshima and Fujiyama, but also with landscapes of a careful and subtle spaciousness that strongly suggest the painting of Sung China (*fig. 444*). This influence grows quickly with the influx of Ch'an priests and paintings, and soon after the Kamakura Period we have monochrome landscape in the Chinese style. From this to the many Japanese monochrome landscapes, Chinese-inspired in style and sub-

ject, associated with the tea ceremony, but with no relationship to the landscape of Japan, is but a natural step. The surviving school of local landscape falls into the decorative pattern we have seen in the later narrative scrolls and exists either in these scrolls or on panels. Landscape painting splits in these two directions, leaving the Kamakura shrine and temple *mandalas* as the first great school of Japanese landscape painting. With these landscapes, the sculptures of secondary deities, the portraits, the military arts, and the narrative scrolls, we have the contributions of the Kamakura Period to Japanese art in particular and to that of the world in general.

337

15. Chinese Painting and Ceramics of the Sung Dynasty

STRANGELY ENOUGH, the political and social conditions of the Sung Dynasty in China, its decline and contraction, proved particularly appropriate conditions for the development of painting. It often seems to be true that great periods of artistic endeavor follow, rather than coexist, with periods of great political, economic, and military strength. One can think, for example, of Florence in the *quattrocento*, already suffering a decline from its great period of commercial enterprise in the fourteenth century; one can think of Holland in its golden age of art, already beginning to wane in the early seventeenth century with the waxing of English seapower. The glories of eighteenth-century Venice were products of a refined but decaying social order; conditions in France during the Impressionist and Post-Impressionist periods come to mind as well. One thing is certain: that one of the reasons for a great development of painting style is patronage, and patronage implies leisure. It is also self-evident that in the Sung Dynasty there was abundant patronage and abundant leisure. The Sung emperors preferred to maintain the state by means of bribes to the barbarians on the outer borders of the empire, rather than by military operations of their own. The result was the ultimate decline and end of the dynasty before the onslaughts of the Tartars, and finally the Mongols. At the same time, the emperors had a great deal of time to spend on important things, such as painting, poetry, and concubines. The result was a marvelous period of painting, one in which ceramics reached heights that have perhaps never been reached before or since, and a period in which philosophy, especially Neo-Confucianism, was formulated, codified, and finally ossified. The Sung Dynasty produced the first really important academy of painting in the Far East. Other academies of one kind or another were to follow, but the academy formed by the painter-Emperor Hui Tsung was the prototype

for any subsequent developments, and was perhaps the only really aesthetically effective academy the Far East ever had.

The problems of Sung painting are many, and not the least of them is the relationship of this painting to modern scholarship. For after all, we now have a great many paintings which claim to be of the Sung Period, and undoubtedly many paintings, though a lesser number, which actually are of the Sung Period. At the same time, the progress of scholarship, particularly in the field of Oriental art and most particularly in the field of Chinese painting, has been slow and hampered by various misconceptions, false starts, and unscientific attitudes. We will admit that, in relation to the number of paintings from the Ming and Ch'ing periods, there are few Sung paintings. We will admit also that there are probably many more literary sources and listings of paintings of the Sung Dynasty than there are actual paintings. At the same time, with rational judgment and with the correlation of literary sources and a scientific attitude to the examination of the paintings, plus a stylistic approach to the analysis of their aesthetic form, it is possible to find some order in this chaotic field and to reasonably determine what probably is Sung and what probably is not. We must distinguish first between contemporary source material and later source material. The sources of the Sung Dynasty are most useful. They list certain paintings by certain artists or describe the styles of certain artists, and this of course is always of particular interest when it is information from its own time. However, the later the sources of information the less reliable they usually are, because then we are dealing with generally unscientific opinion of the most quixotic and romantic kind. Nothing more quixotic can be imagined than the usual Chinese scholar-critic of the seventeenth or eighteenth century when he examines a painting purporting to be

Colorplate 35. Ladies Preparing Newly Woven Silk (after a lost painting by Chang Hsuan of the T'ang Dynasty). Attributed to Hui Tsung, Emperor of the Northern Sung Dynasty, but probably by a court academician. Handscroll, color on silk, height 14⁹⁄₁₆"; length 57¼". Museum of Fine Arts, Boston

340

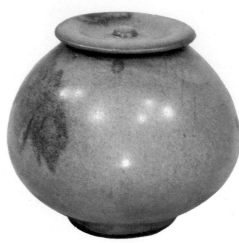

*Colorplate 36. (above right) Covered Vase, height 3¾";
(above left) Flower-Pot Stand, diameter 9¼".
Both: Chun porcelain. Sung Dynasty. (right) Dish.
Ju porcelain, diameter 5¹⁄₁₆". Northern Sung Dynasty.
Cleveland Museum of Art*

of early date. The early sources are most useful; the later sources must be checked constantly.

The kernel of the problem is the question of authenticity. It is misleading to discuss the stylistic qualities of painting in the thirteenth century when one is looking at a seventeenth-century copy of a fifteenth-century copy of a thirteenth-century painting; and this is only too often true. The question is complicated further by the fact, you will remember, that the Sixth Canon of Hsieh Ho emphasized the importance of copying the paintings of the past as a means of brush discipline and of acquiring skill in composition. This copy tradition produced a great many competent paintings of good quality which are copies of now-lost early paintings. All is not lost, however, for it is possible to use a judicious combination of literary sources, scientific analysis of pigment, silk, and seals, and a careful study of the style of Sung painting. What are the pictorial assumptions of the Sung painter? What does he see that is common to others of his age and which a painter of the sixteenth century does not see? If we can partly determine these things, then we can do some separating of sheep from goats. Fortunately, there are existing copies of early paintings where the earlier painting also exists. These are most useful combinations; but it is difficult, painstaking work only just begun, but which does lead to probable Sung paintings.

At this point we ought to mention the major formats of Chinese painting, which by this time were firmly established. In the T'ang Dynasty, certain modes may not have been fully developed; but by the Sung Dynasty, the three really basic forms of portable painting were in full use and painting of large-scale mural decorations was continued. The three formats of primary importance for the Chinese professional and literary painting traditions are the hanging scroll, handscroll, and album leaf. The hanging scroll is a painting, usually either on paper or silk, mounted with paper backing and cloth facing, stored in rolled-up form and exhibited by suspension in unrolled form from a peg or portable stick some seven to nine feet above the ground. The hanging scroll is therefore usually vertical in format, although in some cases it approaches the square; and on some very rare occasions it may have a horizontal arrangement.

341

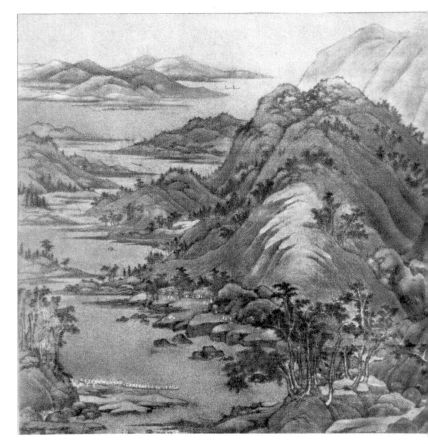

ABOVE RIGHT: *445. Landscape of Lu Shan.*
Style of Ching Hao, Five Dynasties Period. Hanging scroll,
ink on paper, height 73⅛". Sung Dynasty.
National Palace Museum, Formosa

RIGHT: *446. Mountain Landscape with Winding Waters,*
Boats, and Figures. By Tung Yuan. Hanging scroll,
color and ink on silk, height 61½". Five Dynasties Period.
National Palace Museum, Formosa

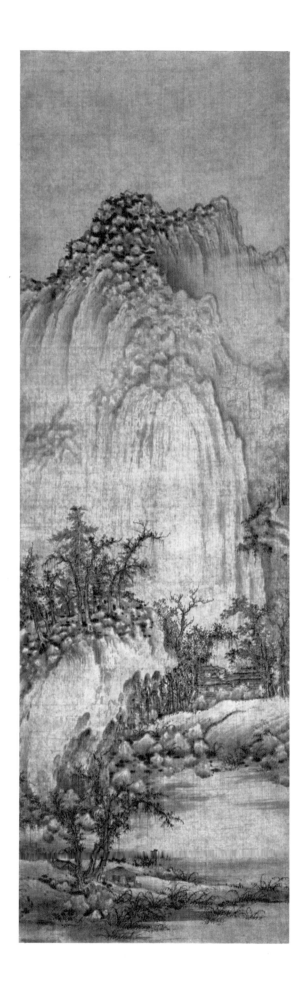

The second major format and one of great interest to Westerners, as we have no such form, is the handscroll. The handscroll, like the hanging scroll, is stored in a rolled-up state, but unlike the hanging scroll, has a primarily horizontal shape. The exterior binding is usually a rich brocade. When the spectator begins unrolling the scroll, from right to left, the brocade section soon ends; then a title appears, written either on paper or silk, usually followed by the painting, again either on paper or silk; and finally, the painting is usually followed by a numerous set of what the Chinese call *ti-pa*, which we would call colophons. These are comments written either by an owner of the painting during the course of its history, or by a person invited to write his opinion of the painting at some auspicious time. In some cases, the number of colophons may go to over thirty, and this often on a painting of a foot or two in length. On the other hand, the paintings may be many feet in length, occasionally reaching to such an ambitious length as forty feet.

The third format used in this period is the album painting, small, sometimes square, sometimes round, and sometimes in an oblate circular fan shape, on either paper or silk. The album painting and the hanging scroll correspond to Western painting in their general format. They are framed paintings with a border of silk around them.

The hanging scroll, being largely vertical, is somewhat different from Western format. The handscroll is obviously the more unusual from our point of view. In addition to these, there are the traditional types of religious wall painting, on wood, plaster, or some other permanent material, and in these we find a continuation and then the ultimate decline of T'ang style. Since these latter paintings have already been considered in more important examples, we will say nothing further about them.

Certainly the most rapid development in the Sung Dynasty occurred in its earliest years; that is, at the end of the Five Dynasties period and the beginning of the Sung Dynasty. This period witnessed the rise of a great school of landscape painting, and if one were to name any one contribution of the Orient in the realm of painting, certainly Chinese landscape would rank as high as or higher than any other. At a period, beginning with the tenth century, when landscape was virtually unknown in the West, despite the earlier beginnings of some concept of landscape art under the Romans, the Chinese produced a school of landscape painting of the utmost complexity and subtlety in its approach

447. Buddhist Monastery in Stream and Mountain Landscape. Attributed to Chu Jan. Hanging scroll, ink on silk, height 73". Northern Sung Dynasty. Cleveland Museum of Art

to nature, both from the standpoint of its organization in suggested space and its representation of natural form. It is significant that this came relatively late in the Chinese history of painting; figure painting developed more rapidly and reached a higher point before landscape painting. Chinese thought in the earlier times was certainly more oriented to the human figure, and this preference received additional impetus from the importation of figure style from India through Central Asia. But, as we have seen, by the end of the T'ang Dynasty, under the influence of men such as Wang Wei, there are the first full attempts at landscape art, of landscape considered as a thing in itself, and symbolized by the lost Wang Ch'uan scroll (fig. 343). In rapid succession, in the tenth and eleventh centuries, we note the continued development and growth of landscape style.

To the Chinese, landscape was not merely a pretty picture or a scene; it was something with major philosophical implications. There was already a foundation in Taoism for interest in nature, even if it was often of a magical kind. There was already a foundation in Confucianism, in the concept of natural law or principle. A combination of these Taoist and Confucian elements was most important in the development of landscape painting, and they would perhaps have developed earlier had it not been for the overwhelming figural influence of Buddhist art. Much has been said about Taoism, nature, and landscape; but it seems more and more true to say that the first important, all-embracing philosophy of nature which could lead to a landscape school was the product of Confucianism and especially of the developing Neo-Confucianism of the Sung Dynasty. It found in nature — in trees and rocks, in water, in mountains — the same qualities of law and order believed to exist in the heavens and in mankind. Confucius in his *Analects* regards nature with a somewhat human bias: "The wise men find pleasure in water, the virtuous find pleasure in mountains" — with the emphasis on the wise and the virtuous man, rather than on water and mountains. But the slightly later compilation, the *Chung Yung* or *The Conduct of Life*, added to by later philosophers to a considerable degree, states a position which is most important for our purpose: "Nature is vast and deep, high, intelligent, infinite, and eternal." This attitude attributes natural order or principle, what the Chinese call *li*, to nature, and therefore makes it a fit subject for the landscape painter, from both a moral and a rational standpoint. The great tenth-century landscape painter, Ching Hao, writes with morality and principle in mind: "Every tree grows according to its natural disposition. Pine trees may grow bent and crooked but by nature they are never too crooked; they are upright from the beginning. Even as saplings, their soul is not lowly but their form is noble and solitary; indeed, the pine trees of the forest

are like the moral character of virtuous men, which is like the breeze." In addition to being interested in the forms of nature, attested to by the very fact that we have literary descriptions of Chinese artists sketching from nature, as well as by the evidence of the paintings themselves, where we find the most beautiful representations of and conventions for natural forms, the Chinese artist was interested in nature from a rational and moral point of view as well. If a landscape painting of the Northern Sung Period (960-1127), with a few exceptions, does not follow this rational order, then we must be very careful indeed and determine whether we are looking at an early Sung painting or at one of later date. Rationality is of the utmost importance, followed by realism through brushwork. In Chinese painting faithfulness to nature is accomplished by means of brush conventions; and by the early Sung Dynasty, such conventions were being developed for the representation of rocks, foliage, bark, water, and so on, satisfactory both as calligraphy and as symbols for natural form. The development of the *tsun*, or wrinkles by which rocks and mountains were defined, is a product of this early period, as well as many other conventions that became standard later on.

Before we study the landscapes, let us briefly outline a framework for the study of Sung painting which has been found useful. It is a framework and nothing more, but it is a convenient one. There are others and there will surely be many more, some useful, others less so. It is only by such a convention that we are able to give some order to a chaotic mass of material. It is an imposed order, but has real relation to the actual development of the painting of the period, insofar as we are able to determine it. It divides Sung painting into five major categories, to be considered in part as progressive. The first is the earliest one, and despite its persistence represents an archaic manner; while the last is the final development of the Southern Sung Period (1127-1279), although it may have had a few earlier ancestors. A painter may work in one, two, or even three styles; but in general, he works in two related styles that stand next to one another in point of development. The names for the styles are descriptive only in a general sense; perhaps they indicate the flavor of the painting rather than offering a scientific description of its style.

The first or Courtly Style, usually in color, is based upon T'ang painting and is the continuation of that tradition of narrative and courtly art. The second is the Monumental Style, primarily of the Northern Sung Period, and comprising the great early school of landscape painting. The word "monumental" is particularly descriptive of these paintings. The third or Literal Style, particularly associated with the Northern Sung Academy of the Emperor Hui Tsung, who reigned

from 1101 to 1126, is transitional between the Courtly and Monumental styles and the later styles of the Southern Sung Period. The fourth or Lyric Style is classic for the Southern Sung Period. Here certain elements of the Monumental and Literal styles are abstracted and developed in a specialized way which tends to be rather romantic in appearance, but we avoid the word as it has implications in European literature and painting which have no relation to the painting we are studying. The fifth and last is the Spontaneous Style, which develops logically out of the Lyric Style, but is an extreme and radical expression of certain brushwork tendencies within that style.

The first or Courtly Style is seen perhaps at its most characteristic in the little album painting, in the shape of an oblate circle, in the style of Chao Po-chu, the most famous practitioner of this T'ang-influenced style (*colorplate 34, p. 322*). The picture in the Palace Collection is painted in rather bright colors of malachite green, azurite blue, red, and some gold. It represents

448. Travelers on a Mountain Path. By Fan K'uan (active c. A.D. *990-1030). Hanging scroll, ink on silk, height 81¼". Northern Sung Dynasty.* National Palace Museum, Formosa

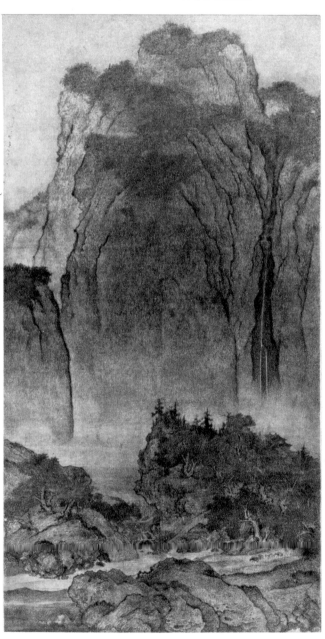

449. Travelers on a Mountain Path. Copy from an album attributed to Tung Ch'i-ch'ang. Hanging scroll, ink on silk, height about 24". Ming Dynasty. National Palace Museum, Formosa

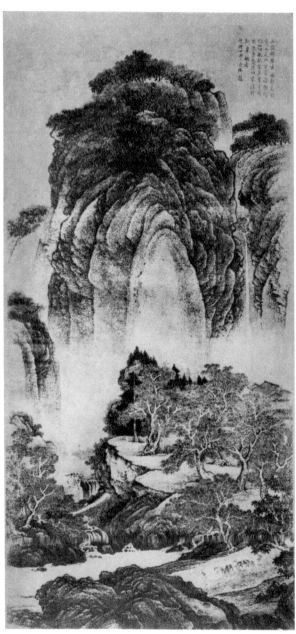

344

a procession of court ladies as they move into a garden from a pavilion area. In the background is a new type of landscape, one that could exist only after the development of the landscape school of the twelfth century. Despite the fact that the artist is a highly conservative twelfth- or thirteenth-century painter, as seen in his treatment of architecture and figures, in landscape he does not hesitate to use some of the inventions and conventions of the later landscape school. The composition is very crowded and full, with sustained attention to detail. One of the greatest clichés of the Western writer on Chinese painting, and one which requires more killing than any other, is that which describes Chinese painting as a great expanse of open silk or paper with just a few brush strokes in the corner. Rhapsodies on the contrast of nothingness with something, and myriad other resulting philosophical implications follow in the turbulent wake of this remark. Nothing could be further from the truth; and nothing could be less descriptive of the majority of fine Chinese painting of all periods. Complexity is at least as important as the convention just described. The use of large blank spaces is characteristic of one particular period, that of the Southern Sung; but it certainly does not represent Chinese painting as a whole. A composition, such as this in the Courtly Style — complex, rich, varied, and detailed — is much more typically Chinese. Numerous other conservative and traditional painters worked in the Courtly Style; we cannot begin to name them here. Chao Po-chu is, let us say, the type-artist for Courtly paintings in this dynasty.

The second category, and perhaps the most important of all, is the Monumental Style. It certainly begins in the Five Dynasties Period, between the fall of the T'ang Dynasty and the foundation of the Sung Dynasty in 960. The first and, from our standpoint, legendary painter of the Monumental Style is Ching Hao, whose remarks on trees were noted before (*see page 343*). Unfortunately, we have no works that really can be considered to be from his own hand, or even of the period. There is, however, a very impressive hanging scroll in the Palace Collection whose tall, rather vertical mountains, stiff in their general outlines, recall in a remote way the comblike mountains of the T'ang and earlier painters (*fig. 445*). On the other hand, the development of the lower part of this picture is so characteristic of a somewhat later date that we must have here a rather free version of what we assume Ching Hao's style to have been. What a remarkable stride has been taken! How different this is from the decorated and incidental landscapes of the T'ang Dynasty! Here is something quite radically new; landscape is the subject of the picture. The scroll may have a title which implies human activity; but the subject of the picture is the landscape, and the landscape dominates the whole composition. In general, the Monumental Style seems

450. *Winter Forest. Close to Li Ch'eng (active c.* A.D. *960-990). Hanging scroll, ink on silk, height 54¼".* Sung Dynasty. National Palace Museum, Formosa

at its best in the hanging scroll; the verticality allows the development of height particularly appropriate to the rational and monumental aims of the painters who produced some of the greatest masterpieces of Chinese painting.

The second master, Tung Yuan, is perhaps best known to Westerners for an early and beautiful painting in Boston, called *A Clear Day in the Valley*, a handscroll on paper. Actually, this painting probably has little relationship to him. There are, however, several paintings which may well be early and close to his manner; and one of them is a large scroll in the Palace Collection, one of the few hanging scrolls with more horizontal development than vertical (*fig. 446*). It ostensibly represents a fishing scene, with nets being pulled in in the foreground. But the human activities are completely dominated by the landscape. In contrast to the vertical development of the scroll after Ching Hao, and of other pictures that we will presently see, Tung Yuan was most famous for his development of far space and rather rolling and resonant mountain shapes. He paints the geography of Southern Chinese landscape more often than the dry and barren land-

345

451. Early Spring. By Kuo Hsi (A.D. 1020–c. 1090). Hanging scroll, ink and slight color on silk, height 62¼", dated 1072. Northern Sung Dynasty. National Palace Museum, Formosa

scape of the North. In this particular painting there is a considerable use of color, principally green and blue, and in that there is some reminiscence of the T'ang Courtly Style. On the other hand, the deep space, the use of a long vista with projecting peninsulas, overlapping as the water twists back and forth in the distance, is quite in the new Monumental Style. There are still some difficulties with the problem of space organization. The planes of the different water areas are not consistent, and seem to follow three different plans for foreground, middleground, and background. This division into self-contained and separated parts, from the standpoint of space and of surface organization, is rather characteristic of the Monumental Style. There is also a great development of rhythmical repetition in the points of land, in the forms of trees, and particu-

346

larly in the folds of mountains; all of these are cunningly used to produce an inner rhythm that dominates the whole composition.

We can also see an increase of realism in landscape in this particular painting. The viewpoint is that of a spectator at an elevated position, as if one were seated high on a mountain looking out over other mountains. Added to this realism in the general appearance of things is a growing realism in the handling of details, the differentiation of greater numbers and varieties of trees, and the representation of different types of marsh grasses and other foliage. There is also a greater differentiation in the conventional *tsun*, those brush strokes that form the different kinds of wrinkles and so identify types of rock and mountain: soft, hard, crystalline, and others.

Another great master of the tenth century was Chu Jan, famous for his towering mountain compositions. In the Cleveland Museum is a hanging scroll showing a landscape with high mountains, which may be very close to him or an excellent early Sung example after his style (*fig. 447*). In this particular picture, one device is used that occurs again and again in the early vertical formats, that is, the division of the picture into two fundamental units: a foreground unit, which includes everything usually considered foreground and near middle ground; and a background unit, separated from the foreground by a gap where the far middle ground would have been, had it been represented. The foreground is conceived as nearby and the eye of the spectator travels over the near detail, taking in the sure brushwork in the foliage and the architecture. But then there is a subtle break between the foreground and the area behind, which is treated as if it were a backdrop, suspended and fitted into a slot behind the foreground. This device adds to the towering quality of the mountains, as they rise precipitously from behind the foreground unit. The large, wet brush spots provide almost musical accents and may well be the first appearance of this technique, so important in the unique style of Mi Fei, an artist to be considered shortly.

We must never forget, despite these aesthetic devices, despite some conventions in the representation of space, such as the tilting of the foreground and the flattening of the background, that one of the things uppermost in the Chinese landscape painter's mind at this time was the question of representation, and particularly of achieving a believable path through the painting. The Chinese write constantly about landscape painting that it shows country good to walk in; we read in the colophons that one travels through the painting, that here we see so and so, and there is such and such, over there a wine shop, and that we cross a ford and reach a certain place. We must remember, despite the fact that the hanging scroll is rather like a framed picture, that it does have a path which one follows through

time, and this becomes particularly important when considering the handscroll. One of the tests of authenticity for a Sung painting is the believability of the landscape as a place to walk in. One must not suddenly climb a rock and find nothing behind it; one does not arrive at a wine shop and find the wall falling over. The Sung painter is intensely interested in logical detail. Each part is a separate part; but each part fits into the whole and the whole is the sum of the parts with nothing left over.

Perhaps the greatest single example of the Monumental Style is the hanging scroll on silk in the Palace Collection attributed to the tenth-century master, Fan K'uan, who died sometime after 1026 (*fig. 448*). All that has been said about the Chu Jan certainly applies to this painting. Again rocks are used in the foreground as a means of creating a barrier to the spectator's eye so that it is not suddenly pulled into the landscape. There is a tremendous complexity in the forest on the cliff, with its small temples nestled among the trees. All this is clearly handled with sharp brushwork so that all the different tree forms, deciduous and coniferous, are shown. The rocks are typical Fan K'uan rocks, slightly more crystalline than, for example, the smooth-flowing rocks of Tung Yuan or the peculiar table-top

rocks characteristic of Chu Jan. The backdrop is a magnificent towering peak covered on the top by areas of low bush. A single cascade of water falls at the right of the picture and is balanced by the cleft in the small mountain at the left. The effect of the whole is overpowering and at the same time it is one of the simplest compositions of Chinese landscape painting. The impression of the size and of the manifest greatness of nature is expressed here in a rational way, and has nothing to do with the romantic notions of empty space and the small man against a great expanse of silk, so dear to believers of the old clichés. Rather, we have an ordered approach to the vastness of nature, observed and realized in complex detail and careful organization. In this respect it bears comparison with any of the great complex landscapes of Western art.

With this particular Fan K'uan, we are in a very fortunate position, for a comparison of copy and presumed original can be made. Remember several things about the Fan K'uan — the natural appearance of the slope; the sharp differentiation of little things, such as the mule team and caravan going down to the ford and how clearly they are silhouetted against the light tone behind; how sharply the waterfall is differentiated from the background by the light and dark pattern;

347

452. *River Landscape in Mist with Geese and Flocking Crows. By Chao Ling-jan (Ta-nien) (active c. A.D. 1070-1100). Section of a handscroll, ink on silk, height 9⁹⁄₁₆". Northern Sung Dynasty. Yamato Bunka-kan, Nara*

453. *Streams and Mountains Without End. Handscroll, ink and slight color on silk, height 13¹³⁄₁₆"; length 83⅞". Northern Sung Dynasty.* Cleveland Museum of Art

and how the great towering backdrop is separated from the foreground forest and ford. With these in mind, let us turn to a copy probably made in the seventeenth century, a copy which the Emperor Ch'ien Lung and his curators accepted as the original Fan K'uan, at the same time that they owned the other painting, which they evidently did not consider to be authentic (*fig. 449*). There is great satisfaction in this, for it tends to confirm that the usual Chinese critic of the seventeenth or eighteenth century, being unscientific and subjective, could not help preferring the work closer to his own way of thinking to that of the Northern Sung painter. Notice how much nearer everything seems; the spectator is physically and psychologically more involved in this landscape than in the other, which appears to be more remote. Note the way in which the waterfall has lost contrast so that it presents a more unified visual appearance. Note how the lines of the mountain bases are pulled down and become involved with the foreground; how the caravan is less sharply contrasted against the darker ground tone. The whole appearance of the copy, from a visual point of view, is more textured, less realistic, and more visually unified than the work of the Northern Sung Period. The authentic work, on the other hand, emphasizes rationality, separation of parts, and realism. Once we make comparisons of this type, we are in somewhat better condition to distinguish original from copy. This latter can be shown to be seventeenth century by comparison with dated seventeenth-century pictures, which used the same textural and visual devices.

Another great master in the development of the Monumental landscape style was Li Ch'eng, the master

of Kuo Hsi. He was most famous for his representation of gnarled, twisted trees and of the barren, distant vistas of the North. A hanging scroll in the Palace Collection depicts his style and is the most aesthetically rewarding picture to which his name is attached (*fig. 450*). The treatment of the magnificent old junipers, with the fisherman at the base of the rocks below the trees, recalls the passage quoted from Ching Hao, about trees being as gnarled and twisted as an upright and virtuous old man. Li Ch'eng's style is unmistakable and was carried on by his most famous pupil, Kuo Hsi, one of the greatest of all Northern Sung landscape painters, (1020–about 1090). In *Early Spring*, the most important picture attributed to Kuo, one can see the derivation of some elements of the style from a painter such as Li Ch'eng: the gnarled trees, the particular topography of the rather dry and barren northern country (*fig. 451*). But Kuo Hsi informed his work with a particular rhythmical quality and complexity which was the envy of his contemporaries. He was listed as the very greatest artist of his day and a rival of the giants of the past; and this for a Chinese is the highest possible praise. One is still conscious of a strongly rational construction in *Early Spring* despite the psychological impression given by the abnormalities of tree formations and twisted rocks. The picture is formed on a grid, with a vertical line down the middle and forms growing out from either side in a regular and rhythmical order. There is again that rather clear separation of near and far which appears almost as a mannerism in these early paintings. A complete break occurs across the picture at this point: from the valley up and around the near hill and then on through and

past the distant mountain range on the far right. The separation leaves an unexplained area between the end of the nearest peak and the lowest point of the beginning of the highest peak. The explanation can be found in nature; mist swirls about the mountains and obviously the Chinese painter had looked at this and used it in his painting. In the Monumental Style of Northern Sung, mist became a device to solve the problem of handling the relationship of near, middle, and far ground. The full solution, without the aid of mist, was found probably in the fourteenth century, and from that time was handled with great skill by the Chinese painter. So from the standpoint of the conquest of visual space, the Monumental Style was, in a sense, archaic. It is of interest that the paintings we consider to be of the Northern Sung Period usually emphasize the silk as mist without any clear form, in contrast to later paintings, in which there is a tendency either to apply paint around the silk so as to make the mist appear palpable, or to actually use pigment to indicate the mist, again making it palpable, full of volume and weight. The treatment of mist by the Northern Sung painter is far more abstract. On the other hand there is much of convincing reality in the Kuo Hsi, notably in the vista to the left up the valley, depicting the almost tundralike country of North China, reaching into space past dry washes of loess soil to the distant mountain ranges. No representational elements have been lost; the differentiation of pine and of gnarled and twisted deciduous trees is quite clear; the representa-

349

455. *Cloudy Mountain Ridge Along a River. By Mi Yu-jen* (A.D. 1086-1165). *Handscroll, ink and slight color on silk, height 17³⁄₃₂″; length 75¹⁵⁄₁₆″, dated 1130. Southern Sung Dynasty.* Cleveland Museum of Art

tion of architecture is believable and strongly drawn. Another of the hallmarks of Northern Sung landscape painting is its rational handling of architecture, both from the standpoint of construction and placement in space. This is a radically different picture from the relatively simple composition of Fan K'uan, but both are encompassed within the Monumental Style.

With the end of the eleventh and the beginning of the twelfth centuries, there is a new facet to the painters' attitude toward nature. We find a more intimate approach to nature in the work associated with one artist in particular, Chao Ta-nien (fig. 452). He uses a non-monumental format; instead there are near views and views of relatively low and nearby horizons. These

456. *Five Tribute Horses. Attributed to Li Lung-mien* (c. A.D. 1040-1106). *Section of a handscroll, ink on silk, height 11″. Northern Sung Dynasty.*
Ex-Kikuchi Collection, Tokyo

small, charming, and intimate views of idyllic, nearby, and understandable nature seem a part of the new atmosphere of the Academy of the Emperor Hui Tsung and of the accompanying Literal Style. In a sense, this innovation of Chao Ta-nien, the low horizon and the near view, can be described as part of that style, since it tends to be a more visually realistic view of nature than the great, noble, and remote compositions of the preceding two centuries. This particular painting is one of two or three leaves probably by or close to Chao Ta-nien. He was a much-admired master, much copied in later days.

At this point, it seems appropriate to show the handscroll, *Streams and Mountains Without End*, because it is a somewhat eclectic picture, painted about 1100, and recapitulates much of the previous development (fig. 453). In terms of the styles of individual masters, it begins with a small, low, intimate landscape, representing the then up-to-date and fashionable style of Chao Ta-nien, goes on to a mountain-encircled space recalling the scroll of Wang Wei, then proceeds to a style of painting rather like Tung Yuan, rolling and resonant in its form, followed by a rather crystalline style based upon another Northern Sung master, Yen Wen-kuei, then moves to a climactic mountain unit painted very much in the towering style of Fan K'uan, and finally ends with a forest and distant mountain area, perhaps close to Kuo Hsi.

The painting is also of great interest because of its format and organization within that format. The handscroll, being unrolled from right to left, allows development, not only in terms of pictorial structure within a frame formed by the beginning and end of the painting, but also demands organization in time and space. In a way it is the ancestor of the motion picture; one can vary the frame by moving the rolled ends from right to left or left to right, thus creating innumerable small pictures at will. At the same time, in moving along the composition from right to left, viewing a few

feet at a time, one passes in time through a landscape, something not possible in the hanging scroll or album painting. In some cases, this passage through time and space can be quite long, though in the case of *Streams and Mountains Without End,* it travels a distance of only seven feet.

This organization through time permits an almost musical character to the painting; in being organized through time, the sequence and spacing by which one sees the aesthetic or the representational organization can be controlled. When viewed from right to left, following the sequence ordained by the painter, one achieves a type of organization very much akin to that found in music and other time arts. Thus we find a composition which begins with a gentle, quiet theme and then gradually shifts to a first climactic theme of mountain peaks and village. Following this the scroll fades into a quieter and, at the same time, strong and rolling theme that moves on into a second climactic variation of the mountain theme, which is also of importance as a forerunner of things to come, as well as a reminder of the recent past. With a shift at this climactic point, we move to a staccato motif of vertical mountains with an almost crystalline structure. This ends, and a rocky variation prepares us for the final great climactic mountain theme in a craggy style with overlapping planes, which produces the most emphatic ink tones reinforcing the largest unit in the picture. Finally, the scroll ends with a varied restatement of the quiet opening passage, but with mountain elements that have occurred throughout most of the picture. This is a coda which, while not dramatically as powerful as some earlier passages, acts as a summary of the whole.

This type of organization, with themes and varia-tions, can become very complex. It is organized not only in terms of aesthetic units, but also representationally. Thus one begins on a path and moves through the village, down and across a ford, on up into and past a wine shop, then over a bridge to another road that leads to a mountain temple, past the mountain temple to another ford, back up into the mountains, and then around and down past the foot of the great craggy peak to another ford, where a ferryman waits to escort the traveler across the stretch of marsh and water into the distant reaches at the end of the scroll. This representational organization is fully as important as the aesthetic one, and from the Chinese point of view was of prime importance. The rich, cool, black ink is combined with very slight, colored, pale washes of green or of red in certain areas, so that the ink areas take on coolness or warmth from the accompanying tints.

Streams and Mountains Without End does not have the monumentality of the great hanging scrolls, or even of the few fragments of handscrolls extant, except in the one climactic unit. This is in part because the artist is trying to come to terms with the handscroll medium. The great format for Northern Sung was the hanging scroll; this was the monumental means par excellence. But the handscroll represented a new challenge in horizontality and extension; and the solution of this problem begins with pictures of the eleventh and early twelfth centuries, such as *Streams and Mountains Without End.*

There is a minor aspect of Monumental Style that involves a particular technique of brushwork probably derived from Chu Jan. This is the *Mi* style, named after the great painter-critic, Mi Fei, who lived from 1051 to 1107, and his son, Mi Yu-jen, who lived in the twelfth

351

457. Five-Colored Parakeet on the Branch of a Blossoming Apricot Tree. Endorsed by Hui Tsung, Emperor of the Northern Sung Dynasty, but probably by a court academician. Handscroll, colors on silk, height 20¹⁵⁄₁₆″; Museum of Fine Arts, Boston

century. There are those who would deny that Mi Fei was a painter at all and say he was simply a collector and critic. But a certain style of brushwork involving the massed use of dashes of ink, building form by the addition of horizontal strokes of the brush to produce a mass of ink resembling rock, mountain, or tree, has always been associated with the name of Mi Fei. Applied to the vertical format of the hanging scroll, the style could be very imposing, as in the hanging scroll of the Freer Gallery, probably a slightly later version of a painting in the style of Mi Fei (fig. 454). There is also a short handscroll attributed to the son, dated 1130 (fig. 455) and painted perhaps a generation after *Streams and Mountains Without End.* In this work we find the *Mi* style with some traces of opaque color, almost an archaistic revival of T'ang coloring. The Mi Fei style was particularly appropriate for representing the landscape topography of South China, such as the low, wet hills of Fukien province. The picture has suffered a great deal; there is some repaint in parts of the mountains. But in the handling of the main form of the composition, of the overlaps, of the repeated rolling rhythms of these low-lying hills, and of the twisting mist with its archaic, trefoil plumes in T'ang style, we have a successful attempt to paint the portrait of the southern coastal region of China. The *Mi* style is important because it became one of the favorite techniques of amateur gentlemen-painters and so it is repeated again and again. There is no method by which it is easier to obtain a faint resemblance to a landscape; there is no method more difficult to use and thereby achieve a great painting. A few painters of the fourteenth century could do it and so could a few individualists in the seventeenth century. But this handscroll must stand as one of the few classic examples of the *Mi* style.

The third style is the Literal Style; and while it is associated particularly with the Academy of the Emperor Hui Tsung, we must mention first an artist who painted in what can well be described as a Literal mode, at the same time that most of his pictures seem to be derived from T'ang narrative or figure composition. This is the master, Li Lung-mien, who lived from about 1040 to 1106. The picture which, more than any other, shows Li Lung-mien's realistic linear style, is a scroll reported destroyed during the war. It is reproduced from a pre-war photograph in figure 456. The handscroll depicts five horses with their five grooms painted in pure ink outlines with an occasional touch of color. While it follows the tradition of T'ang horse painting, such as that of Han Kan, it shows a degree of analysis of the anatomy of the horses and particularly a knack of catching the individuality and racial character of the grooms. Other works attributed to Li Lung-mien reveal similar close observation of nature and of everyday life.

458. *Mountain Landscape with a Winding Stream and Knotty Old Trees. By Li T'ang (c. A.D. 1050–c. 1130). One of a pair of hanging scrolls, ink on silk, height 38½". Sung Dynasty. Koto-in, Daitoku-ji, Kyoto*

But the greatest exponent of the Literal mode, and founder of the academy that particularly practiced it, was the Emperor Hui Tsung. He was the last of the Northern Sung emperors and was carted off to fatal captivity by the Tartars who sacked the capital, Kaifeng, in 1127. While he was a painter of some skill, his patronage of the Academy and his taste in collecting were of primary importance. Simply as a technical performance, the brightly colored copy of a famous T'ang painting by Chang Hsuan, of court ladies preparing silk, shows the great knowledge of the ancient style and the skill in copying required of the court art-

459. *Mountain Landscape with Two Men Looking at a Steep Waterfall. By Li T'ang. One of a pair of hanging scrolls, ink on silk, height 38½". Sung Dynasty. Koto-in, Daitoku-ji, Kyoto*

ists (*colorplate 35, p. 339*). But the emperor's primary interest was in the academicians' representation of what the Chinese call "fur and feathers," the representation of birds or animals, often in conjunction with branches of flowering trees. One of these shows that interest in the literal depiction of birds and flowers which is the hallmark of the Literal Style (*fig. 457*). The desire for realism is such that the birds' eyes are sometimes indicated with lacquer in slight relief, giving a beady bird's-eye look to the final representation. The various parts are carefully examined and analyzed, not only in shapes and their translation into brushwork,

but in color and texture. The feathery texture of the parakeet, in the wonderful picture at Boston, is contrasted to the texture of the apricot blossoms, and in turn to the rough texture of the bark. The emperor was quite individual in his calligraphic style; his endorsement on the right, slightly obliterated, is written in his distinctive, long, spidery hand, much copied but very difficult to imitate. The style that he encouraged may well go back to certain details in T'ang painting of the Courtly Style. The selection of such units, enlarged to almost larger-than-life size, and set against the abstract ground of the silk in order to concentrate the spectator's eye on the object in all its complexity and reality, are essential characteristics of the Literal Style.

The literary background of the style is to be found in the contests held for painters of the Academy, when subjects were set for competition. Judging from the examples described, the painter who took the most literal attitude usually took the palm. The most famous and often quoted contest subject was a poem whose title translates, *The Hunters Return from the Flower Fields.* The winning picture showed horses going through a field with butterflies fluttering about their heels. This quite naïve, literal attitude is typical of the school. The attention of the artist was directed very specifically at the object being painted; and many marvelous small-scale paintings — usually album leaves of birds, animals, fruit, and flowers — are products of this Northern Sung Academy.

With the fall of Kaifeng and the triumph of the Tartars in 1127, the court fled south and took with them most of the great imperial collections. There they played out the next century and a half of their existence at the Southern capital of Hangchou where, even more than before, leisure and the life of the senses were more important than the political and military well-being of what was left of the empire. It was in the South that the Lyric Style evolved, and a very important figure in this transition was the painter Li T'ang. For the reconstruction of Li T'ang's work and of his importance we are in part indebted to that most mundane of all things, Western science. Li T'ang's works were very little known until shortly after the last war, when the Japanese scientifically examined two pictures that had always passed under a traditional and obviously false attribution to the great Wu Tao-tzu (*figs. 458 and 459*). The two paintings, kept in a Zen monastery in Kyoto, were subjected to careful examination by infrared photography. The signature of Li T'ang was found hidden in the trees in the center on one of the two pictures, after having escaped notice for some seven hundred years. It seems only logical to suppose that these are authentic works by Li T'ang; and these, with a very few paintings in the Palace Collection, make many things fall into place, without

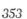

the help of seals or literary sources. These are pictures which retain strong traces of the Monumental Style. In this vertical format, the cliffs and peaks still soar high but there has been a very significant change. The compositions seem cut off at the top; the disposition is not self-contained and not rational. There is a trace, particularly in the convolutions of the trees, in the general type of the composition, and in the simplified treat-

460. Landscape in Rain. By Ma Yuan (active c. A.D. 1190–c. 1224). Hanging scroll, ink on silk, height 43¾". Southern Sung Dynasty.
Seikado Foundation, Tokyo

354

ment of the rocks, of a more direct and intuitive attitude than hitherto. I would say that of these, the most significant was the cutting of the view so that it becomes, in a sense, a detail of one of the older Monumental compositions. This fragmentation of nature is to reach its zenith after the development of the Lyric Style, in the Ch'an masterpieces of the Spontaneous Style. Li T'ang was a very great painter indeed, and the strength of his brushwork, particularly in the great axe-hewn rocks of the lower left foreground, holds its own with that of any of the great names of the past.

The transition was made by an artist like Li T'ang, who served both Northern and Southern courts. The development and the culmination of the Lyric Style were left to two artists whose names are perhaps best known to Westerners with any acquaintance with Chinese painting: Ma Yuan and Hsia Kuei. Let it be said at the beginning that to Chinese critics, especially those of the sixteenth to the eighteenth century, Ma Yuan and Hsia Kuei were not up to their Western reputation. In the Chinese tradition, they are in part suspect because they were important painters at a time when the Dynasty was politically and morally weak, and some moral censure motivates later Chinese verdicts of their paintings. A sixteenth-century critic, in speaking of Ma Yuan and Hsia Kuei, said: "What have I to do with the tail ends of mountains and truncated streams, the products of ignoble refugees?" (translated by A. Waley). Judgment was hardly objective on the part of the later critics. Furthermore, to the Chinese painting tradition the Lyric Style was unorthodox.

One Ma Yuan attribution in Japan shows the artist using a traditional format (fig. 460). It is a vertical composition recalling something of the Monumental Style and of Li T'ang, but indicating an attitude quite different from that of earlier times, particularly by the projection into space of two pine trees with their fantastically elongated and twisted branches. The fragility of these elements thrust into such prominence is a symbol of the changed approach of the painter. More characteristic of his developed style is such a picture as that showing egrets beneath a branching tree (fig. 461). The Chinese writers called him "one-corner Ma," and with reason. Here is a painting where one can speak of the vast expanse of space, of the balance of abstract silk against a complex, one-cornered area. Here, too, are the projecting branches and other elements so important in the *Che* school of the early Ming Dynasty, and to the Japanese painters of the fifteenth century.

One of the reasons for contention between the Sinophiles and the Japanophiles as to the merits of the Lyric Style is that it is much appreciated in Japan; therefore, the Chinese must not like it. Then, too, the style was highly appreciated many years ago; therefore, modern critics must not like it. The result has been an unjustified reaction against this style, in fa-

vor of the more scholarly styles of the late Ming and Ch'ing dynasties. Nevertheless, when Lyric paintings are of the period and in good condition, they are very great indeed, and worth all our study and admiration. But the manner was so popular in Japan that many Japanese copies and even forgeries were made. The result is that the great majority of paintings in the Lyric mode are not from the Sung Dynasty at all, if indeed they were ever painted in China. Ma Yuan in particular is the most romantic and exaggerated practitioner of the asymmetrical composition which is the hallmark of the school; and he, his father, his son, and his nephew, forming the *Ma* school, all painted very much in the same style and with the same results. It is a great collective contribution and one which must be balanced and weighed against the earlier Monumental and later Spontaneous styles.

The second great master of the Lyric Style is Hsia Kuei, active in the first quarter of the thirteenth century, with two very definite styles associated with his name. One of them can be seen in a fragment of a longer scroll, *Twelve Views from a Thatched Hut*, of which only four views now remain (*fig. 462*). This handscroll is, in a way, much more sophisticated than any handscroll of the Northern Sung Period. At the same time it is simpler, with much less complexity in organization and control. The brushwork is completely in ink; there is no color. The forms are much simplified: tree trunks are indicated by heavy thick lines that define the edges of the trunks and at the same time seem to model them in the round. Such things as rocks and mountainsides are indicated without a great development of the *tsun;* instead, they are treated as planes indicated by washes. Foliage is, relatively speaking, undifferentiated. There is little discrimination of types of foliage and trunk textures; the emphasis is upon silhouette and the projection of shapes into areas of blank silk. Distant objects are quite misty and so simplified that they become an almost abstract, hazy ink pattern. This technique is of some significance in the later development of the Spontaneous Style. If we look at a detail of the *Twelve Views from a Thatched Hut*, we can see why the one-corner epithet was given to the *Ma* school (*fig. 463*). At the same time we can see that the convention functions very well indeed and produces as aesthetically satisfying a result as any of the more complex and rational products of the Northern Sung Period. Each style must be given its due. This particular detail, with its brusque and rapid representations of figures against water only vaguely indicated with a few ripples, displays the suggestive and asymmetric style of the Lyric mode at its most developed and sophisticated best. Hsia Kuei was also famous for another manner more directly based on Northern Sung style and very much respected and admired in China. This is best seen in a long handscroll *Clear and*

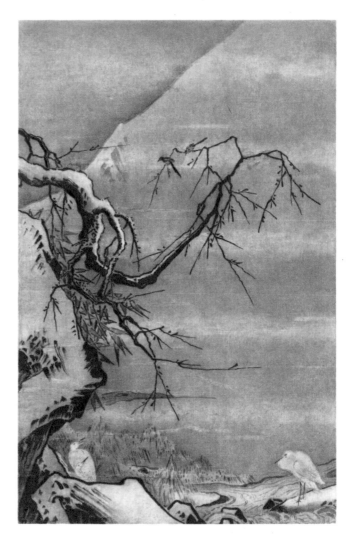

461. *Egrets Beneath a Branching Tree. By Ma Yuan (active c.* A.D. *1190–c. 1225). Hanging scroll, ink and slight color on silk, height 23¼".* National Palace Museum, Formosa

Distant Views of Streams and Hills, kept in the Palace Museum (*fig. 464*). It should not be confused with another and more turbulent scroll of the Yangtse River, also in the Palace Collection, with greater emphasis upon water, fishing boats, and ferries, which was sent to the London exhibition of 1935. The latter is certainly a Ming copy, if indeed it is a copy of Hsia Kuei at all. The former painting, in the Palace Collection, combines sharp and crystalline brushwork in its representations of mountains and rocks, with the same silhouette treatment of tree foliage to be seen in the *Twelve Views from a Thatched Hut*. In this particular case, the Palace scroll of some thirty-four feet in length, there is really an amazingly complex development through time in the finest handscroll tradition. A picture like this was of great importance in the development of early Ming painting, and also an influence on

355

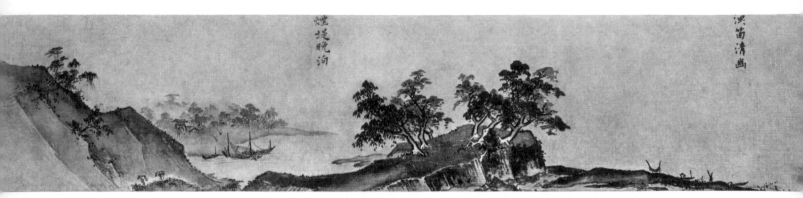

462. *Flying Geese over Distant Mountains; Returning to the Village in Mist from the Ferry; The Clear and Sonorous Air of the Fisherman's Flute; and Boats Moored at Night in a Misty Bay, from Twelve Views from a Thatched Hut. By Hsia Kuei (c. A.D. 1180–c. 1230). Section of a handscroll, ink on silk, height 11". Southern Sung Dynasty.*
Nelson Gallery-Atkins Museum (Nelson Fund), Kansas City

such Japanese painters as Sesshu, in his long scroll in the Mori collection.

The last of the five categories of Sung painting is the Spontaneous Style. Its origins are really twofold. First, abbreviated techniques were derived from ink painting of bamboo and kindred subjects which, as early as the tenth century, had been a preoccupation of the scholar-painter and calligrapher who wished to transfer into pictorial form the discipline of writing. The second influence was that of the Lyric Style, particularly in its gradual dissolution of pictorial form, its emphasis upon rapid, calligraphic brushwork, pure monochrome ink, and the importance of the enlarged detail. A painting attributed to the first great master of bamboo painting in Chinese history, Wen T'ung, eleventh century, shows brush discipline in the control of each stroke simulating the bamboo leaf (*fig. 465*). At the same time, there is a mastery of pictorial composition displayed in the great S-curve of the main stalk, and the subsidiary motifs of the almost moving forms of the bamboo sprays and stems as they reach out from the main branch.

The combination of these two elements, and the added influence of Taoism and Ch'an Buddhism with their intuitive responses to nature and to man, produced the Spontaneous Style at the end of the Sung Dynasty, particularly in the monasteries of South China. Ch'an was also interested in individual character, as seen in the portrait of a priest by a Southern Sung painter, where the careful, detailed style derived from T'ang portraits and T'ang decorative style is used for searching individual and saintly character (*fig. 466*). But Ch'an Buddhist influence, while it is there, is not the dominant one. It provided much of the subject matter, just as its monasteries provided many of the retreats for these painters. We must consider that the prime factor was the gradual shift of the Lyric mode to a more specialized and intuitive development, pushing the Lyric Style

to far extremes of expression. One cannot discount the influence of a still little-understood, early amateur-gentleman attitude to ink painting.

The monk Mu Ch'i, known more often in China as Fa Ch'ang, was one of the two greatest exponents of the Spontaneous Style. The triptych, painted in ink with very slight color on silk and kept in a Ch'an (Zen) monastery in Kyoto, shows how the Lyric mode is executed with such rapidity and abbreviation of brushwork, and such boldness of composition, that the result is, in effect, a new style (*fig. 467*). The pine branches and monkeys, as well as the bamboo grove behind the crane, reveal an extremely spontaneous approach to brush handling — more so than in the more carefully painted crane and white-robed Kuan Yin. The over-all misty tone is still related to the works of the *Ma-Hsia* school.

The most extreme expression of the Spontaneous Style at the hands of Mu Ch'i is the famous *Six Persimmons*, kept at the same monastery in Kyoto (*fig. 468*). Painted in cool, blue-black ink on paper, the *Six Persimmons* has been described by Arthur Waley as "passion . . . congealed into a stupendous calm."[13]

The painting communicates many of the qualities that we associate with Ch'an (Zen) Buddhism: intuitiveness, brusque statement, the enigmatic. But one cannot help noting, in passing, the tremendous skill of hand and brush that painted these persimmons. The subtlety of the modeling of their shapes is remarkable. The heaviest one, with the heaviest weight of ink, is painted as an oblate circle. It seems to have greater weight, as if it had been pushed down a little harder than the others. The long, flowing, thick-and-thin brush stroke that models the lightest of the persimmons seems to make it float in contrast to the heavy, dark one. Note the subtle placement of these "inanimate" objects. There is a slight overlap at the left, a separation of two at the right, a large overlap at the

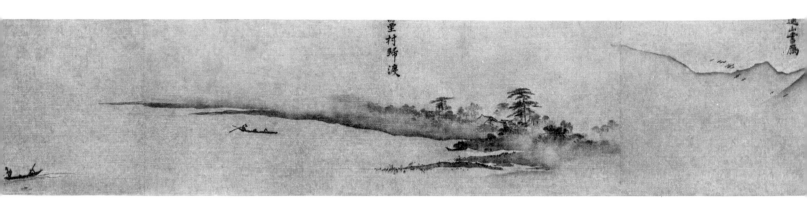

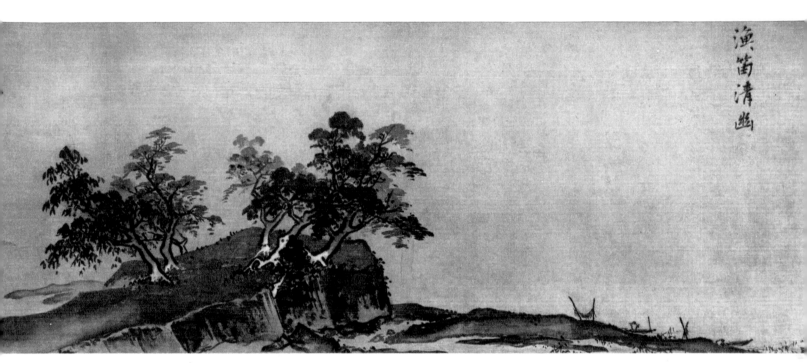

463. The Clear and Sonorous Air of the Fisherman's Flute.
Detail of figure 462

464. *Clear and Distant Views of Streams and Hills.* By Hsia Kuei (c. A.D. 1190-1225). *Handscroll, ink on silk, height 18¼"; length 34'. Southern Sung Dynasty.* National Palace Museum, Formosa

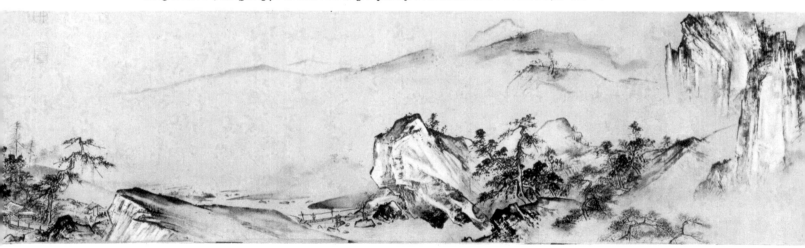

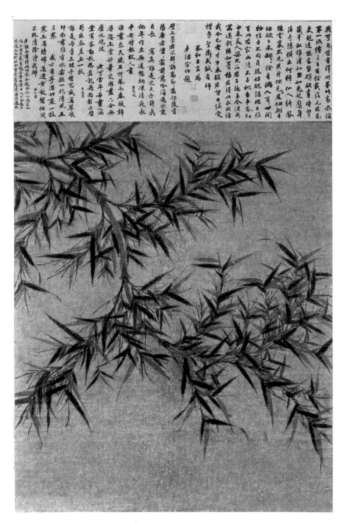

465. *Bamboo. By Wen T'ung* (A.D. 1049-1079).
Hanging scroll, ink on silk, height 52".
Northern Sung Dynasty.
National Palace Museum, Formosa

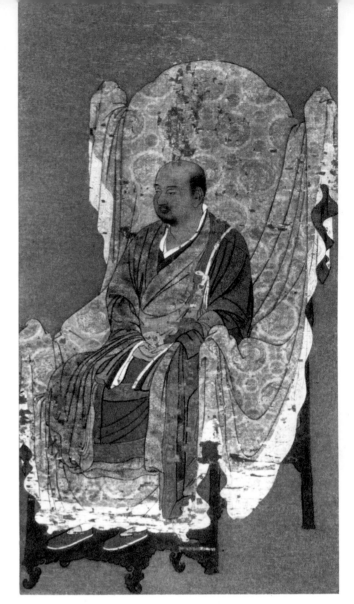

466. *Portrait of Priest Pu-k'ung.*
Traditionally attributed to Chang Ssu-kung.
Hanging scroll, ink and color on silk, height 45".
Southern Sung Dynasty. Kozan-ji, Kyoto

far right, and then the complete separation of the single fruit placed below the level of the others. All of these subtleties and refinements, including the treatment of the stems and leaves, as if they were Chinese characters, reveals brush control at its very highest level. The combination of sharpness and vagueness, of great darkness with extreme lightness are extremes unknown even to the Lyric mode and seem appropriate only to the Spontaneous Style. These extremes recall the short tests or problems, the *Kung-an* (Japanese: *Koan*) of Ch'an Buddhism:

"Who is he who has no companion among the ten thousand things of the world?" "When you swallow up in one draught all the water in the Hsi Ch'iang [river], I will tell you." Another is: "Who is the Buddha?" and the answer, "Three *chin* of flax." Still another example: "What is the meaning of the First Patriarch's visit to China?" with the answer, "The cypress tree in the front courtyard."[14]

The second great master of the Spontaneous Style and, although not a monk, famous for Buddhist subjects, was Liang K'ai. We are fortunate in possessing works by him which show considerable range, beginning with the famous *Shakyamuni Leaving His Mountain Retreat* (fig. 469). This work combines some elements of T'ang Central Asiatic figure style with the Lyric landscape mode, and shows Liang as a very disciplined and original painter, but still within the Chinese court tradition in which he began. One of the great expressions of the Spontaneous Style is the *Hui Neng, the Sixth Ch'an Patriarch, Chopping Bamboo at the Moment of Enlightenment*, which combines the attitude found in Shakespeare — that much can be learned from a fool — with the Ch'an Buddhist idea of

roughness, spontaneity, and the belief that the seemingly impossible provided the answer to everything (fig. 470). The subject is expressed through an appropriate technique ranging from the most precise use of calligraphic brushwork to indicate the joints and movement of fingers, through long curves indicating the roundness of the arms, to the almost scrubby use of a tremendous ropelike brush, giving the texture of the bark of the tree. At the left is the artist's signature, not the neat, carefully written signature of a Li T'ang or a Li An-chung, but the bold, almost illegible, but powerfully conceived insignia of the artist. Liang K'ai and Mu Ch'i are the greatest masters of the Spontaneous school. There are a few other paintings by them, for the most part in Japan, and a very few Sung works in this style in China. For the study of these masterpieces we must go to Japan; for the study of their logical development in China, we must wait for the works of the seventeenth-century individualists.

Chinese ceramics of the Sung Dynasty are probably the classic expression, not only of ceramic art in China, but in all the world. By classic we mean that the ceramics of the Sung Dynasty achieved a unity of the essentials of the ceramic art which has never been surpassed. Shape, potting technique, glaze, from both an aesthetic and chemical standpoint, decoration, and the technique of using the materials and firing them were all unified at the highest level. The result was a flawless series of wares which still command the respect and admiration as well as the despair of the modern potter. In general, the shapes of the Sung Dynasty wares are extremely simple. They tend to be subtle, one form flowing into another, in contrast to the ceramics of the T'ang Dynasty and earlier, with their sharp differentiation of parts. Thus, while one can speak of the neck, body, and foot of a T'ang ceramic, it is very difficult to know in many Sung wares where the neck commences, the body leaves off, or the foot begins. One form flows with ease into the other, producing a unified effect. The glazes of Sung ceramics tend to be monochromatic and have surfaces that are usually

359

467. Triptych: (left) A Crane in a Bamboo Grove; (center) The White-Robed Kuan Yin; (right) A Monkey with Her Baby on a Pine Branch. By Mu-Ch'i (Fa-ch'ang) (b. early 13th Century, active A.D. 1269). Hanging scrolls, ink and slight color on silk, height 70". Southern Sung Dynasty. Daitoku-ji, Kyoto

468. Six Persimmons. By Mu-Ch'i (Fa-ch'ang) (b. early 13th Century, active A.D. 1269).
Ink on paper, width 14¼". Southern Sung Dynasty. Daitoku-ji, Kyoto ·

469. Shakyamuni Leaving His Mountain Retreat. By Liang K'ai (b. third quarter of 12th Century A.D.; d. probably after 1246). Hanging scroll, ink and slight color on silk, height 46½". Southern Sung Dynasty. Tokyo National Museum

floral nature — though some figure ornamentation is known — and it was arranged to enhance the form of the pot. But usually, ornament in the great Sung porcelains was kept to a minimum.

It is important for us to realize the distinctions between North and South in Chinese ceramics, at least from a general standpoint, in order to understand the types of Sung ceramics. It seems to be true that the wares from the North of China tend to be of a white or creamy white color, both in body and in the glazed appearance. White stoneware was the pervasive type of ceramic in the North, used by peasant and rich man alike, with the exception of certain special wares made

470. Hui Neng, the Sixth Ch'an Patriarch, Chopping Bamboo at the Moment of Enlightenment. By Liang K'ai (b. third quarter of 12th Century A.D.; d. probably after 1246). Hanging scroll, ink on paper, height 29¼". Southern Sung Dynasty. Tokyo National Museum

rather soft and mat. They appear to be an integral part of the form of the ceramic object and have a wondrous depth and texture inviting the spectator to touch. This was achieved by a pragmatic chemistry which, while not skilled or knowledgeable from the standpoint of formulas or modern chemical processes, achieved by trial and error a very high level of chemical technique. Fortunately, their chemical method was not perfect and, consequently, their glazes have enough imperfections in the form of chemical impurities to relieve the effect of the glaze from that hard and bright single-color effect so characteristic of later Chinese porcelains. The ornament used on Sung ceramics was, with the exception of one class, very spare, chaste, and subdued when used at all. Often the ornament was incised or carved on the body before the application of the glaze, which served to hide the ornament to a certain extent, allowing the form of the vessel to dominate the decoration. Where incised and molded ornamentation was used, it was generally of a

361

471. *Gallipot Vase. Tz'u-Chou stoneware, height about 18".*
Sung Dynasty. Ex-C. T. Loo Collection, New York

472. *Pillow. Tz'u-Chou stoneware, length about 12".*
Sung Dynasty. City Art Museum of St. Louis

for a limited aristocratic consumption. Contrariwise, in the South the pervasive ware was either pale blue-white or, more often, green, ranging from olive to blue-green. In the North, the pervasive ceramic was a stoneware not fired to the high temperatures necessary to produce porcelain. In the South, porcelain was commonplace, and most of the celadons, the dominant ware of the South, were porcelain by Chinese defini-

tion. Perhaps some of these basic distinctions can be attributed to environment, particularly the landscape and the deposits beneath it. The North was a large area of flat plains — the loess country — with little mountainous terrain, except in certain rather limited areas. In the North, beneath the soil is coal; even by the time of the Sung Dynasty the forest cover had largely disappeared. The South is very mountainous and even today there is forest cover. Perhaps the difference between the white ware of the North and the green ware of the South can be attributed in part to the fuel in the North, coal, which burns at a lower temperature than that reached by the use of faggots of wood. Furthermore, the landscape in the North forced the development of a kiln type called the beehive kiln, built on the surface of the earth. This type of kiln could not produce at that time, in many cases, the high temperatures necessary to produce porcelain. In the South, the hillsides allowed the development of what is called a dragon kiln. Such a kiln stretches up the side of a hill with the opening at the top, where the natural draft produced very high temperatures when combined with the use of wood as fuel. These high temperatures made the production of porcelain much more simple and, indeed, mandatory. All of these general distinctions fall by the wayside when we consider Imperial wares, where anything was possible because of the wealth and the techniques at the command of the emperor and his court. Thus, one can find green wares and black wares in the North, and as many white wares were produced in the South, especially in the later Sung Dynasty. But in general, the distinctions of Northern and Southern types in Chinese ceramics are valid and help to simplify a complicated picture.

We will begin by considering the classic Northern wares and then those of the South. Both Northern and Southern wares were made at the same time, but there is a chronological development from North to South, because the court was forced to move South with the fall of the Northern capital. Thus, the most extremely refined and aristocratic wares were produced at the end of the Northern Sung Dynasty and in the Southern Sung Period.

The standard ware of the North is a decorated slip stoneware, called *Tz'u-Chou*, from one of the principal kiln-site towns in the North. It would be better to call these wares *Tz'u-Chou* type or, better still, Northern slip-decorated stoneware, for the varieties of this ware are extremely numerous, and the quality runs from very inferior peasant wares to those of the highest quality. The essential elements of the *Tz'u-Chou* type are a stoneware body, usually creamy in color, covered with a white slip as the basic ground for further de-velopment of decoration or color (fig. 471). These elements are seen in a vase with a rich, slightly creamy white color, produced by the slip over the buff body

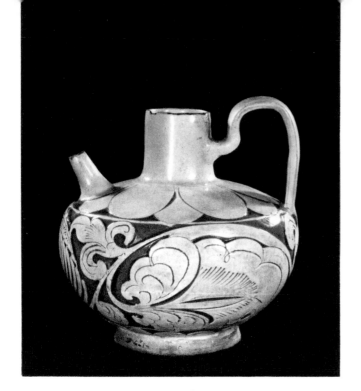

473. *Winepot. Tz'u-Chou stoneware, with carved decoration, height 6⅞". Sung Dynasty.* Cleveland Museum of Art

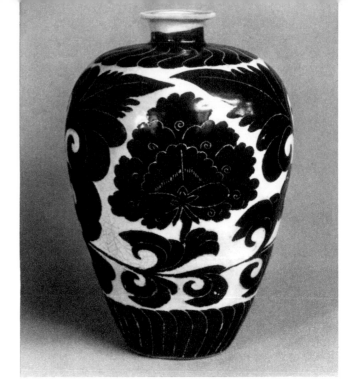

474. *Gallipot Vase. Tz'u-Chou stoneware, with carved decoration, height 12¾". Sung Dynasty.* Inoue Collection, Tokyo

— the latter can just barely be seen at the base of the pot. The first and simplest type of decoration on the white ground is painted. Such decoration was executed in dark brown or black slip and, for Chinese taste, the blacker the color, the more desirable the effect. This standard Northern ware was made for all classes of the population and often tended, therefore, to be rather rough and robust in shape and decoration. Judged by the imperial standards of the Sung and later dynasties, they were not considered part of the classic tradition.

An object made in great quantities in the *Tz'u-Chou* type is the ceramic pillow (*fig. 472*). These are often decorated with rather naturalistic and freely painted designs. The pillow of our illustration, with a bird on a branch looking at an insect, gives us a very good idea of the freedom with which the artist used his brush and of the influence that must have filtered down to him from painters of the period. At the same time, there is the robust, rather devil-may-care handling of the brush and decoration so characteristic of folk art.

In addition to painted decoration, there is a variant which is monochrome, and the reverse of white—black or, in some cases, brown. Such effects are achieved by a thick glaze over the buff body without the intermediate use of slip. Wares of this type are also found throughout North China, and are sometimes called *Honan* wares; but they can be generally grouped with the Northern slip-decorated stoneware category.

The second basic decoration for *Tz'u-Chou* ware is done by incising or carving, or combinations of these. For example, a *Tz'u-Chou* teapot or winepot, with a buff body, is covered with a thick white slip, then the slip is carved away to the buff body and the whole is covered with a transparent glaze (*fig. 473*). The result is a combination of two-tone color with a powerful sculptural decoration somewhat related to certain designs derived from T'ang and early Sung silverwork. Much of the best *Tz'u-Chou* ware appears at the beginning of the Sung Dynasty and shows the influence of T'ang metalwork and of T'ang shapes. This particular teapot, with its high foot and sharp differentiation of neck, body, and foot, reveals a T'ang carry-over in its general form. A variation on the carved decoration is to be found in another vase, a gallipot, where the decoration is carved away from a brown slip, and a white slip is used to fill in the areas cut away (*fig. 474*). In this particular case, the decoration is the standard peony type used so often on the best *Tz'u-Chou* wares, displaying that rich combination of dark black-brown and creamy white which is one of the most characteristic and decorative effects of the ware.

An even more elaborate combination of the incised and carved techniques is to be found in a large vase considered by many to be one of the two or three greatest *Tz'u-Chou* vases in the world (*fig. 475*). The style of the T'ang Dynasty is continued in its shape, with the sharply differentiated spreading lip, long neck, very definitely marked shoulders of the body, and the sharply cut high foot. The technique of the vase is a combination of incising and inlaying, among the rarest of the techniques found in *Tz'u-Chou* ware, and one which seems characteristic of a particular site in Northern China called by various names, but perhaps

363

most commonly Chiao-Tso. Here a combination of brown slips, needle-point incision, and the use of white-slip inlay produces a type of decoration clearly under the influence of metalwork, particularly of incised silver. The strong masculine character of *Tz'u-*

475. Vase. Tz'u-Chou stoneware, with incised decoration, height 16¼". Sung Dynasty, A.D. 960-1279.
Cleveland Museum of Art

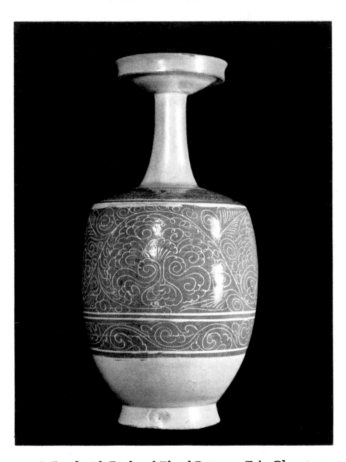

476. Bowl with Bird and Floral Patterns. Tz'u-Chou type, stoneware, diameter 6⅜". c. A.D. 1300.
Cleveland Museum of Art

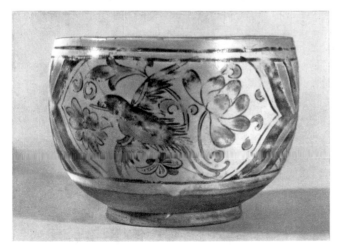

364

Chou shape and decoration is especially marked in this piece.

At the end of the Sung *Tz'u-Chou* tradition we find the use of colored enamels, instead of plain black or black-brown slip, in a series of wares, some of them dated pieces, ranging from 1204 until well into the Yuan Dynasty, with yellow, red, and green enamels on top of the standard white *Tz'u-Chou* slip (fig. 476). These appear to have been made under Mongol or Tartar influence and, while representing but a small group within the Sung Dynasty *Tz'u-Chou* ware, are of great importance for the development of Chinese porcelain in the Ming and Ch'ing periods, for they are the beginning of various color-enameled types that became important to imperial taste in the Ming Dynasty. The enamel technique represents a Chinese allowance for what might be considered barbarian taste: rich color and a rather gay and full effect quite unlike that desired by the Sung court. It should be said in conclusion that *Tz'u-Chou* ware has been made all through the history of Chinese ceramics from early Sung times until the present day, and many of the pieces that were formerly considered to be of Sung, or even Yuan date, we now know as Ming, or even Ch'ing.

If slip-decorated stoneware was the standard Northern ware, then the most important of the porcelains made in the North was the ware called *Ting*, after the type-site at Ting-Chou in Chihli province in North China. Shards of the ware have been found in various parts of North China, and while the center appears to have been around Ting-Chou, the type may have been made at various distances from that site. In contrast to *Tz'u-Chou*, it is porcelain: that is — by Chinese definition—a ware in which glaze coalesces with the body, and which, when struck with a hard instrument, produces a clear, resonant tone. This is in contrast to the traditional Western definition of porcelain, which requires translucency. Obviously almost anything can be made translucent if sliced thin enough; it is also possible to have a true industrial porcelain of the highest known vitreous substance which would not be translucent if it were too thick. The Chinese test of resonance for porcelain is inconclusive only in that certain low-fired earthenwares with a high proportion of chalk can also be resonant. But in general, resonance is as good an indication as any for a highly fired piece, where the glaze and the body adhere tightly together. *Ting* ware, then, is a porcelain, which has a creamy white body covered with a transparent, almost colorless glaze that occasionally accumulates in thick straw-colored drops called tearstains by Chinese connoisseurs (fig. 477). The standard types are usually bowls or dishes, though some vases are known. The bowl in our illustration is one of the great examples of *Ting* ware, the finest-known bowl decorated with swimming ducks, water reeds, and waves indicated by comb marks, all

LEFT: *477. Bowl. Ting porcelain. Sung Dynasty.*
Museum of Fine Arts, Boston

BELOW: *478. Bowl. Ting porcelain,
with molded decor, diameter 10⁹⁄₁₆".
Sung Dynasty.* Cleveland Museum of Art

incised in the white paste of the porcelain. Ting ware has delicacy and refinement combined with simplicity of shape, which make it particularly attractive to the modern Western connoisseur. The ware is relatively thin and was usually fired on its raw rim, thus requiring the addition of a metal rim, usually of copper, rarely of silver, and even more rarely of gold. *Ting* potters, in addition to using incised techniques, also produced wares with molded designs (*fig. 478*). The peony, again, is a favorite decorative motif.

In addition to the incised and molded white porcelains, *Ting* potters produced a rare brown or black glazed ware, called black or purple *Ting* by the Chinese (*fig. 479*). This was simply the usual white porcelain body covered with an iron-oxide glaze which ranged from cinnamon brown to a deep and lustrous black. These are thin and resonant wares, very rarely decorated with painted or gold-stenciled designs applied with lacquer, and are among the rarest of all Sung ceramics. One other type of *Ting* ware seen in a few vases and pillows has a decoration in iron oxide under the transparent glaze, usually with designs of peony scrolls clearly related to *Tz'u-Chou* decor. In figure 480 we see a truncated bottle vase from the Iwasaki collection, perhaps the most perfect and beautiful specimen known. It is differentiated from its *Tz'u-Chou* counterparts by its thinness and, fired at a high temperature, is therefore porcelain—resonant and hard when compared with the softer stoneware.

While the *Tz'u-Chou* and the *Ting* types make up the largest proportion of Northern ceramics, there are important nonwhite categories. The first of these we

will call *Northern Celadon*, since the color is green and appears to have been related to wares produced in the South, particularly *Yueh* ware. *Northern Celadon* is a gray-bodied porcelain usually with a rather brilliant sea-green or olive-green glaze, often with over-incised decoration. It appears to have been made in the North as an attempt to rival the *Yueh* wares of the T'ang and early Sung dynasties from the South and to have used decorative motifs derived from the contemporary *Tz'u-Chou* and *Ting* wares, especially the peony-type decoration or, in this case, the water lily and lotus decoration most characteristic of *Northern Celadon* (*fig. 481*). Japanese attempts to identify it as *Ju* ware have proved to be abortive, and the best name for this ware, apparently not described in the ancient Chinese texts, is still *Northern Celadon*. Perhaps the most extraordinary specimen is the porcelain pillow in the Iwasaki collection, on which a decor of peonies on the sides and of

365

peony scrolls around a flying phoenix on the top recalls the decoration on Southern *Yueh* wares (*fig. 482*). There are a few rare *Northern Celadons* which display a molded decoration.

A second nonwhite ware produced in the North, and oddly enough related to *Northern Celadon*, is called *Chun* ware. It has the same kind of gray to gray-tan porcelain body as *Northern Celadon;* and despite the fact that its glazes, emphasizing blues, purples, and reds, seem radically different from that of *Northern*

Celadon, chemical analysis reveals that they are very close indeed. The difference seems to have been produced by kiln atmosphere and the use of certain ashes thrown into the kiln at the crucial moment to produce the reducing atmosphere necessary for the opacity of color achieved in the *Chun* glazes. *Chun* ware was extremely popular with Western collectors in the period after the initial discovery of Sung Dynasty porcelains, from about 1910 to 1930, in part because of its brilliant color, easier to appreciate for those who had been trained on Ch'ing porcelains, especially the powder blues, "ox-bloods," and "peach blooms." *Chun* experienced something of an eclipse in recent years, but is now returning to favor in those works in the free shapes of the potter's craft rather than those which imitate shapes in metal or other media. The covered vase illustrated (*colorplate 36, p. 340, top*) is one of the rare examples of which the cover has been preserved, and illustrates the essentials of the *Chun* glaze: opaque, rather milky in texture and with color ranging from soft powdery blue to rather deep purple, with occasional splashes of green or red. Another type of *Chun* ware may well be Sung, although there is some argument now that certain examples of this particular shape and type should be dated Ming or even early Ch'ing. These have a brilliant, glassy glaze, with brighter reds and purples, in addition to the powdery blue, and the shapes are usually those influenced by metal or other materials. Oftentimes they have a number incised on the bottom, ranging from one to ten,

ABOVE:
479. Bowl. Ting porcelain, with lacquer decor, diameter 6⅞". Sung Dynasty. Inoue Collection, Tokyo

RIGHT:
480. Truncated Bottle Vase. Ting porcelain, height 7½". Sung Dynasty. Iwasaki Collection, Tokyo

and many of them were apparently used as flower containers (*colorplate 36, p. 340, center*). The illustration shows the flower-container type and a typical combination of liver red and blue. The foliate rim recalls shapes wrought in silver of the late T'ang and early Sung dynasties, as do the three scroll legs.

It is not surprising that by the end of the eleventh century, the imperial court requested special wares from the potters who made the *Chun* and *Northern Celadon* wares and a new ware was developed, called *Ju*. This, coming at the very end of the Northern Sung Period and produced for only a few years, is the rarest of all Imperial wares made during the Sung Dynasty. While undoubtedly some *Ting* and *Chun* wares were made for imperial use and hence could be called Official (Imperial or *Kuan*), the first eclectic ware made for imperial use was *Ju* ware, and an incised testing disk now in the Sir Percival David collection in London gives the specific date of 1107 for its first firing. One of the few known *Ju* pieces in the United States is in the Cleveland Museum of Art (*colorplate 36, p. 340, below*). It appears to be based upon the *Chun* style; its general color is bluish, an indefinable hue of soft, almost bird's egg blue, unlike any of the blues produced either before or since that time. The shapes of the known *Ju* wares are very simple, but subtle, with certain carryovers of the T'ang type, often noted in the concave roll of the foot. But the most important determinant for *Ju* ware, because some Korean celadons do come fairly close to this color, is a special crackle peculiar to all examples of the ware. It can only be described as flaky, as if a very fine and regular pattern of flakes of glaze were laid over the surface of the body. The result is a ware which appeals to the senses of touch and sight, one of the most subtle wares ever produced under imperial patronage. The one little black spot is identified in Chinese sources of the fourteenth century as one of the slight imperfections characteristic of genuine *Ju* ware, which even by the fifteenth century was being forged for the Chinese connoisseur. The prices paid by Chinese collectors through the Ming and Ch'ing dynasties for *Ju* ware would make some of the prices paid today seem mild indeed; for to the great Chinese collector, next to jade, fine porcelain was one of his most prized possessions.

Another Imperial ware, called *Tung*, appears to have been derived from the *Northern Celadon* type and was made for a very short time. The typical color of the *Tung* ware glaze is a warm leaf green, quite different from *Northern Celadon*. Certain *Northern Celadon* decorative techniques were used, but usually in a most refined and precise way, as in the winepot of figure 483. It was acquired as a particularly fine *Northern Celadon* ware, but we are now able to identify it almost certainly as one of the finest examples of *Tung* ware. The little lion used as the spout for the ewer

481. Dish. Northern Celadon porcelain, with carved design, diameter 7¼". Sung Dynasty. Cleveland Museum of Art

482. Pillow. Northern Celadon porcelain, with molded design, length 9¼". Sung Dynasty. Iwasaki Collection, Tokyo

shows the influence of Southern style, particularly in wares of the *Yueh* type, while the over-all appearance of the piece has some relationship to metalwork in its sharply carved design.

Other Imperial (*Kuan*) wares were probably made at special kilns of the Northern capital. It is almost impossible to differentiate these from the Imperial wares produced in the South after the capital was moved. While perhaps some of the pieces we will consider in our discussion of Southern *Kuan* ware were made in the North, we have chosen to consider them together because they form one homogeneous group. When the capital fell, the potters went with the fleeing court. We know, for example, that the *Ting* potters went South to a place called Chi Chou, and there made the same

wares they had made in the North. While the *Ting* potters produced those Southern wares which are almost indistinguishable from those produced in the North, the court was now in the great center of green porcelain production, and the ultimate result was that the greatest of the *Kuan* wares were produced by the Southern celadon potters.

Before we take up the *Kuan* wares, let us first then consider the pervasive ware made in the South, celadon, or more specifically *Lung-Ch'uan* ware, after the type-site Lung-Ch'uan in Chekiang province. The ancestor of the *Lung-Ch'uan* ware was *Yueh* ware, which had been made, you will remember, from the Han Dynasty on. By the tenth century, *Yueh* ware was surrendering its primacy in the South to the products of the Lung-Ch'uan kilns. The finest of these early Sung *Yueh* pieces is a bowl with a carved dragon decoration, in the Metropolitan Museum of Art (*fig. 484*). Despite the rather watery gray-green glaze on the green porcelain body, the total result is masculine and powerful and was considered to be the finest and rarest of all porcelains in the T'ang Dynasty. You will note that there are some imperfections: the glaze is a little thin, so that some of the imperfections in the body tend to show through it, and there is an overreliance on decoration because of the weak character of the glaze. But with

484. Bowl with Carved Dragon Decoration. Yueh porcelain, diameter 10½". Sung Dynasty. Metropolitan Museum of Art, New York

483. Winepot. Tung porcelain, height 7⅜". Northern Sung Dynasty. Cleveland Museum of Art

the arrival of the court in the South, and with the changing taste of the Sung Dynasty, we witness the triumph of *Lung-Ch'uan* and the obliteration of the *Yueh* kilns as far as any wares produced after the tenth century are concerned. Imperial and scholarly Chinese taste triumphed and the result was the rapid development of the Lung-Ch'uan kilns.

At the base of the development of the late Sung *Lung-Ch'uan* celadons and *Kuan* wares is a particular type of taste characteristic of the Chinese scholar and of the Chinese imperial line, which must be understood if we are fully to appreciate the *Lung-Ch'uan* and *Kuan* wares. To the Chinese, jade was the most precious of all materials — the feel of jade, its unctuous texture to the touch and to the eye; the color of jade, ranging from the rich greens through grays to browns and brown-greens; the depth of jade, something very much desired, loved, and honored by the Chinese collector. *Yueh* potters could not produce a porcelain as attractive as jade or even with some of the characteristics of jade. But *Lung-Ch'uan* and *Kuan* potters could; and this desire to produce a ware that rivals jade is at the heart of the great development of porcelain in South China during the Sung Dynasty.

The typical *Lung-Ch'uan* ware can be seen in the vase shown in colorplate 37, page 373. It has a white to white-gray porcelain body which burns to a sugary brown or even a reddish brown where exposed to the flame of the kiln, covered by a thick glaze with many tiny bubbles beneath the surface, and ranging in color from a celadon sea-green to olive-green, blue-green, and a blue that is almost as blue as *Chun.* The color on this vase is a blue-green of great depth; the thickness of the glaze covers any imperfections that may still remain in the body. The result is a material that does indeed rival jade in appearance. It is from such *Lung-Ch'uan* wares that the great *Kuan* wares developed. The bowl (*colorplate 37, p. 373*) is a perfect example of the characteristic sea-green color and also shows the extremely subtle carved decoration sometimes used in *Lung-Ch'uan* wares. The new decoration tends to adhere to the shape, to help form the body; in this case a simple carving of the exterior conveys a suggestion of althea petals. The thick glaze can be sensed by the undulations brought out by the reflections of light from its surface. A variety of shapes was developed especially for the antiquarian taste of the court. One of these was a variation on archaic bronze tripod shapes, but with color and glaze which rival jade.

All of these pieces are devoid of crackle; indeed, the perfect *Lung-Ch'uan* pot is usually completely without crackle. There are, however, certain celadons which show an apparently accidental crackle. This crackle is of great importance for the development of *Kuan* ware, and certainly the experiments of the *Lung-Ch'uan* potters in the use of crackle, at first accidental and then purposeful, were the entering wedge for the characteristic controlled crackle of the *Kuan* wares. An example from the Freer Gallery (*fig. 485*), is a type called *Kinuta*, meaning "club shaped." The name came to be applied to the particular kind of blue-green color seen here, so that the shape name became a color name; and to the Japanese *Kinuta* represents the finest of all celadon colors. The fish handles are particularly well modeled and the proportion of their size to the neck and body of the vase is beautifully calculated. The square vase illustrated in figure 486, from the National Museum in Tokyo, is an example of *Lung-Ch'uan* with an apparently purposeful crackle, yet the glaze and the body seem to be of typical *Lung-Ch'uan* manufacture. It is a moot question whether this is a crackled

369

487. Kundika (Buddhist Ewer for Holy Water).
Stoneware, with incised decor, height 14¼".
Koryu Period. Cleveland Museum of Art

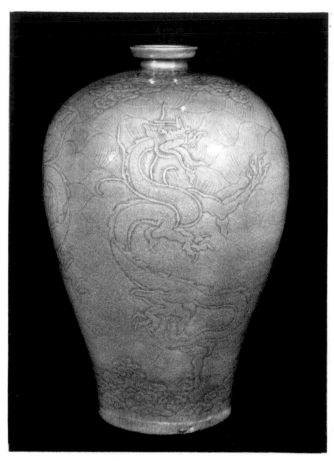

488. Mei-p'ing Vase. Celadon porcelain, with
incised decor, height 13⅞". Koryu Period.
Museum of Fine Arts, Boston

Lung-Ch'uan vase or one of the early imperial crackled pieces derived from celadon. The shape again reveals the antiquarian interests of the court. It is a *ts'ung*, the symbol of Earth, often found in jades of the Middle and Late Chou periods.

Related to the various Chinese celadons are those made in Korea during the Koryu Period (918-1392) (fig. 487). The first wares were based on the *Yueh* tradition, often copying the shapes and decoration characteristic of the earliest Chinese celadon tradition. The thin glaze of *Yueh* was continued by the Koryu potters but with a modified color, a distinctive watery blue-green. A second major influence on Koryu celadons, oddly so since Sung vases of this group relied almost always on color and shape alone, was the slip-decorated stoneware of the North (fig. 489). In this case the decorative variety and nonchalant technique of *Tz'u-Chou* ware were sympathetic to the Korean potters' inclinations. The difficult slip-inlay techniques of the Chinese ware were seized upon and elaborated, producing a rich style called *mishima* by the Japanese (fig. 490). Where

the Chinese strove for and achieved subtle perfection, the Koreans' subtlety lay in their free use of pottery technique to achieve spontaneity with no thought for perfection.

There is no such thing as a "perfect" Koryu celadon; each has a flaw, however minor and unimportant, deriving from the potter's rapid execution and the circumstances of large-scale production. For the ceramic enthusiast the expected blemish enhances the relaxed beauty of Koryu wares. The best works rival the greatest of Sung achievements, and even the Chinese connoisseur acknowledged their merit (fig. 488).

The logical and aesthetic culmination of the Sung celadon tradition is found in the *Kuan* wares made for the court. The tradition of a special Imperial ware goes back at least to the early twelfth century in the *Ju* ware produced for the Northern capital. With imperial resources almost anything was possible; but the imperial desires were quite specific and the results combined the antiquarian instincts of the court with the subtle sensuality of the Chinese scholar-aristocrat. *Kuan* ware,

like *Lung-Ch'uan*, intends to imitate jade but with such sensitive changes — the most important being crackle — that the simulation becomes even more like the precious stone. Beginning with the high-fired celadon glaze, off-white to gray to green to brown, as jade itself was, the potter developed a purposeful and stained crackle that may have simulated the fissures and earth stains of jade. The glaze was made thicker, and the body darker and thinner. This latter tendency was a true innovation of the highest importance, for the dark ground tempered the brilliance of the glaze, softening it, making it as "lustrous as jade." Thinning the body and thickening the glaze heightened the new effect. *Kuan* ware became a glaze suspended on the frail framework of the body.

Some idea of the rarity and desirability of such wares may be had from a tale told in later times:

"Ts'ao Ch'iung of the Chia district of Hsiu, a man of substance and a connoisseur, got hold of a censer two inches and more in height and broad in proportion; the cover consisting of a beautifully carved piece of jade representing a vulture seizing a wild swan — a really lovely piece.

"News of it trickled through to the ears of the local Governor Mo, a eunuch, who jailed Ch'iung and demanded it by way of ransom; and Ch'iung's son had no option but to hand it over. Later a certain powerful person in charge of the Board of Rites seized it from Mo.

"In the time of Cheng Te thieves stole it and sold it in Wu-hsia where Chang Hsin-fu of Tien-shan in Shanghai acquired it for two hundred ounces of gold. Chang took it home and resold it to an expert; and the palace never recovered it. That was a genuine old Ko piece." [Pi Ch'uang So Yu][15]

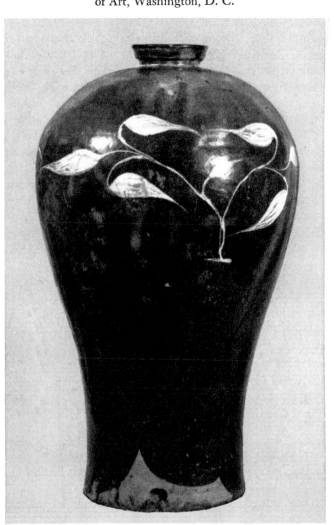

489. *Vase. Black Koryo stoneware, with incised decor, height 13⁹⁄₁₆". Koryu Dynasty.* Freer Gallery of Art, Washington, D. C.

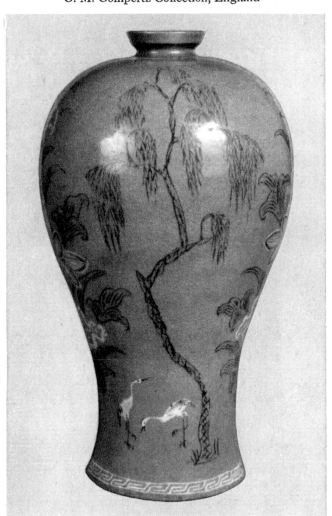

490. *Mei-p'ing Vase. Celadon porcelain, with inlaid design, height 13½". Yi Period.* G. M. Gompertz Collection, England

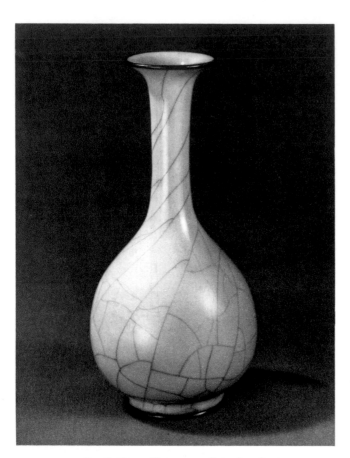

491. Bottle Vase. Kuan porcelain, height 6⅝".
Sung Dynasty. Sir Percival David Foundation, London

492. Tea Bowl. Chien porcelaneous stoneware,
height 2¾". Sung Dynasty. Cleveland Museum of Art

this A type are rather simple and pure ceramic types: notably the "althea petal bowl" and the "gall-bladder vase" (*colorplate 38, p. 374, left*). The B type, including those wares ascribed to the Phoenix Hill kiln in Hangchou, is bluer in its color with a more grainy body and often a smaller crackle pattern. Both purely ceramic shapes and those influenced by ancient bronzes are known, notably the *lu* incense burner (*colorplate 38, p. 374, right*). A third *Kuan* type, the "Suburban Altar" wares from Hangchou, may have been Imperial in part but the majority of them were probably made for general use or as souvenirs for Altar pilgrims.

Readers may find occasional references to *Ko* (elder brother) ware. This seems to be a term of later invention and not applicable to true Sung Imperial wares.

A quite different ware of humble origin was equally specialized and functionally successful. *Chien* ware, named from the province of its manufacture, Fukien, was a heavy, dark brown and purple-bodied ceramic with a thick, iron-brown glaze. It was made only in tea bowls, but these achieved a functional truth equaled only by modern insulation porcelains (*fig. 492*). The tea cult, sometimes associated with Ch'an Buddhism in China, may well have been the spur to the special development of *Chien* ware. Like the spontaneous ink-painting style associated with many Ch'an monk-painters, *Chien* ware was seemingly rough and direct, but with concealed subtleties. Tea should be hot; the cupped hands holding the bowl should be no more than pleasingly warm. Tea is green and needs, especially for the residue, a dark brown background for full aesthetic appreciation. The base of the bowl should feel quietly rough to the palm of the hand; the lip of the bowl should tend to prevent unseemly dripping. All of these requirements were perfectly met by the *Chien* tea bowl and its success led to imitation both near at hand in the *Kian* wares from Kiangsi with their "tortoise-shell" exteriors, and in the North (Honan), where the white body of the tea bowl was camouflaged and made a counterfeit of *Chien* by the application of a dark brown or purple slip over the exposed foot.

These humble tea bowls, much admired by Japanese tea masters of the Ashikaga and later periods, were called *Temmoku*, a Japanese term for all types — *Chien*, *Kian*, and *Honan*. The *Seto* kilns near Nagoya made excellent imitations for the Ashikaga tea masters, the only major difference being in the characteristic gray body of the Japanese bowls.

Unloved in its own day — we have no contemporary Chinese name for the ware — the pale blue-white *Ch'ing-pai* ware, made in Kiangsi near the sites of the later Imperial kilns of Ching-Te-Chen, was of the utmost importance for the future of Chinese porcelain. While its extreme thinness and its frail, sugary, cream-white body would seem to disqualify it as a traveler, *Ch'ing-pai* ware was a staple export. Shards and complete pieces

Two clearly defined types of *Kuan* ware are now identified, an A type, and a B. One is possibly Northern, but definitely more opaque in glaze and wider in crackle than the other (*fig. 491*). Most of the shapes in

373

Colorplate 37. (above) Mei-p'ing Vase, height 9⅛";
(left) Althea Bowl, diameter 8½". Both: Lung-Ch'uan porcelain.
Sung Dynasty. Cleveland Museum of Art

*Colorplate 38. (left) "Gall-bladder Shape" Vase, height 5⅛"; (right) Lu Incense Burner, width 6⅛".
Both: Kuan porcelain. Sung Dynasty.* Cleveland Museum of Art

493. Bowl. Ch'ing-pai porcelain, with incised decor, diameter 5¾". Sung Dynasty. Victoria and Albert Museum, London

were and are found in Korea, Japan, Southeast Asia, and India. The delicately incised floral and figural designs recall those of *Ting* ware, but the paper-thin walls of these bowls and vases give an added delicacy to *Ch'ing-pai* decoration (fig. *493*). This ware, made heavier and whiter with the rather watery and thin character of its glaze modified, was developed into the *Yuan* Imperial ware called *Shu Fu;* and with a clearer glaze and decoration in under-glaze, cobalt blue be-

came the Imperial "blue-and-white" of the Ming Dynasty. All of its more fortunate contemporaries, *Ting, Ju, Chun, Lung-Ch'uan, Kuan,* were to be continued and imitated in declining quality. The styles of the two poor relations, *Tz'u-Chou* and *Ch'ing-pai,* the one with its rich painted and enameled decoration, the other with its pure fragile whiteness, were later combined in the imperial porcelains of the Ming and Ch'ing dynasties.

16. Japanese Art of the Ashikaga Period

THE JAPANESE PERIOD known as Muromachi or Ashikaga (1392-1573) — Muromachi after the quarter in Kyoto housing the *shogun's* palace, Ashikaga after the ruling *shoguns* — is one of disastrous political confusion and continuous warfare. We witness now the solidification of the feudal *shogun* system. What had begun in the Kamakura Period as a pragmatic reaction to the problems of the split between the court aristocracy and the warrior class in the twelfth century, now became a system — with a *shogun* and an emperor. But since it solidified at a time when disorders mounted, it is not surprising that the *shogun* could not exercise power as fully as did Yoritomo and his followers in the Kamakura Period. The emperor's already weakened power became nonexistent, and even the *shogun's* authority was shadowy. The government was unified at Kyoto,

494. Table Top. Lacquered wood, with design in gold and silver, length 23". Ashikaga Period. Cleveland Museum of Art

and this in itself is meaningful. Instead of keeping the government at Kamakura, away from the blandishments of the court, the residence of the *shogun* was returned to Kyoto, and so the *de facto* government was again near the complicated and ritual-ridden atmosphere of the court. As one might expect, a time of troubles, with power no longer effectively wielded by either emperor or *shogun*, indicates that other things were of more interest to them. As the poor became poorer, the wealthy grew richer, chiefly through trade with China and, with their wealth and leisure, devoted themselves to the arts and to the complex culture revolving around Zen Buddhism. Upper-class conduct became standardized, with less of the split existing in the Kamakura Period. Instead of a court art that tended to preserve the aristocratic style of *Yamato-e*, and an *E-maki* style associated with the more effective middle and warrior classes, there was now a substitution of new values based on Sung culture, a product of a like time when men retreated from an undesirable world to the refuge of art and religion.

The binding mortar for the new standards of behavior and interest for the patrons of the arts was Zen Buddhism, and this refuge from growing disaster more than anything else dominated the intellectual life of the time. Accompanying Zen Buddhism was the tea ceremony and a cult of aestheticism which reached heights of dedication — and of ineffectiveness — in the seventeenth and eighteenth centuries. With Zen Buddhism came Chinese art in the form of Sung monochrome painting or Yuan and early Ming painting in Sung style. So overwhelming was the Zen Buddhist control of thought that — as one may see — there was a withering away of interest in native Japanese subject matter and style on the part of the new high intellectuals. The ideal for the Japanese scholar, connoisseur, and painter of the Ashikaga Period was China: Chinese landscape,

ABOVE: *495. Horses and Grooms. One of a pair of
six-fold screens, ink and color on paper, length 12' 1".
Ashikaga Period.* Cleveland Museum of Art

RIGHT: *496. Portrait of Abbot Shoichi-Kokushi.
By Mincho (Cho-Densu)* (A.D. *1352-1431).
Hanging scroll, ink and color on silk, height 100½".
Ashikaga Period. Tofuku-ji, Kyoto*

Chinese-style painting, Chinese ceramics, Chinese
poetry — all under the dominance of Ch'an Buddhism,
called Zen in Japan. Politically, the decline was steady
and the result was to be expected: the rise of a dic-
tator, Nobunaga, who ended the Ashikaga power in
1573, to be followed by the great Hideyoshi.

We have mentioned the importance of first looking
at the traditional or conservative side of a period.
Briefly, the native Japanese styles declined. In the dec-
orative arts and in some paintings, the Fujiwara dec-
orative style of *Yamato-e* was continued largely by art-
ists of the Tosa school. Lacquer in particular was made
for the court in the style of the Fujiwara Period. These
works are of great value today since lacquer is quite
easily damaged, and so few early works remain. The
top of a small lacquer table, illustrated in figure 494,
continues a style of decoration almost identical with
that to be found in the twelfth-century lacquer clothes
boxes. The only indication of a slightly different atti-
tude is to be found in the summary way the silver spit
of land at the left is applied directly over the trunks of
the trees and grasses in gold lacquer beneath. This
rather brusque and arbitrary quality is one used quite
often in painting and especially in the tea-ceremony
works of this period.

In painting, the Tosa school continued the style of the Fujiwara and Kamakura narrative handscrolls in various sizes and proportions. There are numerous handscrolls in a rather debased narrative style; but in the now revived form of the folding screen the Tosa painters produced some of the most important conservative works in the fifteenth and sixteenth centuries. A particularly attractive type, known in several examples, shows warriors and gentlemen pursuing leisure occupations in front of a stable with horses so finely bred, so well groomed and cared for that they require halters around their bellies to prevent them from lying down (*fig. 495*). The individual elements of this style are derived from the *E-maki* style of the Kamakura Period. The arrangement, in this simple repetitive formula, is intended to produce a decorative effect, but this intention does not reach fruition until the beginning of the Momoyama Period.

Portraiture was also continued, and particularly so in the case of the Zen Buddhist sect. We have already seen portraits of the Southern Sung and Kamakura periods (*figs. 466 and 427*), which are the predecessors of the portrait of the abbot Shoichi by the artist Mincho, also known as Cho Densu (1352-1431) (*fig. 496*). Another picture by Mincho will introduce the new monochrome landscape style of the Ashikaga Period. But, for the portrait, one must admit that it adds nothing new to the previous Chinese or Japanese painting. It is an excellent traditional portrait type — the priest seated in a high chair covered with a drapery, with his feet tucked up. The emphasis is on the character revealed in the face: the wrinkles, the one good eye. Such elements of individual character were considered most important by the Zen Buddhists.

One unusual aspect of the traditional art of the Ashi-kaga Period is symbolized by a pair of six-fold screens, the *Sun and Moon* (*fig. 497*). Bordering on folk art, the style is a wild, rough continuation of the *Yamato-e* style that represented the rolling, gentle hills of Japan and the decorative treatment of pine trees, water, rocks, and waves. The sprinkling of gold leaf in the upper left and of some silver in the area to the right of the mountain and around the moon recalls the use of this technique in the *Genji* scrolls. These elements of the Fujiwara decorative style are handled in an exaggerated, even rough way, closer to folk art than to the old aristocratic manner. Other works of this rare type presumably existed in some quantity at the end of the Ashikaga Period, and are of considerable importance for the development of a later decorative style.

The mainstream of creative Japanese painting in the Ashikaga Period is that of monochrome: monochrome painting in Chinese style of Chinese subjects. It was almost a point of honor to ignore the Japanese landscape, though there were notable exceptions. Monochrome painting was associated with the Zen faith, and many of the greatest names of the Ashikaga monochrome style are those of painter-monks. The beginnings of the style go back to the Kamakura Period in certain sketches and a few finished paintings revealing the new mode imported from China. In figure 498 we see one of these very early monochrome examples from Kozan-ji, in Kyoto, a representation of a Zen subject in the new Chinese monochrome technique: the *White-Robed Kwannon*. The subject, seated upon a rock in the midst of the waters, now seems more female than male. The thick and thin treatment of the brush stroke forming the rock; the flowing, waterfall type of drapery; the Chinese style of the face, with the rather

LEFT: 497. *Sun and Moon. Pair of six-fold screens, ink and color on paper, length 10' 4½". Ashikaga Period. Kongo-ji, Osaka*

BELOW LEFT: 498. *White-Robed Kwannon, from Kozan-ji, Kyoto. Hanging scroll, ink on paper, height 36". Late Kamakura Period, A.D. 1186-1333. Cleveland Museum of Art*

BELOW: 499. *Kei-in Shochiku (Hermitage by the Mountain Brook). Ascribed to Mincho (Cho Densu) (A.D. 1352-1431). Section of a hanging scroll, ink on paper, width 13¼". Ashikaga Period. Konchi-in, Kyoto*

379

straight nose and small eyes and a relatively blank or abstract expression, in contrast to the liveliness usually found in Japanese representations — all these derive from such Chinese representations as those of Mu Ch'i. Nevertheless, minor details of brushwork, notably the hints of "nail-head" brush stroke technique in the rock in the foreground, indicate this to be a work by a Japanese painter schooled in native style, making an early attempt at the new Chinese monochrome style. The Ashikaga monochrome school developed from such beginnings.

Mincho also painted in monochrome with landscape subject matter. Of the presumably numerous works of this painter, only one is left: a landscape in the Kon-chi-in in Kyoto depicting a thatch-roofed cottage in a grove of trees overhanging a stream; in the distance are the "axe-hewn" mountains, executed in broad strokes with the side of the brush (fig. 499). If one knows that this painting is Japanese, one can "see" elements different from Chinese style; but the overwhelming impression of the painting is completely and utterly Chinese. This is the extent to which the Japanese priest-painter appropriated, lock, stock, and barrel, the Chinese Ma-Hsia style of the Sung and Yuan periods and used it to develop the Ashikaga monochrome school. These artists believed in the culture and the style with such force and fervor that they were literally able to recreate the lyric style of the Southern Sung Dynasty to such an extent that their work equals or, in some cases, surpasses that of the Chinese masters of Southern Sung. No Chinese critic or Sinologue would ever allow such a statement to go unchallenged, but then — there are the paintings! The little painting by Mincho stands at the threshold of this fruitful development.

Another artist of great importance is Josetsu, active

500. Hyonen Zu (Catfish and Gourd). By Josetsu (active c. A.D. 1400). Hanging scroll, slight color and ink on paper, height 32¾". Early Ashikaga Period, early 15th Century A.D. Taizo-in, Myoshin-ji, Kyoto

501. Winter and Spring Landscape. By Shubun, Abbot of Shokoku-ji, Kyoto (c. A.D. 1390-1464). Six-fold screen, ink and slight color on paper, length 12' 7½". Ashikaga Period. Cleveland Museum of Art

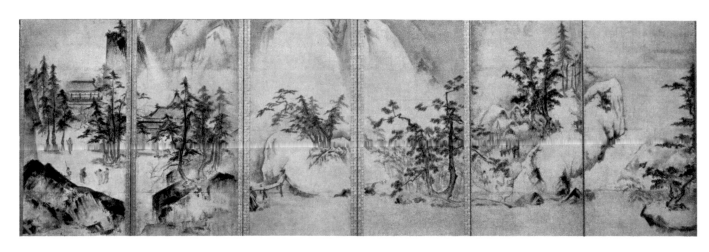

380

around 1400, of whose work we have left only one widely accepted painting, *Hyonen Zu* (fig. 500). The subject, associated with Zen Buddhism, represents a man trying to catch a catfish with a gourd, a typical Zen idea: to present one with something impossible, even ridiculous, in order to make one stop and think. The proposition shocks, produces an impasse at first, and then raises a desire to surmount the impasse. Josetsu's man stands by a bamboo grove on the shores of a little stream, holding a gourd, while in the stream a catfish looks up at the absurd combination. In the distance is the bare outline of a mountain and at the top are thirty-one poems by Zen priests, one of which mentions that this picture was painted as a small screen for the third Ashikaga *shogun*, Yoshimitsu, sometime before 1408. *Hyonen Zu* symbolizes the extent to which the Japanese were absorbed by the new Zen ideal. It became, literally and figuratively, their faith, and they believed in it so strongly that in a sense it was new for them. If one understands an idea and in a sense re-creates it, then the idea is reinvented. Something of that reinvented quality is at the heart of the Ashikaga monochrome school and in the whole ethos of the period.

Josetsu was, according to tradition — and there seems no reason to dispute it — the real founder of the Ashikaga monochrome school. His pupil was Shubun and Shubun's was Sesshu; and from this line came most of the later main developments. It is not necessary here to examine all the different family schools and minor variations of the Ashikaga monochrome school, for all are united by the same interests and general style. Perhaps the greatest master of the fifteenth century, superior even to Sesshu, was the shadowy figure of his master Shubun, active in the first half of the fifteenth century. We know that Shubun was a priest, that he not only painted for the *shogun* but worked on sculpture as well; also that he made a trip to Korea and presumably was familiar with the *Ma-Hsia* style Korean painting of the time. We know that he was primarily a painter of screens and large-scale paintings, though a few small hanging scrolls attributed to him are known. The most skeptical will tell us that we do not have a single work surely attributed to Shubun. However, there does exist a small but important group of screen paintings, some with the seal of Shubun, and traditionally ascribed to him. They are painted in a manner derived from the *Ma-Hsia* style of the Southern Sung Dynasty, and are so powerful and rich that they seem even superior to both earlier and later works. These are the works of Shubun; and one of them is the screen, *Winter and Spring Landscape*, illustrated in figure 501. The subject matter should be read from right to left as if the screen were a handscroll. Winter with its soft snow and cold mist grips the landscape of the first four panels. The temper is like that of two famous

502. *Landscape. By Shubun, Abbot of Shokoku-ji, Kyoto (c. A.D. 1390-1464). Hanging scroll, ink and slight color on paper, height 35". Ashikaga Period.* Seattle Art Museum

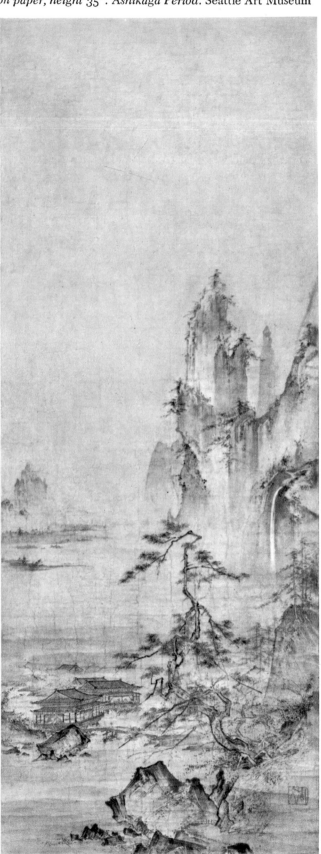

381

Haiku (poems of seventeen Japanese syllables) by Zen monks, emphasizing suggested moods.

Under the winter moon,
The river wind
Sharpens the rocks. Chora: IV, 213

I walk over it alone,
In the cold moonlight:
The sound of the bridge. Taigi: IV, 205

The last two panels convey a softer message; a slight warmth in the tones of the ink changes the chilly steam of winter to the soft breath of spring.

Peace and quiet:
Leaning on a stick,
Roaming round the garden. Shiki: II, 43

503. Winter Landscape. By Sesshu (A.D 1420-1506).
Hanging scroll, ink and slight color on paper, height 18¼".
Ashikaga Period. Tokyo National Museum

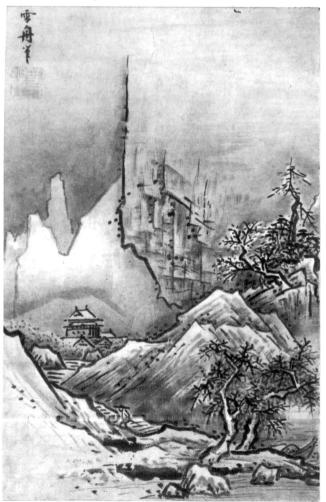

382

Suddenly thinking of it,
I went out and was sweeping the garden:
A spring evening. Tairo: II, 54[16]

Shubun's style had a sound foundation. As painter to the *shogun* he undoubtedly had access to the great collection of Chinese Southern Sung painting formed by Yoshimitsu. While the brush style of Ma Yuan is evident in the axe-hewn strokes defining the rocks, and Hsia Kuei's manner is to be seen in the trees, the general disposition of the trees against the nearby towering, truncated mountains is remarkably similar to the two famous hanging scrolls by Li T'ang from Yoshimitsu's collection now kept at Daitoku-ji in Kyoto. But the artist has not merely borrowed; he absorbs the essence of the Chinese masters and makes their technique and thoughts his own. To this base Shubun added a breadth of scale in part inherent in the large-scale decorative expanse of the folding screen. While grouped hanging scrolls with landscape subject matter were used by the Northern Sung masters, the folding screen was merely decorative in Chinese usage. It remained for the Japanese genius to make decoration and profundity rhyme. Shubun was able to do this by avoiding the extremes of stylized composition and brushwork to which so many later Japanese monochrome painters became addicted. His ink varies from the lightest tones to the darkest; his brush can be soft or harsh at will Complexity lies side by side with simplicity, fused by an almost magical ability to convince without display. The *Winter and Spring Landscape* screen is a product of his mature style, an embodiment of intellect and emotion in perfect harmony.

It should not be thought that Shubun painted only large pictures, screens, or wall paintings, although his strong brushwork and ability to handle complex compositions by unifying them in a simple over-all pattern was particularly suited to such forms. There are, however, some hanging scrolls that bear hopeful attributions to Shubun; very few are accepted. In our judgment there are a few authentic scrolls, one of them, *Landscape*, is illustrated in figure 502. The stylistic elements found here are the same as those in the screen paintings—that same satisfactory unity, simplicity with underlying complexity. The sharply vertical composition owes a great deal to the Sung artist Hsia Kuei, particularly in the reaching pine tree and the structure of the rocks in the foreground, and yet it goes beyond any of the Southern Sung masters in the extreme use of vertical composition. The rather arbitrary placing of the elements of the landscape — waterfall, distant mountains, points of land, even the rocks and trees in the right foreground — seem more decoratively disposed than such elements in the works of Southern Sung painters. The brushwork is suave and the axe-hewn strokes used in the foreground rock are related to sim-

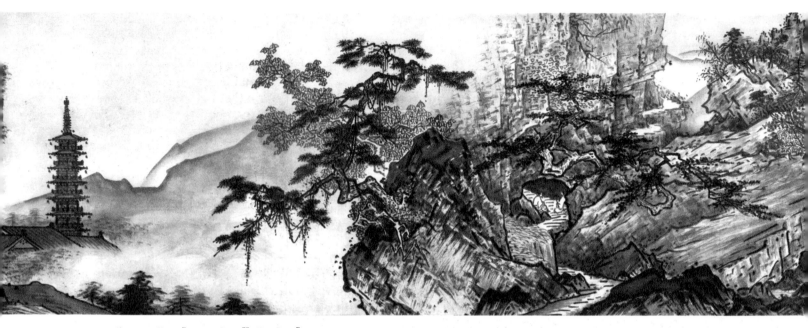

504. Longer Landscape Scroll. By Sesshu
(A.D. 1420-1506). Section of a handscroll, ink
and slight color on paper, height 15¾"; length
of the whole, 52'. Ashikaga Period. Mori
Collection, Yamaguchi

505. Detail from Longer Landscape Scroll

ilar strokes in the screen paintings. The architecture
is convincing, and this is something particularly true
of Shubun's work. He had not reached a point where
emphasis upon brushwork alone was allowed to domi-
nate to the extent that the architecture became unbe-
lievable — a sticklike pattern of strokes. The position
of the architecture on the land plane and the render-
ing of perspective of the buildings in depth and of the
logical quality of their structure are realized to the
fullest degree. Shubun, the master of Sesshu, remains
as the first great artist of the Ashikaga Period and was
never surpassed.

The *Winter Landscape* by Sesshu in the Tokyo Na-
tional Museum (*fig. 503*), is a fitting contrast to the hang-
ing scroll by Shubun. Both are in the same technique,
but the distance revealed between teacher and pupil,
in temperament and appearance, is great. In Sesshu,
there seems to be an impatience, a desire to cut through
matters of suavity and detail, to reach what he con-
sidered the heart of the matter. In this he seems to be
more particularly a Zen painter than Shubun. The brush
strokes in the *Winter Landscape,* in the style called
shin, are a rapid series of sharp, angular strokes, ap-
plied in rather sharp, contrasting tones, either very
light or very dark, and are unified by washes of ink
that simulate the wetness and grayness of the snow in
the half-light under the mountain cliff. The outlines of
the distant mountains are now dominated by the agile
but domineering brush. The architecture has become,
while still believable, more an exercise in vertical and
angular strokes than in that of Shubun. Complexity
has become secondary, and the result is a direct and
extreme simplicity which has been well described as

383

"crackling." Sesshu, like Shubun, was a Zen priest. He, too, went high in the hierarchy and at the end of his life retired to the mountains, spending his declining years in Zen disciplines, painting pictures for a few close friends and associates.

His work can be divided roughly into the two basic types, *shin* and *so: shin*, the style using sharp, angular, and relatively complex brushwork; *so*, a soft, wet, rather explosive and ultra-simplified style, called by the Japanese *haboku*, or "flung ink." Sesshu has customarily ranked higher than Shubun; his works are known in considerable quantity, when compared with the number plausibly associated with his master. It is possible to list some thirty-five works which can, with some degree of certainty, be attributed to Sesshu. The most famous of all is the so-called *Longer Landscape Scroll*, belonging to the Mori family, who have owned it for many generations. A long scroll of some fifty-two feet, it is the most developed of all his works and represents a series of "Chinese" scenes. The detail showing the pagoda tower, flanked on the right by reaching pine trees from a craggy mountain top, and on the left by a plateau of land capped by pine trees and reaching into the background of the picture, is a typical section of the scroll (*fig. 504*). The pine trees recall Shubun, though they are perhaps less soft and a little more mannered in their handling. Indeed, each detail of this scroll sounds overtones that recall other painters, both Chinese and Japanese, and in this sense it is an eclectic work. We know that Sesshu copied Southern Sung masters — Hsia Kuei, Ma Yuan, Li T'ang, and others. Small album-leaf copies, signed by Sesshu with his notation that they are copies of these masters, still exist. He was also familiar with China itself. He traveled there in 1468 as part of an official mission that landed in Fukien province and moved slowly north to Peking. He mentions seeing the work of some of the important Ming painters of the fifteenth-century academic school, among them Li Tsai. He said that the Ming painters did not come up to the finest of the Japanese masters, notably his own teacher, Shubun. And it is certainly true that the basic elements of the early Ashikaga monochrome style are derived from Southern Sung paintings rather than those of the Ming Period. At the same time there are details that remind us of certain Ming painters of the fifteenth century. The general handling of the pine trees on the right and the rather exaggerated near-and-far treatment in the right corner recalls the work of masters of the *Che* school, such as Tai Chin; while the plateau on the left, reaching into the distance, is a favorite device of fifteenth-century Chinese painters.

A close detail of one of the river and forest scenes with figures will best illustrate that particular quality that raises Sesshu to the very high position he occupies in Japanese art history: the strength of his brushwork, the brilliance of his handling of ink on paper (*fig. 505*). A passage such as the one in the center, with an old man followed by a boy attendant amid sharply projecting rocks and rippling water, is not as naturally rendered as in the work of Shubun. Still, it seems to be particularly sympathetic to the Japanese feudal spirit, and also to those Zen Buddhist qualities that also appealed to the martial spirit: the concept of rapid and immediate understanding through instant inspiration, translated into pictorial style by direct and immediate brushwork. At this point, we might anticipate later pictorial developments and mention certain decorative qualities to be discerned here that are quite different from those of Chinese painting whether Sung, Yuan, or Ming. There is a more arbitrary placing of forms; movements from near to far are abrupt; the patterns

506. Ama-no-Hashidate. By Sesshu (A.D. *1420-1506). Hanging scroll, ink and slight color on paper, length 70". Ashikaga Period.* National Commission for the Protection of Cultural Properties, Tokyo

507. *Flowers and Cranes. By Sesshu* (A.D. *1420-1506). Pair of six-fold screens, ink and slight color on paper, length 12' 4". Ashikaga Period.* Kosaka Collection, Tokyo

of the wrinkles on the rocks, the patterns of foliage, and the movements of branches are more exaggerated. Such conscious emphasis is not Chinese and points the way to the growing decorative tendencies of the late fifteenth and sixteenth centuries, ultimately to reach its fullest expression in the Japanese decorative style of the seventeenth and eighteenth centuries. One can readily see where the Kano masters, those rather academic followers of the monochrome school, received the elements of their style and how in overemphasizing

decorative qualities they underestimated the primacy of brushwork and the directness of Sesshu's style.

Sesshu painted, as did most of his colleagues, the Chinese landscape in the Chinese style. Nevertheless, there are certain rare works by masters of the Ashikaga Period in which monochrome ink is used to represent Japanese scenery. By far the most important example of this type is the painting *Ama-no-hashidate* by Sesshu (*fig. 506*). This scenic part of the coast of the Japan Sea northwest from Kyoto features a sandy spit

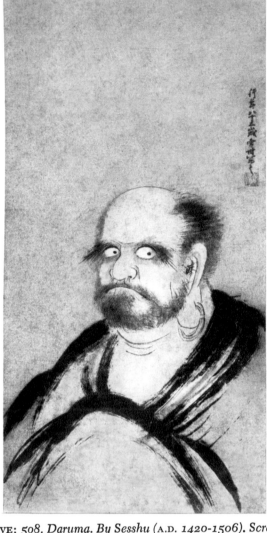

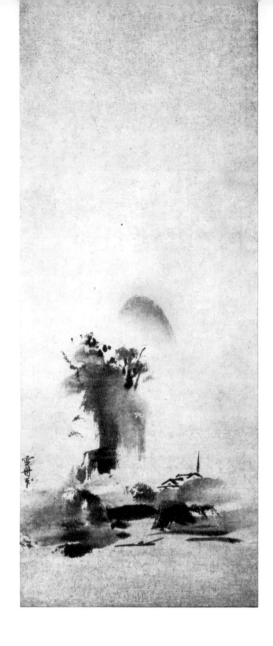

ABOVE: 508. Daruma. By Sesshu (A.D. 1420-1506). Scroll, ink on paper. Ashikaga Period. Yoshinari Collection, Tokyo

RIGHT: 509. Haboku Landscape. By Sesshu. Hanging scroll, ink on paper, height 28⁵⁄₁₆". Cleveland Museum of Art

of land reaching across the mouth of the bay. Ranks of pine trees march along the peninsula to the very end of the point. The scene is represented again and again in later Japanese art and is one of the great pilgrimage sites for travelers, Japanese or foreign. Sesshu represents it in the cold blue ink typical of his later work, with just a few touches of pale orange-red giving some warmth to the mountains on the left and to the roofs of the village. The painter has somewhat modified his style. The hills are undulating; they are not as angular or steep as the imagined Chinese mountains. This intimate quality recalls the landscape we saw in the Fujiwara and Kamakura periods. If the dominant elements of the style are Chinese, their modification produces one of the most interesting of Sesshu's landscapes in the shin style.

He also painted a few folding screens of the six-fold paired type. One of the finest, Flowers and Cranes, illustrates the decorative development of monochrome painting at this time (fig. 507). The addition of slight touches of color — red and green — while decorative,

also contributes a lifelike quality to the cranes and foliage. But certainly the placement of the elements of the composition — pine branch, reeds, rocks, pine trunk, flowers, and the cranes — is extremely arbitrary, almost as if the artist had taken predetermined units and disposed them on the surface of the screen until he achieved a maximum decorative effect. It is not an extreme decorative style at this point, but certainly we can detect the adaptation of motifs derived from China to a different and Japanese taste.

The second style used by Sesshu is that called so or haboku — "flung ink." This is rightly considered the most extreme form of Chinese monochrome painting, and is often associated with Ch'an Buddhism in China and Zen in Japan. Haboku was practiced in China, but rather rarely, and then in pictures largely exported to Japan. In the famous imaginary portrait by Sesshu of the first Zen patriarch, Bodhidharma, known in Japan as Daruma, his steadfast faith is emphasized (fig. 508). It is told that once Bodhidharma, meditating on the Buddha, fell asleep; when he awoke with a start he

was so penitent that he punished himself by cutting off his eyelids and thus assured perpetual contemplation of the Buddha. Thus he is represented by Sesshu, with glaring eyes, pressed lips, and clenched teeth, expressing the ardent nature of his devotion. In the flung-ink style the brush is used rapidly but purposefully: here the drapery is roughly indicated, while greater care is devoted to the more essential portrait features. Sesshu's powerful brush seems as direct as a sword cut, as direct as the intuition felt to be the heart of understanding by the Zen faith, and owes much to such Chinese masters of the flung-ink style as Liang K'ai or Mu Ch'i.

Haboku was also used in landscape painting, and Sesshu painted a few works at the end of his life, making an extreme use of this style. The most famous and often reproduced example is the one painted for Soen, in the National Museum in Tokyo. Another hanging scroll, less well known and less dramatic, is illustrated in figure 509. The style of both is of such simplicity and subtlety that while it is possible to analyze it, to demonstrate that the variation of wash is subtly controlled; that the tones are calculated to the last degree so that each wash takes its place in the imaginary space provided for it; that a foreground rock does come forward; that a distant building and its surrounding shrubbery recedes; still, ultimate knowledge of the picture remains beyond our grasp. It is possible to analyze such contrasts as the sharp strokes of the fisherman in his boat or those representing the wine shop in the distance with its tall staff, as opposed to the soft handling of the washes of the surrounding landscape. In contrast to much later works in the flung-ink style, this has a wide range of tone. But the fundamental requirement of this style is that it should give an immediate and convincing impact. If the painting is sensed in the Zen way, visually and intuitively, one is emptied and only calm remains. Such works are the silent dialogue between a great and aged artist, and the materials he knew best — brush, ink, and paper — and on their own terms.

Among the most important followers of Sesshu at the end of the fifteenth century, particularly in his handling of the *shin* style, was the artist Keishoki. One of his pictures, kept in the Nezu Museum in Tokyo, represents a grotesque cliff structure with a small hut beneath its jutting jaws, while beyond there is a simplified view of mountain ranges and pines (fig. 510). With Keishoki we sense an even more arbitrary handling of the brush and of composition than that of Sesshu. The rhythms of the rocks in the cliffs, the twisting qualities of the branches of the pine trees, and the gradations of the washes seem to be more calculated, even if brilliantly handled. Other artists, such as So-ami (d. 1525), one of the three Ami — No-ami, Gei-ami, and So-ami — tended to work in a softer, rounded style and

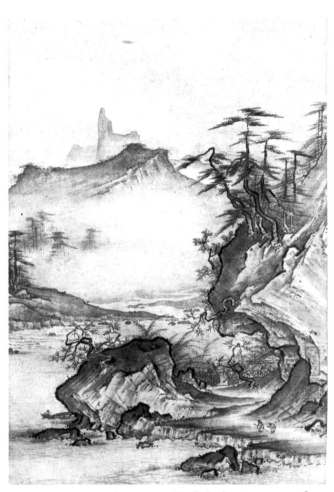

510. A Spring Landscape. By Keishoki (active A.D. 1478–d. 1523). Hanging scroll, ink and slight color on paper, height 20⁵/₃₂". Ashikaga Period. Nezu Museum, Tokyo

511. Wind and Waves. By Sesson Shokei (b. A.D. 1504–active till 1589). Hanging scroll, ink and slight color on paper, height 8¾". Ashikaga Period. Ex-Nomura Collection, Kyoto

388

512. *Tiger and Dragon. By Sesson Shokei. (b.* A.D. *1504–active till 1589). Pair of six-fold screens, ink on paper, length 12'. Ashikaga Period.* Cleveland Museum of Art

produced, particularly in the sliding-screen panels in the Daisen-in, Kyoto, one of the great examples of this softer style of painting.

But the artist of the first half of the sixteenth century with a distinctive style who occupies a ranking just below that of Shubun and Sesshu is Sesson. This artist from the northeastern provinces avoided the Zen centers of Kyoto and Kamakura, but produced a considerable body of work in which he seemed fully aware of the decorative possibilities of rhythmic and graceful movements of the brush, rather than in placement of elements within the composition. Sesson's most famous picture is a tiny rectangle, perhaps twelve inches long, representing a view across a point of land with a wind-blown tree and a rather broken-backed hut with, farther back, a strong sea with a boat driving madly along beneath the wind (*fig. 511*). In his treatment of the waves in the right foreground, in the type of brush

stroke used to represent the wind-blown tree or the curve and bend of the bamboo above the hut, one senses an elegant and refined decorative quality within a masterful *shin* style. The combination is so simple and arbitrary that, in order to sustain it, the flawless brush stroke is all-important. Even working close to the *so* style, the same elegance and decorative treatment of each individual brush stroke is found. No one could mistake such ink painting for that by Sesshu. The effect is perhaps more calculated—not as immediate in the later man's work—but it is certainly much more "stylish," with a light and witty quality quite lacking in the paintings of the fifteenth century. These men—Shubun, Sesshu, Keishoki, So-ami, and Sesson—are some of the greatest names of the fifteenth and early sixteenth centuries.

An investigation of the founding and development of the Kano school is interesting only in its beginnings; the later manifestations seem more properly a matter of national historical interest. The school is traditionally derived from the artist Kano Masanobu (1434-1530), who is represented by one important masterpiece, the painting of the Chinese scholar Chou Maoshu admiring lotuses; with an attendant he is seated in his boat under an overhanging willow tree (fig. 513). The general effect is certainly related to the richness of Shubun, but it has some decorative qualities related more to Keishoki or to Sesson. It is not a standardized or academic work; but the Kano school did ultimately standardize the monochrome style. It became in a very real sense an academy, with a high priest, and an elaborate genealogy with acknowledged masters. The Kano masters devoted themselves also to art criticism and the authentication of paintings, both of the Kano school and of Chinese and Ashikaga monochrome types. The man responsible more than any other for the crystallization of a Kano style was the second of the line, Kano Motonobu (1476-1559). Motonobu's most famous works are at the Reiun-in in Kyoto, where there is a series of hanging scrolls of quite large size, probably originally intended as sliding panels, or *byobu* (fig. 514). The motifs of the crane and pine, already seen in Sesshu, are treated in a way that can only be described as decorative. The arbitrary nature of the curve of the rather wooly pine tree and of the twisting branches, the particularly self-conscious placement of the individual elements—crane, tree, wave, and the cliff suggested behind, each one treated as a separate unit in a series of overlapping stage sets—show developed decorative tendencies that became standard for the Kano school.

The development of architecture in the Ashikaga Period is the story of the growing influence of certain Chinese temple styles, rapidly transformed by the influence of earlier Japanese traditions into a simple, light, and serene style. Its best qualities are associated with aristocratic pavilions, and the tea house. The temple buildings become overelaborate, particularly in their bracketing, and also develop a tendency toward

513. *Chou Mao-shu Admiring the Lotus Flowers.*
By Kano Masanobu (A.D. *1434-1530*). *Hanging scroll, ink and slight color on paper, height 36".*
Ashikaga Period. Ex-Ogura Collection, Tokyo

389

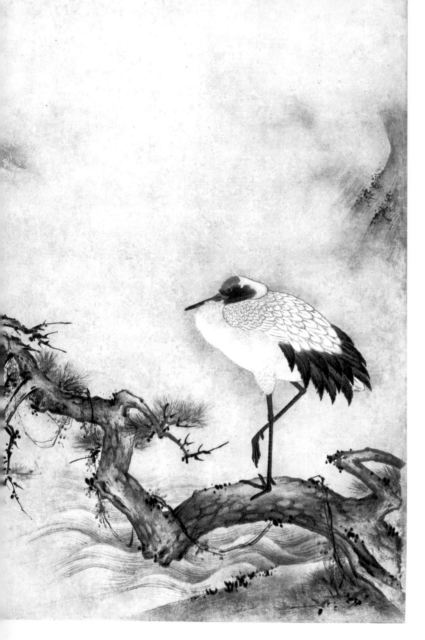

514. *Cranes and Pines. By Kano Motonobu (A.D. 1476-1559).*
Section of a hanging scroll, ink and slight color on
paper, height 70¹⁄₁₆". Ashikaga Period. Reiun-in, Kyoto

scape, the garden, and with the tea ceremony. The most famous of these, recently and tragically destroyed by a crazed Japanese monk, was the Golden Pavilion in Kyoto, the Kinkaku (*fig. 516*). It has lately been rebuilt according to the original plan, but of course with new materials. The illustration shows the original structure, set on an artificially made platform, jutting forth from the land into a pond surrounded by a calculated variety of pines and deciduous trees, producing a natural effect varying as the foliage changes from season to season. The pond has small rock islands, artificially placed, but with a spontaneous and natural appearance. It is as if one had come upon a scene in a Southern Sung painting with the usual small viewing pavilion projecting out over the water. Elaborate bracketing is not used in this "secular" structure, intended for relaxation and pleasure with Zen overtones. The roof is of the native shingle and not the tile which is more typical of Chinese style. Round columns are generally avoided. The whole ensemble is constructed of squared timbers with plain surfaces of largely natural wood, though the roof line and parts of the pavilion were actually covered with gold leaf; hence the name Golden Pavilion. The post-and-lintel system of the simple three-story structure is modified by an asymmetric treatment; the placement of the posts on the exterior corridors on each level is not necessarily symmetrical. The whole is carefully calculated to give an effect of extreme simplicity, almost of random selection, even of studied nonchalance. Kinkaku-ji, built by the third Ashikaga *shogun*, Yoshimitsu, was followed by a second structure, Ginkaku-ji, the Silver Pavilion, built by the eighth *shogun*, Yoshimasa (*fig. 517*). It is no coincidence that these two rulers were the very ones who formed fine collections of Chinese paintings. Ginkaku-ji is almost a small version of Kinkaku-ji, with two stories instead of three. In the same area and in the same garden is a small structure, the Togu-do, housing an image of Yoshimasa. The garden was designed by the painter, So-ami. Behind, and part of the Togu-do, is a small room used for the tea ceremony, and in this very small structure we have the essential elements that were to lead to the tea house or the tea pavilion, factors already seen in the pavilions, but much reduced in scale and made more apparently humble and simple.

The tea pavilion, based on a combination of Chinese pavilions seen in paintings and farmhouses actually seen in Japan, is an unpretentious structure whose subtlety and refined detail was calculated to appeal to the aesthetic and complex tastes and motivations of the cultured warrior. Stone platforms, characteristic of Chinese style, were replaced by piling or wooden posts as supports for the floor structure. It is almost as if one had, in part, returned through two centuries to Fujiwara secular architecture. This native Japanese style, modified by the simplicity of Chinese taste, was placed

surface finish and a justness of minute detail approaching cabinet work. The most famous temple structure in the *karayo* or Chinese style, is Engaku-ji in Kamakura (*fig. 515*). The double roof-line with the heavy thatch is a later addition. The original roof was of tile and much lower in profile. Attention should be directed particularly to the bracketing under the eaves, now a multiple, complex repetition of units beyond the point of function. The openings of windows and doors and the lattice work take on a fine and delicate appearance quite different from the strong, simple, or complex, but still architectural, treatment of earlier Japanese styles.

The most successful and interesting buildings of the Ashikaga Period are those associated with leisure and pleasure — with the contemplation of the moon, the land-

Colorplate 39. Water Pot. Shino stoneware, height 7".
Japanese, 16th Century A.D. Seattle Art Museum

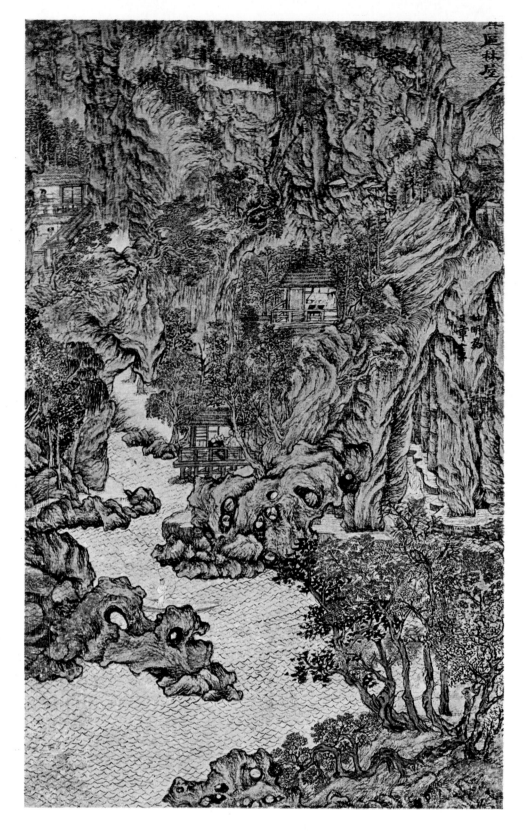

392

Colorplate 40. *Scenic Dwelling at Chu-ch'u. By Wang Meng (c. A.D. 1309-1385). Hanging scroll, ink and color on paper, height 27⁵⁄₁₆".* Yuan Dynasty. National Palace Museum, Formosa

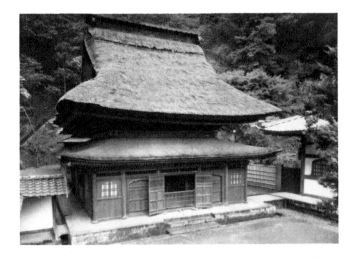

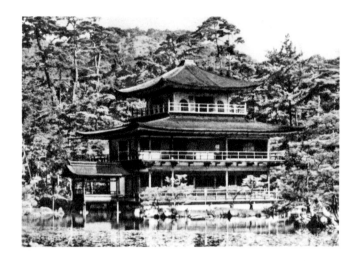

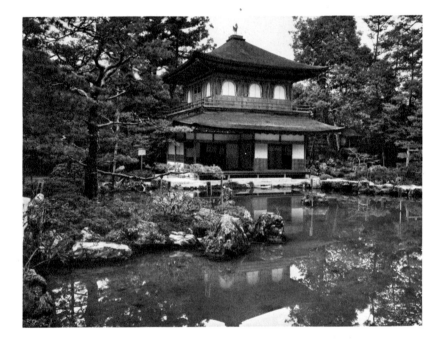

ABOVE LEFT:
*515. Shari-den, Engaku-ji, Kamakura.
Late Kamakura Period,* A.D. *1293-1298*

ABOVE RIGHT:
*516. Kinkaku (Golden Pavilion), Rokuon-ji,
Kyoto. Ashikaga Period,* A.D. *1394-1427*

LEFT:
*517. Ginkaku (Silver Pavilion), Jisho-ji,
Kyoto, Ashikaga Period, c.* A.D. *1500*

at the service of Zen and of its accompaniment, the tea ceremony.

Combined with the architecture, and an integral part of it, was the garden. It could be of various types. The effect of a large garden, such as the one around the Golden Pavilion, was as if one had strayed into a beautiful glen or clearing in the woods. The sand garden was also used, sometimes on a large scale, as in the garden at Jisho-ji, where the dry sand was conceived as water, with the larger trees and shrubs as distant mountain ranges or larger elements of a landscape in the midst of the water. Significantly, many of these gardens were designed by the most famous painters of their day. So-ami, Sesshu, and others are famous for their garden designs. The garden was conceived of very much as if it were a painting, with a curious inversion which seems particularly characteristic of the subtlety and complexity of Japanese taste. The landscape painter made gardens to look like paintings out of the raw material of nature. No reverse twist could be more suited to the Japanese taste. The sand gardens are absolutely intended to be contemplated. One does not walk about in the sand garden, because the raked patterns are all too fragile. It is meant to be viewed from its various sides — a landscape painting in the round, so to speak. In contrast with these sand arrangements are the moss gardens, landscapes where the effect is not a contrast of white and black, as in an ink painting, but different greens producing a richer, more sensuous effect, perhaps related to the old tradition of Japanese landscape painting and to the Japanese garden of the Fujiwara Period.

393

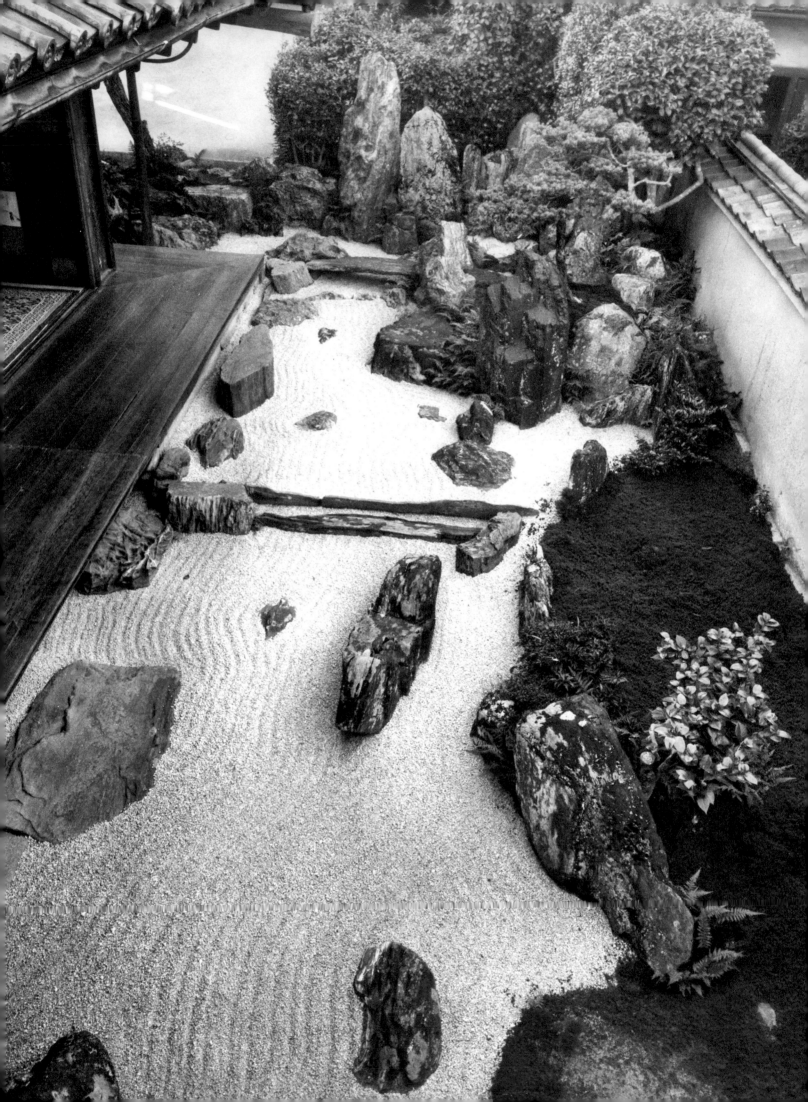

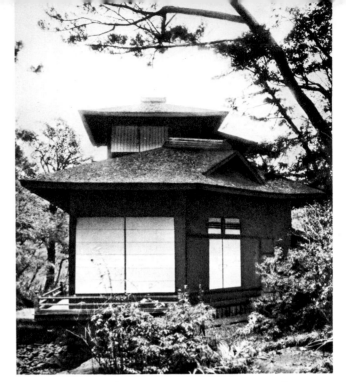

519. *Taigra (Tea House), Momoyama Period.*
Hara Collection, Yokohama

520. *Interior of Taigra, figure 519*

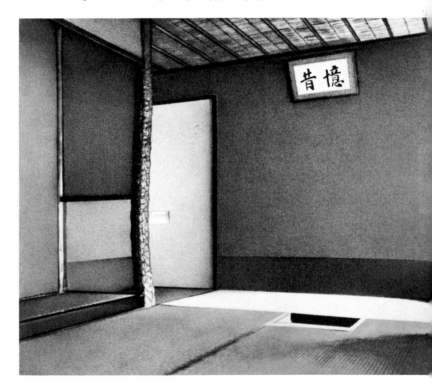

*518. Garden of the Daisen-in, Daitoku-ji, Kyoto.
Attributed to So-ami. Ashikaga Period.*

Yet another type of garden is perhaps the most interesting of all, the tiny garden microcosm representing the vastness of nature with nature's own materials. The most famous of these, and by all odds the most beautiful, is the Daisen-in garden in Kyoto, designed by So-ami (fig. 518). This small garden, constructed of rocks, sand, and shrubs—the sand intended as water, the rock slab as a bridge cutting over from one spit of land to another, and the carefully selected rocks of the background serving as a mountain range — is, in an area of ninety-two square yards, one of the greatest of all the gardens in Japan. Meant to be seen on the two adjacent sides of the porches of the tea house and its approach, it is possible to sit here in the changing light of day or evening and contemplate a landscape as rich and complex as a painting by Shubun or Sesshu.

The tea ceremony (cha-no-yu) was a significant byproduct of the same Ashikaga culture that produced the related arts of monochrome landscape painting and garden design. But it is a debatable point whether the cult of tea is a proper subject for inclusion with the visual arts. Like the dance, the tea ceremony was a series of actions involving the use of works of art — gardens, tea houses, iron kettles, bowls, dishes, hanging scrolls, and others. Beginning as an informal and uncodified meeting of congenial spirits, it became a rigid cult of taste, as ritualistically and artificially dedicated to simplicity as a Byzantine coronation was dedicated to mystic splendor. The actual culture in either case was something less than met the eye.

Tea was first imported from China by the ninth century; but its use in Japan for more than refreshment probably derives from the tea games of the T'ang and Sung literati, in which the color and savor of the tea were artfully judged at the same occasions where history, poetry, or works of art were discussed or even created. Tea also came to be associated with the Ch'an monasteries, perhaps because it is a stimulant and because it provided a pleasant relief from knotty discussion or deep meditation. We have seen that a kiln site in Fukien specialized in producing *Chien* ware solely in the form of bowls especially designed for the drinking of tea. The combination of Zen tea and *Temmoku* tea bowl was certainly established in Japan at the beginning of the Ashikaga Period. It seems equally certain that the tight codification of the tea ceremony did not begin until the end of that period, at the same time that the art of monochrome painting began to suffer from the equally rigid formalism of the developed Kano school of painting.

The traditional founder of the ceremony was Shuko (1421-1501) who reputedly designed the first tea ceremony with the aid of the painter No-ami, at the command of the *shogun* Yoshimasa, whom we have already noted as a great aesthete and collector. But the most famous and revered tea name is that of Sen-no-Rikyu (1521-1591), who lived into the Momoyama Period only to be ordered to commit suicide by the dictator-gen-

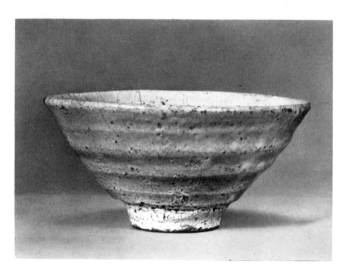

521. Tea Bowl (Shibata Ido). Stoneware, diameter 5¹¹⁄₁₆″. Korean, 16th Century A.D. Nezu Museum, Tokyo

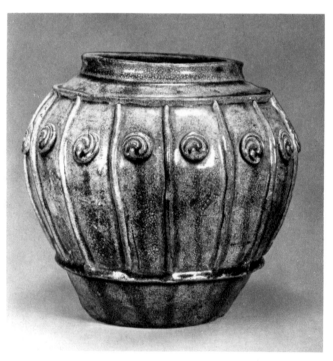

522. Jar. Seto stoneware, in yellow glaze with "Tomoe" design, height 8¹¹⁄₁₆″. Late Kamakura Period, 14th Century A.D. Umezawa Collection, Tokyo

eral Hideyoshi. From Rikyu comes the first codification and from his time the various hereditary lines of tea masters (*chajin*). His four requirements for the ceremony — harmony, respect, purity, and tranquillity — are understandable defenses for the conservative and cultivated few against the robust, gorgeous, and sometimes gaudy tendencies of the new dominant classes of the seventeenth century. Two all-important tea ceremony qualities, *sabi* ("reticent and lacking in the asser-

tiveness of the new" — Sadler) and *wabi* (quiet simplicity), can also be best understood against such a historical background.

Reduced to essentials, the activities of the tea ceremony participants can be simply described. The guests, usually five in number, approach the tea house through an informal garden, stopping enroute by a stone water basin to perform what amounts to a ritual purification of hands and mouth in the old Shinto tradition. When they arrive at the house, a small and calculatedly rustic structure designed with only the interior in mind, they enter through a small, almost square entrance so designed that they must bend low and literally crawl into the tea room, presumably shedding their status as they do so. Once inside they admire in turn the hanging scroll — either a painting or calligraphy — and the vase with a flower arrangement, artfully placed in the *tokonoma*, a niche specifically designed for their display. The guests then seat themselves on mats in a row, the place of honor — for caste has reappeared — being before the *tokonoma*. After they have disposed themselves, the host appears and wordlessly proceeds to serve powdered green tea to each guest in turn after preparing each bowl separately with a graceful and elaborate ritual involving an iron water kettle, bamboo water-dipper, cold-water vessel of stoneware, tea bowls, powdered green tea from a lacquer caddy, bamboo whisk for mixing the tea and water, and a tidily folded, unfolded, and refolded silk napkin. Today the ritual even prescribes the number of sips required to drink the tea (three and one half), the manner of turning the bowl on presentation by the *chajin* and by the recipient before and after imbibing. After the drinking, the various utensils used are laid out for inspection and admiration. The guests depart as silently as they came, but not before noting carefully the small interior with its clean and asymmetrical arrangement of windows, posts, and mats, all made of the humblest materials with conscious rusticity combined with an almost Mondrian-like purity as the aesthetic end in view (*figs. 519 and 520*). What had begun in the fifteenth century as an informal gathering has become an exercise in studied nonchalance with overtones of repression and symbolic poverty. One says "symbolic" because the prices of tea ceremony objects often reach fantastic heights, depending not so much on their intrinsic aesthetic worth as on their past history and association with distinguished tea masters of the past. One small incense box of glazed stoneware brought almost $40,000 in the 1930s.

The recent fossilization of *cha-no-yu* is mirrored in the extremely self-conscious nature of the nineteenth- and twentieth-century objects used in the ceremony. A tea bowl made on the wheel is often deliberately bashed to produce an asymmetry that was a natural result of Korean mass production in the beautiful *Ido*

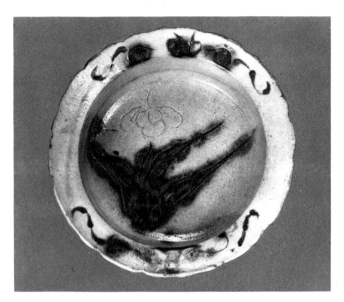

523. *Bowl. Seto stoneware, with leaf design. Ashikaga Period.* Private collection, Japan

bowls of the seventeenth century (*fig. 521*). But such machinations seem paltry when one sees the natural charm of the tea wares produced in Japan in the sixteenth and seventeenth centuries, largely in the neighborhood of Nagoya at the various *Seto* kiln sites. Beginning from olive- or brown-glazed stonewares of the late Kamakura Period, the *Seto* potters developed a varied repertory of wares for everyday use as well as for the cult of tea (*fig. 522*). Bowls imitating Chinese *Chien* ware are the first indications of a specialized tea production and these rather simple products are followed by more accomplished and artful ones. Yellow *Seto*, with its freely incised floral and vegetable designs heightened by splashes of soft green, is one of the rarest and most attractive of these later efforts (*fig.*

523). Another type, called *Shino*, uses an opaque and bubbly, pale cinnamon glaze enlivened by the natural orange-brown burns from the kiln fire and by hastily but delicately drawn decoration of black or dark-brown floral or abstract designs, usually on tea bowls or cold-water vessels (*colorplate 39, p. 391*). *Oribe* ware, using a thin, pale-buff glaze, specialized in more complex asymmetric decorative devices with green glaze and drawn designs, often geometric repeats on teapots, cake trays, and other diversified shapes. Kilns in other regions, notably those that continued a medieval folk tradition, such as Bizen (Okayama prefecture), Shigaraki (Shiga prefecture), Iga (Mie prefecture), and Tamba (Hyogo prefecture), continued to produce their monochrome brown, olive, and unglazed biscuit wares, but in shapes appropriate to the tea ceremony.

The great artistic contribution of the early tea ceremony lay in these various ceramics, so different in appearance from the subtle perfection of the Chinese wares. These Japanese stonewares are justly admired by contemporary Western potters for their rugged simplicity, their daring asymmetric designs paralleling the developments of seventeenth-century decorative painting, and expressing the qualities implied by the words *wabi* and *sabi*. On a minor scale the same may be said of the iron kettles usually made at Ashiya in Hyogo prefecture. Tea house architecture was a small-scale reflection of that peculiarly Japanese originality already displayed in more complete form in religious and domestic architecture. While the tea ceremony is of interest as an exercise in taste and a symbol of later Japanese aestheticism, it seems a more appropriate subject for cultural history and anthropology than for the history of art. That it represents the essence of Japanese art, or even taste, is open to question. The many other manifestations of art in the Ashikaga, Momoyama, and Tokugawa periods should place it in proper perspective as a conservative, elite, holding-action.

17. Later Chinese Art: The Yuan, Ming, and Ch'ing Dynasties

THE YUAN DYNASTY lasted from 1280 to 1368. It followed the fall of South China, and was a period of foreign domination by the great Kublai Khan, made famous through the memoirs of the Venetian, Marco Polo. This Mongol domination was a traumatic experience for the scholar-official of the old school, to whom it meant the triumph of barbarism and the eclipse of Chinese cultural ideals. The fact that the Mongols gave China a period of relative peace, that in many respects their tastes and interests were more vigorous and more masculine, more creative and forward-looking, meant nothing beside the simple fact of foreign domination. In certain areas this foreign domination resulted in some hardship, but on the whole, the first emperor of the succeeding Ming Dynasty, the Hung Wu emperor, a native Chinese and considered the restorer of Chinese tradition, was infinitely more cruel to members of the painter and scholar class than were the Mongol rulers. Nevertheless, the question always present in the minds of the officials of those days was whether to serve the foreign dynasty or to retire from the "dusty world" to the peace, quiet, and political non-co-operation of the provincial town. Many of the more creative painters seem to have taken the course of retirement, while many of the painters who worked for the Mongol court tended to be more academic and conservative.

Before we consider painting, certainly the most important single artistic form in the Yuan Dynasty, it is necessary for us to pay some attention to the ceramic tradition, for what happens to the ceramics of China in the fourteenth century is of the utmost importance for the future development of porcelain. Ceramics, on the whole, declined in quality. This was due in part to a relative decline of official patronage for works of fine porcelain on the part of the emperor's court. The *Tz'u-Chou* tradition of decorated slip ware, made for high and lower classes alike, continued in the Yuan

Dynasty, using the traditional techniques, perhaps with less refinement and with greater emphasis on painting than on the more complicated and expensive techniques of inlaying and incising. Painted jars are rather bolder in their decoration, and there is a tendency toward a more pictorial treatment of the design. A frame is placed about the picture as in the dragon side of the jar illustrated in figure 524. The concept of the frame is also applied to the borders, which in

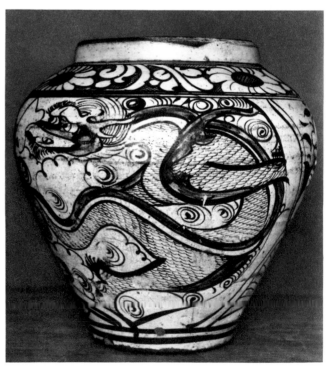

524. Jar. Tz'u-Chou stoneware, height 11". Yuan Dynasty.
Cleveland Museum of Art

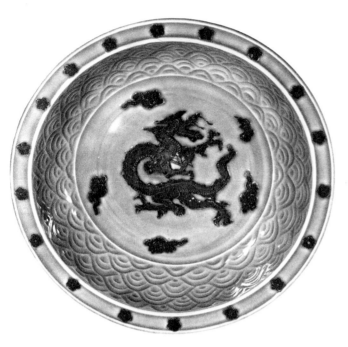

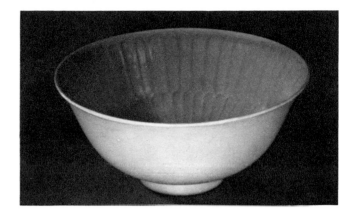

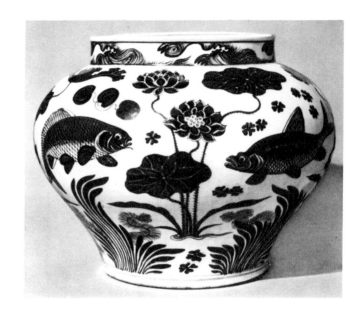

ABOVE:
525. Basin. Lung-Ch'uan porcelain, diameter 17".
Yuan Dynasty. Cleveland Museum of Art

ABOVE RIGHT:
526. Bowl. Shu Fu porcelain, height 3½".
Yuan Dynasty. Cleveland Museum of Art

RIGHT:
527. Jar. Porcelain, with decoration in underglaze blue,
height 12". 14th Century A.D. Brooklyn Museum

the Sung Dynasty wares tended to be self-contained. In Yuan these borders are cut off as if they marked a piece of continuous decoration to be applied above or below as necessary. Nevertheless, the robust qualities of Yuan Period draftsmanship, combined with the usually vigorous qualities of Northern slip-decorated stoneware, continued the traditions of this ware.

The same was not altogether true of other classic wares of the Sung Dynasty. *Chun* ware tended to be somewhat simpler and more crude in its techniques. *Ting* ware became a secondary type. The *Lung-Ch'uan* wares and the celadons produced in the South were continued in wares of rather high quality, particularly in examples displaying a new technique involving, as a form of decoration, the use of the biscuit (the fired but unglazed porcelain body); the glaze was applied to the body of the vessel with certain areas reserved, in this case, a dragon chasing his tail and surrounded by cloud patterns (*fig. 525*). This more pictorial decoration moves away from the pure glaze techniques of the Southern Sung wares toward highly decorated

types characteristic of the later Chinese porcelains.

The key to the development of Chinese porcelain for the future, from the Yuan Dynasty until modern times, lies in a combination of two particular styles. One is that derived from the ware that we have called *Ch'ing-pai*, the pale blue or sky blue, thin porcelain made in Kiangsi province. This tradition is combined with a robust form of decoration in underglaze blue. The logical development of the *Ch'ing-pai* wares is found in a ware made for the Yuan court and called by the euphonious title, *Shu Fu* (*fig. 526*). It was like *Ch'ing-pai* in its pale blue-green color, while the material of its body, also derived from the pale-blue wares produced in the South, was more refined, more homogeneous, and much stronger. The bond between the glaze and the body was more cohesive, the body was a little thicker, and the glaze itself tended to be heavier and more solid. The result was a ware with a slightly thick, milky quality in the glaze and with a pleasing heaviness or weight when lifted in the hand. It combines the strength of the celadons with the

399

color of the *Ch'ing-pai* wares. Now, this *Shu Fu* ware had a relatively short life. But decoration was added to it in underglaze blue to produce the beginning of the great Chinese tradition of blue-and-white. The earliest blue-and-white dates from the fourteenth century and has been identified by John A. Pope as to type and date. The body is a fine white porcelain related to the *Shu Fu* body. The glaze is rather transparent, but slightly green and milky over the underglaze cobalt decoration on the white body. The forms are traditional ones related to some of the *Tz'u-Chou* jars. They seem to combine the strength to be found in folk wares with a rich decoration which would have been considered barbarous in the Southern Sung Period, but which evidently satisfied the new Mongol ruling class. The large jar from the Brooklyn Museum shows the elements of this fourteenth-century blue-and-white at their most superior level (*fig. 527*). The decoration is pictorial. It might almost be a painting by one of the traditional painters of fish of the Yuan Dynasty, such as Lai-an. The wave decoration appears to be a selected part of a continuous decoration. The rich effect re-

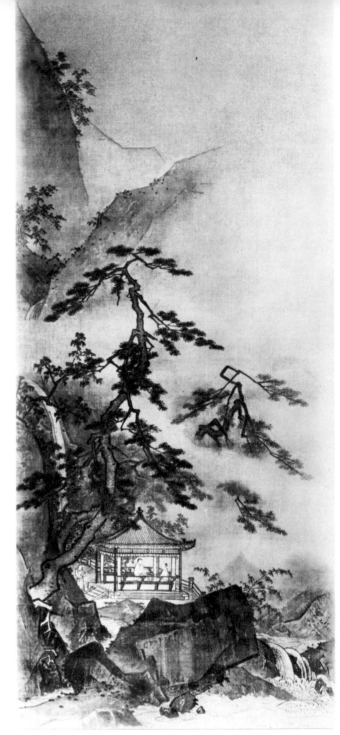

528. Bodhisattva. Nepalese style, dry lacquer, height 10' ³⁄₁₆". Yuan Dynasty. Freer Gallery of Art, Washington, D. C.

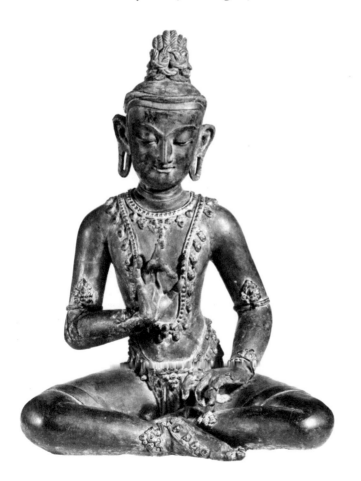

529. Landscape. By Sun Chun-tse (active beginning of 14th Century A.D.). Hanging scroll, color on silk, height 56⅛". Yuan Dynasty. Iwasaki Collection, Tokyo

quired great skill in draftsmanship and in the organization of the picture — for such it is — in relation to the shape of the vase. Being new, it represents a progressive tendency in the ceramics of the time, and the great imperial porcelains of the Ming and Ch'ing dynasties develop from these innovations.

Sculpture continued under imperial patronage in large-scale relief decorations for walls and gates, as well as in a revival of Buddhist sculpture under the impetus of the new Tantric or esoteric sects, whose

complicated forms derived ultimately from Nepal (*fig. 528*) and Tibet. These sects became quite important in the Yuan Dynasty and many sculptures were made under the influence of artisans from Nepal and Tibet. Still, nothing new of any great importance was said in the field of sculpture.

The great creative movement was in painting, and its innovations dominated the work of all later artists. As we have said, it is usually rewarding to study first in the painting of any period its traditional or conservative aspects before considering the progressive works. In this way, one has some idea of what constituted originality. The tradition of the Sung Dynasty was by no means dead and it was continued with some degree of quality and force by numerous painters of the day. The Southern Sung tradition of Ma Yuan and Hsia Kuei, the tradition of "one-corner" or asymmetrical composition, was continued by masters such as Sun Chun-tse, whose works were almost indistinguishable from those of his predecessors (*fig. 529*). His paintings were first imported to Japan in the fourteenth century and were even more popular than those of Ma Yuan, until in the fifteenth century the Japanese discovered for themselves the great Southern Sung masters. The tradition of Buddhist painting was partly continued by brightly colored works in T'ang and Sung style, which preserved, with some weakening of draftsmanship and composition, the ideas of the great early Buddhist paintings. But Buddhist painting was also continued in another and rather more original form though still not to be considered as part of the great creative development of the Yuan Dynasty. This style is best exemplified in the works attributed to the painter Yen Hui. There are many of these in Japan, whereas in China they are relatively rare. This is nothing new and seems typical of the attitude of the Japanese to the Southern Sung tradition of painting in contrast to Chinese coolness to that tradition in later times. Yen Hui painted Buddhist pictures emphasizing the rather strange, gnarled and rude aspects of Buddhist iconography, embodied in the figures of priests or disciples of the Buddha, and Taoist sages. The *Taoist Immortal, Li Tieh-kuai*, gives some idea of Yen Hui's characteristic style (*fig. 530*). The large, massive figure recalls somewhat the T'ang tradition of Yen Li-pen in its scale and proportions, but combines that tradition with something of the mysterious and romantic qualities of Southern Sung, particularly in the distant rocks and water and in the rather rough and rapid treatment of the rock on which Li sits. The touch of Yen's own genius, particularly inclined to the grotesque, is to be found in the treatment of the figure itself, the sad eyes and projecting profile, the grotesquely twisted fingers and toes.

There were also Buddhist paintings in the new Lamaist iconography, derived from the art of Nepal

and Tibet; and, indeed, some of these even show the stylistic influence of Nepalese painting.

A third type of Buddhist painting, representing a continuation of Sung tradition, is found in the works of artists such as Indara, perhaps more properly known as Yin-t'o-lo, whose art, unknown in China, is found only in Japan (*fig. 531*). Now, Yin-t'o-lo's tradition is derived from Mu Ch'i and Liang K'ai. The emphasis upon rapid and spontaneous use of ink which reaches a culmination in Japan in the tradition of flung-ink is

530. Taoist Immortal, Li Tieh-kuai. By Yen Hui (c. 14th Century A.D.). Hanging scroll, ink and color on silk, height 63¾". Yuan Dynasty. Chion-in, Kyoto

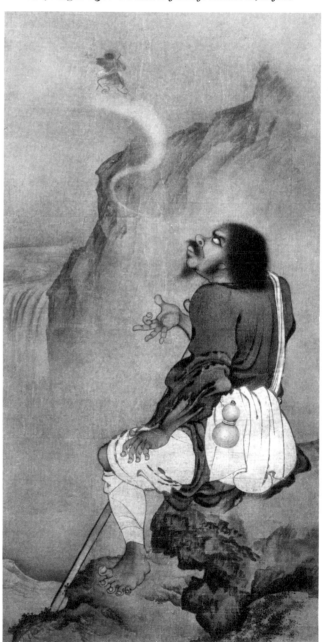

401

evident in the picture of one of a pair of Buddhist sages, where the wet, dark washes of the edges of the garment are contrasted with the rather gray but sharply drawn strokes representing head and fingers, strongly recalling the style of Liang K'ai. In addition to Yin-t'o-lo there were numerous painters who worked in the

Ch'an tradition. And since many Ch'an monks fled to Japan, it is only natural that their works should be found there in considerable quantity when even their names were lost to Chinese tradition.

Another aspect of traditionalism is found in paintings which cannot be classified as religious or official, but which in a sense are derived from the great Sung traditions of the Literal and Monumental styles. Foremost among these artists, and oftentimes grouped with men of the Sung Dynasty, was Ch'ien Hsuan, born in 1235, and particularly famous, according to tradition, for bird and flower painting. Ch'ien Hsuan was a traditionalist in the correct Confucian sense. His subject matter was derived, in his figure paintings, from the old Confucian stories; and his stylistic traditionalism consisted of a conscious archaism to be found in various parts of the paintings attributed to him. A painting which shows this attitude, entitled *Home Again*, is in the Metropolitan Museum (*colorplate 27, p. 291*). Based on a prose poem by the fifth-century Tao Yuan-ming, this representation embodies both traditional and new ideals. The scholar-official returns from his disagreeable connections with the state to his rustic home in the country. The blue, green, and gold style of the courtly manner, common in T'ang and early Sung, is used here in the touches of green, gold, and blue in the rocks in the foreground and especially in the far-distant mountains to the right. The peculiar and exaggerated perspective of the old earthen wall at the far left makes it seem tilted, almost as if it had been painted by a Six Dynasties painter rather than by a great master of the fourteenth century. The figures too, where they are not damaged or retouched, seem deliberately stiff and archaic. On the other hand, the fluent handling of the dead branches of the tree and the carefully realistic willow tree are very much up to date and are in the accomplished still-life manner that was Ch'ien Hsuan's specialty. This picture is one of several short handscrolls based upon the life of the great Confucian poet and scholar Tao Yuan-ming, all sharing this combination of realism and archaism.

But Ch'ien Hsuan is most famous as a bird painter and his paintings in this genre have something of the archaic manner seen in the handscrolls with landscape and figures. The pigeons on a pear-tree branch, illustrated in figure 532, are executed in this formal manner. The color — the soft browns — and the careful treatment of beak and eye, recall the technique used by the Emperor Hui Tsung in the *Parakeet* (see fig. 457). It is precisely the spirit one would expect from Ch'ien

531. *Han-shan and Shih-te (one of two pictures). By Yin-t'o-lo (Indara) (active second half of 13th Century A.D.). Hanging scroll, ink on paper. Yuan Dynasty.* Maeyama Collection, Tokyo

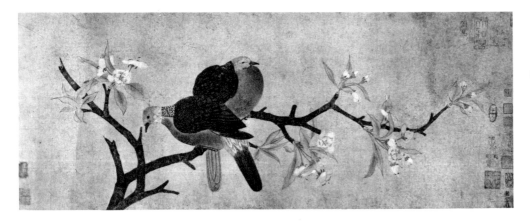

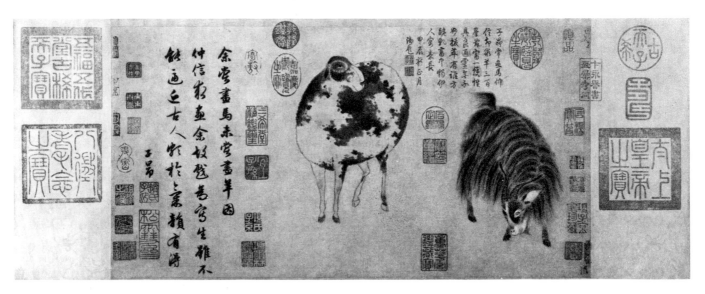

Hsuan, the traditionalist, and these rather still silhouettes possess a charm of their own which seems quite consistent with other paintings attributed to him. The bark of the pear branch is painted with shading at the outer edge, giving a semblance of volume, and with a blotting technique that uses a dry brush to absorb the ink and color on the branches, producing a crystalline pattern. This simulates the texture of the rough bark in a mixed realistic and stylized way. On the other hand, there is a softness and a delicate precision in the painting of the flowers and leaves. If we accept these as characteristic works of Ch'ien Hsuan, then he is indeed an arch traditionalist of Sung tradition, rather than one of the forward-looking Yuan painters.

The second master who is often mentioned as a traditionalist is Chao Meng-fu (1254-1322). He is so described because, rather than choose the life of the protesting scholar-painter, he took service under the Mongol emperor, rising to an extremely high position. The proof of his greatness as a painter is the fact that, despite this catering to the barbarian, he was ranked by later Chinese scholars and critics as one of the greatest of painters, equally famous for his calligraphy. Unfortunately, his name has become a byword for one particular subject: horses. Whenever a horse painting appears on the market, whenever a horse painting is displayed in a private collection, one can shut one's eyes and describe an inscription purporting to be by Chao Meng-fu. He will then be told that it is so inscribed, that this is indeed the genuine article. Every Oriental horse painting from the year of his birth to the present day, with few exceptions, has been attributed to this master. However, if one studies the works reasonably attributed to Chao Meng-fu, one is able to delineate a personality and a style considerably at variance with the hackneyed view of Chao Meng-fu as a realistic horse painter. The Freer Gallery possesses a very short handscroll from the Imperial collection, the *Sheep and Goat,* with calligraphy by Chao at the left in his characteristic rational, yet pleasingly cursive style, which may well provide us with a standard for judging other animal paintings attributed to him (*fig. 533*). The contrast between the sheep and the goat is made even sharper than in reality. The sheep, with

403

its rather formless, awkward body, is delineated with a broken outline, with emphasis on the dappled nature of the wool, on the rather stupid expression of the face, and on the mincing gait of the animal. On the other hand, the goat, with its suggested movement, the firm line of its spine, the sharpness of its hoofs, the beautiful delineation of the hair of his coat, the linear rhythm that runs through the long hairs coming down from the spine, provides a sharp contrast to the fuzzy character of the sheep. This is accomplished with a minimum of line and effort and produces a convincing effect.

If this painting represents Chao Meng-fu's style in a rather conservative vein, there are other pictures, particularly those of bamboo and of landscape, which show him in a more original frame of mind. The painting on silk of an old tree stump with rock and bamboo at its base, in the Palace Collection, is one of the finest examples of this particular facet of Chao's art (fig. 534). The rock is outlined with rapid strokes of the brush. The leaves are not painted in the careful style of traditional bamboo painting, but rapidly, in an attempt to catch the warm, humid limpness of the plant; while the representation of the stumps of the tree is a tour de force embodying the use of a large brush which outlines only in part the exterior edge of the tree trunk, leaving a rough texture of ink scraped over the silk to simulate the bark and provide modeling in light and shade. The resulting stroke is called "flying white" by the Chinese and is particularly associated with Chao Meng-fu. It requires a tremendous control of the brush and a sure sense of when to press and when to lift so as to produce the white areas in the center while the exterior edges of the brush produce the ink modeling. The technique appears easy and to have been accomplished in a relatively short time, but it reveals an extraordinary discipline. This discipline produced bamboo and rock pictures that influenced other painters of the fourteenth century and of the mid-Ming Period as well. The *Landscape with Twin Pine Trees* is one of the most important remaining examples of his landscape art, and an excellent explanation of the fascination he held for the Chinese; that is, his truly calligraphic brushwork (fig. 535). For us it is a rather difficult picture, derived from Northern Sung masters of the Monumental Style, such as Li Ch'eng or Kuo Hsi, in its tree and mountain types, and representing a cleaned-up and purified version of the style of the earlier men. There is a greater emphasis on running brush virtuosity. In a very real sense, it is a skeleton or outline of the past. We are forced to see only the bones of brush and landscape. The landscape is not the subject of the picture; the brushwork is. At the same time, there is some wonderfully observed structure transferred into terms of wash. Chao Meng-fu's son, Chao Yung, is far more conservative than his father, less brilliant in handling his brush but rather more solid in his approach to nature's shapes. An archaistic painter such as Jen Jen-fa is even more specialized than Ch'ien Hsuan, or Chao Meng-fu. The painting in figure 536 goes back in style to the T'ang horse painters. The remarkable thing is that this high quality of line and color has been preserved over a period of three or four centuries.

A group of important painters in the Yuan Dynasty stand between the traditional and the progressive tendencies. These painters seemed to have worked in both styles, as Chao Meng-fu did. We will consider only

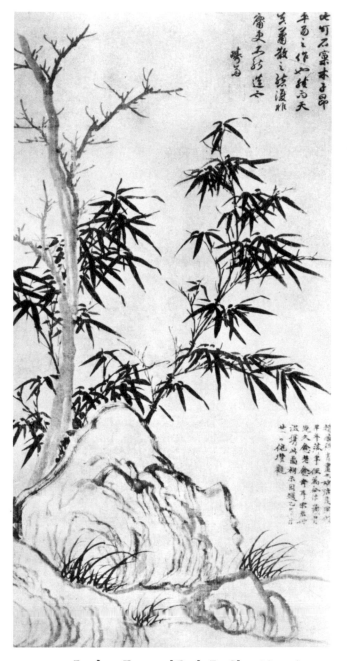

534. *Bamboo, Tree, and Rock. By Chao Meng-fu (A.D. 1254-1322). Hanging scroll, ink on silk, height 39⅛". Yuan Dynasty.* National Palace Museum, Formosa

404

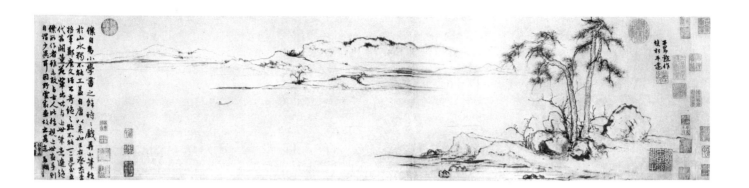

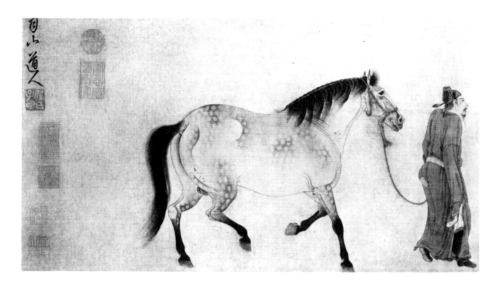

ABOVE: 535. *Landscape with Twin Pine Trees.*
By Chao Meng-fu (A.D. *1254-1322). Handscroll,*
ink on paper, height 10½"; length 42¼".
Yuan Dynasty. C. C. Wang Collection, New York

LEFT: 536. *Horses and Grooms.*
By Jen Jen-fa (A.D. *1254-1327). Detail*
of the handscroll, ink and color on silk,
length 53⅞". Yuan Dynasty.
Cleveland Museum of Art

two, the first being Ts'ao Chih-po, who produced several pictures now in the Palace Collection. One is a picture of a rather traditional type, *Old Trees,* recalling the works of Li Cheng and Kuo Hsi with the subject matter of gnarled trees as symbols of Confucian morality and uprightness (*fig.* 537). That same tradition is carried on by Ts'ao Chih-po in this particular picture of old pine trees. At the same time, if one recalls the paintings attributed to the older masters, one remembers how sharp and precise they were throughout. In contrast, this particular picture is sharp in the foreground, but fades out in the background, an effect realized by a shift of light and shade which tends to make the total effect visual and pictorial, as if it were something seen rather than something conceived solely in the mind and translated into brush terms. The shadowy pine in the middle ground behind the two sharply delineated foreground pines is a device developed in the Yuan Dynasty and characteristic of many landscapes of that time. Still, such a picture, with some new tendencies, is fundamentally traditional. A second picture by Ts'ao Chih-po, while still indebted to the Northern Sung Monumental masters, particularly in its representation of cedar trees, reveals

how completely radical he could be (*fig.* 538). Here most of the characteristics to be found in the Four Great Masters of the Yuan Dynasty are to be found in equal measure. Like the Chao Meng-fu landscape, this is a skeleton or an outline giving only the bones of the Monumental Style and creating thereby a style of its own. Note that the shadowy, misty forest with rivulets coming down toward the open lake gives a solution of the problem of a middle ground. We are no longer left uncertain as to the location of that area between foreground and background. This solution is one which probably occurred first in the Yuan Dynasty and is one of the clues by which we can determine copies from originals of Northern Sung.

The second painter who illustrates this conservative-progressive attitude is the painter Li K'an. Li K'an, too, paints old pine trees, in rather a stronger and more traditional style than that seen in the first picture by Ts'ao Chih-po. In contrast to these is the painting, *Bamboo,* by Li K'an, in which a new style can be seen (*fig.* 539). The Chinese critic-scholar especially admires the strength of the brushwork and the accuracy of the brush in depicting bamboo leaves. No artist of the Sung Dynasty or earlier would have dared to empha-

405

size so much the different tones of the leaves, and to omit almost completely the actual stalk of the bamboo, an unusual effect which seems to have reached its height in this particular work of Li K'an.

In both Ts'ao Chih-po's and Li K'an's progressive pictures a great amount of white paper shows. This implied purity is most important and leads us to the Four Great Masters of the Yuan Period. The close connection of these four progressive masters with the traditionalists is demonstrated in one particularly beautiful picture in the Palace Collection in Formosa, a collab-

orative work of two men (*fig. 540*). The bamboo is painted by the great bamboo painter Ku An, while the rock is by one of the Four Great Masters, Ni Tsan. In that rock with its barely sketched outline, its delicate, refined character, in the emphasis upon maximum use of the paper, and a minimum use of ink, we have some of the qualities associated with Ni Tsan and with at least two of the other three masters.

The Four Great Masters of the Yuan Dynasty — Huang Kung-wang, Wu Chen, Ni Tsan, and Wang Meng — are quite properly looked upon as founders

537. Old Trees. By Ts'ao Chih-po
(A.D. *1272-1355*). *Hanging scroll, ink on silk,*
height 52". Yuan Dynasty.
National Palace Museum, Formosa

538. Verdant Hills in Mist and Old Cedars by
a Brook. By Ts'ao Chih-po (A.D. *1272-1355*).
Hanging scroll, ink on paper, height 49⁹⁄₁₆". Yuan Dynasty.
National Palace Museum, Formosa

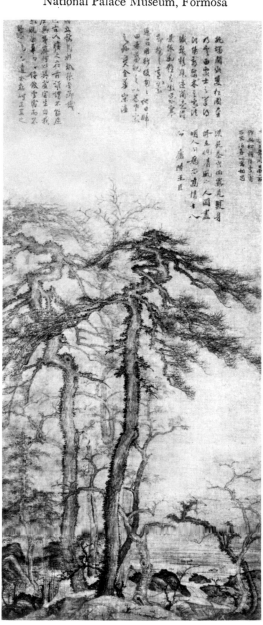

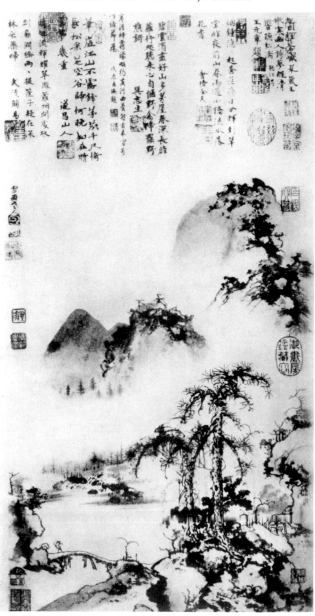

406

539. *Bamboo. By Li K'an (active c. A.D. 1340-1360).*
Section of a handscroll, ink on paper, length 93½".
Yuan Dynasty. Nelson Gallery-Atkins Museum
(Nelson Fund), Kansas City

of the new school of literary painting. They refused
service under the new dynasty. They emphasized what
might be described as an art-for-art's-sake attitude, a
growing development and codification of calligraphic
technique, and the importance of purity and cleanli-
ness in mood partly expressed by the preponderant use
of paper as a ground. Works on silk, by these men, are
almost unknown — an indication of the importance they
attached to the calligraphic touch of the brush on pa-
per and to the sharpness and precision with which the
paper received the ink. It will also be noted that their
subject is almost always landscape. They did not in-
dulge in the painting of horses or still life or things of
mundane nature. It is also of some significance that
they knew each other and tended to live within their
own group rather than in official or social circles.

Huang Kung-wang (1269-1354), the oldest of the
Four Great Masters, is known through very few works
indeed. A long handscroll on paper, representing the
Fu Ch'un mountains, the only work of major impor-
tance possibly from his hand, is kept in the Palace
Collection (*fig. 541*). One can see something of his style
in the detail. It is influenced by the Monumental Style,
but where the earlier manner would tend to produce
a closed composition, one in which mountains could be
seen in their fullness and to their heights, the Yuan
master arbitrarily used the mountains as a means of
orchestrating the length of the handscroll, cutting off
the top at will, extending the *repoussoirs* and points
of land beyond the lower limits of the handscroll. Note
the use of the paper and ink, particularly the emphasis
on sharp groups of strokes rather than on a dispersal

540. *Bamboos, Rocks, and Old Tree. By Ku An (active*
c. A.D. 1333), and Ni Tsan (A.D. 1301-1374). Hanging
scroll, ink on paper, height 36¹³⁄₁₆". Yuan Dynasty.
National Palace Museum, Formosa

of ink throughout the surface of the paper. Texture is
indicated in a simple way, with emphasis on staccato
notes of brushwork against blank paper. The style can
be complex, as we see it in the heavy mountain scene,
or simple, as in another section of the same scroll,
where the dry, almost barren topography supports only
a small clump of trees at the center. Here we witness
the close connection between the art of Huang Kung-
wang and that of Ni Tsan. Huang's works seem more

complicated and cerebral than those of his two colleagues to be considered next.

Wu Chen (1280-1354), despite the cold brilliance of his ink, seems radically different from the considered rationality of Huang Kung-wang. His brusque shorthand, epitomized by the Chinese as the "single-stroke" style, combines the rapid certainty of intuition with calculated but bold compositions and deliberately rough representations. The handscroll, *Fisherman's Pleasure* (1352), embodies these qualities in a major composition which would have been merely a clever narrative but for the artist-individualist's deliberate obliteration of sentimental values (fig. 542). Until one realizes that the content of the scroll is primarily bold brushwork, supported by a daring use of open paper and sharp tone contrasts, the *Fisherman's Pleasure* is figuratively a closed book. Perhaps the particular qualities that distinguished Wu from the other three masters can be attributed to his love of painting bamboo, where the single stroke was mandatory. Significantly enough, the only traces of suavity in the long scroll are

to be seen in the landscape passages. The early Chinese scholar-painter might force man and man-made things into almost grotesque arrangements, but never *the* subject of his art, landscape. This was inviolate until the sixteenth-century innovator Tung Ch'i-ch'ang succeeded in transforming nature into pure painting.

While the *Fisherman* scroll by Wu Chen shows the original brusque, sharp, single-stroke style associated with his name, there are other pictures, particularly in the Palace Collection — and notably a hanging scroll with twin pine trees by a ferry crossing — which indicate sources for the style that was to become his own. Like so many of the more creative Yuan masters, he looked back to the Monumental masters of the Northern Sung, especially to Chu Jan, so famous for the strength of his brushwork (fig. 543). And it was brushwork that ultimately became Wu Chen's main preoccupation, whereas the monumentality of the early master is preserved in but a few hanging scrolls. This particular one might almost be taken for a Chu Jan were it not that the rather heavily tilted mountain creates a

409

Colorplate 41. (above left) Pa-pei Stem Cup. Porcelain, in underglaze blue with red enamel, height 3½". Mark and Reign of Hsuan Te (A.D. 1426-1435); (above right) Wine Cup. Porcelain, with three-color enamels, height 1⅞". Mark and Reign of Ch'eng Hua (A.D. 1465-1487); (left) Jar with Cover. Porcelain, with five-color enamels, height 4". Mark and Reign of Wan Li (A.D. 1573-1619). All: Ming Dynasty. Cleveland Museum of Art

Colorplate 42. (left) Plate. Porcelain, in overglaze yellow, diameter 8⅜". Mark and Reign of Ch'eng Hua (A.D. 1465-1487); (right) Plate. Porcelain, in copper red glaze, diameter 5¹⁵⁄₁₆". Mark and Reign of Hsuan Te (A.D. 1426-1435). Both: Ming Dynasty. Mr. and Mrs. Severance A. Millikin Collection, Cleveland

tension more characteristic of a later period than the tenth century. The sharp break between the foreground and the distant mountains on the far right, linked by that long, bare expanse of water, is most typical of Yuan masters. In detail the brushwork is summary, sharp, and bold — an end in itself. Still these essays in the style of the Northern Sung Period by Wu Chen are so effective that in some cases they have been taken for originals and certain paintings in the Palace Collection, hopefully attributed to Chu Jan or Tung Yuan, are probably by Wu Chen. Perhaps the best word to describe Wu Chen's art is "rough," in the very best sense of that word. It is a sturdy, masculine style, not necessarily pleasing at first sight, largely dependent upon brushwork and upon its strength and simplicity. Consequently, he is particularly admired by the Chinese and rather more difficult to approach by the Western critic and connoisseur.

The third of the Four Great Masters of the Yuan Dynasty, Ni Tsan (1301-1374), is the most famous of them all. Ni is famous not only because of his painting, which certainly excites our admiration and interest, but also for his legendary character. To the Chinese he was the scholar-painter par excellence. For the later Chinese critic no praise was higher than to compare a painting to the work of Master Ni. Son of a wealthy family, he began painting relatively late and always described himself as an amateur. There is a certain devil-may-care attitude in his recorded inscriptions and a certain contemptuous snobbism for the ordinary work-a-day world which was most appealing to the later Chinese scholar-critic. When the extraneous clichés about Ni Tsan are removed, when one strips away the contempt, the snobbism, the scholar-painter-amateur background and considers the paintings alone, there is still quite enough left to rank him as one of the Four Great Masters of Yuan. Ni Tsan, in contrast to Wu Chen with his strength, and Huang Kung-wang with his intellectual consistency, is pre-eminently a poet in paint. His style is very delicate, almost feminine in its effect:

543. A Lonely Fisherman on a River in Autumn (after Chu Jan). By Wu Chen (A.D. 1280-1354). Hanging scroll, ink on paper, height 74⁷⁄₁₆". Yuan Dynasty. National Palace Museum, Formosa

544. The Pavilion of Purple Fungus and a Rock Garden. By Ni Tsan (A.D. 1301-1374). Hanging scroll, ink on paper, height 31¹¹⁄₁₆". Yuan Dynasty. National Palace Museum, Formosa

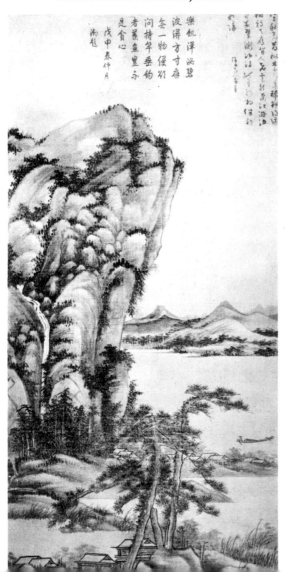

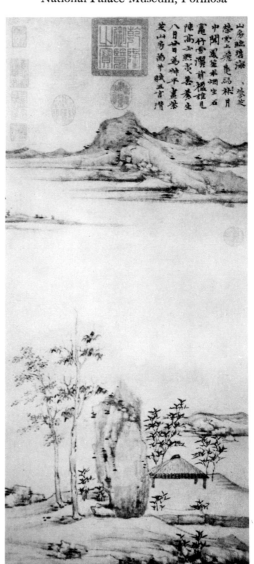

411

He uses a brush in a rather specialized way, making long, thin strokes to define rocks or mountains, or very short but delicate dashes to define the shrubbery on distant mountains or bamboo or leaves. His composi- tions are characteristically simple and depend a great deal upon sensitive placement and upon that particular tension between foreground and background separated by the wide expanse of water so characteristic of the period. There are few complications — usually a domi- nant rock, a few trees, a few sprigs of bamboo, some- times a pavilion, very often a distant mountain; never a human being. The picture in the Palace Collection is pure Ni Tsan (*fig. 544*). Perhaps something of his con- tempt for the human creature can be seen in his pa- vilions with not one soul occupying them. Ni Tsan is most sparing in his use of ink. As the texts repeat, great Chinese painters used their ink sparingly, as if it were gold. And in paintings such as this, with its domi- nant areas of paper and brush strokes acting as a quiet series of notes scattered on the surface, we have an extreme example of the sparing use of ink. Ni Tsan invented a characteristic brush stroke much imitated in later times — a rather crystalline stroke that begins fluently and then bends, producing a sharp angle. Such strokes are used again and again in the rocks and moun- tains, sometimes threaded one on top of the other to produce the *tsun,* or wrinkles, and effects of light and shade. As Ni Tsan was much admired and imitated in later times, he is perhaps the most difficult of all Chi- nese painters to find in authentic works.

One of the most interesting characterizations of the art of Ni Tsan is that of another great individualist of a later date, Tao Chi: "The paintings by master Ni are like waves on the sandy beach, or streams between the stones which roll and flow and issue by their own

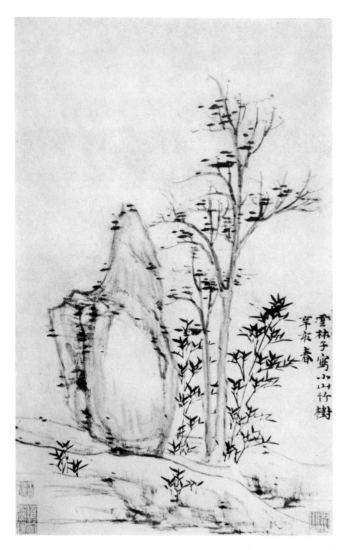

545. *Rock, Bamboo, and Tree. By Ni Tsan* (A.D. 1301-1374). *Hanging scroll, ink on paper, height 36¼". Yuan Dynasty.* National Palace Museum, Formosa

546. *Lion Grove in Suchou. By Ni Tsan* (A.D. 1301-1374). *Handscroll, ink on paper. Yuan Dynasty.* Whereabouts unknown

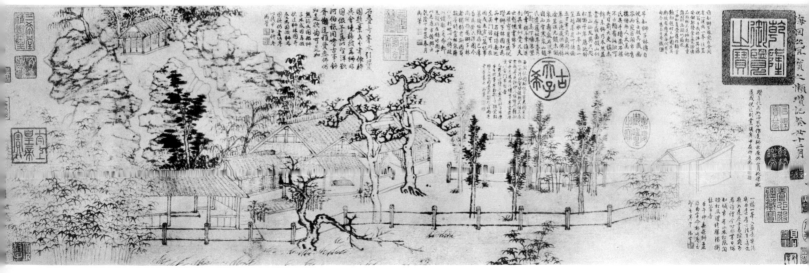

force. Their air of supreme refinement and purity is so cold that it overawes men. Painters of later times have imitated only the dry and desolate or the thinnest parts, and consequently their copies have no far-reaching spirit."[17]

While the tall, vertical landscape with the sharp separation of near and far is characteristic, there is another type of composition for which Ni is equally famous, in which the elements of landscape are largely omitted and only the bare essentials are left us: a rock, a tree, and bamboo. There are several of these, the most striking in the Palace Collection (*fig. 545*). Here one can note particularly the crystalline brush strokes and also the sparing use of dots. The same kind of dot is used to indicate a lichen on a rock or a leaf on a tree. The bamboo, in contrast to that done by the great Sung master, Wen T'ung, or to that at Kansas City by Li K'an, or to one of the great bamboo paintings by Wu Chen, is not as readily recognizable as bamboo, nor does it have that systematic organization or strength of brush stroke which we are led to believe was essential in all bamboo painting. An actual quotation from Ni Tsan explains what he sought. Of one bamboo painting he says: "I Chung always likes my bamboo paintings. My bamboo is painted just to serve as an outlet for the inspiration in my breast. Why should I bother to compare whether it is like bamboo or not; whether the leaves are dense or sparse, the branches bent or straight. At times I smear about for a long while, and when someone sees my picture he may call it hemp or he may call it reeds. I certainly couldn't argue to convince him it is bamboo. Really, I can't help it." (translated by R. Edwards)[18] And by that last phrase, he means not that he can't help it, but rather that he really doesn't care. Contemporary painters in the West and seventeenth-century individualists in China have the same attitude. Ni Tsan stands among the first conscious rebels against tradition.

The *Lion Grove in Suchou* (*fig. 546*), painted toward the end of his life, reveals an unusual aspect of his art and shows that he was at times related to the others of the Four Great Masters. This famous garden featured curious and fantastic rock formations which suggest lions' heads and bodies. Using his typical brushwork, the artist has created a composition with hardly a beginning or an end; rather it is a collection of individual elements placed on the paper with relatively equal emphasis. Here his limitations, when he is compared with the other three of the Four Great Masters, are revealed. Ni's compositions tend to be simple and stereotyped; everything depends on the mood and the sparse brushwork, which contrasts with the bold art of Wu Chen or the complexities of Huang Kung-wang and Wang Meng. But in the *Lion Grove*, however much one may enjoy details of brushwork and the individual touches on a particular tree, one senses a curi-

ous detachment, as though there were no focus or even a desire for one. At the left of the scroll are the famous rock formations behind a typical Ni Tsan bamboo grove, more texture than bamboo. The painting of the architecture is summary and certainly does not conform to the earlier Chinese painter's ideal of a believable building, suitable for living. Instead it is part of the new individualist trend, an abstract series of brush strokes making an aesthetic statement divorced from reality, and not a gross material thing.

The *Lion Grove* scroll with its varied textures is re-

547. Fishing in Green Depths. By Wang Meng (c. A.D. 1309-1385). Hanging scroll, ink on paper, height 34⅝". Yuan Dynasty. S. Junkunc Collection, Chicago

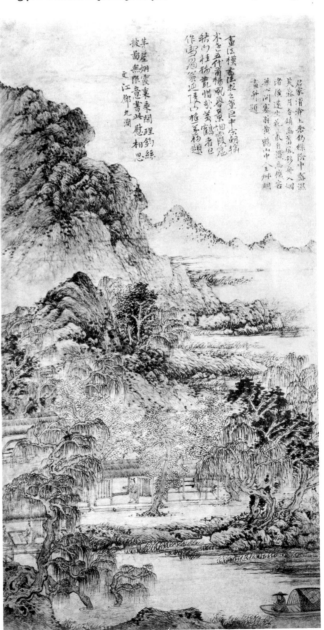

413

lated to the work of the last of the Four Great Masters, Wang Meng (d.1385). Wang was the youngest of the group and perhaps had less fame in his time than Wu Chen, Huang Kung-wang, and Ni Tsan. Nevertheless, his style was of great importance for later Chinese painting and in some ways he stands as the most original and creative artist of the four. Where Ni Tsan was simple, noble, and elevated, Wang Meng is complex, almost coarse with his hemplike brush strokes, like rope, piled one on the other to produce masses of texture combined in a dense and extremely involved over-all pattern. *Fishing in Green Depths* is a relatively simple picture (fig. 547); the poem by Wang Meng at the far upper right reads:

> *Your home is over the clean flood*
> *And you drop your hook under the green shades;*
> *Dew dampens the hibiscus moon*
> *And fragrance dissolves in the lotus wind.*
> *The drifting boat enters misty isles,*
> *And in the press of flowers sits your flute;*
> *Knowing only him who lives forgetting,*
> *No thought for the Old Man of the Frontier.*
> (translated by R. Edwards)[19]

"The press of flowers" is a key phrase describing the visual effect of things being compressed in a tightly locked composition, the typical mode of his pictorial organization. There is a play of textural variety in *Green Depths*, including the sharp, dotlike strokes of the tree on the right, the willow tree with its long, ropelike strokes, a deciduous tree with a series of circles indicating foliage and, just behind the hut, another tree whose foliage is formed with elliptical strokes. These variations of texture are developed throughout the picture. Furthermore, there are certain pressures applied throughout that one does not find in Ni Tsan, Wu Chen, or Huang Kung-wang. The mountain in *Green Depths* appears to be almost writhing and twisting in its locked form; a great spiral movement runs

from the willow tree at the lower left up to the right through the trees and swings back and up into the mountain at the top. These dynamic compositions are strong, complicated and, on the whole, monumental. And in this, perhaps he and Huang Kung-wang knew best the real secrets of the masters of Northern Sung. Wang Meng's figures — for unlike Ni Tsan he deigned to include figures in his pictures — are usually rather roughly drawn, and if one were to judge the quality of a painting by Wang Meng by the skill displayed in the figure drawing, one would be very much deceived. The Wang Meng in the Palace Collection is one of his most developed compositions, and displays the full quality of his style (*colorplate 40, p. 392*). The water is almost lost in the upper part of the picture; everything else twists and writhes in a rolling, rhythmic movement. The details in Wang Meng's pictures, particularly the twisting trees, greatly influenced some of the later Ming artists who delighted particularly in the noble trees of a tradition going back to such Northern Sung painters as Li Ch'eng. Wang Meng, then, is the last of the great masters and, appropriately enough, lived on into the Ming Dynasty to provide a link between the artists of Yuan and those of the Ming Dynasty.

A painting by a little-known master will serve to sum up the contributions and the interests of the Yuan painters. Dated 1360, it is a short handscroll formerly in the Imperial collection, by the little-known Yao T'ing-mei, and titled *Scholar's Leisure* (fig. 548). The painting is followed by colophons written by famous poets and calligraphers of the Yuan and Ming dynasties, all extolling the virtues of leisure, and particularly of scholars' leisure. In this it is characteristic of the Yuan Period, during which the scholar became dominant and remained so from this time on. Painting was not a professional activity but a gentleman-scholar activity, to be executed in leisure time. The intimate connection between painting and poetry is of the utmost importance. Almost all Yuan paintings, even if they

414

548. Scholar's Leisure. By Yao T'ing-mei. Handscroll, ink on paper, height 9¹⁄₁₆"; length 33¹⁄₁₆",
dated A.D. 1360. Yuan Dynasty. Cleveland Museum of Art

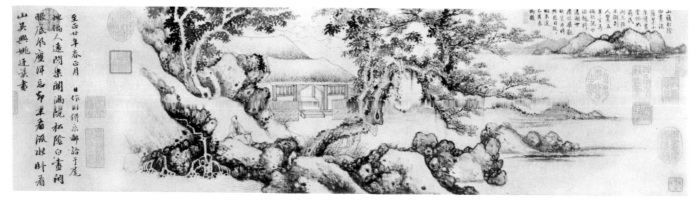

are hanging scrolls, have numerous poems inscribed either on or near the painting. These poems extol the virtues of the painting or, more often, attempt in literary form to match the mood of the painting. They are rarely the literal descriptions of the painting found on many of the works of the Sung Dynasty. The *Scholar's Leisure* is on paper, the favorite ground of Yuan painters, and represents an oft-repeated subject: a hut, a scholar seated by a waterfall, an old gnarled pine tree, and distant mountains. There is nothing new in this, but the disposition of elements is important, and the brushwork more so. The twisted strokes in the rocks and trees, the crumbly textures of the rocks around the waterfall, the style of the architecture, the distant mountains, and the rhythmical swirling of the pine boughs as they reach out to repeat the rolling motif of the distant hills, all recall the style of Wang Meng.

After the Mongol rule of the Yuan Dynasty, there was a resurgence of native power with the founding of the Ming Dynasty by the emperor who is known by his reign title of Hung Wu. He was born of peasant stock, but he was Chinese; and the re-establishment of a native dynasty was an important factor in the developments of the arts, since the desire of artists and craftsmen was not only to create new things but to look back past the Yuan Dynasty to the days when once before there had been a great native dynasty. The facts of the new dynasty are not always as pretty as the dream of native revival. Hung Wu was a ferocious character and caused the deaths of many of the more creative painters, scholars, and calligraphers who had been tolerated under the supposedly tyrannical rule of the Mongols. But the main reason for the flourishing of the arts in the Ming Dynasty was the re-establishment of strong imperial political and economic support for the arts in all fields. The Academy was revived in painting. A great Imperial kiln was developed in Kiangsi province at Ching-Te-Chen, where all the great porcelains of the Ming and Ch'ing periods were made. Lacquer, textiles, and all those industries that require stable conditions and economic support were more elaborately developed than ever before.

Now, however, there was a real gulf between art and handicraft, a split which had begun to develop in the Sung Dynasty through the attitudes of the scholar-painters. The scholar-painter differentiated between the work of the artist, in our sense of the word, and that of the artisan; and by artisan he meant painters who worked in the *Ma-Hsia* style of the Sung Dynasty, or to painters who painted religious pictures, or to those who were not amateur scholar-gentlemen, but professionals who made their living by their art. These were classed as artisans, and, of course, the term included all ceramic, lacquer, and textile workers.

Since the Ming Dynasty was a period of strong central control, with a reasonable degree of peace and

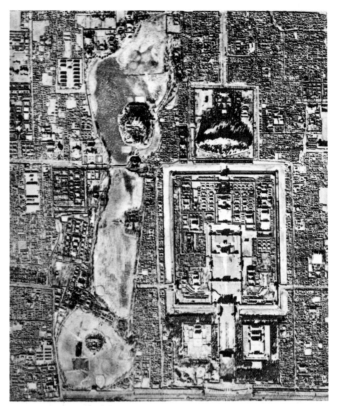

549. *Forbidden City, Peking, China, aerial view*

550. *T'ai Ho Men (Gate of Supreme Harmony), as seen from the platform of T'ai Ho Tien (Hall of Supreme Harmony), Forbidden City. Ming Dynasty,* A.D. *1627 and later*

551. *Hall and Garden of the Summer Palace, Peking. 17th–18th Century* A.D.

prosperity, we would naturally expect architectural work to repair the destruction of the preceding centuries. Much of what one sees today in Peking — the general layout of the city, the Temples of Heaven and Earth, and the palace — is the design of the Ming Dynasty, executed by the architects of Emperor Yung Lo.

While the work of the Ming architects dominates the present Peking scene, no fundamental changes were made in architectural construction and earlier techniques were merely elaborated. The post-and-lintel system, bracketing, tile roofing, stone platforms, the bay system of development for size — all were still fundamentally the same in the Ming Period.

The plan and organization of cities and of palace areas is one of the most significant manifestations of the Chinese mentality that one can study. The orientation of a typical Chinese city or palace is based upon philosophical and cosmological concepts primarily rational in origin and geometrical in appearance. The aerial view of the Forbidden City in Peking shows logical order and balanced arrangement which, while characteristic of most great empires and pyramidal political structures, was developed with characteristic Chinese consistency and balance (*fig. 549*).

The whole is surrounded, of course, by a wall. The wall, so essential to a Chinese city, village, or town, temple, palace, or house, achieved not only protection but also privacy for the unit within it. This great protector symbolized that containment and strong in-group feeling characteristic of the Chinese family in particular and of Chinese society in general.

One approaches the walled palace city from the south through the Gate of Heavenly Peace. The complex series of buildings at the left of the photograph were the offices and departments of the palace government. These numerous and elaborate office structures give some idea of the intricacy of the political organization. The whole area, almost square, has its principal buildings and gates laid out along the north-south axis, their facades facing south. Some of the other buildings and gates are at right angles to the main axis; others are disposed in walled compounds on the same north-south axis. Within the precincts are three main sections separated by gates, the first is a forecourt flanked by temples to ancestors and tutelary gods. Following this is the outer court approached through two gates. The first is the Meridian Gate (*Wu Men*), which housed government offices in the hall and flanking pavilions above its massive wall. *Wu Men* opens on a spacious area crossed from east to west by a bow-shaped waterway, the Golden Water River, confined in marble-balustraded walls and spanned by five marble bridges, symbolic of auspicious fives, such as the Elements, the Virtues, or the Confucian Relationships. Beyond the bridges stands the Gate of Supreme Harmony, opening onto the outer court, heart of the palace group. Here

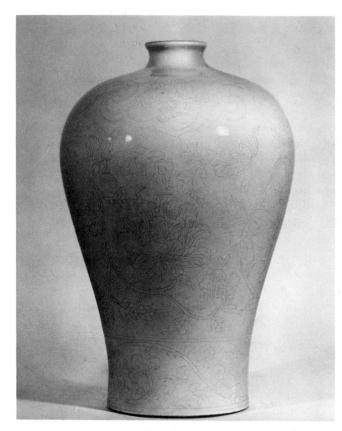

552. Vase. Porcelain, height 12⅝". Reign of Yung Lo (A.D. 1403-1424). Ming Dynasty. Mr. and Mrs. Severance A. Millikin Collection, Cleveland

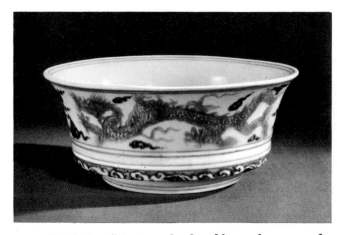

553. Bowl. Porcelain, in underglaze blue and copper red, diameter 6¾". Mark and Reign of Hsuan Te (A.D. 1426-1435), Ming Dynasty. Sir Percival David Foundation, London

are the three ceremonial halls, their importance emphasized by the white marble terrace in three stages on which they stand. Three stairways lead to the largest of the three buildings from stage to stage in successive flights. This is *T'ai Ho Tien*, Hall of Supreme Harmony, where ceremonies for the New Year, the

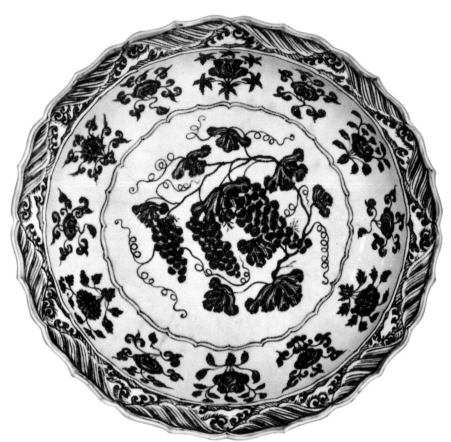

554. *Plate with Grape Decoration. Porcelain, in underglaze blue, diameter 17". Reign of Hsuan Te* (A.D. 1426-1435), *Ming Dynasty.* Cleveland Museum of Art

winter solstice, and the emperor's birthday were held (fig. 550). Directly behind stands the small square Hall of Middle Harmony and beyond is the Hall of Protecting Harmony, where the emperor met the embassies of vassal states and scholars whose successful examinations made them eligible for office.

On either side of the outer court, which was walled in with galleries, were large pavilions used for libraries, temples, the government printing-office, and halls for Confucian lectures and for sacrifice to men of learning.

North of the outer court the Ch'ien Ch'ing Gate leads to the inner court where the buildings, which repeat on a smaller scale the plan and shape of the three ceremonial halls, were devoted to the emperor's personal life. In the Palace of Cloudless Heaven he held audiences; imperial seals were kept in the square pavilion behind it; and the farther Palace of Earthly Tranquillity was that of the empress. Beyond and surrounding this central core of palaces were walled-in compounds with gardens for royal residence, the emperor's Ancestral Hall, his library, offices, studies, theatre, Taoist, Lamaist, and Buddhist temples, treasure rooms, and a park.

So, through symmetry and balance, masses of buildings — relatively uniform in structure, shape, and color —were disposed within a serene and magnificent framework. Their ordering was related to their function, and the whole organization symbolized the underlying harmony of the universe which, in the age-old tradition, the Emperor, Son of Heaven, maintained on earth.

Three basic types of building, the hall or *t'ien*, the tower or *t'ai*, and the pavilion or *t'ing*, were unified by their common elements: tile roof, bracketing, stone platform, and bay construction of wooden post-and-lintels. The tile roofs of Ming buildings were highly decorative. The glazing of large pieces of earthenware had developed to a point where mass production was possible and impressions from black-and-white photographs are belied by the colorful appearance of the buildings with their roofs of yellow — in the case of the imperial buildings, of blue and green — the whole producing a brilliant effect not unlike that to be seen in the mosaic-covered domes of the mosques of Persia. Bracketing, too, was elaborately developed with much use of painted decoration in color. The whole tendency of Chinese architecture was more colorful than that of Japan, where monochromatic and subtle effects were usual.

In less formal architecture, associated particularly with the residences of the aristocratic or well-to-do, and even found in the Summer Palace outside Peking, informality ruled, though the same principles of balance and symmetry remained. Such buildings were on a less elaborate scale, and the bracketing of the post-and-lintel construction was handled in a simpler man-

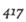

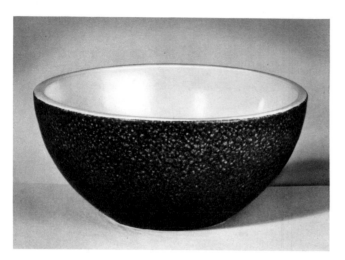

555. *Dice Bowl. Porcelain, in curdled blue underglaze, diameter 9⁹⁄₁₆". Mark and Reign of Hsuan Te* (A.D. *1426-1435*), *Ming Dynasty.*
Sir Percival David Foundation, London

ner, tending to draw attention to the surroundings of the building rather than to the building itself, as if the resident had consciously moved into a landscape to escape the "dusty world" of officialdom.

Lattice was developed in these less formal surroundings to an amazing degree of complexity and variation within the simple purpose of providing interesting grilled windows. But the surroundings of the Chinese palace or house are quite different from the restrained and natural gardens of Japan (*fig. 551*). In the Chinese garden, we find the same interests evident in painting — a fondness for old and interestingly shaped trees, sometimes of great size; flowers and living still lifes arranged in beds or basins as if they had been arranged from or for a painting; and, above all, strange and fantastic rocks that suggest mountains or fantastic beasts, such as the Lion Rocks of the garden in Suchou made doubly famous by Ni Tsan. The effect of the Chinese garden is more formal than that of the Japanese, with its informality, freedom, and careful suppression of any evidence of the constructive hand of man. The use of cut stone in pavement or stone railings, of beds of trees or shrubs with boundaries of stone, creates an effect allied to European garden styles.

Centralization of power and the large sums of money available to the emperor and his court were spurs to the decorative arts. The figures listed in old records of the quantities of porcelains or lacquers ordered by the court for a given year are nothing short of astounding. Quantities such as seventeen thousand first-class "round" pieces were commonplace in the invoices sent to the Imperial kiln, and this for only one year. Such figures give some idea of the extent of destruction since

that time: the wonder is not that we have so many Chinese porcelains but that we have so few.

Before considering the Imperial porcelains, we must mention that Sung traditions were maintained in the private kilns. The basic Northern and Southern distinctions continued. *Tz'u-Chou* ware — Northern slip-decorated stoneware — was produced at the great beehive kilns in still-continuing quantity, even if the quality began to decline. In the South, in Chekiang, the celadon wares were made for domestic use as well as for export in great quantities. These Ming celadons are found throughout Indonesia, Southeast Asia, India, and Japan, wherever the Chinese export trade flourished. But these are fundamentally regressive wares produced in finer quality in earlier times. The creative wares were the Imperial wares, made at Ching-Te-Chen.

We have seen that in the Yuan Dynasty a new style in porcelain developed out of the *Ch'ing-pai* tradition of the Sung Dynasty, beginning with the *Shu Fu* ware made for the Yuan court. Developed use of underglaze blue began at this time and the technique was avail-

556. *Vase. Fa Hua porcelain, height 14¾".*
Ming Dynasty, late 15th Century A.D.
Cleveland Museum of Art

able at the beginning of the Ming Dynasty for further conquests. We will consider this florescence in a sequence of basic types from the earlier to the later reigns of the dynasty, beginning with monochrome white porcelain and white porcelain with decoration in underglaze blue. The classic period for white porcelain was the Yung Lo reign (1403-1424). While blue-and-white and monochrome wares were produced as well as plain white porcelain, it is usually accepted that the white porcelains of the reign are among the greatest ever made (fig. 552). The body of these white porcelains is an almost pure white, with a slight grayish tinge, and has a tendency to burn slightly pink or yellow where it meets the glaze. This basic material is covered with a transparent glaze enhancing the brilliance of the body, which was often enriched by incised or molded decoration under the glaze, so subtle and cleverly applied that in many cases it qualifies as *an-hua* — secret or hidden decoration. Since the shapes were often wheel-thrown, particularly the vases (the bowls sometimes being made by a slip-casting process), the surfaces of the pieces are slightly irregular. The relatively thick transparent glaze fortified the irregularity, producing an undulating surface with a texture which the Chinese liken to that of various citrus skins. These variations, lovingly described and catalogued by the Chinese collector, are in sharp contrast to the more perfect glossy-smooth glazes standard in the best porcelains of the Ch'ing Dynasty.

The next logical step in the development of porcelains was the addition of decoration in underglaze blue, already begun in the Yuan Dynasty. In the Ming Dynasty such underglaze blue decoration was applied with variety of style and extraordinary color control. While blue-and-white porcelain was made during the Yung Lo reign, the Hsuan Te reign (1426-1435) is considered by many to be the classic period for the ware. In this reign objects such as the large plate in Cleveland, with decoration of grapes within a wide border of alternating flowers surrounded by a wave pattern inside the foliate rim, display a notable richness of color and sharpness of decoration (fig. 554). The variety of early Ming shapes is quite extraordinary. Not only dishes, but vases, tea bowls, wine cups, and utensils for Buddhist ceremonial offerings were typically decorated with a blue verging on blue-black and with a pleasing free effect contrasting with the more perfect but colder blues of later times. The general impression made by the blue-and-white porcelains of Hsuan Te is one of austerity and simplicity despite the rich decoration.

Rare variations in the appearance of Hsuan Te blue-and-white porcelain were made by the addition of enamel color, and this was to be a fruitful method for future decoration. An almost unique specimen of the Hsuan Te reign has the six-character Imperial mark, as did most of the porcelains made at the factory, on the inside of a stem cup decorated with underglaze cobalt blue (*colorplate 41, p. 409, top*). On top of the glaze, the mythical beasts sporting in the waves are colored with an overglaze red enamel. The addition of a second color to the blue produces a rich effect. The transition from this relatively austere use of enamels to the gay and brilliant use of five-color enamels in the later reigns of the Ming Dynasty was probably accomplished in the Ch'eng Hua reign (1465-1487). A unique Ch'eng Hua specimen, once in the palace, was copied in the Cheng Te Period and so must have been already a classic specimen. Ch'eng Hua enameled porcelains are usually of the so-called three-color type: underglaze blue with overglaze decoration in red and green enamels. This is a halfway point to the later and standard five-color decoration. The small wine cup, only some two inches high, has the freedom of drawing and pure, clear enamel color, combined with a glaze which was perhaps one of the finest technical achievements of the Chinese potter (*colorplate 41, p. 409, center*). The slightly greenish tinge of the glaze and the slightly yellowish burn of the thin glaze and body at the foot, are firm indications of authenticity. Such wares were much copied from the next reign to modern times and are the rarest of all the enameled porcelains of China. The five-color enamels may have also developed in the Ch'eng Hua Period but they reached their highest de-

557. *Octagonal Jar. Porcelain, with overglaze enamels, height 15". Ming Dynasty, early 16th Century* A.D. Sir Percival David Foundation, London

419

558. Kuan-yin, from Fukien. Te-hua porcelain, height 17¾". Late Ming or early Ch'ing Dynasty, c. 17th Century A.D. Cleveland Museum of Art

velopment in the Chia Ching and Wan Li reigns (1522-1619). The small but brilliantly colored jar of Wan Li porcelain comes from the Cleveland Museum (colorplate 41, p. 409, below). The enamel color added to produce the complex effect was yellow. Beginning with a white body, decoration in underglaze blue was added, covered with a transparent glaze, and then on top of this, decoration in enamels of red, green, and yellow were applied. The process was complex and required several firings, but the final result was a richly colored ware, admirably effective in narrative scenes and freely painted floral designs which became even more refined and complex in the Ch'ing Dynasty.

These great porcelains of the Imperial kilns were produced by what amounts to a mass-production system, at least, by a system involving the division of labor. The man who made the pot did not glaze it; the man who put the glaze on did not decorate it. If one has seen in Japan or China a potter, or rather a decorator painting a pot, one realizes how rapid and even mechanical such a technique can be when done by a man who has done it for a lifetime, as did his father before him, and his father before him. It was

often a hereditary craft of great skill and specialization.

If the most richly decorated porcelains are those of the two-, three-, and five-color types, there was another line of development in Imperial porcelains which was rather more restrained and led to subtle as well as brilliant effects, and this was the development of monochrome porcelain. In the Hsuan Te reign, when underglaze blue-and-white was at its highest development, a few rare Imperial pieces were produced in which an attempt was made to use underglaze copper red. This was a much more difficult technique than the use of overglaze red enamel, and the results varied. But we see in the dragon bowl from the Sir Percival David collection in London the combination of underglaze blue and underglaze red (fig. 553). The developments in monochrome porcelain were to come from the intelligent and subtle use of both underglaze and overglaze colors. In the case of red, it was decided that the underglaze copper red was the most pleasing or desirable technique, and so, in the Hsuan Te reign, monochrome vessels in underglaze copper red, the so-called sacrificial red, were produced. They are extremely rare, and genuine examples are to be counted, even from the Palace Collection, on the fingers of two hands. The red is usually a little mottled and is sometimes described as "liver red." The distinguishing feature of this early Ming underglaze copper red from the rather more common and more famous Lang ware or "ox-blood" red of the late Ming and the Ch'ing dynasties is to be found where the red meets the white (colorplate 42, p. 410, right). You will note at the foot- and lip-rims a fairly large area of white, and that wherever it meets the red there tends to be a subtle cloudy transition. In the later "ox-bloods" this transition is much sharper and less subtle.

Another monochrome type to be expected was underglaze blue. Uniform underglaze blue was relatively common in later reigns, but one particular monochromatic blue is of great beauty and rarity, the "curdled" blue of the Hsuan Te reign (fig. 555). This curdled blue represents the same kind of taste that led to the creation of Chinese rock gardens: a love for forms grotesque, ancient, gnarled. This particular shape is one that is often made both in underglaze blue-and-white and in plain white. It has very thick walls and appears to have been used as a dice bowl for gaming. The most famous monochrome type of the Ming reign is the monochrome-yellow porcelain, produced not by an underglaze technique but by an overglaze technique using yellow enamels (colorplate 42, p. 410, left). They are most often found in bowls and plates. The classic period for resonant yellow is the reign that produced the great three-color porcelains, Ch'eng Hua, though the yellow of the following Hung Chih (1488-1505) and Chia Ching (1522-1566) reigns is also important.

There were porcelains of great interest and impor-

420

559. *Wine Bottle. Punch'ong stoneware, height 10⁹⁄₁₆".*
Yi Dynasty, 15th–16th Century A.D. Duksoo Palace
Museum of Fine Arts, Seoul

White porcelain, the so-called *blanc de Chine,* more properly called by its Chinese name *te-hua,* probably inspired by the Imperial porcelains of the Yung Lo Period, was made in large quantities in Fukien province, near the seacoast (*fig. 558*). It was used both in China and for export. The white porcelain of Fukien can often be distinguished from that of the Imperial kiln by its creamier color and glassier surface.

Related to these Ming porcelains, as a country cousin to the urban sophisticate, are the porcelains produced in the sixteenth and seventeenth centuries under the Li Dynasty in Korea. These somewhat rough but original variations on Koryu and Ming themes are of particular importance for their influence on Japanese stoneware and porcelain of the seventeenth and eighteenth centuries. Those qualities of devil-may-care informality derived from hasty and unselfconscious technique were just what endeared the Li ceramics to the tea-ceremony-conscious Japanese.

While there is much variety in these Korean ceramics, two types are especially worthy of mention. One is derived from the decorated celadons of the Koryu Period, using white or gray slip beneath the now grayer green celadon glaze (*fig. 559*). Sometimes this slip is merely wiped on and the marks of the cloth or brush provide the sole means of decoration other than the

tance made outside the Imperial kiln. *Fa Hua* decorated ware is one of these, a process deliberately imitating cloisonné enamel (*fig. 556*). The white porcelain body was decorated with raised areas outlined in slip as boundaries for flowers or figures, in this case the lotus; the areas inside the raised slip boundary were filled with different enamels. In this case, only two are used, a pale yellow and a pale blue, in addition to the dark blue of the background and the white of the body. The result seems very much in keeping with the blue-and-white tradition, and in this example has a restraint not always found in the *Fa Hua* technique. There were also three-color and five-color bowls and vases of a particular type involving the use of gold in addition to the overglaze enamel decoration. These were made for use in China, but especially for export to Japan. The vase in the David collection gives some idea of the rich, almost brocaded effect achieved in this field (*fig. 557*). Indeed, in Japan they were called brocaded vessels and were very much sought after for use in the tea ceremony. The later imitations founded a new tradition of Japanese porcelain in the seventeenth and eighteenth centuries.

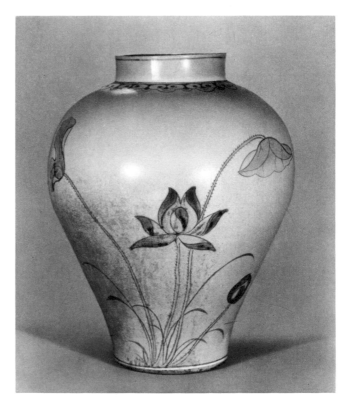

560. *Vase. Porcelain, with decoration in underglaze blue and copper red, height 17¼". Yi Dynasty,* A.D. *1599-1717.* Private collection, Japan

421

glaze. Still others use punched, incised, or carved techniques of *Tz'u-Chou* slip decoration to produce abstract, floral, or fish decorations beneath the glaze. These stonewares are matched by heavy-bodied porcelains with decoration in underglaze blue or more rarely blue and copper red (*fig. 560*). The spare and hasty but sure drawing is notable. Such porcelains were little appreciated until the modern Japanese folk art (*mingei*) and allied Western movements brought attention to them.

The textile industry flourished in the Ming Period. The *K'o-ssu* silk tapestry technique was continued and was often used to produce pictorial effects and copies of famous paintings of the past (*colorplate 43, p. 427*). The results are never direct imitations, but are art forms in their own right, with flat, soft color schemes that heighten the tapestry technique. Embroidery continued as an important textile industry, and the growing use of elaborate costumes involving decoration designating the social status or the official rank of the person wearing the costume furnished a continuing market (*fig. 561*). While few, if any, Ming robes have survived, many early Ch'ing examples preserve their style. Enameling on metal, rare before the Ming Dynasty, was elaborated in the cloisonné and champlevé processes.

We have seen that lacquer had been known as early as the Late Chou Period, when it was used for painted designs. But in the Ming Dynasty, this art probably reached a second peak after the Late Chou Period. The same imperial patronage that demanded the great porcelains required carved cinnabar lacquer, painted lacquer, and incised or gilded lacquer of great aesthetic quality. The early reigns of the Ming Period, such as Yung Lo and Hsuan Te, are well known for their carved cinnabar lacquer. The example in the Low-Beer collection dates probably from the Hsuan Te reign (*figs. 562 and 563*). The dragon is of the same type found on the underglaze blue-and-white porcelains; but in this case, the combination of the red color with the richly sculptured low relief produces an effect quite different from the austerity of the blue-and-whites and rather closer to the aesthetic overtones of textiles and colored porcelains. The technique is a painstaking one, requiring great patience and magical skill, for the lacquer is built up layer on layer before being carved. In the rather rare authentic examples from the early Ming Period, the carving has a vigorous and slightly rounded quality, quite different from the rather flat and decorative effects of later imitations. The carved cinnabar technique, used principally for dragon and peony and lotus decoration in the early reigns, was more rarely used for pictorial effects, and this manner became even more popular in later reigns. The shape of the plate in figure 564 is derived from porcelain shapes; its decoration, showing a garden and terrace scene, is inspired by the work of academic court painters. Each pattern, whether of waves or clouds, refined

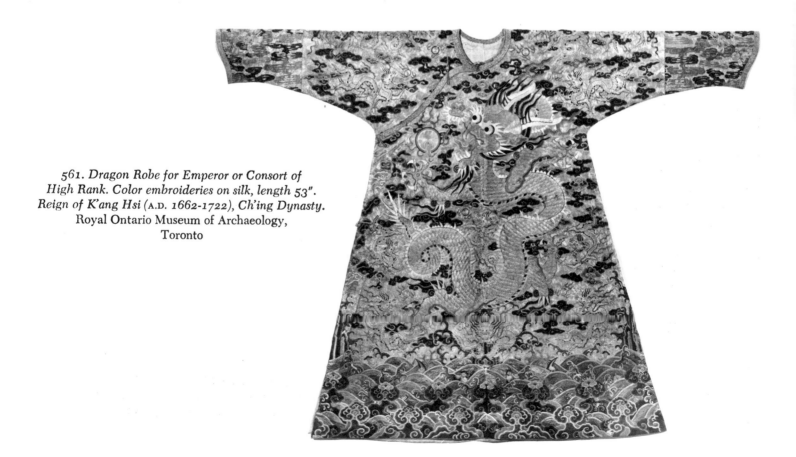

561. *Dragon Robe for Emperor or Consort of High Rank. Color embroideries on silk, length 53".* *Reign of K'ang Hsi* (A.D. 1662-1722), *Ch'ing Dynasty.* Royal Ontario Museum of Archaeology, Toronto

422

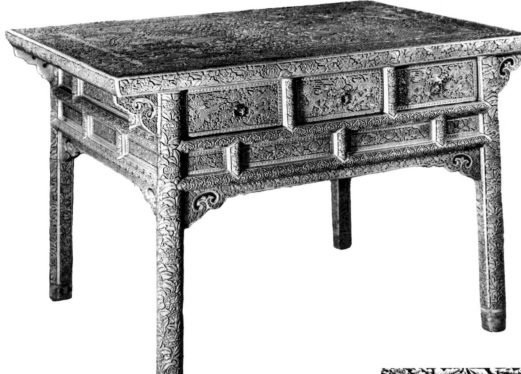

and delicate in the carving, is developed in a consistent, logical, and painstaking way so that one texture complements another. Middle Ming carved lacquer pieces often display many colors. In contrast to the single red color of the early Ming carved lacquers, those of the Chia Ching and Wan Li periods are not only in cinnabar, but in black, dark brown and, in some cases, yellow. Painted lacquers were generally for ordinary use and are found very often in lacquer trays and dishes. But the most complicated technique used by the imperial lacquer craftsmen required the incising of the lacquered object with a design often of dragons, flowers, or phoenixes, the coloring of the incised design by a few simple colored lacquers, and finally, the gilding of details to bring out linear elements of the design. This technique is at its best in the chest with drawers, illustrated in figure 565, dating from the Hsuan Te reign (1426–1435). A view of the whole piece brings out the richness of the design, which is related to the pictorial effects of later Ming porcelain and textiles. A detail (*fig. 566*), reveals the same meticulous refinement characteristic of the carved lacquers of the middle Ming Period.

If we consider the history of painting during the Ming Dynasty as a continuing chronological sequence, we do a stylistic injustice to the material. The very early years of the dynasty, from about 1368 to 1450, show a continuation of the styles already formulated by the conservative and the creative masters of the

423

Yuan Dynasty. The period from 1450 until the close of the dynasty in 1644 witnesses a steady stream of creative painting, almost completely the product of members of the scholarly class, that class we have seen emerging as the dominant school of Chinese painting. The body of critical writing on painting is enormously

564. Plate with Garden and Terrace Scene. Lacquer, diameter 13⁹⁄₁₆". Reign of Yung Lo (A.D. 1403-1424), Ming Dynasty. Fritz Low-Beer Collection, New York

565. Chest. Lacquer, with incised design, length 22⅜". Hsuan Te Reign (A.D. 1426–1435), Ming Dynasty. Fritz Low-Beer Collection, New York

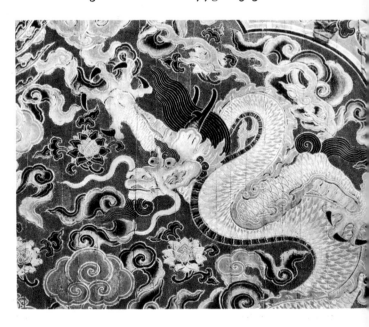

566. Chest. Detail of figure 565

enlarged during these centuries. Nearly all the scholars, scholar-painters, and scholar-critics tried critical writing. A great body of work surrounds the figure of the painter-critic Tung Ch'i-ch'ang (1555-1636). He and his immediate associates were the principal critical spirits behind the formulation of the classification "Northern and Southern schools." While the critical use of this term is extremely confusing, no survey of Chinese painting can omit discussion of these categories. If we realize that the distinction is not a geographic one and is in no way associated with the Northern and Southern Sung periods, but a critical one — Northern implying, on the whole, reactionary and bad, Southern implying progressive, good, and scholarly — then we will have gone far in dispelling the clouds of confusion around these two categories. The Northern school was defined by the literati as a professional artisan school. To this school were relegated painters who were felt to be outside the main scholarly tradition. Ma Yuan and Hsia Kuei, for example, were put into this limbo. On the other hand, painters such as Wang Wei, the late T'ang landscape painter and poet, were put into the Southern school, meaning that they were approved by Ming critics. For us these differentiations are of secondary importance. We will, in general, consider the conservative masters first, and they will largely be members of the Northern school. Then we shall consider the more progressive, scholarly masters of the Southern school. There is no sharp line between these

424

two schools. There are numerous overlappings and hazy areas, and masters have been known to be cited as members of both schools by two different critics. Fundamentally, it is a qualitative and caste judgment.

The early years of the Ming Dynasty saw the continuation of numerous conservative tendencies already explored during the Yuan Period. A painter such as Jen Jen-fa is a direct follower of such archaistic painters of the Yuan Period as Ch'ien Hsuan, or Chao Meng-

fu. The painting shown in figure 536 goes back in style to the T'ang horse-painters; and the remarkable thing is that the high quality of line and color has been preserved over a period of three or four centuries. A second type of conservative painting of quality and interest is that associated with a school called the *Che* school. This school, considered unfashionable by the critics of the later Ming Dynasty and therefore relegated to the Northern category, produced some of the most interesting paintings in the *Ma-Hsia* tradition. Such masters as Tai Chin, in his famous *Fisherman Scroll* in the Freer Gallery in Washington, or Wu Wei, with his rapidly brushed figures of sages and scholars, are typical *Che* school masters. A fine picture by a rare master of that school, Tu Chin, is *The Poet Lin P'u Walking in the Moonlight* (fig. 567). It is a hanging scroll with slight color on paper, and represents a famous poet of earlier times. He is walking between two rocks on a path by a stream; nearby is a twisting tree with one of its branches thrust beneath the water's surface — the latter a typical motif of early Ming painters. The style, while based on that of the *Ma-Hsia* school, is even freer and seems halfway between the Lyric and the Spontaneous Style. The brushwork used in depicting the twigs and branches of the tree is of particular interest, as is the pictorial effect of the pale figure before the lightly washed rock, creating a visual impression of moonlight. A second master associated with these conservative painters is the great bird and bamboo artist Lin Liang, active until about 1505. A painting by Lin Liang represents two peacocks in a bamboo grove (*fig. 568*). In a picture of this type the Chinese, while still maintaining the distinctive quality of their brushwork, came close to the decorative style of the great Japanese painters of the Momoyama and Tokugawa periods. But what distinguishes this painting from that Japanese style is precisely that rather sober and rational control of composition we feel to be Chinese, and especially that emphasis upon the integrity of every brush stroke which is at the heart of all Chinese painting. Where a Japanese painter may occasionally make a brush stroke which is primarily decorative in itself, where he will sacrifice the ideal nature of the brush stroke to the decorative requirements of the painting, the Chinese painter never relaxes control of the brush to that extent. Thus, if we examine the tail of the great cock, with the differentiation of tones in the eyes of the feathers, the long, thin strokes used to show the tail feathers, the sharp, heavy strokes used for the feathers of the wing, as contrasted to the shorter, fuzzier strokes of the hackle feathers, we see that the brushwork has maintained its inflexible integrity at the same time that it differentiates natural textures in the most subtle way. The contrasts, for example, between the softness of the feathers, the firmness of the body underneath, and the very spiny and stiff character of the legs and talons of the bird are

remarkably well achieved. The bamboo is a classic example of fifteenth-century bamboo painting, and again, one can examine every stroke and find the sharpness and sure placement achieved by the great Yuan bamboo painters. Lin Liang's bamboo is rather delicate in the leaves, but very firm in the construction of the

567. The Poet Lin P'u Walking in the Moonlight. By Tu Chin (active c. A.D. 1465-1487). Hanging scroll, ink and slight color on paper, height 61⅝". Ming Dynasty. Cleveland Museum of Art

425

with brush strokes which produce the foliage of trees and bushes, and the wrinkles of mountains (fig. 569). The composition is extremely complex and goes back to the Northern Sung Period for its compositional devices rather than to the forbidden masters of Southern Sung, the *Ma-Hsia* group, called Northern school by the critics. Hsu Pen, of course, was an accepted member of the Southern school, a major figure in the tradition of the late Yuan Period. If one looks at a detail of *Streams and Mountains*, one is again aware of that Chinese integrity of brushwork which we have already analyzed to a certain degree in the quite different work by Lin Liang. The differentiation of the deciduous foli-

568. Peacocks. By Lin Liang (active c. A.D. 1488-1505). Hanging scroll, ink on silk, height 63⁹⁄₁₆". Ming Dynasty. Mr. and Mrs. Severance A. Millikin Collection, Cleveland

569. Streams and Mountains. By Hsu Pen (active c. A.D. 1380). Hanging scroll, ink on paper, height 26¾". Ming Dynasty. Mr. and Mrs. A. Dean Perry Collection, Cleveland

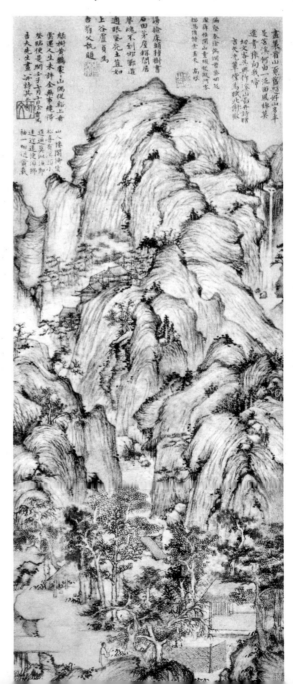

main stalks of the plant. The rationality of the composition is evident, particularly in the use of thrusting diagonals and the balancing of the principal stalk of bamboo by the large area of rock at the lower right.

A second form of conservatism at the beginning of the Ming Dynasty was a continuation of the creative styles of the Four Great Yuan Masters. One artist active in this way was Hsu Pen, who began his painting career at the end of the Yuan Dynasty and became an official of the new court, but because of his failure to conform to the requirements of the ruthless Emperor Hung Wu, he was put in prison, where he died. Hsu Pen, like other masters of this transition, is an original painter in the scholarly tradition of Ni Tsan, Wang Meng, Huang Kung-wang, and Wu Chen. He arrived at a style of his own within Wang Meng's idiom. In a small picture, *Streams and Mountains*, one of only a few surviving, he emphasized texture to an extent comparable to Wang Meng, covering the whole surface of the picture, except for a very small area of sky above,

Colorplate 43.
K'o-ssu Tapestry.
Silk and gold, length 78".
Ming Dynasty.
Cleveland Museum of Art

427

428

溪山深館

嘉靖辛卯秋日五峯文伯仁寫

429

Colorplate 45.
Landscape. By Wen Po-jen
(A.D. 1502-1576).
Hanging scroll,
ink and color on paper,
height 70½".
Ming Dynasty.
Cheng Te-kun Collection

Colorplate 46. Lotus. By Ch'en Shun (A.D. *1483-1544*). *Handscroll, ink and color on paper, height 12",
length 19' 1". Ming Dynasty.* Nelson Gallery-Atkins Museum (Nelson Fund), Kansas City

age conventions — triple-dotted foliage, straw stick foliage, and black dot foliage — each stroke, each dot, each movement of the brush that puts ink to paper can be looked at as an individual stroke and not found wanting. And in this perhaps is one of the major distinctions, not only between Chinese and Japanese painting, but also between Chinese and Western handling of the brush. In the West the usual intention until recently has been to obliterate the brush stroke in achieving the effect of reality in nature. On the contrary, in the scholarly Southern tradition the artist insisted primarily upon precision and integrity of brushwork, even at the expense of verisimilitude to nature.

Three painters stand between the Northern and Southern schools of the early Ming Period. They have been called both Northern and Southern, but should be associated with the conservative group. The first of these is the painter T'ang Yin (1470-1523), probably the master of the other two painters of this triad, Ch'iu Ying (active from about 1522 to 1560), and Chou Ch'en (d. after 1534). T'ang Yin, the oldest of these, goes back beyond the *Che* school to the great Sung master Li T'ang, who stood between the early Monumental Style of the Sung Dynasty and the Lyrical Style of the *Ma-Hsia* school. T'ang Yin occupied a somewhat similar position in the late fifteenth century. His brushwork is rather conservative. He tends to use it not only as brush but also as a means of representing nature in a relatively realistic way; and he is very sober in his compositions. His rocks are built up in a rather characteristic oysterlike way, a series of strokes of increasing circumference making a shell-like rock. His usually tall, vertical compositions are monumental in the earlier tradition, but also have overtones of poetic unity implying a particular mood quite different from the rather generalized and cool monumentality of the Sung painter. In a hanging scroll in the Palace Collection, a monumental landscape format is used to present a summery and luxuriant scene with a marked counterpoint between the rich and soft textures of the foliage and the more austere and angular profiles of rocks and mountains (fig. 570). One is always conscious of a vigorous and masculine talent behind his brushwork. Most of T'ang Yin's paintings, like those of the Sung masters, are on silk. Even the materials of painting are involved in the Northern and Southern categories, for the scholarly painters of the Southern school tended to work on paper, while the conservative "artisans" of the Northern school worked as often on silk as on paper.

Ch'iu Ying, T'ang Yin's pupil, is one of the most admired and forged of Chinese painters. He worked in a variety of styles with a sheer technical skill that permitted him to present the nuances of T'ang, Sung, or Yuan style at will. He was famous for his copies of pictures, some of them painted for such great patrons as the noted collector of the sixteenth century, Hsiang

570. *Murmuring Pines in a Mountain Path. By T'ang Yin (A.D. 1470-1523). Hanging scroll, ink and slight color on silk, height 77½".* *Ming Dynasty.* National Palace Museum, Formosa

Yuan-pien. By his technical brilliance in the use of minuscule detail, as well as by his broad and abstract use of the brush, he commanded the respect of critics who would gladly have relegated his type and style to the Northern school. Perhaps the most famous productions in the West, attributed to him, are the endless series of album leaves or scrolls representing aristocratic ladies in bright colors playing in the park or puttering in houses — pretty, decorative paintings in the worst sense of the word. Needless to say, these are nearly all

Southern Sung Period, notably Chao Po-chu. But the *Emperor Kuang Wu* is a work visually unified in a way that the Sung painters never attempted, a work where foreground, middle ground, and background are exactly known in relation to each other. The handling of detail is carried to such a degree that one can examine the picture with a magnifying glass and still find this virtuosity in the representation of nature. Opaque color of considerable brilliance produces a decorative effect which probably did not endear him to the scholar-critics of the succeeding century. The paintings of Ch'iu Ying, no matter what their scale, can be characterized as those of a great miniaturist in almost every case. Nearly all of his paintings have this quality of exquisitely refined detail, not merely "hard work" as one finds in average late jade carvings, but a sensitive use of the smallest brush. He was also much interested in antiquarian pursuits and was able, through such friends as the collector Hsiang Yuan-pien, to study bronzes of the Shang and Chou dynasties, and Sung ceramics as well. His pictures are full of archaistic details that are archaeologically accurate and interesting, and this, too, distinguishes his work from that of the artisans' copies of later times. One of the finest and most unusual pictures by Ch'iu Ying in this country is in the Museum of Fine Arts in Boston, representing a lady in a summer pavilion in a grove of trees looking out over distant water (*fig. 571*). Painted on paper, it shows Ch'iu Ying rivaling the scholar-painter at his best. Its rather pure, serene air meets the demands of the scholar class, particularly those who emulated Ni Tsan. The *Ni* style can be seen very clearly in the distant view of spits of land and mountains; but if we look at a detail of this picture, with scholar's table and female attendants to the left and right, we see the particular delicate miniature quality that is most characteristic of the style of Ch'iu Ying. His architecture is accurate and believable, the implements on the table in the scholar's study are correct in drawing, and yet if we examine the painting of the trees and their foliage, despite their miniature sureness, we find a freedom and spontaneity of brushwork which ranks him as one of the great painters of the Ming Dynasty.

In sharp contrast to the delicacy and refinement of Ch'iu Ying are the qualities associated with the third member of this trio, Chou Ch'en, also a pupil of T'ang Yin. He is particularly remarkable for one facet of his artistic character — his interest, unusual for its day, in low life and the grotesque. In general, the subject matter appropriate for the later Chinese painter, and espe-

forgeries produced by the artisans of Hangchou and Suchou who began manufacturing Ch'iu Yings as soon as the inevitable demand began, and who have continued ever since. From these poor productions to the really fine works by Ch'iu Ying is a tremendous distance. A large landscape, *Emperor Kuang Wu, of the Western Han Dynasty, Fording a River*, in Ottawa, shows his conservative style at its very best (*colorplate 44, p. 428*). The subject is derived from Western Han history, and the figures illustrate it, though they are of relatively small importance in the over-all composition. The general style of the work shows the influence of his master T'ang Yin, and of the painters of the early

572. *Street Characters. By Chou Ch'en (c. after 1534).
Album leaves mounted as handscroll, ink and color on
paper, height 9⅝", dated* A.D. *1516. Chinese,
Ming Dynasty.* Honolulu Academy of Arts

RIGHT:
*573. Landscape (in the manner of Ni Tsan).
By Shen Chou* (A.D. *1427-1509). Hanging scroll, ink
on paper, height 54", dated* A.D. *1484. Ming Dynasty.*
Nelson Gallery-Atkins Museum
(Nelson Fund), Kansas City

to these unusual subjects. There is one precedent for
this type of subject matter in the secondary parts of
Buddhist icons representing scenes in Hell, on which
one finds subsidiary figures of demons or of unfortu-
nates condemned to the nether regions.

The Southern style of the early Ming Period is domi-
nated by one great master and his immediate succes-
sor, Shen Chou (1427-1509) and Wen Cheng-ming
(1470-1559). Shen Chou was the founder of the *Wu*

433

cially for the scholar-painter, was landscape. If he did
turn to figures, they would be from famous narrative
histories of the past, scenes from famous poems, or
members of his own class. He might occasionally turn
to pseudo-poetic representations of idealized woodcut-
ters or peasants as if he were returning to rusticity as a
Confucian virtue. But Chou Ch'en seemed to have an
almost sociological interest in the lower classes. Whether
it was a sympathetic or a critical one, is hard to say from
his paintings. A handscroll in the Honolulu Academy,
made up from an album, is one of the most striking,
touching, and powerful works by this very important
artist (*fig. 572*). It is a representation of unfortunates:
a series of single or paired figures executed in ink and
color on paper; a street magician in tatters holding a
snake which he has removed from his wicker basket;
a poor beggar or mendicant of grotesque appearance,
with dirty hair, lined face, and tattered clothes. Other
figures are crippled and diseased people — representa-
tions that are unpleasant in themselves or, at any rate,
not in the accepted range of subject matter. Another
picture in a private collection in Japan represents a
cockfight with a group of peasants watching. Chou
Ch'en takes the discipline of brush learned from his
master and applies it with a rapid and free technique

school, and Wen Cheng-ming was his pupil. Between them, they set standards for scholarly painting that lasted until the end of the sixteenth century. Shen Chou looked especially to the traditions of the Four Great Masters of the Yuan Period. There are works by him, such as the hanging scroll, dated 1484, in the style of Ni Tsan (fig. 573). One cannot mistake the tall, thin trees, the open spaces of paper, the rocks with the dotted brushwork to indicate the lichens, the same open and spare style in the distant mountains. But in the hands of Shen Chou, the style of Ni becomes much stronger, much bolder, and much more masculine, and in this, Shen betrays his personal touch, which led him

especially to study the works of Wu Chen. Wu was particularly famous for a powerful, single-stroke style, representing figures with just four or five strokes, or a landscape with a few washed and a few sharp strokes. Shen Chou assumed the style of Wu Chen and developed it to a point which equals that of the Yuan master. To it he added a boldness of composition and touches of color which in many cases anticipate several of the seventeenth-century individualists. His masterwork in this country is a series of album paintings, mounted as a handscroll (fig. 574). One of the series is a scene with peasants, but very idealized peasants, working in the fields beyond a wooden fence. The powerful brush strokes of the leaves and the trunks of the trees, and especially the outline of the bodies of the peasants, show the single-stroke style that he derived from Wu Chen. But the complex composition, with its steplike arrangement of the fence, the fading out of the trees in the alley formed at the central axis, is characteristic of Shen Chou's advanced interests. The finest of the leaves in this scroll is the one depicting a poet on a bluff overlooking a chasm, in heavy and rich ink with slight color on paper (fig. 575). It is a monumental composition with a great thrusting mountain topped by a jutting plateau, while at the right is a temple in a fold of hills. The artist's brush moved very rapidly with thick strokes, the mountains being represented by very simple washes of even tones, rather abstract, even cold. The mood of the picture combines the coldness — in the best sense of the word — that is attributed to Ni Tsan, with the strength of Wu Chen. The result is an objective style. Shen Chou's pictures are not "attractive"; he does not make pictur-

434

ABOVE:
574. Three Gardeners in Fenced Enclosure, from Landscape with Poems. By Shen Chou (A.D. 1427-1509). Five album paintings mounted as handscroll, ink and color on paper, height 15¾". Ming Dynasty. Nelson Gallery-Atkins Museum (Nelson Fund), Kansas City

RIGHT:
575. Poet on a Mountain, from Landscape with Poems. By Shen Chou (A.D. 1427-1509). Album painting, ink and color on paper, height 15¾".

esque and charming compositions; he does not use much color. He inherited the revolution instituted by the Four Great Masters of Yuan and solidified it, producing an objective and complete rendition of its aims.

The last leaf of the scroll under discussion is by Shen's pupil, Wen Cheng-ming (fig. 576). Its inclusion in this scroll shows more clearly than anything else could the difference in temperament and style between the two men. Wen's leaf, showing a stormy sea at the edge of land with trees being driven by the wind and rain, has the same disciplined brush as the album pages by Shen Chou. There is the same manner of outlining trunks of trees; the same manner of forming foliage and rocks. But his page is painted in a much more elegant manner. It does not have that brusque coldness found in the work of Shen Chou. If one looks at the waves in the distant sea, one realizes that they are broken and curled, painted in a rather delicate, detailed style, almost like that of a Southern Sung painter, or of Ch'iu Ying. In the trees and foliage the strokes are not quite as wide, the dots are not quite as fat, while the number of dots in the rocks is reduced so that the rather elegant profile becomes more evident. The whole effect is that of a refined, aristocratic, and elegant rendition of Shen Chou's style: in short, what we should expect in Wen Cheng-ming's early work.

But Wen's fully developed style shows him working in a manner completely his own, and much imitated in later times. The most characteristic products of his complex and somewhat gnarled style are works like the hanging scroll, of a high waterfall amid grotesque cypress and cedar trees, in the Palace Collection (fig. 577). Executed in ink and color on paper, it has overtones of the detailed rendition found in Ch'iu Ying; but the tightly knit and twisting composition conveys a slightly inverted, even repressed, quality that seems characteristic of Wen Cheng-ming. The grotesque quality of Wen's trees and rocks and his interest in tortured

435

and convoluted compositions reach a climax in the handscroll, the *Seven Juniper Trees* (fig. 578). It represents seven famous trees of Hai Yu in Kiangsu province. Both the long poem that follows and the painting clearly reveal the intention of the artist to demonstrate the moral lesson of old age, the qualities that produce the most noble and most sage of men. The trees are painted with all their convolutions emphasized and exaggerated to such a point that the picture becomes almost a complex landscape handscroll, and the movement of branches and foliage becomes the movement of distant mountain ranges, rocks, and hills. With a subject so seemingly simple — seven trees — the painter produced a handscroll as complex as any landscape.

Wen Cheng-ming painted in many different styles, but this seems to be his most characteristic and most creative manner. And at this point, it may be wise to say that the ability of the Chinese painter, especially of the Ming and Ch'ing painter, to paint in different styles, is not to be considered as evidence of a lack of integrity, but rather to be likened to some forms of music, where an artist performs the works of others and adds to it his own personality, his own nuances, and his tremendous technique. At its best, in the hands of a creative artist such as Wen Cheng-ming, the process is similar to Brahms' *Variations on a Theme of Haydn,* in which an earlier composer's work is used by another composer and transformed into a new idiom.

Wen Cheng-ming was the head of a large family of followers, and many relations worked in his style; at least four prominent painters could be cited. The most important of these and the one who added the one

578. *Seven Juniper Trees. By Wen Cheng-ming* (A.D. 1470 1559). *Handscroll, ink on paper, length 11' 10½", dated* A.D. 1532. *Ming Dynasty.* Honolulu Academy of Arts. ON OPPOSITE PAGE BELOW: *Detail of figure 578*

last fillip to Wen Cheng-ming's style was Wen Po-jen, who painted the remarkable large *Landscape*, which is in the Cheng Te-kun Collection (*colorplate 45, p. 429*). Wen Po-jen accepted Wen Cheng-ming's tendency to detail, and eliminating his twisting, grotesque, and ancient quality, produced most attractive pictures that are complex texture studies on a lyrical and elegant scale. The whole *Landscape* composition is based on the Yuan master Wang Meng, but it is so light and fluffy, so lyrical and gay in its general effect that it becomes a completely new creation. Other masters followed the generation of Wen Cheng-ming and developed this same over-all patterning and growing elaboration. Lu Chih, in the handscroll, *Rocky Landscape,* shows an-

other variation of this manner (*fig. 579*). The scroll is covered from bottom to top and side to side with details of rocks and trees and landscape; no horizon line, no sky mitigates the complexity of the composition. Delicate and refined brushwork is found also in the work of Lu Chih, but with a sharp, crystalline charac-ter. To over-all patterning and small scale, Lu Chih added a peculiar quality of color, very tart, like lemon and lime, and quite different from the sweet and lyrical colors of Wen Po-jen.

The bold brushwork of Shen Chou was most appro-priate for the varieties of flower and foliage painting, and a few works by Shen deal with this subject. But the most interesting flower paintings in this manner

579. *Rocky Landscape. By Lu Chih* (A.D. 1496-1576). *Handscroll, ink and color on paper, length 44¾". Ming Dynasty.*
Nelson Gallery-Atkins Museum (Nelson Fund), Kansas City

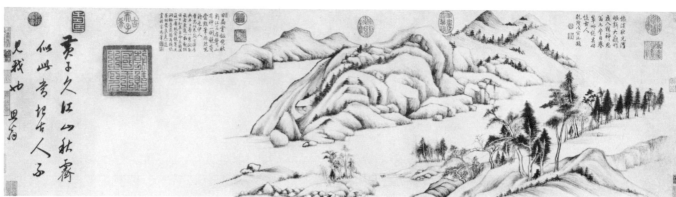

438

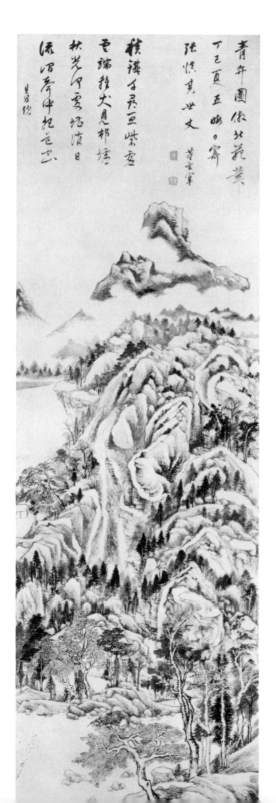

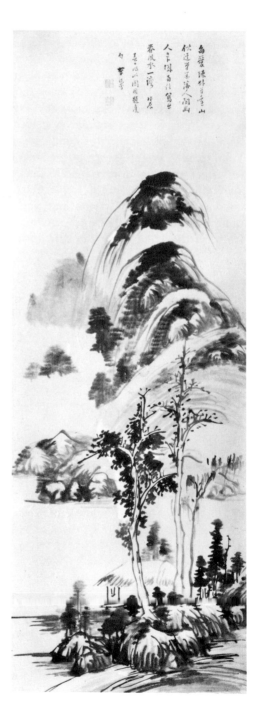

ABOVE:
*580. Autumn Mountains.
By Tung Ch'i-ch'ang*
(A.D. 1555-1636). *Handscroll,
ink on Korean paper, height 15⅛";
length 53⅞". Ming Dynasty.*
Cleveland Museum of Art

RIGHT:
*581. The Ch'ing Pien Mountain.
By Tung Ch'i-ch'ang*
(A.D. 1555-1636).
*Hanging scroll, ink on paper,
height 90". Ming Dynasty.*
H. C. Weng Collection,
New York

FAR RIGHT:
*582. Thin Forest and Distant
Mountains. By Li Liu-fang*
(A.D. 1575-1629). *Hanging scroll,
ink on paper, height 45".
Ming Dynasty.*
Cleveland Museum of Art

are by the slightly later artist, Ch'en Shun (1483-1544), whose handscroll of lotus (*colorplate 46, p. 430*), combines soft and decorative color with vigorous "boneless" brushwork — that is, areas of ink and color applied without boundaries. Still, the dominant mode of the first half of the sixteenth century was that of Wen Cheng-ming — detailed, complex, and dignified.

The end of the sixteenth century closes this period of elaboration of the accomplishments of the *Wu* school. A new impetus was needed and it was forthcoming in the theories and paintings of Tung Ch'i-ch'ang (1555-1636), who dramatically changed the course of Chinese landscape painting. His importance and the extent of his influence is comparable to that in European painting, of Caravaggio — who, incidentally, was active at almost the same time, about 1600.

There is little doubt that we must speak of later Chinese painting as "before Tung Ch'i-ch'ang" and "after Tung Ch'i-ch'ang." His influence on literature, criticism, calligraphy, and painting is paramount. In his writing he asserts the supremacy of the Northern Sung and Yuan masters, and in his painting he attempts to recapture the monumental strength of the former and the controlled calligraphy of the latter. No one could describe the later productions of the *Wu* school as having been universal, monumental, or markedly rational. In opposing the previous direction of the literary school, Tung Ch'i-ch'ang was both a supreme reactionary and a supreme revolutionist. While the result is a loss of the outward reality of nature, there is a really significant aesthetic gain in an arbitrary, even fierce, reorganization of the elements of landscape painting into a monumental scheme (*fig. 580*). This aesthetic specialization involves striking distortions in his most typical pictures. Ground or water planes are slanted, or raised and lowered at will. Foliage areas are forced into unified planes regardless of depth, and often in striking juxtapositions of texture. No small details or minuscule textures are allowed to stand in the way of the artist's striving for a broad and universal expression of the traditional attitudes to nature (*fig. 581*). Malraux's subtle distinction between Chardin and Braque, "In Chardin the glow is on the peach; in Braque the glow is on the picture," applies as well to the works of Tung. The result is realized incompletely and with difficulty, as we see when we compare his works with such later giants as Chu Ta or even the more academic Wang Yuan-ch'i, for theirs was a pictorial genius that accomplished what Tung Ch'i-ch'ang indicated. And others of the later individualists, Kung Hsien for example, took details or specific elements out of Tung's pictures and enlarged or elaborated them.

We must not assume, as the writer once did, that the appearance of Tung Ch'i-ch'ang's pictures comes from a lack of control. Mere competence could have been commanded but, like the Post-Impressionists, the artist was desperately striving to reconstitute the powerful and virile forms rather than the surface likeness of the earlier painters. Tung Ch'i-ch'ang had the last word: "Those who study the old masters and do not introduce some changes are as if closed in by a fence. If one imitates the models too closely one is often farther removed from them."[20]

Tung's official position and his acceptance as the arbiter of taste and authenticity certified the triumph

583. Lonely Retreat Beneath Tall Trees.
By Sheng Mao-yeh (active c. A.D. 1620-1640).
Hanging scroll, ink and slight color on silk, height 71",
dated A.D. 1630. Ming Dynasty.
Cleveland Museum of Art

439

584. *Dream Journey Among Rivers and Mountains. By Ch'eng Cheng-kuei (active c.* A.D. *1630-1674). Section of a handscroll, ink and color on paper, height 10¼"; length 11' 3½", dated* A.D. *1674. Ch'ing Dynasty.* Cleveland Museum of Art

of the literary painters' tradition identified by him and his colleagues with the Southern school, in opposition to that tradition represented by the *Che* school and described as Northern. His own immediate following — Ch'en Chi-ju, Mo Shih-lung (who coined the sometimes confusing Northern and Southern categories), and others — is usually described as the Sung-chiang school, after the town near Suchou that was their center.

The influence of Tung can be seen in numerous other important masters who can only be described as seventeenth-century individualists — a description that can be narrowed to these late Ming men alone, or broadened to include all of the distinctive personalities of the troubled late years of the century, even into the early part of the Ch'ing Dynasty (1644-1912). However, since this latter group was involved in the social and political picture of the new and alien dynasty, these later individualists will be considered subsequently, as a contrast to the almost neoclassic academicism that was the early Ch'ing by-product of the Sung-chiang school. The other Ming individualists are too numerous and relatively recently known to Westerners to be pre-

sented in more than a summary way. Although the poem on one of Li Liu-fang's boldest pictures mentions Ni Tsan, and the brushwork is influenced by the brusque style of Wu Chen, the over-all effect of the landscape would be unthinkable without the intervention of Tung Ch'i-ch'ang (fig. 582). We should note in passing, as a post-Yuan characteristic, the way in which the so-called *Ni* type of composition is visually and compositionally unified from bottom to top. The excellent preservation of the ink and the particularly simplified brushwork combine to offer details which reveal the order of the successive strokes and washes with an almost kinetic force. Consider the fantastic boldness of Sheng Mao-yeh's *Lonely Retreat Beneath Tall Trees,* dated 1630 (fig. 583). Sheng has taken a small segment of a monumental landscape, a mountain notch, and magnified it, treated it with great bravura, producing a large-scale painting with an immediate rather than a cumulative effect. Nevertheless, the fading mists are suggestively handled and show the subtle touch that is found in many of the artist's smaller pictures. The painter is not without humor in the figure of the sage

585. *Greeting the Spring. By Wu Pin (*A.D. *1573-1620). Section of a handscroll, ink and color on paper, height 13¾"; length 51¹¹⁄₁₆", dated* A.D. *1600. Ming Dynasty. Cleveland Museum of Art*

440

and in the grotesque trees. The painting fascinates precisely because of its wild, off-beat quality.

Another of these individualists was a direct pupil of Tung Ch'i-ch'ang. We can see the art of Ch'eng Cheng-kuei in a handscroll whose style is modeled after that of the Yuan master, Huang Kung-wang (*fig. 584*). The composition is equally strange and willful, and is based on near masses and sudden breakthroughs with a jerky, erratic rhythm that is typical of the artist. In other scrolls he exploits this mode even further, but with an even wetter brush and rapid, unshaded handling, using slight color. His extreme specialization is carried over into the titles and inscriptions on the pictures, for he uses the same title for nearly all his scrolls and even numbers them sequentially in each year.

Of course, many in this period continued to practice in a more conservative and detailed style, but often combined it with the new directions indicated by Tung Ch'i-ch'ang. Wu Pin (1573-1620), who was also a master of fine-line (*pai-miao*) figure painting, has left a number of finely executed colored landscapes whose dynamic convolutions amaze the eye and express the twisted and grotesque aspects of nature. *Greeting the Spring* nominally presents the annual equinoctial sacrifices with their accompanying festivals (*fig. 585*). Hundreds of figures are within the borders of the handscroll — scholars traveling the mountains or groups of festive townsmen. But the real subject of the picture is the landscape, ranging from the calm waterways with their tranquil willows to the high mountains, darkly reaching beyond the upper edges of the scroll. The color is structured rather than decorative and serves to accent the openings and movements of the slate-gray hills. The individual use of color becomes one of the major contributions of the Ch'ing individualists whom we shall soon consider.

The Ch'ing Dynasty (1644-1912) was the second of the great foreign dynasties to rule China after the eighth century. Where the Yuan Dynasty had been a period of Mongol domination, the Ch'ing Dynasty was founded by the Manchus, as their name implies, from Manchuria. They succeeded in imposing political and social order on the chaos that was China at the end of the Ming Dynasty. The time of troubles that preceded the triumph of the Manchus was followed by a long period of relative peace and prosperity under a foreign rule which retained the most important and fundamental Chinese cultural patterns for the Chinese. The Manchu rulers themselves, particularly with regard to art, became more Chinese than the Chinese, forming great collections in the imperial city of Peking, works of art which today form the basis of the great Palace Collection — the single largest and most important repository of Chinese art in the world, now preserved on Formosa after years of unfortunate travel.

586. Landscape. By Wang Shih-min (A.D. 1592-1680).
Hanging scroll, ink on paper. Ch'ing Dynasty.
C. C. Wang Collection, New York

The very fact that they were of foreign origin meant that the Manchu rulers and their officials would be opposed by at least a large part of the gentleman-scholar class, particularly those identified with the previous dynasty. This early conflict, largely a literary and verbal one, was followed in the eighteenth century by close cooperation.

The division of the history of Chinese art into dynastic periods is in some cases a sound one, but in the case of the Ming and Ch'ing dynasties the continuity

587. *Ten Thousand Miles of the Yangtze. By Wang Hui (A.D. 1632-1717). Section of a handscroll, ink and slight color on paper, length 80". Ch'ing Dynasty.* H. C. Weng Collection, New York

in the arts is such that one could almost say that the first part of the Ch'ing Dynasty, particularly the seventeenth century, was a continuation, and in some ways a culmination, of tendencies that had already been observed in the later part of the Ming Dynasty in painting and in the decorative arts. What is certainly not true is the view, recently common in the West as a reaction against the earlier views of collectors of Chinese decorative and export porcelains, that the Ch'ing Dynasty was a period of decline and of a relatively low level of production in the arts. This is true only if one judges the creative work of the Ch'ing Dynasty by standards based upon Japanese ideas of Sung and Ming painting or upon excavated Sung ceramics.

The painting of the Ch'ing Dynasty falls into two basic divisions: a conservative style, based upon the late Ming style stemming from the great innovator Tung Ch'i-ch'ang; and an original movement relying more heavily on individualism than any previous school. Such a division into conservative and original forces deliberately overlooks other and stagnant pools of Chinese painting which are truly declining phases of the earlier styles of the Sung, Yuan, and early Ming periods. We will pass by these competent but usually uninspired painters, though in their own fashion they, too, made a contribution.

The conservative style of the Ch'ing Dynasty is based upon the scholarly literati tradition of Tung Ch'i-ch'ang and his school. It is epitomized in the works of the Four Wangs: Wang Shih-min (1592-1680); Wang Chien (1598-1677); Wang Hui (1632-1717); and Wang Yuan-ch'i (1642-1715). The birthdates of these men are given in chronological order. Wang Shih-min was the oldest of

the Four Wangs and also the most traditional (*fig.* 586). He based his style largely on a combination of Yuan versions of Northern Sung painting and the more monumental character and arbitrary handling of space and brushwork we have seen to be the original contribution of Wang Shih-min's teacher Tung Ch'i-ch'ang, fifty or sixty years earlier. Wang Shih-min's compositions tend to be traditional and appear to be rather uninspired. They are always solid, massively built up, and usually of great complexity, with repetition of trees, rocks, and mountains in a basically similar set of rhythms. His brushwork is very correct and consistent; and in this perhaps he recalls somewhat that rational master of the Yuan Dynasty, Huang Kung-wang. Wang Shih-min's patterning of brushwork and use of brushwork over the whole surface of the picture are similarly consistent and seldom flawed. Wang Shih-min is probably more important historically than for his paintings, because he was the pupil of Tung Ch'i-ch'ang and the practical and spiritual master of the three other Wangs.

Wang Chien is a more original and interesting painter, at least in his compositions. For Wang Chien the world was an even more rhythmical one than that created by Wang Shih-min, and his landscapes are dominated by a pleasant and elegant rolling rhythm again highly repetitive and relatively complex. His work, in comparison with Wang Shih-min, with its rather forbidding and imposing qualities, seems lyrical and, if one chose to press the point, to have something of that loveliness we have seen to be characteristic of the rolling landscapes of the early Japanese schools. One is seldom confronted in the work of this artist with a monumental composition of imposing scale or with

powerful brushwork; rather one finds a consistent and elegant use of the brush in compositions dominated by gentle rhythms and sometimes highly decorative color (*colorplate 47, p. 447*).

Wang Hui, who really belongs to the second generation of the Four Wangs, is probably the best known of the group. He was perhaps the most famous painter of his day in China, a prolific master whose genuine works exist in considerable quantity. Wang Hui's style is much more varied than that of either of the preceding two Wangs. His style is based above all upon a markedly competent, indeed gifted, brush style. From his very earliest days, like such geniuses as Dürer and Leonardo, he seems to have been able to do whatever he willed with the brush. If we examine one of his long scrolls, sometimes over forty feet in length, like the one in the Weng collection, we see the most remarkable consistency of brushwork at the service of the most complex kind of organization in time and space to be found in Chinese painting (*fig. 587*). No painter of the Sung Dynasty or later produced works of greater competence. If at times they seem a little dry and less inspired than the works of the earlier painters, it is only because we are now dealing with a group of orthodox painters who, while deriving from the revolutionary Tung Ch'i-ch'ang, have become a bit academic. They consolidated the position won in Chinese painting by the early seventeenth century. Albums, handscrolls, or hanging scrolls executed as themes and

588. Landscape (after Ni Tsan). By Wang Yuan-ch'i (A.D. 1642-1715). Hanging scroll, ink and color on paper, height 31⅝″, dated A.D. 1707. Ch'ing Dynasty. Cleveland Museum of Art

443

variations on the works of earlier men certainly dominate the pictorial production of the traditional group. Perhaps the main reason for the Western neglect, until recently, of the orthodox painters of the Ch'ing Dynasty, has been their relative lack of originality in composition. But for this we have to turn to the individualists of the seventeenth century; and in Chinese eyes composition is a somewhat minor point.

The last of the Wangs was Wang Yuan-ch'i, certainly the most original of the four. He is the youngest and makes our transition to the individualist painters more easily understood. One can see why he is considered the most original of the Four Wangs, for in his work he seems to have incorporated the profoundest lessons of Tung Ch'i-ch'ang. He understood that the lovely pictorial effects often achieved by Wang Chien and Wang Hui were not the essence of the revolution of Tung Ch'i-ch'ang; and that that essence was in the arbitrary reorganization of the elements of nature in terms of brushwork and of an almost abstract pictorial

structure. Consequently, when Wang Yuan-ch'i paints a picture in the style of Ni Tsan (*fig. 588*), it is in homage only to the spirit of Ni Tsan, to the coldness and serenity of that Yuan master. The actual means by which this was achieved are much more under the creative influence of Tung Ch'i-ch'ang. The enormous scale of the trees in contrast to the relatively small scale of the house, the distortion of the tree trunks and the heaviness of their foliage as a balance to the compactly constructed distant mountain-island—these are combined to make a picture which, while recalling Ni Tsan, produces an effect which can only be Wang Yuan-ch'i's; in this sense he is an individualist. His work is recognizable as his and his alone. His brushwork is rather bold, and particularly in the distant landscape he is inclined to rather arbitrary tilts and shifts of terrain, startling if one looks at the picture from a purely representational point of view, but remarkably effective in creating a dynamic and intense effect. For this reason, he has been compared with

589. Myriad Valleys and the Flavor of Pines. By Wu Li (A.D. 1632-1718). Hanging scroll, ink and color on paper, height 41⅛". Ch'ing Dynasty. Cleveland Museum of Art

590. Bamboo and Old Tree. By Yün Shou-p'ing (A.D. 1633-1690). Hanging scroll, ink on paper, height 40". Ch'ing Dynasty. National Palace Museum, Formosa

444

Cézanne in his watercolors, and the comparison is a just and an effective one. It is possible to hang them side by side and to see some relationship between their aims, despite the fact that the coloristic means at the disposal of the French master were richer than those simple color schemes of tart orange, green, and blue available to the Chinese master.

Outside the group of the Four Wangs, also known as the Lou-tung school, were some painters who do not fit into either orthodox or individualist categories. Of these painters, two are particularly worthy of note. One was Wu Li, a unique figure, the only Chinese painter of considerable prominence who ever became a Christian. He died a Christian priest, and consequently has been one of the few Chinese painters of the later orthodox school to be early and effectively studied or published in the West. Wu Li, like the four Wangs, uses the discoveries of Tung Ch'i-ch'ang, particularly in the construction of his backgrounds with their monumental effects and in the distortions of the distant mountains and their tops to produce tense and sometimes contorted effects. In some cases these forms seem to be metamorphic and resemble animals or faces in the same manner as do the rocks of the *Lion Grove,* painted by Ni Tsan. In this painting, *Myriad Valleys and the Flavor of Pines,* the topmost vertical peak looks rather like a squatting animal with a tufted head at the back, haunches a third of the way down, and a face hunched between the rocky shoulders (*fig. 589*). Such suggestions of zoomorphic forms in the midst of landscape seem often to be present in the work of Wu Li, and are not unknown in Western painting, particularly in the modern Surrealist school. This particular composition also reveals Wu's ability to construct a monumental composition by a continuous use of overlaps in the foreground leading up to the markedly vertical mountain in the background, and recalling at least in spirit, some of the compositions of the Northern Sung Period. In detail his brushwork is almost as precise as that of Wang Hui but with a little more angularity and sharpness; not quite so elegant but sharper, almost as if it had been engraved with a burin.

The second of the painters standing between the orthodox and the individualists is Yun Shou-p'ing (1633-1690). Yun has been unjustly typed as a flower painter, for some of his landscapes are among the most beautiful, limpid, and delicate productions of later Chinese painting. But it is as flower painter that he is best known, and in the picture from the Palace Collection, we can see — even in a black-and-white reproduction — something of the wet style particularly associated with him (*fig. 590*). The bamboo, even the tree trunk on the right, seem to be painted with a very wet brush that slithers over the surface of the paper, leaving not a blurred impression but a sharp one, in contrast to the medium dry styles of Wu Li and Wang Hui. This

591. *A Monk Meditating in a Tree. By K'un Ts'an (Shih-ch'i) (active second half of 17th Century A.D.). Hanging scroll, ink on paper. Ch'ing Dynasty.* Formerly Private collection, Peking

wetness of the subtle tints in a great many of his paintings produces an effect which can perhaps be described as rather French and decorative. Many small albums with mixed landscapes and flower subjects by him are known. However, his style is similar to that of the four Wangs and Wu Li and is largely based on the late Ming painters; hence he is placed, not with the most original and creative part of Ch'ing painting, but with the more orthodox group.

The individualists are a different sort. Many were resentful of the new dynasty and felt that they should,

592. *Landscape (after Kuo Chung-shu). By Chu Ta* (A.D. *1626–c. 1705). Hanging scroll, ink on paper, height 43¼".* Ch'ing Dynasty. Cleveland Museum of Art

like the Yuan masters, retire to the mountains or to Buddhist and Taoist retreats where they could practice their art and protest, in literary and verbal ways, against the dynasty. One of them, Chu Ta, was of the Ming royal line, and hence had good reason to oppose the new dynasty. Others, like K'un-ts'an, were monks with a definite antipathy to the Chinese world of the seventeenth century. They are united by a revolutionary position within the limits of Chinese society and their common interest in painting. K'un ts'an, for example, on a well-known painting representing a monk

in a tree (*fig. 591*), a traditional subject with which the artist identified himself, has an inscription reading: "The question is how to find peace in a world of suffering. You ask why I came hither; I cannot tell the reason. I am living high up in a tree and looking down. Here I can rest free from all trouble like a bird in its nest. People call me a dangerous man, but I answer: 'You are like devils.' "21

Or that surprisingly vocal artist, Tao-chi, writes: "I am always myself and must naturally be present [in my work]. The beards and eyebrows of the old masters cannot grow on my face. The lungs and bowels [thoughts and feelings] of the old masters cannot be transferred into my stomach [mind]. I express my own lungs and bowels and show my own beard and eyebrows. If it happens that my work approaches that of some old painter, it is he who came close to me, not I who am imitating him. I have got it by nature, and there is no one among the old masters whom I cannot follow and transform."22

Such sentiments, while known to some degree before, notably in some of the often conceited remarks of certain Ming painters about their versions of earlier artists' works, were not voiced with such strength and vehemence. If the individualists were only vocal, then there would be nothing to write about. But in their painting they produced something justifying their pride and their revolutionary position in the history of painting. Let it be said that their revolutionary position was not as isolated as one might think. Wang Hui, for example, who painted for the emperor and was considered the leading master of the orthodox school, said that Tao-chi was the finest painter south of the Yangtze. Their paintings were collected by many of the Chinese collectors of the day; and although they were aesthetic revolutionaries, they died natural deaths, unlike their early Ming counterparts. But it is also true that they were not collected by the orthodox collectors nor by the imperial collectors; and so it is our good fortune that the work of these individualists is better seen in Western museums and private collections, than in the Palace Collection.

Chu Ta, known as well by his other name Pa-ta-shan-jen, was active from 1650 to 1705, and was a member of the Ming princely line. His work can be divided into at least two main styles. The first was very heavily based on the work of Tung Ch'i-ch'ang. But where the Four Wangs tended to adopt the more easily understandable aspects of Tung Ch'i-ch'ang, Chu Ta took the more radical part of Tung Ch'i-ch'ang's art and produced his own style. He tended to use this first style most often in landscape, as in figure 592. This particular picture is, according to the inscription, based upon a composition of the Northern Sung master, Kuo Chung-shu, but no one would ever mistake it for a Northern Sung painting, nor would one, without the

Colorplate 47. White Clouds Over Hsiao and Hsiang (after Chao Meng-fu).
By Wang Chien (A.D. 1598-1677). Hanging scroll,
ink and color on paper, height 53 5⁄16″, dated 1668. Ch'ing Dynasty.
Freer Gallery of Art, Washington, D. C.

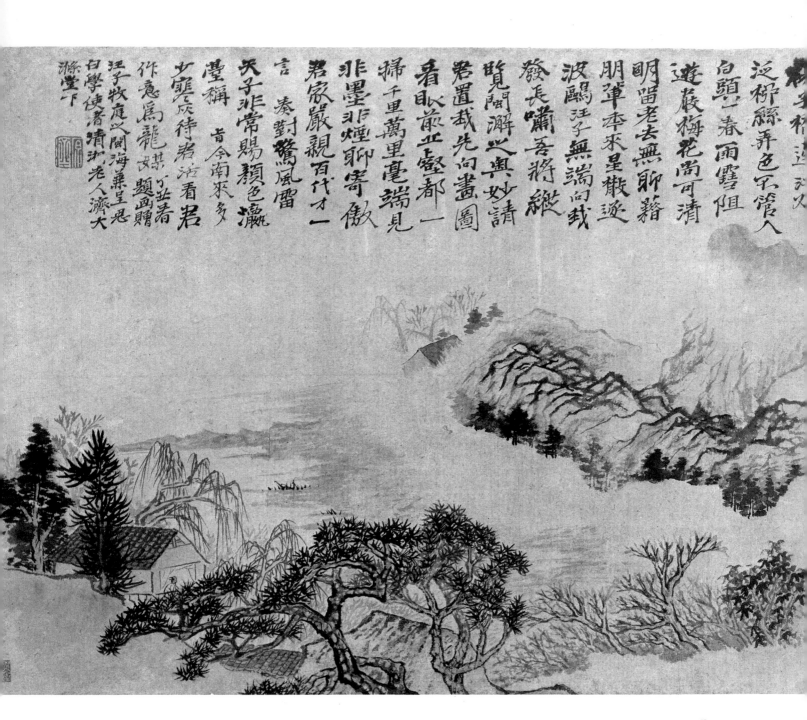

Colorplate 48. Spring on the Min River. By Tao-Chi (Shih-t'ao) (before A.D. *1645–after 1704). Hanging scroll, ink and color on paper, width 20⁷⁄₁₆″, dated 1697. Ch'ing Dynasty. Cleveland Museum of Art*

Colorplate 49. (above) Bottle Vase. Lang porcelain
with "ox-blood" glaze, height 8⅞"; (above right) Lotus-Petal Vase.
Porcelain with "peach-bloom" glaze height 8³⁄₁₆".
Both: Reign of K'ang Hsi (A.D. 1662-1722). (right) Bowl.
Porcelain with "tea-dust" glaze, diameter 8". Mark and
Reign of Ch'ien Lung (A.D. 1736-1795). All: Ch'ing Dynasty.
Cleveland Museum of Art

450

Colorplate 50. (above) Bowl. Porcelain, "famille rose," diameter 5⁹⁄₁₆". Mark and Reign
of Yung Cheng (A.D. 1723-1735). (below) Bowl. Ku Yueh style, porcelain, with raised enamel
on yellow ground, diameter 4¹⁵⁄₁₆". Mark and Reign of K'ang Hsi (A.D. 1662-1722).
Both: Ch'ing Dynasty. Mr. and Mrs. Severance A. Millikin Collection, Cleveland

593. *Fish and Rocks. By Chu Ta* (A.D. 1626–c. 1705). *Section of a handscroll, ink and color on paper, height 11½"; length 62". Ch'ing Dynasty.* Cleveland Museum of Art

594. *The Pao Temple. By K'un Ts'an (Shih-ch'i) (active second half of 17th Century A.D.). Hanging scroll, ink and color on paper, height 52½", dated A.D. 1663. Ch'ing Dynasty.* Kanichi Sumitomo Collection, Oiso

inscription, realize that such an intention was there. The boldness of the brushwork and the particularly individual way in which the trees are bent to support the almost jazzlike rhythm of the picture is something Chu Ta has developed even further than Tung Ch'i-ch'ang. The construction of the picture by means of a series of tentative brush strokes searching for final forms rather than crystal clear and fully realized, is particularly characteristic of this style of Chu Ta. In these landscapes one has a sense of the form growing beneath the brush; one imagines the painter producing the picture. This is a direct denial of the old saw repeated so often, that Chinese paintings were conceived first in the mind and then put down complete, perfect, and without correction from the image in the mind. This was the procedure in some cases but it is certainly not characteristic of most Chinese painting. Indeed, one can study the works of almost any painter and find areas where the artist corrected, changed, added, or in some way showed that his method of thinking and working had at least something in common with that we know to be characteristic of Western artists. The twisting monumentality of this picture is probably what he intended in his reference to Kuo Chung-shu.

The other style of Chu Ta, the one most characteristic of his art and the one which appeals most to Western critics, is an extremely abbreviated one, brilliantly thought out and then put down on paper with great rapidity and ease, or at least with seeming rapidity and ease. We see it in the short scroll, *Fish and Rocks*, a good example of this style (fig. 593). It begins with the overhanging rock and chrysanthemums, executed with a rather dry brush in big swinging strokes, accompanied by a poem which refers to the overhang and the color as related to the clouds in the sky. This is followed with a wetter section, a little sharp but not as dry as the previous one, representing a fantastic rock with two small fish, identified as carp in the in-

451

scription, and shifting the onlooker's point of view from the world above to the world below; from sky to water. The fish in particular are characteristic of Chu Ta's work, with their almost whimsical vitality, their eyes looking up to the rock and the sky above. The feeling

452

595. One leaf from Eight Views of Huang Shan. By Tao-Chi (Shih-t'ao) (before A.D. 1645–after 1704). Album leaves, ink and color on paper, width 10¹¹⁄₁₆". Ch'ing Dynasty. Kanichi Sumitomo Collection, Oiso

of sympathy combined with humor is characteristic of most of Chu Ta's bird, animal, and fish paintings. It is the most easily imitated facet of his art and, consequently, the most often forged. The scroll ends with a completely wet passage. One has passed from very dry brushwork to completely wet brushwork, from very sharp forms to very soft and ill-defined forms, like those of the lotus in the water, where the fish can escape from the world. The third poem alludes to the lotus as a Buddhist symbol and a haven. The poetry of Chu Ta is as sharp, brief, and difficult to read as his painting. The simplicity and the extreme brevity of the thought and of the representation of the thought produces in this work a unity of poetry, calligraphy, and painting.

The second of the four most important individualists is the monk-painter K'un Ts'an, who is often grouped with Tao-chi; K'un Ts'an is also called Shih-ch'i and Tao-chi is called Shih-t'ao, *Shih* in each case meaning stone, and so they are often referred to in Chinese literary history as the "two stones." K'un Ts'an, in contrast to the considerable variety to be found in Chu Ta, tends to be a more limited but more complex painter within his sharply individual style, but limited only in the vocabulary of his painting (*fig. 594*). What he says is every bit as interesting and as profound as that of any other painter of his time. The painting in our illustration represents the Pao Temple and shows his style at its best. He is the most effective colorist among the four individualists, next to Tao-chi, and with warm orange hues he supports the complex interweaving of his brushwork to produce an effect which can be described as ropelike and full of texture. His brush moved

596. A Homestead in the Mountains. By Kung Hsien (active c. A.D. 1660-1700). Hanging scroll, ink on paper. Ch'ing Dynasty. C. Drenowatz Collection, Zurich

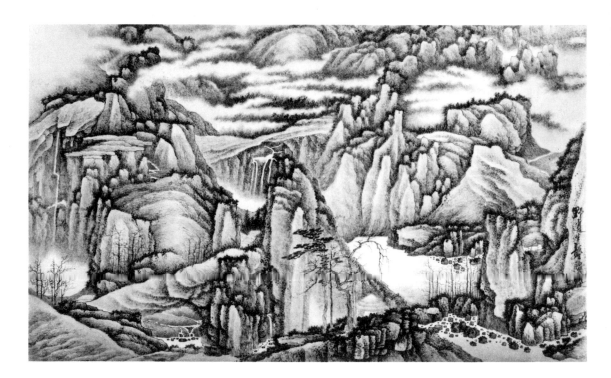

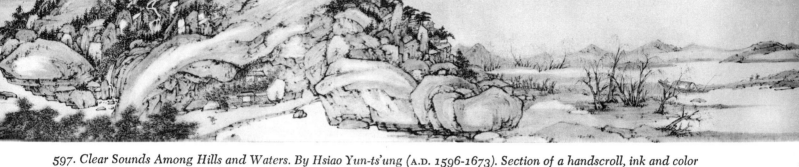

597. *Clear Sounds Among Hills and Waters. By Hsiao Yün-ts'ung* (A.D. *1596-1673*). *Section of a handscroll, ink and color on paper, height 12⅛"; length 25' 7¾", dated* A.D. *1664. Ch'ing Dynasty.* Cleveland Museum of Art

briskly at times or with a rolling, close-knit texture, but the whole is locked into a more compact and graciously rhythmical style than that of the Yuan painter, Wang Meng. The latter tends to be brusque and masculine, direct and uncompromising. With K'un Ts'an there is a greater elegance and something of this can be seen in the cloud forms, the rocks and trees, and even in the convincing representation of thatch on the hut. K'un Ts'an's work is very much rarer than that of the other individualists, and it is almost impossible to see fine work by him in the West.

Tao-chi is, by general consensus, the most varied of these four individualists. His contributions lie in various realms of the painter's craft. In color he is an innovator, using color more richly, more deeply, more like the Western use of watercolor, than any Chinese painter of his own time or earlier (*colorplate 48, p. 448*). He is also more addicted to an extremely bold use of the brush, using it for washes laid one next to the other, sometimes creating a rounded and solid effect, not unlike that achieved in Western watercolor technique. He is also capable of work of the utmost refinement and detail. Another of his contributions is in the realm of composition, for there he creates in each picture a new, unique and often intimate world, as he said, reinventing every composition in Chinese painting. The small album from the Sumitomo collection gives some idea of his detailed style, of the refinement of his brushwork and, at the same time, of the complete originality and daring of his composition (*fig. 595*). Two figures — an old, bearded sage coming from the lower right, half of his body dissolved in the mist, attended by a boy who is also lost in the mist — stand under a cave with hanging grasses, which in turn is topped by a massive, bottomless cliff with a waterfall that appears to be a series of ribbons running over the rocks. The whole effect is one of arbitrary yet consistent and successful placement in relation to the inscription incorporated into the page. The contrast between the delicate, precise, little strokes of the leaves on the bushes at the left of the cliff, and the long, writhing strokes that form the soft

rock formations of the cliff, the movement of the hanging vines and grasses which seem to be a giant satire of the beard and hair of the old man and the boy below, all reveal a bold mind, oriented to visual perception. Like many of these painters, he traveled a great deal, and particularly delighted in the scenery of certain regions, notably Huang Shan (Yellow Mountains), the T'ai-hang Shan range in Shansi, and Hunan with its Hsiao and Hsiang rivers. The production of pictures which were, in a sense, reminiscences of travel, is another facet of Chinese painting in general and of the Ch'ing painters in particular. Each picture by Tao-chi is a new adventure, whether small album leaf or large hanging scroll; in many ways he stands with Tung Ch'i-ch'ang as the most individual and revolutionary figure of the sixteenth and seventeenth centuries.

The fourth of the great individualists is Kung Hsien, and if he is the most limited in style, it is easily and clearly recognizable that he is the most forceful and dramatic in impact. His work has been described variously as gloomy and full of foreboding, possessing an almost funereal air, a world populated by ghosts and wraiths; or that of a monumental, dramatic genius of somber and passionate temperament. Certainly, the style of Kung Hsien, characteristically presented in the hanging scroll with its rich blacks, perhaps the richest ever achieved in all of Chinese painting, and the contrasting whites of mist and rocks, gives a dramatic and somewhat somber effect (*fig. 596*). Like those of Ni Tsan, his landscapes are unpeopled. Nature expresses all that he wishes to say, and even the dwelling places and boats of men are presented in the thinnest and most abbreviated possible manner. He wrote a treatise on landscape painting, and in many of his paintings one senses an almost Western attitude toward light and shade. Of the four individualists, Kung Hsien carried the exploration of the possibilities of light and shade as far as anyone in the history of Chinese painting.

The individualists of the seventeenth century number enough to make a crowd. Typical is a group associated with the province of Anhui in South China,

453

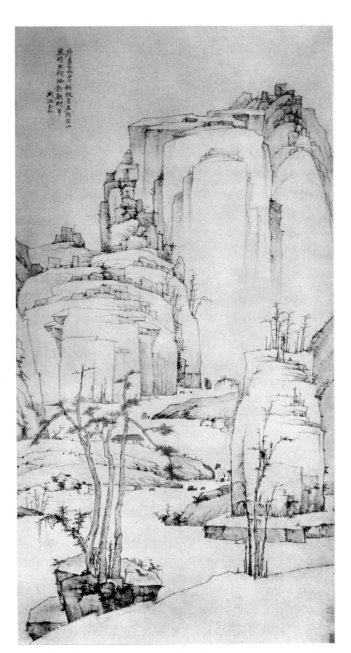

598. *The Coming of Autumn. By Hung Jen (c.* A.D. *1663).*
Hanging scroll, ink on paper, height 48". Ch'ing Dynasty.
Honolulu Academy of Arts

collected in Japan as well as China and influenced numerous scholar-painters of both countries. Hsiao was also important as an influence on slightly younger men from Anhui province who followed him. His own style is represented in a work called *Clear Sounds Among Hills and Waters,* dated 1664 (*fig. 597*). This long handscroll closes with a cave housing a lonely monk and his attendant, followed at the very end of the picture by a harbor scene with clearing banks of mist, and shows his indebtedness to the great Yuan master, Huang Kung-wang. A detail shows a typical unit of the composition with numerous plateaus and a rather characteristic swinging rhythm, based upon the careful juxtaposition of an arc and a countering angle. This slightly syncopated and oft-repeated rhythm provides his characteristic and individual flavor. Hsiao's color scheme is also in part derived from Huang Kung-wang. The use of the slightly lavender blue and pink is similar to the color reputedly used by Huang Kung-wang, from whom we have no actual works in color.

Hsiao was slightly older than the second of the Anhui masters, the monk-painter Hung Jen who, judging from all the evidence, studied with him. Hung Jen has an even more distinctive style than that of Hsiao, clearly recognizable as his, but just as clearly betraying its origin (*fig. 598*). With the style of the Yuan master Ni Tsan as his starting point, Hung Jen makes that style even more cold and abbreviated; the result is an extremely spare, crystalline, wintry style, made especially fine because of the extreme sensitivity of Hung Jen's brushwork. Judging from one or two pictures, he also learned much from Hsiao Yun-ts'ung. Something of the rhythmical repetition in the big hanging scroll in our illustration is surely the result of his association with Hsiao Yun-ts'ung. Other paintings by Hsiao, in turn, seem to show the influence of his pupil. Hung Jen's style, limited and specialized as it is, shows how the style of one of the Four Great Masters of the Yuan Period could still be taken as a starting point for a creative variation on an original theme.

The third of the Anhui masters, Ch'a Shih-piao (1615-1698), is a different personality. Ch'a seems to be more easygoing and extroverted, a painter who enjoys painting with few problems or inhibitions. His paintings always breathe a free and easy atmosphere. They look as if they were rapidly and joyously done without philosophically profound implications. One of his album masterpieces with twelve scenes, most of them in color, presents a favorite Ch'ing theme, variations on the styles of earlier masters, but so radically rephrased that they become fresh and creative new works. One of these, most original in its use of color, is a representation of spring that owes nothing to the great masters of the past (*fig. 599*). The use of green and orange enclosed by black ink produces a glowing effect. This, combined with the gentle washes of blue in the grass

where the Yellow Mountains are a characteristic and famous geographic feature. Paintings of the Yellow Mountains are known from the Sung Dynasty on, and in these wild and fantastic ranges a group of four early Ch'ing painters found inspiration. Probably the senior member of this group was the artist Hsiao Yun-ts'ung (1596-1673), a very important figure, not only for his painting but for his book illustrations. Hsiao designed many of the woodcuts that illustrated one of the most popular seventeenth-century treatises on the technique of Chinese painting. The woodcuts from this book were

and trees, gives a coloristic effect not unlike that produced by the great individualist, Tao-chi. The seventeenth-century individualists, whether the four great ones or such secondary individualists as the Anhui group, are particularly inventive in their use of color, and the period is one when color became a serious means of pictorial construction.

The last of the Anhui individualists, Mei Ch'ing (1623-1697), has perhaps the most individual style of the Anhui group and seems, like Ch'a Shih-piao, to have been of a rather carefree, joyous nature. He goes to great lengths in distorting pictorial elements, whether they are mountains rendered in crumbly, scalloped strokes, or trees and forests become flowers—exotic and decorative, small-scale plants, enormously enlarged (fig. 600). He too, like Hsiao Yun-ts'ung, uses repetitive rhythms which in his case create billowing, almost Rococo effects.

The eighteenth century saw the continuation of the individualist tradition in the work of many painters. One of the most delightful of these is the painter Hua Yen (1682-c.1762), famous not only for his landscapes but for his paintings of animals and birds, treated in a new, enlarged, and decorative style of his own, securing him an honorable place in the history of bird and animal painting. One of his masterpieces is the landscape hanging scroll, *Conversation in Autumn*, an illustration for a famous Sung Dynasty work of rhymed prose by Ou-yang Hsiu (1007-1072) (fig. 601). The author wrote of the sounds of autumn: the rustle of leaves, the trickle of water, and the curious, soft nature of these sounds. Hua Yen seems to have caught these qualities in a work famous in China from the time it was painted. The tall mountain, almost impossibly tall —not unlike those found in the work of the Anhui painter, Mei Ch'ing—seemingly stretches up to the sky, as if it were a plastic substance rather than a thing of rock and earth. The lower part of the picture combines the twisting rocks supporting the scholar's hut with a delicate treatment of the foliage of trees and bamboo. These notes, spare and drifting as one would expect in the autumn, have a delicate, almost musical quality as if sprinkled about the paper in a lilting rhythm. Others of the individualists were monks continuing the great Chinese priest-painter tradition. Two of these are Lo P'ing (1733-1799), and Chin Nung (1687-1764). Their relationship was that of teacher and pupil, and often their styles were identical. Chinese tradition has it that Chin Nung was not much of a painter and that Lo P'ing painted many of the pictures signed by Chin Nung in his characteristic, rather square, calligraphy. The curious style of these two masters harks back to the metamorphic tradition of landscape painting already seen in the *Lion Grove*, by Ni Tsan—the visual pun. In the case of the picture by Lo P'ing, the artist shows us a humorous scene with the drunken demon-queller, Chung Kuei,

599. *Spring, from Landscape Album in Various Styles. By Ch'a Shih-piao (A.D. 1615-1698). Album leaves, ink and color on paper, width 12¾".* Ch'ing Dynasty. Cleveland Museum of Art

600. *One leaf from Landscape Album. By Mei Ch'ing (A.D. 1623-1697). Ink and color on paper, width 17¼".* Ch'ing Dynasty. Cleveland Museum of Art

455

supported by ghosts (fig. 602). The curious gnarled and striated draperies recall the drawing of tree trunks, and the amalgamation of the four figures in one purposely confused mass adds to the effect of the simile. The lyrical hues of the flowering foliage are typical of the later individualists' experiments in color. Their compo-

sitions are oftentimes distorted; tall, narrow pictures and odd juxtapositions are common in their work. These two were perhaps the last significant individualists of the Ch'ing Dynasty. From about the year 1800 on, painting in China became rather repetitive; the creative force was spent. Attempts now being made to revive it by the injection of "peoples' realism" into traditional Chinese landscape painting have produced results as ludicrous as those of Soviet or Nazi academicians.

There were extremely competent and sometimes very gifted painters of flowers and birds, a genre much liked by the Emperor Ch'ien Lung and well represented in the Palace Collection. There were also excellent landscape paintings in the orthodox tradition, landscapes that go back to the Four Wangs of the seventeenth century. However, these really add nothing to a general survey of the field. Still, one particular master should be mentioned as a symbol of Western influence in eighteenth-century China, the Jesuit priest-painter Giuseppe Castiglione, called Lang Shih-ning by the Chinese. Castiglione was an emissary to the Chinese court, and brought with him a fairly good French painting technique. Other artists and technicians came with him, but he became a special favorite of the court, painting many pictures for the emperor as well as influencing the decoration of porcelains. Some of his scrolls are in a mixed Western-Chinese manner, while a very few others are thoroughly Chinese. The long and wide handscroll in the Palace Collection, twenty or thirty feet long, representing a hundred horses, a subject that goes back to the T'ang Dynasty, is a characteristic mixture of Western realism in the shading and modeling of the horses, and of Chinese idealism in the background, which reveals Chinese conventions in the painting of trees and mountains (fig. 603). But the whole painting is permeated with an unresolved conflict of light and shade and the realistic depiction of flowers and horses with academic Chinese conventions. Castiglione's works are competent, if curious and gaudy in color, but they cannot be taken as seriously as works either wholly Chinese or French in style. This mixed manner seems a different thing from the Chinoiserie style in Europe where, in porcelain and textiles in particular, Chinese subject motifs were combined with a creative European Rococo manner to produce a delightful decorative style.

It has become rather fashionable to underrate Chinese porcelains of the seventeenth and eighteenth centuries. They were the first love of those great collectors

601. *Conversation in Autumn. By Hua Yen*
(A.D. 1682–c. 1762). Hanging scroll,
ink and color on paper, height 45⅜".
Ch'ing Dynasty. Cleveland Museum of Art

of the early twentieth century, J. P. Morgan, Benjamin Altman, P. A. B. Widener, and others. One remembers mirror-back museum cases with six ox-blood vases made to look like six hundred ox-blood vases and the resulting sensation of much too much of everything. But this is not a fair test, for the technical refinement of the later Chinese porcelains represents one high point of many in the Chinese ceramic tradition. No finer porcelains have been made before or since from the standpoint of their materials and technique. The

602. *Chung Kuei Supported by Ghosts. By Lo P'ing* (A.D. *1733-1799). Hanging scroll, ink and color on paper, height 38⅛".* Ch'ing Dynasty. Cleveland Museum of Art

603. *One Hundred Horses at Pasture. By Lang Shih-ning (Giuseppe Castiglione)* (A.D. *1688-1768). Italian, worked in Peking during Reign of Ch'ien Lung, Ch'ing Dynasty. Section of a handscroll, ink and color on silk, height 37³⁄₁₆"; length 25' 5".* National Palace Museum, Formosa

wares collected by the great collectors of the early century were usually those which correspond to French taste. They were housed in great mansions whose decor was usually in French eighteenth-century taste. The Chinese, and the Japanese as well, made porcelains for eighteenth-century French and English consumption. Black hawthorn vases, powder-blue vases, jars with decoration in rose or green enamels, were desired by nearly all; and yet there is another type of porcelain, relatively unknown in the West until recently — porcelain in Chinese taste, which now commands the attention of museums and collectors.

A simplified picture of the Ch'ing porcelain tradition, based on appearance and technique, is necessary before we consider the precious porcelains made solely for the Chinese court. Monochromes continue to be made with ever-increasing technical skill in the Ch'ing Dynasty. The basic monochrome technique of underglaze color is to be seen in the ox-blood vases—*Lang* ware (*colorplate 49, p. 449, left*). These, in a variety of shapes, the most common being vases, feature an underglaze copper red, controlled so perfectly that the glaze stops at the bottom of the foot rim with no assistance other than the skill of the potter. Wares ground at the bottom in order to achieve the proper line are highly suspect products of later declining technology. The brilliance

457

of this glowing red color makes it one of the most dramatic glazes, and its bold and masculine effect is a contrast to another underglaze copper color known to the West as peach-bloom, and to the Chinese as apple or bean red. This glaze is very feminine, delicate, and subtle. While the glaze seems closer to the surface, its texture is soft, like the down of a peach — hence the appellation. Sometimes the red color is modified by green mottling, while other variations include an ashes-of-roses effect. Collectors delight in distinguishing the various nuances of color found within each particular ware, sometimes leading to extremes of pigeon-hole classification. Where one separates ashes-of-roses and

LEFT: *604. Vase. Porcelain, "clair de lune."*
Reign of K'ang Hsi (A.D. *1662-1722*), *Ch'ing Dynasty.*
Metropolitan Museum of Art, New York

BELOW LEFT: *605. Bottle Vase. Porcelain,*
soft paste, height 11¼". Mark and Reign of Yung Cheng
(A.D. *1723-1735*), *Ch'ing Dynasty.*
Cleveland Museum of Art

BELOW: *606. Baluster Vase. Porcelain,*
with "famille verte" panels on a "famille noire"
ground, height 17⅜". Chinese, Reign of K'ang Hsi
(A.D. *1662-1722*), *Ch'ing Dynasty.*
Cleveland Museum of Art

458

peach bloom is hardly a weighty matter. Eight prescribed shapes were made for imperial contemplation, nearly all in the reign of the Emperor K'ang Hsi. One of the eight shapes is called the lotus-petal or, less properly, chrysanthemum vase, represented here by a perfect specimen (*colorplate 49, p. 449, right*). Another of the rare and desirable underglaze monochromes is the *clair de lune*, moonlight glaze, with its pale cobalt blue effect suggesting the poetic name (*fig. 604*). These are found both in the prescribed shapes of the peach-bloom group and in other shapes and are largely confined to the reign of the Emperor K'ang Hsi. The great monochromes usually come from this early reign, while the reigns of the Yung Cheng and Ch'ien Lung emperors were richer in the decorated porcelains.

Another group of monochromes, usually of Yung Cheng or Ch'ien Lung date, depended upon iron in the glaze for coloration. Of these the most famous is probably the tea-dust glaze, an olive to gray-green opaque glaze, with a slightly grainy texture (*colorplate 49, p. 449, below*). The shapes of the tea-dust wares are rather simple and oftentimes more amenable to the taste of the modern potter than are the more elaborate monochrome and decorated porcelains. The famous apple-green glaze was produced by an overglaze technique, actually an enamel applied on the surface of the glaze, producing a rich, lime green.

Underglaze blue-and-white was continued, not only in the standard Ming technique used to cold perfection by the K'ang Hsi potters, but also in a rare type called soft-paste blue-and-white porcelain (*fig. 605*). The body of this particular ware, produced largely in the Yung Cheng reign, is made of a buff gray-colored clay, not as homogeneous as the white body of the earlier blue-and-white porcelains, and made white by a coating of slip. The soft body and slip cause the covering glaze to crackle slightly. The creamy white color of the slip is not as hard and brilliant as the usual blue-and-whites.

The most original developments in the Ch'ing porcelains are to be found in the enamel-decorated types. The French appellations, *famille verte* and *famille rose*, have been used so long that they are difficult to avoid. Some demonstrate the use of one enamel and black, over a pure white glaze, forming a taut but rich all-over floral decoration of peonies against a green ground. From this to more elaborate developments is a matter of technical refinement. The green family of decorated porcelains ranges from pure decoration in green, rose, black, and brown enamels, sometimes with the use of underglaze blue or overglaze blue enamels, producing large, florally decorated vases whose predominant color harmony is green, to narrative decorations with many figures, scenes from famous tales or novels, executed with vigorous and bold drawing (*fig. 606*). The *famille verte* technique was also used in combination with another of the enamel techniques, the black-ground style,

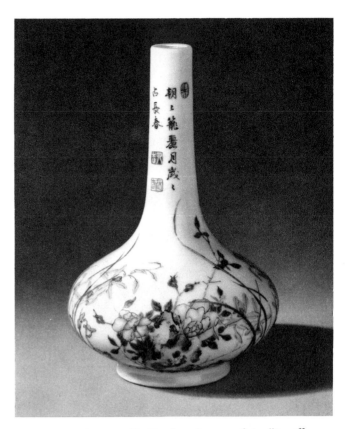

607. *Bottle Vase. Ku Yueh style, porcelain, "famille rose," height 5⁵⁄₁₆". Mark and Reign of Ch'ien Lung* (A.D. 1736-1795), *Ch'ing Dynasty.* Sir Percival David Collection, London

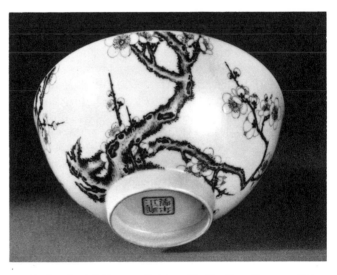

608. *Bowl with Prunus Design. Ku Yueh style, porcelain, diameter 4⁹⁄₁₆". Mark and Reign of Yung Cheng* (A.D. 1723-1735), *Ch'ing Dynasty.* Sir Percival David Collection, London

459

where a black enamel ground gave a dramatic and somber appearance to the decoration, in contrast to the transparent, clean white tonality customary to most Chinese porcelains of Ming and Ch'ing. Again one can

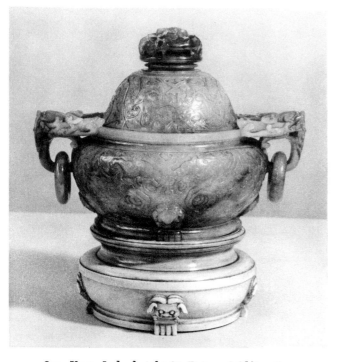

609. Koro. Jade, height 6". Reign of Ch'ien Lung (A.D. 1736-1795), Ch'ing Dynasty. Cleveland Museum of Art

note how much the combination accorded with French eighteenth-century taste.

The *famille rose*, the rose family of porcelains, is more characteristic of the later Ch'ing reigns, especially those of Yung Cheng and Ch'ien Lung. In these porcelains, the white ground is almost always used, and the predominant enamels are rose or yellow, green being used as a supporting note in foliage (*colorplate 50, p. 450, above*). The rose enamels were sometimes used in large vases and plates with decorations of peaches and peonies, birthday presentations to the emperor; but they were at their most refined on smaller porcelains. Some larger pieces were exported, and this was the type that first entered the great American collections. Not until the beginnings of Sir Percival David's collection in the late 1920s, and the London Exhibition of 1935, did the West realize that the *famille rose* technique had been used for Imperial porcelains of a quality surpassing anything known before or since. These enameled wares, beginning at the very end of the K'ang Hsi reign, are called, by the Chinese, wares with "raised-enamel" decoration, or sometimes, after 1743, "foreign-enamel" (*Fa-lang*) decoration. In the West they have been called *Ku Yueh Hsuan* (Moon Pavilion ware), a misnomer derived from a group of late eighteenth- and nineteenth-century glass bottles made for private use, but we propose to return to the traditional Chinese appellations. Beginning at the very end of the K'ang Hsi reign, with brilliant yellow and rose ground porcelains decorated with delicate shading, perhaps showing some Western

influence, we find a new and creative style (*colorplate 50, p. 450, below*). Nearly all examples of raised-enamel ware have the mark of the reign on the base, not in the usual underglaze blue, but in Sung style characters of raised blue or, less often, rose enamel. The height of the technique was achieved in the Yung Cheng reign and in the early years of the Ch'ien Lung reign, under Nien Hsi-yao and T'ang Ying, directors of the Imperial factory. Works were produced such as the superb small vase in figure 607, which combines poetry in black enamel with floral or bird decoration in *famille rose* enamels in a delicate and refined, lyrical and beautifully unified expression of painting and ceramic art. Of course one can prefer Sung porcelains, T'ang pottery, or Neolithic earthenware, but one cannot deny the superb quality of these porcelains, made in small numbers for the court. In figure 608 we illustrate an example that shows the influence of sophisticated, scholarly-style painting in its use of monochrome black for a traditional prunus design on snow-white porcelain.

Other decorative arts are numerous, technically refined, and oftentimes interesting, even beautiful in a decorative way. They display an unmatched technical virtuosity, but a skill which often requires more patience than inspiration: "My, what a lot of work went into that!" To which one adds, "To what end?" Still, the technical virtuosity that could produce a thin, translucent, green jade dish is to be admired and deserves mention in any history of Chinese decorative arts. The jewel jade *Koro* in figure 609, its design worked in raised ridges, giving an almost cloisonné effect to the surface, represents a type of dexterity available only to the court. Naturally such bibelots as this, pleasing to early twentieth-century taste, and admirable to anyone for their unearthly technique, were much copied and are made to the present day. The distinction between a fine piece from the eighteenth century and a mechanical twentieth-century production is one that comes with repeated handling and knowing, but once the distinction is recognized one realizes that the use of dentist drills and machine tools does not produce the same effect as endlessly patient abrasion.

The complex development of official costume and the ritual importance of different court ranks under the Manchu emperors reached new heights, and the results were magnificent robes for all ranks, silk tapestry, and embroidery techniques, with the same rich, almost willfully bold and complicated decorative quality that is found in some of the porcelains and jades. From this to the repetitive inanities of the late Empire and the Republic was but a patient if agonized breath. Nothing, save for a few individualists in painting and calligraphy, was worthy of the past; and China's present achievements are in the nature of propaganda rather than creative art.

18. Later Japanese Art: The Momoyama and Tokugawa Periods

THE MOMOYAMA PERIOD, so called from the "Peach Hill" castle of Hideyoshi at Fushimi, lasted from 1573 to 1615. The Tokugawa or Edo Period, from the early name of Tokyo, lasted from 1615 to 1868 with two eras, the brief Genroku Period from 1688 to 1703, and the remaining Late Edo phase. While it has always been customary to consider Momoyama and Tokugawa separately, it seems far more logical both from the standpoint of political and social history, and from the standpoint of style in art, to consider them as one. The Momoyama Period witnesses the rise of a true military dictatorship begun by Nobunaga and solidified by his successor, Hideyoshi, a general in the army. The military dictatorship that they set up and the hard and fast feudal system accompanying it provided a pattern for Japanese culture until the time of the "restoration" of the Emperor Meiji, who took control in 1867 and began to open Japan to the rest of the world. The dictatorship of Hideyoshi was followed by the *shogunate* of the famous Tokugawa clan. But the *shogunate* was little different from the organization and policy pursued in the Momoyama Period by Nobunaga and Hideyoshi. This period of feudal organization and military dictatorship was one in which Japan was largely isolated from the rest of the world, and indeed this isolation became stronger as the period went on. To be sure, Hideyoshi led a military invasion of Korea, but this was in some part required by the political expediency of finding work for idle military hands to do. Despite the one foreign excursion to Korea with repercussions in art, particularly in the field of ceramics; despite the temporary inroads made by the Portuguese Jesuits and the

Dutch, this was a period of Japanese national strength and of an in-turning by artists which led to a revival of a true Japanese style. It was based in part upon the past, particularly upon the Fujiwara and Kamakura periods, and in part on a new style of decoration which grew progressively stronger as the Momoyama and early Tokugawa periods developed.

The greatest architectural expression of the period

610. *Himeji Castle, Hyogo. Momoyama Period*

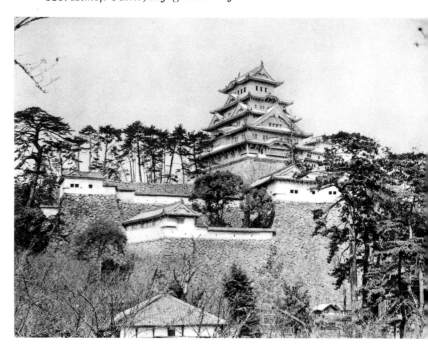

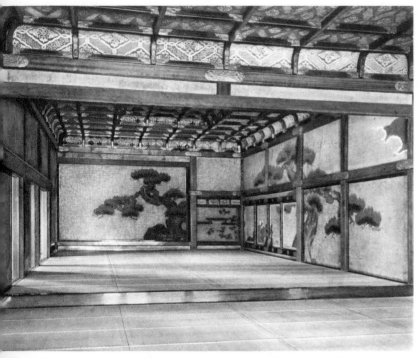

611. *Interior of Ni-jo Castle, Kyoto. Tokugawa Period, 17th Century* A.D.

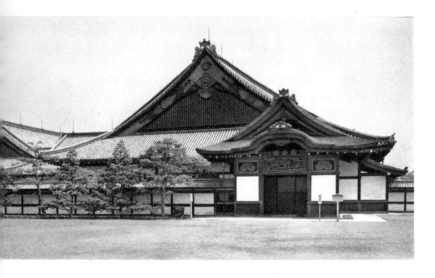

612. *Exterior of Ni-jo Castle, Kyoto. Tokugawa Period, 17th Century* A.D.

greatest example of the castle was the large structure at Nagoya, unfortunately destroyed during the last war; but the Castle of Himeji (the White Heron) on the Inland Sea remains as an outstanding example of castle architecture (fig. 610). The exterior for a third of its height presented a forbidding military aspect: massive masonry construction rose from a moat, towering sometimes fifty or sixty feet above the surface of the water. Above this, however, a more fanciful and less utilitarian structure can be seen: the tile roofs, the raised eaves we have already seen in Japanese temple architecture were piled one on the other to produce a tower of almost pagodalike effect, vastly increasing the height of the structure and giving greater ease of surveillance over the surrounding countryside, providing a focus for local respect, and also making more room for less utilitarian purposes. The interiors of many of the castle rooms presented a far from military aspect, as aesthetic and decorative qualities dominate. Because of the small apertures of the exterior windows and also because of the post-and-lintel construction characteristic of all Far Eastern architecture, the interiors of the great rooms of the castles were inclined to be rather dark (fig. 611). Light penetrated from the windows, or, in the case of interior pavilions, on gardens or open areas, from porches remote from the interior walls of a large room. At the extreme corners, at the sliding panels that separated one room from another, there was but a glimmering kind of twilight. This had considerable effect on the type and technique of decoration that was to develop. One of the few remaining buildings retaining the appearance of an inner castle building is Ni-jo, in Kyoto, whose clean lines and dominating roof are softened by the surrounding trees and open space; but again, the exterior of the building gives no hint of the rich, indeed gorgeous, decoration to be found on the sliding panels and fixed panels of the interior walls (fig. 612). Even the gardens attached to aristocratic pavilions reflected something of the new sumptuousness of the age. The garden of the Sambo-in in Kyoto was designed for the great dictator Hideyoshi himself, and in contrast to the considerable restraint characteristic of the gardens of the Ashikaga Period, such as in the Daisen-in jewel, or the sand garden of Ginkaku-ji, the Sambo-in garden luxuriates in boldly shaped vegetation set in the midst of twisting areas of water and connected by subtly varied bridges (colorplate 51, p. 467). The building of the Sambo-in was brought in from the country by Hideyoshi, and illustrates a continuation of that taste for peasant architecture which we have seen to be one aspect of the cult developed around the tea ceremony. But inside this apparently rustic structure, the richness and brilliance of the colored panels belies the exterior.

This rich tradition of interior decoration in media other than painting is perhaps best seen in the carved wooden panels of the interior of the great audience

was the castle. Military architecture had been well known before. It had been largely a utilitarian form of architecture; the palace and living quarters of the nobles or the lords of a given region were usually separated from the actual military keep, the fortress to which they retired in times of trouble. But with the Momoyama Period, the new military dictatorship and the dominance of a military caste, the fortress and castle were combined into one architectural unity, one of the most striking products of Japanese architecture. The

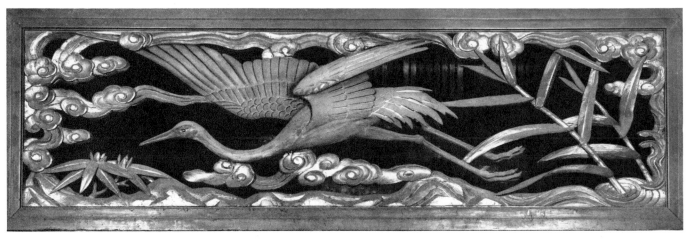

613. *Detail of a carved panel from the interior of Nishi Hongan-ji, Kyoto. Momoyama Period*

hall at Nishi Hongan-ji, pierced and elaborately cut to produce images of waves, flowers, or animals (*fig. 613*). The same decorative emphasis can be seen on a larger scale in the elaborately carved panels of the gate at Nishi Hongan-ji (*fig. 614*). Here, the realistic tradition of wood sculpture that had developed so strongly in the Kamakura Period was modified and used for decorative ends; and the result, while rich and overwhelming in its complexity, was a balanced blend of realism in detail with a decorative use of rhythmical repetition and bold color.

The somewhat restrained style of carved wood decoration characteristic of the Momoyama Period becomes almost a jungle of profusion in the Tokugawa Period. The particular type-site for Tokugawa gorgeousness in architecture is famous Nikko, location of the lavish shrines built by the Tokugawa *shoguns*. Unfortunately, to the average Western tourist, the assorted buildings at Nikko are the best-known examples of Japanese architecture. The famous Yomei gate, with its white base and pillars, elaborately carved and colored reliefs of peonies on the side panels, and the profusion of bracketing to be seen on the upper part of the gate, made even more profuse by the copious use of gold and color, certainly overwhelms the spectator (*fig. 615*). Yet this extreme expression of the decorative style is perhaps the least of the achievements of Japanese architecture. Nikko, with its famous relief of the Three Monkeys, hearing no evil, speaking no evil, and seeing no evil, with its elaborately lacquered and painted interiors, has come, in the eyes of many, to stand for all Japanese architecture. The recent enthusiasm for calculated tea-ceremony taste in architecture as seen in the Katsura Detached Palace is at least an improvement. But a real architectural contribution of this later military society is to be found, if not in the overweening decoration of the shrines, in the stonework at Nikko (*fig. 616*).

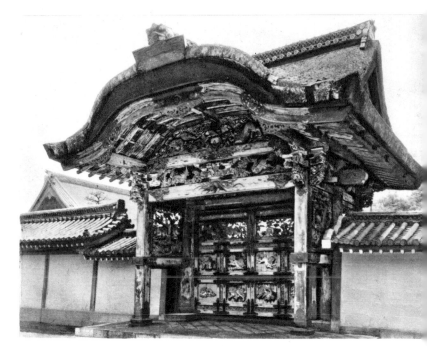

614. *Kara Gate (detail), Nishi Hongan-ji, Kyoto. Momoyama Period*

All of the great walks, stairs, and walls here are made of large blocks of granite, cut and fitted with the utmost precision, and laid in a way that seems to harmonize with the incredibly beautiful forest setting, with its great Cryptomeria trees, some of them over a hundred feet high. This strong and virile stonework seems the true measure of the men who created the Momoyama and the early Tokugawa periods with force and guile. Just as the castle rests on foundations of granite, so does the rather flamboyant decoration of Nikko rest upon remarkable stonework.

The already deeply rooted Japanese taste for simplicity in architecture was not displaced; rather, it was embraced even more avidly, not only by the aristocracy

463

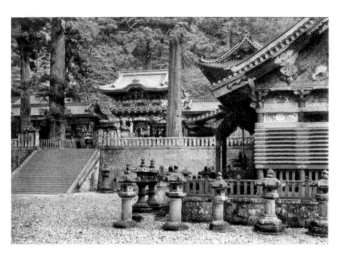

615. *Yomei Gate, Tosho-gu, Nikko. Tokugawa Period, 17th Century* A.D.

616. *Masonry, from Tosho-gu, Nikko. Tokugawa Period, 17th Century* A.D.

617. *Hiunkaku Pavilion, Nishi Hongan-ji, Kyoto. Momoyama Period*

and the military, but by the new, wealthy upper-middle classes. Small tea pavilions continued to be built by all who could afford them, and these continue with more or less success the tea-ceremony architecture that had been established by the middle and late Ashikaga period. Hideyoshi had re-erected a pavilion called the Hiunkaku, in Kyoto at Nishi Hongan-ji (*fig. 617*). The Hiunkaku is in the great tradition of such pleasure pavilions of the early Ashikaga *shoguns* as the Gold and Silver Pavilions in Kyoto. With its dark, exterior woodwork, it seems even more asymmetrical and informal in general plan and arrangement than the earlier structures. Situated in a lush garden, perhaps even more decorative in its effect than that of the Sambo-in, the pavilion was a place where the new dictator and his military acquaintances could gather in an atmosphere making them one with the Ashikaga tradition of the priest-warrior tea cult. But inside the Hiunkaku, while some decorated rooms show the monochrome of the tea tradition, other rooms glory in the use of colored sliding panels in the rich painting style, developed in the Momoyama Period, which was to lead to a second great fruition of the Japanese decorative style.

The great contribution of the Momoyama Period, continued and developed in the Genroku Period, was in the realm of painting in the Japanese decorative style. It seems more meaningful and appropriate to study these paintings in accordance with a plan which grows out of the material and does not necessarily conform to the elaborate traditional Japanese subdivisions based largely on the genealogical lines of various Japanese family schools. This is preferable to the adoption of the Japanese system of numerous subschools and subdivisions leading to a lack of understanding and appreciation of the main points at issue. Such assumed lines were crossed by many artists and make sense only if they are considered as leading tendencies rather than as the product of any one individual or family group. We must also realize that there were creative and stagnant forces, as in any period; and while there were numerous painters continuing in the Chinese-influenced style of the Ashikaga Period, particularly in the Kano school, with one or two exceptions these painters contributed little if anything new to the development of Japanese painting. We must, therefore, seek out the creative trends contributing to new developments and combinations of both native and foreign-influenced styles.

The first of these was the decorative style which has already been mentioned in connection with Fujiwara and Kamakura painting, and seems to represent one of the main styles of Japan, perhaps its most original and creative one. The second, a style influenced by China, was not based upon Sung or early Ming masters, as was the Ashikaga monochrome style and its decadent

618. *Bridge at Uji. Pair of six-fold screens, color on paper, height 59". Momoyama Period.*
Nelson Gallery-Atkins Museum (Nelson Fund), Kansas City

Kano continuation, but on the scholarly, literary paint-
ers of the seventeenth and eighteenth centuries. This
latter style, known as *Nanga* or Southern painting,
from the Chinese critical designation of the Southern
school as the sole creative one, could boast of several
artists of great importance and creative ability. The
third trend was a naturalistic one, influenced in part by
Western art and even more by a growing awareness of
nature as seen, rather than as it was rendered in brush
conventions. Last of all, was a direction in painting that
followed the *Ukiyo-e* tradition and that produced some
very important paintings of mixed decorative and
Ukiyo-e subjects in the seventeenth and eighteenth cen-
turies and culminated in the great woodblock-print
masters of the eighteenth and nineteenth centuries.

The decorative style revives suddenly in the Momo-
yama Period. A screen such as the *Bridge at Uji,* a sub-
ject derived from the ancient *Ise Monogatari* of the Fuji-
wara Period, offers an almost totally new appearance
(*fig. 618*). Certain notes, such as the silver moon, recall
some details of Fujiwara painting; the curving shape
of the bridge and the juxtaposition of the undulating
trees against this more geometric form recall certain
Fujiwara or Kamakura lacquers. But the over-all rich-
ness and splendor of the whole composition, the copious
use of gold in the background, the large and bold
rhythms of the willow tree trunks, the obvious delight
and interest in textures and rather crowded composi-
tions — these are a new and original statement. This
was a Momoyama contribution, and most of the later
decorative style develops from such beginnings. Where,
before, painting had a primarily religious emphasis,
whether it was iconic or the more abstruse and elusive
Zen monochrome, now there is a growing tendency to
consider secular requirements. Sliding panels, single
screens, folding screens, and decorative hanging scrolls
were some of the forms employed by the new style.
The dark interiors prompted a desire to increase the

strength of the light, and gold was found to be one of
the more useful means of accomplishing this. Gold
leaf was used with great effectiveness in backgrounds,
for it reflected light and outlined the silhouettes of
painted trees, animals, or men. The new style began
from the Chinese-influenced Kano school, but soon
forced that style to extremes of pattern and color that
belied the severe aims of the parent style.

This development can be traced from the first great
master of the Momoyama Period, Kano Eitoku (1543-
1590). As his title implies, he was in the main line of the
Kano school, perhaps a pupil of Motonobu. However,
in his painting on the two sliding panels from the Ju-
ko-in in Kyoto, the ostensibly monochrome Kano style
of the representation of the blossoming tree, the birds,
and the bamboo has been considerably transformed to
a decorative style, with greater complexity of composi-
tion and with fewer areas of open space left untouched
by the brush (*fig. 619*). A faint gold wash was applied
to the background sky. From this relatively severe, but
still decoratively inclined style of painting, to Eitoku's
main contribution is a considerable step, but it was
made in one lifetime, and can best be seen in an eight-
fold screen of the National Museum, Tokyo (*colorplate
54, p. 478*). The large cypress tree is not an exercise
in the use of ink, but a massive, even sculpturally mod-
eled, form produced in color. Rich browns and reds
model the general shapes, while the textured bark is
applied in ink. Malachite green indicates the silhouette
of the boughs, as well as their lithe and leafy character.
Rocks are now colored and placed against azurite-blue
areas indicating water. The background, as well as the
swirling clouds, is indicated in gold leaf applied to the
surface of the stretched paper. The result is very largely
an art of silhouettes and of their careful placement
against a background of gold. This ground, an abstract,
unearthly realm in Byzantine art, becomes in the Momo-
yama decorative style a very palpable and solid ground

465

of rich gold acting almost as a stage-flat against which the clear silhouettes of natural forms stand out. Eitoku is still a shadowy figure and few works are surely by him, but he is by tradition and by life span the founder of the Momayama decorative school.

His rival was Hasegawa Tohaku (1539-1610), whom we know to have disliked the Kano line. Like Eitoku, he painted in both monochrome and colored decorative style; but his monochrome paintings, such as the famous *Monkeys and Pines* in the Ryusen-in, derive directly from the art of Mu-Ch'i, especially the famous triptych of Daitoku-ji, rather than secondhand through the late Ashikaga Kano school. If this were the only monochrome work by Tohaku, we would recognize him as a brilliant practitioner of late Southern Sung monochrome style. But Tohaku also painted one of the supreme masterpieces of all monochrome ink painting, the pair of screens, *Pine Wood*, illustrated in figure 620. These screens, executed solely in monochrome ink on paper, reveal the true originality and daring of Tohaku and

619. *Plum Tree by Water. Attributed to Kano Eitoku (A.D. 1543-1590). One of a pair of sliding screens, ink and slight color washes on paper, height 68".*
Momoyama Period. Juko-in, Kyoto

620. *Pine Wood.*
By Hasegawa Tohaku
(A.D. 1539-1610).
Pair of six-fold screens,
ink on paper, height 61".
Japanese.
Tokyo National Museum

Colorplate 51. Garden of the Sambo-in, Daigo-ji, Kyoto. Momoyama Period, completed A.D. *1615*

Colorplate 52. Tigers and Bamboo. By Kano Tannyu (A.D. 1602-1674). Section of a screen with sliding panels, ink on paper, height about 67". Tokugawa Period. Nanzen-ji, Kyoto

621. *Flowers and Maple Leaves.*
By Hasegawa Tohaku (A.D. 1539-1610).
Two panels of sliding screens,
color on gilded paper, height 70".
Japanese, Chishaku-in, Kyoto

his generation. Taking what would have been a detail from an earlier composition, he enlarged the pine trees, but provided them with no background of mountains, no foreground of scholars or rocks, and simply isolated them on the screens, producing spatial implications by means of graded ink tones implying swirling mist around the pine trees. These are painted boldly and simply, with something of the dancing movement and rhythm of the trees in the screens by Shubun. While these influences are implied, the screens exist as an original creation, one expressing something of the grandeur and scale of the Momoyama effort, even in such a usually non-decorative medium as monochrome ink.

Tohaku also attempted the more typically decorative Momoyama style in the numerous sliding panels now preserved at the Chishaku-in, Kyoto (fig. 621). These sliding panels, like those of Eitoku, have gold-leaf backgrounds and are painted in opaque mineral and earth colors, instead of monochrome ink. Indeed, there is little ink to be found in the originals except for occasional accents or as an underpainting guide to the application of color. The gold has been enormously increased in area and enhances the brilliance of the color and especially the importance of the profiles. These silhouettes are not a single dark tone but vary from grays, pinks, and pale greens through to the darkest azurite, malachite, and brown, the result being a wide variety of silhouette tones against the gold ground. The motifs of these screen paintings range from all-over patterns of flowers and maple leaves to dominant, heavy tree trunks and boughs. The bold composition of the tree trunk reaching up and out of the panel at the top, and then returning at the center demonstrates the decorative daring of the new approach. The combination of strong and light notes of the delicate touches in the maple leaves and the bold profiles of the tree trunks, the green leaves of the plants, and the blue of the water seem surprisingly masculine and powerful despite the decorative emphasis.

The third of the great Momoyama decorators is Kano Sanraku (1559-1635). Like the others, he painted in

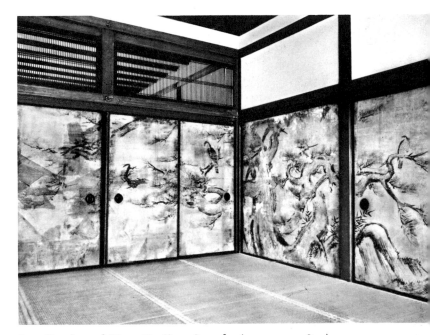

622. *Hawks and Pines. By Kano Sanraku (A.D. 1559-1635).*
Sliding screens, ink on paper. Japanese, Daikaku-ji, Kyoto

both monochrome and colored media. His works can be seen particularly at Daikaku-ji in Kyoto (fig. 622). There, brilliantly painted monochrome panels, showing hawks and other birds of prey on old pines and deciduous trees, are to be seen in rooms next to others containing richly colored panels with gold backgrounds. The screens with Chinese peonies give some idea of the subtlety and restraint characteristic of Sanraku, in contrast to the bold and powerful styles of Eitoku and Tohaku. Some of Sanraku's panels at Daikaku-ji seem to combine the type of composition usually found in monochrome painting with the new colored decorative style. The delicacy and refinement of the branches is supported by the rather powerful tree trunk and rocks, but even these are more stylized than the massive forms painted by the two earlier painters (fig. 623).

469

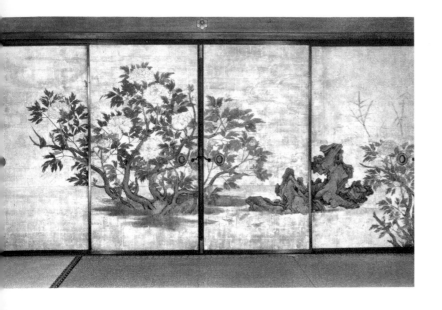

Sanraku seems to anticipate something of the mode to be developed by Sotatsu and Korin in the seventeenth century.

Other Kano painters, famed in their day for monochrome painting, worked in the new decorative style. An artist such as Kano Tannyu (1602-1674), perhaps the most famous name in monochrome painting of the seventeenth century, now seems to achieve his best effort, not in the old-fashioned and trite monochrome subjects, but in the new, colored and gold medium. The screens at Nanzen-ji, picturing tigers and bamboo, the favorite symbols of the *samurai* for strength and pliant resistance, display the gold ground in a way that emphasizes the silhouettes of the animals and complements their interior bulk *(colorplate 52, p. 468)*. There is a trace in these panels of that sharpness of observation particularly important in works of the "realistic" school associated with the name of Okyo. Still, Tannyu was a

ABOVE:
623. Tree, Flowers, and Rocks.
By Kano Sanraku (A.D. 1559-1635).
Four panels of a screen with
eight sliding panels, color on
paper, height 72¾". Japanese.
Daikaku-ji, Kyoto

RIGHT:
624. Thunder God.
By Tawaraya Sotatsu
(A.D. 1576-1643).
Section of a pair of
two-fold screens, color on
gold paper, height 60".
Tokugawa Period.
Kennin-ji, Kyoto

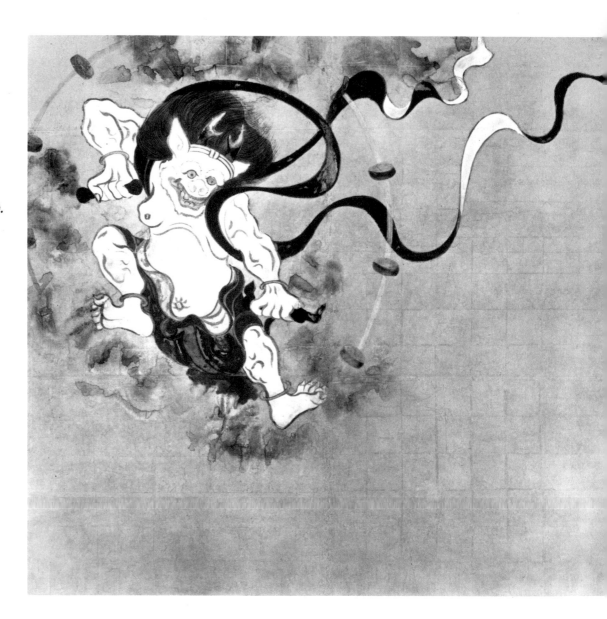

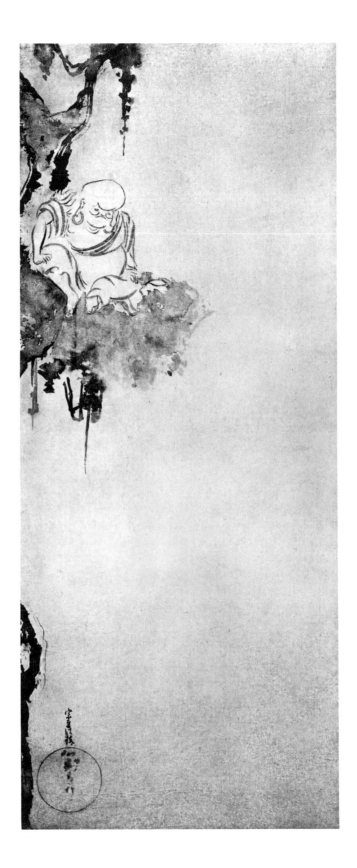

625. Zen Priest Choka. By Tawaraya Sotatsu
(A.D. 1576-1643). Hanging scroll, ink on paper,
height 37¾". Tokugawa Period.
Cleveland Museum of Art

rather repetitive, if talented, late representative of the Kano school.

The Momoyama painters and their followers in the Tokugawa Period established, boldly and at once, a rich, complex style difficult of further development. The statement was so complete and overwhelming — some four hundred-odd sliding panels were made for Nagoya Castle alone — that a new style became almost imperative. A different manner was also required because of the particular needs of the patron. The unabashed splendor of the Momoyama style, while it might satisfy the first generation of the new ruling class, could not continue to please their more refined descendants who became more and more aware of the various contributions of older Japanese art. If the Momoyama Period is considered as a brilliant prelude, then the culmination of later Japanese decorative style is to be found in the school established by Sotatsu (1576-1643). Whereas Sotatsu was merely a name to be mentioned after Korin some thirty years ago, subsequent research and rediscovery of his paintings have led to his just evaluation as the most creative master of later decorative style and the founder of the great Sotatsu-Korin school.

If we look at a major work by Sotatsu, such as the pair of two-fold screens representing the demons associated with thunder and wind, we are aware of a different decorative approach than that practiced by such Momoyama painters as Eitoku, Tohaku, and Sanraku (fig. 624). In contrast to the over-all patterning of these Momoyama painters and their use of Chinese derived motifs, the work by Sotatsu strikes us as more severe and bold and with more emphasis upon asymmetry of composition, simplicity of silhouette, and a greater variety in the handling of color and ink. The subject matter, too, is different from that used by the painters of the earlier generation, being derived from Japanese traditions before the Ashikaga Period, particularly from representations of deities, demons, and noble personages in scrolls produced in the Fujiwara and Kamakura periods. Tawaraya Sotatsu by-passed the Chinese-style paintings of the Ashikaga Period to find other sources more deeply rooted in the Japanese tradition: the decorative style of the Fujiwara Period best seen in the *Genji* scrolls and the narrative tradition of Kamakura handscroll painting with its emphasis upon action and the caricaturelike drawing of figures. However, he did not rely completely upon early Japanese sources for his style but used also techniques of paint application developed in the Ashikaga Period.

471

The clouds surrounding the wind demon show a bold use of the brush indicating a study of the ink painting practiced by Sesshu in his *haboku* landscapes. The fading off of color boundaries, the use of wet areas of color

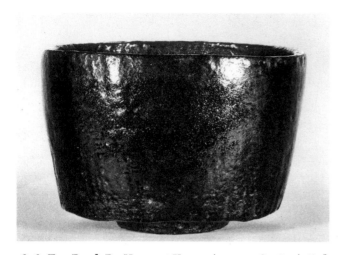

626. *Tea Bowl. By Hon-ami Koetsu* (A.D. *1558-1637). Raku stoneware. Japanese.* Freer Gallery of Art, Washington, D. C.

with ink merging into color producing a blurring and pooled effect, are certainly derived from the *haboku* tradition. We can clearly see this inspiration if we consider one of Sotatsu's important monochrome paintings, a hanging scroll of paper representing the Priest Choka sitting in a tree (*fig. 625*). The subject is derived from Chinese paintings or, more accurately, from Chinese woodblock prints, and was used by such literary painters as K'un-ts'an. But Sotatsu transforms the print, which shows the whole tree and clearly delineates the figure of the monk. He makes of it a daring asymmetrical composition, with most of the tree imagined as out of the picture, and the monk deliberately suppressed by using pale washes of ink, thus creating a decorative composition while adhering to the *haboku*

style of ink. Of few pictures can it be more truly said that one's praises are for what is not there.

Sotatsu did not arrive at his style of painting from tradition alone. Sotatsu's wife may have been related to Koetsu and it is certain that Koetsu had some influence on Sotatsu's new painting style. Koetsu was known as a tea master and made tea bowls in the tradition of the tea masters of the late Ashikaga and Momoyama periods (*fig. 626*). This famous example displays a beautiful control of the slightly asymmetrical bowl shape and an especially interesting and subtle use of glaze colors, the colors of nature: orange, and moss green. Koetsu's training as a tea master undoubtedly prompted his inclinations to a severe artistic approach and to the deliberate roughness we have already associated with the cult of tea. He was also a very important calligrapher, not in the Chinese style of writing, but in the Japanese "running" style. He collaborated with Sotatsu on several scrolls of poems where the text was written by Koetsu and the decoration was executed by Sotatsu. A long scroll with the signature of Koetsu and the seal of Sotatsu represents herds of deer decorating poems from the *Ise Monogatari* (*fig. 627*). The combination of calligraphy, executed with great boldness and freedom in the cursive style, with the informal handling of gold and silver representations of deer, shows how Koetsu's tea inclinations and his accompanying asymmetry and slight roughness combined with Sotatsu's study of Japanese art before the Ashikaga Period to produce something that cannot be said to be a mere development of Momoyama decorative style. The device of allowing the herd of deer to run up and off the paper, with only the head and feet of the first deer being visible at the top of the scroll, is comparable to the compositional means used in the monochrome representation of Priest Choka. Its extremely daring use of the handscroll form

627. *Deer. By Tawaraya Sotatsu* (A.D. *1576-1643); calligraphy by Hon-ami Koetsu* (A.D. *1558-1637). Section of a handscroll, gold and silver on paper, height 12½". Tokugawa Period.* Seattle Art Museum

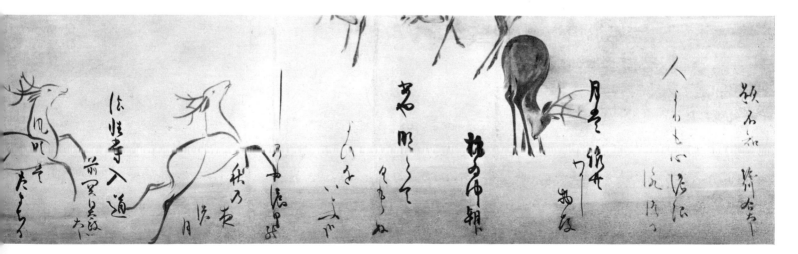

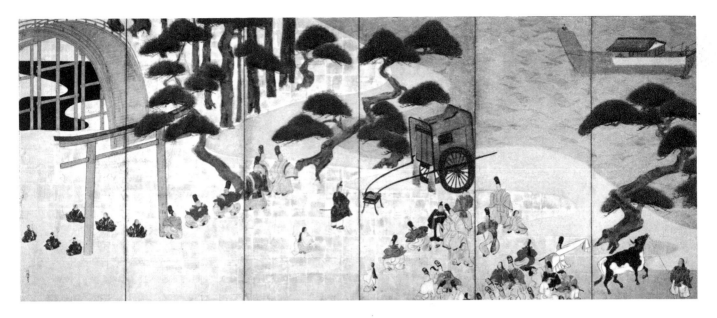

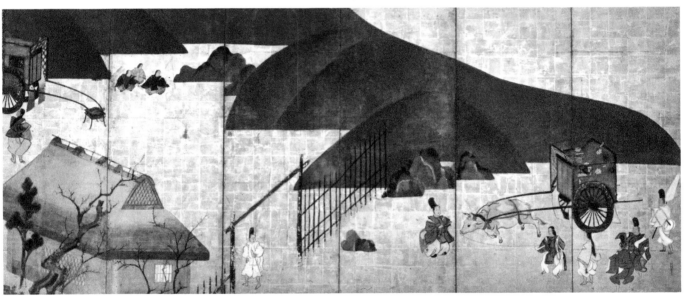

628. *Scene from the Tale of Genji. By Tawaraya Sotatsu* (A.D. *1576-1643). Pair of six-fold screens, color on paper,* *height 61½". Tokugawa Period.* Seikado Foundation, Tokyo

creates a decoration combining the brilliant gold and silver of the Momoyama decorative painters with the asymmetry and roughness of the tea ceremony. Koetsu, then, was in part responsible for the development of the style, but the style will rightly always be associated with Sotatsu's name.

Perhaps the most important of Sotatsu's screen paintings are the pair belonging to the Seikado collection and representing a scene from the *Tale of Genji* (fig. 628). The section of the story illustrated is rather well but subtly developed in the novel, but the illustrative possibilities are played down by the artist. The representational elements are there—the screened cart carrying the lady, Genji, and the two retinues—but certainly

the narrative plays a minor role in these screens. The gold background, the brilliant use of green, blue, and brown, the bold silhouettes of the figures derived from the Kamakura scroll painting, the construction of the landscape as a series of overlapping stage-flats, probably under the influence of both Fujiwara lacquers and Kamakura handscrolls, are all elements derived from the past but fully assimilated and transformed into a new and original style. The placement of these silhouettes is of the highest importance. One almost feels that the artist worked as do such contemporary masters as Matisse—with cut-out figures in a collage technique, adjusting and placing the silhouettes against the gold background with hair-breadth judgment. The use of

473

629. Writing Box with Cranes. Designed by Ogata Korin
(A.D. 1658-1716). Gold-lacquered wood, inlaid with pewter
and lead, length 9⅛". Tokugawa Period.
Seattle Art Museum

630. Baskets of Flowers and Weeds. By Ogata Kenzan
(A.D. 1663-1743). Hanging scroll, color on paper, height 44".
Tokugawa Period. Matsunaga Collection, Tokyo

tilted perspective and of abstract water patterns at the
top of the picture is also a part of this silhouette style.
We need not imagine that we see the influence of Fuji-
wara and Kamakura styles on Sotatsu, for we know
that he was called upon to restore and redecorate some
of the end papers of the famous Sutras at Itsukushima,
which you will remember were key moments of the
Yamato-e style of the late Fujiwara Period (see pages
304 ff. and figs. 393-395); we still have free copies by
Sotatsu from the mid-Kamakura scroll, The Fast Bulls.
There are other origins for his style, but his real contri-
bution was to pull these influences together in a syn-
thesis which was new — and in this he was unlike the
Kano painters who were merely eclectic. A sense of
humor is not lacking in the work of Sotatsu and this,
too, seems in keeping with his Japanese artistic origins.

While Sotatsu undoubtedly influenced numerous
painters, there is a direct line traditionally leading from
him to Korin and Hoitsu, each the leading decorative
master of his generation. Of the painters immediately
around Sotatsu — shadowy figures whose names we are
only now becoming aware of — Koshu is one of the
most significant and seems to have absorbed the lessons
of his master's new and radical approach. The screen,
The Pass Through The Mountains, again ostensibly
illustrating a poem from the Ise Monogatari, is an ex-
ample of Sotatsu's art carried to further extremes, par-

474

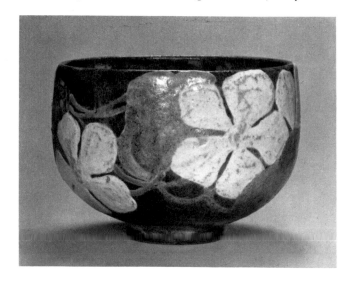

631. Tea Bowl with Flowers. By Ogata Kenzan
(A.D. 1663-1743). Pottery. Tokugawa Period.
Yamato Bunka-kan, Nara

632. *Hozu River. By Maruyama Okyo.* (A.D. 1733-1795). *Pair of four-fold screens, ink and color on paper, length 15' 8".* Tokugawa Period. Nishimura Collection, Kyoto

ticularly in the treatment of the landscape as a series of stage-flats and in the unusual color harmonies of blue and rust red (*colorplate 55, p. 479*).

But the greatest master of the next generation of decorative style painters was Korin (1658-1716). So important is this artist that his name in Japan is often used jointly with Sotatsu's in designating this particular school of painting. Korin was descended from Koetsu's sister. We know more of Korin's life than we do that of Sotatsu and can appreciate how this new style is associated with the new society of the Tokugawa Period, for Korin was not of a noble family but belonged to the wealthy upper-middle-class merchant group. He was once officially reprimanded by the court for an overconspicuous display of wealth when at a party he wrote poems on gold leaf and floated them down a stream, thus emulating the legendary poets' gatherings in T'ang China. His works were collected not only by the new wealthy merchant class but by the aristocracy. In contrast to Sotatsu's works, which seem to emphasize a greater freedom in the handling of paint, Korin's works were more carefully painted, with a greater emphasis upon precise outline and a relatively even application of color. His style seems to be slightly more refined than that of Sotatsu. Korin transforms Sotatsu's boldness into more elegant, even approachable, terms and hence he was famous before the rediscovery and proper evaluation of Sotatsu. One of his two screens in the National Museum in Tokyo, *White and Red Prunus in the Spring*, shows his elegant style, particularly in the painting of the branches of the tree; while at the same time the bold shape of the stream with its swirling waters recalls the daring of Sotatsu (*colorplate 53, p. 477*). The

effective contrast between the tree, with its reaching branches and the swirling silhouette of the stream, is one of elegance with boldness. Korin's most famous paintings, and probably his masterpieces, are the pair of six-fold screens in the Nezu Museum in Tokyo representing irises, a subject derived from the *Ise Monogatari* (*colorplate 56, p. 480*). It is characteristic of the subject matter of the Sotatsu-Korin school that the motifs can usually be traced to a literary source although little, if any, effort is made to illustrate the scene literally, other than by a general overtone or flavor that can perhaps be sensed by the Japanese, if not by us. In this case, the subject of iris rising from a stream bed is but a fleeting image in one of the poems of the *Ise Monogatari*, but Korin has taken this undertone and enlarged it to the sole motif of a great decorative composition, with the malachite-green spikes of the leaves dancing across the screen in counterpoint to the iris blossoms in two shades of azurite blue. The effect from a distance is that of a silhouette modified by vibrations of color within. As one gets closer to the screens, the color becomes ever more dominant until at last the vibration of the blue and green against the gold reaches its full effect. The subject was painted again by Korin in a pair of screens in the Metropolitan Museum, where the bridge mentioned in the poem is included. The iris screens of Korin, and those by his pupil Shiko, are among the most musical of all decorative style paintings.

Korin, like his predecessor Koetsu, worked in lacquer as well as in ceramics, and one of the lacquer boxes attributed to him represents cranes on a dark, black-brown ground (*fig. 629*). The same subject was used by Korin in a screen recorded by Hoitsu, but now lost. In

475

633. *Nature Studies (portion). By Maruyama Okyo (A.D. 1733-1795). Three handscrolls, ink and color on paper, height 12⅜". Tokugawa Period.* Nishimura Collection, Kyoto

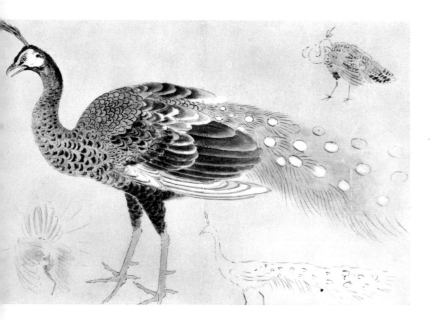

634. *Birds. By Ogata Korin (A.D. 1658-1716). Detail from sketch sheets mounted as a handscroll, ink and color on paper, width 24". Tokugawa Period.* Zenjuro Watanabe Collection, Tokyo

476

this the influence of the tea ceremony and of tea taste is more evident than in the screens. In addition to the gold defining some of the shapes, Korin used pewter and lead, the different textures of which add to the complexity and variety of the presentation, while they also add a note of roughness, of that *shibui* quality so important to the Japanese tea master. The shape of the box, with its slightly domed lid and lack of sharp edges and corners, is in this particular taste. Another box attributed to Korin in the National Museum in Tokyo uses the iris and bridge pattern already seen in his screens.

Korin's brother, Kenzan (1663-1743), must be mentioned in any consideration of these aspects of the Japanese decorative style. Kenzan executed few paintings, but his famous masterpiece, *Baskets of Flowers and Weeds,* in the Matsunaga collection, is a beautiful example of the combination of tea taste and decorative style (fig. 630). The careful calculation of the position of the baskets, the overlap of the two at the top, the tilt of the one at the bottom, the different color notes of the flowers in the three containers, the combination of calligraphy and decorative motifs, and the boldly stylized representation of the wicker-work are in keeping with the flavor of the lacquer box by Korin or the joint works of Koetsu and Sotatsu. Kenzan also made ceramics, especially utensils for the tea ceremony — cake trays and tea bowls. One of his tea bowls shows the same aim and reaches the same achievement as his hanging scroll of flowers and baskets (fig. 631). By representing melon flowers on a black-glazed earthenware ground, he produced a combination of bold decorative design and large silhouettes, and the roughness and the "naturalness" of a utensil in tea taste. Kenzan's influence on later Japanese ceramics is very important and even today his line is continued by the ninth artist to take the name Kenzan.

The last great master of the Sotatsu-Korin school is Hoitsu (1779-1828). That he was of the direct line is quite certain, for on the back of Korin's screens copying Sotatsu's depictions of the wind and thunder gods he painted a representation of weeds and vines by a river bank on a silver background (colorplate 58, p. 492). In this work the tendencies evident in Korin, toward elegance and a more flowing and refined type of composition than that used by Sotatsu, are carried even further by Hoitsu. Here is something comparable to European Rococo decoration — the bold silhouette shapes are gone. The stream is smaller now, and has a more

Colorplate 53. White Prunus in the Spring. By Ogata Korin (A.D. *1658-1716*). *One of a pair of two-fold screens, color on gold paper, height 62". Tokugawa Period.* Tokyo National Museum

478

Colorplate 54. Cypress Tree. Attributed to Kano Eitoku (A.D. *1543-1590). Eight-fold screen, color and gold on paper, height 67". Momoyama Period.* Tokyo National Museum

Colorplate 55. The Pass Through the Mountains. By Roshu (A.D. *1699-1776). Six-fold screen, color on gold ground, height 53⅜". Tokugawa Period.* Cleveland Museum of Art

Colorplate 56. Irises. By Ogata Korin (A.D. *1658-1716). Pair of six-fold screens, color on gold paper, height 59". Tokugawa Period.* Nezu Museum, Tokyo

635. *Westerners Playing Their Music. Pair of six-fold screens, ink and color on paper. Tokugawa Period, c. A.D. 1610.*
Moritatsu Hosokawa Collection, Tokyo

gentle and rhythmical swirling movement. The color scheme is subtle, but something of the old boldness and gorgeousness has been sacrificed even if greater elegance and refinement on a small scale have been attained. Some realistic influence is to be seen in this as well, particularly in the depiction of the effect of wind blowing against the vines at the left; one or two of these autumn leaves swirl in the silvery air, and reveal another facet of Japanese painting, to which we will now turn.

The second main line of later Japanese painting is usually described as realistic, perhaps better as naturalistic. It is seen at its highest level in the work of Maruyama Okyo (1733-1795). The pair of screens representing the Hozu River illustrate the strange combination of a stylized Ashikaga monochrome manner with a degree of observation of nature that approaches Western objectivity (*fig. 632*). The topmost tree, with its slightly stunted trunk, is not a graceful or ideal tree but more like one observed from nature. The textures of the rocks are somewhere between the stylized *tsun* of monochrome painting and the observed texture of volcanic rock. Even the representation of the water and its

rhythmical sweep is between the two extremes of stylization and naturalism. The general composition, however, is somewhat arbitrary and bold, almost decorative. Other works of Okyo betray his realistic interests more clearly, and one roll in particular proves that we do not imagine such an interest in his work (*fig. 633*). These realistic studies of animals and plants in ink and color, in this case leaves and insects, show a directness of observation translated into strokes of the brush following observed forms rather than the conventions of Far Eastern brushwork. The difference between this true naturalism and the stylized or conventional naturalism of the decorative or Kano-style painters can be seen if one contrasts the Okyo roll with a similar roll painted by Korin, where brush conventions seem to dominate to the same degree that naturalism dominates the other (*fig. 634*).

Such realism in pictorial form was derived in part from observation and in part from Western influence. The Portuguese missionaries and Dutch traders in South Japan introduced a style of painting that impressed many Japanese painters, and works were produced by some artists picturing Europeans in court costumes of

636. *Portrait of Ichikawa Beian. By Watanabe Kazan.*
(A.D. *1793-1841). Hanging scroll, color on silk,*
height 50⅞". Tokugawa Period. Goro Katakura
Collection, Tokyo

the seventeenth and early eighteenth centuries, with
backgrounds of a strange and rather naïve, even comical, combination of Western and Japanese techniques
(fig. 635). The same curious, unassimilated mixture of
East and West has already been seen in Castiglione
(*see page 456 and fig. 603*). The use of modeling by
light and shade to develop the sculptural quality of
figures impressed the Japanese, and numerous works

in this particular genre were painted. It remained, however, for a painter of the Japanese scholarly tradition
of the early nineteenth century, Watanabe Kazan (1793-
1841), to produce perhaps the most striking and original works under the influence of Western realism.
Kazan, who painted in Chinese style as well, was able
to absorb the influences so mixed in the style of Nobukata and to apply them with great virtuosity of the
brush. The *Portrait of Beian*, developed by modeling
in light and shade, is a realistic portrait which seems a
unified work combining Chinese, Japanese, and Western methods (*fig. 636*). We know that he prepared such
portraits very carefully from the sketches that he made
for them. In the watercolor sketch for the *Portrait of
Beian*, realism and the influence of Western modeling
is even more clearly evident (*fig. 637*); and one can
realize the extent to which these were modified to harmonize with Far Eastern brush style. Kazan, a political
outcast and a suicide, is one of those individuals who
stands outside of the mainstream of painting, but he

637. *Sketch for the Portrait of Ichikawa Beian.*
By Watanabe Kazan (A.D. *1793-1841). Hanging scroll,*
ink and color on paper, height 15½". Tokugawa Period.
Goro Katakura Collection, Tokyo

483

can be considered as a culminating master of the naturalistic style.

Some isolated artists, such as the warrior-painter Niten (1584-1645), were able to use the monochrome style of Sesshu and Tohaku and produce paintings such as the picture (formerly Nagao collection), *Shrike on a Dead Branch*, which certainly stands as one of the great Japanese monochrome paintings (*fig. 638*). Much has been written comparing the "single" stroke of the branch with the cut of a sword, since Niten was a *samurai.* However, a careful examination of the painting, even in a reproduction, indicates that not one but at least three strokes were used to produce the branch. This is no criticism of the quality of the picture but merely indicates the degree of thought and care resulting in the apparent "swiftness" of this particular painting. The boldness of the bird's silhouette and the elegance of the composition, the shrike balancing back to the left against the branch with its leaves at the lower right, indicate more decorative interest than does a similar Chinese theme. The arbitrary fading off of the bamboo stem at the lower left as it moves to the upper right is certainly not a naturalistic device but a decorative one. Niten's known works are in monochrome and of a remarkably high consistency, but in this respect he stands alone. His style is that of a great and gifted individual remote from the emptiness of the Chinese-influenced Kano style.

The third of the creative styles of later Japanese painting is called *Nanga* (southern painting) by the Japanese. Practiced by numerous painters of the eighteenth and nineteenth centuries, the *Nanga* style claims some of the most original and creative painters of the period. The style is derived from Chinese literary-school painting. The *Nanga* painters studied the printed books explaining literary style; they saw literary men's paintings from China. Without the developments of the seventeenth- and early eighteenth-century individualism in the Ch'ing Dynasty, it is most unlikely that these Japanese masters would have produced the *Nanga* style. Nevertheless, like the great Japanese monochrome paintings by the best painters of the early Ashikaga Period, these men took an effective style from China and transformed it into a new and creative manner, a manner which they believed in so thoroughly that they were able to raise it above the level of mere imitation. The *Nanga* painters, as did their early Ashikaga ancestors, tended to exaggerate the elements of Chinese literary men's painting, not only in composition but in brushwork, and added to them a strong sense of humor.

Two names in particular are closely associated: Ikeno Taiga (1723-1776), and Yosa Buson (1716-1783). Taiga is one of the wittiest and most daring of *Nanga* painters. His works, when colored, usually have a summery, light, and cheerful tone (*fig. 639*). He emphasizes brush-dotted textures, and a rolling, rollicking rhythm runs through nearly all of his pictures, implying an extroverted good

639. *Fishing in Springtime. By Ikeno Taiga*
(A.D. *1723-1776*). *Hanging scroll, ink and color on silk,*
height 48⅜″. *Tokugawa Period.*
Cleveland Museum of Art

humor. In an album, *The Ten Conveniences and the Ten Enjoyments of Country Life,* painted jointly with Buson, Taiga's pages seem to breathe this humorous and, at the same time, bold and creative air. Like the Anhui individualists of the seventeenth century in China, Taiga, in the picture of an old scholar standing on a grassy point up in the mountains, seems to be showing us a visual pun: the scholar looks like the mountain, and the mountain looks like the scholar (*fig.* 640). The old and grotesque type of the scholar with his bulbous nose is an extension of the traditional ideal of the Lohan or Arhat, the rough exterior with a heart of gold. The soft tones of ink and brilliant simplification of the figure are the work of a man who was a master of the brush. Buson is less humorous, but just as gay, with a rather springlike, pleasant, and even disposition. The pages from the album painted jointly with Taiga have this quality, which is closely related to that of the Chinese individualists (*fig. 641*). His most fascinating scroll, a view of a village in the snow, seems to recall Sesshu and to be a reinterpretation of that artist in *Nanga* style (*fig. 642*). Even Sesshu would not have been so bold as to play with the tones of ink in the sky so freely, even carelessly; and even Sesshu would not have felt it proper to indulge in the rather humorous and lilting hit-or-miss treatment of the roof lines; but perhaps only Sesshu could have achieved the effect of the dampness and weight of wet snow achieved so playfully by Buson.

Recently, another master of the *Nanga* school, Gyokudo (1745-1820), has become highly appreciated. In contrast to Taiga and Buson, he is the more dramatic and somber painter of the *Nanga* group. These compositions with their feathery, high mountains, their emphasis on tilted, circular planes that seem to be floating in different layers of space, and their sudden movements in the midst of the rich ink reveal an arbitrary method related to the equally arbitrary compositions of the decorative style, but handled in the witty and flexible medium of the scholarly painter. His generally acknowledged masterpiece is the great composition, *Frozen Clouds Sieving Powdery Snow,* where, again, the texture, weight, even the feel of the snow are produced in his unique style (*fig. 643*). The fluttering rhythms, the swinging arcs indicating rocks, mountains, and movements are his particular handwriting.

The fourth of these mainstreams of pictorial style is usually called *Ukiyo-e,* pictures of the floating world, using "floating" in the Buddhist sense of transient or evanescent, the world of everyday life and especially of pleasure — theater, dancing, love, or festivals. While the term *Ukiyo-e* is particularly associated with the popular art of woodblock prints, it really describes a style that begins with paintings of a mixed heritage. We have seen the realistic and story-telling style of the *E-maki,* narrative picture scrolls, produced during and after the Kamakura Period. Another great style, developed from earlier manifestations, but consummated during the Momoyama and Tokugawa periods, was the decorative one fulfilled by Sotatsu and Korin. These, combined with something of both native and foreign realism as well as Chinese elements of the Kano school,

640. *Viewing Fine Scenery, from* The Ten Conveniences and the Ten Enjoyments of Country Life. *By Ikeno Taiga (A.D. 1723-1776). Album leaves, ink and slight color on paper, height 7", dated A.D. 1771. Tokugawa Period. Yasunari Kawabata Collection, Kanagawa*

641. *Enjoyment of Summer Scenery, from* The Ten Conveniences and the Ten Enjoyments of Life. *By Yosa Buson (A.D. 1716-1783). Album leaves, ink and slight color on paper, height 7", dated A.D. 1771. Tokugawa Period. Yasunari Kawabata Collection, Kanagawa*

642. *Snowing Landscape at Night. By Yosa Buson (A.D. 1716-1783). Hanging scroll, ink and color on paper, length 52". Tokugawa period. Kinta Muto Collection, Kobe*

were adapted to the new and, in traditional eyes, vulgar demands of the merchant and plebeian classes of urban Japan after the seventeenth century. If even Hideyoshi delighted in gorgeous displays of "vulgar" art and decoration for the delight of the assembled masses on festival days, what was to prevent the adaptation of the existing styles of painting to more popular consumption?

Some of the earliest *Ukiyo-e* are screen paintings loosely associated with an almost folk-hero artist, Matabei. These are actually not too closely related in personal touch, with the handwriting of the artist; but they all share a delight in gorgeously dressed large-scale figures performing commonplace pleasures or tasks (*colorplate 59, p. 493*). Often the figures are of low-class women, even prostitutes, dressed in gay every-day costume. Traces of various other styles are easily found — even the subject matter may ostensibly be the traditional Kano one of "The Four Accomplishments": Writing, Music, Dancing, and Games. But the new interest in the floating world, the latest hairdo, and the fashionable robe dominate the screens through their motivating power — the pursuit of pleasure, whether visual, auditory, or tactile; hence the almost hypnotic power of the newly popular *Kabuki* theater. Signed or not, and usually not, these screens are not merely the work of an artisan. The placement of the figures and their interrelations, psychological and aesthetic, show a calculation and subtlety worthy of the great decorative masters.

In addition to the painting traditions at hand, *Ukiyo-e* artists exploited another, until then basically nonartistic,

485

tradition — the woodblock print. The printing of books, even single prints, had been known in the Far East from the eighth century. But the technique had largely been used for literary material, cheap Buddhist icons or illustrated texts, and numerous painting manuals and textbooks, the most famous of these being the Chinese *Mustard Seed Garden* and *Ten Bamboo* manuals. These numerous productions formed a tool which had yet to be fully exploited from either technical or aesthetic viewpoints. Despite the fantastic ability of the woodcutters to reproduce *paintings*, little had been done to produce *prints,* works of art in their own right with their own rules of form appropriate to the medium. The new interest in the urban everyday world and the new market of the moderately well-to-do and the not-so-fortunate motivated the swift development of original and numerous *Ukiyo-e* woodblock prints designed for mass consumption, changing from moment to moment in accordance with popular fashion and whim, and representing the various interests of the urbanite, whether vulgar or refined.

Hundreds of thousands of prints were produced in the two hundred years from 1658, the year of Hishikawa Moronobu's first recognized illustrated book, until the death of Ando Hiroshige in 1858, when the first great tradition of woodblock artistry ended. These thousands were usually despised by the upper-class artists and their patrons, and considered expendable amusements by the classes that consumed them. Thus Japan is relatively poor in fine old prints today. But in Europe, and by extension, America, fine Japanese print collections are legion, largely because of the succeeding waves of enthusiasm displayed by Western artists such as Van Gogh and Toulouse-Lautrec, and their circles during the late nineteenth and early twentieth centuries. This patrimony has had one somewhat unfortunate result — Japanese art has often been judged by standards derived from the appreciation of woodblock prints, if indeed earlier Japanese art has been seen at all. If to many these prints are a culmination of Japanese traditions, and certainly the sheets combine some elements of nearly all earlier styles, to others they represent the last creative emergence of the great earlier traditions in a final popular expression before the sad decline of Japanese art in the late nineteenth and early twentieth centuries. This fall has only recently been arrested and turned by the rise of modern international art movements and by the shock effects of the Second World War.

The complex and specialized development of the

RIGHT: *644. Street Scene in the Yoshiwara.*
by Hishikawa Moronobu (c. A.D. 1625–c. 1695).
Woodblock print, width 16". Tokugawa Period.
Metropolitan Museum of Art, New York

BELOW RIGHT: *645. Parody on a Maple-Viewing Party.*
By Okumura Masanobu (A.D. 1686-1764). Color woodblock
print, height 16¼", dated c. A.D. 1750. Tokugawa Period.
Metropolitan Museum of Art, New York

Japanese woodblock print can be but barely summarized here. Hishikawa Moronobu (1625-1695) is generally accredited as the first *Ukiyo-e* print artist. His *Street Scene* is set in the red-light district of Edo (Tokyo) and, while it is indebted to traditional book illustration, it recalls sections of the earlier narrative handscrolls (fig. *644*). The artist's line, if based on brush drawing, is adapted to the cut of knife on wood. The print is restricted to black and white and, until the invention of color printing, about 1741, what restricted color was used was applied by hand. Printmakers of this early period are called Primitives. Even at this time the woodblock print was the result of close collaboration of the artist-designer, the publisher, who often molded the taste displayed in the print, the wood engraver, and the colorist.

The leading master of the transition from single-block prints to the early two-color engravings was Okumura Masanobu (1686-1764) who, in addition to exploiting the new techniques of 1741 and later, is credited with the invention of a new shape in prints — the extremely tall and narrow "pillar" print. The subtlety possible with block-applied color, in contrast to the rapidly applied rich color of the manual technique, led to more delicate, low-toned color combinations at the same time that the growing command of the artist produced more complex figure compositions. The *Maple-Viewing Party* combines the Tosa version of the narrative scroll tradition with the decorative development already seen in the costumes of *The Four Accomplishments* screens (fig. *645*).

In 1765 the two-color print technique was expanded and the polychrome print using numerous color blocks was the result. Prints were evidently popular, for the new technique was far more expensive and time-consuming than the old. The first artist to take full advantage of the new possibilities was Suzuki Harunobu (1725-1770), whose lovely prints show the most refined and subtle taste achieved in the medium. Harunobu, like Sotatsu, knew the value of plain areas contrasted to complex ones, of purposeful juxtapositions such as flowering plant and beautiful woman, or of deliberate suppression. The latter is particularly significant in the representation of the lion-vehicle of Monju (fig. *646*). Not only is it aesthetically effective, but it serves to

646. *Youth Representing Monju, God of Wisdom,
on a Lion. By Suzuki Harunobu* (A.D. 1725-1770).
*Color woodblock print, height 11½". Japanese,
Ukiyo-e School.* Cleveland Museum of Art

a frank presentation in permanent form of the over-acted, almost Grand Guignol realism of the *Kabuki* theater, may well have startled the pleasure-loving public, more attuned to charming ladies or flowering clichés.

The heyday of the figure print ends with the eighteenth century. The most creative printmakers of the first half of the following century, Katsushika Hokusai (1760-1849) and Ando Hiroshige (1797-1858), were primarily landscapists. Figures play a subdued if effective role in Hokusai's masculine compositions, while in Hiroshige's prints they become sticklike *staffage* to the serene and feminine beauty of his famous views. Landscape series became most popular in the nineteenth century and Hokusai exercised remarkable ingenuity in

647. *Bust of a Beautiful Lady Dressed in Kimono,
from Types of Physiognomic Beauty. By Kitagawa Utamaro*
(A.D. 1750-1806). *Color woodblock print, height 15"*
Japanese, Ukiyo-e School. Cleveland Museum of Art

downgrade the Buddhist significance of the print, producing instead a fashionable youth with elegantly elongated neck and almost unbelievably tiny hands and feet. Harunobu's style and mood was adapted by Kitagawa Utamaro (1753-1806) with somewhat bolder draftsmanship and more monumental scale, the most remarkable example being the *Types of Physiognomic Beauty* of 1794, where tinted mica backgrounds add to the daring decorative effect (fig. 647).

Such new boldness was grasped for the incredibly brief span of eight months in 1794-95 by an artist-actor with noble connections, Toshusai Sharaku. His 136 caricatures and portraits of *Kabuki* actors combine decorative power with the long-dormant satirical qualities formerly displayed in the Kamakura Period (fig. 648). This aggressive style was often made more dramatic by the free use of dark mica backgrounds which seem to throw the silhouettes of the posturing actors out at the spectator. Significantly, Sharaku's output ceased abruptly and we know that his prints were not popular. Such

OPPOSITE: 648. *Otani Oniji III as Edohei. By Toshusai
Sharaku* (active A.D. 1790-1795, d. 1801). *Color woodblock
print, height 14¾", dated A.D. 1794. Japanese,
Ukiyo-e School.* Art Institute of Chicago

東洲齋寫樂畫帖

489

649. *Mount Fuji Seen Below a Wave at Kanagawa, from Thirty-six Views of Mount Fuji. By Katsushika Hokusai (A.D. 1760-1849). Color woodblock print, width 14¾".* Japanese, Ukiyo-e School. Museum of Fine Arts, Boston

650. *Rain Shower on Ohashi Bridge. By Ando Hiroshige (A.D. 1797-1858). Color woodblock print, height 13⅞".* Japanese, Ukiyo-e School. Cleveland Museum of Art

making his views more than local scenes. The *Thirty-Six Views of Mount Fuji* are universal landscapes, usually dramatic and capitalizing on unusual juxtapositions — Fuji and the fisherman dwarfed by the clawing wave, or Fuji enmeshed in a mackerel sky (*fig. 649*).

As the popular taste for figure prints became evermore garish, landscape remained as the last remaining outlet for the sensitive and original artist. Hiroshige's achievement was to portray the "lovely" aspects of the Japanese landscape by using velvety color, technical virtuosity, and a more naturalistic, even Western-influenced, viewpoint. His landscapes are nearly always idyllic, but still particular. They have a local flavor as well as look. In this respect his numerous series of views, the *Fifty-Three Stages of the Tokaido Highway*, the *Sixty-Nine Stages of the Kiso Kaido Highway*, the *Hundred Views of Edo*, and others, maintain interest from print to print because of their particularity, while the subjects of Hokusai's landscapes seem far less important than their willful inventiveness and daring organization (*fig. 650*). Both artists, especially Hiroshige, whose paintings are singularly dull and pretty, are much indebted to the amazing skill of the engravers and printers who produced the prints from their designs. Traditional Japanese pictorial art ends in a consummate craft.

The potter's art, one of the supreme creations of the Far East, was an accurate reflection of artistic currents, both aristocratic and popular. The development of fine porcelain manufacture in seventeenth-century Japan,